Calling Memory into Place

Calling Memory into Place

DORA APEL

Rutgers University Press

New Brunswick, Camden, and Newark, New Jersey, and London

Library of Congress Cataloging-in-Publication Data

Names: Apel, Dora, 1952- author.
Title: Calling memory into place / Dora Apel.
Description: New Brunswick : Rutgers University Press, 2020. | Includes bibliographical
 references and index.
Identifiers: LCCN 2020004540 | ISBN 9781978807839 (hardback) |
 ISBN 9781978807853 (epub) | ISBN 9781978807860 (mobi) | ISBN 9781978807877 (pdf)
Subjects: LCSH: Collective memory. | Memory—Political aspects. | Memory—Social aspects. |
 Memory—Psychological aspects.
Classification: LCC BF371 .A54 2020 | DDC 153.1/2—dc23
LC record available at https://lccn.loc.gov/2020004540

A British Cataloging-in-Publication record for this book is available from the British Library.

www.rutgersuniversitypress.org

Manufactured in the United States of America

For my brother, Max

Contents

Introduction 1

Part I Passages and Streets

1 A Memorial for Walter Benjamin 17
2 "Hands Up, Don't Shoot" 21

Part II Memorials and Museums

3 Why We Need a National Lynching Memorial 35
4 "Let the World See What I've Seen" 77

Part III Hometowns and Homelands

5 Seeing What Can No Longer Be Seen 101
6 Borders and Walls 120

Part IV Hospitals and Cemeteries

7 Sprung from the Head 141
8 Parallel Universes 156

Part V Body and Mind

9 Reclaiming the Self 175
10 The Care of Others 185
 Conclusion 215

Acknowledgments 217
Notes 219
Selected Bibliography 233
Index 239

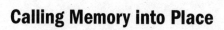

Calling Memory into Place

Introduction

Writing eighty years ago, the German philosopher and culture critic Walter Benjamin offered a visionary response to a small ink drawing by Paul Klee that still resonates today:

> A Klee painting named *Angelus Novus* shows an angel looking as though he is about to move away from something he is fixedly contemplating. His eyes are staring, his mouth is open, his wings are spread. This is how one pictures the angel of history. His face is turned toward the past. Where we perceive a chain of events, he sees one single catastrophe which keeps piling wreckage upon wreckage and hurls it in front of his feet. The angel would like to stay, awaken the dead, and make whole what has been smashed. But a storm is blowing in from Paradise; it has got caught in his wings with such violence that the angel can no longer close them. The storm irresistibly propels him into the future to which his back is turned, while the pile of debris before him grows skyward. This storm is what we call progress.[1]

I think of this while looking at a diptych of photographs titled *Bibliography: Memory Effects*, which pictures six stacks of books, each one on a subject related to the Holocaust. The stacks in the photographs lean together to form an open cave threatened by burning edges, as if the fiery residue of past incendiary horrors and passions are creeping into the scene. The diptych becomes a visual counterpart to Benjamin's fiercely imagined prose; it pictures not the angel of history but seems to allude instead to the wreckage piling up at its feet.

The work is by Buzz Spector and the books are all the ones I read in preparation for writing my own first book *Memory Effects: The Holocaust and the Art of Secondary Witnessing*. As the daughter of Jewish Holocaust survivors from

1

Poland, writing that book allowed me to work through an obsession with the Holocaust that held me in thrall all my life, always burning at the edges, flaring up when my mother or her fellow survivors told their terrifying tales at our kitchen table. These were often stories of burning shame and humiliation, stories always doused in tears. In *Memory Effects* I began to examine the consequences of those traumatic memories on the second generation, my generation, focusing on the work of postwar artists attempting to come to terms with inherited trauma and its meaning for their own sense of personal and cultural identity.

An artist best known for his work with books, Spector has made other such deftly conceived photographic works as portraits of his friends, just as these messy piles of books on traumatic memory represent something fundamental about me.[2] Spector turns most of the titles away from the viewer, suggesting all the pages once read and now forgotten. They have become an archive of the inexpressible, the silences of those who perished, and the occlusions of the survivors, who may pluck some facts from memory and order events into stories told and retold in hopes they convey something of the complexities of their trauma, the chaos and terror of events, the horrifying "choiceless choices," in Lawrence Langer's phrase. Spector also reveals a few carefully selected titles, among them Cynthia Ozick's *Quarrel and Quandary* and Bruno Schulz's *Street of Crocodiles*, Sander Gilman's *The Jew's Body*, and John Weiss's *Ideology of Death*. All of them rest on a foundation that includes the writings of Leon Trotsky, Isaac Deutscher's *The Non-Jewish Jew*, and *The Book of Questions* by Edmond Jabès. The philosophical theories, cultural and political histories, memoirs, novels, and essays on art and literature all stand in danger of succumbing to the flames themselves. But memory effects are not about the past. How do they shape the present and future? Can the way we remember the past play an active role in fighting ongoing forms of oppression and persecution? These are the questions at the center of this book.

I wrote down some of the stories told to me by my mother as an epilog to *Memory Effects* and read them to her after the book came out, when she was ninety-three. We sat on a bench in the sunshine outside her assisted living home, some sixty years after she had fled Poland. She burst into tears after my reading, exclaiming, "You remembered the stories!" I wept too, and felt a kind of anguished joy, realizing this had been one of my reasons for writing the book—wanting to make sure her memories were remembered. Though *Memory Effects* was about inherited trauma, I hoped that my mother's reconstructed memories, filtered through me, would also help mobilize Holocaust memory for contemporary emancipatory purposes.

In the still developing field of memory studies, it's understood that memory is not simply deposited in places, books, and objects as a static and bounded thing. Instead, memory is constantly translated and transmitted through generations, taking shape in new forms of media across disparate groups and cultures. This continual translation and transmittance produces dynamic forms of

Buzz Spector, *Bibliography: Memory Effects*, 2002, interior dye diffusion prints (Polaroid), diptych. (Courtesy of the artist.)

remembrance that transcend fixed ideas of meaning just as they transcend ethnic and national boundaries. Moreover, all memory is mediated by society, language, and representation: films, photographs, artworks, texts, memorials, monuments, stories. Memory and identity are therefore subject to negotiation and transformation, construed as open-ended and inclusive, comparative rather than competitive, so that we may see links between, say, the Holocaust and the mass killing of Native Americans or other forms of race terror and group persecution, and these links become the basis for a new understanding and common political struggle. Though this new model of memory promoted by the field of memory studies is always contingent and contested, it has the potential to shift the scales of discourse in favor of the formerly unremembered, marginalized, and repressed.

The role of memory in the writing of history took on greater importance in the 1970s, and memory studies have boomed in the last several decades. Since the 1990s, memory has become increasingly reconceptualized, especially the central belief that memory functions like a fixed and permanent archive. The interdisciplinary scholar Jens Brockmeier writes, "The traditional model of memory as a static and stable place of storage, where past perceptions and experiences are retained and from where they can be retrieved, proved increasingly to be inadequate—in fact, obsolete."[3] Brockmeier organizes memory studies into four fields: the literary and the artistic, the technological, the social and cultural, and the biological and cognitive, each with its own cultural traditions.[4]

The literary and artistic arenas were the first to interrogate memory and the construction of the self, which began in the early twentieth century and accelerated at the end of the century. In the fields of media and technology, the digital revolution has transformed how we remember into a digitally mediated model with nearly endless possibilities for contextualization, which, moreover, blurs the line between private and public, individual and collective. Rather than an archive, multimedial and networked computers create new contexts that are inherently mutable, changing not only the consumption of memory but also the production of memory. Memory and the global are increasingly studied together as mass media and especially the internet allow events almost anywhere in the world to be viewed globally in real time, a phenomenon that allows such events to be linked to new forms of democratic participation and activism. The global audience for this memory production, which is rooted in the staging of images, transcends the nation and subjects it to global observation and critique. This form of memory activism stimulates a growing moral consciousness expressed in part by the increasing number of public acts of commemoration and official apologies.[5]

We can see the awareness of a global audience already present during the postwar Nuremburg trials in Germany, followed by the Eichmann trial in Jerusalem in 1961. Holocaust memory has largely driven memory studies, which has powered the recognition of many other genocides and atrocities in local and global memory cultures. Holocaust memory became a catalyst for memory activism and serves as a universal yardstick against which to measure other atrocities; it is rivaled, however, by imperialist and colonialist experience, which is equal to the Holocaust regarding claims to morality and recognition.[6]

In social and cultural fields such as history, cultural studies, and the social sciences, sites of memory become places where those who experienced trauma share individual and cultural memory. They remain memory sites long after those who were there have died because later generations "remember the memories of others," in Brockmeier's phrase. Such memories are continually reconfigured according to the needs and pressures of the present, as new archives are opened or new voices are raised by the previously silenced or marginalized. These new perspectives helped produce new academic approaches on subjects such as postcolonialism, race, and gender studies. An example is the reconstruction of the narrative at Monticello, which puts the stories of enslaved families into the narrative and acknowledges for the first time without equivocation the relationship between Thomas Jefferson and the enslaved woman Sally Hemmings and the children they had together.[7] Memory, constructed by language and place and defined by social practices, is subject to reconstruction, a process in flux rather than a fixed entity.

The fourth area in Brockmeier's schema is the field of neuroscience, which is his primary area of expertise, and where a neurological discovery confirms the insights of memory studies scholars in the humanities and social sciences. This

is the understanding that there is no biological correlate to "memory." There is nothing in the brain that distinguishes remembering the past from perceiving the present or imagining the future, "whether in a visual, acoustical, or tactile mode." Memory, in other words, has no location; the neuronal circuits are the same for past, present, and future. This suggests that memory must be constructed by a more complex consciousness than that provided by neuronal circuits and this can only be society and culture, language and narrative, which accounts for the widely diverse concepts of memory and time among different cultures. These diverse concepts of memory and time in turn align with different concepts of the self, varied cultural values and worldviews.[8] The social construction of memory also explains how memory changes, both individually and collectively, as social contexts and public narratives undergo modifications and challenges. Because memories are not fixed and permanent entities to begin with, they are adaptable and changing all the time in response to events, narratives, and changed expectations.

It is a well-studied phenomenon, asserts Brockmeier, which shows that every act of remembering mixes elements of experience from the past with elements of experience from the present, and conversely, all new input encounters experience from the past, which shapes its meaning, texture, and emotional quality. This mutual influence and shaping of experience and memory, both past and present, is the opposite of an archive that encodes, stores, preserves, and retrieves from long-term and short-term storage. Memory, instead, is the product of cultural construction and reconstruction, mediated by intention, and embedded in environments and contexts, including media and technology, art and literature, language and stories, that are themselves subject to historical mediation. Memory is therefore dynamic and unbound, moving across cultures, generations, media, and disciplines.

Returning to the work by Buzz Spector, we might now consider the photographic diptych as a mediated visual memory of the literature, language, and stories of others, some of which may be forgotten even as the image carries their memory forward. The work is made with a media technology now obsolete—the large format Polaroid—coinciding with the era in which these books were written and producing the accidental effect of the burning edges, which not only mediates how we experience the subject of the work but also suggests the fading of the photos themselves and the contingency of memory. Yet the inquiry into memory, place, and identity that originally motivated the writing of *Memory Effects*, for which these books served as a bibliography, and Spector's subsequent image, is still ongoing in this book, now mediated by other literature, language, and stories, as well as events and experiences in a changed political era.

In *Memory in a Global Age*, Aleida Assmann and Sebastian Conrad argue that even when memory is not invested with universal claims, contemporary debates

about the past are informed by the global context in which they unfold, allowing memory activists to appeal to shared pasts in support of common moral or political agendas.[9] The debate over Confederate monuments, the opening of a national lynching memorial in Montgomery, or a controversy over a painting of Emmett Till by a white artist, all take place in the era of Trump and other global authoritarians, an era when democratic rights are openly spurned and white nationalism is on the rise, which gives these debates important moral and political significance.

As white supremacism becomes resurgent, social and economic inequality grows worse, and climate change accelerates, racial violence, the global refugee crisis, and immigration become more desperately urgent issues. This global context helps shape the conflicted reception of commemorations and representations of the oppressed. It makes sense then that the memory landscapes for both the Holocaust and American racial violence contend with overlapping questions: How to commemorate histories of persecution and oppression? Who has the right to produce such representation? How does visual representation narratively construct the nation and national identity? The public culture of memory is a site for negotiation and debate because memorials, art, and stories remap cultural memory and change how we think about history, group identity, and ourselves.

The Jewish question and the black question have always been intertwined for me. After our chicken farm went bankrupt, my parents, immigrants and Holocaust survivors, sold chickens and eggs door to door for several years. One day after school, when my mother was ill, my father offered to take me along for a delivery to a single customer. This was highly unusual and surprising since my father had never offered to take me along on the egg route and I had never met any of their customers. But he wanted me to meet this one.

It was 1964, after my mother had put a framed color photograph of John F. Kennedy on the dining room wall following his assassination, and after the lunch counter sit-ins, the Freedom Rides to integrate interstate buses, the racist church bombings, the protests against them, the March on Washington, the voter registration campaigns, the Civil Rights Act. The woman my father wanted me to meet was a black schoolteacher in her mid-thirties, who invited us into her home. I was amazed when my father accepted the invitation and we sat in her living room for an hour while they talked. My father's English was limited and usually he let my mother do the talking. The fact that he wanted me to meet this woman and that we were now sitting in her living room while he spoke in English with her for a whole hour was astonishing.

I no longer remember what they talked about, but I remember my impression of her: poised, cultivated, attractive. How unlikely they seemed, my usually reticent, mid-fifties immigrant father, with his heavy accent, and this African American schoolteacher at least twenty years his junior. She was intelligent, educated, and willing to have long serious discussions with him. I understood that my

father was trying to teach me something about difference and acceptance, about outsiders and kindred spirits finding each other and connecting. I understood that I should not mention this visit to my mother.

I learned more about such relationships several years later when I was fifteen and became friends with Steve, a black boy in my grade. We read each other's poetry and talked about books and music for hours on the phone. Then we began meeting at the public library. One day my father saw me walking with Steve outside the library and there was a pregnant pause as I got into the car. He asked if this was the friend I always met at the library. I said yes, waiting for an admonition to find a Jewish boy. But my father said nothing. I did not think, then, about the black schoolteacher.

My friends were not as accepting. Edith, an older girl I knew and admired, angrily accused me of "using" my friendship with Steve to "show off." Show off what? I wondered. My ability to have friends who were not white? It was clear to me now that whiteness, not Jewishness, was the issue, a category of identity constructed for the sole purpose of differentiating it from blackness. When Jews first emigrated to the United States—along with Irish Catholics, southern Italians, and Greeks—they were seen as a distinct racial group and only gradually became "white," demonstrating the contingency of the concept of whiteness. But it was still hard for me to understand how my friendship with Steve threatened Edith. Then Steve told me his friends teased him relentlessly about me. I was equally shocked by this. The pressure got to him and he told me we needed to stop seeing each other. I was hurt, but I understood that our friends felt somehow betrayed, unwilling to accept that we were kindred spirits.

Our friends' reactions were infuriating and bigoted, enforcing racial difference on both sides that constructed blacks and whites as essentially different, just as Jews had been constructed as racially different by the Nazis. It was disconcerting to realize that I was not just Jewish but "white." As a child, I had thought the two were separate, that I would always be "other." It seemed natural to me to identify with the marginalized and oppressed, natural that Jews, having suffered pogroms, made up half of the revolutionary cadre in Tsarist Russia despite being a tiny percentage of the population, and played a strategic collaborative role in the Civil Rights movement. It does not surprise me now that the artist Dana Schutz, at the center of a controversy about cultural appropriation because of her painting of Emmett Till, is Jewish. For white nationalists today, their racism is equal to their antisemitism, which is still premised on the conviction that Jews are racially different.

In my late twenties, I met D., a charismatic black intellectual. We were both members of the Trotskyist Spartacist League, newly arrived in Detroit, and antiracist activists who found ourselves attracted to each other one night after a spirited discussion of dialectical materialism. Soon after our first date at a Muddy Waters concert, we moved in together in Highland Park, a working-class black

city surrounded by Detroit not far from the original Ford auto plant. I was his first white girlfriend and he was my first black boyfriend. A highlight of our work was an anti-Nazi mobilization that stopped the Nazis from holding a public rally downtown. I helped organize it; D. was a key speaker at it. About five hundred people came. That night we had a party and danced to Motown with joyful abandon.

But I never stopped being aware of the hostile stares we often received in public, the assumption by the Highland Park police, who would stop me on the street, that I was a prostitute. D.'s favorite fantasy, one that seemed almost preordained for black men and white women at the time, was of him as a big buck seducing a plantation owner's daughter. I was never entirely comfortable with it, finding it difficult to identify with my role, and it seemed to me the owners of those hostile stares had the same fantasy.

To be black in America is to risk humiliation, harassment, or harm every time you are in public. With the election of the corrupt and overtly racist Donald Trump, the dedication of a national lynching memorial and museum in Montgomery in April 2018 came at a time of exacerbated national tensions, embodying the deepening anxieties of a nation long in conflict, where the Civil War, it can be argued, has never ended. White supremacism, always dominant, reared its ugly head with renewed energy, provoking, among other things, local and national conflicts over Confederate commemorative monuments, especially in the American South. The culture of memory "calibrates existing narratives to emergent social realities," observes Ann Rigney, but "remembrance is also a resource for redefining the borders between 'them' and 'us.'"[10]

Commemorative monuments can take on new meaning that derives from events occurring at those sites. The Confederate monument of Robert E. Lee in Charlottesville, Virginia, for example, will forever be associated with the murder by a white nationalist of a thirty-two-year-old woman and the serious injury of nineteen others who were protesting a "Unite the Right" rally in defense of that monument in August 2017.[11] White supremacists, nationalists, and neo-Nazis chanted, "White lives matter," "You will not replace us," and "Jews will not replace us," correlating their fear and hatred of African Americans and other people of color with their fear and hatred of Jews, who are differentiated from those who are white, while attempting to preserve an increasingly threatened sense of white supremacy.

Suggesting that falling birthrates will lead to white people being replaced by nonwhite people, white supremacists, who also fear that their political and economic supremacy is being undercut by women, believe that white women should not have the right to work or vote, that instead they should stay home and raise families—a throwback to the Confederate South commemorated by the monuments they defend.[12]

The body has also been recognized as a site of social and cultural construction and as a place of embodied knowledge and inherited trauma that influences how we respond to stress. By embodiment, I mean the radically material nature of human existence, in which the lived body makes meaning out of bodily experience. Along with the moods, anxieties, and stories by which parents transmit trauma to their children, recent developments in epigenetic studies show that mood disorders such as depression and bipolar disorder may be understood as interactions between stress and an individual's inherited vulnerability to stress. Epigenetics explains how external events such as trauma or stress may trigger chemical changes to DNA, which affect how a person's genes are expressed without changing the DNA sequence. These chemical changes can pass to the next generation and even the third generation. This is a major insight into the nature of inherited trauma, a form of embodied knowledge demonstrated in studies of mice taught to fear the smell of cherries who pass that fear on to their offspring, or in studies showing that traumatic stresses on Civil War soldiers affected their sons' lifespans.[13]

Trauma studies, related to the field of memory studies, grew after the American Psychiatric Association officially recognized post-traumatic stress disorder in 1980. More recently, however, scholars have been critical of dominant trauma theory that posits trauma as necessarily inassimilable experience. They reasonably suggest that this understanding may be too narrowly conceived, that it "emphasizes a victim position and potentially fails to give due attention to the expression of agency."[14] This study considers the expression of agency rooted in trauma, both for those who experience it directly and those who inherit trauma.

The gendered nature of experience is also integral to these themes and came into focus with the establishment of memory studies. The experiences of women in the Holocaust, for example, became a systematic subject of study following a watershed conference organized in the United States in 1983. Initially, the work concentrated on recapturing the lost histories of women's experience and memory. The pioneering volume *Women in the Holocaust* (1998) further examined how women's experience was different from that of men, the roles women played in the ghettos, resistance movement, and camps, and how their different areas of expertise and gender conditioning inflected their responses to the Nazi onslaught. It also examined consequences of women's biological differences and their greater vulnerability to sexual assault and abuse.[15]

While some feminists raised concerns that women were being reduced to their biology by focusing on pregnancy, motherhood, and sexual violence, others argued that to deny these gendered experiences would be to maintain the status quo that denied women's unique biological and social experiences. Those in masculinity studies have pointed out that men were also humiliated and abused in biological terms and that we must examine male experience in tandem with women's experience to understand the similarities and differences.[16]

What the literature has made clear is that we cannot consider the experience of Jewish men to be the norm. It is necessary to see how Nazi policies and circumstances of the Holocaust in multiple contexts constructed gender and how gender inflects traumatic memory and representation, helping to shape cultural memory and inherited trauma. Many scholars argue that using gender as a category of analysis is fundamental to understanding the Holocaust, along with categories such as religious beliefs, political ideologies, social class, or age, even though, in the end, everyone was killed because they were Jewish.[17]

In the last decade, the focus on gendered experience has been extended to lynching and racial violence.[18] Not only were 150 women lynched between 1880 and 1930 (of which 120 were black, others white or Mexican), but many more were tarred and feathered, whipped, raped, and burned. In addition, scholars have only recently begun to consider in a systematic way the effects of the lynchings of black men on their wives, daughters, and mothers, the active and activist roles played by women, the transgenerational effects of lynching trauma on families, and the collaborative antilynching activism—or active complicity—of white women. The emphasis on black men has elided the collective effect of lynching on black communities and specifically occluded the experience of black women, which tends to be less visible than the public torture and emasculation of black men. The #MeToo movement, initially launched by celebrity white women who refused to continue to quietly submit to sexual harassment and assault, quickly spread, here and internationally, to black and working-class women, and must also be understood as another outcome of the increasing emphasis on making visible gendered experience.

Calling Memory into Place thus advocates for a renewed understanding of the relationship between racism, antisemitism, and sexism. It engages the overlapping themes of Holocaust trauma, racial violence, and gendered experience, which intersect with the experience of place and embodied knowledge. By investigating relations among place, memory, and identity, we hope to reveal the dynamic nature of memory, which crosses generations, rewrites an understanding of the self, and generates ongoing debates and political struggle by shaping and reshaping the culture of memory.

Place is here conceived as a center for meaning, self-reflection, and belonging, and, conversely, of dislocation, forced mobility, and atrocity. I rely on phenomenology's central insight into place, which is that existence itself is always placed, always situated, and cannot make itself known otherwise. Memory and experience are emplaced through association with embodiment. The embodied awareness of place is therefore fundamental to knowing and consciousness. We always inhabit a place. But memory is also connected to place independently of the body; we might say memory is written upon place and place is written upon the body. The memory of place may refer to unique personal events or to historical events that are transferred across generations. But places, bodies, and memories are subject to change, so that visiting or revisiting a place is as much about the present as the past.[19]

This book considers the ongoing construction of memory through memorials, photographs, artworks, and stories, including my own, as forms of representation that inherently structure memory as a collective way of knowing, even if rooted in the personal, producing cultural memory that changes how we understand the past and approach the present, often by remembering what was formerly considered unworthy of being remembered or by reinterpreting its meaning. Put another way, the reconstruction of cultural memory begins a process of unforgetting, like the inclusion of enslaved experience in the Monticello narrative, in order to counter disbelief, construct a sense of empathy, and achieve a greater understanding of the roots of racial and ethnic oppression and of the ongoing struggles for equality and social justice. The goal of this book is to serve as an example of this kind of reconstruction of memory in our deeply troubled political era, marked by ever increasing inequality, persecution, discrimination, and racialized violence. It uses personal narrative, imagery, and analysis to help us see through the eyes of others, whose experiences may be very different from our own, but who embody and connect us to larger histories. As James Baldwin is quoted as saying in Raoul Peck's masterful film *I Am Not Your Negro* (2016), "History is not the past. History is the present. We carry our history with us. We are our history."[20]

Yet we know there is no "pure history" free of cultural trends and representations. The memory landscape in Holocaust representation, for example, includes videotaped witness testimonies, films, photographs, novels, memoirs, written histories, legal proceedings, museum displays, and memorials, which haves become inextricably woven together in public memory. Because history is always subject to the political needs and pressures of the historical moments in which such representations are produced, memory and embodied knowledge enrich and deepen history, rendering both memoir and historical analysis dynamic and unbound.

Although I deploy artistic images throughout, which resonate in one way or another with ideas or issues in the text, this is not primarily a work of art history. The images, including works by artists such as Nick Cave, Kwame Akoto-Bamfo, Sally Mann, Annette Messager, Carmen Winant, Diana Matar, and Yael Bartana, among others, for me become another way of knowing; they are capable of producing embodied responses even before we think about what they might mean or why it's important; they construct knowledge that resonates with intellectual analysis and personal narrative, as with the photographic diptych by Buzz Spector.

The essays in this book include cultural and political critique as well as memoir and family history. Because the formal conventions of scholarship often fail to convey the visceral feelings of embodied encounters with places, events, or visual images, the book's structure is an experiment in the mixing and juxtaposition of different writerly formats. While scholarly conventions tend to enjoy a privileged status, my claim is that embodied and experiential ways of knowing are equally valid and construct knowledge in unique and complementary ways.

The book therefore shifts between the scholarly, the personal, and the visual as different ways of knowing, in order to perform in practice an attention to the political and affective dimensions of trauma, memory, and place.

My hope is that such an alternative, hybrid approach might enable new insights into the traumatic legacies of racial, ethnic, gendered, and political violence as they continue to reverberate today. The essays also consider the role of trauma in agency and survival, some more overtly than others, gesturing at ways in which traumatic inheritance might lead to productive effects. These explorations are meant to offer different forms of access to embodied experience and its relationship to the dangers and opportunities of our present political moment in hopes of helping to promote a more just and compassionate future.

Calling Memory into Place is divided into five parts that represent different sites of memory, with two essays in each part that reach backward and forward to resonate with other essays. I use the essay format for the greater freedom it offers. If history is an ongoing interpretive process, the essay allows for the experiential approach of discovery and self-discovery, the freedom to experiment that permits impressions, reflections, and emotions, and the space to produce different ways of shaping knowledge by putting forth an argument or "reading" a visual image.

In the first section on passages and streets, "A Memorial for Walter Benjamin" considers the formal and informal memorialization of individuals, beginning with a memorial in Portbou, Spain, for philosopher Walter Benjamin, who fled the Holocaust in Germany; it opens a space to question the received history and memory of his death. The second essay, "'Hands Up, Don't Shoot,'" analyzes the persistent street memorials for Michael Brown, who was killed by a police officer in Ferguson, Missouri, and the popular slogan that in part attempts to assuage liberal anxieties about race.

The second section looks at two museum and memorial controversies in the United States that focus on how we remember the past in order to change the present. "Why We Need a National Lynching Memorial" examines the controversy over a large public memorial to the nation's thousands of lynching victims and an accompanying museum on slavery and mass incarceration in America, which opened in the midst of resurgent white nationalism. The essay further reflects on the debate over Confederate monuments and the role of women in white supremacist ideology. "'Let the World See What I've Seen'" critiques the controversial essentialist claims made by critics of Dana Schutz's painting of Emmett Till in the 2017 Whitney Biennial and further examines the issue of diversity in museums.

The third section on hometowns and homelands further investigates the way memory is rooted in place. In "Seeing What Can No Longer Be Seen" we visit sites of oppression through images, return to my parents' hometown in Poland, take a tour of Auschwitz-Birkenau, and stop in places once inhabited by Freud and Trotsky in Vienna. "Borders and Walls" analyzes the contested

politics of place during a visit to Israel-Palestine for a world conference on Jewish Studies, including interviews with Israeli and Palestinian artists, a tour of border wall checkpoints, and visits with Palestinian families living on the street after an Israeli court evicted them from their homes in East Jerusalem.

The fourth section on hospitals and cemeteries considers the places of memory associated with birth and death as written on the body and the effects of trauma both remembered and inherited. "Sprung from the Head" explores artworks that evoke lost children and childbirth, and chronicles my attempt to compensate for my mother's traumatic postwar experience of giving birth in a German hospital with my own birth experience forty years later. "Parallel Universes" recounts my mother's final days, her surprising command over her fate, her conviction that she had access to a parallel universe, and the traumatic recurrence of Holocaust memory.

The final section on body and mind explores the body traumatized by illness as a site of productive or creative intervention that draws on memory of the past. "Reclaiming the Self" focuses on the visual imagery of Hannah Wilke's *Intra-Venus* series, a body of photography made during the artist's mortal illness in which she effectively creates her own memorial before her death. This chapter is meant as a companion piece to the final essay, "The Care of Others," which is a memoir of my year of breast cancer treatment and my struggle for control and self-advocacy within the medical institution. Wilke's relationship to her mother and to the Holocaust played a part in how she conceived of her final work, just as my embodied response to illness and treatment was shaped by memory of my parents' Holocaust experience and my mother's resilience in the face of that trauma.

The processes of remembering and meaning-making, influenced by cultural forces, make the construction of the self and of culture mutually constitutive. Through the never-ending process of remembering, we interpret and provide meaning to the past, shaping and reshaping culture and our own consciousness, making and remaking ourselves and the world.

Part I

Passages and Streets

1

A Memorial for
Walter Benjamin

The general outlines of the inconclusive story are well known. On September 25, 1940, a small band of weary refugees made their way by foot over the Pyrenees in a nine-hour journey from France to the steep rocky coast of a small Spanish village on the northern Costa Brava in Catalonia, on the other side of the French border. The Jewish writer and critic Walter Benjamin was forty-eight years old. That evening, after securing rooms in a hotel, Benjamin's papers were found not to be in order by the local authorities. Under threat of being sent back the next day and fearing internment in a camp, Benjamin died that night in his hotel room, a suicide resulting from a morphine overdose. The other members of his group made it safely to America. But there are odd elements to the story. A manuscript Benjamin carried across the Pyrenees disappeared. The suicide note, two, actually, that he allegedly left were destroyed by his traveling companion, Henny Gurland, who then rewrote them herself as she "remembered" them (one for her, one for Theodor Adorno). The coroner's report mentioned no evidence of morphine. Other details do not mesh. Benjamin's identity was confused with a Dr. Benjamin Walter, and his remains were placed in the Catholic part of the Portbou cemetery for five years, after which they were removed and placed in a collective grave. They can no longer be found. An article in the *New York Times* intimates that Benjamin did not commit suicide after all, but was murdered by a Stalinist agent—his traveling companion, Henny Gurland.[1]

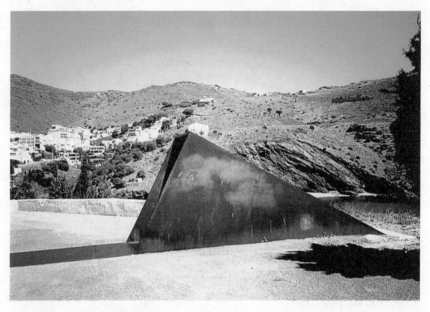

Dani Karavan, *Passages: Homage to Walter Benjamin*, 1990–1994, exterior view, Portbou, Spain. (Photo: Gregory Wittkopp.)

A headstone was erected and placed in the Portbou cemetery in 1990, the year Israeli artist Dani Karavan began work on a monument next to the cemetery, *Passages: Homage to Walter Benjamin*, completed four years later.

The road to Portbou from Barcelona is arduous, with many twists and turns around a mountainous terrain with a sheer drop, doublings back, and near terrifying moments when other cars or vans approach from the opposite direction on the narrow road. We rise higher and higher, then descend to the sea and the former fishing village. My fear that the way to the monument will be unmarked is laid to rest by a sign that proclaims "Walter Benjamin Monument" with an arrow. We enter a hotel across from the Tourist Information Bureau, which has postcards and brochures for the monument at the front desk, and pay double the rate of an inside room for one with a view of the sea.

We drop our bags and walk to the monument, arriving a little after nine o'clock in the evening. It's still light out. A rusted steel portal provides the entrance to a corridor through the rock to the sea. The picture postcard at the hotel does not prepare me for the effect of this passage, the long flight of stairs through the steel rectangle ending above the water thrashing over the rocks below, visible through a thick pane of glass set two-thirds of the way down. The glass prevents one from accidentally falling—or from hurtling oneself down—but the pull through the glass is surprising, haunting, frightening.

Benjamin's native German words are etched onto the glass at the top, translated at the bottom into three other languages, Spanish, French, and English: *It*

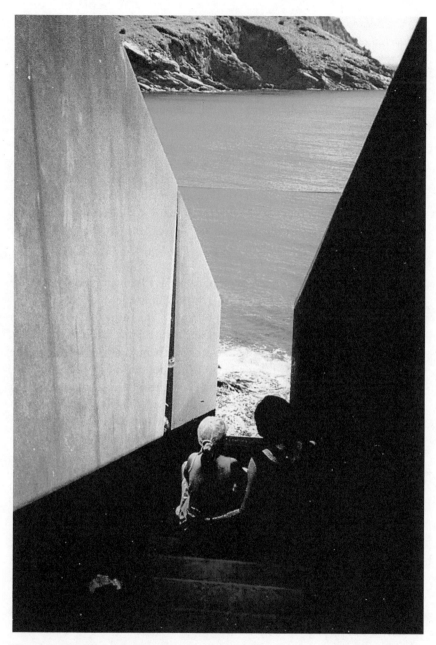

Dani Karavan, *Passages: Homage to Walter Benjamin*, 1990–1994, interior view, Portbou, Spain. (Photo: Gregory Wittkopp.)

is more arduous to honour the memory of the nameless than that of the renowned. Historical construction is devoted to the memory of the nameless. Though Benjamin wrote these words before the Holocaust, I nonetheless think of the gas chambers. But this monument is not intended for the unheard of and unheralded; it's for Benjamin. Sitting on the steps in front of the glass, inside the sea of sound, water, and wind, I notice the blue sky behind me reflected as a rectangle on the water and rocks below, my own shadow within the rectangle, dark and anonymous.

The wind gusts up with a surprising power in Portbou; the mountains become a dense blackness. The beach along the quay is made up of sharp rocks. How was it sixty years ago crossing the Pyrenees on foot? At that dark moment during the night? The thought of flying off the narrow winding mountain road into the sea on our return the next day seizes me with terror again and again during the night.

What is the function of the public monument? Traditionally, monuments are meant to yield resolution and consensus by providing a form of historical closure to contentious events. As a commemorative form, the public monument is meant to last forever as a repository for an "unchanging" collective memory. Think of Maya Lin's Memorial Wall in the Vietnam Veterans Memorial, the Berlin Memorial to the Murdered Jews of Europe, and the National September 11 Memorial & Museum in New York City. The debates surrounding them raise basic questions: What memory is to be preserved? How? For whom? In the nineteenth century, these questions were invariably resolved in the form of heroic figures performing symbolically noble acts or triumphant gestures in a manner consistent with the prevailing myths and ideology of the dominant culture. Thus, it proved impossible to remember slavery through the public representation of a black person; instead, Abraham Lincoln stood for all. In the second half of the twentieth century, after the profound disillusionment produced by the Second World War and subsequent wars, memorializing monuments have increasingly departed from the redemptive model, becoming nonrepresentational and more concerned with loss, mourning, and sorrow than with purity of purpose, heroic sacrifice, or other moral certainties.

The central feature of Dani Karavan's monument to Walter Benjamin, its memorializing function, like much contemporary art about the Holocaust, is predicated on the impossibility of a satisfying historical closure. There are other elements, too, dispersed around the area—an olive tree and a steel cube among others, but these take on the status of sentimental knickknacks cluttering the main idea. The steel passage itself invokes the uncertainties of the historical role and political agency of the individual. Is there another path, one that does not lead into the depths of the sea? The stairs that go downward also go up. Might Benjamin have resisted the gravity of despair?

2

"Hands Up, Don't Shoot"

Four years after the killing of eighteen-year-old Michael Brown by a Ferguson police officer, Brown's father led the rebuilding of a street memorial on the spot where his son had been shot to death. Immediately after his death in 2014, there were several makeshift memorials for Brown, consisting of stuffed animals, baseball caps, candles, balloons, and flowers. These were destroyed several times. One memorial burned while police watched and claimed they could not put out the fire; another memorial was driven over. A tree and dedication marker planted in a nearby park were vandalized when part of the tree was cut off and the marker stolen. Ferguson police representative Timothy Zoll described a new memorial on Canfield Drive around a telephone pole near the spot where splotches of Brown's blood still stained the street as "a pile of trash." He was suspended after the *Washington Post* quoted him. Each time the street memorial was destroyed, members of the community rebuilt it, and protests against the killing went on for months. In 2015, a year after Brown's death, the city finally embedded a permanent memorial plaque in the sidewalk near the spot where he was killed.[1] This, however, did not prevent the rebuilding of the street memorial in 2018 on the fourth anniversary of the killing, one of several commemorative events. The street memorial keeps Brown's memory alive, invoking the presence of the departed, the injustice of his death, the grief of the bereaved, and the importance of place when a violent and sudden death has occurred, and communicates all this with the public.

What is the significance of the permanent plaque embedded in the sidewalk by the city when cities have not installed such markers for the thousands of

other young black people murdered by the police? The plaque may be seen as a concession wrested from the city, which must have realized that destruction of the memorials would not prevent their reconstruction. Although the city claimed the piles of flowers, balloons, and teddy bears were a traffic hazard, the greater problem with the street memorial was that it inverted the memorial function of providing closure to a painful event, instead serving as a form of ongoing protest that would not allow the killing to recede into the past. The street memorial was not meant to provide closure, but to prevent it.

Scholars postulate that the increasingly pervasive appearance of roadside memorials constructs new forms of mourning, that the old rituals no longer seem sufficient, especially when death is sudden, violent, and senseless. While most roadside memorials mark traffic fatalities and may be understood as public places for private grief, Michael Brown's street memorials are the opposite, becoming public places for collective grief; we could regard the street memorial as a traumatic liminal space for transformation from passive victimization to activist memory, and in this way, a forum for community consolidation.[2]

In other words, those who build and gather at the street memorials refuse to allow Michael Brown's brutal killing to be forgotten. Prosecuting Attorney Robert McCulloch, who led the highly criticized investigation into Brown's death and did not file charges against Officer Darren Wilson, was ousted in 2018 by black Ferguson City councilman Wesley Bell, who vowed criminal

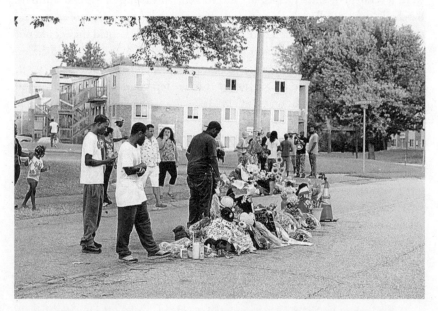

People gather at makeshift memorial for Michael Brown on Canfield Drive where he was killed by police officer Darren Wilson; Ferguson, Missouri, August 30, 2014. (Photo: ginosphotos/iStockphoto.com.)

justice reform but has resisted pressure to reopen the investigation into the killing. Brown's mother called on the Missouri governor to reopen the investigation in an online petition with sixteen thousand signatures, despite receiving $1.5 million from the city in a wrongful death lawsuit.[3]

In an amateur photo taken at the site, mostly black community members gather, adding more objects to the growing tokens of mourning or paying their respects through their presence near the site. A woman approaches holding a young girl by the hand while several young men solemnly contemplate the memorial, one protectively crossing his arms. The photo is taken at a random moment, the mourners affectively connecting to the death site as an act of embodied and collective memory.

The protests began immediately after the killing and spread across the nation. *Time* pictured the protest on its September 1, 2014 cover with an image of a single protester on her knees in the road with her hands up, facing a flash bomb set off by police. Despite the defiance in her locked elbows and flexed wrists, the posture has the quality of lone sacrifice. It represents one of two dominant kinds of images in response to the murder of Michael Brown: black protesters with their hands up in the posture of surrender, or police in riot gear sometimes aiming weapons at the protesters. In solidarity with the demonstrators, sympathizers from around the country posted photos with their hands up on social media such as Twitter's #handsupdontshoot, while the chant of "hands up, don't shoot" became a constant refrain on the streets of Ferguson and in demonstrations from New York to Los Angeles.

The "hands up" gesture is equivalent to an animal in a fight baring its neck, its most vulnerable part, signaling defenselessness and submission. According to Brown's friend Dorian Johnson, Brown was shot with his hands up, facing the cop that shot him six times, with the final, fatal bullet entering the top of his head, suggesting he was going down or on his knees. The gesture of surrender, then, failed to do its work, exacerbating the outrage at the killing of an unarmed black teenager by making it seem even more vicious and gratuitous.

The summary execution of a black man by the police is a common occurrence in America, and the cops routinely suffer no consequences or else get a slap on the wrist, indicating the official stance on such deaths. Although blacks and antiracist whites saw the killing of Michael Brown and others like him as an outrage, more money was raised in support of the killer police officer, Darren Wilson, than for the family of Brown. There were those who described the black protesters as "troublemakers"—meaning those who fought back against the police by throwing rocks or bottles, engaged in looting, or simply voiced their outrage by protesting peacefully, by protesting at all, even with their hands raised in surrender. For the racist whites who support the police, peaceful protesters and looters are all the same. For those who support the protesters, looting is a diversion from the main story of racist murder. Even news crews, reporters, and bystanders in Ferguson, regarded as sympathetic to the protesters, were attacked

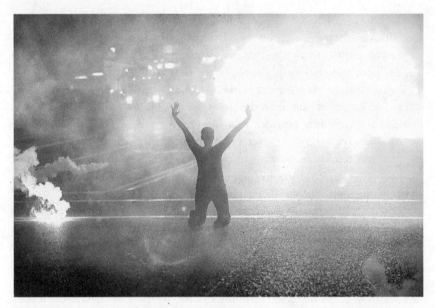

Tear gas rains down on a woman kneeling in the street with her hands in the air after a demonstration against the killing of Michael Brown by a Ferguson police officer on August 17, 2014 in Ferguson, Missouri. (Scott Olson/Getty Images.)

or arrested by the police. Black protest, it would seem, is viewed by many not as a constitutional right in a democracy but as a form of "violence," a public assertion of rights that cannot or should not be tolerated.

If the shooting of Brown is considered by many to be justified, and protest, whether angry or supplicating, is regarded as infuriating and intolerable, then we must see such cop killings of unarmed black men as a form of modern, *legalized lynching*.

At the height of private and spectacle lynchings from the 1890s to the 1930s, black people were considered "uppity" if they were not sufficiently deferential and submissive, which was grounds for lethal action. Not much has changed in the intervening decades for police and racist whites. A joint *Huffington Post* and YouGov poll found that 76 percent of black respondents said the shooting was part of a broader pattern in the way police treat black men, nearly double the number of whites who agreed (40 percent). Similarly, a Pew Research Center poll found that 80 percent of blacks favored the statement that Brown's shooting "raises important issues about race that need to be discussed" while only 18 percent of whites favored this statement over another that said "the issue of race is getting more attention than it deserves."

While the performance of nonresistance expressed by the "hands up, don't shoot" gesture of defenseless surrender is meant to advance black interests by exposing the violation of basic civil rights and due process, it is also meant to pressure and shame the racist establishment into effective reform. But for the

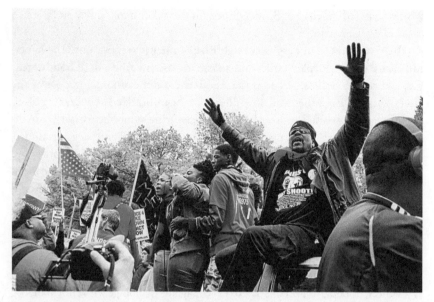

Protester with "hands up, don't shoot" gesture at rally to protest killing of Michael Brown; Ferguson, Missouri, 2014. (Photo courtesy Shanna Merola.)

racists in charge, the police are just "doing their job" when they humiliate, brutalize, and kill black people on the street.

The police have always been the frontline defenders of a racist capitalist system that is built on the repression of poor and working people, especially blacks and Latinos, in the service of a tiny wealthy elite, the only ones to whom the police are accountable. As if demonstrating their power to kill with impunity, despite the protests against Brown's killing, two days later in Los Angeles cops killed Ezell Ford, another unarmed black man. Eight days later and less than four miles away from where Brown was killed, police in St. Louis fatally shot Kajieme Powell, a mentally ill and agitated black man on the street holding a knife.

The submissive hands up gesture of black protesters facing a militarized police force is meant to appeal to liberal sympathies by showing that they are "respectful" and law-abiding, suggesting the opposite of "uppity." Yet the deference of the act has the paradoxical effect of reinforcing white stereotypes about black people. As Martin Berger demonstrates in his revisionist study of iconic civil rights photos, *Seeing through Race*, white-run newspapers selected civil rights photos showing black passivity in the face of police violence, while black-run newspapers selected photos that showed both protesters and police as active agents. Berger suggests that white editors selected images of blacks offering no resistance to police violence because it was easier to gain white liberal sympathy by visually defining racism as excessive acts of brutality, from which moderate and liberal whites could distance themselves. At the same time, their racial anxiety could be quelled by the picturing of black nonresistance, which meant that

whites were still in charge. Black editors, on the other hand, often preferred to show black agency.[4]

The visual record of Ferguson establishes similar juxtapositions. The hyper-militarized police deploy tanks and automatic assault rifles, flash bombs, tear gas, and rubber bullets, weapons that recall the water cannons and dogs of the civil rights era. Both then and now, photos of the militarized police facing black protesters who are non-resistant perform reassuring symbolic work that manages white anxieties about race. Whites are still in control and racism is understood as brutal acts of violence, not as part of the insidious indignities and brutalization of everyday life. Picturing blacks as non-threatening and non-resistant effectively places them in a role of limited power; it does not fundamentally threaten white racial power. As Berger observes of civil rights photos, "The photographs presented story lines that allowed magnanimous and sympathetic whites to imagine themselves bestowing rights on blacks, given that the dignified and suffering blacks of the photographic record appeared in no position to take anything from white America."[5] Whether progressive or reactionary, whites, not blacks, are constructed as the agents of change while normalizing black passivity and even subtly promoting ongoing black humiliation. Equating racism only with acts of police brutality obscures the values of whiteness that are foundational to the racial hierarchy and that repress black agency.[6]

In a photo taken by photojournalist Scott Olsen, a young black man in jeans and T-shirt stands passively with hands held high while confronted by a mob of

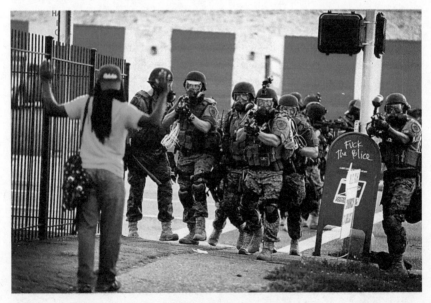

Black protester with hands up facing line of militarized police in Ferguson, Missouri, 2014. (Scott Olson/Getty Images.)

police officers in riot gear, at least three of whom train their weapons upon their lone, unarmed subject. In this case, however, the apparent calm of the young person and the agitation of the police, who maintain a certain distance, subtly subverts the dynamics of the scenario, which is reinforced by the graffiti scrawled on a nearby mailbox: "Fuck the Police."

Demonstrating their control of the black body even after death, the police left Brown's corpse in the street for four and a half hours, lying face down with blood streaming from his head in broad daylight in the summer sun. Although officers quickly secured the area with yellow tape, they stood at a distance while horrified neighbors called news stations, shielded their children, and took shaky cell phone videos that have found their way into the national media. Although a passing paramedic covered Brown's body with a sheet for a brief period, his feet were left exposed and his blood was visible. More cops were called to the scene as the tension levels mounted among shocked residents.

The Ferguson police defended the long delay by asserting that the time that elapsed in getting detectives to the scene was not out of the ordinary, and that conditions made it unusually difficult to do all that they needed. However, the former New York City chief medical examiner, Dr. Michael M. Baden, who was hired by the Brown family's lawyers to do an autopsy, observed that there was "no forensic reason" for leaving the body in view for so long.[7] At best, allowing Brown's body to remain in public view in the presence of distressed family members suggests gross incompetence and insensitivity. At worst, it continues the legacy of American lynching in which white supremacists left murdered black bodies exposed as warnings to members of the black community to "stay in their place."

Images of nonresistant protesters are not the only photos of the protests available, however, because this was not the only attitude protestors assumed. Perhaps the most iconic picture taken in Ferguson is that of a young black man wearing an American flag T-shirt and hurling away a tear gas canister with one hand while casually holding a bag of potato chips in the other. His relaxed attitude suggests that defending himself from racist attacks was nothing new, that his was an act of ordinary self-defense against the perpetrators of violence. For racist whites who are predisposed to see images of blacks as active agents in their own defense as a form of "violence," such an image validates what they want to believe about the proper hierarchy of racial power. But he became a hero to the Black Lives Matter movement as a symbol of resistance, the act of tossing away a tear gas canister a badge of honor for the protestors.

The protester was Edward Crawford, who identified himself after the image went viral, appearing on T-shirts and cell phone cases. In an interview with CNN, Crawford explained that he did not throw the burning tear gas canister back at police but was protecting himself and the young people around him: "Before the photo was taken, the canister . . . was shot and it landed a couple of feet away from me and some children standing on the sidewalk," he said. "I was

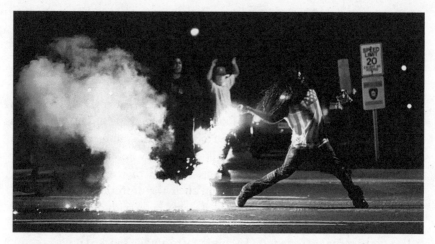

Edward Crawford throwing burning tear gas canister at protest in Ferguson, Missouri, after police fired tear gas at crowd; August 13, 2014. (Robert Cohen/St. Louis Post-Dispatch/Polaris.)

merely getting the canister away from me and the kids," noting that the police were thirty or forty feet away. "I can't even throw a baseball that far, let alone a burning can of tear gas." Crawford was nonetheless charged a year later with assault and interfering with a police officer after coming to be regarded as a strong voice against police abuse.

Tragically, the twenty-seven-year-old father of four was found dead in his car from a gunshot wound in 2017, a suspected suicide, which was a shock to many. The St. Louis police said that Crawford shot himself in the backseat of a car while it was moving, according to two women who were in the front of the car. They said he had been distraught. He had failed to meet with his attorney earlier that day to discuss a plea deal over the charges he was facing, which would have meant pleading guilty to assaulting a police officer. Crawford was adamant that he was not guilty. He also faced financial difficulties.[8] The external pressures initiated by the police were clearly too much.

Crawford is not the first Ferguson protester to die, and some of those deaths are far more suspicious. There are now six deaths involving young men with connections to the Ferguson protests. Deandre Joshua and Darren Seals were found shot to death in burning cars. No one has been arrested in those cases. Danye Jones was found hanging from a tree in the yard of his north St. Louis County home. His mother, Melissa McKinnies, was active in Ferguson and posted on Facebook after her son's death, "They lynched my baby." But the death was ruled a suicide.[9] Bassem Masri, a Palestinian American who frequently livestreamed video of Ferguson demonstrations, was found dead of an overdose of fentanyl on a bus.[10] In at least one clear-cut suicide, MarShawn McCarrel shot and killed himself on the steps of the statehouse in Columbus,

Ohio, writing on Facebook earlier that day, "My demons won today. I'm sorry." As journalist Trymaine Lee observes, such suicides "speak to the overwhelming emotional and psychological toll the resistance has taken on its young standard bearers."[11]

Cori Bush, a frequent leader of the Ferguson protests, who has publicly complained about harassment, intimidation, and death threats, reports that her car has been run off the road, her home vandalized, and in 2014 someone shot a bullet into her car, narrowly missing her daughter, who was thirteen at the time. She suspects white supremacists or police sympathizers. The activist Rev. Darryl Gray found a box inside his car that was checked out by the bomb squad, which found no explosives but discovered a six-foot python inside.[12] The intent to create a climate of fear seems beyond dispute.

This stems from the fear of seeing blacks as more than passive and nonresistant, that is, as active agents in defense of their rights, which raises the specter of more organized social and political struggle, in concert with allied whites and others, against the racist system that allows the criminalization of blackness and the wanton killing of black people. The police have become so militarized in large part as a response to the threat of social struggle. Military-grade hardware found its way into the hands of local police forces around the country long before the attacks on 9/11. In 1990, the National Defense Authorization Act empowered the Pentagon to transfer to federal and state agencies Department of Defense equipment for counterdrug activities. Thus the "war on drugs," which targeted black men disproportionately, greatly furthered the militarization of the police and stockpiling of hardware that we see today in towns and cities such as Ferguson. SWAT teams consisting of helmeted and masked police who enter homes with guns drawn, knocking down doors with a battering ram and rushing inside, originally were formed to deal with "civil unrest" and life-threatening situations. Today they are routinely deployed to serve drug-related warrants in private homes.[13] An amateur photo of two sharpshooters atop a SWAT vehicle with a weapon trained upon an unseen "enemy" could just as easily have been taken in a theater of war in Iraq or Afghanistan.

As economic inequality continues to grow exponentially, the state increasingly invests in security, surveillance, and weaponry. Far more money is spent on policing and government efforts to counteract protest movements than on rebuilding our declining cities by creating jobs, renewing infrastructure, or providing adequate housing, city services, or access to health care and education. While it is more difficult to photograph the complex social dynamics of economic decline, the impoverishment of city populations in hundreds of cities across the nation, and the criminalization of black men and women, another Ferguson image alludes to the larger racial dynamic in America. A young black protester stands by the side of the road with his fist in the air holding a sign written on cardboard that says, "My blackness is not a weapon." He is author, podcaster, and Black Lives Matter activist DeRay Mckesson, who writes, "On

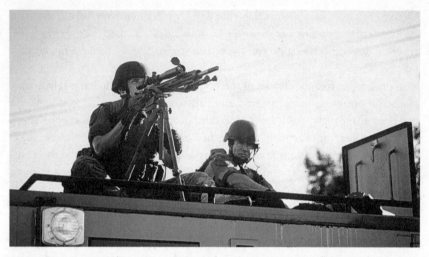

Police sharpshooter atop a SWAT vehicle at Ferguson protests; 2014. (Photo: Jamelle Bouie [CC BY 2.0 (https://creativecommons.org/licenses/by/2.0)] via Wikimedia Commons.)

the first night that officers patrolled the entire area on foot, when they stormed the crowd, I ran with my hands high, thinking that I could be taking my final steps. I'll never forget running past the police, fighting back tears, with my hands as high as possible, afraid of my country."[14]

The assertion that "blackness is not a weapon" recognizes that, in a country where racial equality has yet to be achieved, blackness itself is regarded as a threat, especially if one is young and male. As conservative pundit Ben Stein openly said of Michael Brown on Newsmax, "He wasn't unarmed. He was armed with his incredibly strong, scary self."[15] Blackness evokes white racial anxiety and the need to contain and control that anxiety through racist repression. For this reason, moral appeals through passive nonresistance or other symbolic gestures, while raising the visibility of injustice, are not enough to counter such repression. Organized social struggle begins by remembering the atrocities of the past and actively using that memory to guide emancipatory struggle in the present, a struggle that begins in the streets.

Like the killing of Emmett Till by racists in Mississippi, the killing of Michael Brown helped galvanize a generation of activists. The documentary film *Whose Streets?* by filmmakers Sabaah Folayan and Damon Davis, who spent a year in Ferguson, debuted at Sundance in 2017 and tells the stories of activists' lives in Ferguson. Recognizing the importance of stories in constructing activist memory, Folayan observed, "I wanted to go and bear witness. My main agenda going in was really just to provide an outlet for people to tell their stories, for people to know that their stories were important, that their stories were valuable, that somebody was listening."[16]

Along with the films, photos, and markers, the rebuilt street memorial on the anniversary of Brown's death, however temporary, also helps keep those stories alive through a form of public mourning that transforms a profane space into one imbued with historical memory, gives agency to the mourners who enact civil protest through a form of public memorialization, and helps renegotiate the meaning of the killing of Michael Brown.

Part II

Memorials and Museums

3

Why We Need a National Lynching Memorial

The tree of memory sets its roots in blood.
—Aphorism

There are two versions of Montgomery, Alabama, which coexist in mutually exclusive forms of public memory that mirror this country's history. In white supremacist Montgomery, which was the first capital of the Confederacy, the most important Confederate memorial is the First White House of the Confederacy. Subsidized by taxpayer money, it celebrates the life of Confederate president Jefferson Davis as a "renowned American patriot" in the home where he lived for less than a year during the Civil War. Slavery as a cause leading to the Civil War plays no part in the historical presentation of the house, which focuses on the objects and memorabilia that celebrate the life of Davis and his family.

In this Montgomery, streets and schools bear the names of beloved Confederate generals, such as the Robert E. Lee High School, which sports a statue of Lee on a pedestal near its entrance, or Jefferson Davis Highway. According to the Equal Justice Initiative (EJI), there are fifty-nine monuments, markers, and memorials to the Confederacy in the city.

At the First White House of the Confederacy, I asked the older male docent who introduced the house and was clearly a history buff whether Davis had owned slaves. He readily admitted that the Confederate president and his family enslaved "130 people," and informed me that many "remained loyal" to Davis, invoking the myth promoted by many southern slaveholders that they

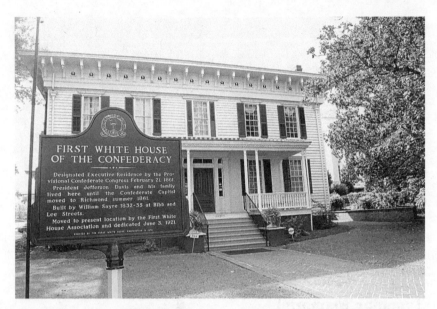

The First White House of the Confederacy, executive residence of Confederate President Jefferson Davis and his family in 1861 while Montgomery was capital of the Confederacy.

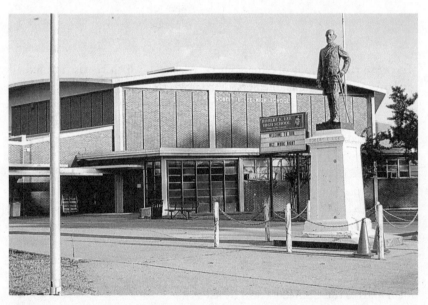

Robert E. Lee High School, one of two high schools named after Confederate generals in Montgomery, Alabama, along with Jefferson Davis High School.

were beloved by their slaves. According to historian Jill Lepore, a small group of enslaved families who lived on Davis's thousand-acre cotton plantation Brierfield, in Mississippi, made a break for freedom in 1862, with at least 137 of the more than 200 slaves who lived on the plantation leaving after the fall of nearby Vicksburg in 1863.[1] What, I asked, did our docent think of the new Legacy Museum and lynching memorial in town? Growing wary, he said carefully, "A journalist from the newspaper asked me that too. I think it's wonderful."

In many places, the history of slavery is erased or elided. From 1850 until the end of the Civil War, Montgomery was the most active southern port in slave trading, surpassing New Orleans. Between 1808 and 1860, the enslaved population of Alabama grew more than tenfold, from less than 40,000 to more than 435,000, one of the largest slave populations at the start of the Civil War. Two-thirds of the Montgomery population consisted of enslaved people; free blacks could not legally reside in the city.

Court Square, the main slave market where slave traders sold men, women, and children alongside livestock, has an official sign next to it that describes it as a "historic hub for business in Montgomery." This would be like describing a Nazi concentration camp as a "historic hub for communal labor." The sign that explains the nature of that "business" is several blocks away, one of many put up by the EJI to introduce facts about the Montgomery slave trade, slave warehouses, and slave depots that were avoided by local historians.

Montgomery's downtown is dominated by the Alabama State Capitol, a massive Greek revival structure that sits atop Goat Hill at one end of Dexter

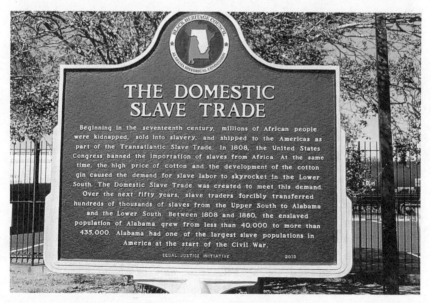

Memorial plaque on the domestic slave trade, placed by the Equal Justice Initiative; Montgomery, Alabama, October 2017.

Avenue, the city's main street, with Court Square at the other end, symbolically connecting the "business hub" with the "business owners." In front of the state capitol, a nine-foot high bronze statue of Jefferson Davis overlooks the city like a beneficent civic father.

Nestling under the shade of a nearby tree is another statue, this one of James Marion Sims, known as "the father of gynecology." Sims developed important gynecological surgical techniques by conducting dozens of operations on enslaved women without anesthesia. He was convinced that black women could not feel pain the way white women could. Sims's practice recalls the medical abuses of other African Americans, such as the Tuskegee experiment that injected black sharecroppers with syphilis and left them untreated to see what happened, or the eugenics movement in the early twentieth century, aimed at "improving" the genetic composition of the population through selective breeding, which largely victimized women, people with disabilities, and racial minorities. The city of New York removed a statue of Sims from its pedestal bordering Central Park in 2008, but in Montgomery, Sims reposes peacefully on the capitol lawn.[2]

On the north side of the capitol is an eighty-eight-foot Confederate Memorial Monument, erected in 1898 with public funds and dedicated to Confederate veterans.[3] Its cornerstone was laid by Jefferson Davis, for whom a bronze plaque in the shape of a star marks the spot on the capitol steps where he stood when he was sworn in as the first Confederate president, placed there after his death by the Daughters of the Confederacy. Some have called for removal of the Confederate Monument but only the four Confederate flags that surrounded it were removed in 2015 by the Alabama governor in the wake of the Charleston church massacre of nine black congregants. In May 2017, the Alabama state legislature passed the Alabama Memorial Preservation Act, which made it illegal to remove a monument on public property more than forty years old, effectively preventing the removal of Confederate monuments from public lands.[4] The Southern Poverty Law Center reports that 1,740 Confederate monuments still exist in public spaces nationally.

The State Capitol is also where the fifty-four-mile march in 1965 along Jefferson Davis Highway from Selma to Montgomery ended. It was in support of voting rights for African Americans, with some twenty-five thousand people gathering there that day. The Baptist Church within view of the capitol is where Martin Luther King, Jr. and other activists planned the Montgomery bus boycott after police arrested Rosa Parks for refusing to move to the back of the bus for a white passenger in 1955. Originally called for one day, that boycott lasted a year and led to the rise of King as a leader in the black community. Montgomery is also home to the Rosa Parks Museum, and the Civil Rights Memorial Center at the Southern Poverty Law Center (SPLC), which tracks hate groups in America and includes a civil rights memorial designed by Maya Lin. The SPLC is under constant guard because of threats to the center.

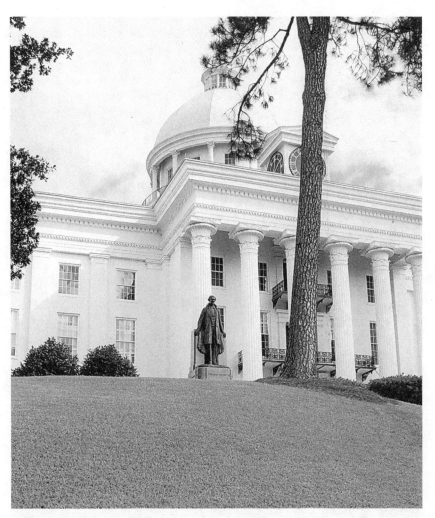

Statue of Jefferson Davis in front of the Alabama State Capitol, Montgomery, overlooking the city.

Along with the King Memorial Baptist Church, where King became pastor at the age of twenty-five, downtown Montgomery is home to the Equal Justice Initiative. Bryan Stevenson, a Harvard University–trained lawyer who created the EJI in 1994 to fight for justice for people on death row, became interested in the history of lynching and eventually served as the driving force behind both the Legacy Museum and its companion site, the National Memorial for Peace and Justice. The Legacy Museum tells the story of slavery, segregation, lynching, and mass incarceration, and the National Memorial for Peace and Justice memorializes the thousands of lynching victims in America between 1877 (the year Reconstruction was abandoned) and 1950 (when the civil rights movement gained momentum), commemorating these deaths on a national level for the

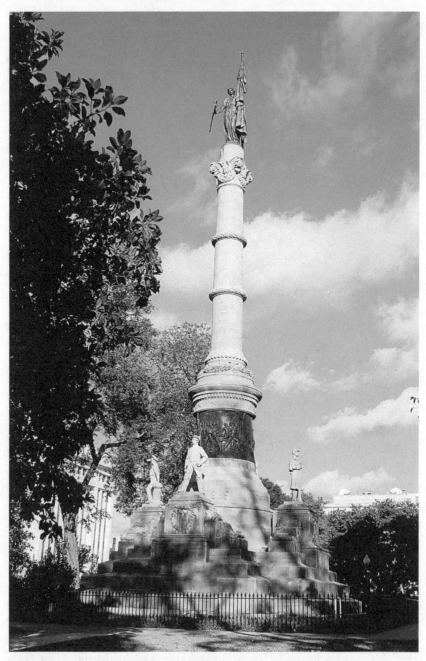

The 88-foot Confederate Memorial Monument on the north side of the Alabama State Capitol in Montgomery, commemorating the 122,000 Alabamians who fought for the Confederacy during the Civil War, dedicated in 1898.

first time. These and other institutions and memorials constitute the alternative Montgomery. One is known as the "Cradle of the Confederacy," the other as the "Birthplace of Civil Rights."

The Legacy Museum

What is the legacy of slavery? Has the United States ever confronted its past as a nation? The single most important thing to understand about the United States from its inception to the present moment is that it is a democratic republic built upon enslavement. The destructive effect of this profound contradiction continues more than two centuries later, embodied in the iconic words of the Declaration of Independence itself: "We hold these truths to be self-evident, that all men are created equal, that they are endowed by their Creator with certain unalienable Rights, that among these are Life, Liberty and the pursuit of Happiness." Among the founders of the nation who endorsed these sentiments, men who spoke boldly and eloquently about liberty and equality, were slave owners, including George Washington, the first president of the nation, and Thomas Jefferson, the principal author of the Declaration of Independence, who refused to recognize the injustice of slavery. In her ambitious account of American history, framed by this fundamental contradiction between freedom and slavery, Jill Lepore observes, "To study the past is to unlock the prison of the present."[5]

The divide between abolitionists and slave owners, free states and slave states, inflected national development every step of the way. From the beginning and without giving black people any rights, the three-fifths rule allowed enslaved people to be counted as three-fifths of a white person for the purpose of proportional representation. This gave the southern states a great advantage in the Electoral College, so that for thirty-two of the first thirty-six years of the Republic, the president of the United States was a Virginian slave owner. When the Union admitted Missouri as a slave state in 1820 along with the free state of Maine, it entailed a "compromise" that reaffirmed the institution of slavery in the southern states. John Quincy Adams, who was critical of slavery, presciently wrote in his diary, "Take it for granted that the present is a mere preamble—a title page to a great, tragic volume."[6]

The white men who ruled also endorsed the attempted genocide of Native Americans and the theft of their land. As the nation expanded westward, the question of the day was whether new states would be slave or free. The flagrant contradiction that formed the very foundation of the republic finally caused southern states to secede from the Union in order to maintain an economy based on slavery, which exploded into a civil war. Despite losing that war, southern legislatures began passing "black codes," which were race-based laws that effectively continued slavery through indentures, sharecropping, and other forms of service.

The Ku Klux Klan, founded in Tennessee in 1866 and comprised of Confederate veterans, began a reign of lynching and racial terror aimed, in large part, at preventing black freedmen from voting. Klansmen knew freedmen would vote for the opposition party that had supported their freedom, which would constrain the power of southern white supremacists who refused to regard black men as "created equal." Their white robes, according to one original Klansman, were meant to evoke "the ghosts of the Confederate dead, who had arisen from their graves in order to wreak vengeance."[7] A decade later, following the public withdrawal of northern troops, which signaled the collapse of Reconstruction and abandonment of the fight for black civil rights, a new set of black codes, known as Jim Crow laws, segregated blacks from whites in all possible public places.

The question of black civil rights has continued to divide the nation. Still disenfranchised through election chicanery and voter suppression, murdered by police with impunity, incarcerated in vastly disproportionate numbers, poet Claudia Rankine sums up this dismal history of atrocity and persecution: "The condition of black life is one of mourning. Dying in ship hulls, tossed into the Atlantic, hanging from trees, beaten, shot in churches, gunned down by the police or warehoused in prisons: historically, there is no quotidian without the enslaved, chained or dead black body to gaze upon or to hear about or to position a self against."[8] From any perspective, there is no getting around the legacy of the past in the present, so that how we remember and interpret the past is crucial to the ongoing struggle for equality and democracy.

The Legacy Museum, which opened in 2018, employs unique technology and videography to dramatize the enslavement of African Americans, describing in four sections the evolution of the slave trade, the terror of lynchings, legalized racial segregation, and mass incarceration in the world's largest prison system. It begins with the international slave trade that carried by force twelve million Africans to the Americas. When Congress finally banned the importation of slaves in 1808, the domestic slave trade took over, trafficking some 1.2 million enslaved people from the upper South to the Deep South. Painted on a red brick wall after reading about this are words that deliver a gut punch: "You are standing on a site where enslaved people were warehoused." You realize you are not just in a museum, but in *one of the places where the enslaved were imprisoned*. A ramp downward into the main gallery leads to a corridor of slave pen replicas where six-foot video screens in the prison cells depict enslaved men, women, and children who plead, pray, sing, and narrate their stories, seeming to respond to your presence, as they await sale at auction.

What is remarkable about the museum program, "From Enslavement to Mass Incarceration," is that it refuses to construct a redemptive narrative, as most history museums do.[9] Instead, it insists on the unhappy reality of a country where the ethos of liberty founded on enslavement has evolved to mean that one in three black boys today will likely go to jail or prison in his lifetime, a

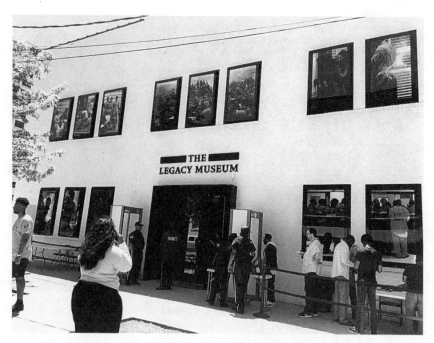

Legacy Museum; Montgomery, Alabama, 2018. (Photo courtesy Julie Langsam.)

continuing subjugation of black people that criminalizes them on the basis of their skin color.

Exhibits in the Legacy Museum include video touch screens, interactive maps that can show where lynchings have occurred in any state, and films on lynching and mass incarceration. Especially affecting is a cluster of four enclosed desks, built to resemble prison visitation rooms, where museumgoers don a headset and pick up a phone to listen to an inmate's prerecorded testimonial while watching him on a life-size video screen. There are texts and facsimiles of advertisements for enslaved people as well as discriminatory signs and statutes from the Jim Crow era, though artifacts are generally secondary to the interactive and narrative nature of the museum, except in one inventive display.

The EJI hit on the powerful idea of collecting soil samples in jars from lynching sites around the nation, each jar labeled with the name of the person lynched (when known), the place of the lynching, and the date. Like urns with ashes, the jars of soil evoke the bodies of the dead, creating a web of connection between place, memory, and the body. Since we can't be at all the sites where lynchings have occurred, these places symbolically come to us through the accretion and materiality of soil samples, their different colors and textures standing in for the different individuals and geographical locations. Massing together more than three hundred jars on shelves, the display conveys a sense of

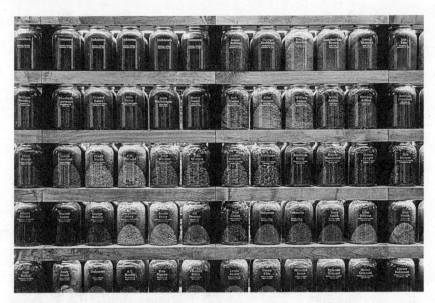

Jars of soil from lynching sites around the nation collected as part of EJI's Community Remembrance Project, on display at the Legacy Museum. (© 2018 by Ricky Carioti/The Washington Post.)

absence and loss that is both specific to individuals and representative of the thousands killed whose blood has soaked the earth across the nation.

Three jars bear the names of Elias Clayton, Elmer Jackson, and Isaac McGhie, respectively, who died in Duluth, Minnesota, in 1920. They were falsely accused of raping a white girl and lynched by a mob of five to ten thousand people that watched as Clayton and Jackson, nineteen, and McGhie, twenty, were hanged from a lamppost in the center of town. More than eighty years later, a multiracial group of Duluth residents brought to fruition the first substantial lynching memorial to commemorate their lives, consisting of sculptural relief figures and a series of quotations in a small memorial park across from the actual lynching site.[10]

The commemorative process in Duluth, constructed to remember a buried past and foster a shared sense of community, produced forums for discussions of the lynchings and their contemporary implications, and created a locus for the structuring of collective memory. The memorial makes visible a black political and cultural presence in Duluth, a largely white city, bringing disparate antiracist elements of the populace together. In 2017, about a hundred people watched as black elders and community leaders shoveled soil at the memorial into three jars, one for each victim of the triple lynching, in conjunction with officials from the EJI and the Duluth NAACP. The following year, about three dozen Minnesotans took a ninety-eight-hour bus trip to Montgomery to visit the Legacy Museum and National Memorial for Peace and Justice.[11] In part,

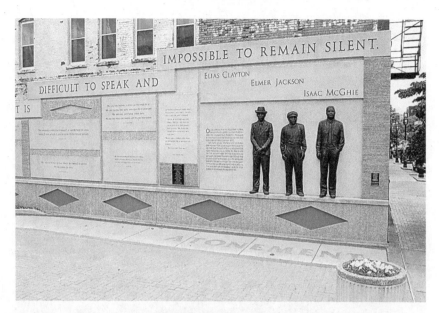

IMPOSSIBLE TO REMAIN SILENT.

DIFFICULT TO SPEAK AND

ELIAS CLAYTON
ELMER JACKSON
ISAAC McGHIE

Carla Stetson and Anthony Peyton Porter, Clayton Jackson McGhie Memorial, Duluth, Minnesota, dedicated in 2003. The text along the top says, "An event has occurred about which it is difficult to speak and impossible to remain silent."

the poignancy of this event resides in the collective remembrance of the names and fates of the three murdered young men for whom no relatives were ever found.

As one exits the main gallery, a corridor contains artwork by Titus Kaphar, Sanford Biggers, Elizabeth Catlett, John Biggers, Yvonne Meo, and Kay Brown. After immersion in the history of racial terror and injustice through the powerful texts, films, and new video technology, however, the small gallery of artworks seems anticlimactic.

On the way out of the Legacy Museum, another cluster of touch screens under the sign "What Do I Do Now?" offers information on a range of issues that connect the educational program to the advocacy work of the EJI. The museum notes, for example, the language of school segregation in the Alabama constitution: "Today, the Alabama constitution still mandates that there be racial segregation in education with 'separate schools for white and colored children.' While federal law prohibits barring black children from attending schools with white students, the Alabama constitutional ban still exists. In 2004 and 2012, an effort to remove this language from the state constitution through a statewide referendum was attempted. On both occasions, predominately white voters elected to ratify this language and keep this restriction in the state constitution." The wall text then asks, "What does it mean that the Alabama constitution still prohibits racial integration in education and what

At a soil collection ceremony at the Clayton Jackson McGhie Memorial in Duluth, community elder Portia Johnson shovels dirt into containers held by CJM Memorial founder Heidi Bakk-Hansen, bound for the Legacy Museum in Montgomery. (Photo by Clint Austin, *Duluth News Tribune*.)

should be done about it?" Evoking an activist tradition of social justice advocacy, the question suggests that *something* should be done, raising the need for social struggle.[12]

The National Memorial for Peace and Justice

The National Memorial for Peace and Justice sits high on a six-acre site in downtown Montgomery and contains over eight hundred corten steel columns, one for every county in the nation where lynching occurred. Each pillar carries the names of victims lynched in that county. The pillars are six feet tall, evoking the height of a person, and the choice of corten steel allows them to weather to different shades of brown. A square structure, it has four roofed corridors surrounding a courtyard. Entering at eye level with the pillars, which sit on the ground, visitors then slowly descend on a slanted wooden plank floor around the next three sides while the columns seem to rise above, eerily evoking rows of hanging bodies. Some of the steel slabs have "unknown" etched among the names, creating an archive of the lost within the archive of the known. The effect of standing before the hundreds of hanging columns is visceral, creating what might be called an embodied act of ethical spectatorship,[13] a symbolic "seeing" that turns us into historical witnesses and a way of "feeling" the traumatized bodies produced through the horror of lynching in an act of radical empathy.

The fourth corridor offers a wall of falling water dedicated to the thousands of victims, and beyond it a "monument park" contains horizontal replicas of the steel slabs in the memorial structure, which are waiting to be claimed and

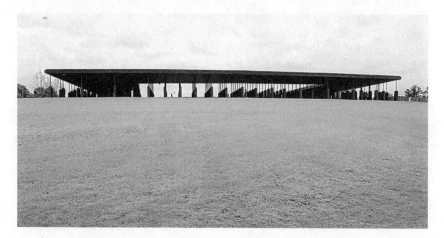

Montgomery National Memorial to Peace and Justice, dedicated in 2018. Set on a six-acre site, the central memorial square includes eight hundred six-foot monuments to represent thousands of racial terror lynching victims.

Montgomery National Memorial to Peace and Justice, detail of hanging steel monuments.

installed in the counties they represent. In this way, those communities that are willing—or unwilling—to confront their own lynching history will become visible. The invitation to install the steel monuments offered by EJI is a challenge to cities and towns across the nation to resurrect memory that has been largely repressed, ignored, or discounted. While plaques, statues, and monuments to the Confederacy litter the southern landscape, most sites where victims were lynched remain unmarked and unrecognized. "The absence of a prominent public memorial acknowledging racial terrorism," writes the EJI about such sites, "is a powerful statement about our failure to value the African Americans who were killed or gravely wounded in this brutal campaign of racial violence." The communities that failed to value African Americans in the past are also where African Americans today "remain marginalized, disproportionately poor, overrepresented in prisons and jails, and underrepresented in decision-making roles in the criminal justice system."[14] Some communities and institutions, however, wish to change their narrative and construct a more complete racial history despite the fierce resistance.

To create its 2015 report, *Lynching in America: Confronting the Legacy of Racial Terror*, Bryan Stevenson and a team of EJI researchers spent six years combing through court records and local newspapers and talking to local historians and family members in order to document more than 4,400 lynchings. Stevenson found people who were lynched for knocking on a white woman's door, for failing to address a police officer as "mister," and for bumping into a white girl while trying to catch a train. Men and women were lynched for "being disrespectful," "standing around," "bothering a white woman," or for having the temerity to try to vote, organize sharecroppers, report a crime, demand their wages, or for being associated with someone who did. Primarily people were lynched for being black.

Yet despite the thousands killed, most Americans cannot name a single person who was lynched. The National Memorial for Peace and Justice therefore names names, transforming the undifferentiated mass of victims into individuals, family members, and ancestors, turning them back into grievable bodies. The evocative steel columns serve as a counterpart to the jars of soil at the Legacy Museum, both producing a plangent effect as materiality and as metaphor.

Links to themes of slavery, segregation, and mass incarceration central to the narrative at the Legacy Museum are also made at the lynching memorial through figurative sculptures placed around the more imposing memorial structure. Near the entrance is a sculptural installation by Ghanaian artist Kwame Akoto-Bamfo, which portrays a group of the enslaved who were captured in Africa, setting an emotional tone as one enters the site.

The invitation to produce the sculpture came while Akoto-Bamfo was in the midst of sculpting 1,300 individualized heads for an installation at Cape Coast Castle on the Ghanaian coastline, known as a "slave castle" where people were

Montgomery National Memorial to Peace and Justice, detail of engraved county names and names of the victims.

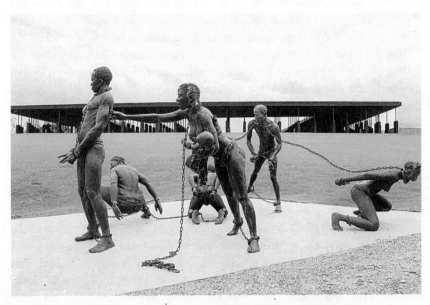

Kwame Akoto-Bamfo, *Nkyinkyim Installation*, bronze, permanent installation at the Montgomery National Memorial for Peace and Justice in Montgomery, Alabama.

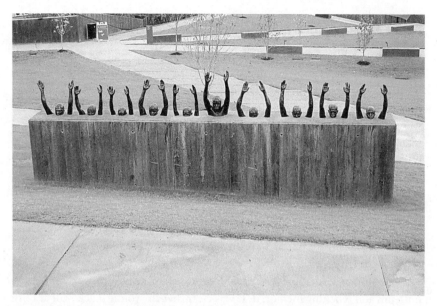

Hank Willis Thomas, *Raise Up*, bronze, permanent installation at the National Memorial for Peace and Justice in Montgomery, Alabama.

held captive in underground dungeons in the weeks before their transatlantic migration to a New World life of enslavement. His sculpture for Montgomery evokes that transatlantic voyage with seven bronze life-size figures of men, women, and a child straining against their shackles and conveys their stoicism, suffering, and distress. While individualizing his figures, Akoto-Bamfo memorializes the millions of transatlantic slave trade victims and underscores their African heritage. Asserting that representations of the enslaved in art tend to lack individuality and humanity, he handily remedies this condition in his own work.[15]

As one exits the memorial site, a sculptural work by Hank Willis Thomas, *Raise Up*, evokes police violence and the warehousing of black youth in jails and prisons. The work consists of ten bronze figures, black men with their heads barely visible, their hands raised in the air, with most of their bodies sunk into concrete, a kind of metaphorical quicksand from which there appears to be no escape—or else they are slowly emerging from it. The work is based on a 1960s picture by the South African photographer Ernest Cole of miners being subjected to a humiliating group medical examination.[16] Through American eyes, the same figures suggest police suspects lined up at gunpoint or a reference to Michael Brown and the "hands up, don't shoot" gestures of protest that followed his murder by a police officer in Ferguson, Missouri.

Black Memory and White Montgomery

Given the long history of Confederate monuments celebrating white suprem-
acy, it is not surprising that many of the conservative white townspeople in
Montgomery oppose the new lynching memorial as subversive history. They
suggest it digs up the past unnecessarily, that it is "better not to open old
wounds" and "let sleeping dogs lie." But are the dogs really sleeping? One local
man told a reporter, "It's a waste of money, a waste of space and it's bringing up
bullshit."[17] Tommy Rhodes, a member of the Alabama Sons of Confederate
Veterans said, "Bring that stuff to light, and let it be there, but don't dwell on it.
We have moved past it.... You don't want to entice them and feed any fuel to
the fire."[18] Some locals questioned the accuracy of the lynching numbers of the
EJI report. Indeed, it beggars the imagination to consider that more than 4,400
men, women, and children were hanged, burned alive, shot, drowned, and
beaten to death by white mobs.

In an informal survey, I also asked local inhabitants how they felt about the
museum and lynching memorial. It was clear that the young black staff at both
institutions comprise a fervent cadre dedicated to their mission. The woman
behind the front desk of the Legacy Museum beamed with joy when I told her I
thought the museum was powerful. The young man at the photo booth at the
end of the exhibition wanted to know about Detroit and its ruins; he was proud
of the museum staff's book club and ongoing political education.

But how did the public confrontation with the history and legacy of slavery
and race terror change the narrative for whites in Montgomery who grew up
with a different version of history, one that found it more politically convenient
to regard the Civil War as a fight over "states' rights" than slavery?

A pained look often crossed the faces of young whites—part sheepish, part
defiant—when I asked what they thought. A server at a local restaurant with a
goatee and ponytail dropped his gaze to the ground, hesitated, and said, "I don't
think presenting a history of violence is helpful." Not helpful? "It won't bring
about change by focusing on the past." Then he looked at me and asked, "Does
that make sense?" He was clearly uneasy but willing to talk about it. As Bryan
Stevenson points out, "People take great pride in the Confederacy because they
actually don't associate it with the abuse and victimization of millions of enslaved
black people. So that has to be disrupted."[19] One way to do that is by talking to
people, which is prompted by changing the commemorative landscape.

The young woman behind the counter at the Hank Williams Museum, who
seemed to know everything there was to know about the country music star,
said, "Honestly? I like history and I think it's important to know history, the
good and the bad, so I'm glad the museum is here." Then she paused and looked
down. "But the problem is the publicity and the people coming from out of
town who take it out of context." Out of context? "I feel weird saying this. I'm
not a racist and I accept all people for who they are, but people come from out

of town and they're like, 'Black power!' I believe *all* lives matter," she said, echoing the refrain of those who see no special black oppression. She went on to suggest that the Confederate flag was misunderstood: "It just stands for the South and people should be able to accept it for that." What about the fact that neo-Nazis and white supremacists carry that flag? "Yeah," she conceded, "that's a problem." And isn't the South that is represented by that flag the slaveholding South? She conceded that too, plaintively adding, "But that's not what I mean. I grew up with that flag. People should be able to accept me."

For some, the national conflicts over race pose a choice between a destabilizing transformation of identity as white southerners or maintenance of a status quo that dismisses or minimizes the racial violence of the past and its implications for the present. Yet as I turned to leave, she called out, "I enjoyed this conversation." She, too, was willing to think about these issues even though they made her uneasy.

For these two visibly conflicted people, the focus on racial violence was "not helpful" or took things "out of context"—the context being the normalization of southern white dominance—because it placed in doubt their upbringing and way of life. These young southerners are products of an educational system that does not effectively teach the history of slavery and the suppression of black civil rights. Although the context is different, it recalls the generation of Germans born in the wake of the Nazi era who struggled to come to terms with the legacy of their parents and grandparents. As one such descendant observes, "Many of my generation were either frozen in guilt and shame or locked into a defensive position, rejecting responsibility by insisting that one cannot be blamed for something that happened before one was born. From what position then can descendants of perpetrators speak? It's too easy to feel like a victim of the guilt and shame handed down by the parental generation, and it all too often feeds into a politics of resentment."[20]

No doubt the young people I spoke to operate from the position of resenting being made to feel blame and shame, yet they are troubled by witnessing the impact of racism, which confronts them with a parental legacy of racialized violence to be worked through. But when I asked one of the young black docents at the lynching memorial whether she often heard comments from white visitors about the folly of focusing on the past, she told me her own grandmother had "said the same thing." In this case, one can imagine an older black generation fearing the effects of stirring up white resentment.[21]

"People are uncomfortable talking about these issues because they have never talked about them before and don't even have the vocabulary," said the young white woman behind the desk at the Freedom Rides Museum. She provided a vivid account of the Freedom Riders, begun by an integrated group of young people, mostly college students, who attempted to integrate interstate transportation and were attacked by a crowd of racist whites in 1961 at the Greyhound station that now houses the museum. They nevertheless succeeded in

The Freedom Rides Museum in the former Greyhound Bus Station, where Freedom Riders in 1961 were attacked by racist whites but succeeded in desegregating southern bus and train stations. Opened in 2011.

helping to end segregation on interstate transport. To people who say the past should be left in the past, she responds, "Should we forget about Anne Frank too?" She also observed that Montgomery was conservative in other ways and had only one gay bar and no visible LGBTQ community.

At the Montgomery Museum of Fine Arts, an impeccably groomed elderly white woman behind the front desk looked at me cannily when I asked her thoughts about the new museum and memorial. "Well the tourists like them," she said, before leaning toward me conspiratorially and whispering, "But nobody here goes to them." At least, I presumed, no one she knew. Resisting her assumption of my "solidarity," I pressed her a bit. She gave me a flinty look, as if I were dense or foolishly trying to get her to speak that which is not spoken publicly, before changing course and walking back the idea that she was speaking for others: "I'm not originally from here. I'm from Wisconsin but I've been here seventy-five years, so I guess I can call myself a southerner." Then she dismissed the museum and memorial as belonging to the distant past. "Things used to be terrible," she said, "but thank goodness that's all worked out now." Her certainty left no room for contradiction. Here was the voice of white racist gentility.

A visit to the Scott and Zelda Fitzgerald Museum offered further connections to Montgomery's racial history. Zelda's father Anthony Sayre served in the state legislature and then as an Alabama Supreme Court judge for twenty-two years. According to the director of the Fitzgerald House, he helped pass a law that prevented black people from voting until 1964. Zelda's great-uncle

William Sayre, a merchant, brought his brother Daniel, a planter, to Montgomery, and William built what became the First White House of the Confederacy; both brothers lived there before it was physically moved and became Jefferson Davis's home. Zelda's paternal grandfather became a Confederate congressman and served as president of Kentucky's Confederate legislative council. What did the young white female director of the Fitzgerald House, a native of Montgomery, think about the Legacy Museum and lynching memorial? "It's about time," she said with exasperation. Here was the voice of the other Montgomery for whom the museum and memorial were a historic step forward.

For Confederate patriots, commemoration of the history of lynching represents a threat to the hegemony of southern whiteness; hence, their willingness to forget this history as something they have "moved past," that may not even be true, or will only "fuel the fire" of indignation and a demand for democratic rights. French historian Pierre Nora theorized memorials as polemical vehicles, suggesting that "when certain minorities create protected enclaves as preserves of memory," they do so because "without commemorative vigilance, history would soon sweep them away."[22] If the histories of slavery and lynching were not threatened with denial or oblivion, there would be no need for insisting upon them. As another local resident supportive of the project observed, "This is something our children need to know, so they can understand the struggle."[23]

This is the mission of the Legacy Museum and the lynching memorial, which together attempt to change the narrative of American history and demonstrate how the legacy of slavery evolved to the present-day conditions of black life in America. Together they not only emplace black memory but also construct an activist form of memory that changes how we think about racial justice. As Bryan Stevenson remarked in an interview, "I believe that the North won the Civil War, but the South won the narrative war. They were able to hold on to the ideology of white supremacy and the narrative of racial difference that sustained slavery and shaped social, economic, and political conditions in America. And because the South won the narrative war, it didn't take very long for them to reassert the same racial hierarchy that stained the soul of this nation during slavery. . . ."[24]

Despite local opposition, surely emboldened by President Trump, but also because of it, the lynching memorial opened at a time when many welcomed such a national reckoning in an increasingly polarized country. Indeed, Trump began his term in office as if he were a Confederate president reasserting white rule. As Rebecca Solnit observes, "In the 158th year of the American Civil War, also known as 2018, the Confederacy continues its recent resurgence. Its victims include black people, of course, but also immigrants, Jews, Muslims, Latinx, trans people, gay people and women who want to exercise jurisdiction over their bodies."[25] The Republican efforts to manipulate and restrict black voting rights during national elections, the horrendous separation of children from their parents at the Mexican border, and whole families held in ICE

U.S. Border Patrol agents conduct intake of illegal border crossers at the Central Processing Center in McAllen, Texas; Sunday, June 17, 2018. Photo provided by Custom and Border Protection to reporter on tour of detention facility. Reporters were not allowed to take their own photos. (CC0 via Wikimedia Commons.)

detention centers (evoking the internment of Japanese Americans during World War II), are just some of the racist, antidemocratic atrocities of the Trump administration.

The lynching memorial received front-page coverage in national and international print publications such as the *New York Times*, *Washington Post*, and *The Guardian*. The *Montgomery Advertiser* offered a critique of its own role in the past. Known as the leading paper of the Confederacy in the nineteenth century, it was historically opposed to lynching but supported it in practice, reinforcing white supremacy right through the era of the civil rights movement. The current forty-one-year-old editor, Bro Krift, however, greeted the opening of the lynching memorial by printing the names of lynching victims from Alabama on the front page alongside an editorial acknowledging and condemning the newspaper's complicity. This principled act reminds us of the shameful role that newspapers often played in the past by announcing lynchings before the fact with dates, times, and places, and justifying lynchings by presuming that blackness was linked inextricably to criminality, a presumption still in force today.

Remembering or forgetting the history of lynching constitutes two mutually exclusive ways of preserving history, and the two sets of Montgomery memorials, focusing on the Confederacy or on black history, preserve contradictory historical narratives that are nevertheless inextricably linked. The Legacy Museum and National Memorial for Peace and Justice disturb the hierarchy of

power through the insurgent eruption of black memory into public discussion and public life on both a local and national scale, producing a confrontation with the country's past that is long overdue.

The Debate over Confederate Monuments

The debate over what to do with Confederate monuments has been raging since at least 2015, when the young white supremacist Dylann Roof massacred nine black people in the fellowship hall at the Emanuel African Methodist Episcopal Church in Charleston, South Carolina. This church was one of the first black congregations in the South. Founded in 1818, whites destroyed it in 1822 because of its role in a failed slave rebellion and hanged many church members. The church was reconstituted and served as a sanctuary and center of resistance through Reconstruction to the civil rights era.

In a manifesto found on Roof's website, he cited his "awakening" by the 2012 killing of seventeen-year-old Trayvon Martin by George Zimmerman, a neighborhood vigilante who shot Martin in the chest because the unarmed young black man in a hoodie looked "suspicious." A jury acquitted Zimmerman of the crime. Roof also drew inspiration from the Council of Conservative Citizens and the Northwest Front, both white supremacist organizations, and posted photos of himself posing with segregationist symbols and the Confederate flag. In the two weeks following the mass shooting, racists torched eight black churches, recalling the hundreds of church fires set by the Ku Klux Klan. Roof's association with Confederate symbols prompted South Carolina's governor and legislature to remove the Confederate battle flag outside the state capitol in Columbia, and that led to a push to remove symbols of the Confederacy across the South—flags, monuments, and statues—a push that extended north to places as far-flung as the Bronx and Seattle. In Boston, protesters reenacted a slave auction to demand a name change for Faneuil Hall, named for Peter Faneuil, a colonial slave owner.

Georgia elections for governor in 2018 erupted in controversy over the three-acre Stone Mountain Confederate Memorial Carving, the largest Confederate monument in existence, dedicated in 1970. Black Democratic gubernatorial candidate Stacy Abrams called for its removal by sandblasting. Abrams termed it a "blight" upon the state, and civil rights groups have called for its removal for years. The enormous bas-relief represents the southern Civil War leaders Robert E. Lee, Jefferson Davis, and Thomas J. "Stonewall" Jackson on horseback. Proponents of the monument, with strong ties to the Klan, first proposed it in 1914. The carving stalled during the Great Depression but a segregationist governor who bought the land in 1958 had it completed and wrote a law that mandated its operation as a "perpetual memorial" to the Confederacy. The carving's public prominence was revived with a cross burning atop Stone Mountain in 2015.[26]

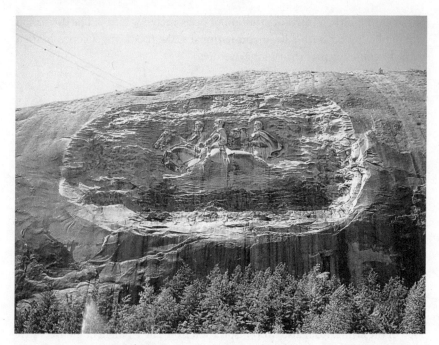

Stone Mountain Confederate monument, a bas-relief of three acres four hundred feet above the ground depicting three Confederate generals on horseback; Stone Mountain, Georgia. Stone Mountain was the site of the founding of the second Ku Klux Klan in 1915. (Photo: ©2012–2018 VickyM72 via www.deviantart.com.)

In Charlottesville, Virginia, white nationalists held an infamous "Unite the Right" rally in August 2017, in which a car driven by a twenty-year-old neo-Nazi plowed into a group of antiracist protesters, killing thirty-two-year-old Heather Heyer and injuring nineteen others. The purpose of the rally was both to unite the various factions of neo-Nazis, neo-Confederates, and neo-Klansmen into one nationalist movement and to oppose removing a statue of Robert E. Lee from the city's Emancipation Park (renamed Market Street Park in 2018).

After these violent events helped reignite a debate about Confederate monuments, the American Historical Association released a statement describing such monuments as "part and parcel of the initiation of legally mandated segregation and widespread disenfranchisement across the South." Confederate monuments, the statement maintains, erected primarily during the Jim Crow and Civil Rights eras, were meant "to obscure the terrorism required to overthrow Reconstruction, and to intimidate African Americans politically and isolate them from the mainstream of public life during the Civil Rights era."

Crucially, the statement notes the unilateral nature of this shaping of the memorial landscape: "Nearly all monuments to the Confederacy and its leaders were erected without anything resembling a democratic process. Regardless of their representation in the actual population in any given constituency, African

Americans had no voice and no opportunity to raise questions about the purposes or likely impact of the honor accorded to the builders of the Confederate States of America."[27]

Those who vigorously defend Confederate monuments in the South do so by arguing they are part of southern history, but the history they represent is that of white supremacist suppression of black civil rights. Issues of class and gender are also important components of Confederate monument building. The southern elite built monuments in the 1910s that compared Confederate soldiers to World War I soldiers as a way of reasserting the patriotism of the former by conflating them with the latter. The monuments were meant to burnish the cause of white supremacy by appealing to the patriotism of the working class, not unlike the way Donald Trump appealed to his base by promising a capricious wall on the Mexican border as a way of consolidating white working-class identification with the white ruling class.[28]

The 1910s also marked the height of the women's suffrage movement, which brought about a period of intensive monument building by the upper-class white women of the United Daughters of the Confederacy who opposed the vote for women. Striving to hold on to a former way of life in a changing world, they used the monuments to create inscriptions about "love" that reinforced traditional gender roles in which women stayed home, raised children, and supported their men.[29]

White supremacists today still see feminism as a scourge. Anders Breivik, for example, murdered seventy-seven people in Norway in 2011 in order to publicize his white nationalist manifesto in which he blamed "Islamism," "cultural Marxism," and "feminism" for a European "cultural suicide" and the emasculation of white men. In the United States, male supremacy has joined with white supremacy to preach the inferiority of women who, they believe, exist primarily for their reproductive and sexual functions. Die-hard defenders of Confederate monuments are part of a larger history of attempts to reclaim southern masculinity and virility in the face of the defeat of the South in the Civil War and in response to a felt sense of emasculation by the gains of women and their economic status.

Adding a class component to the antifeminism of white nationalists is the fact that they are mostly downwardly mobile, lower-middle-class men that experience economic displacement because of globalization and neoliberal economics. Unlike many minorities, however, as white men they believe they are entitled to greater economic prosperity and success and feel emasculated by their inability to achieve it. Sociologist Michael Kimmel argues that white nationalist organizations offer not only a sense of belonging but a restoration of masculinity.[30] Like the conservative white elite in the early twentieth century, white nationalists today boost white men's sense of masculinity by insisting on gender essentialism, the subordination of women to men, and the primary function of women as mothers and sex objects.[31]

White nationalists embrace "Great Replacement" or "white replacement" conspiracy theories that posit a concerted plan to replace whites with non-whites through such means as immigration, abortion, intermarriage, and racial integration. There are a variety of sources for replacement theory, which has been expressed in Europe, North America, and other countries. These include the neo-Nazi concept of "white genocide," which refers primarily to contraception and abortion, and French right-wing theorist Renaud Camus's 2012 book *The Great Replacement*, which focuses on the replacement of Christian white people in France with Muslims and others. The two ideas have merged into "white extinction anxiety," a phrase coined by Charles Blow that refers to the fear that whites will become a minority stripped of their race-based privilege.

In 2017, the white nationalists in Charlottesville chanted, "You will not replace us" and "Jews will not replace us," demonstrating their embrace of "replacement theory," their combined hatred of blacks, Jews, Muslims, and migrants, as well as the global connections among white nationalists who fear an existential threat to their existence. Replacement theory has been cited most recently in the manifestos of the mass shooter who killed twenty-two people at a Walmart in El Paso, Texas, fearing a "Hispanic invasion" and the shooter who massacred more than fifty Muslims at two mosques in Christchurch, New Zealand. This fear of replacement, along with an aggressive white patriarchal masculinity, has been galvanized and modeled by Donald Trump as the nation's president and is central to his rhetoric and campaign to restrict immigration.

While white nationalists fear replacement by people of color and Jews, whom they consider racially different,[32] and regard, as part of the solution, keeping white women at home producing more white babies—preventing them from working, voting, and controlling their own reproductive health—right-wing lawmakers, hoping for a compliant right-wing Supreme Court in the event of challenges, have passed highly restrictive anti-abortion bills that threaten to imprison women who get abortions or doctors who perform them. By attempting to control women's bodies, criminalize abortion, and overturn Roe v. Wade—which would return women to an era when tens of thousands obtained illegal or self-induced abortions and many died—conservative lawmakers carry out a program that perfectly accommodates a white supremacist agenda.

Despite the conservative morality promoted by religion, wealthy women can always find the money and resources to obtain a safe abortion if needed. Access to abortion is therefore a class demand, because it is poor and minority women who suffer the consequences of restriction to abortion, just as overall health care is a class demand, because the wealthy always have access. In a truly democratic society, abortion would be free on demand as part of free, quality health care for all, along with free daycare. The white nationalists who believe that abortion deserves greater punishment than rape—therefore making no exceptions for rape or incest in their anti-abortion bills—don't consider sexual violence a real crime. Far-right Congressman Steve King, for example, defended

his position of not allowing exceptions for rape and incest in anti-abortion bills by asserting that sexual violence was just normal practice: "What if we went back through all the family trees and just pulled those people out that were products of rape and incest? Would there be any population of the world left if we did that?"[33] Both Trump and Brett Kavanaugh, who was appointed by Trump and confirmed to the Supreme Court, have been accused by numerous women of being sexual predators.

Fear of replacement also blossomed in the Jim Crow era when conservative southerners feared racial eclipse by freed slaves and northerners who moved south. The erection of Confederate monuments asserted the political and cultural hegemony of southern whites by taking control of public space and defending a Confederate narrative, while blacks had little to no opportunity for memorialization. Upholding the values of the planter aristocracy, memorial building reinforced a class and gender hierarchy that was integral to the racial hierarchy in response to the changing status of whites and women in the 1910s as well as the 1960s. It is not surprising that impassioned defense of these monuments in the 2010s arises under similar circumstances, when many whites perceive similar threats to their status both from people of color and from women, in part galvanized by the #MeToo movement.[34] Modern memorials that instantiate black history and memory therefore help redress this historical repression lasting more than a century.

One might possibly argue that the lynching memorial, like other monuments and memorials, will become a repository of memory that abrogates the responsibility to remember and paradoxically functions as an agent of forgetting. But as Lewis Hyde argues in *A Primer for Forgetting*, "Forgetting appears when the story has been so fully told as to wear itself out. Then time begins to flow again; then the future can unfold."[35] We still have a long way to go to reach that point in history.

What's in a Name?

The design of the lynching memorial (credited to Bryan Stevenson and the EJI working with MASS Design Group and several artists) combines key elements of some of the most well-known commemorative memorials of the past several decades. These include an insistence on names or, conversely, a lack thereof, as well as an abstract structure that resists heroization. Remembering even thousands of names by writing and reciting them is among the oldest forms of perpetuating memory, especially in Jewish practice. When the medieval Pinkas Synagogue in Prague's old Jewish Quarter was turned into a memorial to Holocaust victims in the 1950s, the interior walls were covered with more than 78,000 names of Jews from Bohemia and Moravia, most of whom were sent to Theresienstadt and then to their deaths in Auschwitz. Former U.S. Secretary of State Madeleine Albright, who found out late in life that her paternal grandparents were

Pinkas Synagogue, with 78,000 names of Holocaust victims from Czech lands on the synagogue's inner wall; Prague, Czech Republic. (Photo by Øyvind Holmstad/CC BY-SA 3,0 from Wikimedia Commons.)

Jewish, went straight to the Pinkas Synagogue on a visit to Prague that same year and found her grandparents' names on the wall. The evidence of names serves as a countermemory to the fictions and omissions of an earlier generation.

The power of the Vietnam Veterans Memorial in Washington, D.C., likewise resides in the 58,000 names of soldiers who died in that war that are etched onto its two converging black walls. Visitors often come to make crayon or pencil rubbings of a family name, making the memorial the second-most-visited monument in the United States after the Lincoln Memorial. The Oklahoma City National Memorial and Museum, which commemorates the murder of 168 men, women, and children in the 1995 bombing of the Alfred P. Murrah Federal Building by the white nationalist Timothy McVeigh, also names and pictures every victim at the museum.

Similarly, the National September 11 Memorial and Museum in New York City inscribes the names of 2,983 victims on 152 bronze parapets on the two square reflecting pools that mark the footprints of the Twin Towers. In addition, color photographs of the victims are displayed in the museum's In Memoriam gallery, which also features family photographs, oral remembrances, and rotating selections of personal artifacts.

In contrast to the archival detail of such memorials, which seeks to remember every individual involved, the Holocaust memorials designed by Rachel

Michael Arad, reflecting pool with names of victims inscribed on surrounding parapets; National September 11 Memorial & Museum, New York City, dedicated September 11, 2011.

Whiteread and Peter Eisenman take a seemingly opposite approach. The "Nameless Library," Whiteread's site-specific memorial in the Judenplatz of Vienna for Austria's 65,000 lost Jews, is a cast concrete inverted library. It has doors with no handles or hinges, and books with spines turned away from the viewer, as if to create a world of untold sagas and stories, which remain nameless. This is the ultimate loss of history, the silencing of whole generations, their unwritten futures sealed in concrete as an unknown and unknowable archive of knowledge and experience. On three sides around the base of Whiteread's structure are engraved the names of the forty-one death camps where Austrian Jews perished.

The unknown archive is not just about the destruction of the futures of thousands and what they might have written, discovered, created, and composed. The memorial also evokes the destruction of books as the destruction of the past. It recalls the burning of the great Library of Alexandria in ancient Egypt, the Imperial Library of Constantinople burned by Crusaders, the monastic libraries destroyed by Henry VIII, the burning of Maya codices by conquistadors, the destruction of libraries in Cambodia, Bosnia and Herzegovina, Iraq, Lebanon, and Timbuktu, and, not least, Nazi book burnings.

As if to underscore this idea, underneath Whiteread's Holocaust Memorial are the ruins of a medieval synagogue, whose existence was unknown and only discovered when construction on the memorial began.[36] In 1421, eighty Jews committed suicide by barricading themselves inside the synagogue and burning it down rather than renounce their faith. This occurred after two Jews were

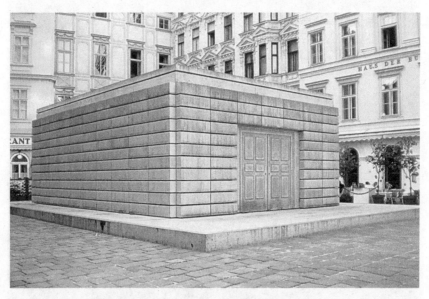

Rachel Whiteread, Judenplatz Holocaust Memorial (aka Nameless Library), steel and concrete; Vienna, Austria, dedicated in 2000.

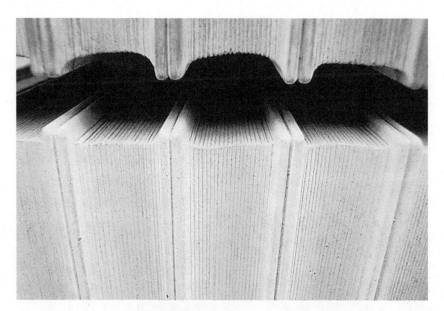

Detail of books, Judenplatz Holocaust Memorial.

found guilty of "blood libel" and a thousand Jews were killed or expelled from Vienna by the Catholic Church and its followers.[37] The Nazis marched into Vienna on the anniversary of the burning of the synagogue, some five hundred years later. Whiteread's memorial thus maps one memory site onto another, mediating the meaning of each and calling into place, through the blank pages of the closed books, the untold stories and histories of the Jews who perished both half a millennium earlier and in the Holocaust. Whiteread's initial plan to inscribe the names of Vienna's 65,000 lost Jews was not carried out because, it turned out, no such comprehensive list of names exists—another kind of forgetting by the state.

In the same way, Peter Eisenman's "Field of Stelae," which became the Memorial to the Murdered Jews of Europe near the Brandenburg Gate in Berlin, signals the unwritten legacies of the millions of Jews who were lost. With its undulating field of some 3,000 gray stone pillars varying in height from one and a half feet to ten feet, the memorial recalls anonymous headstones, caskets, and ancient stelae, becoming stand-ins for the bodies themselves, as do the steel slabs of the lynching memorial. The lack of names suggests the vicissitudes of memory itself. Called a "monument of shame" by Bjoern Hoecke, a spokesman for the far-right Alternative for Germany Party, it seems likely that a similar sense of shame is evoked for white nationalists in the United States by the national lynching memorial in Montgomery, and that this is, at least in part, behind the opposition to the monument.

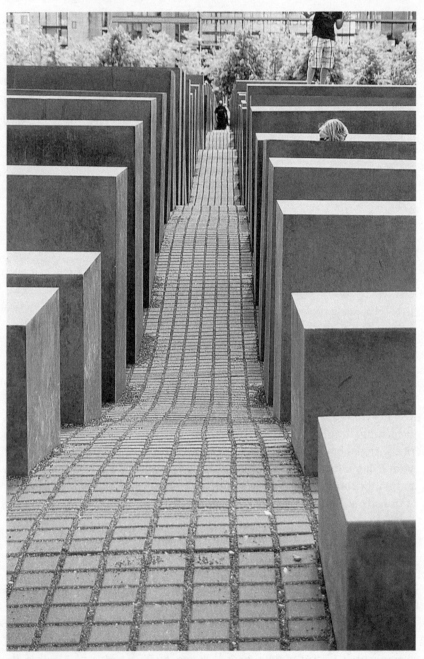

Peter Eisenmann, Memorial to the Murdered Jews of Europe, with 2,711 concrete slabs in a grid pattern; Berlin, Germany, dedicated in 2005.

Eisenman's and Whiteread's memorials are often regarded as countermonuments and negative-form designs that in themselves remember nothing specific, yet they paradoxically act as countermemories to a history of forgetting and become sites of resistance to lost memory on behalf of the millions murdered. By their very dependence on anonymity, they invite a form of historical memory that encompasses the enormity of the destruction. Eisenman's field of blank gray stones and Whiteread's unreadable library point to the cultural losses that are impossible to quantify, both past and future.

Yet the accretion of thousands of names in the end has a parallel effect, also producing an overwhelming sense of collective absence and loss. Through individual naming or a sea of blankness, these concepts of the memorial project suggest an equivalent impact, one that engages our disconnection from the past by calling into place a history prone to denial or forgetting and by recognizing the enormity of the loss. As James Young asserts, the job of such memorials is to "articulate this terrible loss without filling it with consoling meaning."[38] The Montgomery lynching memorial combines these two methods of the memorializing project, the known and the unknown, representing the void of loss without attempting to fill it with redemptive or consoling meaning, while resurrecting the names of those whose names have not been lost and thereby concretizing the loss, shaping what is remembered and how it is remembered for the future.

Mainstreaming White Supremacism

Trump's immigration war against Muslims and Central Americans and his objection to accepting immigrants from Haiti, El Salvador, and unspecified countries in Africa because they are "shithole countries," while endorsing the acceptance of immigrants from countries such as Norway, is yet another example of eugenicist and white supremacist ideology intent on rolling back the gains of the civil rights era. At stake is the attempt to define who can be an American citizen and who is not qualified to have that right, a battle that began at the Union's inception with the fight over freedom versus slavery.

In a penetrating essay, the writer Pankaj Mishra argues that it's not just the United States but the entire western Anglophone world, where whiteness has ruled without question, which is in full-scale panic mode. Concerned about the rise of "black and yellow races" more than a century ago, nineteenth-century racist pseudoscience about the inferiority of nonwhite peoples helped forge a theory of "higher races" by politicians and pundits in Britain, the United States, Australia, and Canada. Contemporary fear of the decline of white power, which, writes Mishra, has now "reached its final and most desperate phase," led President Trump to declare, "The fundamental question of our time is whether the West has the will to survive," meaning, by "the West," white power.[39]

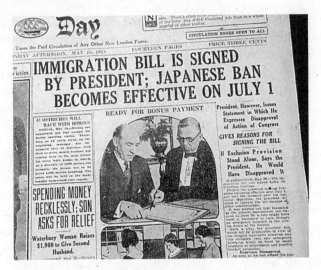

The Immigration Act of 1924, aimed at restricting immigration from southern and eastern Europe, which included the Asian Exclusion Act, banning Japanese immigrants.

The mainstreaming of white supremacism in English-speaking liberal democracies today must be understood in the context of more than a century's worth of global migration and racial mixing. For fearful ruling classes struggling to contain the mass discontent caused by early industrialization and globalization, it was necessary to forge an alliance between "rich and powerful whites and those rendered superfluous by industrial capitalism," as Mishra notes. Excluding, blaming, and degrading nonwhite peoples became a way of marshalling the loyalty of and offering dignity to those who were marginalized by economic and technological shifts. Eugenics, aimed at "improving" the genetic quality of a population, became popular, and Australia adopted a "White Australia" policy that restricted "colored" migration for most of the twentieth century.[40]

The United States adopted its own highly restrictive immigration law whereby immigration quotas were based on country of origin. The Immigration Act of 1924, which included the National Origins Act and the Asian Exclusion Act, restricted immigration based on perceived racial desirability. It was aimed at southern and eastern Europeans, especially Italians, Slavs, and Jews, who were not considered "white." It severely restricted Africans and outright banned Arabs and Asians (aiming at the Japanese since the Chinese were already banned under the Chinese Exclusion Act of 1882). It greatly limited immigration overall and prevented thousands of Jews, including Anne Frank and her family, from escaping to America during the Holocaust. The racial theories promoted by eugenicists and social theorists, aimed at preserving what was called the "Nordic" race, informed this legislation, which became the basis for the official ideology of Nazi Germany.[41]

Enacted at the height of the Jim Crow era, this restrictive immigration law prevailed until the civil rights era, when Congress repealed the per-country quotas in the Immigration and Nationality Act of 1965. No longer based on race and national origin, the new system emphasized family ties to American citizens and residents, so that people already admitted could sponsor their relatives overseas through a process Trump calls "chain migration." Others have come as refugees or in search of jobs or higher education through the diversity visa lottery, a 1990 program for underrepresented nationalities.

Conservative members of Congress who supported the family-based preferences in 1965 believed this system would bring more Europeans into the country; instead, more Latin Americans and Asians came, as well as people from Africa and the Caribbean, along with some Europeans. The total number of immigrants has grown overall in recent years, greatly alarming conservatives who fear that a disturbingly high proportion of the American population will be foreign-born. In response, the Trump administration wants to emulate the immigration law of 1924 by barring immigrants from majority black and Muslim countries and ending "chain migration" and the diversity visa lottery. For the Trump administration, the reigning criterion for American citizenship appears to be native-born, Christian whiteness.

The backlash to immigration is thus a reaction to the "browning" of America, with Trump's restrictive proposals aimed at countries that were once subject to colonial domination. At the same time, he has strengthened U.S. government support for Israel, which Mishra aptly describes as "the world's last active settler-colonialist project." The struggle for racial equality is therefore also a struggle for the rights of citizenship. Do refugees fleeing war, climate change, poverty, and persecution have the human right to immigrate to the United States? Should America serve as a haven for the persecuted and oppressed? Is national citizenship itself becoming an increasingly obsolete category as millions of refugees roam the earth looking for a safe haven? What does it mean for global refugees to have no citizenship anywhere and therefore no human rights?

It appears to mean that anything can be done to them: they can be incarcerated, fenced out, separated from their children, and left to drown on the high seas or die of thirst in the desert.

"Very Fine People"

Race is still the most volatile issue in America. For the state, blackness is a threat that must be contained and controlled, as demonstrated by the regular killings by police of unarmed black men and women with virtually no legal repercussions. Although the police keep no count, others who do record the killings estimate that approximately one hundred black Americans *per month* since 2013 have died at the hands of police in near daily assaults, totaling more

than a thousand deaths per year, according to the website Killed by Police. Today, as in the past, police serve as front-line defenders of a racist capitalist system that is built on the repression of the poor and the nonwhite in the service of a tiny, wealthy elite, the only ones to whom the police are accountable. For the wealthy elite, black protest against racist oppression is not a democratic right but a form of terrorist violence.

Even the popular Marvel film *Black Panther*, while promoting black pride and empowerment, nonetheless delivers a conservative political message. The antagonist who must die is the one who is angry and wants to fight the oppression of black people everywhere; the protagonist who vanquishes him and becomes king of a mythical black nation in Africa is the one who wants peace and accepts the status quo. He does nothing more radical than open an outreach center in Oakland, California, a weak homage to the real Black Panthers who originated there. But they fought for black equality and an end to de facto segregation, police brutality, and the military draft, as well as founding community social programs. They were ultimately destroyed by the FBI's counterintelligence program (COINTELPRO) led by J. Edgar Hoover, which surveilled, infiltrated, harassed, and criminalized the party, and assassinated Panther leaders Mark Clark and Fred Hampton as they slept in their beds.

Racial discrimination continues today in jobs, housing, health care, and education, contributing to the triple oppression of class, race, and gender for black women. It continues through the disproportionate imprisonment of black men and the everyday harassment and murder of black people by police on the streets of American cities. It continues through cold-blooded racist killings by white supremacists. As the legacy of slavery and segregation, black oppression remains the foundation of racist capitalist America, even when a black president occupied the White House. In an example of racist indifference to the education of African Americans, a Federal District Court judge dismissed a class action lawsuit filed by black students at troubled schools in Detroit by ruling that "access to literacy," which he also described as "minimally adequate education," was not a fundamental right. He made this ruling despite conceding that conditions in some Detroit schools were "nothing short of devastating."[42]

The police victimize black women in uniquely gendered ways, and their deaths do not conform to the pattern of black men who are shot during traffic stops or stopped on sidewalks.[43] The officer who arrested twenty-eight-year-old Sandra Bland in Texas for failing to signal while changing lanes, for example, made her get out of the car and slammed her head into the ground. Three days later, she was found hanging in her jail cell. While the police claimed suicide, her family and friends rejected that explanation. They wondered why an inexplicably high level of THC was found in her bloodstream and a "pasty white discharge" was found at the entrance to her vagina, according to the autopsy report. Was she drugged and raped while in custody and lynched to silence her?

Sandra Bland, a 28-year-old black woman found hanging in her jail cell in Waller County, Texas, on July 13, 2015, three days after being abused and arrested for failing to signal a change of lanes. In July 2015 alone, five black women died in police custody.

Bland's family filed a wrongful death lawsuit and settled out of court for 1.9 million dollars, while the officer who arrested her was indicted only for perjury, a charge later dropped in exchange for his agreement to end his law enforcement career. Waller County, where the arrest and death occurred, had among the highest numbers of lynchings in the state between 1877 and 1950, according to EJI's report *Lynching in America*.[44]

The national media regards the killing of black people not as an effect of the racist state but as the result of individual aberrations: in the case of white nationalists, stemming from "mental illness," in the case of the police, requiring greater "sensitivity training." Yet everyone knows that an afternoon workshop on sensitivity training will not end racism in America, as racism is embedded in our institutions and as the incidents of whites calling the police on innocent black people minding their own business continue to multiply. Examples include the white Starbucks manager who called police on two black men who sat down in a Philadelphia shop and were arrested for trespassing, or the white neighbor in Sacramento who called police on a black teen holding a cell phone in his grandmother's backyard. Police shot the teen dead. Or the white Yale student who called police on a black female classmate napping in her dormitory's common area. A month earlier the white student had called police on another black student to whom she said, "You're making me uncomfortable. I don't feel safe around you. You're an intruder. You need to leave, you need to get out."[45] There is nowhere black people can feel entirely safe.

This is the legacy of a history of enslavement, lynching, segregation, and criminalization. Individual psychology flows from institutionalized racism, which in turn has led to the widespread impoverishment of American blacks and their forcible segregation at the bottom of the economy. Racism has turned the American dream of upward mobility through hard work into a bitter joke for most people of color and poor working people generally, who instead find themselves in a downward economic spiral. Even wealthy and accomplished blacks are as vulnerable as poor ones to racial profiling and harassment, as when Harvard University professor Henry Louis Gates, Jr. was arrested at his front door in Cambridge after a neighbor reported him trying to break into his own home.[46]

Former Imperial Wizard of the Ku Klux Klan David Duke credited Trump with inspiring the Charlottesville "Unite the Right" rally, where Heather Heyer was killed, in an interview with the *Indianapolis Star*: "This represents a turning point for the people of this country. We are determined to take our country back. We are going to fulfill the promises of Donald Trump. That's what we believed in, that's why we voted for Donald Trump because he said he's going to take our country back and that's what we're going to do."[47] Loath to alienate his base, Trump refused to denounce the white nationalist rally, instead condemning the violence "on many sides." He further reached out to white supremacists by claiming they included "some very fine people."

Perhaps Trump had in mind his own father, Fred Trump, one of seven men arrested on Memorial Day in 1927, when a thousand white-robed Klansmen

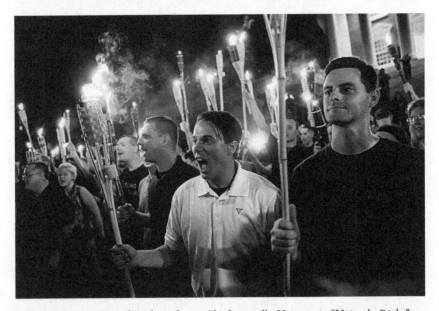

White supremacists march with torches in Charlottesville, Virginia, in "Unite the Right" rally; August 13, 2017. (Anadolu Agency/Getty Images.)

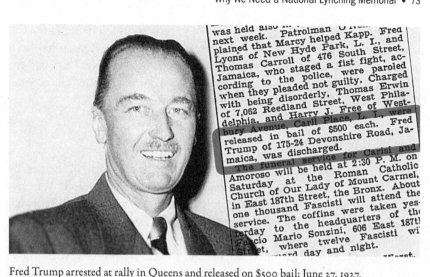

Fred Trump arrested at rally in Queens and released on $500 bail; June 27, 1927, *New York Times*.

marched through a Jamaican neighborhood in Queens, New York, inciting a brawl with a hundred police officers. They were protesting "Roman Catholic police of New York City" whom they accused of assaulting "native-born Protestant Americans."[48] Fred Trump was also notable for his racial discrimination against potential tenants in the real estate and construction business his son now runs. In 1973, the U.S. Justice Department's Civil Rights Division sued Fred Trump and his company, including Donald Trump, for refusing to rent apartments to black people after the Urban League sent black and white testers to apply for apartments he owned. Only whites got the apartments.

Neo-Nazis turned up at campaign rallies and the Republican National Convention in support of Trump, and his election to the presidency in 2016 greatly invigorated neo-Nazi and white supremacist movements. It also generated a plethora of books, television shows, films, and comics on the subject of parallels between Trump and Hitler. Hitler admired the slaughters that took place in Europe, such as the Armenian genocide, but he was truly inspired by America and its enslavement of African Americans. He was also encouraged by the doctrine of Manifest Destiny and the mass murder of Native Americans, which has been compared to the doctrine of *Lebensraum* by which Hitler justified his assault on Europe, and was further influenced by the racist ideas of Henry Ford and Charles Lindbergh, the American eugenics movement, and American race laws.[49]

California's eugenics program of forced sterilization directly inspired the Nazi sterilization law of 1934. Likewise, the American government first used the fumigating agent Zyklon-B to "disinfect" Mexican immigrants as they crossed the border. It was licensed to an American company by the German company IG Farben, which later supplied a modified version to Auschwitz for

gassing Jews to death. Hitler praised American restrictions on immigration following the Immigration Act of 1924. Since entering office, Trump has been compared repeatedly to Hitler, most of all by the American Nazi Party and the Ku Klux Klan, who were enthused and emboldened when he hired the proudly racist, Hitler-loving Steve Bannon as his first chief of staff.

Reasserting Blackness

The steel columns at the lynching memorial and the jars of soil in the Legacy Museum signal not only the long history and widespread geography of lynching, but also the invisibility of most of its victims. Yet sometimes invisibility is a useful strategy as an act of self-preservation and the assertion of personhood.

The vicious police beating of Rodney King in Los Angeles in 1992, one of the first such episodes caught on videotape, led to massive protests when a jury acquitted the officers involved. African American artist Nick Cave responded to the national outrage by developing ornately colorful, oversized, full-body costumes called Soundsuits that disguise and transcend ordinary identity. Allowing the wearer to assume a larger-than-life magical persona, the Soundsuit reads as a racialized figure of excess that resonates with African masquerade and Mardi Gras. Inside a Soundsuit, one is enchanting, impervious, and dazzling, expressing a form of resistance to the daily oppression of racial discrimination and violence through a form of invisibility. The Soundsuit obscures and thereby protects individual identity while asserting a joyful and confident selfhood in fantastical form.

One Soundsuit, however, eschews such celebratory vibrancy. In *TM 13*, Cave evokes both the killing of Trayvon Martin and the acquittal of his killer, the same events that helped inspire Dylann Roof's murderous rampage in Charleston. The sculpture takes the form of a black man in a hooded sweatshirt with symbols of childhood such as a Santa Claus figure, a teddy bear, and an angel strapped to the figure and partially obscured by beaded netting, as if Martin were caught in the mesh of his own innocence and desire for a normal life. In this misshapen form, from which only a sneakered foot emerges, the oppressive constraints that transform blackness into a cage suggest the subjugation and precariousness that continue to characterize the condition of black life in the U.S. today. In the context of Trump's America, this work also evokes the caging of children taken from their parents at the U.S.-Mexican border by U.S. immigration authorities.

As Edward Said observed, "Collective memory is not an inert and passive thing, but a field of activity in which past events are selected, reconstructed, maintained, modified, and endowed with political meaning."[50] The Legacy Museum and the National Memorial for Peace and Justice opened at a crucial time in U.S. history. They perform a necessary act of commemorative vigilance that serves as an "unforgetting" of black history and counternarrative to

Nick Cave, *TM13*, 2015, mixed media including blow molds of Santa Claus, a teddy bear, an angel, netting, and metal. © Nick Cave. (Courtesy of the artist and Jack Shainman Gallery, New York.)

disbelief and to the ideology and values of the Confederacy. They also function as a counterforce to a wildly resurgent and desperate white supremacism that has produced a rising tide of hate crimes in the United States and abroad.

By emplacing black history, the museum and memorial strike a blow against the culture of silence that has existed around lynching, just as contemporary reenactments of a quadruple lynching in Moore's Ford, Georgia, in 1946 break that silence. The reenactments, which have taken place since 2005 and include whites as well as blacks, offer public legitimation of black memory and history through a confrontation with the past.[51] It is not just a question of recognizing and acknowledging the enormity of the thousands of lives lost, but also a question of how we understand the world today and what kind of world we want to live in. As historian James Grossman said of Trump's opposition to removing Confederate monuments from public view as "erasing history," when such monuments are altered, "You're not changing history. You're changing how we remember history."[52] The way we interpret and bestow meaning on events in the present and future originates with our construction of cultural memory about the past.

4

"Let the World See What I've Seen"

Mamie Till's great accomplishment in 1955 was to turn a quiet American lynching into a cause for national outrage and mourning, especially for the nation's black population. When she had the sealed coffin holding the remains of her slain fourteen-year-old son opened and held a four-day public viewing to which tens of thousands of people came, it was an emphatic protest against the racist killing and the entrenched racism that for decades countenanced the lynching of black people. Mamie Till encouraged publication of the funeral photographs, saying, "I couldn't bear the thought of people being horrified by the sight of my son. But on the other hand, I felt the alternative was even worse. After all, we had averted our eyes for far too long, turning away from the ugly reality facing us as a nation. Let the world see what I've seen."[1]

This courageous act of exposure by Emmett Till's mother succeeded spectacularly. The photos of Till's terribly disfigured face as he lay in his casket, formally dressed in a white shirt and black jacket, deeply shook the nation. It galvanized so many young black people that some called it the Emmett Till generation; many wrote about its emotional effect on them, and thousands became impassioned activists in the civil rights movement. Mamie Till helped burn the image of her son's tortured face into national cultural memory, helping to mobilize the country's fight for black civil rights, which also brought the sympathy of many whites to her side and to the cause of civil rights.

Unknown photographer, *Mamie Till Bradley and Her Son Emmett Till*; Chicago, Illinois, 1955. (Library of Congress, Washington, D.C., Prints and Photographs Division.)

Unknown photographer, Emmett Till in open casket at funeral; Chicago, Illinois, 1955. (Permission of the Chicago Defender.)

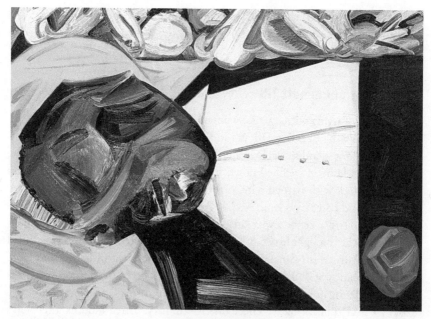

Dana Schutz, *Open Casket*, 2016, oil on canvas, 38.5 × 53.25 inches. ©Dana Schutz. (Courtesy of the artist and Petzel, New York.)

Why then did Dana Schutz's painting *Open Casket*, based on the famous photograph of Till in his casket, cause a major controversy when it was shown at the Whitney Biennial in New York City in 2017? And what does it say about the state of the struggle for black rights today?

Hannah Black, a British-born biracial artist living in Germany, posted an open letter on Facebook with more than thirty signatories, asserting that it was not the white artist's story to tell and accusing her of cultural appropriation and the exploitation of black pain. The letter suggested that, by virtue of her whiteness, Schutz needed to recognize her complicity with a history of racist oppression. The letter urged the Whitney curators to take the work down, but did not stop there. It also called for the destruction of the painting. The letter quickly went viral, exploding into a national debate with thousands of people commenting on digital media, blogs, and essays in newspapers and magazines.

Because of the disturbing demands raised by the critics, it necessarily became a debate about the folly of censorship and the nature of white empathy, though the debate also raises larger questions about black oppression in America today and the potential role of museums in addressing such questions. Those critical of Schutz accused her of failing the empathy test, while those opposed to the critics rightly pointed out that historically, only deeply conservative and repressive forces have sought to control art and culture. I will further argue that accusing Schutz—and by extension, any white artist—of presuming to engage sympathetically with

subject matter not properly "hers" is a counterproductive politics of retreat and despair that ignores the history, and the necessity, of political alliance and integrated political struggle.

The Legacy of Emmett Till

For allegedly flirting with a white woman on a dare during a visit to cousins in Mississippi, young Emmett Till was abducted by two white men—J. W. Milam and Roy Bryant—and savagely beaten, shot, and thrown into the Tallahatchie River, his nude body weighed down by a hundred-pound iron cotton-gin fan tied to his neck with barbed wire. His body nonetheless floated to the surface and was found three days later. Acquitted by an all-white jury, Milam and Bryant admitted to the crime a year later during an interview with *Look* magazine.

Till's mother brought his body back to Chicago, insisted on opening the sealed casket, and turned his funeral into a national public event of horror and grief. Published photos of Till's formally arrayed battered body, in addition to images of him as a living boy and his grieving mother at his funeral, had an emotionally explosive and transformative effect on the country. Three months after Till's funeral, the antisegregation activist Rosa Parks refused to give up her seat on a bus in Montgomery, Alabama, sparking the year-long Montgomery bus boycott. Parks related her decision, in part, to the shock of seeing the photographs of Emmett Till. Despite decades of both quiet and spectacle lynchings, the killing of

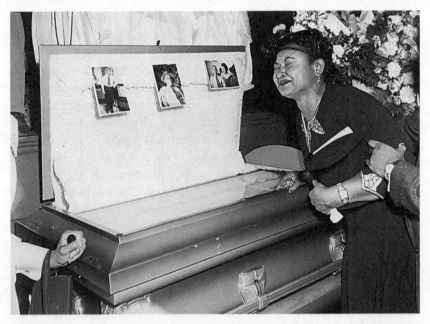

Mamie Till Bradley at the funeral of her son Emmett Till; Chicago, Illinois, 1955. (AP Photo.)

Till and the widely publicized photos of his grieving mother and mutilated body, in what was effectively a spectacle funeral, shocked the nation.[2]

The cultural trauma of Till's murder has continued to haunt American memory and imagination, generating over the past sixty years more than 140 novels, plays, poems, and songs by artists such as Langston Hughes, Gwendolyn Brooks, Toni Morrison, Audre Lorde, and Bob Dylan.[3] There are numerous historical studies, memoirs, and documentary films, such as Keith Beauchamp's 2005 *The Untold Story of Emmett Till*. In 2006, the "Emmett Till Memorial Highway," was dedicated. In 2012, the Emmett Till Interpretive Center in Sumner, Mississippi, opened across the street from the restored courthouse where his murder trial took place. The Emmett Till Memory Project website and phone app identifies fifty-one places associated with him. In 2015, Florida State University Libraries created the Emmett Till Archives. In 2017, the Smithsonian's National Museum of African American History and Culture opened an exhibition that included the original casket in which Till was buried (after his remains were exhumed for an autopsy in 2005, he was reburied in a new casket).[4] The Emmett Till Historic Intrepid Center in Glendora, Mississippi, is a small museum housed in the building from which Till's killers took the fan to weigh down his body before throwing him in the Tallahatchie River, and is part of the U.S. Civil Rights Trail launched in 2018, which includes more than a hundred sites across fourteen states. In 2020, Congress passed the Emmett Till Anti-Lynching Bill after 120 years of failing to pass such a bill. The shocking murder of Till serves as a hinge moment in American culture, placing the heavy burden of lynching history on the shoulders of this fourteen-year-old boy whose cultural visibility provides a necessary counterweight to a long history of blind silence.

Refusing Solidarity

Schutz is a safe target for the anger, frustration, and despair provoked by other, more difficult to control political forces that lead to racial violence. In fact, they are the same forces that compelled Schutz to produce the painting in the first place. In a statement of political solidarity, she asserted that she conceived of the painting in August 2016 "after a long, violent summer of mass shootings, rallies filled with hate speech, and an ever-escalating number of black men being shot execution style by police, recorded with camera phones as witness."[5]

Mass shootings, hateful rhetoric, and escalating numbers of black people murdered by police testify to the fact that we are living in a state of emergency, and no one feels this more keenly than the young black people who are its primary victims. The emotional response to Schutz's painting, largely from young black artists, comes at a time when black people are under constant attack in America, erupting at a moment when African Americans are at greater risk than ever under the rule of an openly racist state. The shameless contempt for immigrants and people of color under the Trump administration has emboldened a

rabid white supremacist movement by tapping into fears of the "browning" of America. This racial resentment spans the white ruling class to the white working class, deepening the anxiety that generates the heat and vitriol of this controversy. But Schutz's painting counters this white supremacist perspective, making the attack by Hannah Black and her cosigners historically blind and politically misguided.

Identity politics must be understood in the context of class politics. A Marxist perspective on the double oppression of blacks, in terms of both race and class, starts with the understanding that the black question is central to everything in U.S. culture and society. This includes health care, education, sports, religion, music, sex, and art.[6] It is central to everyday life in our capitalist society because racism is a system backed by legal authority and institutional control, "a system of advantage based on race." Precisely because whites are very much part of this system, they can choose to disrupt it, critique it, oppose it, and ultimately join with others to replace it.[7]

In his essay, "Black Liberation Struggle," Marxist theorist Jacob Zorn notes that the goal of building a multiracial party that will lead a multiracial working-class struggle for power through worker revolution is derailed through racial divisions exploited by the capitalist class. This is what makes the black question so important to contemporary American politics. Zorn argues that the common belief among many blacks and even white leftists is that all white people are irredeemably racist. We must understand this as a form of race essentializing that makes the idea of integrated struggle seem virtually impossible. "There is a difference," writes Zorn, "between the racism of the ruling class, which *depends* on black oppression to maintain its power, and the racism of white workers, which is an *obstacle* to their class interests." At important junctures in U.S. history, starting with the Civil War, white working people have fought alongside black working people for their common interests, and such interracial struggle can break down racial and ethnic divisions.[8]

It is therefore telling that Hannah Black removed the names of white signatories to her open letter to the Whitney Museum, signaling a decision to reject politically sympathetic whites as allies to her cause.[9] In addition to rejecting the empathy of Dana Schutz, the protesters' refusal of political solidarity by cosigners enforces their belief in essentialized racial identities that cannot be mitigated through subjective choice and conscious political agency.

This was not the view of black activists historically, such as the great anti-lynching campaigner Ida B. Wells, who was the first to advocate for the support of white women as a necessary part of any campaign against the lynching and rape of black women. Following World War I, white women began to reject their role as the rationale for lynching and to join the antilynching campaign led by the Anti-Lynching Crusaders, an organization of black women who were campaigning to pass the Dyer Anti-Lynching Bill, first introduced in 1918. By

1922, many white women's organizations came out strongly against lynching, mob violence, and the rape of black women. Although racist southern congressional representatives filibustered and defeated the Dyer Bill, as they did with nearly two hundred antilynching bills in the first half of the twentieth century, black and white women throughout the 1920s and 30s continued to work for the passage of a federal antilynching bill.[10]

There are also times when solidarity *should* be refused. Black artist Parker Bright told a journalist that he signed Hannah Black's letter out of solidarity, while confessing that he actually opposed the demand for destruction of Schutz's painting, making it an unprincipled form of "solidarity." Black artist Clifford Owens, on the other hand, wrote on Facebook, "I don't know anything about Hannah Black, or the artists who've co-signed her breezy and bitter letter, but I'm not down with artists who censor artists."[11] Parker Bright launched his own small protest on the first day of the Whitney Biennial by standing in front of Schutz's painting wearing a T-shirt that said "Black Death Spectacle" written in black sharpie on the back. Yet Schutz's painting may be seen as a reminder of the much larger "black death spectacle" that Mamie Till orchestrated at her son's funeral, suggesting that Schutz was resurrecting that memory, in principled solidarity with Till's mother, rather than exploiting it.

Artist Parker Bright protesting in front of Dana Schutz's painting *Open Casket* at the Whitney Biennial in 2017. (© Photo: Michael Bilsborough.)

The Problem with Liberalism

Black writes in her letter that Till's mother made her son's body "available to Black people as an inspiration and warning," implying that the famous photo of the mutilation was not meant for white eyes. Others have cited the fact that the photo appeared primarily in the black press, most famously in *Jet* magazine but also in black newspapers such as the *Chicago Defender*, the *Pittsburgh Courier*, the *Amsterdam News*, and the *Crisis*, and in Ernest C. Withers's published booklet *Complete Photo Story of Till Murder Case* in 1956. Till's killing, however, and the trial of his murderers were also covered in mainstream white magazines and newspapers such as *Time*, *Life*, *Newsweek*, the *New York Daily News*, and the *Chicago Sun-Times*. Yet it is true that most editors of white newspapers chose not to print the horrific photo of Till's face. Why not?

Mamie Till wrote that it was "important for people to look at what happened on a late Mississippi night when nobody was looking, to consider what might happen again if we didn't look out." She was convinced the public "would not be able to visualize what had happened, unless they were allowed to see the results of what had happened. They had to see what I had seen. The whole nation had to bear witness."[12] Till's mother wanted as many people as possible— "the whole nation"—to see the gut-wrenching results of what had been done to her son, rightly convinced they would be horrified.

However, as Martin Berger has shown, liberal white newspapers that published photos of the funeral chose not to publish the most gruesome image, not because his mother opposed it or because they had difficulty obtaining rights to the image (as some have claimed), but because they thought it "inappropriate." The innocence and vulnerability of black children cast their white abusers in a light that was too shaming for many whites, which made them especially uncomfortable with images of brutalized children. White editors also largely refused to publish pictures of children as the targets of police water hoses or bitten by police dogs during peaceful civil rights demonstrations because such images "reflected poorly on their race."[13] These liberal editors understood the power of the shocking Till photo as well as Till's mother did and shied away from its inflammatory effects.

Unlike antiracist whites who joined with blacks in the civil rights movement, liberal middle-class whites in the North were more comfortable with images that challenged racist excess but not the racial hierarchy itself. "Photographs and news reports that reinforced black passivity, white control, ideological divisions among whites, and the supposed social and cultural distance between blacks and whites," writes Berger, "crowded out images and articles that promoted competing narratives."[14] White press interest in the Till case centered on "the novelty of placing whites on trial for the murder of a black boy, and later on the injustice of the acquittal, rather than on the death itself." Mamie Till's emphasis on the importance of the world seeing "the death itself"

was therefore critical. By suppressing the image, the white liberal press aligned itself with the perpetrators who went to great lengths to hide the body. Why did they feel the need to do so after so many decades of public lynching? Berger argues it was because Till was a boy, not the sexually threatening man Milam and Bryant's defense attorneys tried to make him out to be. The sympathy evoked by the innocence of Till's youth, which was described in the white press, did nothing to defuse the stereotype of the sexually predatory adult black male.[15]

Even without publication of Till's mutilated face by the white liberal press, the news coverage of his killing was unprecedented and credited with being "the first great media event of the civil rights movement."[16] Cassius Clay (Muhammad Ali), John Edgar Wideman, Lew Alcindor (Kareem Abdul-Jabbar), Eldridge Cleaver, Anne Moody, Charlayne Hunter-Gault, and many others have testified to its emotional effect on them. All three national television stations as well as international news covered the trial, bringing the state of Mississippi under heavy criticism. Exposing the atrocity to the world had an electrifying effect, even though many whites may not have seen the photo of Till's face until 1987, when the first episode of *Eyes on the Prize*, a civil rights television documentary, aired on television.[17] There is no doubt, however, that Till in his casket is an image the nation can't forget, despite the political cowardice of white liberal newspapers that originally suppressed the image, adding irony to the demand that Schutz's painting be removed from view.

"Profiting" from Till's Legacy

Black's letter belittles Schutz's painting as created for "profit and fun." The concern over "profit" drives both the demand for the painting's destruction and the fury over its exhibition. Black and her cosigners suggest that Schutz chose the subject matter for purely cynical and mercenary reasons because white artists cannot or *should not* identify with black suffering (although Schutz made clear even before the Biennial that she had no plans to sell the painting). Therefore, they regard any white artist who engages with racial issues as automatically exploitative, effectively demanding that white artists "wallow in shame," as Coco Fusco observes in her own acerbic response to the controversy.[18] This demand for shame rests on the essentializing and ahistorical belief that whites are irredeemably racist or inescapably complicit with institutionalized racism.

There has indeed been cynical use made of Till's legacy in recent public life, but not by white artists. Emmett Till is the one black name of the thousands lynched that most people recognize today as a cultural signifier for racial injustice, and Camille Cosby invoked it in defense of her husband Bill Cosby after his belated conviction for sexual assault, one of more than sixty that women have reported. "Since when are all accusers truthful?" she asked. "History disproves that. For example, Emmett Till's accuser immediately comes to mind." Andrea Constand, a gay woman whom Cosby drugged and raped, is likened to

Carolyn Bryant, the white woman who admitted in a 2007 interview with historian Timothy Tyson that she had lied about the threat Till posed when she was a twenty-one-year-old store clerk. Bill Cosby is likened to Till himself, his conviction for sexual assault a lynching.[19]

This recalls Clarence Thomas's response to charges of sexual harassment made by Anita Hill during his public confirmation hearings for the Supreme Court in 1991. Hill alleged that Thomas had sexually harassed her for ten years while she worked for him. Thomas turned the tables on his interrogators and claimed that the senate hearing and public probing into his private life was itself "a high-tech lynching for uppity blacks." Senators responded by discounting Hill's testimony and confirming Thomas to the nation's highest court. In both cases, these self-serving ploys invoked a powerful symbol of collective shame to cow those who would judge them for being sexually abusive, playing the ultimate race card as a defense: lynching a black man for imagined sexual offenses. Only Thomas got away with it.[20]

Censorship and Cultural Policing

Black's letter states, "The subject matter is not Schutz's; white free speech and white creative freedom have been founded on the constraint of others, and are not natural rights. The painting must go." The danger of suggesting that free speech and creative freedom must be limited because they are not "natural rights" or of advocating for the repression of visual art in the name of any cause is chilling. We have seen too many historical examples of this—from the Taliban who destroyed the magnificent Bamiyan Buddhas in Afghanistan, to the Stalinist "socialist realist" stranglehold on art and culture, to the Nazi destruction of thousands of modernist artworks deemed "degenerate" because of their use of abstraction, their interest in free sexuality, and their "primitivist" fascination with tribal cultures. As Coco Fusco observes, this places the protesters "on the wrong side of history."[21] No doubt many of those calling for destruction of the work would not align themselves with repressive religious and fascist regimes, yet this is where their position leads. It recalls the way that feminists Catharine MacKinnon and Andrea Dworkin aligned themselves with ultra-conservative politicians in the early 1980s when they framed pornography as a form of sex discrimination and promoted antipornography laws. Repressive politics makes for unsavory bedfellows.

In the immediate aftermath of the controversy, *New York Times* art critic Roberta Smith asserted that censorship is abhorrent, though people who are outraged by a work of art are certainly free to protest, and museums would do well to foresee and frame potentially controversial works with labels or programming. Smith notes that Abel Meeropol, a white Jewish schoolteacher, wrote the painfully beautiful antilynching ballad *Strange Fruit*, made famous by Billie Holiday in 1939.[22] A year later, however, some senior art critics

suggested that Schutz did indeed cross a line by representing black experience, including Roberta Smith, who backtracked by suggesting that perhaps Schutz wasn't the "right" white painter to take on the subject.[23] Schutz herself, in a *New York Times* interview, observed that perhaps she had gone too far. This is sad but, more importantly, it is wrong.

Schutz's critics align themselves with those who would remove art they simply do not like, such as Rudolph Giuliani and the group of Roman Catholics who in 1999 were offended by the Turner Prize–winning artist Chris Ofili's painting of a black Madonna and child in the Brooklyn Museum as part of the *Sensation* exhibition. The painting included small cutouts from porno magazines and small balls of dung varnished and set with beads. Giuliani, then mayor of New York, not only wanted to remove Ofili's painting but to cut off funding to the Brooklyn Museum.[24]

As Fusco observes, "audience offense" is insufficient reason for museums to remove artworks. "Many of those endorsing the call," she writes, "have either forgotten or are unfamiliar with the ways Republicans, Christian Evangelicals, and black conservatives exploit the argument that audience offense justifies censorship in order to terminate public funding for art altogether and to perpetuate heterosexist values in black communities."[25] She notes "the impossibility of effective museum management if curatorial decisions are handed over to angry mobs, or the long-term effects of taking art works down just because someone doesn't like them."[26]

Fusco also reminds young protesters that ethnic communities have often been unkind to members of their own groups when the work they make does not accord with pre-existing expectations, recalling the Black Arts Movement of the 1960s and 70s, which many ultimately accused of being essentialist and sexist, often marginalizing the role of black women. Black artists also launched a campaign against the work of fellow artist Kara Walker as hurtful to black people. Betye Saar attempted to stop the display of Walker's work and denounced her in a letter suggesting that she felt "a sense of betrayal at the hands of a black artist who obviously hated being black." As Lisa Saltzman observes, Saar and her generation fought against black stereotypes and saw Walker's obscene fantasies as reactivating and perpetuating those disparaging stereotypes; what Saar didn't see in their manifest unreality was a critique confronting the dark side of a lingering white supremacist memory of slavery.[27] Saar and her fellow critics suggested that black artists should represent blackness only in certain approved ways—another example of why art must not be constrained.

This brings us to the assertion that "the subject matter is not Schutz's," the root of the issue. In reaction to the controversy, Schutz said, "I don't know what it is like to be black in America but I do know what it is like to be a mother. Emmett was Mamie Till's only son. The thought of anything happening to your child is beyond comprehension. Their pain is your pain. My engagement

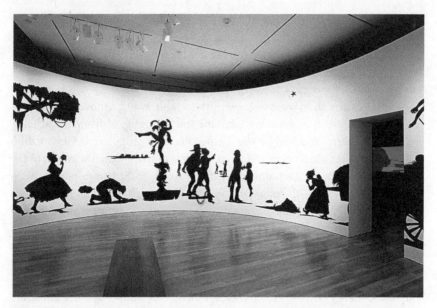

Kara Walker, *Slavery! Slavery! Presenting a GRAND and LIFELIKE Panoramic Journey into Picturesque Southern Slavery or "Life at 'Ol' Virginny's Hole' (sketches from Plantation Life)" See the Peculiar Institution as never before! All cut from black paper by the able hand of Kara Elizabeth Walker, an Emancipated Negress and leader in her Cause* [detail], 1997. Cut paper on wall, 12 × 85 feet. Installation view: *Kara Walker: My Complement, My Enemy, My Oppressor, My Love*, Hammer Museum, Los Angeles, 2008. (Photo: Joshua White. Artwork ©Kara Walker, courtesy of Sikkema Jenkins & Co., New York.)

with this image was through empathy with his mother."[28] It was indeed the anguished photos of Mamie Till at her son's funeral that evoked widespread sympathy among whites and helped bring the nation to her side. Yet we might also see in this a defensive gesture that reduces Schutz's identification to one that resists being impugned.

Schutz's critics, however, dismissed even this claim as irrelevant or impossible. Aruna D'Souza in her book *Whitewalling* asserts a categorical indictment of whiteness and offers a hodgepodge of rationales for censoring and destroying Schutz's work while rejecting the idea of maternal empathy between white and black mothers. Instead, she aligns Schutz's painting with "the lies" of Carolyn Bryant and further dismisses Schutz's statement about the escalating killings of blacks in contemporary America as inspiration for the work. D'Souza accuses Schutz of "sidestepping" her own culpability in racist murder because she identifies with Till's mother rather than with his white accuser, reinforcing an essentialist view of whiteness as irredeemably racist.[29]

Many artists and critics of all races condemned Black's call for censorship, and in response, the argument broadened to general anger over bias against

black artists in the art world. Lack of access to resources, institutional racism, and exclusionary practices in relation to artists of color (as well as women artists) are indeed long-standing practices and still denied by some large art institutions. However, in another irony, this controversy arose at a moment when the Whitney Biennial had for the first time ever given about half its space to artists of color and half to women (the 1993 Whitney Biennial, curated by Thelma Golden, represents an earlier attempt to diversify artists). The Biennial curators Christopher Y. Lew and Mia Locks, themselves Asian-American, chose artists that represented a range of ethnicities, regions, and identities. This was no doubt in response to criticism of the 2014 Biennial that had only nine black artists out of about 118 (and included the participation of the fictional "Donelle Woolford," a "black woman artist" who turned out to be the alter ego of the white male artist Joe Scanlan). Many of the works in the 2017 Biennial addressed themes of racism and violence, though this was lost in the debate over censorship and white empathy.

The Importance of Seeing

The controversy also raises the question of representation of the black body by black artists, such as the painting by Henry Taylor, *THE TIMES THAY AINT A CHANGING, FAST ENOUGH!* The painting takes us inside a car with a dying Philando Castile, a thirty-two-year-old black man shot by a Minneapolis police office, whose gun can be seen pointing ominously through the window.[30] The painting of the 2016 fatal shooting is in the same Whitney Biennial as Schutz's painting. Apparently, a small group of black artists and museum professionals protested Taylor's painting as well, displeased with the idea that he, too, might "profit from black death."[31] The horror of commodification, a charge hurled against artists not for the first time, must be reconciled with the fact that we live in a capitalist economy, where artists must sell their work in order to make a living.[32] But is such representation disrespectful to those who have been murdered, trivializing and exploiting their suffering and making the viewers complicit? Are we simply voyeurs?

It seems to me that a failure to make racialized violence visible is a much worse danger. Although the risk of prurient interest is always present, the more important imperative is to remember the specificity of injustice and to act as historical witnesses, seeing what should not be forgotten. To suppress or prevent such images would perpetuate a racist hegemonic perspective and whitewash the crimes of white supremacism. Visual imagery shapes how we understand the world in ways that are immediate, visceral, and often more powerful than written text. Without the impact of visual imagery, we risk sanitizing atrocity, and for too many decades the nation's public memory of lynching was shaped by "suffocating silences."[33]

Henry Taylor, *THE TIMES THAY AINT A CHANGING, FAST ENOUGH!* 2017, acrylic on canvas, 72 × 96.8 inches. © Henry Taylor. (Courtesy of the artist and Blum & Poe, Los Angeles/New York/Tokyo. Photo: Cooper Dodds.)

Like Mamie Till , Philando Castile's girlfriend Diamond "Lavish" Reynolds also courageously implored the world to see, using her cell phone to livestream a video to Facebook of the killing of her fiancé, which millions of people watched. Reynolds, sitting in the car with her four-year-old daughter, narrated the video, telling her audience that Castile's arm had been nearly "shot off" by the police officer who had stopped them for a broken taillight, and shows the cop's gun pointing into the car. This "act of heroism, and the conversation it prompted," writes Allyson Hobbs of Reynolds's video, made her reconsider her own stance of not showing images of atrocity in her college American history class, because she realized that such images have the power to change consciousness. Both Mamie Till (then known as Till Bradley) and Reynolds "asked onlookers to view the bodies of two black men and see a son, a brother, a boyfriend, a loved one. Looking is hard. It shakes us and haunts us, and it comes with responsibilities and risks. But, by allowing us all to look, Bradley and Reynolds offered us real opportunities for empathy."[34]

The same can be said for Taylor's and Schutz's paintings, though the visual format is different. In the West, we identify knowledge with vision, which makes the subject "real," even though we know that photography and art are mediated. Both Taylor's and Schutz's paintings are based on documentary

photography or video, which heightens their sense of authenticity, blurring the border between art and documentary and reproducing a sympathetic point of view. The very fact of looking becomes an ethical act that keeps alive memory of the atrocity as part of a larger cultural horizon of memory. Shared looking, though it may be painful, makes visible and acknowledges the trauma, provides witness to the humanity of the victims, and offers the basis for progressive political alliance. It is the refusal to look, the unwillingness to see and to acknowledge, as with those who scorned the Legacy Museum and memorial to lynching victims in Montgomery, Alabama, which blocks the possibility of empathy.

In a twist on the censorship argument, some suggested that Schutz can paint whatever she wants but that the Till painting nonetheless *should not be seen.* Though not naming Schutz directly, Kara Walker responded on Instagram:

> The history of painting is full of graphic violence and narratives that don't necessarily belong to the artists own life, or perhaps, when we are feeling generous we can ascribe the artist some human feeling, some empathy toward her subject. Perhaps, as with Gentileschi we hastily associate her work with trauma she experienced in her own life. I tend to think this unfair, as she is more than just her trauma. As are we all. I am more than a woman, more than the descendant of Africa, more than my father's daughter. More than black more than the sum of my experiences thus far. I experience painting too as a site of potentiality, of query, a space to join physical and emotional energy, political and allegorical forms. Painting - and a lot of art often lasts longer than the controversies that greet it. I say this as a shout to every artist and artwork that gives rise to vocal outrage. Perhaps it too gives rise to deeper inquiries and better art. It can only do this when it is seen.

Walker, writing from the American Academy in Rome, refers to one of the rare women painters in the seventeenth century and her painting *Judith Slaying Holofernes* in the Uffizi in Florence. At the age of eighteen, one of her father's colleagues, Agostino Tassi, raped Gentileschi. Previously imprisoned for raping his sister-in-law and conspiring in the murder of his wife, Tassi was convicted in a trial a year after Gentileschi was tortured with thumbscrews to "confirm" her testimony. Because the Grand Duke of Tuscany considered Tassi such a good painter, however, he pardoned him. Gentileschi produced several versions of the biblical story of Judith savagely beheading Holofernes in order to save her people, the Israelites.

These works offer more than a way for Gentileschi to "take revenge," a popular interpretation of her subject choice. Her gruesome depiction of women triumphing over tyrannical men is powerful in ways that go beyond personal experience. To reduce it to that is to limit the power of the work because, as Walker suggests, she was more than just her trauma. She painted many subjects and was a great painter herself, the first woman to enter the Academy of Art

Artemisia Gentileschi, *Judith Slaying Holofernes*, c.1620, Uffizi Gallery. (PD-US via Wikimedia Commons.)

and Design in Florence in an era overwhelmingly dominated by men. Like Gentileschi, Walker, and Schutz, we must be open to and capable of imaginative acts of empathy, to regard the work of art, in Walker's words, as a "site of potentiality, of query, a space to join physical and emotional energy, political and allegorical forms."

Critics such as D'Souza also argued that Schutz did not meet her responsibility to her subject matter because of her use of abstraction, which made the face unrecognizable. We could point out that Till's face is unrecognizable

because it *was* in fact unrecognizable, and it was precisely its unrecognizability that was so devastating to his mother and shocking to the world. Mamie Till allowed a mortician to fix the worst of it, telling a *Chicago Defender* interviewer several decades later, "When I saw it, the right eye was lying on his cheek. His tongue had been choked out by the weight of the fan and the barbed wire that was around his neck was still attached to the fan, parts of both ears were missing. The back of the head was practically separated from the face area. The mouth was wide open. You could only see two of the three remaining teeth."[35] We could argue that Schutz's painting, through its abstraction of Till's face, conveys a more realistic impression of the original brutalizing disfigurement, even alluding to the protruding tongue. As Roberta Smith initially wrote of the subtle effect of Schutz's handling of paint, "Her sliding brushwork guides our eyes away from them [the wounds], suggesting a kind of shocked visual reflex."[36]

The larger problem, however, is the suggestion that abstraction is somehow less legitimate than realism, another autocratic and moralizing claim that presumes to dictate to artists how best to represent a subject. Twentieth-century debates regarding aesthetic strategies and the depiction of violence ultimately demonstrated that realism and abstraction are not inherently radical or conservative—it all depends on how they are used.

In short, Schutz's painting translates the Till photo into tactile, painterly terms, a memorializing and commemorative gesture. Rather than attack the artist who brings the memory of Emmett Till to light once more, we would be better served by using this moment to teach people his story and honor the courage and foresight of his mother. Rather than attack the painter for being white, we might more usefully consider the critical possibilities of the image as an appraisal of the continuing legacy of racism. If the murdered body of a black boy repeats an iconography of suffering and violence, it also invites an attitude of political resistance. As Fusco asserts, Schutz was "stepping out of line with the dominant culture in underscoring the connection" between contemporary police killings and lynchings.[37] Schutz's painting is an act of cultural remembering and implicit protest against the ongoing murders of black people in a country where the history of black oppression is as much white history as black history.[38]

Just as the Holocaust and its imagery have helped shape Jewish identity, so, too, lynching imagery has helped shape black identity, including the antilynching work of social movement activists and artists who have responded to racial violence and persecution over the course of U.S. history. White artists such as Paul Cadmus, George Bellows, Reginald Marsh, Harry Sternberg, and Japanese American Isamu Noguchi in the 1920s and 30s utilized lynching photographs to challenge and condemn the racial hierarchies that white supremacists sought to construct and reinforce with those images, which were often sold as souvenir postcards that upheld a sense of white power over black bodies. Antilynching artists appropriated lynching images as powerful tools against the

white power hierarchy, which played an important role in arousing national antilynching sentiment. They also demonstrated that the meaning of images is not fixed and stable but may be mobilized for opposing political purposes. The determining factor was not the color of the artist's skin but the principles of their politics. Given how resistant Congress was to act on antilynching legislation, the NAACP and Communist-affiliated groups (the John Reed Club, International Labor Defense, and the Harlem Vanguard group) sponsored two major antilynching exhibitions in New York City in 1935, including both black and white artists, to rally wider support. The racially integrated art exhibitions in themselves flouted segregationist art-world conventions.[39]

Intellectual freedom is fundamental to the making of art, as is the right to dispute and protest imagery with which we disagree, without calling for the destruction or censorship of such works. Even Nazi art has not been and should not be destroyed but studied for what we can learn about the historical era in which it was produced. Schutz's painting, however, is in no way analogous to Nazi art, which was intent on reinforcing German nationalism, "Aryan" supremacy, and traditional gender roles. In the end, the call for censorship is tantamount to enforcing a narrow conception of what is acceptable, and positions Schutz's critics as the arbiters of taste for all. Leon Trotsky and André Breton wrote in their "Manifesto: Towards a Free Revolutionary Art" in 1938, in response to both Stalinist and Nazi cultural repression: "In the realm of artistic creation, the imagination must escape from all constraint and must, under no pretext, allow itself to be placed under bonds."[40] It is no less true today. The independence of art requires our vigilance against all forms of constraint. Hannah Black and her supporters assume the right to speak for all black people in a revived form of cultural nationalism and racialized essentialism—essentializing both blackness and whiteness—which threatens to homogenize race-based political and artistic diversity, stifle dissent, and narrow the range of voices.

Diversity in the Museum

The lack of diversity in art museums has become another source of protest with a cultural, nationalist bent. In response to the decision by the Brooklyn Museum in 2018 to hire a white woman as an African art–consulting curator, critics on social media argued that this selection represented "ongoing legacies of oppression." The museum defended the choice of Kristen Windmuller-Luna, as did two senior black scholars who were her teachers and mentors. In a statement released by Anne Pasternak, director of the Brooklyn Museum, renowned Nigerian-American curator and scholar Okwui Enwezor said:

> I regret deeply the negative press and social media around the appointment of
> Dr. Kristen Windmuller-Luna, formerly a brilliant student of mine, to the
> position of the Sills Consulting Curator at the Brooklyn Museum. The criticism

around her appointment can be described as arbitrary at best, and chilling at worst. There is no place in the field of African art for such a reductive view of art scholarship according to which qualified and dedicated scholars like Kristen should be disqualified by her being white, and a woman.[41]

Others point out that most students in the field are white and female. "Art history, generally, has not always attracted people of color or first-generation students," notes Chika Okeke-Agulu, a professor of African art at Princeton University who supervised Windmuller-Luna's PhD thesis, "and there is still not enough black and African students in U.S. institutions interested in studying and making a career in ancestral arts of African societies." In any case, Okeke-Agulu does not believe that museums should hire only black curators to oversee African arts.[42] Indeed, it would be an act of essentializing and stifling restriction to allow people of color to work only in fields assigned by ethnicity or race.

The real issue is greater diversity at all levels of the museum, including staff, curators, conservators, educators, and museum directors. This would better reflect the changing demographics of the American population and produce a broadening of audiences, issues, and represented artists. It is not a question of a smorgasbord of perspectives but rather a shift in the way the history of art is conceived and narrated, one which includes those who typically have been marginalized or excluded, and whose inclusion necessarily means revising the narrative and "remembering" what has been dismissed or repressed.

In response to the critics of the Brooklyn Art Museum, Okeke-Agulu points out that "the most vehement outrage" was not really about diversity but a sense of ownership of African art. A diversity campaign, he argues, would have focused equally on a second hire made at the same time—Drew Sawyer, a white male, as a curator in photography. Photography, however, is seen as a "white people's domain," so the hire did not arouse the same kind of outrage. But diversity means reconstructing the narrative in every area. While 38 percent of the American population identifies as Asian, black, Hispanic, or multiracial, only 7 percent of museum personnel are black or Hispanic. In an essay on the growing focus on curators of color, Robin Pogrebin notes that some museums are establishing paid internships and collaborating with mentoring programs in high schools and colleges to cultivate such young curators. These curators will help rethink the narrative of art history not only in an area such as photography but in the entire canon, which typically focuses on the Renaissance and Western European ideals.[43]

This depends, however, on knowledge and experience and is not merely a function of skin color or ethnicity. Critics of the Brooklyn Museum also invoked the film *Black Panther*, in which the film's black antagonist confronts a white female curator about European colonial expropriation of African art and material cultures. Okeke-Agulu notes the misplaced political outrage here, arguing that the power of the scene did not lie in the curator's skin color, and would not have changed if she were black, but "in its critique of Western

museums as symbols and products of colonialism and repositories of empire's loot." The claim to cultural ownership of African art and heritage, argues Okeke-Agulu, should not be confused with "who could or should curate, teach and study African art," which depends on *acquired* knowledge and experience." He writes, "To argue, as many have done, that a person of color, by dint of her ancestry, would naturally grasp the intricate histories, and complex aesthetics of historical African art is to misunderstand the work of the curator or scholar."[44]

The Politics of Retreat and Despair

Subsequent to the Whitney controversy, a group of eight protesters tried to block an exhibition of Schutz's work at the Institute of Contemporary Art in Boston, distributing an open letter that called on the ICA to "please pull the show" before it opened in July 2017. Although *Open Casket* was not in the exhibition, the Whitney controversy sparked the protest. This time, eighty-three artists and architects affiliated with New York's National Academy issued an open letter supporting Dana Schutz and the ICA. "We would like to voice our unequivocal support for Dana Schutz, who has recently been excoriated by a group of Boston artists who are demanding that her current exhibition at the ICA in Boston be canceled, a demand meant to penalize Schutz," stated the authors. They included well-known artists such as Marina Abramović, Ann Hamilton, Alfred Leslie, Catherine Opie, Philip Pearlstein, Ed Ruscha, Carolee Schneemann, Dread Scott, Cindy Sherman, and Kara Walker.[45]

Schutz's critics impugn her motives without a shred of evidence and ignore the history of antiracist art produced by nonblack artists; they posit a gulf between races that denies the cultural construction of race and refuses the history of interracial struggle. Their critique retreats to identity essentialism, a circling of the wagons based on an unfortunate if understandable sense of hopelessness in response to the real and ongoing assaults on black people and the mounting disillusionment with the politics of liberalism.

Indeed, liberalism, like its conservative counterpart, supports the same capitalist system that depends on black oppression, though it often does so in less overt or extreme ways—but the politics of cultural nationalism that essentializes race is a politics of retreat and despair. A far more radical approach would address the economic and institutional foundations on which systemic racism depends. The construction of race and racial persecution is therefore not only a black problem, just as the oppression of Native Americans, Arabs and Muslims, Latinx, women, trans, and gays are not only problems for those groups. These forms of oppression are all linked to each other and to the capitalist system that has created and sustains them.

To suggest an insuperable biological-racial antagonism as our fundamental political condition is to give up the fight before it has begun. The sense of endangered white power expressed with such exquisite clarity by the Trump

administration and his supporters points to the intensifying contradictions of capitalism that have led to widening income inequality, anti-immigrant nativism, and intensified racial terror—but these issues have worsened under both Democratic and Republican administrations. Accelerated by the neoliberal globalization that began in the 1970s, the ongoing battle to preserve racial hierarchies represents an alliance of capitalism and whiteness that enriches only a tiny elite of millionaires and billionaires while immiserating millions of people and destroying the earth's environment. What the controversy surrounding Schutz's *Open Casket* reveals, more than anything, is not the merits or flaws of the painting but the state of charged racial polarization in which we find ourselves in the current era, when the ruling class conveys open contempt for democratic ideals and has set about dismantling the hard-fought gains of the civil rights movement. It is not only a matter of empathy (which Schutz's painting invites) but of recognizing our common interests in creating a society where everyone can be free and equal.

Coda: The River

Sally Mann, a white photographer who was born and raised in Virginia, where she still lives, made the South a major subject of her work, along with the history

Sally Mann, *Deep South, Untitled (Emmett Till River Bank)*, 1998. Gelatin silver print–tea toned, 40 × 50 inches. (© Sally Mann. Courtesy Gagosian.)

of landscape photography, death, her family, and her realization as a teenager who went north to boarding school that racism pervaded the southern landscape and its people. "It's a touchy subject, but as a southerner you can't ignore our history any more than a Renaissance painter can ignore the Virgin Mary," Mann told a reporter.[46] She named her firstborn Emmett after Emmett Till.

Mann's photograph *Untitled (Emmett Till River Bank)*, from her series Deep South, returns to the place where Till's body was found in the muddy Tallahatchie River. The almost too intimate descent of the earth, a cut like a wound, disappears into the river's opaque reflective waters, aptly evoking the workings of memory and our inability to plumb the depths of the past from the vantage point of the present. The four dark corners, technical faults of the negative in the wet collodion process used by Civil War photographers, frame the image as Mann looks to connect the almost blurry, humid landscape to the tragic events of the past. Though the task seems impossible, the image nonetheless calls up the absent figure of Till and the sound of the splash as his weighted body was heaved from a bridge into the water in the dead of night.

Although Mann's image evokes violent events and the photographic memory of Till's mutilated body, the placid scene produces empathy through the picturing of place. After being led by a local guide to the riverbank where Till's body was found, Mann said, "There was, in fact, something mysterious about the spot; I could see it and feel it, and when I released the shutter I asked for forgiveness from Emmett Till."[47] This spatial location on the Tallahatchie riverbank is not only historically and politically meaningful but also understood affectively by Mann, whose experience of place draws upon the values, memories, and anxieties of her life growing up in the South. Imbuing the image with the sorrow and sadness of her embodied awareness, the photo produces a melancholy interplay between memory and loss.

Photography is a cultural technology capable of producing collective horizons of experience that are available to everyone, irrespective of race, class, and gender, and exclusive to no one, making it possible for people to empathetically take on memories of people unlike themselves that otherwise might have remained private to a particular group. This creates the basis for political alliance. Attempting to convey the effects of historical trauma through her encounter with the materiality of place, Mann's memorial image—created in the context of widespread cultural representations about Emmett Till and landscape photography itself—likewise produces an affective emotional charge that both contributes to a progressive politics of memory and strongly suggests what should be clear by now: Emmett Till's tragic death haunts the nation and affects us all.

Part III

Hometowns and Homelands

5

Seeing What Can No Longer Be Seen

Return visits to places we know well produce an uncanny feeling. As phenomenologist Dylan Trigg observes, "The memory of place forces us to return to the immediacy of our environment and to all that is absorbed, both familiar and strange, within that environment. In doing so, not only do we feel the measure of time pass through our bodies, but through attending to the phenomenon of place, we catch sight of how memory forms an undulating core at the heart of our being."[1] The material environment that helps shape our memory, our "undulating core," in turn shapes our concept of selfhood.

However, as we saw with Sally Mann's photo of the Tallahatchie riverbank where the body of Emmett Till was found, one doesn't have to have visited a place previously or have been present at a traumatic event for the memory of place, formed within a social context, to shape one's embodied awareness and sense of identity. In the two examples below, the first examines a project by American photographer Diana Matar of the ominous disappearance of her father-in-law, in which Matar photographs sites that convey the memory and materiality of places where political prisoners disappeared in Libya. The second is an account of my visit to Poland and Vienna after my mother's death in search of connections to my parents' pre-World War Two life.

Diana Matar's father-in-law was a Libyan opposition leader who was kidnapped from his home in Cairo by the Egyptian secret police and turned over to the Gaddafi regime in the early 1980s. Matar traveled to Libya with her husband

after Gaddafi's death, and tried to capture a sense of place that portrayed the terror and repression produced by the political regime as well as the traumatic impact it had on her. She writes, "I came to believe that spaces hold memory and that by photographing the places where acts of state-sponsored violence occurred, the land could speak, the trees could bear witness, and the dead could whisper."[2]

Matar's father-in-law has never been found and his disappearance never solved, like thousands of other disappearances in Libya. She spent six years (2005 to 2012) photographing places where Gaddafi executed and tortured Libyans, and produced the book *Evidence*, which also includes archival images, letters, and Matar's diary entries. When she visited Libya in 2012, she photographed places associated with the disappeared as sites of traumatic memory, noting, "I have this strong intuition that the past remains and that history's traces are somehow imprinted on buildings, landscapes and even faces, by events that have taken place in the past."[3]

In one of three letters written by her father-in-law, Jaballa Matar, from Abu Salim prison, he wrote, "At times a whole year will pass by without seeing the sun or being let out of this cell." In another, he says, "The cruelty of this place far exceeds all of what we have read of the fortress prison of Bastille. The cruelty is in everything. . . ."[4] Every image is haunted by Jaballa Matar's disappearance— the interiors, buildings, city squares, the entrance to an underground prison in Gaddafi's Benghazi compound. Matar writes, "What is seen in these images can no longer be seen in the physical world."[5]

Her photograph *The Chair*, for example, pictures a simple metal chair with a pattern of light and dark made by a nearby tree, a stained wall, and a brick floor. There is no seat on the chair, just as there is no one to sit on it. Matar writes, "This is a man's house, even though your wife has lived here alone for the past 20 years. She has the custom of moving the living and dining areas each few months, and every time I visit the configuration is decidedly different. Yet with each of these moves there remains a chair, a place, ready for you at the head of the table."[6]

For Matar, anything in the environment may absorb the memory of events and act as a witness, since almost all the evidence for Gaddafi's crimes has disappeared. Matar's images—her "evidence"—are meant as documents of those crimes. Her photo of Abu Simpson prison, *Evidence VII*, which shows a concrete compound, walled and well lit, is made more forbidding by the long dark shadows in the foreground and a lone black car parked near the entrance. The photo is taken from a middle distance, at night, and the atmosphere is suffused with foreboding. Matar writes, "On June 29th, 1996, it is estimated by Human Rights Watch, that 1,270 political prisoners were massacred in Abu Salim prison in Tripoli."

Her photographs are shadowy, elusive, ominous, and poetic, focusing on what remains to evoke displacement, disappearance, memory, and loss. Most of her images were taken at night with long exposures. She explains, "The exposures are

Diana Matar, *The Chair*; Easter 2005, Cairo. (Courtesy of the artist.)

all more than 30 minutes long—some are more than an hour—so I'm standing in these places for a very long time. I think obviously there's a resonance to that and a feeling that you get when you're in a place where these things have happened. Standing in these places I felt a lot and I wanted to utilise a language that communicated what I felt and not what I saw."[7] Like Sally Mann, Matar responds to an embodied sense of place and to the historical memory of trauma, the black-and-white images distancing the viewer from the contemporary and positioning us in the past.

Diana Matar, *Evidence VII*; 2012, Benghazi, Libya. In defiance of international rules of warfare, regime tanks fired on civilian residences in this Benghazi neighborhood on 19 March 2011. (Courtesy of the artist.)

Matar concludes *Evidence* with these thoughts: "Like the silent spaces between notes in a musical score, the silence of a disappeared man or woman creates a sound, often deafening, which is unable to be ignored. It asks the question, what remains? The philosopher Emmanuel Levinas tells us that to connect to another we need the face—but what happens when the face has disappeared and when all traces of the disappearance have disappeared as well? How then do we connect?"[8]

How indeed?

My parents remembered their hometown in eastern Poland with affection. My mother attended a Polish primary school, was friendly with many Christian Poles, and spoke fluent Polish as well as Yiddish, but it was always clear that the Poles were Polish and the Jews were Jewish. Although the older generation of Jews was mostly Hasidic, my mother's generation rebelled to a degree against

their parents, dividing between two general political trends, the Zionists and the Socialists. My mother joined the young Zionists but lost her interest in moving to Israel after World War II, when she had a young son and understood how difficult life there would be.

Three waves of young Polish Jews "made aliyah" (immigrated) to Palestine before the war, including some of her cousins and friends, and they survived the genocide there. Though my mother maintained an abiding interest in Israeli affairs to the end of her life, she was afraid of flying and thus loath even to visit the friends and relatives with whom she had corresponded for decades. My father, on the other hand, had been a young socialist and a "freethinker," who, I learned from my brother after my father's death, had once heard Trotsky speak—this was after I myself had become a Trotskyist. He, however, was eager to settle in Israel after the war, not for Zionist reasons, but to be near his niece, his one surviving relative. My parents came to America, but my father yearned to travel to Israel for the rest of his life.

This history haunted me when I made my own trips to Israel and Poland. I thought that by going to my parents' birthplace and hometown in Poland, I might better understand the world they came from and therefore where I came from, and that it would also strengthen the bond between my daughter and her memory of her grandmother through the connection to place. I wanted all this even though I knew this town wouldn't be and couldn't be now what it was then, that the past could not be revisited.

I waited about five decades. How do you know when you are ready to journey into the past of your parents? In my case, it was when they were gone and the connection to the past had been severed, when I could identify with them because I had reached the age they had been when I was a child. I went back to their hometown and to the imagined alternate past that might have been their future if they had been able to live out their lives peaceably in Poland. Perhaps I felt ready to revisit the past because I was finally able to separate their story from my own. My mother would often introduce herself to people by telling them that her whole family had "died by Hitler." If they knew nothing else about her, they would know this. Then I began to say it too, telling people I had just met that my family had died in the Holocaust. Her trauma had become my trauma, though I had known none of the parents, sisters, nieces, nephews, aunts, and uncles. Still I mourned their loss. Eventually I stopped telling people this, and I hoped that I was now a more objective observer as well as a custodian of her stories.

I traveled to Poland with my husband Greg and our daughter Rachel the summer after she graduated from high school. We took a train from Krakow to Lublin; Emil, our driver and guide, whom I found through a website called the Virtual Shtetl, met us outside the Waksman Residence, a hotel at the edge of the old town in Lublin by the Grodzka Gate. Emil was younger than I had imagined, friendly and voluble, a young historian and media expert for Grodzka

Gate—NN Theatre, which was reviving the full prewar history of Lublin, meaning the life of the Jews in the city before 1939. The actual Grodzka Gate once served as the informal dividing line between the Christian and the Jewish quarters of the city, although sometimes Christians lived in the Jewish quarter and Jews in the Christian quarter. It was surprising to learn that it was not as regimented as I had imagined. Emil drove us to Hrubieszów, the town whose name I had heard my parents say countless times.

First, we stopped at Chelm, where my father was born and which was sixty percent Jewish before the war, and Emil took us to the restored Jewish cemetery. As we approached, my heart leapt for a moment as I wondered if I would find gravestones engraved with the family name, ancestors of my father who had died peacefully before the war. The inscriptions, however, were in Hebrew or Yiddish, which I couldn't read. But it didn't matter. A sign informed us that this cemetery contained no original tombstones, only a few headstones and memorials to the victims of the Holocaust, placed there later by family members and survivors. The cemetery was overgrown, but Emil said that various groups in the town maintained it, including a group of prisoners in the town jail. This seemed to transform maintaining the old Jewish cemetery into a punishment. I felt the dead begin to whisper and grew anxious to leave.

Driving through the lush greenery and passing farmhouses reminded me of nothing so much as Vineland, where I had grown up, with its country roads, its fields and farms and trees, where so many Jews from eastern Poland began new lives after the war as poultry farmers. I felt sure this uncanny similarity was not lost on the Polish survivors in New Jersey, who must have been comforted by some sense of familiarity that reminded them of home. Some of the differences, however, included large fields of orange poppies around Hrubieszów where the crop chemicals hadn't killed them, and enormous stork nests atop the telephone poles filled with families of white storks that flew to South Africa for the winters.

Emil talked about the impoverishment of this southeastern region of Poland, and it was evident in the cheap market goods and the clothes people wore on the street. In the sweltering sun, during a Europe-wide heat wave, Emil himself was wearing corduroy pants. Łukasz, our guide in Hrubieszów, gave up his apartment in Lublin every summer to move an hour and a half south, where the rent was cheaper. He wore the kind of sneaker slip-ons I first saw in the dollar stalls in the poorer neighborhoods of South Philly. Emil went to university in Warsaw and studied Eastern European history, while Łukasz earned his PhD in film history and attended a program at Harvard.

With something of a shock, I realized that Hrubieszów was nothing like what I had expected, even as I recognized that I had expectations of which I was not fully conscious. What anachronistic picture had I painted in my mind's eye? A main square with pastel colored buildings, horses and carriages, and old wooden houses. But there were no horses and carriages, and Hrubieszów was

White stork nest atop a telephone pole; Hrubieszów, Poland, 2010. Storks begin arriving in March to breed, building nests up to five feet in diameter, and leave by the end of August for their return flight to Africa.

bigger and more urbane than I could have imagined, more sophisticated than dozens of Midwestern downtowns I have traveled through. It was the same with Chelm, the city with the unfortunate reputation for producing fools. My parents were not bumpkins from a village after all, as I sometimes feared when they seemed baffled by American conventions. This was not *Fiddler on the Roof*. On the contrary, the Polish peasants were the ones who lived in the surrounding small villages. They brought their goods to the market square in town, where my mother would help her father in his wholesale goods shop and knew all the other business owners, where her sister owned a fabric shop and lived above it with her family.

As for the wood houses of the Jews, the first thing Łukasz told us was that all the former Jewish homes were gone and all the old people who remembered the prewar years and were willing to talk about them had died. I felt stricken and bereft, realizing with a fresh pang that I had lost access to the best possible source of information about the prewar years, which I had had at my disposal for so many years. Why hadn't I asked more questions? When my mother was alive and I proposed traveling to Hrubieszów for the unveiling of a new monument in the restored Jewish cemetery, she vehemently opposed it. Though she never objected to my travels in Germany, she begged me not to set foot in Poland. Finding Jewish homes, *her* home, occupied by hostile Polish neighbors after the war, was a betrayal she could not forgive.

By the middle of the nineteenth century, Hrubieszów was the second-largest town in the district after Lublin. Until the destruction of the ghetto, Jews had

lived in Hrubieszów for five hundred years. In 1939, there were 11,000 Jews in Hrubieszów, more than half the population; of these, 7,000 were sealed into the ghetto, established in June 1940, while around fourteen hundred escaped to the Soviet Union, my parents among them. The Christian community worked mostly in agriculture and the Jews owned most of the shops and craft workshops and stalls at the marketplace. They were carpenters, bricklayers, hatters (like my father), bakers, blacksmiths, and tailors. They helped establish the textile, sugar, and tobacco industries as well as building industries. They built Jewish hospitals, schools, and a nursing home. There were Jews in the town council, courts of law, and in the social and cultural life of the town, and they participated on the boards and committees of loan and savings and credit associations, proving that Poles and Jews could work together.

The first Jewish-run hospital in Poland was inaugurated in Hrubieszów in 1818; a magnificent Baroque-style new synagogue, built to replace one that had burned down, was inaugurated in 1874; and the old age home opened in 1905. The imposing structure of the synagogue was built of brick, with a mansard roof, arched windows with tinted glass, and carved oak doors. The Germans vandalized the stately building during the Second World War, eventually tearing it down and selling it for building materials.

Today in Hrubieszów there are only traces and fragments of the thriving Jewish life that once existed there: I found a plot of fenced greenery where a small synagogue once stood and a menorah design on the iron grillwork of a door to a building, both near the old Jewish quarter.

The primary synagogue of Hrubieszów, inaugurated 1874 and destroyed by the Germans during World War II.

In 1942, the Hrubieszów ghetto swelled to 10,000 with transports of Jews from neighboring villages, and from Częstochowa, Mielec, and Kraków. A resistance movement formed in the ghetto, but the deportations to the death camps Sobibór and Budzyń also began that summer; several hundred people were killed at the Jewish cemetery and another several hundred were forced to work at the newly established labor camp. The following year, the Nazis liquidated the labor camp, and the Hrubieszów ghetto ceased to exist. Seventy-two members of my mother's extended family perished, along with my father's first wife and five-year-old daughter, his uncle, and two brothers. In addition, the Germans destroyed all the synagogues and prayer houses, as well as the cemetery itself. The Red Army liberated Hrubieszów in 1944.

I knew that present-day Hrubieszów would be changed, but I still looked for a way to see what my mother and father might have seen. The possibilities were meager: stone apartment buildings, the striking nineteenth-century Eastern Orthodox church with its thirteen cupolas, the river where my mother had gone ice skating with her fifteen girlfriends and once fell in, the old Jewish cemetery, where the Nazis forced the last 143 Jews to pull up all of the headstones to use paving the streets.

We walked around the town while Łukasz pointed out where Jewish homes used to be, around the old marketplace and in the neighboring streets. He took us to the cemetery, timed with the arrival of an American tour group, so that the gates would be unlocked. Why lock the gates to the cemetery unless it was still threatened? Then again, there were no gravesites to visit and no one to visit them.

Jewish cemetery in Hrubieszów, Poland, c. 1910–1920. Nazis destroyed the cemetery and used the tombstones to pave the streets.

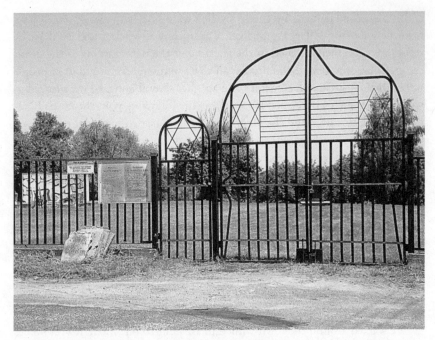

Gate to restored Jewish cemetery in Hrubieszów. In the background is a memorial made of recovered broken tombstones, dedicated in 1997.

There were only three monuments: one erected by the Soviets, one by the town of Hrubieszów, and one by Jewish survivors in the late 1990s. Of the thousands of graves dug over the course of five hundred years that lie under the rolling green meadow, not one can be located or identified. Only the river Huczwa was still there and the trees by the river, where the cemetery slopes downward, and where the Nazis executed hundreds of Jews from the town and buried them in mass graves, my grandparents likely among them. In his memoir, Holocaust survivor Henry Orenstein describes "execution pits" at the cemetery where "Jews were ordered to undress and lie down in a row at the edge of the pit." A member of the Gestapo went from one end of the line to the other, shooting each one in the head. Jews in a burial crew were then ordered to throw the bodies into the pit and bury them.[9]

I stood above the slope, not able to trample upon that blood-soaked ground where the bones of my grandparents may have lain, even as I trod upon other graves below the unmarked grass. The landscape, which looked so peaceful and ordinary, took on the chilling effect of history's traces, the trees bearing witness and the grasses whispering. I could not help but imagine the horrors that had occurred here and could never again see this landscape as peaceful and ordinary. For me, this was the most disturbing moment of my visit to Poland.

River Huczwa in the old Jewish cemetery and the site of numerous mass graves where Jews were shot and killed, the two largest consisting of hundreds of people each and several smaller ones holding five to twenty people; Hrubieszów, Poland, 2010.

We stopped to rest and cool off at a restaurant called Chocolat and ordered the delicious thin Polish pancakes known as *naleszniki* with chocolate sauce. They took more than an hour to arrive. The waiter did not expect to be tipped and therefore was in no hurry. In the meantime, the head of the town's visitors bureau joined us and gave me a certificate to sign showing I had visited the town. He told stories about the Jews in the prewar period while Łukasz translated, including one about a woman with a baby in her arms whom the Nazis shot three times in the cemetery before she finally died. I asked if he knew where Henry Orenstein had lived, the only survivor from the town who had published a memoir. Łukasz said that the house was destroyed, but the man said no, Orenstein lived right there, pointing to the building across the street, where Łukasz himself rented an apartment. Łukasz was thunderstruck and I was delighted to find a place that matched up with a prewar Jew.

My cousin Jean, an Auschwitz survivor from Hrubieszów, had urged me to read *I Shall Live*, the memoir in which Orenstein, who became a successful inventor, entrepreneur, and poker player, described how he hid with his parents and brothers behind the walls of their basement until they could bear it no longer. They emerged from their hiding place and walked down the street together in full daylight, where the town's gentiles were amazed to see them. Then the Nazis arrested them and sent them to a series of concentration camps from which only Henry came out alive. He, too, moved to southern New Jersey.

A recently divorced man had bought the former religious school for boys and was transforming it into a residence when we visited. He told us about a secret wine cellar below the school that was used by the Partisans during the war while the Germans occupied the quarters above, and how his cousin, one of the Partisans who also worked for the Germans, reported on them. Emil and Łukasz suggested that perhaps this was the *cheder* my father had attended, but I knew it hadn't opened until the end of World War I, when my father would have been ten years old. That was when he left school following the death of his mother and went to work sewing hatbands into hats. Yet this eagerness for discovery and the misrecognitions it generated seemed to me a perfect example of the allure of place foiled by time. I was chilled, nevertheless, when I stepped inside and imagined all the little boys who might have passed through here.

We repeated this experience almost immediately with the Polish primary school. I was interested in finding the school my mother might have attended. Łukasz became excited, and we drove a long distance to the largest primary school in the region. I knew before we got there that it could not be the right school, that it had to be walking distance, which was further confirmed when we saw that the school was built in the 1930s, long after my mother had completed primary school. Nonetheless, we stood and admired it for a few minutes, and then serendipity struck: I noticed the army barracks built across the way and realized it was quite possible that my father, who was in the Polish army, had stayed in one of these barracks.

After Hrubieszów, we drove about an hour to Zamość, which was built as an "ideal" Renaissance city by Paduan architect Bernardo Morando in the sixteenth century and restored over the years. Morando conceived the city's urban design as a grid, and the Italianate buildings show the influence of Polish architects as well, who added ornate attics to conceal the roofs. The beautiful city was a prewar center of Hasidic Judaism, but its most famous citizen was Marxist theorist and revolutionary Rosa Luxemburg. A plaque commemorating Luxemburg on a tenement in Zamość was removed in March 2018, however, allegedly because it violated the new law against "promoting communism"—the so-called "decommunization" law.

The Nazis had planned to keep Zamość as a model town, to be renamed Himmlerstadt, for the relocation of 60,000 ethnic Germans. Himmler modestly refused because Hitler did not yet have a town named after him, so they decided on the prosaic name Pflugstadt—Plow City—to symbolize the way Germany would "plow the East." The Germans expelled 110,000 Poles from the Zamość region and sent them either to concentration camps or to Germany as slave labor. They kidnapped about 30,000 children for potential "Germanization," placing them with German families or SS Home Schools. Only eight hundred were found after the war and sent back to Poland. The Nazis managed

to settle about 10,000 German colonists, but the Polish Underground offered fierce armed resistance, known as the Zamość Uprising. They were joined by Soviet partisans and numbered over several thousand forest fighters. After a few major battles, including one in Hrubieszów, the Germans lost control of the region by the spring of 1943.

We returned to Lublin, and Emil took me to a gathering at a still well-preserved *shtibl*, a small house of prayer in someone's home, but I could not determine the nature of the gathering until I arrived. Emil introduced me to Pawel and pointed out that, unlike most of Lublin's thirty-eight Jews who admitted to a Jewish relative, Pawel's parents were both Jewish. "I know who I am," said Pawel proudly. Emil gave me a grand introduction and a woman promptly stood up and announced that this group was celebrating their completion of a two-year program in Jewish Cultural Studies. I was taken aback by this information. It made the Jews of Lublin and Yiddish culture more generally feel more thoroughly and completely gone, now that they were objects of study like butterflies under a magnifying glass. I myself felt a bit like a specimen. "How wonderful!" I exclaimed, even as I felt an acute sense of strangeness. This was my first encounter with philosemitism. Having just returned from a long, hot day searching for the Jews in Hrubieszów and finding mainly a vast and troubling graveyard, I didn't know what more to say. In that moment, it seemed as if Yiddish culture could only be resurrected in flattened and diminished forms by those who studied it from a distance in a city without Jews. Yet I was grateful for these scholars whose research and dedication kept this history alive.

Geneviève Zubrzycki, a scholar who studies philosemitism in Poland, describes this cultural phenomenon as part of an attempt by certain political and social groups to build a more pluralistic state in Catholic Poland. She argues that "bringing back Jewish culture and 'resurrecting the Jew' is a way to soften, stretch, and reshape the symbolic boundaries of the nation that the Right wants to harden and shrink using Catholicism as its main tool."[10] Affiliating oneself with Jews is no easy matter in Poland, despite the growing philosemitism. After a new antisemitic wave in 1968 drove out some 15,000 Jews, there were only 3,000 left in the country. Young and middle-aged people did not care to proclaim their Jewish heritage. Out of the 3.3 million Jews who once lived in Poland, in 2006 the Jewish population was estimated at only 20,000, mostly in Warsaw, Wrocław, Kraków, and Bielsko-Biała.[11] That makes the little band of scholars in Lublin all the more admirable, making me wish I had shaken off my sense of shock and engaged them more fully.

The Jews of Lublin came alive for me when I entered the room used for communal prayer. I could imagine the men swaying with their fringed white *talliesim* over their black suits and white shirts; I could hear them *davening* together as they did in the small orthodox *shul* I attended with my parents and brother on the High Holy Days in Vineland, where the entire congregation

consisted of immigrant survivors and their children. During breaks, the adults would stand around in groups on the tarred surface in front of the synagogue, speaking Yiddish, while we children, in our best clothes, pulled out tall spears from the succulents that grew in clumps behind the synagogue and pretended they were swords. The wood in the Lublin prayer room still seemed warm from the presence of ghostly bodies, the space like a true sanctuary from a troubled outer world, with its old scrolls and *tefillim* and two old Torah pointers, one wood and one brass with tiny hands and pointer fingers. In 1939 there were almost 43,000 Jews in Lublin, and many *shtiblach* like this one, as well as synagogues, including the synagogue that once was the largest building in Lublin after its famous castle. They are all gone now.

Pawel and his mother, a sweet diminutive woman whom Emil described as "the leader of the Jewish community," didn't strike me as religious. Pawel showed me where he had pried open a *tefillin* to expose the tiny scrolls inside and gleefully recounted how his mother explained that he was not supposed to do that. Emil confided that he has never seen all thirty-eight self-identified Jews in one place together, implying that they might not be willing to identify as Jews in public. How many Poles today have a parent or grandparent who was secretly Jewish but spent their lives as Christians? How many have been shocked to learn in their teens, when they were thought to be old enough to keep the family secret, of a Jewish parent or grandparent that was a hidden or converted Jew? How many felt their lifelong sense of identity suddenly destabilized, throwing them into crisis, confronting them with the difficulty of assimilating this historically troubled identity, freighted with hatred and persecution and repressed for so long in Poland?

Some who survived the Holocaust as children raised by Christian families have discovered their own Jewish identity late in life; many are searching for genealogical links. What, indeed, does it mean to emerge from the closet of "hidden Jews" in Poland today? One such group of young people in Kraków formed a support group called Czulent to discuss their feelings about Jewish identity, tell family stories, and explore Jewish culture, despite the fearful responses of many parents. Since 1988, the Jewish Culture Festival has taken place every summer in Kazimierz, the historic former Jewish quarter of Kraków. Music might include Israeli hip-hop, klezmer, Yiddish songs, and jazz in conjunction with workshops, meetings, exhibitions, and tours. Along with many Poles and tourists, we attended a vocal concert in a church sung by cantors. But a new wave of antisemitism in recent years is exemplified by the front-page article of the right-wing newspaper *Tylko Polska* (Only Poland), which instructs readers on "how to recognize a Jew."[12]

I tried to take my leave, but Pawel was avid, excited, and importunate. He seemed to want to say so much but then faltered. I could not discern what he wanted from me, perhaps some happy acknowledgment of his Jewishness, or

perhaps he wanted more excitement from me about the project of Jewish reclamation—but I was at a loss. In the car on the way back, Emil said that Pawel could be strange sometimes. I would not be surprised if all the Jews in Poland feel a little strange.

Auschwitz-Birkenau

For the sake of Rachel's education, I finally decided to visit a concentration camp, which I had avoided on previous trips to Europe as too painful. Now it seemed necessary to go to Auschwitz-Birkenau, located about an hour from Kraków, and we spent three and a half hours there looking at piles of shoes, glasses, suitcases, pots and pans, children's clothes, an execution wall, poles for mass hangings, and the place where the orchestra played. Yet of all the places we had been, Auschwitz, ironically, was the most emotionally chilly, which seemed to be an effect of its popularity. We were compelled to participate in a tour, surrounded by people and rushed along to make way for the tour groups behind us. All of us wore headphones through which the hushed voice of our guide intoned crimes and statistics as we looked at wall photos and walked from one room to the next, one block to the next, surreptitiously taking forbidden photos. The headphones blocked the ambient sounds of the spaces we occupied, blunting the felt experience of the environment, while the barrage of spoken information and objects behind glass further stunted the emotional experience of place. The buildings were used as picture and artifact galleries, the tour was informational rather than experiential.

Only the prison cells were deeply affecting, dark and terrible spaces within the larger prison. The "standing cells" were tiny, bricked-in chambers where three or four prisoners were forced to stand together for days, often dying as they stood with no room to fall; the starvation cells and the suffocation chambers all offered different places for dying. We tore off our headphones and stood before these terrifying cells as long as we could. Then we walked through a gas chamber, its atmosphere unspeakably oppressive. Afterwards Rachel said, "We trampled on the tragedies of other people's lives."

Most Jews were killed in Birkenau, less than two miles away. With its vast open space, and without the sensory deprivation and regimented tour program, the experience was different. We walked along the awful latrines and stood just inside barracks; walked all the way down to the ruins of the crematoria, which the Nazis had blown up in hopes of destroying the evidence; surveyed the footprints of the field of destroyed barracks with their chimneys still standing like sentinels.

I felt close to my cousin Jean, recalling the description I heard her give my mother at our kitchen table when I was four years old, them huddled at one end, I at the other trying to be invisible so they wouldn't send me away. Jean

told of arriving on the platform with her mother and everyone being sent to the left or the right by a jerk of Josef Mengele's thumb, one direction leading straight to the gas chamber, the other to the barracks. She and my mother bowed their heads together and wept as Jean recounted how the starving prisoners, mad with hunger and thirst, ran over when a horse defecated to pick out undigested kernels of corn, or thrust their tin cups under the horse's stream of urine. She spoke of Mengele's handsomeness and the camp women's nickname for him: *puppe*, meaning doll, which was also my mother's nickname for me. This was the first time I heard an eyewitness account of life in Auschwitz. With my knees drawn up tightly to my chin, I was frozen with horror.

Here I was, standing on the very ground where the trains had stopped, and the new arrivals had had their fate decided. This was the selection site where Jean and her mother had stood, awaiting the turn of Mengele's thumb, where they could see the red fire and ash belching into the sky from the crematoria at the far end. The green grass would not have been here; it would have all been mud. The perimeter would have been marked by guard towers, with an electrified fence on both sides of the tracks which ran through the middle, separating the men's camp from the women's camp. This was the alternate universe Yehiel Di-Nur described as "planet Auschwitz" in his books published under the number tattooed on his arm instead of his name.[13] I thought of other Auschwitz survivors I knew, the mothers of friends, and of my mother and father. As

Ruins of one of four crematoria with underground gas chambers at Birkenau. Hundreds of thousands of Jews were murdered at each site with Zyklon B poison gas and their bodies burned.

terrible as their wartime experiences were in slave labor and refugee camps, including years of starvation and illness, I was glad they were spared this.

The crematoria are in ruins now. Hoping to remove evidence of their crimes, the Nazis burned the buildings in November 1944 as Soviet troops advanced. On January 20, 1945, two days after the camp was abandoned and the Jews sent on a forced death march, fleeing SS men dynamited whatever had not been removed. One of the four crematoria, however, was ruined by a prisoner revolt.[14]

Though my mother protested the idea of my visiting Poland while she was alive, I nonetheless traveled here because of her, who often spoke about Hrubieszów and Łodz, Lublin, and Kraków, just to be where she had been, to "remember" her life across time and geography even though these places were not the same as they had been then. How ironic to discover that the physical landscape of her hometown, which had grown to near-mythical proportions in my mind over a lifetime, was so like the region in which I had grown up. It was a memory sensation that seemed like a fairy tale in which I had to make a long arduous journey in order to find myself at home. Place triggers memory even as it embodies its own complex layers of memory. Perhaps I had found some trace of my parents in Poland after all.

Trotsky and Freud in Vienna

We took the train from Kraków to Vienna, a city that felt wealthy, bourgeois, and decadent after the impoverishment of southeastern Poland. "You probably get asked this a lot," I said to a waiter at the Café Central in Vienna, "but do you know where Trotsky sat?" For me, Trotsky was a towering political figure whose brilliant writings were passionate, witty, and penetrating, whose critique of Stalinism was clear and devastating, whose founding of the Fourth International when the Stalinists failed to oppose Hitler and the Nazi Party was principled and courageous.

From the waiter's expression, I could see that he had probably never been asked this question, but I knew that Trotsky had frequented this café in 1913, and the waiter seemed to know after all, or pretended to know, taking me to a booth at the back where one could observe the entire café and see anyone who entered. It felt right and I grew unreasonably happy to sit where Trotsky might have sat, to see this view of the Café Central as he would have seen it, with its beautifully painted Gothic ceiling and arches. It was physically thrilling to look out onto the world as though through Trotsky's eyes. Since there are no real bridges to the past, we latch onto these ordinary material fragments—a painted ceiling, a river, a patch of land, a small brick cell—and embody the experience, each place incongruent, nostalgic, uncanny, each burdened with history and connecting us to the subjectivities of others.

Now, several years later, a look at Wikipedia reveals that the Café Central was also a meeting place for regulars such as Victor Adler, Theodor Herzl, Hugo von Hofmannsthal, Adolf Loos, Tito, Freud, Stalin—and Hitler. I also learn that the Central closed at the end of World War II, and in 1975, the building in which it is located, the Palais Ferstel, was renovated, and the Central opened in a different part of the building and was renovated again in 1986. The waiter might have known that Trotsky had, in fact, never sat anywhere in this precise place but hadn't wanted to disappoint me. On realizing this, I feel cheated and foolish. But isn't this the way of place? Building sites are renovated, remodeled, torn down, and built over, adding to the layers and sedimentation of history and time. And yet we return. Radical alteration of place does not destroy it—as long as memory survives, the destruction of place happens far more slowly than its physical changes.

In Freud's apartment at Berggasse 19, I was surprised at how deeply moved I felt just by sitting in his consulting room and library, though most of the furnishings were no longer there, other than a desk. This was where he had analyzed patients and produced his writings for forty-seven years, where he theorized the unconscious as the site of repressed memories and desires. A small brass plaque on the door said simply "Prof. Dr. Freud" and "3–4," a single hour each day for patients to visit. I stayed a long time, just sitting, looking at the photos on the walls, reading from the notebook that told about the people in

Sign indicating visiting hours of one hour a day on door to Freud's office in Vienna.

the photos and included many excerpts from Freud's letters, finally tearing myself away from the magnetism of the room when Rachel and Greg came looking for me.

What was it about being there, where Trotsky and Freud had been, where my parents and grandparents had been? We long to sense something of their experience, to brush against the past through the materiality of place. Like Diana Matar, we want to see what can no longer be seen. We want the land to speak, the walls and trees to bear witness, the dead to whisper. Place is like a palimpsest, written upon and erased, yet we still sense vestiges of the past. Though the structural nature of place may be altered, the symbolic value remains.

I thought about my parents, driven by fear of the advancing German army, leaving their homes and families and crossing the river to the Soviet side, and Freud, who already had jaw cancer, compelled to abandon his apartment in Vienna for London when the Nazis annexed Austria. Although I hadn't thought I was looking for it, here in Freud's chambers I found another encounter with the persecution of European Jews and the cultural loss it represented. Phenomenologists argue that our bodily response to place is not isolated but imbued with the subjectivity of others. Our response, in a sense, is not strictly our own but connects us to communities, events, and traditions that help us construct our own evolving identity. This happens because our sense of being in the world is always mediated by place, which produces embodied knowledge.[15]

On the plane flying home, I looked into the mirror in the tiny bathroom, and for an uncanny instant, I saw my mother's eyes looking back at me.

6

Borders and Walls

I felt nervous for weeks before leaving on my first visit to Israel one summer to present a paper at a conference and was not sure why. The instability of the region? The heat? There seemed to be some unpredictable and mysterious quality to Israel, a place that has always been fraught with too much meaning. As a child, Israel meant a tree planted for my brother's bar mitzvah, "making the desert bloom," up-tempo Hebrew songs sung at Judean Girls Club meetings, "Hava Nagila" and dancing the hora at weddings, chocolate matzos arriving at Passover from cousins I had never met. Israel also meant constant appeals for funds and a nationalist fervor I found embarrassing at times as I tried to fit in with American culture as a first-generation Jewish American born to immigrant parents. I resisted the signifiers of difference, of language, religion, and culture, even as I felt its tribal pull. Israel was more symbolic than real, and my feelings on approaching the ground of its reality, now that I understood more of its history, were pulled in different directions.

We had never learned about the Palestinian experience, how the "birth" of one nation in the war of 1948 meant the catastrophe of another whose people were driven out, dispossessed and displaced. If reconstructing memory of Palestinian suffering has emancipatory potential, the use of Holocaust memory by the state of Israel has a conservative effect. Drawing on Holocaust memory in order to define the nation as a victim of the infinitely weaker Palestinian populations in Gaza and the West Bank is meant to elicit international sympathy and legitimize the repression of the Palestinians. This narrative produces a contradictory and competitive form of nationalism based on the memory of collective suffering, which nonetheless has nothing to do with the Palestinians.[1]

At dawn, the cabin attendants tell us to open the shades, and there in the distance is a white city: Tel Aviv. Almost against my will, a strange feeling comes over me, like yearning or homecoming, and to my surprise, tears spring to my eyes. What is Tel Aviv to me? Then I know. I feel the presence of my father almost forty years after his death, his thwarted desire to move to Israel after the war to be near his sister's daughter Ruth in Ramat Gan, a suburb of Tel Aviv. He never met his niece, his only relative to survive the Nazi genocide of the Jews, and he never saw Israel.

Israel was a young country when my father dreamed of a new life there, still riding on the idealistic rhetoric of a socialist experiment. My father would have learned Hebrew and grown accustomed to the desert heat and humidity if my mother, at the last moment, hadn't refused to emigrate there from the Displaced Persons camp in Germany, afraid of the mandatory military service for my three-year-old brother, forcing my father to resell the stove and refrigerator he had bought to bring along. Instead, they crossed the ocean for twelve days aboard the USS General Harry Taylor and landed in New York City. I have found their names listed in the ship manifest of the Ellis Island database. Without a word of English, my father traded a pack of cigarettes for a chocolate bar and found his way to a poultry farm in New Jersey, where surviving friends and acquaintances from their hometown in Poland had preceded them.

My mother knew through letters from friends and relatives who had emigrated from Poland to Palestine before the war that a hard life would have awaited them; but a hard life awaited them in New Jersey too. It was eight years of six A.M. chicken feedings and late-night washing and packing of eggs before my parents could afford to buy a washing machine and my mother could stop doing the laundry by hand on a washboard. Then a chicken epidemic decimated more than half the chickens and bankruptcy followed. My mother built a door-to-door business selling wholesale chickens and eggs; two days a week, they were "on the road" for the rest of their lives together. The summer my father died of a heart attack, they had finally planned a trip to Israel where my father would have met his niece. They never made it.

As we descend, I feel as if I am fulfilling a promise, one I hadn't known I'd made to my long-dead father, in a land where memory and history is as conflicted as anywhere in the world. As soon as we arrive in our hotel room, I call Ruth, anxious to see her, to learn anything she can remember about my father's family. I had called her from the United States before leaving, and she told me she was ill but would still like to see me. Now she says not to come, she is too ill, her heart cannot take any excitement. She says she is dying. I hang up the phone and weep, for her and for my father. Like him, I am too late. Perhaps Ruth intuited my desire to probe the past and didn't want to revive those traumatic memories. I call her son in desperation to see if he might help, but he grows impatient and hangs up on me. Long after her death, I find online testimony she gave about her last days in Hrubieszów with her parents.

Tel Aviv, built on the sand dunes outside of Jaffa, is a cosmopolitan and secular city, a high-rise metropolis perched on the edge of the Mediterranean Sea with white sand beaches, each section of the city with its own character and inhabitants. It contains the largest collection of Bauhaus style buildings anywhere, built by seventeen former German-Jewish Bauhaus architectural students who fled Germany after the Nazis shut down the Bauhaus. There are more than a thousand Bauhaus or International Style white buildings, with their cubic extruded rectangles, windows running in rows, rounded balconies, and lack of ornament. These are the buildings that turned Tel Aviv into the White City. On seeing them from the air, I couldn't help but feel a sense of optimism.

Yet International Style goals, meant to foster harmony and unity around the world, failed spectacularly here. Tel Aviv is only forty miles north of Gaza, where Palestinians live in dire poverty, constrained behind border walls and fences, the world's largest open-air prison. They live without electricity for most of the day and under continuous blockade from Israel. Their homes have been bombed and largely destroyed, with no building materials having been allowed in for several years. In 2008, soldiers on an Israeli gunboat killed a family that was picnicking on the beach; in 2018, Israeli soldiers killed dozens of Palestinians protesting the blockade and injured more than a thousand. The forced containment of Palestinians in Gaza and the West Bank and the ominous architecture of wall-and-tower Jewish settlement construction has long overshadowed any modernist utopian visions.

We walk to the Mediterranean from our hotel and along the seaside promenade to the ancient port city of Jaffa, the site of Antoine-Jean Gros's 1804 painting *Napoleon in the Pesthouse in Jaffa*. The painting promoted a myth of Napoleon as a benevolent, Christ-like savior miraculously healing his plague-ridden soldiers with the touch of his bare fingers. In reality, he suggested having them all poisoned with a fatal dose of opium, though the expedition's chief doctor refused. Napoleon ransacked Jaffa, killed scores of inhabitants, and ordered the massacre of thousands of Muslim soldiers who had surrendered to the French. Many more died of bubonic plague. In 1948, the Jewish paramilitary organizations of the Irgun and the Haganah launched offensives against Jaffa that again decimated the largely Arab population. Jaffa today has a majority Jewish population, but the signs of Arabic life feel pervasive, in the very stones of the old city streets, which evoke a feeling of desolation. We wander through the steep and narrow cobblestone warrens of the old city and make our way down to the sea.

Not far from the shore is Andromeda Rock where Perseus rescued Andromeda. She was an Ethiopian princess chained to the rock as a sacrifice by her parents to the sea god Poseidon, whom they had angered when Andromeda's mother bragged that her daughter was more beautiful that Poseidon's sea nymphs, the Nereids. The sacrifice was meant to save their kingdom. Perseus flew over the region and saw Andromeda tied to the rock, lashed by the sea, and dying of thirst and exposure. He fell in love, freed her from a fate of certain

death, and married her. An Israeli flag now stands on Andromeda Rock, as if laying claim even to the territory of myth, the sin of pride committed by Andromeda's mother and the vengeance of Poseidon replaced by the pride and vengeful claims of the state.

Israeli artist Yael Bartana produced a performance video in which a man rows out to the rock, carefully removes and rolls up the Israeli flag, and replaces it with an olive tree, a simple act that embodies the plight of the stateless against the state. The olive tree is a highly charged symbol of Palestinian identity and Palestinian claims to the land because of its slow growth and longevity—some trees are a thousand years old and still bearing fruit—but in its relentless persecution of the Palestinians, Israel has uprooted some 800,000 to one million trees since 1967. Bartana observes, "The plant is a symbol for Palestine, where, for that matter, many trees were destroyed in order to create a better field of vision for the Israeli military."[2] A source of livelihood for many Palestinians, the destruction of olive trees represents the destruction of one way of life in "defense" of another, although the Israeli military is far superior in strength to that of the nationless Palestinians.

The olive tree is also an ancient symbol of peace, both biblical and mythological. Yet it seems to have as little possibility of taking root in Andromeda Rock as the Israeli state is likely to share power or the full right of citizenship with the Palestinian people. Since 1948, more than sixty-five laws have been used to restrict the rights of more than 1.5 million Palestinian citizens in Israel, culminating in the 2018 "Jewish nation-state law" that declared Israel the nation-state of the Jewish people (and no one else), formally codifying what has long existed: a democracy for Jews only. Bartana's work, *A Declaration*, produces a kind of memorial for the suffering of the olive trees who stand in for the Palestinian people, a declaration of remembrance, of home, of peace, at least on this rock for the duration of this video, as a pointed counterpart to the Israeli flag and the exclusionary pride of nationalism.[3]

In the narrow street along the waterfront, an Israeli truck blocks the road, forcing all the cars to back up as the driver moves forward. About halfway down the street, the truck driver stops alongside a car, extends a kind of forklift from the side of the truck that lifts and deposits the car in the back of the truck, and drives off. It seems like a small allegory for the Israeli state and the Palestinians whom it dominates. As we catch a taxi back to our hotel in the late afternoon, we hear the haunting voice of the muezzin calling the remaining Muslims to prayer.

As research for my book *War Culture and the Contest of Images*, I have planned museum visits and set up meetings with Israeli and Palestinian artists. At the Indian restaurant Tandoori, Yael Bartana talks about her three-part project *And Europe Will Be Stunned*, which includes *Wall and Tower*, a kibbutz she built in the middle of Warsaw across from the future Museum of the History of Polish Jews, and *Mary Kozmary* (Nightmares), a film in which a young

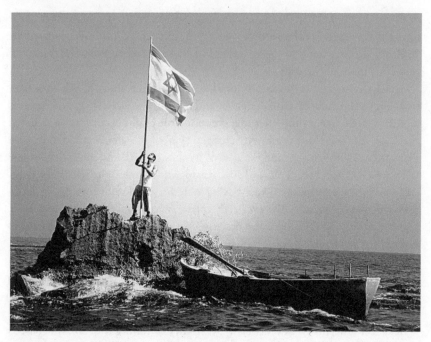

Yael Bartana, *A Declaration*, 2006, video still. (Courtesy of Annet Gelink Gallery, Amsterdam, and Sommer Contemporary Art, Tel Aviv.)

leftist Polish politician speaks in ringing tones to an empty stadium, evoking Leni Riefenstahl films, but calling for the Jews to return to Poland, to heal the sense of incompleteness the Poles now feel. Yael says there is a far-right movement in Poland that is planning a demonstration against her the following month. They have missed the irony of her project and are afraid the Jews might really come back.[4]

The Herzliya Museum outside the city shows work that includes Arab artists. In one video, *To You With Love*, the Arab-Syrian artist Fahed Halabi belly dances in front of a mirror to Arabic pop music wearing a belt with construction tools. He is playful, relaxed, unself-conscious as he shimmies and rolls his hips. The tools seem to testify to his masculinity even as they sway around his abdomen in a sensual rhythm.[5] During a side trip to Petra in Jordan, we eat dinner one night at the rooftop restaurant of the Swiss-owned Mövenpick Resort at the entrance to the park, where a DJ and percussionist play music as diners eat. At one point, all the waiters hold hands and dance. When the DJ changes to belly dance music, one of the waiters belly dances as the others watch and laugh indulgently, setting me to wonder about the difficulties of gay sexuality in a country where a man may take up to four wives, but where one might feel safe on the roof of a Swiss hotel inhabited by foreigners.

A video by Gregor Schneider at the Herzliya Museum explains the suppression of a work he planned for the Venice Biennale in the Piazza San Marco. He meant to construct a black cube sculpture inspired by the Kaaba in Mecca, the destination of the millions of believers who make the pilgrimage every year, but it was deemed "too political." The German authorities also rejected it for an exhibition in Berlin, explaining that it would have offended Muslims. Interviews with Muslims follow, in which they say they would not have been offended; on the contrary, they would have enjoyed seeing it in Berlin. Moreover, Islam does not forbid the replication of the Kaaba. *Cube Hamburg* was finally erected at the Hamburger Kunsthalle and made politically safe as part of an exhibition titled *The Black Square—Homage to Malevich*, transforming it from the Kaaba into an abstraction that refers to the abstractions of Russian Suprematism.

We eat "peasant" organic hummus, warm and thick with whole chickpeas mixed in, and meet at a café with Israeli artist Boaz Arad. He makes funny and fascinating videos about Hitler, concerned with the difficulty and complexity of locating the self in relation to history, especially a history so dominated by this invisible and, for years, taboo figure in Israel.[6] In one work, *Hebrew Lesson*, Arad splices together bits of video from Hitler's speeches and has him apologizing to Israel in Hebrew. Both ludicrous and mesmerizing, it expresses the second-generation yearning to mitigate the trauma of their parents' generation. Many, like my mother, never spoke about "the Holocaust," instead always saying it was "Hitler" who killed their families.

Arad's work reminds me of a recurring fantasy or dream I had when I was six years old. I am hiding under the white tablecloth of a café table while watching Hitler at a nearby table with Eva Braun. I'm holding a pistol and about to shoot him in the temple, an act by which I will completely avert the Holocaust. But Hitler and the whole scene vanish whenever I try to pull the trigger. It seems I unconsciously knew I couldn't undo the catastrophe, or the prohibition against murder, even of Hitler, was too strong. Yet there is something perversely satisfying in watching Arad's repeating thirteen-second video in which Hitler apologizes again and again.[7]

We visit Ruth, the sister of my friend Joan, who is head of the Department of Health Promotion in the Health Ministry of Israel, and thus in charge of public health. She does her best to construct progressive policy and devises projects in collaboration with Bedouin communities, Palestinian communities, and Ethiopian communities among others. Israeli health care covers everyone in Israel, and a Jew can become a citizen the day he or she arrives—though this means also becoming eligible for the army, up to twenty years old for girls and twenty-two for boys. Ruth tells us about her nephew who moved to Israel from the United States, where he had no health insurance, and six weeks later was diagnosed with a heart condition that required open-heart surgery. The state

picked up all his medical expenses, including taxi rides to and from the hospital. A few months after he recovered from the surgery, he moved back to the U.S.

Ruth left the U.S. as a youth and has lived for thirty-six years at Nachshon, a secular kibbutz that began as a utopian socialist experiment, where she raised three children. Now she says the kibbutz idea is dead and Nachshon, like many other kibbutzim, was privatized three years ago, forcing her to open a bank account for the first time in her life. She gives us a tour of the complex, which now employs migrant labor from Thailand, and shows us the goats from which they make goat cheese for commercial sale and the plastic bag factory that is their main source of income. Baby sheepdogs watch over the baby goats. We see the winemaking building, the crop fields, the chicken houses, and the baby houses, where Ruth had refused to let her own babies sleep. It caused a crisis then, her refusal to let the practicality of the baby house, which allowed parents to work, become an ideological imperative. The kibbutzniks finally acquiesced, rationalizing her "irrational" behavior as "American."

Ruth's own comfortable house, which she has earned as a senior member of the kibbutz, includes the requisite "safe room" that can be sealed in case of attack and is found in all the houses. Ruth's partner Kish, who has been on the kibbutz since its founding, has his own house nearby, and the arrangement suits them. But the dream of cooperative support, the financing of their children's educations, the communal dining room, has all quietly expired. Now one must pay to eat in the dining room. What started as a place of egalitarian idealism has become a place of capitalist disillusionment.

We dine with Ruth and Kish in Abu Gosh, a Palestinian village where the main restaurant, also called Abu Gosh, was built with money won in the American lottery; it is perched atop a hill overlooking the stone houses of the village. The grilled lamb, Ruth says, is the best in Israel, and Greg and Kish both order it, but Ruth, Rachel, and I feast on the delicious variety of salads that line the long table from one end to the other. There are three kinds of eggplant salad alone. Ruth's grown children join us later, eschewing the house specialties, and chowing down on a big plate of French fries.

The young people here follow a different trajectory than in the United States. After high school, they perform army service and then take a year or longer off, traveling to South America, India, or the beaches of Indonesia, where they smoke dope and hang out. Most don't enter university until their mid-twenties or later, giving them plenty of time to figure out what they want to pursue. There is a higher value placed on the two or three years spent as part of an occupying army than on post–secondary school education. Ruth has two sons, one in the army, who was in Gaza, and one living in Texas, who served as a sniper in an elite unit. They both knew, she said, that she would have been satisfied if they had refused to serve and gone to jail instead, but there are few conscientious objectors in Israel, and little respect or job prospects for those who do not serve. An editorial in *Haaretz* bemoans the state of high school education in

Israel and the fact that schools compete for status and prestige based not on academic achievement but on how many of their graduates serve in elite army units.

I delight in hearing Ruth's stories about herself and her three sisters, who grew up in conservative Las Vegas with a leftist activist mother. During one of her mother's visits to Israel, she and Ruth went to the King David Hotel in Jerusalem for breakfast shortly after the first war in Lebanon. Ariel Sharon, who led the war, was having breakfast there too, and after a while, Ruth's mother, unable to hold her tongue any longer, marched over to Sharon's table and cried, "Murderer! You're a murderer!" I marvel at her spirit, as well as the unimpeded access to the country's leader in a public place, at her managing not to be hauled away by security guards.

Ruth drives us to Yad Vashem at the far edge of the city, where the guard wants to know our nationality before he decides whether to let Ruth drive in and drop us at the entrance. If we had been Israeli, Ruth says, he would have said, "Let them walk." I find that the Children's Memorial lives up to its reputation and feel moved by the innumerable floating images of lost children. But we realize too late that the main building, designed by Moshe Safdie, stops admitting visitors an hour before closing time. We are twenty minutes too late, and the guard refuses my pleas and entreaties, my insistence that we have come all the way from America. He could not care less—but I have an idea. There is a young woman guarding the exit to the main building, to whom I had spoken earlier, and I suggest we go in through the back exit. She lets us in, and we see about two-thirds of the exhibits and videos in the time we have left. It's enough for me. Rachel and Greg go back a few days later and spend another few hours there.

Jerusalem is completely unlike Tel Aviv, a flux of peoples and cultures, yet far less cosmopolitan, with many neighborhoods of ultra-orthodox Jews. I still get heat exhaustion every day after being out for a few hours, but the humidity is only thirty percent compared to Tel Aviv's sixty percent. We stay at the Palestinian-owned Jerusalem Hotel in the Palestinian section of Jerusalem near the Damascus Gate of the walled Old City. Its garden restaurant in a courtyard with a canopy of grapevines is a meeting place for artists and intellectuals, human rights workers, journalists, students, and political activists. It also has the best lemonade, made from scratch for each order in a blender with fresh lemons and big handfuls of mint that turn the lemonade green.

After a week, we begin to feel part of the community. I meander over to an American tour group when I hear someone speaking about the Palestinians in English. The speaker turns out to be Jeff Halper, a well-known human rights activist who moved to Israel from the United States years ago and became director of the Israeli Committee against House Demolitions. They worked with Yael Bartana on a project in which she videotaped the rebuilding of a demolished Palestinian home and paired it with an idealistic Zionist film made in the thirties.

When the tour group leaves, I introduce myself to Halper and tell him where I teach. "Oh, Wayne State," he says. He was invited to speak there by Thomas Abowd, an Arab American anthropology professor. I had supported a grant proposal by Abowd as a member of a university grant committee and heard him give an excellent lecture on his work. Halper tells me that Abowd organized a conference on the Palestinian question two years earlier and was subsequently driven out of the university for being "anti-Jewish." I am shocked, not only because this has happened, and not only because I know these are groundless charges, but also because I knew nothing about it. It seems I must come to Jerusalem to discover the persecution of a Palestinian scholar on my own college campus.[8]

Rachel and I put on our long skirts as required by the Orthodox rules of modesty and walk through the Muslim quarter of the Old City with its endless variety of markets—clothes and shoes, pastries and candies, heaps of fragrant spices—then head through the armed Israeli checkpoint until we emerge in the open at the Western Wall encasing the Temple Mount on which once stood the Second Jewish Temple that was destroyed by the Romans. We make our way to the women's side where female tourists gather and Orthodox women pray. Touching my forehead to the ancient stones, I am suddenly overcome, to my surprise, and find myself in tears, as if the stones themselves have drawn them from me. I feel as though I have touched more than a thousand years of Jewish history, full of suffering and destruction, and offer my own kind of prayer for the peace of my parents' souls and the long and healthy lives of everyone in my family. This is what my mother used to pray for every week when she lit the Shabbos candles, and here, at this old wall, I do it in her honor, in memory of her bending over those candles on a thousand Friday nights.

Every crack and crevice of the limestone wall is crammed with folded notes bearing the fervent wishes of visitors and supplicants, for the healing of illness and disease, for good fortune and fruitful endeavors, and now people try to shove in more notes on top of these, hoping for a direct line to a higher power through the ancient rock. As we leave, we notice that the Orthodox women don't turn their back on the wall but reverently walk out backwards, and we walk out backwards too.

The Old City is crowded and chaotic with a constant crush through the narrow stone alleyways, but as we walk through it every day to explore the different quarters and churches, we grow accustomed to its rhythms and notice the ancient columns, capitals, and other architectural details that have been preserved, the remnants of ancient Roman walls and streets, the different ways the Muslim women dress, the young ones with designer sunglasses and jeans under their long black garments. We walk through the Muslim residential quarter where there are no markets or tourists, but here I feel like an intruder. We pass children playing on the tiers of stone steps and I wonder what it's like to grow up running up and down stone steps as a playground.

Notes packed into the seams and cracks of the Western Wall, Jerusalem.

From behind a door, we hear children crying and then a woman screaming. A Palestinian man pounds on their door as he passes but the screams continue. Every ethnic group has its share of substance abuse, domestic abuse, and sexual abuse. Ruth has told us how a few days earlier the religious Jews were rioting because one of the mothers in their community was charged with starving her baby. She was diagnosed with Munchausen syndrome by proxy—a disorder in which a person, often a mother, falsifies or induces health problems in a child— and had been caught by a hospital video disconnecting her starved baby's feeding tube. Still, the Orthodox community was outraged at the idea that an Orthodox mother would be accused of such a thing, convinced that this rare disorder could not exist among them. They hid her other children so that health authorities could not examine them.

What the Israelis call the Temple Mount, the Muslims call Haram al-Sharif (Noble Sanctuary), where the octagonal Dome of the Rock sits with its enormous golden dome, the most prominent structure in Jerusalem. The tile work that covers the shrine and surrounding structures is surpassingly beautiful. Muslim men and women enter, and, though I know they are not letting in visitors, I go up to the men at the entrance and try to say *as-salāmu'alaikum* (peace be upon you), as I have heard others do, and ask permission. They refuse, saying it is only for prayers. A long and complicated history here includes not only the two destroyed Jewish temples but also the miraculous nocturnal journey to

heaven of Mohammed. It surely qualifies as one of the most fraught memory sites in the world.

The question of civil rights becomes urgent when I meet with Palestinian artist and activist Rana Bishara at the Jerusalem Hotel garden restaurant. I think we will talk about her work, but Rana talks only about the oppression of the Palestinians, which is, in fact, what all her work is about. Though born in Israel in a village in Galilee to a Catholic family, the Israeli government refuses to recognize her nationality as either Palestinian or Israeli. Where nationality should be listed on her passport, she shows me where they have instead printed eight asterisks: ********. No nationality. This is typical, she says. Rana is fluent in Hebrew as well as Arabic and English.

She has spent the last four days with two Palestinian families fighting their evictions from their homes by the Israeli police in the nearby neighborhood of Sheikh Jarrah. Rana recounts how people who joined the families in solidarity and protested the evictions were beaten and arrested. She herself was fingered for taking photographs and narrowly avoided arrest. Rana is planning to go there again that night and invites me to join her. Am I risking injury or arrest? Greg and Rachel are at the Israel Museum and will have no idea what has happened to me if I don't return. I'm scheduled to give a paper at the World Conference of Jewish Studies the next day. I decide to go anyway, and we hop on a bus.

Three brothers and their two large families, the al-Hanoun and al-Ghawi families, have lived next door to each other for decades. Now they sit on plastic chairs and stools under the spreading branches of an olive tree on the sidewalk across from their homes. Small children sit on laps and teenage girls move to a pile of sleeping mats to make chairs available for visitors or sit in a circle on the sidewalk. The boys sit on the street curb or stand. A small table with plastic cups holds thermoses of tea and coffee. More than fifty people from these two families were evicted from their three adjacent homes two days earlier and are now encamped here on the sidewalk, homeless. The women and children sleep with neighbors; the men sleep on the street, sometimes joined by sympathizers. Minutes after Israeli police took their furniture and belongings out of the houses, a family of Jewish settlers waiting nearby occupied one of the homes, the evictions having been set in motion by Jewish settler groups.

As Rana and I walk past the occupied home, the settlers are visible from the street, peering through the windows of the house they have now wrapped in material to keep out the wind where the Israeli police broke doors and windows. They have also wrapped the houses in barbed wire, with added police barriers on the sidewalk that bar entry to all but the settlers. There is a constant police presence on the street. "They always live behind barbed wire," says Rana. "How can they feel good about themselves occupying other people's homes?"

Rana describes how the belongings of the families were thrown randomly into boxes by the police, with food from the refrigerators thrown on top of

The al-Hanoun and al-Ghawi families protesting on the sidewalk across from their former homes in the Sheikh Jarrah neighborhood of Jerusalem after the Israeli police evicted them; August 2009. (Photo courtesy Rana Bishara.)

clothes. Two of the Palestinian teenagers have their arms in casts and slings from injuries caused when the police struck them with rifles. "It's just the muscles," says one boy, Rami, making light of it. A girl whose arm is also in a sling has three steadfast friends who keep her company all evening, the four sitting in their headscarves, talking and laughing. There is a grim determination here that makes it possible to laugh. But in the faces of the women Rana photographs, there is sorrow, anger, and shock.

Others were also beaten and arrested—first internationals, then Israeli Jewish sympathizers, then Palestinians, according to Rana. Internationals and Israeli Jews have received stiff fines and were banned from the area for three weeks under penalty of further stiff fines. One Palestinian boy who stood up to the police was banned from his own home across the street and spent several days in jail. A tall young Scottish fellow in a cap arrives, and Rana tells me he was beaten, fined, and spent three days in jail. He is banned from the area. Yet here he is again, joining the families in solidarity and planning to sleep on the street with the other men. "He is like a son," says Rana; Nadia, one of the mothers, nods and agrees.

The evictions follow five months of legal battles in which a lawyer for the Palestinians demonstrated that in 1956 the Jordanian government and the United Nations Relief and Works Agency (UNRWA) gave the houses to these families, who were refugees from the 1948 war. They have legal documents obtained from Ottoman archives in Istanbul. The Jewish settlers insist these

were previously Jewish-owned homes, dating to the nineteenth century. In an earlier court case regarding the eviction of another Palestinian family, Palestinian lawyers submitted Ottoman documents demonstrating that the houses had been rented to Jews in the nineteenth century, not sold, but the Israeli court rejected the evidence, claiming it was submitted "too late." Each side accuses the other of forging documents. Palestinians, unlike Jews, do not have the right to reclaim their former homes in Israel prior to the 1948 war.

Two hearings have already taken place on the most recent evictions and a third is scheduled for the next day. We speak with Maher Hanoun, one of the brothers, who is hopeful that the families might be returned to the two homes that are still unoccupied, knowing that once settlers have moved in, the courts are unlikely to throw them out again. Four police vans with flashing lights are parked on the street, prohibiting entrance to the compound across the street where Jews have also claimed a house among the twenty-eight homes of Arab families who live there. We can see an Israeli flag waving on the roof of a distant house. Nadia tells me that the Red Cross and UNRWA offered charity, but they refused. "We do not want aid," she says, "We want our homes." Nor do they want to live in tents, which the police take down anyway, as they repeatedly took down the tent of the woman evicted from the home with the Israeli flag, whose husband suffered a heart attack and died following the eviction.

Other visitors arrive to sit for a time in solidarity with the families, talking, drinking tea, and smoking. Rana is here every day. She greets everyone, shaking hands with the men, kissing the women and children, who flock around her. She distributes wristbands that say, "I love Palestine" to the children, offering them a choice of orange or green. She commiserates with the parents, getting the latest updates. One of the brothers asks me, "What state are you from?" I say, "Michigan." "Michigan!" he exclaims. "I lived for a year in Dearborn! I have a brother in West Bloomfield and another brother in Troy!" I know all these places. Michigan has half a million Arabs, once the largest population outside the Middle East, now second to Los Angeles. We smile broadly at each other.

Maher Hanoun asks me if I will write about the evictions in Sheikh Jarrah and I say that I will. He says that even if it doesn't help them, perhaps it will help some of the other twenty-eight families. They are quite certain that the Israelis intend to evict all the Palestinian families in the neighborhood, to use this area as a link between Mt. Scopus, where Hebrew University is located, and the Old City, and ultimately to claim all East Jerusalem.

My paper for the conference at Hebrew University was the catalyst for this trip to Israel but I skip the first four days of the conference and only go to the sessions on modern art. My presentation analyzes the debate between survivors and young artists over the *Mirroring Evil* exhibition at the Jewish Museum in New York City and defends the representational strategies of irreverent and

satirical young artists who address the highly mediated ways in which our understanding of the Holocaust is shaped by cultural depictions such as films and advertisements. Their work demonstrates that we have no access to the historical events of the Holocaust *except* through representation and addresses the commodification of the Holocaust in contemporary culture and its political exploitation by the Israeli state for repressive policies against the Palestinians.[9]

Standing before a roomful of sixty or seventy people, mostly Israelis, I feel a certain tension, even hesitation, as I present my defense of this artistic critique of Israeli policy. Usually I can read an audience, but I can't read this one. I forge ahead, and when I sit down, conference organizer Ziva Amishai-Maisels, who wrote the first substantial book on art and the Holocaust and who invited me to this conference, turns and gives me a big smile and enthusiastic head nod. I am relieved I haven't disappointed her.

When discussion begins, an Israeli woman identifies herself as having a PhD and asks me three rapid-fire questions: Aren't I being reductive? Is this trend, if it exists, evident in literature? How can I blame Ariel Sharon alone for the policy of city destruction? I explain that of course, there are other trends in Holocaust representation, but in this debate, there was a generational divide over who owns "Auschwitz." Do these trends exist in literature? I ask the audience. They respond with a rousing Yes! and I realize they are with me. As to her last question, certainly I'm happy, I say, to lay the blame for the policy of city destruction on the Israeli government as a whole. She has no more questions.

In a cab that I share with an American couple back to the Jerusalem Hotel, the man tells me he is a lawyer but gave a paper on philosophy. He expresses surprise that I have given a paper on art related to issues of the Holocaust and says they have never talked to their daughter about the Holocaust because they want to "focus on happy things." They are staying near the King David Hotel in the heart of West Jerusalem, and he expresses amazement that I'm staying in the Arab quarter. He is perhaps wondering if I am some sort of "self-hating" Jew while I am wondering how they can pretend to ignore the history and memory of the Holocaust and close their eyes to the Israeli oppression of the Palestinians.

On a tour called "Jerusalem—A Political Tour," along with two young Australian men backpacking through the Middle East, our guide is a Palestinian named Mahmoud who formerly worked for human rights organizations and now does community-organizing work. We drive along the oppressive concrete wall Israel is building to enclose the West Bank, which varies from tall to towering. We see how the wall is used to steal territory, with Palestinian villages on both sides, the wall cutting them in two or cutting farmers off from their land, and how short drives to the city center now become two- or three-hour ordeals through Israeli checkpoints. We go through a checkpoint for Palestinians and wait in the lengthy bottleneck of vehicles. We see the long cattle pen–like

Gates and pens at Israeli checkpoint for Palestinians at Qalandia between Jerusalem and the West Bank city of Ramallah.

enclosure through which Palestinians traveling by bus must pass through on foot. We all get out of the van to experience this space, and Rachel later says it made her feel quite anxious. The passage seems designed to induce a sense of maximum isolation and intimidation, its steel bars clearly evoking prison bars and the power of the state. There are eleven checkpoints around the city, and more can be set up at any time. Palestinians can't even choose which checkpoints to pass through but are assigned a checkpoint based on where they live—and it's never the nearest one.

The wall depletes commerce and undermines the West Bank economy. We drive through impoverished refugee camps that have become permanent encampments. At the end, I ask if we can stop at Sheikh Jarrah, and Mahmoud agrees. We sit down and one of the girls in the family tells us the story of the evictions. A disabled young man from the United Kingdom living with one of the families elaborates on the situation. Everyone is moved. I'm glad that Greg and Rachel have experienced this firsthand. Settlers have now moved into all the houses, and videos and articles begin to proliferate online at standupforjerusalem.org.

That night I watch a YouTube video on Sheikh Jarrah in which a reporter asks an Israeli woman in her early twenties with shorts and long blond hair on the street in West Jerusalem if she has heard what has happened in East

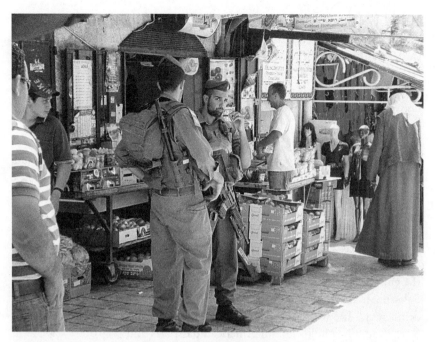

Armed Israeli soldiers in the Arab quarter of the Old City, Jerusalem.

Jerusalem. "What happened?" she asks. The reporter explains that two Arab families who have lived in their homes for more than fifty years have been evicted and are homeless on the street, that Jewish settlers have moved into their homes. "Excellent," she says.

We are quietly outraged by the way Israelis breed fear of the Palestinians, whom they always refer to by the more general term Arabs, when we join a tour of the tunnels under the Western Wall, the only Israeli tour we take because there is no other way to see the tunnels. Our young Israeli guide announces before we exit that we will be emerging into the Muslim quarter of the Old City and they will have armed guards in front and behind our group, clearly implying that we might otherwise be attacked. He warns us that if we leave the group, we do so at our own risk. This is how "the Arabs" become essentialized and racialized by the dominant discourse as inherently violent and "other." We have been walking through the peaceable Muslim quarter every day for a week and have only been disturbed to observe the intimidating presence of uniformed Israeli soldiers who stand about with their rifles slung across their chests. When we emerge from the tunnels, we immediately leave the tour group and its armed guards.

On our last day, I'm anxious for news of Sheikh Jarrah. World opinion has turned against the Israeli action, *Haaretz* has editorialized eloquently against

it, Hillary Clinton has publicly opposed it, and the United Nations coordinator for the Middle East Peace Process has condemned it, but none of them has the least influence on the Israeli court. In the meantime, right-wing Israeli officials have visited the neighborhood with bodyguards, gloating to the evicted Palestinians that this is now Jewish territory. Fighting breaks out between the bodyguards and some of the evicted. They arrest three Palestinians and levy heavy fines against them.

There is a candlelight vigil that night for Sheikh Jarrah, starting at the Damascus Gate, and there will be many internationals and Israeli Jews, including Rabbis for Humanity, who oppose the evictions. Rana is going, of course, and I wish I could go too, but we must leave for the airport before it begins.

A Palestinian taxi takes us to the airport, but Israeli guards pull us over at the entrance for a car search with special detectors and long-handled mirrors to see the carriage underneath the van. "Does this happen every time?" I ask the driver. He looks weary and says it's his third trip to the airport that day and all the guards know him, but he is pulled over and searched every time. "Is every Palestinian always pulled over?" "Yes, of course," he says, "Welcome to Israeli democracy." They call him into the station and check his cell phones. We wait by the van. Greg holds up our American passports and they don't search our luggage, but we see Palestinian families with small children trudging into the station with their bags and suitcases. Thirty minutes later, we are allowed to continue. This is what you can expect if you hire a Palestinian driver to take you to the airport.

The Israeli Supreme Court ruled against the al-Hanoun and al-Ghawi families in 2009, but the protest movement, which eventually mobilized thousands and led to pressure in the media and internationally, put a general halt to the evictions. Ten years later, however, there is a new wave of evictions in Sheikh Jarrah. The Sabbagh family, forcibly expelled from their homes in Jaffa in 1948 and now numbering forty-seven people living in five adjacent homes, were told in 2019 to make way for Israeli settlers who would be moving in. Many see this as a result of Donald Trump's support for the Israeli government, which may uproot as many as five hundred people in Sheikh Jarrah.[10]

Israel is full of contradictions: home to socialist kibbutzniks whose sons serve in elite army units; a state that refuses citizenship to many of its own citizens and evicts people from homes they have lived in for half a century; a democracy for one people and a prison house for another. Rooted in complex layers of history and subject to conflicting memories and competing interpretations, its ancient cities are perpetually caught in contests of meaning over place, memory, and identity. For me, the experience of Israel, its old stones and border walls, became inseparable from the experience of longing and loss, deepening an embodied awareness of oppression, the importance of how we tell the story of the past, and the bitter ironies of this deeply divided country. It is a place

where one set of people is barricaded into ghettoes by another people once forced into ghettoes, where an ethnic minority is persecuted and dispossessed by another people once persecuted and dispossessed, and where the daily trauma of one group is justified by the historical trauma of another, producing lives that are scarred by exile, loss, longing, homelessness, and pain for generations.

Part IV

Hospitals and Cemeteries

7

Sprung from the Head

While in San Antonio, Texas, for a conference, I went with friends to see an installation by the French artist Annette Messager at Artpace. Standing alone for some time, I took in the soft objects and stuffed corpses of small animals enclosed in black or white netting that hung from the ceiling, the walls, and pooled on the floor, and the small votive objects, all of it evoking a sense of internal body parts, both tender and menacing. Suddenly I was flooded with a feeling of grief and an urge to weep, overwhelmed by the sensation that I was in the presence of death, specifically of stillborn fetuses. I fled the room. Meeting my friends outside, I found myself unable to explain the devastating effect the work had evoked, but later it occurred to me: my response was connected to the embodied memory of the previous year when I had suffered a miscarriage early in a pregnancy. That loss had struck me with unexpected force, and like many women, I tried to repress the experience and didn't talk about it. I didn't know then that the grief of lost pregnancies can affect women for years and that those who suffer miscarriages early in their pregnancies feel as much grief as those who miscarry later.[1] I was still mourning a lost child.

Messager's work, begun in the postwar period, often represents blood, fallopian tubes, dangling objects, animals, netting, and doll's body parts, evoking the lives and gendered experiences of women, including the suffering and abuse of Holocaust victims and survivors. Conveying the embodied nature of memory, Messager produced this work at a time when women historians were arguing for the validity and legitimacy of gendered experience, particularly in Holocaust studies. Through work such as Messager's, what was regarded as not

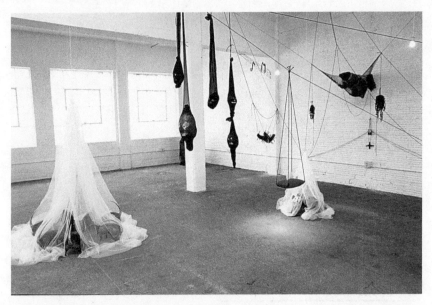

Annette Messager, *Protection, Protection, Protection*, 1995, installation view. Originally commissioned and produced by Artpace San Antonio. Courtesy of the artist and Marion Goodman Gallery. © Annette Messager. (Photo: Roberta Barnes Photography.)

worth remembering, or consciously repressed, becomes unforgotten, validated, and part of the culture of memory.

The title of Messager's installation at Artpace, *Protection, Protection, Protection*, urgently repeats what cannot be achieved for the lost child whose life ends too soon. The space Messager created conjures an alternative world where the presence of lost children survives in memory, where those missing futures might still exist, while the scale of the installation produces a sense of dislocation and disorientation in time and space. The objects evoke uterine spaces, the first, original place from which we all emerge, in a kind of memorial to unborn children.

What was it like for the women, weakened and emaciated, who survived the Holocaust and became pregnant after the war? For my mother, who discovered her pregnancy while in a Displaced Persons camp and gave birth under duress in a Berlin hospital?

Haggard, traumatized, and grief-stricken after their years in a slave labor camp or in hiding and still stunned by the loss of their homes and families, my parents returned to their Polish hometown of Hrubieszów and organized a quick marriage, with ten fellow survivors as guests and a bottle of vodka to celebrate. Without a place in the world, my father arranged a ride in the back of an ambulance to Berlin, where my parents registered at a relief agency in Charlottenburg before entering a Displaced Persons camp.

They were among the seven million people who lived in DP camps across Europe in the year immediately after World War II. These included forced laborers, people who had fled or hidden (about 200,000 Jews survived the war in the Soviet Union, including my parents), prisoners of war, partisans who had fought the Nazis, and concentration camp survivors. The majority, not being Jewish, were repatriated to their home countries, but almost a million no longer had a place to go. In Germany, the Jewish DPs lived in some 200 DP camps established by the American, British, and Russian powers that occupied Germany after the war. Conditions were harsh and crowded, and rations were restricted.

The camps remained under the control of the allied military, but UNRRA, a UN refugee organization, eventually managed operations while Jewish voluntary organizations delivered supplementary food and supplies. The Jewish DPs elected central committees and organized congresses; some of the larger camps had their own newspapers and even theater groups that performed mournful plays. The sudden growth of a Jewish population in Germany in the immediate postwar period, however, meant this devastated and homeless population now had to live among the perpetrators, who did not welcome them, having to contend with their own harsh postwar conditions.

"You leave with nothing, you have become nothing. You have no record of who you are. You are a shadow, and you will be haunted by shadows," writes André Aciman of the DPs.[2] Of the 250,000 Jews in DP camps, about 80,000 immigrated to the United States, my parents among them. The number would surely have been higher if the U.S. immigration law of 1924 hadn't severely restricted immigrants by country of origin and imposed other restrictions. The majority went to Israel and most of the DP camps closed by 1952, seven years after the end of the war.

The modern displaced persons are global refugees fleeing from war, violence, poverty, and climate change; they too become shadows who have no place in the world. In illegal and inhumane attempts to deter people of color from Central America and elsewhere from immigrating to the United States, the Trump administration has separated thousands of children from their parents at the U.S.-Mexican border, even when those parents legally sought asylum, and placed them in detention centers where they have been caged and abused; expanded the detention system, which now captures and holds as many as 400,000 immigrants each year; strong-armed Honduras, El Salvador, and Guatemala into "safe-third-country" agreements, which allow the United States to send asylum seekers to the same countries that many of the migrants are already fleeing; and, in an even more bizarre twist, proposed fortifying a border wall with a moat stocked with snakes or alligators, electrifying the wall and adding "flesh piercing" spikes on top, and shooting migrants in the legs.[3] While it may be tempting to regard detention centers as modern DP camps, the crucial

Ethel and Samuel Apel (author's parents) as Displaced Persons in postwar Berlin.

difference is that people are held against their will and without trial or due process, so that these centers must be understood as concentration camps.[4]

My parents got in line for food rations but noticed a separate line for pregnant women, who emerged with extra rations. "Get in that line and say you're pregnant," my father urged my mother, and she did. After starving during the years of hiding, her weight had dropped to eighty-five pounds. She truthfully told the camp officials she didn't remember the last time she had her period. Starvation caused women to stop menstruating (though many women in the concentration camps thought the Nazis had "put something in the soup"). To my mother's surprise, a pregnancy test was positive. Since most survivors were in their twenties and thirties, the birth rate in the DP camps was high. She emerged with a bigger bag of groceries and my parents rejoiced over the extra food, if not the unexpected pregnancy. Assigned to a small room they shared with three boys from another family, they were displaced, dispossessed, and disoriented.

Sitting on the side of the double bed I shared with her, my mother blew across a saucer of hot tea she had poured from a cup for me. I was ill, about four years old, but I took advantage of this moment to ask a question I had been wondering about.

Where do babies come from?

She replied, smiling, that she bought me in the "5 and 10 cent store." I knew it wasn't true and I didn't think it was funny. On another occasion, I asked

again, and she said I sprang from her forehead. She said it with such an odd fervor that I pictured myself popping out of her head fully formed, an image so astonishing I was cowed into silence. Finally, one day when I asked again, she lifted her clothes and showed me a thick red gash under her belly, where she had been cut open twice to deliver my brother and me. I knew I'd gotten to the truth but what kind of truth was it? There was pain and anger in her face but a certain pride too. She insisted on showing me the scar several more times over the years but by then I didn't want to look at this sign of maternal sacrifice.

When I was five, while peeling potatoes at the kitchen table one afternoon, my mother told me the story of giving birth to my brother in postwar Berlin. She said she was afraid the German doctors would poison her. She wanted a Jewish doctor but there were no Jewish doctors. She missed her mother and father and her sisters, who had perished along with their husbands and children, aged one to seventeen. She said, "I was alone." Although I knew my father was there, I understood this to mean that pregnancy only intensified her sense of loss and the keenly felt absence of her mother and sisters who would have offered guidance, comfort, and support during the momentous events of pregnancy, labor, and birth. Her experience of pregnancy instead became one of trepidation.

At the hospital in Berlin, they gave her ether and told her to count backwards from a hundred, and as her consciousness slipped away, she heard the nurse remark to the doctor, "You know she's a Jew."

I was chilled and could vividly imagine this scene. I had just been hospitalized myself to have my tonsils removed and they had given me ether, too, and asked me to count backwards from a hundred. I pictured my mother lying on a bed in a cold white environment with her eyes closed, the nurse standing by, speaking quietly to the doctor, the terror of hearing the nurse's words in the remaining seconds of consciousness, not knowing if she would ever wake up again. I felt a terrible sense of dread, as if it were me, not my mother, lying in that bed in postwar Berlin, hearing those chilling words and feeling utterly helpless.

At the Museum of Modern Art in New York City, photographer Carmen Winant covered opposing walls of a narrow twenty-foot gallery with the project *My Birth*, comprised of over two thousand found photos of labor and birth taken from pamphlets, books, and magazines as part of MoMA's exhibition *Being: New Photography 2018*. Traversing the installation like a birth canal, viewers were faced with an abundance of images, which one reviewer described as "unnerving," "violent," and "both horrific and miraculous," confronting viewers with experiences about which many are "scared to ask, scared to look."[5] Another reviewer described the images as "frankly mind-blowing."[6] Few contemporary artists have dared to focus on the difficult imagery of labor and birth as opposed to pregnancy and motherhood, the safer conditions of before and after.

Carmen Winant, *My Birth*, installation view of the exhibition *Being: New Photography 2018*; Museum of Modern Art, New York. (Photo: Martin Seck. Digital Image © The Museum of Modern Art/Licensed by SCALA/Art Resource, NY.)

What makes it so difficult? Even when films allude to birth, it's always rather quick and involves no messy physiological aspects such as the afterbirth of the placenta or even cutting the umbilical cord. In a *Vogue* interview, Winant credits artist Mierle Laderman Ukeles with inspiring her, and cites Ukeles's account of giving birth in 1968 and her subsequent "shock" that no one asked about it. Winant observed, "She said something like, 'Weren't they curious about what it felt like to create life? But with no language, it was like I was mute.' And I wept when I read those words because I was undergoing a similar experience, having never recognized it for myself."[7] We have no language for the experience of childbirth because no one dares to ask about it, leaving women to feel isolated, their enormous experience repressed or seemingly unworthy of being remembered.

Winant suggests that since birth is not generally regarded as the concern of men, "the *image* of birth has not yet entered the mainstream as mutually interesting and worthwhile, belonging in different ways to both genders. Just as we have the mistaken idea that terminating pregnancies has nothing to do with the men who were involved in creating them (only women are charged with, and bear the consequences of, illegally seeking abortions in the United States and abroad), our cultural imaginations are too limited around the experience of birth."[8] Winant's project makes the largely shrouded, taboo, and invisible subject of childbirth aggressively visible through an onslaught of imagery that validates this fundamentally embodied and gendered experience. Casually taped to

Carmen Winant, detail of *My Birth*, showing women in various stages of childbirth, installation view of the exhibition *Being: New Photography 2018*; Museum of Modern Art, New York. (Photo: Martin Seck. Digital Image © The Museum of Modern Art/Licensed by SCALA/Art Resource, NY.)

the wall, the images are individually vulnerable and fragile yet powerful in their aggregation.

My mother recounted the events of my own birth, which were, like those of my brother's, traumatic in their own way. It was an unplanned pregnancy, and my mother traveled to New York City with the intention of having an illegal abortion, primarily because she wanted to avoid a second C-section, which at that time doctors thought necessary after a first one. Kept in bed for six weeks following my brother's birth, as was the custom, she had developed thrombosis in one leg, so she didn't want to risk the danger of another blood clot by being kept in bed again. Her cousin Jean Peltz, with her husband Leo, met her in Manhattan and begged her not to get the abortion, insisting they would take the baby because they could not have one of their own. My mother agreed and returned home, giving birth at a hospital in Philadelphia and enduring another C-section. Then she refused to give me up. "You can't give away a baby!" she exclaimed when she told me this story.

I was eight years old when my parents put me on a bus by myself to New York where I would stay for a week with Jean and Leo, who were part of the Holocaust survivor community living in Rego Park, Queens. Leo was one of the few

people to escape from a transport to a death camp by prying loose boards and jumping out of the moving train. There were snipers with machine guns on top of every third or fourth cattle car and they shot at him, but they missed. He escaped into the woods and managed to survive the war. His wife and three children remained on the train and went to their deaths.

My father escaped when the Nazis entered Poland, after hearing rumors of male Jews made to scrub streets with toothbrushes by the Nazis in Vienna, crossing the River Bug into Soviet territory. After two months of Nazi occupation, all male Jews in the town between the ages of sixteen and sixty were ordered to report the following morning to a central location. About 2,000 Jewish men joined another 2,000 from Chelm and were forced to march in terrible conditions for four days; about half returned—the rest had been shot and killed. Only recently, years after Jean's death, have I learned that as a teenager, Jean had guided men from Hrubieszów to the River Bug at night so they could escape what has come to be known as the Death March and cross to the Soviet side.[9]

On my first evening with Jean and Leo, they hosted a dinner party and their friends flattered me by remarking on my maturity, by which they meant, I thought, my taciturnity. As a quiet and serious child who usually felt unnoticed, the attention was a boost to my confidence. But after that evening, I spent the remainder of my visit staring out of the second-story window from Jean and Leo's dark living room, watching kids in the playground down the street while munching on Jordan almonds from a bowl on their coffee table. Maybe Art Spiegelman, who grew up in Rego Park, was one of the noisy boys I could see. On the third day, realizing what I was doing, Jean offered to take me to that playground, but I shook my head, daunted by an urban space full of boys.

I wondered why Jean and Leo had wanted me to come and stay with them. After a few days, I decided they were testing me, as if I were a practice child or a surrogate child. I also realized I was failing the test. I was painfully shy and we hardly spoke. I waited for them to ask me questions, but they had nothing to ask. The denouement came at the breakfast table one morning when Leo tried to tickle me. Startled, I upset my cereal bowl and we all watched as milk ran to the edges of the table. Then Leo stood up with a sober expression, looking off into the distance, and walked away while Jean cleaned up the mess and I retreated to the darkness of the living room.

Years later, I learned that Jean had had a child in the Hrubieszów ghetto, where she lived in a house with a group of women, all of whom were hiding their children in the attic. Jean's daughter was four years old. Her first husband had fled to the Soviet Union and died there, which she learned when two men returned to the ghetto with his watch. One day the Nazis arrived and sent most of the adults in the house to the labor camp at Budzyń. Jean, her mother, and the other women had no choice but to abandon their children hidden in the attic. From Budzyń, Jean was transferred to ten more camps, ending in

Auschwitz-Birkenau. There she was subjected to Josef Mengele's medical experiments on women. As a result, she suffered seven miscarriages and was unable to bear more children. In a sense, I was the ninth lost child, a promise broken by my mother, after the murder of Jean's daughter and the seven miscarriages that followed.

Only after the war did Jean learn what had happened to her daughter. Henry Orenstein describes the event in his memoir, *I Shall Live*: "During the day, while most of us were out working, a Polish woman had gone to the Gestapo and told them that she had heard the sound of crying babies coming from one of the empty Jewish houses. Wagner went to investigate and found a skrytka [hiding place] with nine small children in it, together with five old women—some of them the children's grandmothers. He took them all outside, and serenely, with a half-smile, shot them one by one in the head. One little girl tried to escape, but Wagner ran after her and shot her down too."[10] Hans Wagner was captured after the war and Jean was called to testify at his trial. Knowing he had shot her child, she fainted in the courtroom at the sight of him and had to be carried out. Wagner was sentenced to death and hanged.

The inability to protect their children was a special form of suffering for women during the Holocaust, and the destruction of Jewish children was a conscious part of the Nazi mission. Pregnant women in the camps were tortured, beaten, and sent to the gas chambers, while women with children who arrived in the camps were often faced with the horrendous choice of staying with their children and perishing in the first selection as railcars unloaded or abandoning their children in hopes of surviving. Many testimonies affirm that the killing of children was likely the most psychologically damaging Nazi policy for women, one of the gendered differences in the experience of men and women. Jewish women were targeted not only as Jews, but also as women whose reproductive capacity represented the next generation the Nazis sought to prevent.[11]

I thought I might be infertile, thinking of myself as "barren" because my mother was in her forties when she gave birth to me. I was therefore shocked when I conceived on the first try, just after completing my doctoral coursework. Why had I imagined my inner field of fertility as an arid desert? Perhaps I feared being a terrible mother. Or perhaps it was the fear of reproducing my mother's traumatic birth experiences. When I became pregnant, everyone at the hospital congratulated me as if I had achieved something marvelous, and, overcoming my initial hesitations, I began to be happy. Six weeks later, I miscarried. They performed an ultrasound at the hospital and said matter-of-factly, "It isn't there anymore." No one expressed sympathy or condolence. Dazed, I waited in an examining room for a young doctor who performed an internal exam without preamble and treated my lost pregnancy as if it were a cut finger.

I was devastated. Even though I knew it had been a tiny blob of cells, it was *my* tiny blob of cells and I had become attached to it more than I had realized.

How had Jean endured this heartbreak seven times? Greg was in Pakistan for work. I sat in my apartment feeling numb and bereft, with no one to turn to in my grief because we hadn't told anyone, and finally called my dissertation advisor in Los Angeles who said, "At least you know you can get pregnant." This made me feel better—but also worse, because I knew she had been trying unsuccessfully.

Three months later, Greg and I stopped in Amsterdam for one night on our way to Düsseldorf where I was planning to study German at the Goethe Institute. We were jet-lagged but made love anyway for the first time after the requisite three-month waiting period, and in the weeks that followed, I started craving spinach. Back in Amsterdam a month later, the guttural sounds of a Dutch radio newscaster as we drove to a market made me feel nauseous, and the sight of dead fish on ice and ducks hanging by their necks made it worse. Then it struck me: I was pregnant again. On the second try.

I studied for my doctoral exams as my belly grew, but pregnancy books were an irresistible lure, along with the Anita Hill–Clarence Thomas hearings on television. Then I was ten days overdue. I knew from the beginning it would be a big baby because my mother had two big babies and Greg's mother had three big babies. I had wide hips and was not worried. Like a religious zealot, I read and reread *What to Expect When You're Expecting*.

At my birthing class, the nurse told us everyone has a specific fear and instantly I knew what mine was: the C-section. My mother's angry red gash. Without quite realizing it, I had come to regard my pregnancy as a way to repair my mother's past, to compensate for her suffering. I was determined not to carry forward the trauma, to have a natural childbirth, and I interviewed several obstetricians, selecting the one with the lowest rate of C-sections: 2 percent instead of the average 20 to 25 percent.

My belly was huge, I was overdue, and my ob-gyn called to say he was worried that the baby might be too big to deliver safely in the Birthing Center, which he had founded. The Birthing Center created a home environment, mostly free of medical equipment; it had a bathroom with a bathtub, and treated birth like a natural event instead of a medical condition. He wanted me to check into the hospital. This could only mean one thing: he thought I might need a C-section. "Please," I said, "don't do this to me. I need your support. You're going to deliver this baby in the Birthing Center. It's going to be fine." I was reassuring him instead of the other way around and he backed down.

For centuries, doctors performed cesarean operations only on women who were dead or dying, but they were rarely able to save the babies, who by that point were in too much distress. It was only in the late nineteenth century that survival for mothers and babies in the West became common (though indigenous peoples in Africa had been successful for much longer). Today about a third of women give birth this way, often at their own request, for the sake of convenience, despite the increased risks of surgery and infection. For me, however, it

represented an unnecessary wounding of the body—and the terror of birth in a German hospital after the war.

What made my mother announce that I had sprung from her forehead like Athena emerging fully formed from the head of Zeus? Perhaps it was a way to imagine those births without having to endure those two surgeries alone in a hospital, the first time in a hostile place with a medical staff she thought might kill her, the second while my father stayed home to watch over the chicken farm. Perhaps that mythic event spoke to her sense of the heroic effort it had taken to overcome her fear and suffering the first time and then, the second time, having to reenact that trauma all over again. The idea that we sprang from her forehead transformed the harrowing births of her children into mental feats of endurance and survival.

I went to a chiropractor when I was nine days overdue and he observed that labor stops in animals if something frightens them. It seemed a nice way of telling me my own fear was holding up the birth, and though I hadn't thought I was afraid, that night I lay in bed and let myself feel my own rising terror, which crawled up my body. Despite all the reading I had done about labor and delivery, I hadn't come to terms with this. I accepted the fear and let it slowly dissipate out of my body so I could welcome the birth of my baby. We knew it would be a girl. We knew we would name her Rachel.

The next morning, I awoke and did not feel afraid. I lay in bed, stimulated my nipple to release oxytocin, and had a huge contraction. I knew that labor often stopped for many women when they got to the hospital. I wanted to stay home as long as possible. My friend Andrea came over and started timing contractions, which gradually grew closer and lasted longer. By two o'clock, I felt ready to leave but Greg was in a meeting at work. I waited forty-five minutes—as long as I could—before calling. "I'm leaving in five minutes," he said.

"Leave now."

The car ride to the hospital was difficult—not the contractions as much as the bumps in the road. I seemed to feel every loose pebble and crack in the asphalt while Rachel pushed hard against my ribs and made it difficult to breathe. Greg pushed me to the doctor's office in a wheelchair, but when the nurse saw me in the chair, she sent me straight to the Birthing Center in the attached building.

My room had a double bed and boom box; Andrea put on soothing music. Another nurse pronounced me fully dilated at ten centimeters. What happens next? A nurse asked if I had an urge to push and realized I didn't, not in the least. She said there was no point trying to push without the urge and to wait for it to happen, which made sense to me. Then the doctor called her out of the room, and when she returned she reversed herself per his orders. I was to start pushing. Who was this man, whom I had seen for nine months, who delivered onerous orders without deigning to speak to me? It didn't occur to me to refuse.

For the next hour and a half, I made miserable, ineffectual efforts to push in various positions that only made me feel inadequate. Finally, I decided to stop and lay down on my left side. Then it happened. Perhaps the baby had turned. The next contraction was different. I could push.

I started making a terrific groaning noise with each contraction, the power of the sound amazing me. Now the doctor came in and told me to use that energy to push instead and to try pushing in a semi-upright position. I didn't want to be in a semi-upright position and quickly turned back onto my side, staying there to the end. It took another hour and a half, ten hours after the contractions first began.

Greg held both my hands, or rather, I held his and squeezed them through all the pushing while he took big breaths with me at the start of each contraction and then counted loudly. This was surprisingly helpful. I had entered an altered state where I could not remember how to breathe. Greg kept me breathing at a steady pace during contractions. During a pause, I heard him say gently that I was bending his wedding ring. I tried not to grip so hard as my body tensed and shook. Andrea, meanwhile, was behind me, holding up my right leg and applying gentle pressure on my head to keep my chin tucked, which helped with the contractions. With the two of them on either side of me, I felt safe and supported, while the surging power of the contractions exceeded anything I could have imagined. I trembled in every fiber with the force of it and concentrated on staying on top of them, riding the contractions like a surfer on ocean waves. I felt I had tremendous strength, and the intensity was exhausting and exhilarating all at once. My friend Nancy had warned me not to listen to stories of birthing pain because pain and pressure were two different things and she was right. This was sixty pounds of pressure. As long as I rode above it, I felt powerful in a way I never had before, as if I could bend steel beams between my knees.

Between each contraction I rested. When the top of the baby's head appeared, one of the nurses held up a mirror and I lifted my head to look. Everyone was more excited by this than I was. I wanted to see the whole head. The doctor told me to push the baby up and forward to get her past my pubic bone. Abstract as this was, I understood what he meant and pushed around a corner internally. Then I felt the baby's head bulging my perineum and I knew it was ready to come out, but I was at the end of a contraction and had to rest. They urged me to go on, but I ignored them. Then the head was out and with two more pushes, the shoulders were out. Then the whole baby was out. It was over. She was alive. I could rest. The past had not been repeated. The inherited trauma, I hoped, had ended with me.

We had bright-eyed Rachel to ourselves for an hour and just watched her coo and sigh and make dear little sounds. My mother was still in New Jersey awaiting news, too infirm at eighty-seven to travel to Detroit by herself. Greg phoned

her. We ate dinner in bed. And then, while still leaning back against pillows in bed, I fainted.

Scientists have shown that trauma may be transmitted through DNA from one generation to the next, making the body the most fundamental site of memory. Dr. Rachel Yehuda, director of Mount Sinai's Traumatic Stress Studies Division, led a study in 2015 examining the DNA of Holocaust survivors and their children, which found similar variations from the norm in the gene associated with depression and anxiety disorders. This "epigenetic inheritance" demonstrates that intense psychological trauma can produce a genetic impact.

Specific fears can be inherited too, at least in animals. Scientists at Emory University trained mice to fear the smell of cherry blossoms by pairing the smell with a small electric shock. Eventually the mice shuddered at the smell even without the shock. Their offspring, which had never encountered the smell, had the same fearful response and so did some of their own offspring. The offspring of mice conditioned to fear another smell or who had no such conditioning had no fear of cherry blossoms.

My brother and I had a double inheritance of trauma from our mother and father, which must have played a role in the depression with which my brother was later diagnosed. My father, but my mother fiercely the mantra *Protection, Protection, Protection.*

When my mother returned with my father to Hrubieszów to find everyone she had left behind dead and gone, she wanted to go to her parents' home to retrieve her grandmother's jewelry, a hiding place only she knew, having buried the treasure in the basement herself. Most of all she wanted a photo album, or at least one picture of her parents, whom she had last seen alive six years earlier. But a Jewish woman warned her that Jews had been shot on their own former doorsteps by the new Polish owners who had appropriated their homes, in case the Jews were coming back to reclaim them. "Forget the jewelry," the woman told my mother, "It's not worth your life."

Of course, she had to forget the pictures too. I grew up with the fantasy of returning to Hrubieszów one day to find the house and unearth my grandmother's jewelry. No doubt Poland is rife with buried treasure, though perhaps someone found my grandmother's jewelry and it turned up on the black market in Warsaw or Berlin, adorning the wrists and necks of other women, or perhaps it sits in the jewelry box of someone in Hrubieszów. The pictures, however, are lost forever, and even if they have somehow made their way into an anonymous photo archive of prewar photos, such as the YIVO Digital Archive on Jewish Life in Poland, how would I ever recognize the grandparents I never knew? Many of the online pictures on their website, among tens of thousands of photos, have generic captions such as, "A group of young men and women, in a

Ethel Apel with author, two years old, and her brother Max, seven years old, in Vineland, New Jersey.

discussion" in a photo from Bialystok, or "Portrait of a boy with a bowtie" in a picture from Ostrow. As Rachel grows up, I take many pictures, in part as a legacy for her, in part because my mother lost all her pictures and I have never seen the faces of my grandparents.

At home after giving birth, Greg served my meals in bed, every tray adorned with a tiny arrangement of wildflowers from our backyard. When I had an accident on the hallway floor while Greg went on an errand, my bladder still frozen,

he came home and cleaned it up, easily brushing away my embarrassment. I hoped Rachel would find a love like this.

My mother-in-law came for a week to help. I was excited to show her the pictures of the birth that one of the nurses had taken, but she glanced at one or two and turned away, doing her best to hide her discomfort. To me it was an enormous event and a categorical miracle. It didn't matter one bit that women had been giving birth for eons. It was still my own amazing experience; but I recognized that the messy processes of the body were perceived as unseemly and embarrassing, if not downright gross. I didn't show the pictures to anyone else. They certainly never made it into a photo album, and I no longer know where they are. But I felt a certain satisfaction when a version of them was eventually displayed on the walls of MoMA by Carmen Winant.

We flew to New Jersey to visit my mother when Rachel was four months old. As we gave her a bath together, my mother said, "Babies grow in the bath." I just rolled my eyes at her Old World superstitions, remembering how, as a child, I had to chew a piece of bread to show I was not a corpse when she sewed a button onto clothing I was wearing. "Don't make it too hot! Don't make it too hot!" she cried as I poured in water, so I made it cooler. "Oh, it's too cold!" she said, dipping an elbow. When my mother asked skeptically about my breastfeeding, which I knew was something she had never done and thought might not be as good as formula, I told her Rachel was very healthy. She spit three times, fast, "ptuh, tuh, tuh!" to keep away the evil eye.

As she grew older, Rachel calmly accepted squeezing and smooching from my mother, who was enthralled watching Greg and Rachel roll a ball back and forth. I was enthralled watching my mother's pleasure. One day as we watched a soap opera together, Rachel tore up a stack of *Hadassah* magazines and spread the pages around on the floor. My mother looked over at it and I tensed, expecting a rebuke, but she only laughed. She had mellowed so much. It was true what they said: having a child brings you closer to your own mother. Now I understood the intense, unconditional love of motherhood, the feeling of connection through the generations, and through the body. What a terrible sense of loss, loneliness, and terror my mother must have felt giving birth alone in that hospital in Berlin, longing for the comfort and support of her own mother, the grandmother I had always longed to know, my namesake.

8

Parallel Universes

There is a large Holocaust memorial in a corner of Alliance Cemetery in Norma, New Jersey, where my parents are buried. Alliance Cemetery is the resting place for many Holocaust survivors, including Miles Lerman, who played a leading role in the founding of the United States Holocaust Memorial Museum in Washington, D.C. After escaping from a forced labor camp and fighting with the resistance in the forests around Lvov for almost two years, he came to Vineland after the war and bought a poultry farm, like my parents. He later served as chair of the Holocaust Museum's governing council from the time of its opening in 1993 to 2000, and earlier, chaired the campaign that raised the money to build and endow the museum. He also persuaded Soviet bloc countries to give thousands of Holocaust artifacts to the museum, including the milk can that held part of the Ringelblum Archives, a collection of diaries, letters, and accounts of Polish life under Nazi occupation that were gathered and hidden in the Warsaw Ghetto in the hopes they would survive and speak from the other side.

Alliance Cemetery was founded in the late nineteenth century when forty-three Jewish families escaped the pogroms in Russia and settled in southern New Jersey. They belonged to an agrarian movement among Russian Jews who sought to establish utopian socialist agricultural colonies in America. There were twenty-six attempts to establish such colonies in eight states in the 1880s, including Kansas, Nebraska, Arizona, the Dakotas, Montana, and Oregon. While most of the colonies in other states failed relatively quickly, those in New Jersey were the largest and most durable, lasting until the 1930s and 1940s when succeeding generations migrated to cities such as Philadelphia, New

Entrance to the Holocaust Memorial, with the inscription "Remember Not to Forget" at Alliance Cemetery, Norma, New Jersey, founded by Russian Jews escaping pogroms in the late nineteenth century.

York, and the thriving Jewish community in Vineland. The colonies helped to integrate the immigrant population into mainstream America.

In the 1990s, the Jewish community in Vineland erected the circular Holocaust memorial in Alliance Cemetery that includes a multitude of plaques naming the victims related to local residents. My mother's family names are among them. Above the memorial entrance, the words "Remember Not to Forget" in Hebrew and English evoke the notorious sign at the entrance to Auschwitz—*Arbeit macht frei*—and the postwar refrain *Never Forget*. Yet here it is slightly different, a double injunction enjoining us to "remember" in order "not to forget."

It seems meant not for the generation that can't help but remember but for those who follow, as though the memorial creators suspect us of wishing to forget the trauma of annihilation. Perhaps they are right. But we are the guardians of that memory, entrusted with the ongoing interpretation of its meaning, the inheritors of its ongoing effects, the keepers of lost futures.

Perhaps the generation that experienced the trauma directly, who have now grown old and almost disappeared, would like the peace of forgetting too, now that their suffering has been publicly acknowledged and memorialized. Perhaps the function of memorials is to become the repository of collective memory so that we as individuals may forget, preserving the communal loss into the future but relieving us of the burden of actively carrying it; let the memorials remember the names of the dead, as this one does with plaques on the wall.

Plaque sponsored by author's mother with family names at the Holocaust Memorial in Alliance Cemetery, Norma, New Jersey.

The paradoxical function of commemorative monuments perhaps represents both the desire to remember and the desire to forget, "as if assigning a monumental form to memory divests us to some degree of the obligation to remember," as James Young writes. In his book on the virtues and failures of forgetting, Lewis Hyde suggests, "Monuments often become invisible, marking the end of something so that everyone can turn away from the past," though he notes that this can only happen when the injustice of the past has been fully acknowledged.[1] By depositing an overly burdensome memory into a public monument, it prevents historical forgetfulness but also shifts the responsibility of memory to the larger culture, which, it would seem, must be willing to shoulder that responsibility.

Placing the memorial in a cemetery pairs it with more traditional memorial markers. But we are a culture that likes to sanitize the process of death and dying, relegating it, since the early twentieth century, to professionals in hospitals rather than at home. Studies show that approximately 80 percent of Americans would prefer to die at home, if possible, but that only 20 percent actually do.[2] We tend not to talk about the profound experience of death and dying so that dying stops being part of life and becomes remote, invisible, unremembered. How do we come to terms with this inevitability for each of us? What are the rewards, in J. M. Coetzee's phrase, of "escorting someone to the door"?

For a century, my mother hung onto her life with gusto, enjoying the live music, bingo, word games, mahjong, hour-long discussions of current events, survivor

meetings, fashion shows, morning seated exercise, afternoon hot chocolate, and sing-alongs at her assisted living home. I watched her endure the increasing difficulties of performing simple tasks like standing up from her chair and finding the food on her plate. She was most troubled by her fading eyesight and ashamed to admit she could no longer read the newspaper and keep up on world events. Eventually confined to a wheelchair, she was often exhausted and ready for bed after dinner. "Everyone wants to live a long life," she would say, "but they forget it means getting old." One day while we were sitting together in the main lobby area, I looked over at her and saw she was bone weary. "Mom, are you getting tired?" She became fierce and retorted with eyes blazing, "Is it better to be six feet under the ground?"

My mother was my last connection to the Jews of Eastern Europe, the world before the war, the Holocaust, the Yiddish language, my youth. My older brother and I had thought that each recent birthday might be her last, but this had gone on for several years. Her resilience, her fortitude, and her ability to persist through her sheer will to live continually astonished us, though I was most amazed by her emotional growth.

Shortly after we brought her to Detroit, a Lands' End catalog advertised jeans with embroidered flowers along the outer leg seam; the embroidery was uncannily similar to flowers I had embroidered on my own jeans when I was a senior in high school. At the time, my mother had taken one look and told me only a prostitute would wear such jeans. What prostitutes did she know that wore flowered jeans? We quarreled and I wore them to school despite her disapproval.

Now I order the jeans for Rachel, who is ten years old, and when they arrive, I say, "Put on your new jeans. We're going to visit Bubba." I walk into my mother's room first and sit down to watch her reaction as Rachel trails in behind me. My mother takes one look and says, "Rachel, what beautiful pants you have on!"

"What?" I sputter, "Do you remember—"

She cut me off. "I remember. I was wrong." Simple as that.

Instantly, a weight I don't know I've been carrying for almost thirty years lifts off me. She could have forgotten, or pretended to have forgotten, but instead she acknowledges the mistake. A therapist once told me that we underestimate the powers of the elderly, who often make the greatest strides in emotional growth.

One day during our daily phone call, she tells me she has something special to discuss. "Dora, I won't be around, but one thing I would like for Rachel . . ." she hesitates, "is that she marries a Jew." I have heard this refrain my whole life.

"That's not up to me," I say.

"I know, but, aside from love, if she asks you for advice, or if a boy comes to the house, you know, the other things aside from love, if you have anything to say. Of course, I wouldn't say this in front of Greg. Greg is a wonderful person.

I like him very much. The only thing, but it's not his fault, he just didn't happen to be born Jewish. But I like him very much. He likes me too. He would do anything for me; he would run to the store or anywhere if I needed something. He's very good-natured too." I agree with her. She pauses. Then she says, "I take it back. We can't predict the future. We can't be prophets. Rachel should fall in love and be happy."

Just like that, she changes her mind, transforming herself before me and dismissing the importance of whatever exists "aside from love." The life lesson of her terrible losses has suddenly crystallized into this: embracing happiness when you find it. I'm as moved by witnessing this sudden transformation as by the wholehearted acceptance her words finally imply of my own choice. A new world has unexpectedly opened to my mother, a magnificent spiritual leap. *I take it back. Rachel should fall in love and be happy.* It's a gift, this taking back, given in a moment of sudden clarity, after a lifetime of dogged certainty, of insistence, of commitment to her sense of loyalty to the dead. It's an enormous reversal, this epiphany of love and generosity that embraces the world and those she holds dear without any further conditions or reservations. She has become selfless and deep, a bodhisattva enlightened by loving-kindness. She has become the mother I always wanted.

Several years later, it is late afternoon and the light is fading as she sits up in bed after a visit to the doctor. "Don't cry when I close my eyes for the last time," she says. "I'm very old, after all. Only God knows what I have suffered . . . what I have told you doesn't even begin to tell the story. When I used to cry over my mother and father and sisters, how I had lost everyone, your father used to say, 'but you have me, you have me.' He said this about a year before he died. I remembered it at his funeral: *You have me.*" Then she added, "But I've had a long life. And I can't say that God hasn't treated me fairly. He has." Again, the speed with which her irony and bitterness turns to acceptance and appreciation is breathtaking. After all she has lost, she is still grateful for what she has had. I can hardly believe my ears: *I can't say God hasn't treated me fairly.* The next day she says, "Ben asked me how I was feeling. I said if I wake up in the morning and find that I'm still alive . . ." She breaks off with giddy laughter, joyful just to be, as she calmly awaits the knock at the door, the approaching summons.

Greg and I were walking to a restaurant for dinner late one Saturday evening when my cell phone rang. It was Mona, my mother's overnight caregiver, calling to tell me that my mother was having abdominal pains. What should she do? Impatience and annoyance sweep through me. Hasn't this happened many times before? Wasn't it likely to be gas pains? It's an inconvenient time and I'm looking forward to dinner with my husband. I feel ashamed of these feelings and also a pang of fear. What if this time is different? What if it's serious? I trust my mother's instincts and ask Mona to suggest going to the hospital. My mother is always quite definite about whether she thinks she needs to go to the hospital.

But this time she doesn't know. What does Mona think? She doesn't know, either. I decide to risk another hour. When I call Mona again, my mother is worse.

I dreaded the long afternoons at doctor's offices and emergency rooms, finding myself still subject to twinges of cringing when she speaks in Yiddish and people turn their heads. I dreaded the process of putting on her coat while she was in a wheelchair, getting her in and out of the car, heaving the wheelchair in and out of the trunk, maneuvering it up ramps, through doors and elevators, the ordeal of taking her to the bathroom once we get there. Then the interminable waiting to see the doctor, the return trip home, and the process reversed. She would always suggest that pushing the wheelchair might be hard for me, as if this, the easiest part, were the worst of it. "Don't be ridiculous," I would say in response, both of us knowing that it was everything else we were talking about. By the end, I would be wrung out and short-tempered, losing patience when she began offering advice on my driving. "Don't drive behind that truck." "Don't go so fast." "Why is that car stopped for so long?" "It's a red light, Mom!"

I went through the whole routine many times without a mishap, coaching her through the difficulty of getting in and out of the car like the professional physical therapist I'd once seen do it, until it all went wrong. On a snowy January day, as she exited the car, she couldn't maintain her balance long enough to get in the wheelchair. "It's slippery," she shouted and began to sink down. I grabbed her under both arms and held her up off the wet ground by inches, getting some help from the car by pushing her against it but unable to lift her up again. I tried to soothe her panic as my own rose by repeatedly telling her that someone would come along to help us. Finally, after holding her this way for ten or fifteen minutes, my strength giving out, a man arrived to visit his elderly parent. He hurried over when he saw this dire tableau and helped me lift her into the wheelchair. I never made another doctor's appointment in the winter months.

At the age of one hundred, my mother became convinced that she possessed a "mirror apartment," just like the one in which she lived at the assisted living home. It had the same furniture, the same pictures on the wall, the same clothes in the closet, the same objects. She told me that sometimes she slept in it. When my brother and sister-in-law are planning a visit, she says they can sleep there too.

"They can't sleep there," I say.

"Why not?"

I have to think fast. "There's only one single bed."

"Oh, you're right."

At another point, I ask, "If it's the same as your apartment, how do you know when you are there?"

"Don't be ridiculous," she says. "I know. It's completely different."

What faculty of mind has created this parallel universe, both exactly like and completely different from the one she already knows? What about its sameness is different? Her nighttime caregiver Sharon, who stays in the room with her, tells me she likes this other apartment better because she has her "own room," without her nighttime care companions, on whom she feels we are throwing away money that she wants to save for her children and grandchildren. This is a parallel universe where she enjoys freedom and autonomy, where there are no wheelchairs, walkers, and caregivers.

I discover that the Nobel Prize–winning physicist Erwin Schrödinger gave a lecture in Dublin in 1952 in which he asserted the radical idea of multiple universes operating simultaneously. Hugh Everett, a doctoral candidate in quantum physics at Princeton University, also posited the idea of parallel universes in 1954. The "many worlds" theory is meant to explain the erratic behavior of quantum matter that contradicts classical physical laws and suggests other laws at work in the universe that operate at a level beyond the one we know. In the last seventy years, there have been many proponents of the multiverse hypothesis, including Neil deGrasse Tyson and Stephen Hawking.

We arrive in my mother's room to find her prone on the bed and moaning. I realize instantly that this isn't gas pain. Guilt and dread sweep over me as we rush her to a nearby satellite emergency room. Greg goes home while I stand by her side all night, demanding more pain medication every few hours; I accompany her to a hospital at five in the morning. By six o'clock, the wait seems endless, and her pain desperate. I accost every nurse and doctor who walks by and beg each one to help her while we wait for a hospital bed. All I have been told is that a growth blocks her bile duct. She hasn't yet been diagnosed with a severe liver infection, inflamed pancreas, and sepsis, any one of which is enough to kill her.

Then a passing doctor says an extraordinary thing to me: "Don't let her die in pain." Although I don't know how I will prevent it, I vow to myself that I will fulfill this mandate. I begin to raise my voice at the nurses, aggrieved and insistent that they give my mother the painkiller she has been prescribed but has not yet received. I know I'll be perceived as obnoxious and think of Shirley MacLaine running in circles around the nurses' station in *Terms of Endearment*, demanding a painkiller for her daughter who is dying of cancer. I'm merely running up and down one side of the nurses' station closest to my mother's gurney, on which she lies oblivious to everything but her pain. I know the emergency room is full and the nurses are busy, overworked, and doing their best, yet I don't care about anything but my mother's pain. "Where is the painkiller for my mother?" I demand until, exasperated, a nurse drops what she is doing, unlocks the cabinet holding the narcotics, and gives the painkiller to my mother.

Later that morning, in intensive care, three doctors stand on one side of her bed, Greg and I on the other; they speak in somber tones about the mortal danger she is in, warning me that she might not survive through the coming night, that anything that can be done might only extend her life for a few weeks. She has been unresponsive to their queries, in a narcotic stupor. At one point she mumbles something, and I'm not sure if she is asking God to "take her." Then she clarifies. Hearing the comments of the doctors and realizing they are giving up on her, she somehow marshals all her strength, turns her head, opens her eyes, and says slowly and distinctly, "I want to live!" Then she closes her eyes, turns her head back, and returns to an unresponsive state.

The five of us gape at her, speechless with awe. I recognize once again the iron will that saw her through typhus, malaria, homelessness, and starvation during the war, and through the grief at the loss of her entire family. This is the determination that helped her recover from the death of my father and the penniless state in which she found herself after paying for his funeral. She went to work cutting up chickens for $1.87 an hour. Her drive parlayed my father's meager investments in the stock market into savings that would help support her for another forty years.

I look at her face and the thought that she might die without regaining consciousness fills me with a desperate desire to talk to her one more time. The doctors think she is ninety-seven and, for the first time, I wonder if there is some logic in always making herself younger. Would they give up more easily on her if they knew she was 101?

"We'll take a few more weeks!" I say. They make phone calls until they find a surgeon willing to come to the hospital and perform the emergency procedure that saves her life. My brother flies in from New Jersey and stays up all night with her while I go home to sleep after being awake for thirty-six hours. The next morning when I arrive at the hospital, she is herself again. "I thought I was going to die yesterday, but I wasn't quite ready," she says happily.

"You wanted a little more time?"

"Just a little more time."

"Are you afraid?"

She considers for a moment. "No."

We have come a long way in the few short years since I first moved her to Detroit, when she confessed that she was afraid to die. I have witnessed a graceful evolution from fear to acceptance; she has been telling me for months, "I am closer to the door."

When Greg arrives, she tells him the most pressing thing on her mind: how her mother, father, and sisters were "killed by Hitler." She tells him how her sister Pearl came to say good-bye when she was leaving Poland and the train official refused to let Pearl get off the train, whose husband and baby were waiting at home, how it was only my mother's begging and pleading that got him to

relent and release her younger sister, whom she never saw again. Then comes a confession I have never heard. She had said good-bye to her father but not to her mother, who was not at home at the time my mother left. She has quietly carried this burden of regret for sixty-eight years. How lucky I feel to be able to say good-bye.

The next day, in horror, she announces that her two older sisters and her parents are dead. She is back in that moment when she first learned this devastating news and in shock over this overwhelming loss. She doesn't mention Pearl, who lived in another town, and I surmise that in the moment to which she has returned, she hasn't yet learned Pearl's fate.

What if there were a parallel universe in which Pearl had stayed on the train, escaped with my mother, and survived?

The following day, she announces, "Pearl is dead!" The trauma continues vividly to the end as unassimilated experience. It has resided all these years alongside her everyday life. She still isn't reconciled to the deaths of the people she loved and has never stopped missing them or mourning them.

In the following days, we declare our love for each other many times and sing Yiddish songs together when there is nothing to say. I arrive at the hospital in the morning and stay all day, spending the long hours feeding her, helping the nurses turn her, conferring with the doctors, grading papers when she is sleeping. Home at night, I google medical terms. I hardly see Greg and Rachel and enjoy their visits as much as she does. Her face lights up whenever she sees them, especially Rachel. I remember her saying, "I don't know if you're really a maven on Rachel. Do you know how smart she is?" My mother understands Rachel's nature in a way, I think, she has never understood mine, and Rachel, in turn, demonstrates a warm kinship with her grandmother, attuned and empathic.

"If I had been born in America," my mother would say, "I would have been something. I would have been a mathematician." At least she found some gratification at the end; a community college in Vineland awarded her and other local Holocaust survivors honorary diplomas. My brother went to the awards presentation and brought her the diploma in its red faux-leather holder, which she carried in the bag on her wheelchair to show everyone at the assisted living home. One of her caregivers related how my mother made acceptance speeches for her award during the night in her sleep, declaring that she had never had a chance to finish college but now she had finally done it; she had graduated. This diploma was the fulfillment of a lifelong dream.

What if there were a parallel universe in which the Holocaust had not occurred, the millions of murders had not happened, and my mother had studied mathematics at a university?

Shortly thereafter, the Jewish Federation in Detroit gave me an award for my book *Memory Effects* and I made a short acceptance speech during a formal evening presentation; I dedicated the award to my mother, though she couldn't be there. An administrator from the assisted living home attended the award

ceremony and told my mother about it the next day. "I won an award too," said my mother, meaning her diploma. We read the words on it to her over and over, emphasizing "Bachelor of Arts." Late in life she began painting watercolors, despite her macular degeneration, and was proud of a wonderful watercolor she had painted just a week or two before her final illness. "Maybe I would have been an artist instead," she says. "Maybe they knew I was a good artist and that's why they gave me the award, because they wrote 'Bachelor of Arts.'"

She always kept *Memory Effects* on display in her room and introduced me to everyone by saying: "This is my daughter. She has a PhD. She wrote a book." I was embarrassed but happy she was proud of me. A few months after we moved her to Detroit, when we could still take her to outings, she attended a lecture I gave at the Detroit Institute of Arts, the only time she ever saw me in my role as an art historian. We placed her wheelchair near the front of the auditorium. I announced that I was pleased to have my mother in the audience, and instantly, she pushed herself up in her seat, turned around, and gave the queen's wave with a broad smile from one side of the auditorium to the other. I may have been the speaker, but *she* was the mother.

In those last weeks in the hospital, she becomes increasingly forgetful. "Do you know who I am?" I ask. "You're my sister." She means Pearl and I'm good with that, more than good. Another day she asks about me, as if I'm not there, and says, "My daughter gives me a lot of honor." I well up. This feels like forgiveness for all my transgressions against her. She knows that I love her.

Her top denture keeps falling and I'm unreasonably distressed that she can't keep it in place. "Don't you know how to push it up?" She shakes her head, as if the idea were entirely beyond her. "Take your finger and push it up!" She pushes at it but can't figure it out. I want to scream.

After twelve days in the hospital, my mother is suddenly babbling nonsense and struggling to complete a thought. Then she pauses and says, "*Bin meshuge*." I'm crazy. In a moment of lucidity, she knows she isn't making sense and we both laugh. The doctor dismisses it, saying it's simply the result of being in the hospital so long at her age. The next morning, the day of her release, the doctor has great difficulty waking her up and she is barely responsive. "They get vegetative after being in the hospital too long," the doctor says as she is washing up. But it doesn't feel right to me.

My mother sleeps as they dress her and transport her to rehab; she sleeps all day before becoming lucid again. She tells me she loves me. We sing "Bei Mir Bistu Shein," a popular Yiddish love song from the 1930s. We kiss each other's cheeks. But she has already had a small stroke, which no one has recognized, and it is followed that night by a massive stroke. Even then, no one recognizes it until the physical therapist sounds the alarm the next afternoon. I watch as he lifts her left arm and it falls, lifeless. The left side of her mouth is sagging. Back she goes to the hospital. I drive there separately and pull off to the side of the road along with all the other cars as the ambulance carrying my mother passes us.

Greg meets us in the hospital emergency room. For a short period, she becomes lucid and wants to know if Greg and I love each other. We tell her we do, and Greg says he will always take care of me. She smiles. "That's the way it should be." Then she lapses into a stupor. Perhaps she is relieved of the burden of worrying about her children. The next day I test her memory, but the names of her parents, older sisters, husband, and children elude her. Then I ask, "Do you remember Pearl?" Her eyes fill with sorrow. "Pearl is not alive," she says. I ask if she knows who the president is, and she turns disdainful. "Who could forget Bush?" We laugh.

I ask the nurse if we should put her dentures in and the nurse asks me carefully, "Does she need them?" I realize the answer is no. "Then let's not bother her." The dentures, it dawns on me, were for my benefit, not hers. When I tell her I love her, she says, "Thank you! I love you, too," then asks, "What's your name?"

She touches my arm in the way she always did when she wanted to make sure I was listening and inclines her head conspiratorially to say, "I am full of questions. It's nice and funny. People expect answers." I marvel at this philosophical turn and begin to write down what she says. "Later we will begin questions and answers. We are all a bunch of intelligent people!" She grins. A few minutes later, she informs me, "There is a lot of entertainment."

What parallel world is she in now? A place of learning, with questions and answers, followed by entertainment. This is a happy world. She begins to sing a song: *Dray iber das raidel, mach fun a yingel a maydel.* Turn the wheel of life, transform a boy into a girl. She says she learned this extraordinary song from a girl in Poland decades ago, though I have never heard it. She seems to be contemplating transformation.

Then she announces, "I like all people. I don't hate nobody." She is beatific, thanking the nurses for every small gesture they make on her behalf, asking for nothing, smiling her happy, toothless smile, which has come to seem adorable to me. She becomes the nurses' favorite and they fuss over her. Her instinct to feed the masses kicks in; she repeatedly says "senevich, senevich" and I ask, "Would you like a sandwich?" No, she says, she wants everyone to have one. On another day she wonders, "Who will mix me up?" "I think you're mixed up enough," I say, unable to resist. We laugh. It turns out she wants to mix up dough to put in the oven "to feed all the people." She sweeps her arm around to indicate everyone in the hospital.

Za nicht schlecht, she says when she thinks I am questioning a nurse too closely. Don't be bad. She hasn't said this to me since I was a child, when she accused me of refusing to eat just to spite her. The old feeling of resentment flares up and dies away just as quickly. I realize that her meaning is different now, encapsulating her philosophy of life. *I like all people. I don't hate nobody.*

"I like you," she says.

"Do you know who I am? I'm your daughter."

"Then I like you double."

I'm exhausted and come down with a jaw infection at the site of an oral surgery I had three months earlier. For a couple days, I am flat on my back and can't visit her. When I return, her roommate says she has been asking for her daughter. I feel stricken, but glad she is still in this world, remembering she has a daughter.

She returns to rehab after another four weeks in the hospital and one day, while sitting up in bed, she says, "I am not alive." I'm chilled and frightened. "What do you mean?" I venture.

"I died by Hitler."

This is another kind of parallel universe, one where trauma is always present in some other dimension of space and time. But I have never seen it come to the surface like this, the embodied trauma of the past blocking her experience of place and identity in the present.

How should I respond?

"But you are here talking to me."

"I am not in this world."

I resist my own resistance to her words, suppressing the urge to contradict her, to try and convince her that she is "here" when she is clearly experiencing some kind of radical estrangement. André Aciman writes of survivors, "You are eternally dislodged, eternally transitional, and eternally out of sync with the world. You cannot ground yourself. You and earth, like you and time, have become strangers. Place is unreal, time is unreal, you are unreal. You are frozen—which is why the words 'alive' and 'dead' are no more than figures of speech."[3]

What if there were a parallel universe in which my mother had failed to escape Poland in time? Where she was sent to Majdanek and murdered with other members of her family, or was shot and buried in the mass graves of Hrubieszów? Where she did not have a daughter to remember her?

I steel myself before asking the next question. "Do you want to live?" Now she looks at me differently. "Why not?" As though I have asked a ridiculous question. She has returned to me and the rupture in space and time has resealed.

After a day by her bedside without her recognizing me, suddenly she knows who I am and appeals to me just as I am about to leave, saying, "Dora, stay with me."

I am seized with guilt, but too exhausted to stay any longer, too overwhelmed by it all. "Mom, I have to go. Give me a hug," I sit down on the bed next to her. She looks confused. I put my arms around her, pull her to me, and pat her back. She puts her right arm around me, her left still limp from the stroke, and pats my back in return. "This is a hug?" she asks. Now she is in a place where she experiences this intimacy for the first time. I find this heartbreaking.

She can't sit upright by herself anymore, has no trunk control, no sense of her centerline, no sense of her body in space. Having her body handled is noxious to her and she responds to the physical therapist sitting her up with a startle reflex

in which she flings out all her limbs. I watch as the therapist gathers her in his arms after sitting her upright. I have asked for him, the only one who recognized her stroke, the one who told me how much he cares about his patients and that my mother was like his "own Bubbe." Her forehead nuzzles his shoulder as her arms dangle in her lap. For a moment, they are like lovers hopelessly consoling each other. I find it unutterably sad. He is waiting for her to relax so he can keep her arms together and lift her into the wheelchair, where he props her up with a pillow to keep her from curling around her left side. In the therapy room, she lies down on a mat and I encourage the smallest movements she makes with her left leg and arm. The therapist suggests that, with a year's time, she can recover. I am hopeful, even though she's 101. What parallel universe am I living in?

There is something very satisfying about feeding her. Perhaps it's the reversal of terms. At first, she refuses to eat, turning her head away with a firm, "I'm not hungry." I cajole, offering her a dessert of sweet pureed fruit, wondering how she would react if I said the things to her that she used to say to me: "Be good and eat this." "If you love me, you'll eat this." "You don't have to be hungry to eat." Or the big gun: "I swear on my life. If you don't eat this, it means you want me to die." Only now it means that *she's* dying, though I still can't grasp this. It turns out that she eats more for me than for the nurses. When, as a child, I resisted all her entreaties and threats, and there was nothing left for her to say but that my heart was made of stone, I thought I would never forgive her. But she has lived long enough to heal those wounds. *My daughter gives me a lot of honor.*

Dislodged from history, out of sync with the world, it is up to me to carry her memory forward, to embrace her body as a place of memory.

A nurse calls to say she isn't eating. I finally realize she is in the process of disconnecting from the world, that I have been deluding myself about her recovery. But the next day she seems better and has eaten all her breakfast. In physical therapy, she maintains upright trunk control, unsupported, for several seconds. To keep her engaged, the therapist asks her questions while she's sitting up.

"Where are you from?"

"Poland."

"What languages do you speak?"

"Polish, Yiddish, German, Russian, English." *She reads Hebrew, too*, I think.

"What were your favorite subjects in school?"

"Mathematics."

"If I owe you sixty dollars and give you one hundred, how much change would you give me?" She hesitates, then says, "Forty dollars." I feel a leap of pride.

Lying down, she raises her left hand to her forehead three times, unaided, and for the first time moves her left leg. I'm encouraged. Back in her room, she sits in her wheelchair.

"Is it hard being here?"

"Yes, it's hard."

"What makes it hard?"

"I'm waiting. I'm waiting."

This moment is more painful than the moments of confusion. It seems as if her diminished state will make it easier to let her go, but it isn't true. My brother and I console ourselves with the fact that she continues to live, that she is not in pain, that she smiles, that we have had her for so long, that she brought us together at a time when we were estranged. We think we will be prepared, but preparation is an illusion. A void will open.

The rehab nurse calls me. They have found her unconscious and called an ambulance. I arrive at the urgent care center near the rehab center just minutes after she does. Her blood pressure is very low, her oxygenation poor, her heart rate far too rapid. I say, "I am here, I am here. You are not alone." They have hooked her up to monitors and her vital signs slowly go up.

Her eyes are slightly open but there is no focus. The doctor asks how aggressively I want them to treat her. My brother and I have discussed it and decided on no invasive treatment. But the instructions from rehab say take all measures. The decision must be made again, but now it's agonizing. I try to call my brother but can't reach him. I make the decision again: no invasive treatment.

When the nurses and doctor leave the room, I begin singing to her, and her vital signs slowly improve. The doctor comes back to say he is calling an ambulance to take her to the hospital. I think she will live for a few more days. The doctor walks in again and tells me the hospital doctor asked him, "Will she die in the ambulance?" He told the doctor he didn't know. I'm unhappy he says this in her presence. The ambulance never comes.

For two hours, I sing to her every Yiddish song I can think of, mainly the ones she used to sing to me when I was a child, and the ones we had recently sung together. Twice she gives my hand a little squeeze. I sing "America the Beautiful," which she had always liked because it represented the country to which she was always grateful. I sing "Happy Birthday," feeling it's somehow appropriate. Finally, I make up my own song, in Yiddish, to the tune of "My Yiddishe Momme," in which the refrain is "Chajeteleh, yederah liebt dich." It's her childhood name followed by "Everyone loves you." I feel she has returned to a childlike state. One by one, I enumerate her parents and sisters, her children and grandchildren, and sing that each one loves her. I try to call forth their presence and love as I sing each name; I feel an expansion of my energy that fills the room and surrounds her.

This is the last song. Her vital signs begin to drop and her breathing begins to slow. The doctor comes in and says it's the end stage of "agonistic breathing," that her breath will stop first and then her heart. I ask to be alone with her. He closes the door. I hold her shoulders. I caress her hair. I tell her to go with God

Ethel Apel at ninety-eight, with author and her husband Gregory Wittkopp, and daughter Rachel Apel Wittkopp; West Bloomfield, Michigan, October 2004. (Photo: Thomas Hansen.)

because I know she believes in God. Her breathing stops. Then I watch the numbers on the heart monitor steadily descend to zero.

I sit with her for another hour, taking off the sticky pads that were applied for the EKG. I kiss her forehead and her cheeks and lay my head on her breast. I toast her with a cup of tea that the nurse brings me. "Have a cup of tea with your mother," she says. "That's what I would do, too." The nurse thanks me for the "gift" I have given her. "It was beautiful," she says. "You talked her through it. In fifteen years, I have never seen that. My mother died when I was a baby and I never got to do what you just did."

I had always wanted to be with her to the last. This was her final gift to me. I felt she had waited for me and rallied as long as she could. I felt her go toward the door bravely, knowing the time had finally come. I felt privileged to be with her. She had six more weeks after that morning in the ICU when they contemplated letting her go, a bounty of time.

I call my brother and he says, "We knew this day would come." He sounds strong, and this allows me not to have to be strong. My work is done. He has made all the arrangements to have her body transported back to New Jersey to be buried beside our father. Now he goes into action. I hug the nurse and go home. We will catch the first flight to Philadelphia the next morning, a Friday, so that we can accompany her body, and drive a rental car to Vineland in time to bury her before sundown. That night I lay awake for hours reliving her final

moments, her last breaths, her final heartbeats, mentally writing her life, her strength, her humor, her love. I sleep for an hour before we get up at 4 A.M.

She had flown only twice in her life, the first time when we brought her to Detroit almost ten years ago, and now on her return flight, in cargo. Knowing that she was terrified that first time, Greg and I sat on either side of her as the plane took off for Detroit. When there was no shaking, rattling, or thundering, she relaxed, saying, "Oh. It's like a flying bus." Driving from the Detroit airport to the assisted living home, she marveled at the glassy corporate buildings, comparing them to the beauty of Kraków, the most beautiful city she knew, and marveling at the six lanes of traffic. Though we ourselves were enamored of neither the corporate sky-scrapers nor the dozens of cars, it made us proud to have her admire the city in which we lived. I was concerned about how she would adjust to such a major life change at the age of ninety-two, but I needn't have worried. As we wheeled her over the threshold of her new home, she raised her arm in a regal wave and announced to everyone that she was coming here to live, claiming her place.

Max and I buried our mother next to our father. When my brother first saw me at the cemetery he said, "Be strong." I was always afraid he would break down when this time came. Instead, I was the one who felt I might fall apart at any moment. Having Max, of all people, tell me to be strong gave me courage and helped me to feel stronger. His rabbi was there and a number of his Orthodox colleagues. As we stood by the open grave, Max spoke about my mother and then, hesitating to the last moment, I spoke, too, though it was unorthodox for women to do so, telling the small assembled company how deeply good she was. Later Max told me he had insisted to the rabbi that I speak if that was my wish and I felt moved by his willingness to contravene convention on my behalf. The religious men offered me their condolences and one told me I spoke movingly, which helped me to feel I had honored her memory properly.

We found the plain pine box made without nails beautiful. The men shov-eled earth on top of her casket, and we did too. Max and I made a cut in our clothes, took off our shoes, and sat on low chairs, beginning shiva, the week of mourning. I thought it was little enough to offer, these cold feet for my mother in the crisp November air by her grave. The Orthodox men said the prayer of condolence separately to my brother and to me, each one standing in front of us as they did so. It was comforting having Max next to me, to see some of my mother's old friends. The rituals did their work. A year later at the unveiling ceremony, my mother's headstone was graven with her name and years of life, her memory made permanent in the oldest, most enduring of memory sites.

Part V

Body and Mind

9

Reclaiming the Self

A once-svelte body that has become bloated and exhausted from cancer treatment is a condition that would make most people retreat from creative work and shun the camera altogether. Yet visual and performance artist Hannah Wilke rejected any sense of humiliation or shame that might accompany the ravages of illness and instead produced a remarkable series of self-portrait photographs titled *Intra-Venus*. They offer a searing and complex view of the embodied knowledge that results from mortal illness and its medical treatment. Wilke's lifelong body of work—under the influence of feminism, her mother's death from breast cancer, and awareness of the Holocaust as the child of Jewish parents with Eastern European roots—addresses the wounding and othering of women in patriarchal society while, at the same time, celebrating the physicality of womanhood. *Intra-Venus* was part of her final project, made when she was in treatment for what proved to be a fatal case of lymphoma.[1]

There is still a widespread sense that the mind and body are two separate entities that may or may not work together, rather than a wholly inseparable experience of continuous embodied knowledge. Theorists in cognitive science assert there is no separation at all: there is no mind, or independent conceptual knowledge, without the feelings, emotions, and experiences of the body interacting with the environment. Such an embodied view of knowledge suggests there is no meaning without a biological organism engaging with the world; thus, all knowledge and meaning is embodied. As philosopher Mark Johnson asserts, "One of the more important themes emerging from the last century of philosophy and the past three decades of cognitive neuroscience is that the self

Hannah Wilke, *Gestures*, 1974, black-and-white video still. © Marsie, Emanuelle, Damon, and Andrew Scharlatt, Hannah Wilke Collection & Archive, Los Angeles. Licensed by VAGA at Artists Rights Society (ARS), New York. (Courtesy Electronic Arts Intermix, New York.)

that defines our personal identity is not a thing, but rather an ongoing experiential process."[2]

This has been a central tenet of phenomenology as well as Marxism and feminism, which use embodied methods in an attempt to know and represent the body as an object of knowledge. Karl Marx recognized that bodies are central to the work we do, as both subjects and objects of labor. When labor becomes a coercive and alienating activity, one that "belongs to others," we lose the free play of our body and mind and our bodies are transformed into objects from which we are alienated. Feminists have shown how the mind-body opposition has been correlated with an opposition between male and female, which can be extended to colonizer and colonized and upper and lower classes, in order to structure the female, worker, or racialized other as somehow more biological and corporeal—more emotional and therefore less rational—than their subjugating counterparts. Proceeding from the understanding that knowledge is always embodied suggests that the body is a memory site that can't be separated from mind and experience. Photographing the body thus becomes an exploration of embodied feeling and experience, just as thinking and writing is an

embodied process, and, more generally, all creative, social, and political action is embodied.[3]

Judith Butler's theory of gender performativity explains how bodies that conform to the dominant discourse of binary gender norms become intelligible, legitimate, and livable, while those that transgress it become "unthinkable, abject, unlivable bodies." Engaging with eroticism and culturally defined standards of female beauty in her final photo series, Wilke's work departs from past representations of womanhood in ways that some might regard as unthinkable and abject. But Wilke rejects culturally prescribed forms of decorum. The *Intra-Venus* photographs reimagine representation of the traditionally idealized female body by transgressing the taboos against visualizing and normalizing the sick body, telling her own story as a way to valorize and memorialize the female body in all its manifestations.[4]

The title *Intra-Venus* alludes to both the divinity of Venus as the goddess of love, sex, and beauty and the corporeality of the body mediated by the ubiquitous plastic tubes to which Wilke appears permanently attached in the hospital. On a deeper level, the title suggests penetrating beneath surface beauty to the core of existence, to the life force, and to death. The hybrid *Intra-Venus* is a goddess of love and healing, but she also engages illness and mortality. A lover of language and puns, this final wordplay captures Wilke's simultaneous irreverence toward death and profound engagement with life, her love of female sensuality, and her insistence on "ongoing processes of self-creation," as Nancy Princenthal asserts in her comprehensive monograph on Wilke.[5] Though ultimately tragic, *Intra-Venus* conveys Wilke's pleasure in creating new images and reinventing the representation of the nude on her own terms, through the embodied knowledge of illness and in opposition to idealized patriarchal norms that fear the sick and deviant female body.[6]

The posthumous exhibition of Wilke's last body of work included twelve self-portraits. In the photographic diptych *Intra-Venus No. 1*, Wilke poses nude in the image on the right, with bandages on her hips marking the places where bone marrow was harvested. She balances a large plastic pot of flowers on her head, like a Greek caryatid, the sculpted classical figure used in place of a column as an architectural support. Caryatids were the maidens of Karyai and were considered especially strong and beautiful. The goddess Artemis, in her guise as Karyatis in the village temple of Karyai, enjoyed the ecstatic dancing the women performed while carrying baskets of live reeds on their heads. Here, the flowers seem to sprout from the head of a smiling Wilke, transforming a banal hospital bouquet into a colorful capital on a zaftig odalisque and conveying a sense of erotic agency.

In the pendant photo on the left, Wilke's austere counterpart wears a different sort of crown; her face droops with exhaustion and the circles under her eyes are darker. Having lost her hair, she looms imperiously above the viewer, wearing a white shower cap like a regal headdress. She is the queen of physical

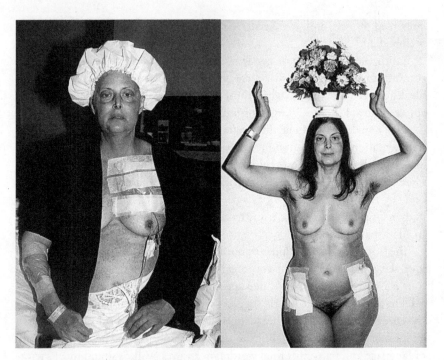

Hannah Wilke, *Intra-Venus No. 1*, June 15, 1992 and January 30, 1992; performalist self-portrait with Donald Goddard, two chromogenic supergloss prints, 71.5 × 47.5 inches each. (Courtesy of Donald and Helen Goddard and Ronald Feldman Gallery, New York.)

endurance, demonstrating her strength by revealing her trussed and taped left bosom and right arm, dangling tubes, and hospital wristband, while sitting stoically erect as if holding court.

What Wilke accomplishes in her project is a measure of control and self-empowerment in extreme circumstances, a way of affirming her personhood on her own terms. In this sense, the work was a kind of "cure" for passivity and despair, and at one point Wilke wanted to name the *Intra-Venus* exhibition "Cure."[7] She deflects the stigma and revulsion attached to the sick and medicalized body, which in her case included surgery, chemotherapy, radiation, and bone marrow transplants, in order to assert herself anew, creating a moving body of work as a memory site for her experience of illness. In the photographs, Wilke's inner force seems to transcend the debilitation of the body, and her continual act of self-representation affirms her own being against the ruination of the idealized female body represented by the classical nude.

Wilke told Joanna Frueh, "My art is about loving myself."[8] Through her work, Wilke created and recreated herself in an ongoing process. When she photographed her mother's breast cancer surgery and hospitalization in *So Help Me Hannah* and *Support Foundation Comfort*, she saw that work as "curative" too: "I took thousands of photographs of her over the next four years, hoping

the images of her would keep her alive. . . . The images I made of myself and my mother kept me alive."[9]

In the diptych *Intra-Venus No. 4*, the image on the left presents Wilke nude and bald, with an unattached intravenous tube piercing her hand, her face partially obscured by the shaped and polished fingernails at the tips of her long graceful fingers. She seems to be in dull shock, as if her baleful gaze were saying *behold, this is what I look like now, a grotesquerie*. On the right, Wilke counters the image by evoking the inner serenity of the Virgin Mary, the blue of the cotton hospital blanket in which Wilke wraps herself associated with Mary throughout the history of art. Her closed eyes and tilted head convey a sense of peacefulness. Sensual goddess, suffering queen, virgin mother, woman with no illusions—Wilke suggests she is all of these.

The photographs are not commensurate with the body; though both are sites of memory, the photographs portray constructed or "performalist" moments, Wilke's term, that nonetheless convey embodied knowledge. Suggesting that the performance of identity has infinite variations, Wilke uses iconic prototypes from the history of art in order to construct her own personhood and to insert herself into that history—but her performative circumstances also subvert those iconic prototypes. They suggest the messy, multifaceted nature of human experience and the ceaseless, ongoing process of identity formation. This is not a critique of conventional constructions of femininity, as Amelia Jones suggests when she asserts that Wilke's project aligns with that of Cindy Sherman. Sherman's

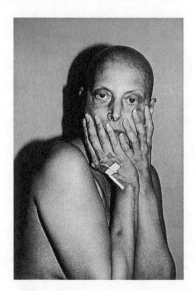

Hannah Wilke, *Intra-Venus No. 4*, July 26 and February 19, 1992; performalist self-portrait with Donald Goddard, two chromogenic supergloss prints, 71.5 × 47.5 inches each. (Courtesy of Donald and Helen Goddard and Ronald Feldman Gallery, New York.)

personality dissolves into the many feminine personas she creates in her photography, while Wilke's project, as Nancy Princenthal points out, is fundamentally different. Unlike Sherman, Wilke is not primarily interested in the cultural construction of desire and femininity but in representing her embodied knowledge. Wilke does not therefore dissolve into her performative personas but uses them as a vehicle to reveal her understanding of herself in the moment. The photos do not represent a masquerade, behind which Wilke becomes invisible; rather, the personas dissolve into Wilke, who uses them to represent the changing and complex aspects of her embodied subjectivity.[10]

Her work is often raw, commanding, and breathtaking in its self-exposure. Wilke hides nothing. Photos show her nude and sitting on a portable commode, lying in bed with an enormous teddy bear between her legs, standing nude and bald in contrapposto like a Botticelli Venus. One astonishing image shows her lying in the bathtub and offering a very different version of a Courbet-like, Origin-of-the-World perspective, one that does not fetishize anonymous female genitalia but gives us the whole body. By placing her painfully red and swollen vagina in the foreground, Wilke exposes the burning effect of chemo, stark evidence of another, usually hidden, bodily indignity to which female cancer patients are often subject. Instead of a bathtub filled with soothing water, a drip above Wilke's forehead evokes an ancient form of gradually maddening torture.

Intra-Venus No. 7 juxtaposes two images of Wilke, one closer to the beginning of treatment, before she lost all her hair, and the other at the end, when drugs have changed her skin, thickening the texture and darkening the color to a leathery brown. Most critics describe her expression as a look of resignation, but it seems to me much more. If she had harbored hopes of being part of the tiny percentage that survived, those hopes appear to be gone, but her confrontation with the camera nonetheless contains a kind of dignity that conveys self-knowledge. Wilke confronts the enormity of her own impending death. Her steady gaze suggests she is still making decisions about how she wants to be seen and remembered through the photographs and contains a depth of feeling even as we see the light fading.

The power of her project is that it allowed her to have agency over the perception of her illness by others, asking the viewer to witness her experience of mortality, an experience from which none of us is exempt.[11] A few months after this photo was taken, Wilke died, in January 1993, at the age of fifty-two.

Wilke laid herself bare in every sense, and the creative act of self-representation became a way of parrying debility, defying mortality, and even, at times, creating something akin to joy and the celebration of life. She was unflinching and unashamed, committed to representing her embodied knowledge candidly, dispassionately, and even humorously. Having always used her body as a primary means of expression, the compulsion to work that began when she was healthy and uncommonly beautiful remained undeterred when

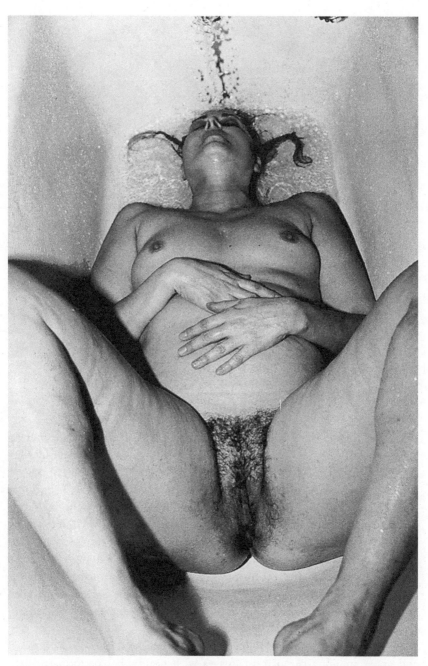

Hannah Wilke, from *Intra-Venus No. 3*, August 17, 1992, February 15, 1992, August 9, 1992 (detail); performalist self-portrait with Donald Goddard, three chromogenic supergloss prints, 3 panels, 71.5 × 45.5 inches each. (Courtesy of Donald and Helen Goddard and Ronald Feldman Gallery, New York.)

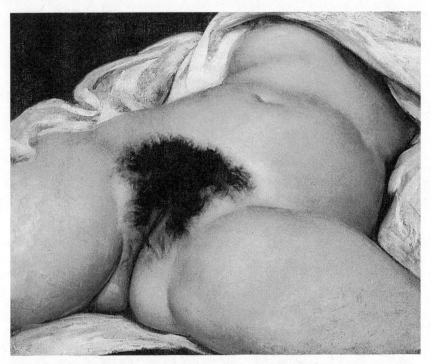

Gustave Courbet, *The Origin of the World*, 1866. Musée d'Orsay, Paris. (PD-US via Wikimedia Commons.)

she found herself trapped in a world of medicalized illness with a growing awareness of death. In her self-empowering work, she refused to consider her body unthinkable, abject, and unlivable. As Richard Vine wrote in his review of the posthumous exhibition in 1994, "Watching her mother die, Wilke once complained that clinical procedures take the afflicted away from us, hiding them as though death itself were a matter of personal shame."[12] Although many accused Wilke of narcissism in her early work, in which she employed her nude self, and of reproducing the objectification of the female body, Wilke rejected those charges and asserted her liberation from what she regarded as misogynistic cultural strictures. She was determined to represent her own embodied experience as a woman, including, at the end, a woman in extremis. As her critics now concede, it was all one project.

Fragile, defiant, grave, and vulnerable, Wilke endowed *Intra-Venus* with wit and grace, imbuing the painful images with beauty, her performative self-display refusing all conventions and limitations even as she engaged with them. These creative acts transformed her subjective experience of illness into a lasting legacy while providing an emotionally restorative "cure" within the dehumanizing context of the medical environment. Wilke resisted the disempowering clinical gaze by constructing her own, self-directed gaze.

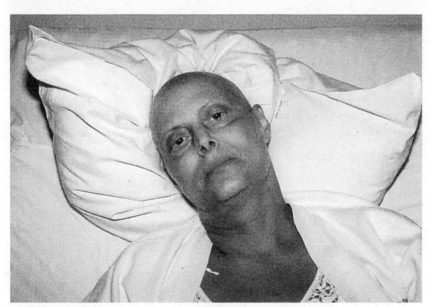

Hannah Wilke, *Intra-Venus No. 7*, February 20 and August 18, 1992; performalist self-portrait with Donald Goddard, two chromogenic supergloss prints, 47.5 × 71.5 inches each. (Courtesy of Donald and Helen Goddard and Ronald Feldman Gallery, New York.)

Tamar Tembeck notes that Jean-Luc Nancy, who has written about his own illness, describes the "I" who experiences illness as irreconcilable with the "I" who does not. This is a useful way to frame the fractured subjectivity of the self in traumatic conditions, which drastically reduce life to the needs of the body and bare survival. That Hannah Wilke was able to harness her physically distressed self to the will of her artistic self is a remarkable feat. The resulting photographs are mediated memories of the body that live on in cultural memory long after the body has perished. The images enjoin us to bear witness not only to Wilke's suffering and mortality but also to the inspiring, transformative power of her creative spirit.

These photographs serve as an introduction to and inspiration for my own struggle with illness and mortality in the next chapter. How would I fare in confronting the greatest trauma of my own life? What had I usefully absorbed from the traumatic experience of my parents?

10

The Care of Others

Why did I wait?

Maybe it was because my mother lived to be 101 and I thought I would live long too, no matter what. Maybe it was because, over the summer and early fall, I was touring architectural sites and bourbon country in Indiana and Kentucky with Greg, giving book talks, remodeling the kitchen, and preparing my courses for the fall semester. I was much too busy. There were a dozen ways to rationalize waiting. Other people I knew waited too. Were we all engaged in magical thinking? Resilience through denial?

"It's your worst nightmare," says the doctor's assistant. I am stunned and cannot respond. I have been telling myself for seven or eight months that it was nothing, a benign cyst. I called my holistic doctor and got a referral to a doctor who specialized in breast cancer, and I *called*. But they couldn't give me an appointment for six weeks, so I called an alternative therapist. I often employ complementary therapies and have tried many modalities—acupuncture, various forms of energetic healing, homeopathic remedies—and they have helped me when conventional western medicine has failed. I know western medicine often rejects some of these therapies, but I see that as a function of arrogance or ignorance. I don't always trust alternative practitioners either, but I haven't really trusted medical doctors since I was young and found myself on a hospital examining table trying, and failing, to convince a skeptical doctor that I was in terrible pain.

Three girlfriends and I had been racing down the street on our bikes on a spring afternoon. Just when I hit top speed, I felt the pedals spin freely and

realized the chain had come off. This meant I had no brakes and could do nothing but wait. As the road inclined downward and the bike picked up momentum, I fell forward on the handlebars; the bike wobbled violently and fell over. The impact thrust one of the handlebars into my side. I was in shock and my friend walked me home and washed my bruises; after she left, I lay in bed in pain while waiting for my parents to come home. In the bathroom, I peed blood, though I didn't think to mention this to anyone, not knowing what it meant. I was twelve. Two hours later my parents arrived home and I made my way downstairs, deathly pale. They took one look at me and said we were going to the hospital. This amazed me because my parents were not the kind of people to rush off to the hospital. They didn't trust doctors either.

The doctor probed my side and asked if it hurt. The pain by now was excruciating. "Yes," I replied weakly. But he mistook my fatigue and stoicism for something else. "Does it hurt a lot?" "Yes," I said. Still he was unconvinced and asked, "Does it hurt like the devil?" Now I had to consider what "hurting like the devil" might mean. I thought *could it hurt any worse?* I decided it couldn't. "Yes," I said again. I had been hemorrhaging internally for about three hours by now. The avuncular doctor leaned over me, brought his face close to mine, and said, "I think you're just scared."

He was the only one who could save me, and he didn't believe me. I understood too little about what might be happening to be scared. I just knew it *hurt like the devil*. Perhaps he expected me to be screaming or crying, but I was not a screamer or crier. I didn't know what to do. I was aware of his condescension but too dazed by pain and blood loss, and too shy to contradict a grown-up in a position of authority. I felt helpless.

What is the relation between belief and memory? Incredulity can have a crushing power, often consigning memory to oblivion. There were those who warned about the Nazi concentration camps before the war ended, but they weren't believed, and those who still deny the Holocaust today. There are those who refuse to believe there were so many lynchings across the nation, or who believe that those who were murdered must have been guilty of *something*. There are those who believe that Confederate monuments are not icons of white supremacy but symbols of proud heritage, and those who believe that women should subordinate themselves to paternalistic authority. It's no accident that women and girls who are victims of sexual assault rarely receive justice, or that a mantra of the #MeToo movement is that women should be believed. Nonbelief in all these cases suppresses historical memory of lethal persecution, discrimination, and abuse.

The doctor didn't believe me because he was sure that a girl in pain would behave a certain way and I wasn't conforming to his belief. Decades later, I recognized the same self-control in my own two-year-old daughter. She sat on an examining table in the hospital emergency room looking at a children's book while a third-year resident, who cursorily examined her, assured me that she

didn't and couldn't have pneumonia because, if she did, she wouldn't be sitting there so calmly looking at a book. I knew better. I saw the illness in her eyes and the next morning took her to her pediatrician who found the pneumonia at the bottom of her lung.

As I lay on the examining table on the edge of consciousness, the doctor said he was ordering X-rays just to be sure; I passed out on the X-ray table. When I awoke, I was lying on a gurney. The doctor leaned over me again and told me my renal artery was ruptured, that they would have to operate and remove my kidney. He said there was nothing else they could have done. There was a hint of guilt and apology in his voice. I thought, *thank God you're going to do something.* But I didn't believe him. I believed he could have saved my kidney if he had acted sooner—if he had believed me. This moment planted the seed of my lifelong distrust of doctors, hospitals, and allopathic medicine. A few years later, our longtime family physician, Dr. Sugar, was convicted of slowly poisoning his wife and burying her body in the backyard under a picnic table. It was front-page news in the local paper and even made the *New York Times.* I had never trusted him either.

The next morning as I rose into consciousness, I heard two women talking at the foot of my bed. My mother's best friend Genia was reassuring her that I would be all right now, after nearly dying on the operating table from blood loss. My mother had raged through the corridors in a fever of agony. Opening my heavy eyelids, I found my wrists tied to the bed rails—apparently I had been flailing my arms during surgery. I understood this as my response to unconscious rage at the doctor.

There were other moments when I mistrusted doctors: when I was five, I risked the wrath of my parents rather than allow our gruff, white-haired German doctor, whose fingers were permanently bent, to administer a shot of penicillin, his remedy for everything. His virtue, for my parents, was his willingness to make house calls. But the memory of the terrifying angle at which he held a hypodermic needle between his second and third fingers, sometimes drawing blood, sent me deep into hiding under my mother's bed. My father dragged me out by my feet, but I ran into the bathroom and locked the door. My father pounded on it and shouted angry demands, but I refused to open the door. When he threatened to get an axe and chop it down, I opened the bathroom window and climbed out onto the roof, staying there atop our two-story house until I finally heard the doctor's car drive away. *It's my body.* Six decades later, the memory of sitting on that roof, afraid but exhilarated, is still sharp.

Long before the diagnosis, the alternative therapist I had called sent me a blend of essential oils meant to support breast health and reduce cysts. That is what most breast lumps are, and I decided this was probably what it was. One of the oils was frankincense, which kills cancer cells, and this seemed like good insurance. I massaged the pleasant-smelling oil on my breast twice a day for the next few months and the cyst seemed to get smaller. Then it seemed to get

bigger again and a new lump appeared in my armpit. I saw a holistic gynecologist who sent me to a clinic an hour away that does biopsies the same day.

At the clinic, they have me lie on my side and put a pillow under my back to push up the lump for an ultrasound. My heart thuds to a stop when I see the lump this way. It's much bigger than I thought and is actually two lumps connected. And I know. I want the doctor to say it's probably a cyst, but when he actually *does* say this, I know he is wrong. He has forgotten the lump in my armpit. I remind him, though I don't want to. A few days later, the biopsies will confirm breast cancer.

It's late October and the trees are bare, the temperature chilly. Greg had driven me to the clinic, and as we begin the hour-long ride home, it is difficult to breathe, as if we are in a sealed capsule and the air is thin. Long minutes pass and we don't speak, in a state of mutual shock. Except for the stabbing pains in my breast and armpit from the three biopsies, the incisions covered by little strips of tape, I feel amorphous, as if I have lost track of myself. I'm floating and have somehow entered another dimension where everything moves in slow motion. I want to unravel the last few months and start over but there is no going back.

Finally, I say, "I guess I didn't think it could happen to me." I think Greg might blame me for waiting so long, for relying on alternative therapy, for being stubborn, or for succumbing to wishful thinking. But he doesn't say any of these things. Instead, he says, "Neither did I," in a voice as astonished as I feel. I'm grateful. We are admitting to each other that neither of us had wanted to know, and this is strangely comforting, a form of solidarity, even if it means we had been mutually deluding ourselves. Greg has been protective and supportive for twenty-five years of marriage and he doesn't disappoint now, though part of me feels he has every right to accuse me, devastating as it would be.

The biopsy doctor, however, had no qualms about taking Greg into a separate room and telling him he wished we had acted six months earlier. Was he encouraging Greg to blame me? Was he suggesting it was too late? How was it helpful to say this? He sent me for a mammogram to check the placement of the tiny titanium markers he inserted into the tumors during the biopsies, but it was predictably pointless. Blood from the biopsies obscured the images and the bleeding and pain were surely made worse by the breast compression. When I pull off the strips of tape a week later, I'm black and blue.

On the drive home I feel shattered, as if hit by a bomb that has blown up my life. It doesn't matter that Greg isn't blaming me because I don't need someone else to do that; I can do it myself. How did I let this happen? Had I doomed myself? *Was* it too late? How did I get to this place?

I know nothing about chemotherapy, but picture skeletal patients like concentration camp victims, with their bodies pumped full of poison painfully

wasting away. I can't imagine voluntarily undergoing this kind of trauma. "I'll never survive chemo," I say. "I can't do it."

Greg surprises me with his anger. "What, so you're giving up?"

I feel a flash of resentment and then think *wait, is that I'm doing?* I *am* feeling hopeless; I *am* feeling desolate. Then my paralysis gives way to some instinct for survival and a budding sense of resolve. I can't just give in to despair and I'm certainly not ready to die. Alternative therapies are not an option now because I don't know what they are, and I should have researched them much sooner and done much more. The weight pressing down on me lightens for just a second as the competent, rational part of me takes back control from the me that is a limp husk filled with self-recrimination, fear, and despair. "Okay, I can do chemo," I say. "I can do whatever I need to do." I have snapped back to myself.

I have taught art history and visual culture at a university for the last eighteen years, beginning late for an academic. I started graduate work when I was thirty-five after working at various jobs following college (waitress, art history tutor, graphic designer). I married Greg at thirty-eight, gave birth to our daughter at forty, and got my PhD at forty-two. I worked hard, published five books, and became a full professor. I found I loved writing and analyzing the power of images to shape politics, society, and culture across the twentieth century and into the present. My most recent book focuses on Detroit's ruin imagery and came out just a few months before the diagnosis. I was invited to give a book talk at a local contemporary art museum in early October. This, I must admit to myself, was also one of the reasons I waited.

The talk is a kind of culmination, a homecoming, speaking in my own city which has become an international symbol of economic decline. Hundreds of people come to photograph the ruins, and everybody is interested in the subject. I have spent the summer thinking about it, preparing, and, by all measures, it's a triumph. The large room is packed with standing room only, the audience is rapt, including people from the community, artists, friends, colleagues, and current and former students (one shouting "Dora for President!" during the Q & A when I assert that higher education should be free). It should feel like a career pinnacle and it does. Yet as I stand at the podium smiling and absorbing the applause at the end, I feel oddly hollow. Gratifying as it is, my pleasure seems shallow and vain. Maybe I'm already aware of the risk I am taking, the danger I am in. Maybe I'm thinking about the legacy of my work and whether my writing will truly make a difference. What, I wonder, do accolades really mean when it comes to determining the quality of a life?

I will have many months of solitude to contemplate these questions.

The night we arrive home from the clinic, I call one of the energy healers who will work on me long-distance before every chemo infusion. She hears the

terror in my voice and says, "Stay in the now." I try to stop thinking about what might happen, about death. *Stay in the now.* It becomes a kind of mantra and proves to be useful.

It's a constant struggle, however, especially in the beginning, to maintain a sense of self as a person, not as a clinical problem, especially with my doctors. It's too easy to become overwhelmed, to remain passive, and to submit. It becomes difficult to react quickly when they tell me things I'm not sure I agree with or even understand. It becomes difficult to think clearly, to think at all, as everything narrows down to statistics, protocols, and "the standard of care." I keep thinking that their standard of care is *one size fits all*. It doesn't matter if you are old or young, healthy or ill, fat or thin. Who I am matters not at all. They ask me nothing about myself.

It would be much easier to let them do what they want, to surrender control, and allow them to take charge of everything. Aren't they the ones with medical training? Aren't they supposed to be up-to-date on the latest research and developments in the field? Isn't this why I chose this hospital and cancer center, because they are a research and teaching faculty and not-for-profit? Don't they treat hundreds, thousands, of patients just like me? But that's the thing. No one is just like me. We are all different. And no one knows my body or my needs better than I do. It's true I lost sight of my own best interests, had tried to cope by not coping at all, but that isn't how I want to live through the rest of this. I need a new level of consciousness, a greater self-awareness, and willed alertness so that I can help steer my destiny and not be helplessly subject to the perceptions and decisions of others. I need to resist the trauma. The main thing for me now is this: How can I regain a sense of control?

The phone call that confirms the diagnosis comes the day our kitchen renovation is finished, one stressful situation ending and another, far worse, beginning. The woman in charge of the work team wants to come back and photograph the kitchen for her website, so I tell her my diagnosis. She bursts into tears, throws her arms around me, and tells me her best friend died of breast cancer.

Fear closes in on me again and it is hard to breathe. I can't sit still, can't focus on anything, can't eat. I call Sue Ann, a visionary healer in California whom I only call when it's really important: my daughter's ear surgery (Should we do it? Yes, she said, a hidden cyst would make her deaf if it wasn't removed, and she was right.); a missing colleague; my mother near dying; and now. I'm afraid to ask the obvious question: Will I survive? Is this a death sentence? But I don't have to ask. She says, "I see the cancer in your right breast. The cancer is going to go away. And it will never come back. Follow the plan of the doctors. And don't try to do less."

I collapse in my chair and tears spring to my eyes. This changes everything. There is another possibility: *I can heal.* I embrace this idea as fully as I have ever

embraced anything. Why not assume the best instead of the worst? Don't our emotions strengthen or weaken our immune system? I think that now it's only a question of getting through the treatment. Fear releases its death grip. The literature says your attitude toward your illness is crucial and mine becomes one of unshakeable optimism.

Even though the specter of death, which had moved closer, moves farther away again, death is no longer an abstraction. A heightened sense of mortality becomes my constant companion as I contemplate how I want to live the rest of my life. I ask myself the obvious questions: What do I want to accomplish with the time I have left? What is really important? I often think about Sue Ann's admonition: *Don't try to do less.* At first, I have no idea what it could mean. Later, it haunts me as I begin to do my own research and constantly try to do less.

I keep teaching as if everything is the same as before, as if I'm not in the grip of life-altering circumstances. Less than two weeks later I go through a new round of scans at the cancer center and the tumor board (oncologists, surgeons, nurse practitioners, but no nutritionists) meets to discuss my case. Greg takes notes as we meet with the doctors. I have an aggressive, stage two, HER2-positive tumor. The good news is that there is a drug, Herceptin, which kills these kinds of tumors. We have a plan: five months of chemo to shrink the tumor, then surgery, then six weeks of radiation, and a year of the drug Herceptin. Chemo will start the following week. I go home with a bag of literature; overwhelmed, I promptly shove it into the shadows.

I email close friends to let them know, including Leslie, my longtime editor, who assumes I have taken good care of myself and have caught it very early. I can't admit to her that this is not quite true. Other friends asked me when I first felt the lump, a question I always evade. "Oh, a few months ago." It's hard to admit to this part of the story, but the rest of the story would not exist without it.

They want to do a body scan with contrast dye to check for metastases. I know the contrast dye is harmful to my one remaining kidney; they haven't checked my medical history. I point this out and they switch to a PET scan. I feel sure they won't find anything but it's still frightening because . . . until the fat lady sings. As I lie in the scanning machine, I meditate on my breathing. The PET scan comes back. Nothing. Relief.

After Sue Ann's optimistic prognosis, it's easier to say I have breast cancer. I start a mailbox on my computer email labeled Cancer, and all the correspondence from family and friends goes into it. However, I refuse to think of myself as ill and bristle inwardly if anyone refers to me as sick. *I'm not sick. I have a condition and it's going to heal.* I don't want people to think I'm weak and dying. I want Greg to tell them, when they ask, that I'm doing well, even when I'm not, though I know he won't. I think this perspective insulates me from feeling helpless and sorry for myself. In the novel *Alice & Oliver*, when Alice must undergo

brutal treatment for leukemia, her best friend says, "Cancer, schmancer, as long as you're healthy." Alice laughs and has her friend make it into a banner that hangs in her hospital room. That's how I feel too.

I think of my mother, who suffered starvation, illness, and unspeakable loss. I feel I can draw on her strength, her determination, her survival instincts. My brother Max, who lives across the world outside of Jerusalem, emails me about the treatment plan: "As long as it brings you back it'll be worth it. Daddy and Mommy got through World War II, typhoid, concentration camps, yellow fever, so you will get thru this." It was typhus and malaria, but I appreciate his point. My mother's resilience in the face of trauma is what I cling to now for my own survival. This is another kind of inheritance. It's no surprise that my brother and I think of the suffering of our parents, always using that as a yard-stick against which to measure our own, both of us having grown up under the shadow of that catastrophe. This is something only he and I share, and remem-bering it together comforts me as much as the love and concern I feel from him.

I speak to my department chair at the university about medical leave, and he says he will not tell my colleagues the reason for it. "It's OK to tell them," I say, "it's not a secret." The impulse toward privacy makes no sense to me in this con-text. All it does is isolate you. Greg, too, says at first that he will not tell anyone at work, but I urge him to tell everyone. How else can he get their support? Caregivers need support too, and I'm keenly aware of the pressures he will face, having been a caregiver for my mother the last nine years of her life. Besides, we have already made this mistake once, when I got pregnant the first time and we didn't tell anyone. The miscarriage six weeks later, while Greg was in Pakistan, left me alone with my grief. The decision not to tell anyone was a mistake.

Greg tells his boss, whose own wife had breast cancer five years ago, and he tells Greg to take off work so he can drive me to every single appointment at the cancer center that is almost an hour away. This is a huge relief for both of us. Greg wants to be there, and I can't fathom doing it without him. I need his steadiness, his competence, and constancy, like a net that will catch me if I fall. Primo Levi wrote about the chances of survival in the camps being much higher if one had a single friend.

At one early visit, I'm slow to respond to the doctor and Greg speaks first, asking the obvious question. But I feel sidelined. I mention it later, and thereaf-ter he is careful to wait while I collect my thoughts through the fog of chemo so I can speak first.

I find two instructors as teaching replacements for both my courses and tell my students at the end of class on my last day of teaching. This is unexpectedly difficult—I have to say the words aloud, in public, which makes them real in a new way. In my large introductory course, I can see the alarm on students' faces who think I am dying because I'm going on medical leave. I try to reassure

them. In my small upper-level class, where I know each of the students, I decide to give them more information but must pause and compose myself before I can say the words "breast cancer." I feel a wave of sympathy roll toward me and see tears in the eyes of one of my graduate students. Spontaneously, I announce I am available for hugs and dismiss the class. They line up to hug me one by one and I say a few words of encouragement to each of them. An older student who is my age waits to the last. He is the class curmudgeon, but I have praised the intelligence and humor of his writing. He grips me in a bear hug and weeps on my shoulder. "Promise you'll come back," he says. I promise.

The concern and support of my students buoys me for days, but it's a great relief to stop teaching. I have been feeling overly stressed for at least a couple years as I have taken on greater responsibilities for shaping the graduate program and clashed with my more conservative colleagues or department chair. In the months ahead, invitations come in via email to write articles for journals and give talks at symposia, lectures at exhibitions, and papers at conferences. I say no to everything, without regret; in fact, I'm happy to have an excuse to say no. I have worked with an obsessive focus since graduate school and I want to take stock, reassess, and rest.

Even though I love teaching and mentoring, I'm feeling thoroughly drained by it all. It's hard for Greg, who works much longer hours, to understand the source of my stress and hard for me to explain. I just know there are many times when I force myself to drive to the university, to read papers, to respond to emails, and I come home exhausted. All I want is time to read and think. Or maybe my tolerance and stamina gradually diminished as the tumor and inflammation in my body grew. Tumors can take eight or ten years to develop, and the signs of illness were there, in retrospect, at least a couple years before the diagnosis. I see them in photos of my pale and swollen face, most evident on that bourbon tour, in the fatigue that became chronic, in my growing awareness that I was less and less capable of coping with stress.

Besides Greg, I have a support team composed of two couples who are neighbors and several other friends. They check on me, drive me to local appointments, visit and bring food, organize gatherings next door to keep me from feeling too isolated. I remark to Tom, an old friend diagnosed with HIV years earlier, how emotionally moving and consoling expressions of support from others have become. "The care of others is the most important part of healing," he says. This strikes me with the force of revelation. *The care of others is the most important part of healing.* How could anyone ever go through this alone? Tom emails me regularly to say he is thinking of me.

It's most difficult telling Rachel, our twenty-three-year-old daughter. Who in their twenties, a time when you are focused on figuring out your own life, wants to consider the mortality of a parent? To worry about someone you expect to be there for you without question, whom you want to take for granted

and should be able to take for granted? I hear the catch in her throat before she says a word and I feel as if my heart will burst. It's all I can do to restrain my tears, not wanting to burden her further with that. I feel as if I'm failing her. It also means I will not be able to fly to Minneapolis the following month to take care of her during a scheduled ear surgery. This saddens me, though even if I have permission to fly (risking infection of a chemo-compromised immune system) I know I will not have the physical or emotional stamina. Greg will have to go alone. "You will have to be me as well as yourself," I tell him.

The truth is that the idea of retreating from everything is immensely appealing. I relish being free of responsibility, of all academic and professional obligations, not having to go anywhere, see anyone, do anything I don't want to do. Turning inward and healing becomes my new project. Instead of feeling lost, as I did at first, I feel purposeful again.

I want my medical oncologist to be warm and reassuring, but instead find him detached and clinical. He is a large, placid man with a soft body. I can imagine him picked last for sports teams in school. He cites statistics. Sixty-three-percent chance of cure for my cancer is the statistic I remember, but I immediately discount it as too low in my case. He tells me the chemo will cause the tumor to shrink and make the surgery easier. If I'm lucky, he says, the tumor will not only shrink but also disappear. I think *yes, it will disappear.*

Kelly, his nurse practitioner, is the opposite of cool detachment, looking into my eyes and saying, "You are not alone." This is better. She jokes, connects easily, and is not afraid to ask me what I need ("Are you guys intimate? Do you need a suggestion for a natural lubricant?" She offers coconut oil.). She hugs me after every visit.

At one visit, I glance at my file when both leave the office for a moment and am startled to see the phrase "patient anxiety." I'm incensed. I have breast cancer! I'm undergoing grueling treatment! Who wouldn't be anxious? Then again, I haven't thought of myself as anxious. That they find me so makes me feel vulnerable. I want sympathy and support, but I also want to be seen as strong. Why does it matter? Maybe I don't want to be told I'm "just scared" by a patronizing doctor.

What I don't realize is that my chronic complaint of a rapid heartbeat thudding in my chest is indeed a symptom of anxiety, and they don't tell me this. By not telling me, it leads me to think that despite the heart tests showing no problems, there must be something wrong, which only adds to my anxiety. By the end of treatment, I have also cracked three teeth. It all happens at night, the pounding heartbeat, the jaw clenching, when my subconscious takes over.

Chemo is even more toxic than I imagined. "You'll only remember about a third of what I'm telling you," says a nurse, while Greg scribbles in a notebook. She describes the main drug they will give me for the first two months and how this drug, called Adriamycin, will turn all my body fluids, including my tears,

orange. She says I should use paper towels to dry my hands at home, not only so that I won't pick up germs but also to prevent the transfer of toxic chemo to others. These words stay with me.

During my first chemo infusion, the nurse, gowned and gloved like a hazmat worker, pushes the Jell-O–red drug through the IV in my arm by hand, explaining that if any of it were to escape onto my skin I would have to be rushed into surgery. At home I google Adriamycin, known as the "red devil," and discover that it's flesh eating. *Flesh eating.* After that, the sight of a red soft drink in the hospital cafeteria or on television makes me jump, my body responding to that memory before my mind can intervene.

The hospital elevators, corridors, waiting rooms, and beds, the constant filling out of information forms, the drawing of body fluids and administering of medical fluids, the repetition of my name and birthdate all make me feel anonymous, alienated, and stripped of identity. I know the medical personnel are trying to help me, but they seem detached and require my passive conformity. Even now, stepping into a hospital, especially that hospital, evokes an embodied traumatic response.

After the first chemo infusion, I double over with nausea on the sofa at home. "I don't know how I can do this for five months!" I wail to Greg. A headache plagues me throughout the night and the next morning I go to a Chinese acupuncturist. "Pay attention to your headache," she says as she plops two needles simultaneously into the headache points on both hands, and I feel the headache disappear. As a migraine sufferer my whole life, this feels like a miracle. Drugs have never worked. She gives me Chinese herbal pills for the nausea, and I begin eating tiny amounts of food every hour or two to avoid an empty stomach, which promotes nausea, even eating small snacks during the hours-long chemo infusions. Fatigue overwhelms me by the time we get home, but the extreme nausea I experienced after that first infusion never returns, nor does the chemo-induced headache.

With each infusion of Adriamycin, a nurse attaches a dispenser the size of a dental floss container to my stomach with a short fine needle. It injects a drug six hours later meant to keep my white blood cell count from dropping too low. The second time they apply it, I feel myself involuntarily "shield," a tai chi chuan technique, sending my body energy outward against an incoming force. The needle goes in sideways and later injects the drug just under my skin, leaving a tender red spot that lasts for weeks. Greg must drive me to a hospital satellite center the next day for another shot, and thereafter I concentrate on *not* shielding, which takes some effort. I have demonstrated to myself I can shield, however, and I take some satisfaction in this.

Chemo is cumulative, and with every biweekly infusion I become weaker, thinner, and more fatigued. By now, I have read the bag of literature they have given me and begun to email friends to ask about their own experiences with breast

cancer. One recommends the book *Beating Cancer with Nutrition*, and I download it on my Kindle, learning that most people who become ill on chemo suffer from malnutrition because they lose their appetite at a time when their body needs more nutrients than usual, not less. I determine this will not happen to me. Food becomes a primary focus, and I wake up each morning thinking about what I will eat, preparing simple food as a kind of Zen practice, my only real activity performed upright, other than showering (to wash off the chemo-infused perspiration of the previous night). I focus on green vegetables and eat only organic. I cut out processed sugar and white flour entirely to help starve the cancer cells of the glucose on which they thrive. My neighbors John and Sandy make organic kale and strawberry smoothies with hemp protein and bring one over at eleven in the morning every day, giving me a reason to get dressed.

I feel the tumors begin to shrink almost immediately. Kelly and the oncologist nod at me indulgently when I point this out as they clumsily measure them with a small ruler. They obviously doubt that I'm able to notice such minute changes, but I have been on intimate terms with these tumors every day for many months. I know their shape; I know every lump and bump. This is *my* body. There's no doubt in my mind.

When we switch to new chemo drugs for the last three months, my food program, literally, goes down the toilet: the chemo drug Taxol gives me diarrhea. Now I can hardly eat at all, only bland white foods (rice, toast, bananas, and mashed potatoes with no butter). Nothing raw, not most fruits or vegetables, no fats. Smoothies are out of the question. Spinach is the only green vegetable I can manage but mostly it all comes out shortly after going in. I worry about dehydration.

Taxol also causes the neurological side effect of clumsiness. I lose my balance, become uncoordinated, drop things, and inadvertently pitch food around the kitchen. The morning I decide to try cooking some blueberries and strawberries because I can't eat them raw turns into a disaster, with hot cooked berries smeared on the stove, the floor, and the cabinets. I have a vision of my future as an elderly woman living alone, flinging food around the kitchen, and starting fires. It's a relief when I realize my physical ineptitude is another side effect and not my inner klutz claiming dominance.

My hair starts to fall out about two weeks into chemo, but I'm not particularly distressed. I know it's coming and I'm ready. I make an appointment at the local wig shop to get a buzz cut, which feels good because my hair follicles have begun to hurt, as my hair stylist warned me they would at our last appointment. Who knew? My neighbor Susan comes with me for moral support and when the deed is done, she declares I look great. Since her own hair is nearly as short, I almost believe her. The truth is that I'm glad I don't have to worry about my hair anymore while in treatment. I'm too tired to wash and dry it. "No more bad hair

days," I say to Rachel on the phone, "just no hair days." She laughs. I'm less sanguine about losing my eyelashes and eyebrows, which stay attached a few weeks longer. At the bathroom mirror getting ready for bed one night, Greg observes "one adorable eyelash" hanging on by itself in the middle of my other-wise bald right eyelid. It does not feel adorable. Later I get a sty in this eyelid, which lasts for weeks.

Chemo feels like a long, dark tunnel with dark gray walls, on the other side of which is the world and all its concerns. It's winter and darkness falls earlier each day, cocooning me in the lamplit space of my living room among pillows and a blanket on the sofa. At the end of eight weeks, I find myself lying on the living room floor one night, not certain how I got there. I remember standing up and, more vaguely, going down. Greg is in Minneapolis and I don't mention it on the phone, not wanting to worry him. He has enough to do worrying about Rachel.

Sometimes I grow faint after a shower and have to throw myself onto the bed still wrapped in a damp towel; or while cooking, I turn off the burner and fast-walk to the sofa, or plop on a nearby stool and put my head down if I can't make it to the sofa. One evening, Greg asks if I would like to try going out to dinner and I agree. I stand up from the sofa, walk a few steps, get wobbly and light-headed, and fling myself back onto the sofa. I want to give Greg a break from the relentless nights at home, but I'm not strong enough. Feeling miserable and guilty, I put my face in my hands and weep. "Don't cry! We don't have to go! Don't cry!" Now Greg is seized with remorse.

Early one morning I get out of bed and make it as far as the bedroom door before everything goes black without warning. I wake up on the hallway floor in the semidarkness, with Greg sitting astride me saying my name repeatedly. For a moment, I don't know where I am and stare at him, wild-eyed. Then the urgency to pee comes back to me. "Get me to the bathroom," I whisper.

"Your head is in a pool of blood," he replies. He wants an explanation for what has happened.

"Bathroom," I say. But he doesn't budge. We go back and forth like this, hav-ing two different conversations, and then I feel a partial bladder release. Now I'm lying in pools of blood and urine. I try to get up, and Greg holds me tightly around my waist as we hobble our way to the bathroom. Then, standing at the toilet, he will not let go and I can't sit down.

"Greg, you have to let go of me."

He doesn't respond. "Greg, let go." He is in his own traumatic haze.

Finally, he releases me, and I sit, pulling my wet nightgown over my head. Now I'm feeling light-headed again and lower my head to my knees. The next thing I know I have fallen off the toilet and am lying naked on the bathroom floor. I open my eyes. Greg is leaning against the bathtub, pale and shaken. He has always fallen apart at the sight of blood. Once all six-foot-three inches of him keeled over in the narrow aisle of a Brookstone after he tested the edge of a

pair of scissors against his thumb, drawing blood. I know he is overwhelmed by the extremity of the moment, the responsibility of taking care of me. I close my eyes, thinking *what a ridiculous pair we make* and pass out again. When I come to, Greg is gone. I crawl into the hallway, which he has already cleaned up, and call his name. He responds faintly and sounds far away.

"Where are you?"

"I'm lying on the living room floor."

I crawl to the bedroom and heave myself onto the bed, not caring that I'm bleeding onto the pillow. Greg comes upstairs and wants to take me to the emergency room, but I can't move. I want to sleep. He calls the cancer center so they can tell me to go to the emergency room. When I finally get up, we notice blood on the doorjamb. This is where my head struck, which broke my fall and probably prevented a concussion, but caused a three-inch gash.

The young female doctor in the ER is kind and matter-of-fact, which is comforting. I manage to support my weight on my arms while she pours water over the back of my head, and it feels cleansing and restorative, as if she is baptizing me into the survival of cancer treatment. She stitches the wound closed. I don't feel any pain.

When I call the cancer center the next day, Kelly tells me to sit on the edge of the bed for a moment before standing up because the drugs can affect my blood pressure. I wonder why they didn't mention this sooner. But Kelly thinks it may have been dehydration. Perhaps, I think, it was a combination of dehydration and the Rick Simpson Oil, a cannabis extract known for its cancer-fighting properties. The oil comes in a plastic syringe to make measuring the rice-grain-sized dose easier, but one needs to increase the dose gradually as tolerance rises and it's difficult to get right. Too little and you feel nothing, too much and you are in the twilight zone.

When a friend brought over a cannabis mint cookie and a couple brownies, I ate the whole mint cookie, not knowing it was enough for four doses at my tolerance level. I was lost in space for hours, my head lolling on the sofa in a delirium. Greg offered little sympathy and seemed to think it served me right, as if I had done this on purpose. I was too stoned to speak. After that, I rationed the brownies into small bites, which helped with mild nausea and increased my appetite.

Buzz in St. Louis emails me a poem. His wife had breast cancer about fifteen years earlier. I remembered her telling me about mouth sores and thought of her when I developed them too. The poem speaks to the detachment needed as the bleak months stretch on. I am moved that he has written it for me.

DECEMBER RAIN
I went looking for a poem tonight
to offer something in a language

fit for replacing what you are going
through with itself.

Such stuff as occupies my mind
from far away, of an offering some-
how capable of making distance
a thing, not a scope.

Or a scope of distance you might
seek so as to regard the strange garden
in your body from the vantage
of a bystander.

From what window to see the rain
fall from above the rain, not in it.

My tai chi chuan teacher invites me to lunch with some other members of our school. Though I'm weak, I decide to go, and Greg drops me off. I can see my friends trying not to look shocked by my gaunt appearance. As the conversation wears on, I feel myself slipping down in my seat, unable to stay upright. I know I can't do this again. As I walk to a friend's car for a ride home, my heel becomes painful and I begin to limp. At home, I see that my heel is red and swollen. Within a day, my hands are red too, and they keep swelling until they are like burning mitts, making it painful to hold a spoon or pull up my pants. I turn to Google and discover that chemo is leaking out of the capillaries in my hands and feet. This is the worst side effect yet. I call Kelly, who responds to my plea for help with, "Huh. Yup, that's a side effect," making it clear she has nothing more to offer.

Just when the leakage is at its worst and I'm at my most miserable, my neighbors organize a small social gathering for me. I'm happy to see my friends, but without warning, as I hug Sandy, I burst into tears, unable to contain myself, and sob on her shoulder for a long moment. The three men quietly leave the room as we three women sit down and she says, "Chemo is a bitch." This makes me feel better. Sometimes you just need to have your suffering acknowledged. My holistic doctor recommends two homeopathic remedies and within three days, the swelling begins to retreat. When it's gone, the skin peels off my burned hands. After a shower, I feel a jolt of fright when I see the skin peeling off my heel in one large piece, as if I were molting.

Kelly approves of cannabis and acupuncture as adjunct treatments, and tells me that many patients use them, but she makes it clear she can't officially recommend either because it's not part of their "standard of care." I get the same response when I tell her about the homeopathic remedies that have cleared up the chemo

leakage. "You should tell your patients to try this," I say. "I can't," she responds, though we both know the standard of care has nothing else to recommend.

With chemo at its worst, I have one dreadful moment when a feeling of guilt washes over me, as if I deserve to have breast cancer. Where did this feeling come from? I actually say something about punishment to a friend who calls from New York on my birthday. He pauses and, in that pause, I hear how foolish I sound. "Jewish guilt?" he says. "I knew there was Catholic guilt . . ." I think *of course, Jewish guilt*, though I'm not sure why. I know there are certain Orthodox Jews who believe that "God had a good reason" for the genocide of the Jews, though I find that repulsive. I feel mortified at this lapse, at allowing myself, even so briefly, to sink into its grip. I know there is no redemptive meaning to be found in such "punishment," pull myself together, and shake it off.

Now I realize I inherited this inchoate sense of guilt from my father. When he fled Poland, convinced that only the men were in danger, he left behind his first wife and small daughter, who later went into hiding and were betrayed to the Nazis by another Jew. This man then turned up in the same Siberian slave labor camp as my father, who somehow discovered the truth. He had never spoken about the war years to us before, but he related this incident one night at the Seder table when I was ten years old. We all fell silent, my mother, father, brother, and I. Finally, I asked, "What did you do?" Without lifting his gaze from the soup, he said, "I killed him." We were stupefied. Then my mother jumped up and shouted, "No, he didn't!"

And that was all that was said on the subject. Somehow, we all went on with the Passover Seder as though we hadn't just heard this astounding declaration from my father. I didn't believe my mother, but I couldn't be certain, yet I didn't bring up the subject again until decades later, long after my father was gone. Then I finally asked her if it was true that my father had killed this man. "I don't know!" she cried, "I wasn't there! We never talked about it!"

A few years after the Seder, my father came into the kitchen, deeply shaken, and told my mother he had just killed a muskrat on the farm with a shovel. It struck me even then that his shocked reaction was extreme, that this act of violence must have awakened the horror of a darker memory. I think I witnessed a moment of traumatic doubling in which my father's traumatized self and everyday self were at odds because the ethical contradictions could not be resolved. Though I always believed the Nazi murder of his first wife and child was the defining trauma of his life, the one that left him hard to reach emotionally, now I think the effects of that other traumatic memory, the act meant to expiate his sense of guilt for not being able to protect them, instead deepened it.[1]

Psychiatrists saw a pattern for those, mainly men who survived the Holocaust and suffered from chronic, low-level depression because they blamed themselves for the deaths of their families and their inability to protect them. They had difficulty attaching to their second families.

I felt my father withdraw his affection from me when I was four years old, the age of his first daughter when he last saw her alive. When I had a bike accident at twelve and almost died, he retreated even further—my mother blamed him for buying me that bike and the possibility of my death must have evoked terrible feelings of guilt. He didn't even visit me in the hospital, perhaps afraid that I would blame him too. There was a great distance between us until his fatal heart attack when I was eighteen. I grew up wondering if I was unworthy of love. Had I done something to deserve his rejection? It has taken me decades to understand that my father was afraid to love me, afraid he might lose me, too, afraid he could not protect me. It completely alters my memory of him now and of the emotional climate of my childhood and teenage years. I think now not about my own hurt but about the devastating, trauma-associated guilt and shame that oppressed my father.

Another unexpected side effect appears. My tai chi chuan teacher suggests I stand in the sun for three minutes a day to absorb its energy, which sounds like a good idea. I begin stepping outside my front door each morning, sitting on the top step, and turning my face upward for three or four minutes. It's February and the sun is not very hot. On the third day, my face breaks out in a rash. It turns out that Taxol is photosensitive. Kelly, who is kind and compassionate, once again has nothing to offer. She says it's "probably" the drug, even though there is nothing else it could be, and the literature says it's a known side effect. She asks me to send pictures and I realize they haven't encountered this problem before. So I do my own research while lying on the sofa in my nest of pillows and blankets and find a case study in an online oncology journal that discusses a similar rash. The authors demonstrate that it's the drug solvent, rather than the drug itself, that is the problem, and that switching the patient to the same drug in a nontoxic albumin carrier solves it.

I send a message to my oncologist and Kelly through the hospital portal requesting a switch to Taxol in an albumin carrier and include a link to the journal article. When I go in for my next appointment, the oncologist says he will switch me, though I sense some reluctance. Why didn't he start me on this in the first place? I ask. "It's more expensive," he says. He adds there is some evidence that the drug in the nontoxic carrier can increase side effects. This makes no sense to me. With more research, I discover this is based on a flawed study that has already been debunked in the literature. I send him that, too, against Greg's recommendation. It may not be tactful to prove him wrong, but I think the doctor's need to know is more important.

It all brings home the fact that the interests of the doctors, hospitals, and insurance companies are not necessarily the same as my best interests. Nor can I count on the ability of doctors to keep up with all the published research. The doctors follow their approved hospital protocols, which no doubt change slowly, addressing the most statistically common issues, and certainly do not consider

the many variables of an individual case. The hospitals are concerned with success rates and go for extreme measures, while the insurance companies want the cheapest drugs. The switch to the albumin-based drug not only means it's less toxic but that I no longer need the pre-med infusion of steroids and Benadryl to prevent allergic reactions or the anti-emetics for nausea and vomiting, all of which produce their own side effects. It means I can spend less time in the infusion chair attached to plastic tubes and bags on beeping metal trees, and it means the diarrhea side effect abates because it's the toxic carrier that causes this too. It feels like a glorious victory and it would not have happened if I hadn't researched it and advocated for myself. This begins to make me feel whole again.

Greg's older brother Roger is diagnosed with stage-four lung cancer. For the first time, I develop a bond with him that has eluded us for the previous twenty-five years. We are both going through chemo at the same time and have something real to talk about, something no one else who has not gone through it really understands. Roger is more isolated than I am, and he knows I won't be unsettled by his frank talk. He is grounded and calm and has no illusions.

When Rachel comes home for Thanksgiving, we all go see Roger and his wife Patty. I tell Rachel it is probably the last time she will see Roger. Rachel and Greg cook for me in the days before Thanksgiving and Rachel makes two pecan pies to bring to Patty's house. We gather around the large kitchen table to eat with Roger's two grown children, their partners, and Patty, while Greg stays in the living room with his brother, who is too weak to get up and remains in his favorite easy chair. Roger eats only some apple pie and ice cream.

I ask Roger's son and daughter if they want to talk about how they feel. It quickly becomes apparent they want to absolve their father of blame. They assert that anyone can get lung cancer and that many people who smoke, like Roger, do not get it. This makes me wonder if they are secretly angry with him for getting cancer and trying to rationalize it away. I know Roger doesn't have much time left. Then Rachel bursts into tears and sobs in my arms. This, I think, is as much about me as Roger, and I welcome the release. In the two days she has been home, we haven't broached the subject of my cancer at all. Now we go around the table so people can share their feelings. It's as close to each other as we have ever felt. Afterwards, Roger's son tells Rachel her tears expressed his feelings too.

Roger tells me his most fervent desire is for chemo to stabilize the disease long enough that he can walk from one room to another in his own home without losing his breath. This is what would make life worth living. But the chemo doesn't work, doesn't stop the tumors from growing, and they halt the treatments. As his body fails and he embraces the inevitable, Roger tells me that Patty gets angry if he talks about dying. When I talk to her, she is angry that he will not drink the healthy green drinks she makes for him and resists the car

rides she wants to take him on, which I know must be exhausting for him. Then Roger calls to tell me he has stopped eating. We both know what this means. Most cancer patients die of starvation. He gets the acceptance from me that his poor grieving wife is unable to give because she so desperately wants him to live.

I understand how Patty feels. I remember how, ten years earlier, when my mother didn't want to eat at the end of her life, I panicked too. I wasn't ready. I cajoled her into eating a few bites by using the very trick she had used on me as a child: I asked her to eat if she loved me. But we cannot eat for love. Roger's memorial takes place a month later.

Even before the end of chemo, my tumors have completely disappeared. I expect joyful noises from the oncologist but don't get them, only the cool official description of the results—pathological complete response. *What do you have to do to get some affirmation from this guy?* "I did really well on the chemo, didn't I?" I ask, as if I have aced an exam. I want acknowledgment for the long months of endurance, for my own role in my healing and the careful attention I have paid to diet and nutrition, even if he doesn't know about it. "You did excellent," he admits. That's more like it.

For months, I'm not sure if they will want to do a mastectomy or lumpectomy, even though I know there is no reason for a mastectomy. Either option seems to be on the table, but a mastectomy scares me, so I'm prepared to argue against it. I remember my friend Ewa describing her own mastectomy ten years earlier as causing "big pain." I read about reconstructive surgery, which involves two further operations, and decide I won't do that either, if it comes to it. Ewa goes on the warpath when she hears this. "You have to have reconstructive surgery! You can't give up on yourself as a woman!"

Is that what I would be doing? I don't think so. The only thing that scares me more than the internal invasion of my body by cells that will not stop dividing is the external invasion of my body by sharp instruments and toxic drugs. Nevertheless, she has a point: How will I feel with one breast? I still remember the protest against the Miss America contest in the late sixties by second-wave, "bra-burning" feminists. Though they never actually burned any bras, they railed against the patriarchal fetishization of women's breasts as signifiers of femininity and desirability. I have internalized this fetishization too. Moreover, what would the asymmetry of one breast do to my sense of self? How would I adjust to losing a part of my body, a part like any other? I do not want any surgery at all, yet I'm haunted by the admonition: *Don't try to do less.* The oncologist says that even if a fraction of a percent remains, the cancer can grow again.

The surgeon agrees that the lumpectomy (also called, a little less inelegantly, breast-conserving surgery) is a good option, though it means adding radiation. I have a month off to recover from chemo. He tells me he plans to take all my underarm lymph nodes. "How many is that?" He looks momentarily uncomfortable. "At least ten." I know it can be more, even thirty or forty. He notes

that cancer centers like Sloan Kettering and MD Anderson have changed this protocol, but he doesn't agree with them. "What about lymphedema?" I ask, referring to the lifelong swelling of the arm, shoulder, and chest that is a well-known side effect of lymph node removal. The arm, especially, becomes swollen and heavy with lymph fluid because of the interrupted lymph chain. He admits it's a risk in about 40 percent of cases but points out there are arm-length rubber sleeves that can be worn. This is no comfort. Although 40 percent is high enough, my research shows the risk is much higher and I have no desire to wear a rubber sleeve. I'm pleased he has alerted me to the new protocol but discover that he not only disagrees with it, he is a leading voice against it, maybe the most conservative surgeon in the country, and has argued his position in a national debate posted online. The new protocol takes only the sentinel node (or up to three nodes) and dissects them while the patient is still in surgery to see if any live cancer cells remain. If there is no cancer, no more nodes are taken. Recurrence risks are no worse than taking all the nodes and the risk of lymphedema is greatly reduced.

I send the surgeon an email explaining that I am not willing to risk all the side effects of the most extreme procedure, especially lymphedema. He writes back affirming his position as the "standard of care" but conceding that "quality of life" is a consideration. I insist. He gives in, with the warning that he will take all the lymph nodes if there are any live cancer cells.

On the day of surgery, wires are placed to indicate the titanium markers that were inserted into the tumors during the biopsies so the tumor sites can be found (and the markers removed), especially if the tumors disappear with chemo, as mine have. I meet with the doctor who will place the wires. She sits on a tall stool wearing a pencil skirt and high heels, looking imperious. I ask a question about the procedure and immediately sense her irritation: Who am I to question her? It isn't only male doctors that are patronizing. Yet she fails to place a wire for the lymph node marker, which the surgeon only discovers after I have conked out under anesthesia. He decides to go ahead with the surgery and to search for the marker but doesn't find it. When I awake after surgery, I anxiously question the nurse. Only three nodes, she says. No cancer cells. I smile.

However, they ask me to come in a few days later for an ultrasound to look for the errant marker. As the radiologist repeatedly pushes the scanner over my skin, the ultrasound reveals nothing. "You'll need to have a mammogram," she says. I refuse and she's taken aback. She wants me to do this, she says, as if I haven't understood. Still I refuse. She says something about researching the radiation at Hiroshima, to show me she is sympathetic to what she imagines is my primary concern, though she has not asked. "I'm not going to do it," I say simply. She fumes and says she is going tell the surgeon, saying it the way a schoolteacher might say she is going to report me to the principal.

I wait in the surgeon's office and when the door opens, he walks in, followed by Kelly and his own nurse practitioner, no doubt as witnesses to what he senses will be a confrontation. "Why did you refuse the mammogram?" he asks. The three of them stare at me. Months earlier, I might have withered under this kind of scrutiny. Now I meet the surgeon's eyes. "There are three reasons. First, I just had surgery and the pancake smash of a mammogram would be too painful. Second, there were no live cancer cells anywhere so the chance that there would be any in the lymph node with the marker is infinitesimal. Third, even if the marker were still there, I would not have another surgery to remove it." His expression softens. "I agree with you," he says, "but we still don't know for absolutely certain." His need for certainty, however, is not mine. "I can live with that," I say, "and we can find out six months from now at the next mammogram."

In truth, though, I'm planning to switch from mammograms to the infrared imaging of thermograms since studies show they are at least as accurate, detect abnormal cell changes much sooner, and involve no radiation. I ask him his views on thermography and it's no surprise he disapproves, offering as his reasons the fact that the hospital standard of care doesn't accept thermograms and that a mammogram would be needed in order to pinpoint a biopsy site. We already know the hospital doesn't accept many helpful modalities as part of their standard of care, and if a thermogram indicates the need for a biopsy, a mammogram can be done. I say, "Is that your best argument?" He admits that many of his patients have switched to thermograms.

As he is walking out the door, I can't resist asking, "Aren't you glad you didn't take all the nodes?" For me it's a huge success, the avoidance of an extreme intervention and its potentially disastrous side effects. There were no live cancer cells and I still have most of my lymph nodes. For him, the radiologist's screwup caused him to leave a marker, which would not have happened if he had taken all the nodes. He turns and gives me an unreadable look.

My breast is swollen with a fluid-filled sac where the tumor has been excised, known as a seroma. It's square, as if I had a small box implanted under my skin. The surgeon cut the tumor out in *a square* rather than an organically rounded shape that would be more consistent with the natural shape of a breast, a body. Do the female surgeons excise tumors this way? Because of the swelling, my breast rests higher on my chest than the other one, and the nipple points in a different direction. I can hardly bear to look in the mirror, feeling freakish and repulsed by my short, enlarged breast. Having avoided a mastectomy, I find myself rejecting the modified breast still attached to my body. I didn't expect this, though I'm not sure what I expected. I mourn the missing chunk of tissue.

Being bald doesn't help me feel lovely either. While in treatment, I wear a soft cotton cap, a "chemo hat." Sometimes I tie a scarf around it. There are

websites that sell all kinds of hats, some with hair attached, and instructions on different ways to tie scarves, but they all say *cancer patient*. At the cancer center, they have pictures on the elevator doors of smiling women with bald heads. It's too cold for that, and their big smiles don't convince me this is a good look either. For those times I don't want to look like a cancer patient, I get a wig. A custom wig is very expensive, so I get one that is not quite like my hairstyle but matches my color and fits with some adjustments. I wear it for the first time at Roger's memorial. I feel strange in it, as if I'm impersonating myself. People comment on how "natural" it looks, yet the fact of their commenting means they know it's not natural.

A chemo nurse says that some patients who wear wigs take them off when they get to the infusion center. This puzzles me. Why wear it only to take it off? Once I start wearing one, however, the answer becomes clear. The tight band that keeps the wig on my head is annoying, but even worse, it's hot. Toward the end of treatment, I begin to wear it more often in the hope I'll look more like a real person to the doctors, but riding home one warm summer day, it suddenly becomes unbearable. Do I need a wig for them to take me seriously? I rip it off my head and toss it onto the back seat. "I'm never wearing this again," I swear, "and if anyone doesn't like the way I look, that's their problem." Greg says nothing. He has always felt the wig made me look like someone neither of us recognized.

As my hair grows back, the wig sits on my bureau for months, along with a worse-fitting one provided free by the cancer center, the two of them like sad, furry creatures. I donate them to the wig shop, which donates them to a hospital program that sends wigs to cancer patients in Africa. I feel a little weird about this, sending a white woman's hair wig to black women in Africa.

At chemo infusions, different nurses will sometimes ask me if I'm still working. *Still working?* I can barely stand up for more than a few minutes at a time in the days following an infusion. Yet I know other people keep working, usually because they cannot afford to do otherwise. I am fortunate in being able to exert control and advocate for myself. My ability to question my doctors, to have the time to conduct my own medical research, to play a role in my treatment is, I realize, in large part a consequence of race and class. Others are not so lucky. They are subject to financial hardship and lack of access to quality health care, to racist perceptions and racial bias that contribute to higher disease rates and shorter life spans for African Americans and other racial and ethnic minorities.

Some doubt that such bias, often unconscious, continues to persist, but many studies show that blacks and other minority groups in the United States are prescribed less pain medication and experience more illness and worse outcomes compared with whites. Indeed, the U. S. has a long history of medical abuse and unethical experiments performed on poor women, prisoners, mental

patients, and, especially, African Americans, without their knowledge or consent. This includes the racist pseudoscience of eugenics, segregated hospitals, J. Marion Sims's gynecological surgeries on black women without the benefit of anesthesia, and the forty-year Tuskegee syphilis experiment.[2]

My mother once told me how she lay in a hospital for weeks with typhus near the beginning of the Second World War, her fever rising higher and higher. Her first husband had died from the disease only weeks earlier and the nurse was sure my mother would die, too. Then one night she had a dream in which her own mother came to her, held out her hands, and said, "Here is the remedy." In the morning, her fever had broken. The nurse declared it a miracle. Toward the end of her life when she was living alone in her apartment and her balance was precarious, she told me that her mother and father sometimes held out their hands underneath her to keep her from falling. At bad moments, these memories lift me, and I find myself appealing to the spirit of my mother: *help me*.

Much of the time, though, I'm not miserable. I read novels and watch movies, detective stories, and dark Scandinavian thrillers. I take baths in the middle of the day and talk to friends on the phone. I appreciate the care and support that surrounds me, the efforts people make on my behalf, the text and email check-ins. Though weak, I also feel strong. I draw on the inherited trauma of my mother's experience and the memory of her fortitude, taking control of this experience as best I can. If fear still lives in a corner of my consciousness, it doesn't own me. And death is inevitable. I don't want to die just yet but think that I have come closer to accepting it peacefully when the time comes.

Radiation is the next challenge. Five days a week for six weeks is the plan, which seems very long, arduous, and frightening in a whole new way. I begin my online research and find two studies from Great Britain showing that slightly more radiation each day for lower total amounts in half the time has proven just as effective as the older protocols, but with fewer side effects. I meet the radiation oncologist prepared with my arguments. He is immediately receptive. "I've seen those studies and have been using fractionated radiation on my patients with great success!" he enthuses. "Have you seen the latest study?" He runs to his office and prints out a copy for me.

This is a new and refreshing experience, the first time in all the months of treatment when I feel I'm a welcome collaborator in my own treatment rather than an annoying and recalcitrant patient with whom they struggle to be patient. He is in his thirties, a decade or two younger than the medical oncologist and surgeon, and maybe his sense of authority is not as easily threatened, or he is less straitjacketed by traditional protocols, or more willing to tailor the standard of care to the individual patient. His sense of excitement about the latest science is palpable and he *likes* discussing it with me. I can see him read my bodily reactions to various treatment options and respond accordingly.

Instead of six weeks, the radiation lasts three weeks, and I refuse, with his consent, the final "burst" concentrated on the tumor site that causes the most scarring and side effects. But it means doing less. I text Sue Ann: "Do I need the burst?" "No," she replies, "you're clear." The radiation oncologist also finds the errant titanium marker in a preliminary CT scan and includes the site in the radiation area, just to be sure.

He warns me about the breakdown of skin, the potential burning, blisters, and open wounds, which is terrifying. His assistant hands me two small tubes of aloe vera gel and Aquaphor before I leave, which, given what he has said, are obviously insufficient. I call my holistic doctor and he recommends another homeopathic, radiatum, which I take once a day right after radiation exposure. When I get home, I apply four layers of essential oils and plant-based lotions, and repeat it before going to bed. My skin gets red but nothing worse happens, although my ribs and nipple are tender for months. At the end of my treatment, the radiation oncologist says, "Your skin is in remarkable condition," and when I explain what I have done, he says, "I am learning from you." Now *that* is something no doctor has ever said to me.

I want to celebrate the end of radiation treatment. Feeling a burst of energy, I drive to two different stores for ingredients and bake a mixed berry crumble for a dinner party. I'm tired by the time my neighbors arrive; perhaps I have overdone it. We sit on the back deck on a warm summer evening with a sense of camaraderie. After dinner, I take one hit of a joint, feeling a bit reckless and inhaling more than I should. Minutes later, I feel my blood pressure drop, a feeling I have been familiar with since I was twelve and fainted on the kitchen floor. An attractive young man in his early twenties had chatted me up for over an hour. He was there to check the water heater and my parents weren't home. I was barefoot in my pink sleeveless nightgown, a very mature-looking twelve-year-old. I stood stock-still while he talked, my arms folded across my chest, too embarrassed to sit down in my nightgown and too polite to cut him off and go upstairs.

Boom! I crashed down in front of him, scaring him and relieving the impossible tension that had built up in me. I remember the feeling of my blood pressure dropping, though I didn't know what it was at the time, and it became familiar over the years under different circumstances (being overheated, giving birth, too much weed). The next few times I keeled over, people caught me, but I learned to react quickly and lower myself to the floor to keep from passing out.

It has never happened while I've been sitting. I know I should lower my head, but I don't have time to speak or move my chair before everything goes black and my head drops back. As I come to, I see alarm on Greg's face. He stands me up, the worst thing to do, and tries to walk me into the house to lie down. I'm unable to speak before falling backwards in a dead faint. Susan catches my head and Greg my body. When I regain consciousness, I'm lying flat on the deck and

Susan is sitting cross-legged next to me emanating calm and a comforting sense of peacefulness. Greg, however, is standing in a black cloud at my feet. I try to tell them all that it's OK, just a faint, nothing to worry about, but on the heels of cancer treatment, I know it's hard to believe. Greg's only experience of my fainting is the morning I gashed my head, and I missed the opportunity of explaining then what to do in case I fainted again.

When I feel better and want to resume the dinner party, Greg is nervous and will not let me stand unaided, pulling me up by my armpits despite my protests. Feeling infantilized and silenced, a surge of rage burns through me but I resist lashing out, not wanting to shout at Greg in front of our friends. I have a flash of insight into the anger and frustration our mothers must have felt as their independence was eroded by degrees in the assisted living homes where they spent their last years, the sense of indignity and humiliation they must have suffered as they were treated like invalids at the hands of their well-meaning but often patronizing family members and staff aides who ignored their wishes in the service of their safety. In *Being Mortal*, the physician Atul Gawande argues that what makes life worth living should be up to the individual, no matter how old or frail, even if fulfilling those wishes means accepting the risks that come with them.

We go on with the evening as best we can but the ease and relaxation with which we began is gone. "Did I ruin the dinner party?" I ask Greg the next day. He looks at me as if to say *of course you ruined the dinner party*. I learn from Susan that they had considered taking me to the hospital, that Sandy had cried for fright, that Greg had gotten angry about the joint, and accusing words had been spoken. My resentment at Greg dissipates; instead, I'm crestfallen at realizing how much I had scared everyone and caused bad feelings.

Although I am bald, sunken-eyed, and dry as paper, Greg suggests we have sex. In that moment, I expect to feel put upon, to suspect he doesn't truly appreciate my debilitated condition. Yet I know this isn't true and I decide not to feel put upon. I realize I'm surprised and pleased that he still finds me desirable in my current state and game to see if I can rally my flagging body. Besides, Greg is a master of the art of back scratching and nothing can diminish that exquisite pleasure. Sex becomes an opportunity to retain some sense of normalcy in our life together and for me to give something back to Greg. I remember a friend telling me on the phone, after his wife had been in treatment, that "Eros was gone" and the terrible sadness in his voice. Though I can't do much of anything, the intimacy brings us closer, and we lie together in perfect contentment as we always have. We make love throughout my treatment except for a period of six weeks, when the effects of chemo are at their worst.

It's difficult in a way to write this because I know that eventually my daughter will be reading it. On the other hand, that seems like a good reason to do it. She and I have never really talked about sex and I feel derelict as a mother. My

mother and I didn't talk about sex either and I always swore to myself that I would be different—but I wasn't. I shied away from it. I waited for Rachel to ask questions that never came, and all those years slipped by before I realized we had never talked about it. What kind of parent was I? I take some comfort in the fact that Greg and I have set a different example for her than my parents set for me, so that she knows what a loving relationship looks like.

The free expression of sexuality was never easy for me. My body became a source of shame at an early age. When I was ten, I wandered outdoors on our chicken farm one hot summer day wearing shorts and a sleeveless top and a white man hired by my father to work on the farm raked me up and down with his eyes. He was heavyset, middle-aged, sweaty, and mean-looking, and the violence of that look made me acutely aware of my body. I was terrified. Yet I felt somehow implicated. I was home alone and hid from him in the house, saying nothing to my parents when they returned, not only because I didn't know how to put the threat into words but also because I thought they might denigrate my fear and humiliate me further, or accuse me of something. I must have already sensed that my sexuality was suspect.

A couple years later, I read a teen romance in which a couple named Julia and Joe lay down by the river and Julia became pregnant. I couldn't imagine taking off your clothes while lying on the cold damp ground, so I asked my mother, "Can you get pregnant through your clothes?" She laughed derisively but didn't answer. When menarche hit, I didn't tell her (Rachel and I jumped up and down together in the bathroom to celebrate when she told me), but when my second period was three weeks late, I got worried and asked her if that was unusual. She grew angry and accused me of being a prostitute, an accusation that shocked me into speechlessness. How could she call me a prostitute when only a few months earlier I had asked if a girl could get pregnant through her clothes? Why did she get so angry at my questions about periods and conception? My interest in sex or anything related to it seemed to incense her. In a fury, I went to the library on my first mission to conduct independent research in the face of intransigent authority and learned that periods can be irregular in the beginning of menstruation. I still wasn't sure how one got pregnant.

I continued to feel violated by the male gaze even as I invited it. In junior high, I wore tight skirts to attract boys, but when they looked at me, I felt ashamed of what they might have been thinking. I wanted to be sexy but sexy was bad. My mother had warned me that all men wanted only "one thing," which she clearly found disgusting. She implied that if you were a willing participant, you must be disgusting too.

Eventually an intuition came to me that my mother's mistrust of sex was the result of never having experienced an orgasm. I wanted to find out. On a visit home during my senior year in college, I told her I wanted to talk about sex and began describing the feeling that builds and builds to a crescendo; she interrupted, saying, "I enjoyed sex in my thirties, but not later." I went back to my

description and asked her if she understood the experience I was trying to define. Her puzzled look turned to sudden understanding. "Yes! I know what you mean. That's something men have."

I felt stricken. Now it all made sense, the disgust, the hostility, the years she and my father had slept in separate bedrooms across the hall from each other (though she told me once, when I asked why they slept apart, "You can cross a hallway, it's not an ocean."). She had been cheated and I felt saddened that my father hadn't known how to give her this pleasure. I wonder now at the fact that she seems never to have masturbated, but it didn't occur to me then to ask and it wasn't a subject I would have known how to broach. This was the first time we had ever spoken frankly about sex. I can imagine my parents' mutual ineptitude and I wonder, now, if my mother experienced incidents of have impacted sense of sexuality.

Eventually I realized that my mother's antipathy to sex and distrust of female sexuality, *my* sexuality, had transmitted itself to me, that I, too, felt deep down there was something dirty about it, even though I consciously rejected that idea. It took years to overcome my reluctance to "descend" from the mind to the body, to let passion take over without shame, to appreciate Woody Allen's quip: "Sex is only dirty if you do it right." I hope I didn't transmit this repressed antipathy to Rachel, like a defective gene, by not talking about it. This is me talking about it.

My hair grows back in silver and black. Never black before, it seems as if the gene memory of my father, whose hair was black, has infused my new incarnation. My stylist says I look like a Siberian Husky, and I like the fierceness this implies. I decide to keep it short and abandon the chin-length bob I have worn for years. I look completely different and it feels more authentic to who I am now.

"It's liberating," says Rachel. It *is* liberating, but from what exactly? From artifice? From a long-standing idea of my own femininity? From the grip of conventional cultural ideals? It's all these things, but also something more: perhaps a liberation from the fear of my own masculinity, or from the artifice of both femininity and masculinity as social constructs. Just thinking about it in these terms is something Rachel's investment in contemporary gender theory has encouraged in me. I renew my driver's license when my hair is barely an inch long and the rather androgynous photo is the opposite of the one on my last driver's license, where my hair surrounds my face in a fluffy pouf. I much prefer the austerity of the current picture, which seems to say *don't fuck with me*.

The final leg of treatment is infusions of Herceptin every three weeks for twelve months. By this point, it's a hateful, if familiar, routine of blood draws, doctor's appointments, paperwork, waiting rooms, and hours in the infusion center, with my two pillows and two blankets in a recliner, my water bottle, snacks, and Kindle crowding the side table, and Greg sitting a few feet away working on

his laptop. I spend the evening exhausted on the sofa. My heart pounds relentlessly, especially at night, and I begin my online research of Herceptin. It can be toxic to the heart. Every chemo drug they have given me can be cardiotoxic, and my heart has pounded for months, but this gives me the excuse I want. Since most of its effects occur in the first six months and I have been on it for eight months, I argue for ending treatment. (Later a study will come out showing no difference in survival rates between six months and twelve months.) At my next visit with the oncologist, I make my case and he agrees. I want to whoop for joy. A couple weeks later I have the port removed, the half-ping-pong ball sitting on my chest for a year that connects directly to my jugular and prevents the chemo from frying the veins in my arm. It's finally over.

Of course, it's not really over. It takes a year for the box-shaped seroma to disappear, and several more years to rebuild my immune system and recover my stamina. I still get faint when I am overheated, and my hand sometimes swells. Traumatic effects are reawakened at times, returning me to memories of dark days on the sofa. But I also resume my tai chi chuan training, return to teaching at a reduced schedule, and start writing again, accepting various commissions. I even travel to Israel for my nephew's wedding and a joyous reunion with my brother.

My year on the sofa felt like an altered state. I was fragile and unable to cope with the slightest degree of tension between Greg and me. If I made an effort to sit at the dinner table and something stressful arose, my chest would get heavy , and I would have to lie down, retreating inside myself. Yet perhaps isolation under the influence of powerful drugs also produces a kind of purity of consciousness, which is gradually lost as one returns to the world. I find I want to hang on to certain feelings from that time of intense inwardness: the need to let go of greed, envy, jealousy, vanity, pride; the need to be kind; the meaninglessness of material accumulation. It was as though these basic truths, as old as Buddhism, became solid inside me, though now they easily turn to smoke. I learned to live in the moment, at least for a time.

And I made it through. I knew I would, because I had to believe something, and this was what I had to believe. You can't pretend to believe it; you have to really believe it in order to act on it. Sue Ann gave me a way to do that. I wish I could have done it for someone else. My friend Nancy brought over a young woman newly diagnosed with breast cancer to meet and talk, hoping I had something to offer her. I sensed the dark sinkhole she had descended into, the total trust and surrender to her doctors, the rejection of any complementary practices. I hadn't yet digested what I had learned and I couldn't pull her out of that pit of terror. I kept track of her and she kept getting worse. Less than a year after her diagnosis, she died.

Julie, an acquaintance with metastatic breast cancer, went through a variety of regimes both allopathic and holistic. She lived about four years after her diagnosis. When I first spoke to her right after my own diagnosis, she admitted to being "so scared" for the first year, but said it was the most interesting thing that had ever happened to her and she was going to be all right. I was taken aback at the time and couldn't imagine what she meant. But I think I have come to understand. All right can mean many things. All right can mean living as fully as possible in the moment and being at peace with your mortality.

My friend Joan in Los Angeles, who listens to my stories about the medical research I'm doing, remarks, "It's the academic approach to cancer." We laugh about what a pain the doctors must think I am, but I know it's the only way I can maintain a sense of control over my own fate and therefore preserve a sense of myself. Before she died, my mother told me about her grandfather in Poland, who gathered the family together one day and calmly explained to them that he was old and was going to die that evening. He said that he had led a good life and was ready, and that they need not mourn. That evening he died peacefully, like a Jewish yogi. But I needed no more inspiring example than the memory of my mother, who at 101 emerged from an unresponsive state in the ICU at a moment when the doctors were contemplating letting her die and telling them emphatically that she wanted to live, changing her fate until she was ready.

Aftermath

In her memoir *Hourglass*, Dani Shapiro writes about trying to become the person who would have helped her shallow younger self. This makes me think about helping the younger self inside me, the many younger selves, whose insecurities clash with who I want to be now. I tell people I feel different but I'm not sure what I mean by this except that my desire to be as authentic as possible has grown stronger. This has something to do with making peace with those younger selves, trapped in various ages when something traumatic or life changing happened. I remember being five and feeling small, unimportant, and unloved, crouching in the safety of our darkened living room and saying to myself *I'm having an unhappy childhood*, as if I were observing myself from the outside. I was feeling my father's detachment and knew even then that my childhood would affect me later, though I couldn't know how. Now I see how the traumas of my parents have impacted me and how their memory inspires me.

I am being inducted into the Academy of Scholars, the highest honor for faculty at my university, and it is forcing me to think about my work and my purpose. While at first I feel intimidated at the thought of standing before them and speaking about myself, maybe this is precisely what I need to do at this point

in my life. Isn't this what struck me so powerfully that night I gave a talk to a crowd at a local art museum, the thing I had held out for, put off seeing a doctor for, thought would show me who I am? What was that hollow feeling about as I stood listening to the applause? This reckoning has been a long time coming. The doctors may not have asked me who I am, but this group is asking me precisely that. I must grow into myself. The sense that I can is a kind of liberation.

I see more clearly the fierce loyalty and sense of responsibility in Greg, who blamed himself for my choices when they turned out badly. When we went to a sauna, I warned him I might faint from the heat and that he couldn't freak out or take responsibility for it. I did faint, just for a second, while on the floor with my head down, but he was fine and I was fine. We knew a potter who lived in Detroit his whole life. His wife had family in California, and after they retired, they moved there, but he died of heart failure within a few months. I said to Greg, "The move must have been too difficult a transition for him." Greg responded, "But he accomplished getting his wife settled where she wanted to be before he died." I could only gaze at my husband in awe and wonder.

Friends, students, and people I hardly knew surprised me by texting and emailing, by sending cards and gifts, bringing over chicken soup or full meals. My brother sent emails without fail every week and often made me laugh, reviving a closeness that brought back memories of when we were young. I am grateful and humbled and strengthened by all the love and care and concern of other people.

But Rachel's reaction to my post on Facebook announcing that I was cancer-free brought tears to my eyes. "Mama, the warrior!" she wrote. I hadn't failed her.

Conclusion

Personal trauma, such as a serious health crisis, threatens to turn us inward, cutting us off from the world and keeping us focused on our emplaced and embodied experience. But even in such dire circumstances, the inheritance of the past continues to shape and inflect our responses. To understand who we are, we must tell our own stories, and remembering those stories is a way of discovering new meaning about the past and altering our sense of ourselves. Just as body is continuous with mind, so is personal memory continuous with collective memory and past continuous with present, each mediating the other and making memory, identity, and culture subject to change and transformation under changing personal and historical circumstances. The memory of trauma across generations can be productively mobilized.

Looking for the past in the landscape, in structures preserved or transformed, in memorials, in photographs, in places our parents yearned to see but never did, we return to places of memory to touch the past, sometimes as an act of mourning, trying to see what cannot be seen, to glean new insight through embodied awareness, to better understand the nature of the experience of others. The fluid dynamics of remembering, which produce new forms of knowledge, not only uncover what has been denied or forgotten but evoke empathy—seeing through another's eyes—that contributes to the possibility of social change. We remember the atrocities suffered, the resistance against the odds, the resilience of those who survived. Their resilience strengthens our own and helps transform mourning and nostalgia into activist memory for political struggle against persecution, violence, and inequality.

Ongoing cultural remembering produced through museums, memorials, texts, and photographs plays a critical role in this process. These cultural

technologies allow us to insert ourselves into larger histories; they not only become vehicles by which we remember the dead and give voice to those who were silenced, forgotten, or oppressed but also become a means of constructing moral consciousness. The memory of events that people did not themselves live through but which they are still able to experience in affective ways—what Alison Landsberg calls "prosthetic memory"—is not bound by class, race, ethnicity, gender, era, or geography, and therefore "has the ability to challenge the essentialist logic of many group identities." Such memory does not erase difference but allows for social and political recognition of radically different backgrounds, for "ethical thinking" beyond one's own immediate circumstances.[1]

Thus the memory of lynching and racial violence, genocide, and gender inequality is capable of galvanizing organized political struggle that challenges the massive economic and social disparities under which we continue to labor and the rapacious, profit-driven capitalist system that produces and justifies these conditions as "normal." If the point of activist memory is to inspire struggle for a future where everyone is free and equal, remembering histories of subjugation and oppression in the past becomes crucial to political struggle for social justice in the present.

Despite what has been called the "crisis" of Marxism and a retrogression of class consciousness over the past several decades, the rise of memory studies in this period indicates that the impulse for social justice cannot be stifled.[2] The vision of an egalitarian society has been battered but a rational society organized around a collectivized economy is still our best hope for the future. The alternative is enormous inequality and global ecological devastation. It was a hundred years ago that the revolutionary Rosa Luxemburg made famous the slogan "socialism or barbarism,"[3] and it is still the order of the day, now more than ever, in a world wracked by systemic racism, exploitation, and the hoarding of wealth endemic to capitalism.

Acknowledgments

I am grateful to friends, family, and colleagues for their support and encouragement in the last few years, during which I experienced the unexpected health challenge I write about in the last chapter of this book. For reading an earlier version of that chapter, I thank Matthew Biro, Laura Crary, Beverly Fishman, the late Jeanne Graham, renée hoogland, Leslie Mitchner, Valerie Parks, Kay Perreault, Michelle Perron, Buzz Spector, Sarah Turner, Joan Weinstein, and especially Nancy Jones, who read the earliest draft and pushed me to go deeper. For reading other chapters at various stages, I thank John Corso Esquivel, Coco Fusco, Kathryn Goffnett, Buzz Spector, and Rachel Wittkopp for their helpful comments. For reading the entire manuscript, I am grateful to Andrea Mensch for her insights, and especially to the anonymous press reader whose generous and valuable suggestions helped make this a better book.

For offering support in other ways, I thank Danielle Aubert, Susan Aaron-Taylor, Iris Eichenberg, John Ganis, Ewa Harabasz, David Hochner, Sandra Schemske, Harry Taylor, Millee Tibbs, Tom Trombley, Michael Ashmore and the Wu Tai Chi Chuan Academy Ferndale, and the Apel and Wittkopp families. I thank my smart and hardworking students who, in various courses that engaged with some of this material, helped me to think harder about these subjects. I am also grateful to members of the Academy of Scholars, the Emeritus Academy, and the Humanities Center at Wayne State University where I presented talks related to this book.

I thank my editor, Nicole Solano, for her fulsome enthusiasm, encouragement, and support, everyone on production, and the whole RUP team for their conscientious work and professionalism.

For helping to fund this project, at Wayne State University I thank Walter Edwards, director of the Humanities Center, which provided a Humanities Center Faculty Fellowship as well as travel funds to Israel-Palestine. For

subvention funds, I thank Stephen Lanier, vice president for Research; Dean Matthew Seeger and the College of Fine, Performing and Communication Arts; and Brian Kritzman, interim chair of the James Pearson Duffy Department of Art and Art History. The W. Hawkins Ferry Research Fund also provided travel monies.

Special thanks to my brother, Max Apel, for his love and kindness, his constancy through a long period of treatment, and for his support of my work despite our differences. As always, I am immensely grateful to Gregory Wittkopp, my partner in life and always my first reader, who has challenged and fortified me throughout and helped make this book possible, and to our daughter, Rachel Apel Wittkopp, who keeps me on my toes.

A shorter version of "Hands Up, Don't Shoot" first appeared in *Theory and Event* 17, no. 3 (2014), in a special issue on "Ferguson and the Tragic Presence of the Past." A shorter version of "A Memorial for Walter Benjamin" first appeared in *Bridge* 2, no. 1 (2002) as "Reflections on *Passages: Homage to Walter Benjamin*, 1990–1994." The poem "December Rain" is reprinted with permission from Buzz Spector. Unless otherwise credited, photographs were taken by me.

Notes

Introduction

1 Walter Benjamin, "Theses on the Philosophy of History, (1940)" in *Illuminations*, trans. Harry Zohn (New York: Schocken Books, 1969), 249. The Klee drawing is dated 1920.

2 See *Buzz Spector: Shelf Life: Selected Work* (Saint Louis: Bruno David Gallery, 2010), which includes essays by Buzz Spector, Garrett Stuart, and myself.

3 Jens Brockmeier, "After the Archive: Remapping Memory," *Culture and Psychology* 16, no. 1 (2010): 10.

4 Brockmeier, "After the Archive." Also see Lucy Bond, Stef Craps, and Pieter Vermeulen, eds., *Memory Unbound: Tracing the Dynamics of Memory Studies* (New York: Berghahn Books, 2016), who, in their introduction, structure their volume into four different categories: transgenerational memory, transcultural memory, transmedial memory, and transdisciplinary memory.

5 Aleida Assmann and Sebastian Conrad, eds., introduction to *Memory in a Global Age: Discourses, Practices and Trajectories*, Palgrave Macmillan Memory Studies (New York: Palgrave Macmillan, 2010).

6 Assmann and Conrad, introduction to *Memory in a Global Age*, 9.

7 This is in part the result of the twenty-five-year project Getting Word, an oral history archive for descendants of Thomas Jefferson's enslaved laborers, which includes some four hundred people. See Andrew M. Davenport, "Putting Enslaved Families' Stories Back in the Monticello Narrative," *Smithsonian Magazine*, June 14, 2018, www.smithsonianmag.com. Jefferson enslaved four hundred people at Monticello and two hundred at other properties. Monticello also organized the traveling exhibition *Visiting Slavery at Jefferson's Monticello: Paradox of Liberty*.

8 Brockmeier, "After the Archive," 22.

9 Assmann and Conrad, introduction to *Memory in a Global Age*, 9–10.

10 Ann Rigney, "Remembrance as Remaking: Memories of the Nation Revisited," *Nations and Nationalism* 24, no. 2 (2018): 251, 253.

11 "Race and Cultural Landscapes: A Conversation with W. Fitzhugh Brundage," The Cultural Landscape Foundation, Nov. 22, 2017, tclf.org.

12 See Nellie Bowles, "As Birthrates Fall, Fearing 'Replacement' on Far Right," *New York Times*, March 19, 2019; and David Futrelle, "The 'Alt-Right' Is Fueled by Toxic Masculinity—And Vice-Versa," NBC News, April 1, 2019, www.nbcnews.com.

13 Fabiana Franco, "Childhood Abuse, Complex Trauma and Epigenetics," Psych Central, October 30, 2018, psychcentral.com; Olga Khazan, "Inherited Trauma Shapes Your Health," *The Atlantic*, October 16, 2018, www.atlantic.com.

14 See Antonio Traverso and Mick Broderick, "Interrogating Trauma: Towards a Critical Trauma Studies," *Continuum: Journal of Media and Cultural Studies* 24, no. 1 (February 2010): 7. The prevailing conventional psychoanalytic theory of subjective dissociation has been subject to much debate in recent years in an attempt to define and broaden ideas of psychological versus cultural trauma, leading to numerous theories and concepts of trauma. For an early seminal text, see Cathy Caruth, ed., *Trauma: Explorations in Memory* (Baltimore: Johns Hopkins Press, 1995). For more recent studies, see Monica J. Casper and Eric Wertheimer, eds., *Critical Trauma Studies: Understanding Violence, Conflict and Memory in Everyday Life* (New York: New York University Press, 2016).

15 See Esther Katz and Joan Miriam Ringelheim, *Proceedings of the Conference on Women Surviving the Holocaust* (New York: Institute for Research in History, 1983); and Dalia Ofer and Lenore J. Weitzman, eds., *Women in the Holocaust* (New Haven: Yale University Press, 1998).

16 See, for example, the insightful analysis of literary scholar Sara Horowitz, "Gender, Genocide, and Jewish Memory," *Prooftexts* 20, nos. 1 & 2 (2000): 158–190.

17 See Zoë Waxman, *Women in the Holocaust: A Feminist History* (Oxford: Oxford University Press, 2017); Sonja M. Hedgepeth and Rochelle G. Saidel, eds., *Sexual Violence against Jewish Women during the Holocaust* (Boston: Brandeis University Press, 2010).

18 See, for example, Crystal Feimster's *Southern Horrors: Women and the Politics of Rape and Lynching* (Cambridge: Harvard University Press, 2009), and Evelyn Simien, ed., *Gender and Lynching: The Politics of Memory* (New York: Palgrave Macmillan, 2011).

19 Janet Donohoe, *Remembering Places: A Phenomenological Study of the Relationship between Memory and Place* (Lanham, Md.: Lexington Books, 2014).

20 From a Q & A session on December 10, 1986, after a National Press Club lecture, in the film *I Am Not Your Negro* (released in the United States in 2017).

Chapter 1 A Memorial for Walter Benjamin

1 Ed Rothstein, "CONNECTIONS; A Daring Theory That Stalin Had Walter Benjamin Murdered," *New York Times*, June 30, 2001; see also Stuart Jeffries, "Did Stalin's Killers Liquidate Walter Benjamin?" *The Guardian*, July 8, 2001, www.theguardian.com.

Chapter 2 "Hands Up, Don't Shoot"

1 Trymaine Lee, "Iconic Michael Brown Memorial Torn Down," MSNBC, July 20, 2015, www.msnbc.com.

2 See Mirjam Klaassens, Peter Groote, and Vincent Breen, "Roadside Memorials; Public Places of Private Grief," November 22, 2007, unpublished paper presented at URSI research conference, researchgate.net, and Ann Collins and Alexandra Opie, "When Places Have Agency: Roadside Shrines as Traumascapes," *Continuum: Journal of Media & Cultural Studies* 24, no. 1 (February 2010): 107–118.

3 "Michael Brown's Family Receives $1.5 Million Settlement in Wrongful Death Lawsuit," CBS News, June 23, 2017, www.cbsnews.com.

4 Martin A. Berger, *Seeing through Race: A Reinterpretation of Civil Rights Photography* (Berkeley: University of California Press, 2011).

5 Berger, *Seeing through Race*, 8.

6 Berger, *Seeing through Race*, 159–160.

7 Julie Bosman and Joseph Goldstein, "Timeline for a Body: 4 Hours in the Middle of a Ferguson Street," *New York Times*, August 24, 2014.

8 Ryan J. Reilly, "Edward Crawford, Man in Iconic Ferguson Photo, Found Dead amid Plea Deal Negotiation," *Huffpost*, May 5, 2017, www.huffingtonpost.com.

9 Associated Press, "Deaths of Six Men Tied to Ferguson Protests Alarm Activists," NBC News, March 17, 2019, nbcnews.com.

10 Crawford's family and friends also wonder if his death was accidental or linked to the series of inexplicable deaths of young black men who had been active in the Ferguson protests, though no connection has been found. Email to author from St. Louis Post-Dispatch photographer Robert Cohen, November 6, 2018.

11 Trymaine Lee, "Death of Ferguson Protester Edward Crawford Highlights Struggle to Live Free," NBC News, May 5, 2017, nbcnews.com.

12 Associated Press, "Death of Six Men Tied to Ferguson Protests Alarm Activists."

13 Robert Bridge, "How America's War on Drugs Turned Ferguson into a War Zone," *RT*, April 19, 2014, http://rt.com; "Paramilitary Police: Cops or Soldiers?" *The Economist*, March 20, 2014, www.economist.com.

14 Quote and image at DeRay Mckesson, "My Blackness Is Not a Weapon," *Medium*, August 23, 2014, https://medium.com/@deray/my-blackness-is-not-a-weapon-3383056faf3d; Mckesson wrote *On the Other Side of Freedom: The Case for Hope* (New York: Penguin Random House, 2018), about his life as a Black Lives Matter organizer.

15 Ahiza Garcia, "Ben Stein: Michael Brown Was 'Armed with His Incredibly Strong, Scary Self,'" *TPM Livewire*, August 29, 2014.

16 Adam Gabbett, "*Whose Streets?* Powerful Ferguson Film Focuses on Flashpoint Moments," *The Guardian*, August 11, 2017, www.theguardian.com. A second documentary film, "Stranger Fruit," directed by Jason Pollock, was shown at the SXSW film festival and released in 2018. See Anita Busch, "'Stranger Fruit' Trailer: Documentary about Ferguson Shooting of Michael Brown," *Deadline Hollywood*, March 27, 2018, deadline.com.

Chapter 3 Why We Need a National Lynching Memorial

1 Jill Lepore, "The Face of Battle," chap. 8 in *These Truths: A History of the United States* (New York: W.W. Norton Co., 2018), Kindle.

2 On the removal of the Sims statue in New York City, see Vanessa Cuervo Forero, "Not What's Broken; What's Healed: Women in El Barrio and the Healing Power of Community," in *Controversial Monuments and Memorials: A Guide for Community Leaders*, ed. David B. Allison (New York: Rowman & Littlefield, 2018), 232–238. For more on Sims's medical experiments, see Sara Spettel and Mark Donald White, "The Portrayal of J. Marion Sims' Controversial Surgical Legacy," *The Journal of Urology* 185 (2011), www.urologichistory .museum.

3 Equal Justice Initiative, *Slavery in America: The Montgomery Slave Trade* (Montgomery, Ala.: Equal Justice Initiative, 2018), 70–71; see also *Segregation in America* (Montgomery, Ala.: Equal Justice Initiative, 2018), and *Lynching in America:*

Confronting the Legacy of Racial Terror, 3rd ed. (Montgomery, Ala.: Equal Justice Initiative, 2017), www.eji.org.

4 In January 2019, an Alabama circuit judge struck down the law, saying it violated the fourteenth amendment addressing citizenship rights. The state attorney general appealed the ruling and the law was upheld by the Alabama Supreme Court.

5 Lepore, introduction to *These Truths*, Kindle.

6 Lepore, "A Democracy of Numbers," chap. 5 in *These Truths*, Kindle.

7 Lepore, "Of Citizens, Persons, and People," chap. 9 in *These Truths*, Kindle.

8 Claudia Rankine, "The Condition of Black Life Is One of Mourning," *New York Times Magazine*, June 22, 2015.

9 In another refusal of a redemptive narrative, artist Fred Wilson raised the issue of enslavement and its repressed museum presence in his pivotal exhibition *Mining the Museum* at the Maryland Historical Society in 1992. Wilson set up chilling juxtapositions of objects in the galleries that challenged the museum's basic display categories. Instead of a historical chronology, the museum presented, for example, slave-made silver repoussé vessels and elegant nineteenth-century armchairs under the rubrics of "metalworking" and "woodworking." Wilson added slave shackles to the vessels and a whipping post to the armchairs, unmasking the way museums occlude the effects of colonization and slavery and conform to dominant white perspectives.

10 Dora Apel, "Memorialization and Its Discontents: America's First Lynching Memorial," Special Issue on Lynching and American Culture, *Mississippi Quarterly: The Journal of Southern Cultures* 61, nos. 1/2 (Winter–Spring 2008): 217–235; see also Erika Doss, *Memorial Mania: Public Feeling in America* (Chicago: University of Chicago Press, 2010), and claytonjacksonmcghie.org.

11 John Myers, "Duluth Soil Heading to National Lynchings Memorial," *Duluth News Tribune*, September 17, 2017, www.duluthnewstribune.com; Evan Frost, "Minnesota Residents Travel to View Lynching Memorial," AP, May 19, 2018, apnews.com.

12 For a thoughtful review of the museum and lynching memorial, see Jason Morgan Ward, "The Legacy Museum: From Enslavement to Mass Incarceration; the National Memorial for Peace and Justice," *American Historical Review* 123, no. 4 (October 2018): 1271–1272.

13 I am borrowing the phrase from Anne Oliver, "Trauma, Bodies, and Performance Art: Toward an Embodied Ethics of Seeing," *Continuum: Journal of Media & Cultural Studies* 24, no. 1 (February 2010): 119–129.

14 EJI, *Lynching in America*, 66–67.

15 Linda Matchan, "Bearing Witness to Slavery: A Sculpture's Trans-Atlantic Passage from Ghana to Alabama," *Boston Globe*, May 30, 2018, www.bostonglobe.com.

16 Holland Cotter, "A Memorial to the Lingering Horror of Lynching," *New York Times*, June 1, 2018, nytimes.com.

17 Sam Levin, "Lynching Memorial Leaves Some Quietly Seething: 'Let Sleeping Dogs Lie,'" *The Guardian*, April 28, 2018, www.theguardian.com.

18 Levin, "Lynching Memorial Leaves Some Quietly Seething."

19 Sarah Lewis, "Truth and Reconciliation: Bryan Stevenson in Conversation with Sarah Lewis," *Aperture* 230 (Spring 2018), aperture.org.

20 Martin Beck Matuštík, "Future's Past: A Conversation about the Holocaust with Gabriele M. Schwab," in *Critical Trauma Studies: Understanding Violence, Conflict, and Memory in Everyday Life*, ed. Monica J. Casper and Eric Wertheimer (New York: New York University Press, 2016), 122–123.

21 With all of the people to whom I spoke, I didn't ask their names, hoping for greater candor.

22 Pierre Nora, "Realms of Memory," in *Memory*, ed. Ian Farr, Documents of Contemporary Art (1984; repr., Cambridge: MIT Press, 2012), 61–66.

23 Levin, "Lynching Memorial Leaves Some Quietly Seething."

24 Lewis, "Truth and Reconciliation."

25 Rebecca Solnit, "The American Civil War Didn't End. And Trump Is a Confederate President," *The Guardian*, November 4, 2018, www.theguardian.com.

26 Richard Fausset, "Embodiment of a Racist Past, Etched Across 3 Acres of Granite," *New York Times*, October 21, 2018, 16.

27 American Historical Association, "AHA Statement on Confederate Monuments (August 2017)," www.historians.org.

28 Thomas R. Seabrook, "Tributes to the Past, Present, and Future: World War I Era Confederate Memorialization in Virginia," in *Controversial Monuments and Memorials*, 66–69.

29 Seabrook, "Tributes to the Past, Present, and Future," 69–73.

30 Cited by Dave Gilson, "You Can't Understand White Supremacists Without Looking at Masculinity," *Mother Jones*, July/August 2018, www.motherjones.com.

31 See, for example, the Southern Poverty Law Center website discussion on Male Supremacy, www.splcenter.org.

32 For a persuasive argument on how antisemitism forms the theoretical core of white nationalism, see Eric K. Ward, "Skin in the Game: How Antisemitism Animates White Nationalism," *Political Research Associates*, June 29, 2017, politicalresearch .org.

33 Erin Murphy, "Rep. Steve King: 'I Know I Can't Certify that We're Not Part of a Product of Rape and Incest,'" *Journal Des Moines Bureau*, August 14, 2019, siouxcityjournal.com.

34 Seabrook, "Tributes to the Past, Present, and Future." See also Julian C. Chambliss, "Don't Call Them Memorials," in *Controversial Monuments and Memorials*, 79–82, and the excellent study on the development of monuments in Kirk Savage, *Standing Soldiers, Kneeling Slaves: Race, War, and Monuments in Nineteenth-Century America* (Princeton: Princeton University Press, 1997).

35 Lewis Hyde, "Myth," notebook 1 in *A Primer for Forgetting: Getting Past the Past* (New York: Farrar, Straus and Giroux, 2019), Kindle.

36 See Abigail Gillman, "Cultural Awakening and Historical Forgetting: The Architecture of Memory in the Jewish Museum of Vienna and in Rachel Whiteread's 'Nameless Library,'" *New German Critique* 93 (Fall 2004): 145–163.

37 Blood libel is the scurrilous accusation that Jews murdered Christian children in order to use their blood in religious rituals, such as the making of matzo.

38 James Young, *The Stages of Memory: Reflections on Memorial Art, Loss, and the Spaces Between* (Amherst: University of Massachusetts Press, 2016), 4–6.

39 Pankaj Mishra, "The Religion of Whiteness Becomes a Suicide Cult," *New York Times*, September 2, 2018.

40 Mishra, "The Religion of Whiteness."

41 See Roger Daniels, *Coming to America: A History of Immigration and Ethnicity in American Life*, 2nd ed. (New York: Harper Perennial, 2002).

42 Jacey Fortin, "'Access to Literacy' Is Not a Constitutional Right, Judge in Detroit Rules," *New York Times*, July 4, 2018.

43 Morgan Jerkins, "The Important Conversation about Sandra Bland's Death No One Is Having," The Daily Dot, August 10, 2015, www.dailydot.com.

44 David A. Graham, "Sandra Bland and the Long History of Racism in Waller County, Texas," *The Atlantic*, July 21, 2015, www.theatlantic.com. For the EJI report, see lynchinginamerica.eji.org/report.

45 Paula Rogo, "Napping While Black? White Yale Student Called Cops on Black Student Sleeping in Common Room," *Essence*, May 10, 2018, www.essence.com.

46 Krissah Thompson, "Arrest of Harvard's Henry Louis Gates, Jr. Was Avoidable, Report Says," *Washington Post*, June 30, 2010, www.washingtonpost.com.

47 Jennifer Rubin, "Why Trump Had to Be Badgered to Condemn Neo-Nazis," *Washington Post*, August 14, 2017, www.washingtonpost.com.

48 Philip Bump, "The Fix: In 1927, Donald Trump's Father Was Arrested after a Klan Riot in Queens," *Washington Post*, February 29, 2016, www.washingtonpost.com.

49 See Alex Ross, "How American Racism Influenced Hitler," *New Yorker*, April 30, 2018, www.newyorker.com.

50 Edward Said, "Invention, Memory, and Place," *Critical Inquiry* 26, no. 2 (Winter 2000): 185.

51 Dora Apel, "Violence and Historical Reenactment: From the American Civil War to the Moore's Ford Lynching," in *Violence and Visibility in Modern History*, ed. Juergen Martschukat and Silvan Niedermeier (New York: Palgrave Macmillan, 2013), 241–261.

52 Quoted in Jennifer Schuessler, "Historians Question Trump's Comments on Confederate Monuments," *New York Times*, August 15, 2017.

Chapter 4 "Let the World See What I've Seen"

1 This is a widely cited quote. See Martin A. Berger, *Seeing Through Race: A Reinterpretation of Civil Rights Photography* (Berkeley: University of California Press, 2011); also Maurice Berger, *For All the World to See: Visual Culture and the Struggle for Civil Rights* (New Haven: Yale University Press, 2010).

2 See my "Lynching Photographs and the Politics of Public Shaming," in *Lynching Photographs* with Shawn Michelle Smith (Berkeley: University of California Press, 2008).

3 Christopher Metress, "Literary Representations of the Lynching of Emmett Till: An Annotated Bibliography," in *Emmett Till in Literary Memory and Imagination*, ed. Harriet Pollack and Christopher Metress (Baton Rouge: Louisiana State University Press, 2008), 223–250.

4 Federal authorities ordered the exhumation, partly in response to Keith Beauchamp's film, to search for new evidence because an autopsy had never been done, and to confirm that it was Till's body, which had only ever been questioned by his killers' lawyers.

5 Statement posted as part of a revised wall label in the Whitney gallery on March 28, 2017.

6 Jacob Zorn, "Black Liberation Struggle: The Key to American Socialist Revolution," *Workers Vanguard*, February 8, 2019.

7 David Wellman, quoted in Robin DiAngelo, *White Fragility: Why It's So Hard for White People to Talk about Racism* (Boston: Beacon Press, 2018), 24.

8 Zorn, "Black Liberation Struggle."

9 The full text of the letter and its signatories can be found online at e-flux conversations, "Hannah Black's Letter to the Whitney Biennial's Curators: 'The Painting Must Go,'" March 2017, https://conversations.e-flux.com.

10 Crystal N. Feimster, *Southern Horrors: Women and the Politics of Rape and Lynching* (Cambridge: Harvard University Press, 2009), 221–233. In 2005, the U.S. Congress belatedly passed a resolution apologizing for its failure to pass antilynching legislation and apologizing to the families of lynching victims. The resolution was led by Democratic senator Mary Landrieu of Louisiana, who noted the work of the "extraordinarily brave journalist" Ida Wells-Barnett.

11 Antwaun Sargent, "Unpacking the Firestorm around the Whitney Biennial's 'Black Death Spectacle,'" *Artsy*, March 22, 2017, www.artsy.net.

12 Mamie Till Mobley and Christopher Benson, *Death of Innocence: The Story of a Hate Crime that Changed America* (2003), cited in Berger, *Seeing through Race*, 133.

13 Berger, *Seeing through Race*, 125–140.

14 Berger, *Seeing through Race*, 112.

15 Berger, *Seeing through Race*, 125–140.

16 David Halberstam quoted in Berger, *Seeing through Race*, 125–126.

17 Berger, *Seeing through Race*, 129.

18 Coco Fusco, "Censorship, Not the Painting, Must Go: On Dana Schutz's Image of Emmett Till," *Hyperallergic*, March 27, 2017, https://hyperallergic.com.

19 Cleve R. Wootson, Jr. and Sonia Rao, "Camille Cosby on Her Husband's Conviction: 'This Is Mob Justice, Not Real Justice,'" *Washington Post*, May 3, 2018. Carolyn Bryant Donham told Tyson that she was not truthful when she told the judge Till grabbed her, whistled, and made sexual advances, saying "Nothing that boy did could justify what happened to him." Quoted in Kirkus Reviews, January 31, 2017, www.kirkusreviews.com. In 2018, the U.S. Justice Department reopened the investigation into Till's death, saying they had "new information."

20 See, for example, Emma Coleman Jordan, "For Clarence Thomas, Lynching Is Personal. Only." *Washington Post*, October 14, 2007, washingtonpost.com.

21 Fusco, "Censorship, Not the Painting, Must Go."

22 Roberta Smith, "Should Art that Infuriates Be Removed?" *New York Times*, March 27, 2017.

23 "Arguably another artist, regardless of race, might have done justice to the Till images, but not one with Ms. Schutz's comic-grotesque vision and penchant for conflating heroes and villains." Roberta Smith, "Dana Schutz's New Paintings Just Might Be Her Best," *New York Times*, February 7, 2019, www.nytimes.com. In her initial response, Smith noted that Schutz often focused on suffering and traumatized bodies, such as Michael Jackson on an autopsy table, Terri Schiavo on life support, and Ukraine's former president Viktor Yushchenko with his face disfigured by poison. Smith, "Should Art that Infuriates Be Removed?"

24 Giuliani filed a court case against the museum, calling Ofili's work "sick" and "disgusting," and the museum filed a countersuit for breach of the first amendment, which it eventually won.

25 Fusco, "Censorship, Not the Painting, Must Go."

26 Coco Fusco, email to author, July 3, 2018.

27 Fusco, "Censorship, Not the Painting, Must Go"; Lisa Saltzman, "Negative Images: How a History of Shadows Might Illuminate the Shadows of History," in *Memory*, ed. Ian Farr, Documents of Contemporary Art (2006; repr., Cambridge: MIT Press, 2012), 192–199.

28 Quoted in Randy Kennedy, "White Artist's Painting of Emmett Till Draws Protests at Whitney Biennial," *New York Times*, March 21, 2017.

29 Aruna D'Souza, *"Open Casket*: Whitney Biennial, 2017," in *Whitewalling: Art, Race and Protest in 3 Acts* (New York: Badlands Unlimited, 2018), 15–63.

30 A jury acquitted the officer who shot Castile, Jeronimo Yanez, of all charges, and he later resigned from the force. Philando Castile was a thirty-two-year-old cafeteria supervisor at the J. J. Hill Montessori Magnet School in Minnesota and often helped the schoolkids by paying for their lunches. Three years after his death, his mother continued her son's legacy by donating $8,000 to a Minnesota high school to settle school lunch debts. See Shannon Van Sant, "Philando Castile's Mother Wipes Out School Lunch Debt, Continuing Son's Legacy," NPR, May 7, 2019, www.npr.org.

31 Sargent, "Unpacking the Firestorm."

32 A similar accusation was made against Diego Rivera when he was commissioned to paint murals in the United States and his critics in the Communist Party called him "a painter for millionaires." See my "Diego Rivera and the Left: The Destruction and Recreation of the Rockefeller Center Mural," *Left History* 6, no. 1 (Spring 1999): 57–75.

33 Amy Louise Wood and Susan V. Donaldson, "Introduction: Lynching's Legacy in American Culture," Special Issue on Lynching and American Culture, *Mississippi Quarterly: The Journal of Southern Cultures* 61, nos. 1/2 (Winter–Spring 2008): 5. See also my *Imagery of Lynching: Black Men, White Women, and the Mob* (New Brunswick: Rutgers University Press, 2004).

34 Allyson Hobbs, "The Power of Looking, from Emmett Till to Philando Castile," *New Yorker*, August 5, 2016, www.newyorker.com.

35 Aruna D'Souza, "Can White Artists Paint Black Pain?" CNN Opinion, March 24, 2017, www.cnn.com; quoted in Malcolm West, "Mamie Till-Mobley, Civil Rights Heroine, Eulogized in Chicago," *National Report*, January 27, 2003, www.highbeam.com.

36 Smith, "Should Art that Infuriates Be Removed?"

37 Fusco, "Censorship, Not the Painting, Must Go."

38 Likewise, the celebration of black achievement during Black History Month— while laudable in itself—tends to be separated from an overall social context and reinforces the idea that the other eleven months of the year are "white history," that white history is the norm for history and black contributions lie outside the norm. See Robin DiAngelo, *White Fragility: Why It's So Hard for White People to Talk about Racism* (Boston: Beacon Press, 2018), 26–27.

39 See Apel, "The Antilynching Exhibitions of 1935: Strategies and Constraints," chap. 3 in *Imagery of Lynching*; also Helen Langa, "Two Antilynching Art Exhibitions: Politicized Viewpoints, Racial Perspectives, Gendered Constraints," *American Art* 13, no. 1 (Spring 1999): 10–39.

40 André Breton and Leon Trotsky, "Manifesto: Towards a Free Revolutionary Art," in *Theories of Modern Art: A Sourcebook by Artists and Critics*, ed. Herschel B. Chipp (1938; repr., Berkeley: University of California Press, 1982), 483–486.

41 Anne Pasternak, "Brooklyn Museum: We Stand by Our Appointment of Dr. Kristen Windmuller-Luna as Consulting Curator of African Arts," *Brooklyn Reader*, April 6, 2018, www.bkreader.com.

42 Quoted in Carla Herreria, "People Want to Know Why Brooklyn Museum's New African Art Curator Is White," *Huffpost*, March 28, 2018, www.huffingtonpost.com.

43 Robin Pogrebin, "Cultivating Curators of Color," *New York Times*, August 9, 2018.

44 Chika Okeke-Agulu, "Outrage over Hiring a White Woman as African Art Curator Misunderstands Expertise," *Frieze*, April 18, 2018, https://frieze.com.

45 Greg Cook, "Prestigious Artist Group Defends ICA Exhibit by Artist behind Controversial Emmett Till Painting," *The ARTery*, August 10, 2017, www.wbur.org.

46 Quoted in an interview with Blake Morrison, "Sally Mann: The Naked and the Dead," *The Guardian*, May 28, 2010, www.theguardian.com. For a discussion of the Till photographs and their relation to geographical place and space, see Sandy Alexandre, "Mississippi Goddam: Emmett Till's Photographs and Geographic Identity," *The Properties of Violence: Claims to Ownership in Representations of Lynching* (Jackson: University Press of Mississippi, 2012).

47 Quoted in an interview with Maude Schuyler Clay, "Sally Mann's Vision," *Oxford American*, May 12, 2015, www.oxfordamerican.org; see also the penetrating essay by art historian Ayelet Carmi, "Sally Mann's American Vision of the Land," *Journal of Art Historiography* 17 (December 2017), 22–25.

Chapter 5 Seeing What Can No Longer Be Seen

1 Dylan Trigg, preface to *The Memory of Place: A Phenomenology of the Uncanny* (Athens: Ohio University Press, 2012), Kindle.

2 See www.dianamatar.com, and her book *Evidence* (Amsterdam: Shilt Publishing, 2014). The quote was on the wall of the exhibition *Traversing the Past: Adam Golfer, Diana Matar, Hrvoje Slovenc* at the Museum of Contemporary Photography, Columbia College Chicago in 2018.

3 Amelia Smith, "Photographer Diana Matar on Libya, Her Father-in-Law's Disappearance and Portraying Absence in Her Work," *Middle East Monitor*, October 22, 2014, www.middleeastmonitor.com.

4 Sean O'Hagan, "'The Cruelty Is in Everything': Photographing the Dead and Disappeared in Gaddafi's Libya," *The Guardian*, November 12, 2014, www .theguardian.com.

5 Diana Matar, "Periphery," wwwdianamatar.com/periphery#4; also *Source* magazine 56 (Autumn 2008).

6 Diana Matar, "Disappearance/Evidence" (2005–2012), www.dianamatar.com /disappearance#5.

7 Smith, "Photographer Diana Matar on Libya."

8 Diana Matar, "Evidence," *LensCulture*, www.lensculture.com, n.d.

9 See Henry Orenstein, *I Shall Live: Surviving the Holocaust 1939–1945* (New York: Beaufort Books, 1997), 117. Also, Barry Megdal, whose survivor father, Meyer Megdal, was in Hrubieszów until 1943, notes that his father recalled numerous mass graves in the cemetery. See "Hrubieszów: Lubelskie," International Jewish Cemetery Project, March 2005, iajgs.org.

10 Geneviève Zubrzycki, "Nationalism, 'Philosemitism,' and Symbolic Boundary-Making in Contemporary Poland," *Comparative Studies in Society and History* 58, no. 1 (2016): 66–98.

11 POLIN Museum of the History of Polish Jews, which held its grand opening of the core exhibition in 2014, narrates, documents, and researches a thousand-year history of Jews in Poland, producing conferences, publications, and the Virtual Shtetl website.

12 See Cnaan Liphshiz, "Polish Right-Wing Newspaper's Front Page Teaches 'How to Recognize a Jew,'" *Times of Israel*, March 14, 2019, www.timesofisrael.com.

13 See, for example, *Shivitti: A Vision* by Ka-Tzetnik 135633 (New York: Harper & Row, 1989). Ka-Tzetnk is derived from *ka tzet*, the pronunciation of KZ, which is the abbreviation for *Konzentrationslager*.

14 See "Auschwitz-Birkenau: The Revolt at Auschwitz-Birkenau (October 7, 1944)," Jewish Virtual Library, www.jewishvirtuallibrary.org.

15 For phenomenological analyses of memory and place, see Janet Donohoe, *Remembering Places: A Phenomenological Study of the Relationship between Memory and Place* (Lanham, Md.: Lexington Books, 2014), and Trigg, *The Memory of Place*.

Chapter 6 Borders and Walls

1 See Edward W. Said, "Invention, Memory, and Place," *Critical Inquiry* 26, no. 2 (Winter 2000): 175–192.

2 Quoted in Clelia Coussonnet, "Reversing Power, Allowing Possibilities: Yael Bartana in Conversation with Clelia Coussonnet," *Ibraaz*, January 22, 2017, www .ibraaz.org.

3 Bartana's 1:46 minute video is available on YouTube, http://www.youtube.com /watch?v=HsQf4TWGFvg.

4 *Mary Kozmary* (2007) is the first part of the trilogy *And Europe Will Be Stunned*, including *Wall and Tower* (2009) and *Assassination* (2011).

5 The 3:01 minute video is available on Fahed Halabi's website at https://www.fahed -halabi.de/work/video-art/.

6 For more on Arad's work, see https://boazarad.net, and my *War Culture and the Contest of Images* (New Brunswick: Rutgers University Press, 2012), 224–226. Arad committed suicide in 2018, after an Israeli newspaper reported a four-year consensual relationship that occurred twenty-five years earlier with a young woman who was his student for two of those years. His sister, Michal Arad, is working to clear his name with the help of his friends and former students. Emails from Michal Arad to author, July 9, 2019.

7 Arad's video, *Hebrew Lesson* (2000), is available on YouTube, https://www.youtube .com/watch?v=hw1XloTlK40. It was also in the controversial exhibition *Mirroring Evil* at the Jewish Museum in 2002.

8 The "anti-Jewish" charges were found to be baseless, but Abowd was denied tenure and his contract was not renewed. See his chapter, "The Boycott, Divestment and Sanctions Movement and Violations of Academic Freedom at Wayne State University," in *The Imperial University: Academic Repression and Scholarly Dissent*, eds. Piya Chatterjee and Sunaina Maira (Minneapolis: University of Minnesota Press, 2014; see also his book *Colonial Jerusalem: The Spatial Construction of Identity and Difference in a City of Myth, 1948–2012* (Syracuse, N.Y.: Syracuse University Press, 2014). Abowd currently teaches at Tufts University.

9 See my chapter "Art" in *The Oxford Handbook of Holocaust Studies*, ed. Peter Hayes and John K. Roth (Oxford: Oxford University Press, 2011), and my essay "Trespassing the Limits: *Mirroring Evil: Nazi Imagery/Recent Art* at the Jewish Museum" in *Other Voices: The (e)Journal of Cultural Criticism* 2, no. 3 (January 2005), www .othervoices.org.

10 For more on the complicated history of the evictions, see Oren Ziv, "After a Decade, Evictions Set to Return in Sheikh Jarrah," *+972*, December 3, 2018, 972mag.com, and Sarah Wildman, "Facing Evictions in Sheikh Jarrah," *New Yorker*, April 9, 2013, www.newyorker.com.

Chapter 7 Sprung from the Head

1 Elizabeth Leis-Newman, "Miscarriage and Loss," *American Psychological Association* 43, no. 6 (June 2012), www.apa.org.

2 André Aciman, "After Auschwitz," *Tablet*, March 24, 2016, www.tabletmag.com.

3 Michael D. Shear and Julie Hirschfeld Davis, "Shoot Migrants' Legs, Build Alligator Moat: Behind Trump's Ideas for Border," *New York Times*, October 2, 2019, nytimes.com.

4 A letter signed by hundreds of Holocaust scholars and academics from around the world, including me, was sent to the U.S. Holocaust Memorial Museum after it rejected the concentration camp designation by asserting that no possible analogies could be drawn to the Holocaust. "An Open Letter to the Director of the US Holocaust Memorial Museum" argues that this is a fundamentally ahistorical view. The letter was initiated by Andrea Orzoff, associate professor of history and honors at New Mexico State University, and Anika Walke, associate professor of history at Washington University in St. Louis, and was printed in major media outlets, including the *New York Review of Books*, www.nybooks.com.

5 Alicia Kroell, "Carmen Winant's Radical Images of Women Giving Birth," *Hyperallergic*, June 7, 2018, hyperallergic.com; see also *My Birth* by Carmen Winant, published by SPBH Editions, March 2018. I thank Marissa Gannascoli for calling my attention to this work.

6 Laura Regensdorf, "Artist Carmen Winant on Why 2,000 Images of Childbirth Belong at MoMA," *Vogue*, March 19, 2018, www.vogue.com.

7 Regensdorf, "Artist Carmen Winant."

8 Carmen Winant, "The Art of Birth," *Contemporary Art Review.la*, July 21, 2016, contemporaryartreview.la.

9 See Eliyana R. Adler, "Hrubieszów at the Crossroads: Polish Jews Navigate the German and Soviet Occupations," *Holocaust and Genocide Studies* 28, no. 1 (Spring 2014), 14. For accounts of the Death March, see Lazar Kahan, "Chelm Yizkor Book: The Slaughter of the Jews in Chelm," 1954, www.jewishgen.org/yizkor/chelm /che505.htm. These accounts suggest only a handful of survivors.

10 Henry Orenstein, *I Shall Live: Surviving the Holocaust, 1939–1945* (New York: Beaufort Books, 1997), 127–128.

11 Nicole Ephgrave, "On Women's Bodies: Experiences of Dehumanization During the Holocaust," *Journal of Women's History* 28, no. 2 (2016): 12–32.

Chapter 8 Parallel Universes

1 James Young, "Germany's Memorial Question: Memory, Counter-Memory, and the End of Monuments," *South Atlantic Quarterly* 96., no. 4 (1997): 855; Lewis Hyde, *A Primer for Forgetting: Getting Past the Past* (New York: Farrar, Straus and Giroux, 2019), 280.

2 "Where Do Americans Die?" in Palliative Care, Stanford School of Medicine, 2020, palliative.stanford.edu.

3 André Aciman, "After Auschwitz," *Tablet*, March 24, 2016, www.tabletmag.com.

Chapter 9 Reclaiming the Self

1 In addition to self-portrait photographs, Wilke produced sculptures made of medical paraphernalia, watercolor self-portraits, thirty hours of videotape, and drawings made with hair lost because of chemotherapy, producing a kind of "public reliquary of her person." See Tamar Tembeck, "Exposed Wounds: The Autopathographies of Hannah Wilke and Jo Spence," *RACAR* 33, nos. 1/2 (2008): 91; see also Nancy Princenthal, *Hannah Wilke* (New York: Prestel Verlag, 2010), and Saundra Goldman, "Gesture and the Regeneration of the Universe," in *Hannah Wilke:*

A Retrospective, exhibition catalog (Copenhagen: Nikolaj Contemporary Art Center, 1998). Wilke worked with the help of her partner and husband Donald Goddard (they married a month before she died).

2 Mark Johnson, *The Aesthetics of Meaning and Thought: The Bodily Roots of Philosophy, Science, Morality, and Art* (Chicago: University of Chicago Press, 2018), 203.

3 Torkild Thanem and David Knights, introduction to *Embodied Research Methods* (Thousand Oaks, Calif.: Sage Publications, 2019), Kindle.

4 Among the few artists who have represented illness are Goya and Géricault, who painted the effects of insanity or syphilis in the nineteenth century, but, like most representations of illness in the history of art, their work conveyed an overriding sense of the abject. Artists have rarely represented mortal illness using their own afflicted bodies as their subject. Among these are British photographer Jo Spence, who produced a photographic series on her breast cancer treatment (*The Picture of Health?*) and a second series on the return of cancer in the form of lymphoma (*The Final Project*); and Canadian painter Robert Pope, who made a series of paintings about his experience as a patient with Hodgkin's disease before dying at the age of thirty-four. See also the photographic self-portrait *Beauty out of Damage* by Matuschka on the cover of the Sunday Magazine section of the *New York Times* from August 13, 1993, in which she wears a white dress designed to expose the scar left by her amputated breast due to breast cancer, found at www .beautyoutofdamage.com.

5 Princenthal, *Hannah Wilke*, 8.

6 Tembeck, "Exposed Wounds."

7 Tina Takemoto, "Looking through Hannah's Eyes: Interview with Donald Goddard," *Art Journal* 67, no. 2 (2008): 132. Here the title is given as "Cured" but Nancy Princenthal and others give it as "Cure." The catalog for the posthumous exhibition was *Intra-Venus* (New York: Ronald Feldman Fine Arts, 1995) and included an essay by Amelia Jones, "Intra-Venus and Hannah Wilke's Feminist Narcissism."

8 Joanna Frueh, *Erotic Faculties* (Berkeley: University of California Press, 1996), 150.

9 Hannah Wilke, "Seura Chaya," *New Observations*, June 1988; quoted in Princenthal, *Hannah Wilke*, 99.

10 Amelia Jones, "The 'Eternal Return': Self-Portrait Photography as a Technology of Embodiment," *Signs* 27, no. 4 (Summer 2002): 947–978; Princenthal, *Hannah Wilke*, 150–153.

11 Tembeck, "Exposed Wounds," 87–101.

12 Richard Vine, "Hannah Wilke at Ronald Feldman—New York, New York— Review of Exhibitions," *Art in America*, May 1994, Bnet Research Center, web .archive.org.

Chapter 10 The Care of Others

1 On traumatic doubling, see Cathy Caruth, "An Interview with Robert Jay Lifton," in *Trauma: Explorations in Memory*, ed. Cathy Caruth (Baltimore: Johns Hopkins Press, 1995), 137.

2 See, for example, Harriet A. Washington, *Medical Apartheid: The Dark History of Medical Experimentation on Black Americans from Colonial Times to the Present* (New York: Random House, 2008).

Conclusion

1 Alison Landsberg, *Prosthetic Memory: The Transformation of American Remembrance in the Age of Mass Culture* (New York: Columbia University Press, 2004), 8–9.

2 On the crisis of Marxism, see Enzo Traverso, *Left-Wing Melancholia: Marxism, History, and Memory* (New York: Columbia University Press, 2016); for a Trotskyist program of political struggle, see *Workers Vanguard* and other publications of the International Communist League (Fourth International), www.icl-fi.org.

3 The slogan was based on the writing of Karl Kautsky in *The Erfurt Program: A Discussion of Fundamentals* (1892) before he became a socialist renegade: "As things stand today capitalist civilization cannot continue; we must either move forward into socialism or fall back into barbarism."

Selected Bibliography

Aciman, André. "After Auschwitz." *Tablet*, March 24, 2016. www.tabletmag.com.

Adler, Eliyana R. "Hrubieszów at the Crossroads: Polish Jews Navigate the German and Soviet Occupations." *Holocaust and Genocide Studies* 28, no. 1 (Spring 2014): 1–30.

Alexandre, Sandy. *The Properties of Violence: Claims to Ownership in Representations of Lynching.* Jackson: University Press of Mississippi, 2012.

Allison, David B., ed. *Controversial Monuments and Memorials: A Guide for Community Leaders.* New York: Rowman & Littlefield, 2018.

American Historical Association. "AHA Statement on Confederate Monuments (August 2017)." www.historians.org.

Apel, Dora. *Imagery of Lynching: Black Men, White Women, and the Mob.* New Brunswick: Rutgers University Press, 2004.

———. "Art." In *The Oxford Handbook of Holocaust Studies*, edited by Peter Hayes and John K. Roth, 461–467. Oxford: Oxford University Press, 2011.

———. "Memorialization and Its Discontents: America's First Lynching Memorial." Special Issue on Lynching and American Culture. *Mississippi Quarterly: The Journal of Southern Cultures* 61, nos. 1/2 (Winter–Spring 2008): 217–236.

———. "Violence and Historical Reenactment: From the American Civil War to the Moore's Ford Lynching." In *Violence and Visibility in Modern History*, edited by Juergen Martschukat and Silvan Niedermeier, 241–261. New York: Palgrave Macmillan, 2013.

Apel, Dora, and Shawn Michelle Smith. *Lynching Photographs.* Berkeley: University of California Press, 2008.

Assmann, Aleida and Sebastian Conrad, eds. Introduction to *Memory in a Global Age: Discourses, Practices and Trajectories.* New York: Palgrave Macmillan, 2010.

Baer, Elizabeth R. and Myrna Goldenberg, eds. *Experience and Expression: Women, the Nazis, and the Holocaust.* Detroit: Wayne State University Press, 2003.

Berger, Martin A. *Seeing through Race: A Reinterpretation of Civil Rights Photography.* Berkeley: University of California Press, 2011.

Birke, Lynda. *Feminism and the Biological Body.* New Brunswick: Rutgers University Press, 2000.

Black History and the Class Struggle, no. 24. A Spartacist Pamphlet. New York: Spartacist Publishing Co., 2014. https://archive.org/details/black_history_24/page/n11/mode/2up.

Bock, Charles. *Alice & Oliver.* New York: Random House, 2016.

Breton, André and Leon Trotsky. "Manifesto: Towards a Free Revolutionary Art." 1938. Reprinted in *Theories of Modern Art: A Sourcebook by Artists and Critics*, edited by Herschel B. Chipp, 483–486. Berkeley: University of California Press, 1982.

Brockmeier, Jens. "After the Archive: Remapping Memory." *Culture and Psychology* 16, no. 1 (2010): 5–35.

Brodsky, Joyce. "Painful Viewing: Hannah Wilke and Susan Sontag." In *Bodies in the Making: Transgressions and Transformations*, edited by Nancy N. Chen and Helene Moglen. Santa Cruz: New Pacific Press, 2006.

Carmi, Ayelet. "Sally Mann's American Vision of the Land." *Journal of Art Historiography* 17 (December 2017): 22–25.

Caruth, Cathy, ed. *Trauma: Explorations in Memory*. Baltimore: Johns Hopkins Press, 1995.

Chambliss, Julian C. "Don't Call Them Memorials." In *Controversial Monuments and Memorials: A Guide for Community Leaders*, edited by David B. Allison, 79–82. New York: Rowman & Littlefield, 2018.

Clay, Maude Schuyler. "Sally Mann's Vision." *Oxford American*, May 12, 2015. www .oxfordamerican.org/item/581-sally-mann-s-vision.

Collins, Ann and Alexandra Opie. "When Places Have Agency: Roadside Shrines as Traumascapes." *Continuum: Journal of Media & Cultural Studies* 24, no. 1 (February 2010): 107–118.

Cook, Greg. "Prestigious Artist Group Defends ICA Exhibit by Artist behind Controversial Emmett Till Painting." *The ARTery*, August 10, 2017. www.wbur.org.

Coussonnet, Clelia. "Reversing Power, Allowing Possibilities: Yael Bartana in Conversation with Clelia Coussonnet." *Ibraaz*, January 22, 2017. www.ibraaz.org.

Daniels, Roger. *Coming to America: A History of Immigration and Ethnicity in American Life*. 2nd ed. New York: Harper Perennial, 2002.

DiAngelo, Robin. *White Fragility: Why It's So Hard for White People to Talk about Racism*. Boston: Beacon Press, 2018.

Donohoe, Janet. *Remembering Places: A Phenomenological Study of the Relationship between Memory and Place*. Lanham, Md.: Lexington Books, 2014.

Doss, Erika. *Memorial Mania: Public Feelings in America*. Chicago: University of Chicago Press, 2010.

Dray, Philip. *At the Hands of Persons Unknown: The Lynching of Black America*. New York: Random House, 2002.

D'Souza, Aruna. "*Open Casket*: Whitney Biennial, 2017." In *Whitewalling: Art, Race & Protest in 3 Acts*, 15–63. New York: Badlands.Unlimited, 2018.

Ephgrave, Nicole. "On Women's Bodies: Experiences of Dehumanization during the Holocaust." *Journal of Women's History* 28, no. 2 (2016): 12–32.

Equal Justice Initiative. *Lynching in America: Confronting the Legacy of Racial Terror*. 3rd ed. Montgomery, Ala.: Equal Justice Initiative, 2017.

Equal Justice Initiative. *Slavery in America: The Montgomery Slave Trade*. Montgomery, Ala.: Equal Justice Initiative, 2018.

Erll, Astrid. *Memory in Culture*. Translated by Sarah B. Young. New York: Palgrave Macmillan, 2011.

Erll, Astrid, and Ansgar Nünning, eds. *A Companion to Cultural Memory Studies: An International and Interdisciplinary Handbook*. Berlin: De Gruyter, Inc., 2008.

Feimster, Crystal N. *Southern Horrors: Women and the Politics of Rape and Lynching*. Cambridge: Harvard University Press, 2009.

Fogelman, Eva. "Sexual Abuse of Jewish Women during and after the Holocaust: A Psychological Perspective." In *Sexual Violence against Jewish Women during the*

Holocaust. Edited by Sonja M. Hedgepeth and Rochelle G. Saidel. Boston: Brandeis University Press, 2010.

Franco, Fabiana. "Childhood Abuse, Complex Trauma and Epigenetics." Psych Central, October 30, 2018. http://psychcentral.com.

Frueh, Joanna. *Erotic Faculties*. Berkeley: University of California Press, 1996.

Fusco, Coco. "Censorship, Not the Painting, Must Go: On Dana Schutz's Image of Emmett Till." *Hyperallergic*, March 27, 2017. https://hyperallergic.com.

Gawande, Atul. *Being Mortal: Medicine and What Matters in the End*. New York: Picador, 2015.

Gibbons, Joan. *Contemporary Art and Memory: Images of Recollection and Remembrance*. London: I. B. Tauris, 2007.

Gillman, Abigail. "Cultural Awakening and Historical Forgetting: The Architecture of Memory in the Jewish Museum of Vienna and in Rachel Whiteread's 'Nameless Library.'" *New German Critique* 93 (Fall 2004): 145–163.

Goldman, Saundra. "Gesture and the Regeneration of the Universe." In *Hannah Wilkie: A Retrospective*. Exhibition catalog, edited by Elisabeth Delin Hanson, Kirsten Dybbøl, and Donald Goddard. Copenhagen: Nikolaj Contemporary Art Center, 1998.

Graham, David A. "Sandra Bland and the Long History of Racism in Waller County, Texas." *The Atlantic*, 21 July 2015. www.theatlantic.com.

"Hannah Black's Letter to the Whitney Biennial's Curators: 'The Painting Must Go.'" e-flux conversations, March 2017. https://conversations.e-flux.com.

Hobbs, Allyson. "The Power of Looking, from Emmett Till to Philando Castile." *New Yorker*, August 5, 2016. www.newyorker.com.

Horowitz, Sara. "Gender, Genocide, and Jewish Memory." *Prooftexts* 20, nos. 1/2 (2000): 158–190.

Hyde, Lewis. *A Primer for Forgetting: Getting Past the Past*. New York: Farrar, Straus and Giroux, 2019.

Johnson, Mark. *The Aesthetics of Meaning and Thought: The Bodily Roots of Philosophy, Science, Morality, and Art*. Chicago: University of Chicago Press, 2018.

Jones, Amelia. "The 'Eternal Return': Self-Portrait Photography as a Technology of Embodiment." *Signs* 27, no. 4 (Summer 2002): 947–978.

Kalanithi, Paul. *When Breath Becomes Air*. New York: Random House, 2016.

Khazan, Olga. "Inherited Trauma Shapes Your Health." *The Atlantic*, October 16, 2018. www.atlantic.com.

Kochheiser, Thomas H., Joanna Frueh, and Hannah Wilke. *Hannah Wilke: A Retrospective*. Columbia: University of Missouri—St. Louis, Gallery 210, 1989.

Kroell, Alice. "Carmen Winant's Radical Images of Women Giving Birth." *Hyperallergic*, June 7, 2018. https://hyperallergic.com.

Landsberg, Alison. *Prosthetic Memory: The Transformation of American Remembrance in the Age of Mass Culture*. New York: Columbia University Press, 2004.

Leis-Newman, Elizabeth. "Miscarriage and Loss." *American Psychological Association* 43, no. 6 (June 2012). www.apa.org

Lepore, Jill. *These Truths: A History of the United States*. New York: W.W. Norton Co., 2018, Kindle.

Lewis, Sarah. "Truth and Reconciliation: Bryan Stevenson in Conversation with Sarah Lewis." *Aperture* 230 (Spring 2018). https://aperture.org.

Linenthal, Edward T. *The Unfinished Bombing: Oklahoma City in American Memory*. New York: Oxford University Press, 2001.

Matar, Diana. *Evidence*. Amsterdam: Shilt Publishing, 2014.

Matuštík, Martin Beck. "Future's Past: A Conversation about the Holocaust with

Gabriele M. Schwab." In *Critical Trauma Studies: Understanding Violence, Conflict, and Memory in Everyday Life*, edited by Monica J. Casper and Eric Wertheimer, 122–134. New York: New York University Press, 2016.

Metress, Christopher. "Literary Representations of the Lynching of Emmett Till: An Annotated Bibliography." In *Emmett Till in Literary Memory and Imagination*, edited by Harriet Pollack and Christopher Metress, 223–250. Baton Rouge: Louisiana State University Press, 2008.

Mullins, Charlotte. *RW: Rachel Whiteread*. London: Tate Publishing, 2004.

Muñoz-Alonso, Lorena. "Dana Schutz's Painting of Emmett Till at Whitney Biennial Sparks Protest." *Artnet News*, March 21, 2017. https://news.artnet.

Novick, Peter. *The Holocaust in American Life*. Boston: Houghton Mifflin, 1999.

Nora, Pierre. "Realms of Memory." 1984. Reprinted in *Memory*, edited by Ian Farr, 61–66. Documents of Contemporary Art. Cambridge: MIT Press, 2012.

Oliver, Anne. "Trauma, Bodies, and Performance Art: Toward an Embodied Ethics of Seeing." *Continuum: Journal of Media & Cultural Studies* 24, no. 1 (February 2010): 119–129.

Okeke-Agulu, Chika. "Outrage over Hiring a White Woman as African Art Curator Misunderstands Expertise." *Frieze*, April 18, 2018. https://frieze.com.

Orenstein, Henry. *I Shall Live: Surviving the Holocaust 1939–1945*. New York: Beaufort Books, 1997.

Pető, Andrea, Louise Hecht, and Karolina Krasuska, eds. *Women and the Holocaust: New Perspectives and Challenges*. Warsaw: Central European University Press and Institute of Literary Research of the Polish Academy of Sciences, 2015.

Princenthal, Nancy. *Hannah Wilke*. New York: Prestel Verlag, 2010.

Raiford, Leigh. "Photography and the Practices of Critical Black Memory." *History and Theory* 48, no. 4 (December 2009): 112–129.

Regensdorf, Laura. "Artist Carmen Winant on Why 2,000 Images of Childbirth Belong at MoMA." *Vogue*, March 19, 2018. www.vogue.com.

Rigney, Ann. "Remembrance as Remaking: Memories of the Nation Revisited." *Nations and Nationalism* 24, no. 2 (2018): 240–257.

Rogo, Paula. "Napping While Black? White Yale Student Called Cops on Black Student Sleeping in Common Room." *Essence*, May 10, 2018. www.essence.com.

Ross, Alex. "How American Racism Influenced Hitler." *The New Yorker*, April 30, 2018. www.newyorker.com.

Said, Edward W. "Invention, Memory, and Place." *Critical Inquiry* 26, no. 2 (Winter 2000): 175–192.

Saltzman, Lisa. "Negative Images: How a History of Shadows Might Illuminate the Shadows of History." 2006. Reprinted in *Memory*, edited by Ian Farr, 192–199. Documents of Contemporary Art. Cambridge: MIT Press, 2012.

Sargent, Antwaun. "Unpacking the Firestorm around the Whitney Biennial's 'Black Death Spectacle.'" *Artsy*, March 22, 2017. www.artsy.net.

Savage, Kirk. *Standing Soldiers, Kneeling Slaves: Race, War, and Monuments in Nineteenth-Century America*. Princeton: Princeton University Press, 1997.

Seabrook, Thomas R. "Tributes to the Past, Present, and Future: World War I Era Confederate Memorialization in Virginia." In *Controversial Monuments and Memorials: A Guide for Community Leaders*, edited by David B. Allison, 65–78. New York: Rowman & Littlefield, 2018.

Shapiro, Dani. *Hourglass: Time, Memory, Marriage*. New York: Alfred A. Knopf, 2017.

Simien, Evelyn M., ed. *Gender and Lynching: The Politics of Memory*. New York: Palgrave Macmillan, 2011.

Skelly, Julia. "Mas(k/t)ectomies: Losing a Breast (and Hair) in Hannah Wilke's Body Art." *Thirdspace: A Journal of Feminist Theory and Culture* 7, no. 1 (Summer 2007). http://journals.sfu.ca/thirdspace.

Smith, Amelia. "Photographer Diana Matar on Libya, Her Father-in-Law's Disappearance and Portraying Absence in Her Work." *Middle East Monitor,* October 22, 2014. www.middleeastmonitor.com.

Takemoto, Tina. "Looking through Hannah's Eyes: Interview with Donald Goddard," *Art Journal* 67, no. 2 (2008): 126–139.

Tembeck, Tamar. "Exposed Wounds: The Autopathographies of Hannah Wilke and Jo Spence." RACAR 33, nos. 1/2 (2008): 87–101.

Thanem, Torkild and David Knights. *Embodied Research Methods.* London: Sage Publications, 2019.

Traverso, Antonio and Mick Broderick. "Interrogating Trauma: Toward a Critical Trauma Studies." *Continuum: Journal of Media and Cultural Studies* 24, no. 1 (February 2010): 3–15.

Traverso, Enzo. *Left-Wing Melancholia: Marxism, History, and Memory.* New York: Columbia University Press, 2016.

Trigg, Dylan. *Memory of Place: A Phenomenology of the Uncanny.* Athens: Ohio University Press, 2012.

Ward, Jason Morgan. "The Legacy Museum: From Enslavement to Mass Incarceration; The National Memorial for Peace and Justice." *American Historical Review* 123, no. 4 (October 2018): 1271–1272.

Washington, Harriet A. *Medical Apartheid: The Dark History of Medical Experimentation on Black Americans from Colonial Times to the Present.* New York: Random House, 2008.

Waxman, Zoë. *Women in the Holocaust: A Feminist History.* Oxford: Oxford University Press, 2017.

Wertheimer, Eric, and Monica J. Casper. "Within Trauma: An Introduction." In *Critical Trauma Studies: Understanding Violence, Conflict, and Memory in Everyday Life,* edited by Monica J. Casper and Eric Wertheimer, 1–18. New York: New York University Press, 2016.

West, Malcolm. "Mamie Till-Mobley, Civil Rights Heroine, Eulogized in Chicago." *National Report,* January 27, 2003. www.highbeam.com.

Winant, Carmen. "The Art of Birth." *Contemporary Art Review.la,* July 21, 2016. http://contemporaryartreview.la.

Wood, Amy Louise, and Susan V. Donaldson. "Introduction: Lynching's Legacy in American Culture." Special Issue on Lynching and American Culture. *Mississippi Quarterly: The Journal of Southern Cultures* 61, nos. 1/2 (Winter–Spring 2008): 5–26.

Young, James E. *The Stages of Memory: Reflections on Memorial Art, Loss, and the Spaces Between.* Amherst: University of Massachusetts Press, 2016.

———. "Germany's Memorial Question: Memory, Counter-Memory, and the End of Monuments." *South Atlantic Quarterly* 96 no. 4 (1997): 853–880.

Zubrzycki, Geneviève. "Nationalism, 'Philosemitism,' and Symbolic Boundary-Making in Contemporary Poland." *Comparative Studies in Society and History* 58 no. 1 (2016): 66–98.

Index

Page numbers in *italics* represent images.

Abdul-Jabbar, Kareem, 85
abortion, 60, 146, 147; anti-abortion
 bills, 61
Abowd, Thomas, 128, 228n8
Abramović, Marina, 96
Abrams, Stacy, 57
Abu Salim prison (Tripoli, Libya), 102
Academy of Art and Design (Florence,
 Italy), 91–92
Aciman, André, 143, 167
Adams, John Quincy, 41
Adler, Victor, 118
Adorno, Theodor, 17
African Americans. *See* blackness; civil
 rights; lynching; racial violence; slavery;
 voting rights
Akoto-Bamfo, Kwame, 11, 49, *50*, 51
Alabama Memorial Preservation Act, 38,
 222n9
Alabama Sons of Confederate Veterans, 52
Albright, Madeleine, 61, 63
Alcindor, Lew. *See* Abdul-Jabbar, Kareem
Ali, Muhammad, 85
Alice & Oliver (Bock), 191–192
Allen, Woody, 211
Alliance Cemetery (Norma, New Jersey),
 156–157, *157*, *158*
Alternative for Germany Party, 65
alternative medicine/therapy, 185, 187–190,
 199–200

American Historical Association, 58
American Nazi Party, 74
American Psychiatric Association, 9
Amishai-Maisels, Ziva, 133
Amsterdam News (black newspaper), 84
And Europe Will Be Stunned (Bartana), 123
Andromeda Rock (Tel Aviv, Israel),
 122–123
Angelus Novus (Klee), 1
Anti-Lynching Crusaders, 82
Apel, Dora (author), *154*, *170*: breast cancer,
 185–214; care of elderly mother, 158–169,
 192; childbirth, 150–155, 189; daughter of
 Holocaust survivors, 1–2, 192; father and,
 6–7, 105–106, 121, 187, 200–201, 211, 213;
 inherited sense of guilt, 200; inherited
 trauma, 150–151, 153, 207; marriage, 189;
 *Memory Effects: The Holocaust and the
 Art of Secondary Witnessing*, 1–2, 5,
 164–165; miscarriage, 141–142, 149–150;
 mother and sexuality, 209–211; visit to
 parents' pre-World War II life, 101,
 104–117; *War Culture and the Contest of
 Images*, 123
Apel, Ethel (author's mother), 6, 121, 128,
 152–153, *154*, 158–169, 164, *170*, 187, 213:
 author's visit to parent's hometown, 101,
 104–117; childbirth, 142, 144–145, 147,
 150, 155; death, 101, 170; grave site, 156, *158*,
 170–172; Holocaust, 125, 192, 207; life in

Apel (cont.)
Displaced Persons camp, 142–145, *144*;
murder of family members, 167; parallel
universe, 160–161, 164, 166–167;
pregnancy and sense of family loss, 145,
155; sex talk with daughter, 210–211
Apel, Max (author's brother), 153, *154*,
171–172, 192, 193, 214
Apel, Samuel (author's father), 6–7, 112, 121,
153, 187, 200–201, 213: author's visit to
parent's hometown, 101, 104–117;
birthplace, 106–107; escape from Poland,
148; grave site, 156, 170–171; life in
Displaced Persons camp, 142–145, *147*;
survivor's guilt, 200–201
Arabs, 96, *135*
Arad, Boaz, 125, 228n6
Arad, Michael, *63*
Arad, Michal, 228n6
Arizona, 156
Armenian genocide, 73
Artpace (San Antonio, Texas), 141–142
Aryan supremacy. *See* Nazi Germany; white
supremacism/supremacist
Asian Exclusion Act, 68, *68*
Assmann, Aleida, 5–6
Auschwitz-Birkenau concentration camp,
12, 61, 73–74, 111, 115–117, *116*, 149, 157
Australia, "White Australia" policy, 68
authoritarianism/authoritarian, 6

Baden, Michael, 27
Bakk-Hansen, Heidi, *46*
Baldwin, James, 11
Bamiyan Buddhas (Afghanistan), 86
Bannon, Steve, 74
barbarism, 216, 231n3
Bartana, Yael, 11, 123–124, *124*, 127
Beating Cancer with Nutrition (Quillin), 196
Beauchamp, Keith, 81, 224n4
"Beauty out of Damage" (Matuschka),
230n4
Being Mortal (Gawande), 209
Being: New Photography 2018 (Museum of
Modern Art exhibition), 145
belief, relationship with memory, 186
Bell, Wesley, 22–23
Bellows, George, 93
Benghazi, Libya, 102, *104*
Benjamin, Walter, 1, 12, 17–20
Berger, Martin, 25–26, 84–85

Berlin, Germany, 20, 65–66, 125, 142, *144*,
145, 153, 155
Bibliography: Memory Effects (Spector),
1, 3, 11
Bielsko-Biala, Poland, 113
Biggers, John, 45
Biggers, Sanford, 45
bipolar disorder, 9
Birkenau. *See* Auschwitz-Birkenau
concentration camp
Bishara, Rana, 130–132, 136
Black, Hannah, 79, 82–89, 94
Black Arts Movement, 87
black codes, 41
Black History Month, 226n38
"Black Liberation Struggle" (Zorn), 82
Black Lives Matter movement, 27, 29
blackness: art and, 87; criminalization of, 7,
29, 56, 69; cynical use of, 86; perceived as
threat, 30; reassertion of, 74–76;
stereotype as "uppity," 24–25. *See* African
Americans; civil rights; identity;
lynching; racial violence; slavery
Black Panther (movie), 70, 95
Black Panther Party, 70
"The Black Square—Homage to Malevich"
(Schneider), 125
Bland, Sandra, 70–71, *71*
blood libel, 64–65, 223n37
Blow, Charles, 60
Bock, Charles, 191–192
the body: connection with lynching sites soil
samples, 43; memory site, 153, 168, 176;
photographing, 176–177; as separate
entity from mind, 175–176, 215; site of
social and cultural construction, 9; taboos
about sick body, 177–184, 230n4
Bohemia, 61
Book of Questions, The (Jabès), 2
books, destruction of, 64
border wall, 59, 143
Bosnia, 64
Boston, Massachusetts, 57
Bradley Till, Mamie. *See* Till, Mamie
Brandenburg Gate (Berlin, Germany), 65
Braun, Eva, 125
Breivik, Anders, 59
Breton, Andrè, 94
Brierfield plantation (Mississippi), 37
Bright, Parker, 83, *83*
Brockmeier, Jens, 3–5

Brooklyn Museum, 87, 94–96, 225n24
Brooks, Gwendolyn, 81
Brown, Kay, 45
Brown, Michael, Jr., 12, 21–31, 51
Brown, Michael, Sr., 21
Bryant, Roy, 80, 85
Budzyń death camp, 109, 148
bus boycott, 38, 80–81
buses (interstate), integration, 6, 53–54, 54
Bush, Cori, 29
Butler, Judith, 177

Cadmus, Paul, 93
Cafè Central (Vienna, Austria), 117–118
Cambodia, 64
Camus, Renaud, 60
cancer treatment, 175–184, 185–214
capitalism, alliance with whiteness, 97
Castile, Philando, 89, 90, 226n30
Catholic Church, 65
Catlett, Elizabeth, 45
Cave, Nick, 11, 74, 75
censorship, 86–89, 94
chain immigration, 69
Chair, The (Matar), 102, 103
Charleston, South Carolina, 38, 57, 74
Charlottenburg (Berlin, Germany), 142
Charlottesville, Virginia: Emancipation
 Park, 58; Market Street Park, 58; Unite
 the Right rally, 8, 58, 60, 72
Chelm, Poland, 106–112
chemotherapy. See cancer treatment
Chicago Defender (black newspaper),
 84, 93
Chicago Sun-Times, 84
childbirth. See labor/childbirth, imagery
Children's Memorial (Yad Vashem,
 Israel), 127
Chinese Exclusion Act, 68
Christchurch, New Zealand, mosques
 shootings, 60
church bombings, 6
civil rights, 25–28, 38–39, 41, 42, 53 , 59, 67,
 84, 85
Civil Rights Act, 6
Civil Rights movement, 7, 56, 58, 77, 97
Civil War, 9, 35, 37, 52, 55, 59. See also
 Confederate monuments
Clark, Mark, 70
class. See social class
Clay, Cassius. See Ali, Muhammad

Clayton, Elias, 44–45, 45
Clayton Jackson McGhie Memorial
 (Duluth, Minnesota), 45, 46
Cleaver, Eldridge, 85
Clinton, Hillary, 136
CNN cable network, 27
Coetzee, J. M., 158
cognitive science theory, 175
Cole, Ernest, 51
collective memory. See memory; monu-
 ments/memorials
Columbia, South Carolina, 57
commodification, horror of, 89, 133
Communist Party, 226n32
Complete Photo Story of Till Murder Case
 (Withers), 84
computer, memory consumption and
 production, 4
concentration camp, 144, 229n4. See also
 specific camp
Confederate flag, 53, 57
Confederate Memorial Carving. See
 Stone Mountain Confederate
 Monument
Confederate Memorial Monument
 (Montgomery, Alabama), 38, 40
Confederate monuments, 6, 8, 12, 35–41, 36,
 49, 52–61, 76, 186
Conquistadors (Spanish empire), 64
Conrad, Sebastian, 5–6
Constand, Andrea, 85
contraception, 60
Cosby, Bill, 85–86
Cosby, Camille, 85
Council of Conservative Citizens, 57
Courbet, Gustave, 180, 182
Crawford, Edward, 27–28, 28, 221n10
creative freedom, limiting, 86
Crisis (black newspaper), 84
Crusades (religious wars), 64
Cube Hamburg (Schneider), 125
cultural memory. See memory
cultural policing, 86–89
cultural versus psychological trauma,
 220n14. See also memory, traumatic/
 trauma studies
"Cure"/"Cured" exhibition, 230n7. See also
 Intra-Venus series
Czech Republic, 61, 62, 63
Częstochowa, Poland, 109
Czulent ("hidden Jews" support group), 114

Daughters of the Confederacy, 38
Davis, Damon, 30
Davis, Jefferson, 35, *36*, 37, 38, *39*, 55, 57, *58*
Davis High School, Jefferson (Montgomery, Alabama), *36*
Davis Highway, Jefferson (Montgomery, Alabama), 35, 38
Death March, 148
"December Rain" (Spector), 198–199
Declaration, A (Bartana), 123, *124*
Declaration of Independence, 41
Deep South, Untitled (Emmett Till River Bank) (Sally Mann), 97
deGrasse Tyson, Neil, 162
Detroit, Michigan, 70
Detroit Institute of Arts, 165
Deutscher, Isaac, 2
Di-Nur, Yehiel, 116
Displaced Persons camp, 121, 142–145
DNA, trauma/stress chemical changes, 9. *See also* inherited trauma
Donham, Carolyn Bryant, 68, 88, 225n19
Donohoe, Janet, 220n19
Duke, David, 72
Duluth, Minnesota, 44–45, *45*, *46*
Dworkin, Andrea, 86
Dyer Anti-Lynching Bill, 82–83
Dylan, Bob, 81

education. *See* school segregation; segregation efforts, racial
Eichmann, Adolf, 4
Eisenman, Peter, 64, 65, *66*, 67
EJI. *See* Equal Justice Initiative
Electoral College, 41
El Paso, Texas, 60
El Salvador, 67, 143
Emanuel African Methodist Episcopal Church (Charleston, South Carolina), 57, 74
Emmett Till Anti-Lynching Bill, 81
Emmett Till Historic Intrepid Center (Glendora, Mississippi), 81
Emmett Till Interpretive Center (Sumner, Mississippi), 81
Emmett Till Memorial Highway, 81
Emmett Till Memory Project (website and phone app), 81
Emory University, 153
Enwezor, Okwui, 94–95
epigenetic inheritance, 153

Equal Justice Initiative (EJI), 35, 37, *37*, 39, 43–45, *44*, 49, 71
ethical spectatorship, 47
eugenics, 38, 68, 74, 207
Everett, Hugh, 162
Evidence (Diana Matar), 102, 104
Evidence VII (Diana Matar), 102, *104*
Eyes on the Prize (television documentary), 85

Faneuil, Peter, 57
FBI, COINTELPRO (counterintelligence program), 70
feminism, 59, 176
Ferguson, Missouri, 12, 21–31, 51, 221n10
"Field of Stelae" (Eisenman), 65
First White House of the Confederacy (Montgomery, Alabama), 35, *36*, 37, 55
Fitzgerald, F. Scott, 54
Fitzgerald, Zelda, 54–55
Fitzgerald Museum, Scott and Zelda (Montgomery, Alabama), 54–55
Florida State University Libraries, Emmett Till Archives, 81
Ford, Ezell, 25
Ford, Henry, 74
Frank, Anne, 54, 68
frankincense oil, 187–188
Freedom Riders, 53–54
Freedom Rides, 6
Freedom Rides Museum (Montgomery, Alabama), 53–54, *54*
free speech, right to, 86
Freud, Sigmund, 12, 118–119, *118*
Frueh, Joanna, 178
Fusco, Coco, 85, 86–87, 93

Gaddafi, Muammar, 101–104
Gates, Henry Louis, Jr., 72
Gawande, Atul, 209
gay sexuality. *See* homosexuality
gender, issues of, 9–10, 59, 141–155, 177, 200–201, 216. *See also* performalist self-portraits; women
Gentileschi, Artemisia, 91–92, *92*
Géricault, Théodore, 230n4
Germanization of kidnapped children, 112–113
Gestures (Wilke), *176*
Getting Word, 219n7
Ghana, Cape Coast Castle, 49, 51
Ghawi, al- family, 130–137, *131*

Gilman, Sander, 2
Giuliani, Rudolph, 87, 225n24
global community, 4, 59, 97
global migration, 67
Goethe Institute (Düsseldorf, Germany), 140
Golden, Thelma, 89
Goya, Francisco, 230n4
Gray, Darryl, 29
Great Replacement, The (Camus), 60
Great Replacement conspiracy theory, 60
Greyhound Bus Station (Montgomery, Alabama), 53–54, 54
Grodzka Gate (Lublin, Poland), 105–106
Gros, Antoine-Jean, 122
Grossman, James, 76
Guardian, The, 56
Guatemala, 143
Gurland, Henny, 17

Haaretz (Israeli newspaper), 126–127, 135–136
Haganah (Zionist paramilitary organization), 122
Haitian immigrants, 67
Halabi, Fahed, 124
Halper, Jeff, 127–128
Hamburger Kunsthalle (art museum), 125
Hamilton, Ann, 96
Hampton, Fred, 70
"Hands Up, Don't Shoot" chant/gesture, 23, 24, 24–26, 25, 26, 51
Hanoun al- family, 103–137, 131
Hanoun, Maher al-, 132
Haram al-Sharif (Noble Sanctuary). See Jerusalem, Temple Mount
Harlem Vanguard, 94
hate crimes. See racial violence
Hawking, Stephen, 162
health care discrimination, 70, 206–207. See also segregation efforts, racial
Hebrew Lesson (Boaz Arad), 125
Hemmings, Sally, 4
Henry VIII, 64
Herzegovina, 64
Herzl, Theodor, 118
Herzliya Museum (Israel), 124–125
Heyer, Heather, 8, 58, 72
Hill, Anita, 86, 140
Himmler, Heinrich, 112
Himmlerstadt, Poland. See Zamość, Poland
Hispanic invasion, fear of, 60

history, defined, 11
Hitler, Adolf, 73–74, 105, 112, 117, 118, 125, 167
Hobbs, Allyson, 90
Hoecke, Bjoern, 65
Hoffmannsthal, Hugo von, 118
Holiday, Billie, 86
holistic medicine, 199, 208
Holocaust: author's parents' experiences, 105–117; catalyst for memory activism, 4; children of Holocaust survivors, 1–2, 121, 153, 175; deniers, 186; driver of memory studies, 4; gendered nature of experiences, 9–10, 141–155, 200–201; mass graves, 109–110, 111, 113, 167, 227n9; memorials, 61, 62, 63–67, 156–157 (see also specific memorials); memory for Israelis and Palestinians, 120; postwar artists, 2, 132–133; subject of artwork, 1–2; survivor's guilt, 200–201; survivors' stories, 2; traumatic memories, 2, 13, 157, 167, 200–201
homeopathic medicine, 199–200
homosexuality, 96, 124
Honduras, 143
Hoover, J. Edgar, 70
Hourglass (Shapiro), 213
housing discrimination, 70, 73. See also segregation efforts, racial
Hrubieszów, Poland, 106–113, 107–111, 117, 121, 148, 153, 167, 227n9
Huffington Post, 24
Hughes, Langston, 81
Human Rights Watch, 102
Hunter-Gault, Charlayne, 85
Hyde, Lewis, 61, 158

I Am Not Your Negro (film), 11
identity: black, 93; Jewish, 93, 114; Palestinian, 114, 123; performance of, 179; personal and cultural, 2–3, 5–7, 53, 74, 101, 119, 136, 167, 176, 195, 215; politics, 82; racial essentialism and, 7, 12, 59, 82, 85, 87–88, 94–96, 135, 216
Ideology of Death (Weiss), 2
IG Farben, 73
immigrant/immigration: chain immigration, 69; contempt for, 81–82; detention centers, 55–56, 56; diversity visa lottery, 69; family-based preferences, 69; policy, 60, 67–69, 68, 74, 97, 143; refugees, 69; separation of children from parents, 55, 69, 74, 143–144, 229n4

Immigration Act, 68, *68*, 69, 74
Immigration and Nationality Act, 69
Imperial Library of Constantinople
 (Byzantine Empire), 64
incest, and anti-abortion bills, 60–61
indentures, 41
Indianapolis Star, 72
inherited trauma, 2, 9, 151–153, 207, 215.
 See also memory
Institute of Contemporary Art (Boston,
 Massachusetts), 96
International Labor Defense, 94
Intra-Venus series (Wilke), 13, 175, 177, 182:
 No. 1, 178; *No. 3*, *181*; *No. 4*, , 179, *179*;
 No. 7, 180, *183*
Iraq, 64
Irgun (Jewish underground organization),
 122
I Shall Live (Orenstein), 111, 149
Islamism, 59
Israel: artistic critique of policy, 132–133;
 author's trip to, 105, 120–137; border wall
 checkpoints, 13, 133–134, *134*; restriction
 of Palestinians' rights, 123, 130–137;
 Supreme Court, 136; U.S. support, 69;
 West Bank settlements, 120, 122,
 130–137, *134*

Jabès, Edmond, 2
Jackson, Elmer, 44–45, *45*
Jackson, Michael, 225n23
Jackson, Thomas J. "Stonewall," 57, *58*
Jaffa, Israel, 122, 136
Japanese Americans, 56, 68, *68*
Jefferson, Thomas, 4, 41, 219n7
Jerusalem: checkpoint, 133–134, *134*;
 Damascus Gate, 127, 136; Dome of the
 Rock, 129; Old City, 127, 128, *135*; Temple
 Mount, 128, 129; Western Wall, 128,
 129, 135
Jet magazine, 84
Jewish Culture Festival, 114
Jewish Federation (Detroit, Michigan), 164
Jewish Museum (New York City, New
 York), 132
Jew's Body, The (Gilman), 2
Jews: blood libel, 64–65, 223n37; communi-
 ties in the United States, 156–157;
 Displaced Persons, 142–145; "hidden
 Jews," 114; immigration restrictions, 68;

in Poland, 104–119; perceived as radically
 different, 7, 68. *See also* Holocaust; Israel
Jim Crow era, 42, 58, 61, 69
J. J. Hill Montessori Magnet School,
 226n30
John Reed Club, 94
Johnson, Dorian, 23
Johnson, Mark, 175–176
Johnson, Portia, *46*
Jones, Amelia, 179
Jones, Danye, 28
Joshua, Deandre, 28
Judenplatz Holocaust Memorial (Vienna,
 Austria), 64–65, *64–65*
Judith Slaying Holofernes (Gentileschi),
 91–92, *92*

Kaaba (Mecca), 125
Kansas, 156
Kaphar, Titus, 45
Karavan, Dani, 18, *18–19*, 20
Kautsky, Karl, 231n3
Kavanaugh, Brett, 61
Kennedy, John F., 6
Killed by Police website, 70
Kimmel, Michael, 59
King, Martin Luther, Jr., 38–39
King, Rodney, 74
King, Steve, 60–61
King Memorial Baptist Church
 (Montgomery, Alabama), 38–39
Klee, Paul, 1
Kraków, Poland, 109, 113, 114, 117:
 Kazimierz, 114
Krift, Bro, 56
Ku Klux Klan, 42, 57; Fred Trump and,
 72–74

labor/childbirth, imagery, 145–147
Landrieu, Mary, 225n10
Landsberg, Alison, 216
Langer, Lawrence, 2
language of death/dying, 158
Latinx, 96
Lebanon, 64
Lebensraum doctrine, 73
Lee, Robert E., 57, *58*, 58; High School
 (Montgomery, Alabama), 35, *36*;
 monument (Charlottesville, Virginia), 8
Lee, Trymaine, 29

Legacy Museum: From Enslavement to Mass Incarceration (Montgomery, Alabama), 12, 37, 41–47, *43*, 49, 74; Community Remembrance Project, *44, 46*
Lepore, Jill, 37, 41
Lerman, Miles, 156
Leslie, Alfred, 96
Levi, Primo, 192
Levinas, Emmanuel, 104
Lew, Christopher Y., 89
liberalism, 84–85, 96
Library of Alexandria (Egypt), 64
Libya, 101
Life magazine, 84
Lin, Maya, 20, 38
Lincoln Memorial (Washington, D.C.), 63
Lindbergh, Charles, 73
Locks, Mia, 89
Łodz, Poland, 117
Look magazine, 80
Loos, Adolf, 118
Lorde, Audre, 81
Los Angeles, California, 25, 74
Lublin, Poland, 105–107, 113–114, 117
lunch counter sit-ins, 6
Luxemburg, Rosa, 112, 216
Lvov, Poland, 156
lynching: active complicity, 10; antilynching activism, 10, 82–83, 93–94, 216, 225n10; compared to police and racist white attitudes, 24; death of Danye Jones, 28; deniers, 186; exposed bodies as warnings, 27; gendered experience, 10, 86; history as threat to hegemony of southern whiteness, 55; map of sites, 43; memorializing victims, 61, *62–64*, 63–67, *66* (*see also* Legacy Museum: From Enslavement to Mass Incarceration; National Memorial for Peace and Justice); reenactments, 76; soil samples, 43–45, *44, 46*, 49, 74; terror of, 42; transgenerational effects, 10, 91; to prevent voting, 42; Waller County, Texas, 71. *See also* racial violence; Till, Emmett
Lynching in America: Confronting the Legacy of Racial Terror, 49, 71

MacKinnon, Catharine, 86
MacLaine, Shirley, 162

Majdanek (concentration camp; Lublin, Poland), 167
Manifest Destiny doctrine, 73
"Manifesto: Towards a Free Revolutionary Art," (Trotsky and Breton), 94
Mann, Emmett, 98
Mann, Sally, 11, 97–98, 101, 103
March on Washington, 6
Marsh, Reginald, 93
Martin, Trayvon, 57, 74
Marx, Karl, 176
Marxism, 59, 82, 176, 216
Mary Kozmary (Nightmares; Bartana), 123–124
Maryland Historical Society, 222n9
masculinity, restoration of, 59, 60
Masri, Bassem, 28
MASS Design Group, 61
mass incarceration, 12, 39, 42, 43, 49, 51, 70. *See also* Legacy Museum; National Memorial for Peace and Justice
Matar, Diana, 11, 101–104, *103, 104*
Matar, Hisham, 101–102
Matar, Jaballa, 101–104
Matuschka, Maxi, 230n4
Maya codices, 64
McAllen, Texas, *56*
McCarrel, MarShawn, 28–29
McCulloch, Robert, 22
McGhie, Isaac, 44–45, *45*
Mckesson, DeRay, 29–30, 221n14
McKinnies, Melissa, 28
McSpadden, Lesley (mother of Michael Brown), 23
McVeigh, Timothy, 63
Medici, Cosimo de' (Grand Duke of Tuscany), 91
Meeropol, Abel, 86
Megdal, Barry, 227n9
Megdal, Meyer, 227n9
Memorial to the Murdered Jews of Europe (Berlin, Germany), 20, 64, 65, *66*
Memorial Wall. *See* Vietnam Veterans Memorial
memory: activism/activists, 4, 6, 55; biological and cognitive field, 3, 4–5; black memory, 52–57, 75; brain location, 5; Brockmeier's organization, 3–5; collective memory, 5, 20, *46*, 74, 157, 215; constructed by language and place, 4;

memory (cont.)
cultural, 6, 10, 11, 77, 91, 93, 158, 215–216;
culture of, 8; defined by social practices,
4; effect, 2; embodied knowledge, 9–11,
119, 175, 177, 179, 180; embodiment of
place, 10, 141; fixed and permanent
archive, 3; gendered nature of experience,
9–10; historical forgetfulness, 61, 67, 74,
76, 158; individual changes, 5; interplay
with loss, 98; literary and artistic field, 3,
4; lynching sites, 43; media and techno-
logical field, 3, 4; mediated by society, 3;
naming names to perpetuate memory, 61;
new model of memory, 3; of place (*see* place);
prosthetic—, 216; public culture, 6;
relationship with belief, 186; resistance to
lost memory, 67; social and cultural field,
3, 4, 5, 216; social construction, 5; subject
to reconstruction, 4; transcultural,
219n4; transdisciplinary, 219n4;
transgenerational, 10, 91, 219n4;
translated and transmitted, 2–3;
transmedial, 219n4; traumatic/trauma
studies, 2, 9–10, 102–103, 130–137, 195,
215; witnessing (*see* seeing, importance
of); white supremacist memory of slavery,
87. *See also* Holocaust; inherited trauma;
lynching; memory site; racial violence
*Memory Effects: The Holocaust and the Art of
Secondary Witnessing* (Dora Apel), 1–2, 5,
164–165
Memory in a Global Age (Assmann and
Conrad, eds.), 5–6
memory site, 4. *See also* monuments/
memorials; *specific memory site*
memory studies, field of, 2–4, 9, 219n4
Mengele, Josef, 116, 149
menstruating, 144
Meo, Yvonne, 45
Messager, Annette, 11, 141–142, *142*
#MeToo movement, 10, 61, 186
Mexican border wall. *See* border wall
Mielec, Poland, 109
Milam, J. W., 80, 85
mind as separate entity, 175–177, 215
Mining the Museum (exhibition; Wilson),
222n9
Minneapolis, Minnesota, 89
Mirroring Evil exhibition, 132–133
miscarriage, 141–142, 149–150
Mishra, Pankaj, 67–69

Missouri statehood, 41
MoMA. *See* Museum of Modern Art
Montana, 156
Montgomery, Alabama: black memory,
52–57; bus boycott, 38; business hub, 37–38;
capital of Confederacy, *36*, 41; Confeder-
ate memorials, 35–41, 49, 52–61; Court
Square, 37–38; march from Selma, 38;
national lynching memorial, 6, 8, 91; slave
trade port, 37, *37*; State Capitol building,
37–38, *39*, *40*. *See also* Legacy Museum:
From Enslavement to Mass Incarceration
Montgomery Advertiser, The (Alabama
newspaper), 56
Montgomery Museum of Fine Arts
(Alabama), 54
Monticello (Jefferson estate), 4, 11, 219n7
monuments/memorials: collective memory,
20, 22, *46*, 157; commemorative, 8, 158;
countermonuments, 67; historical
forgetfulness, 61, 74, 76, 158; makeshift
street memorial for Michael Brown, Jr.,
21–23, *22*, 31; memorializing function, 20;
negative-form designs, 67; permanent
memorial plaque for Michael Brown, Jr.,
21–22; redemptive model, 20, 222n9;
roadside memorials, 22. *See* Confederate
monuments; Holocaust, memorials;
specific monuments
mood disorder, 9
Moody, Anne, 85
Moore's Ford, Georgia, 76
Morando, Bernardo, 112
Moravia, 61
Morrison, Toni, 81
motherhood and unconditional love, 155
Mount Sinai Hospital (New York City,
New York), Traumatic Stress Studies
Division, 153
Murrah Federal Building, Alfred P.
(Oklahoma City, Oklahoma), 63
Museum of Modern Art (New York City,
New York), 145, 155
Museum of the History of Polish Jews
(Warsaw, Poland), 123
Muslims, 60, 67, 69, 96, 123, 125, 128–129
My Birth (Winant), 145, *146*, *147*, 155

NAACP, 44, 94
Nachshon (secular kibbutz; Israel), 126
"Nameless Library" (Whiteread), 64

Nancy, Jean-Luc, 184

Napoleon Bonaparte, 122

Napoleon in the Pesthouse in Jaffa (Gros), 122

National Academy of Art (New York), 96

National Defense Authorization Act, 29

National Lynching Memorial. *See* National Memorial for Peace and Justice

National Memorial for Peace and Justice, 6, 8, 12, 37, 39, 41, 47–51, *47, 48, 50, 51,* 52, 67, 74

National Origins Act, 68

National September 11 Memorial & Museum (New York City, New York), 20, 63, *63*

Native Americans, 41, 74, 96

Nazi Germany, 53, 64, 68, 73–74, 86, 94, 112–113, 117, 143. *See also* Holocaust; World War II

Nebraska, 156

neuroscience field, 4–5

New Jersey, 156

Newsmax Media, 30

newspaper, role in racial indifference, 56

Newsweek magazine, 84

New York City, New York: Central Park, 38

New York Daily News, 84

New York Times, 17, 56, 86, 87, 187, 230n4

Nixon, Jay, 23

Nkyinkyim Installation (Akoto-Bamfo), *50*

Noguchi, Isamu, 93

Non-Jewish Jew, The (Deutscher), 2

non-resistance performance, 24–26, 27, 29, 30. *See also* "Hands Up, Don't Shoot" chant/gesture

Nora, Pierre, 55

Norma, New Jersey, 156, *157, 158*

North Dakota, 156

Northwest Front, 27

Nuremburg trials, 4

Oakland, California, 70

Ofili, Chris, 87, 225n24

Oil, Pearl (author's aunt), 163–166

Okeke-Agulu, Chika, 95–96

Oklahoma City National Memorial and Museum (Oklahoma), 63

Olsen, Scott, 26–27, *26*

Open Casket (Schutz), 7, 12, 79–83, *79, 83*–89, 96, 97

Opie, Catherine, 96

Oregon, 156

Orenstein, Henry, 110–111, 149

Origin of the World, The (Courbet), *182*

Orzoff, Andrea, 229n4

Owens, Clifford, 83

Ozick, Cynthia, 2

Palestine: author's trip to, 120–137; family evictions, 13, 130–137; Gaza, 120, 122; Jewish immigration, 105; Sheikh Jarrah neighborhood, 130–137

parallel universes, 160–161, 164, 166–167

Parks, Rosa, 38, 80–81; museum (Montgomery, Alabama), 38

Passages: Homage to Walter Benjamin, 18, *18–19,* 20

Pasternak, Anne, 94

Pearlstein, Philip, 96

Peck, Raoul, 11

Peltz, Jean (author's cousin), 111, 115–116, 147–150

Peltz, Leo, 147–149

performalist self-portraits, 179

Pew Research Center, 24

Pflugstradt, Poland. *See* Zamość, Poland

phenomenology/phenomenologists, 10, 119, 176

Philadelphia, Pennsylvania, 71, 156–157

philosemitism, 113–114

photography: landscape, 96–97; photographing the body, 176–177, 230n4; regarded as white people's domain, 95

Pinkas Synagogue (Prague, Czech Republic), 61, *62, 63*

Pittsburgh Courier (black newspaper), 84

place: author's connection to parents' pre–World War II life, 105–117; bodily response, 119; borders and walls, 120–137; defined, 10; destruction of, 118; emotional experience, 115; lynching sites, 43; Mann's experience in the South, 98; and memory, 13, 101–119

Plow City, Poland. *See* Zamość, Poland

Pogrebin, Robin, 95

Poland, 1–2, 101, 104–119, 148, 156

police shootings of unarmed blacks, 21–31, *30,* 51, 69–74, 81, 93, 221n10

Polish Underground, 113

politics: class, 82; identity, 82; of retreat and despair, 96–98

Pollock, Jason, 221n16

Pope, Robert, 230n4

pornography, 86
Porter, Anthony Peyton, *45*
post-traumatic stress disorder, 9
Powell, Kajieme, 25
Prague, Czech Republic, 61, *62*, 63
Primer for Forgetting, A (Hyde), 61
Princenthal, Nancy, 177, 180, 230n7
prosthetic memory, 216
Protection, Protection, Protection (Messager), *142*, 153
psychological versus cultural trauma, 220n14. *See also* memory, traumatic/trauma studies

Qalandia (Palestine), *134*
Quarrel and Quandary (Ozick), 2
Queens, New York, Ku Klux Klan march, 72–73
Quillin, Patrick, 196

Rabbis for Humanity, 136
racial hierarchy, 67–69, 93–94, 97
racial violence: civil rights and due process violation, 24–25; gendered experience, 10; hate crimes, 76; memorials acknowledging (*see* Legacy Museum: From Enslavement to Mass Incarceration; National Memorial for Peace and Justice); memory landscape, 6, 216; normalization of southern white dominance, 53; public confrontation with history and legacy, 52–57; reaction to Reconstruction, 58; to prevent voting, 42; witnessing, 53, 89–94. *See also* blackness; Black Panther Party; lynching; police shootings of unarmed blacks; white supremacism/supremacist; Till, Emmett
racism as brutal acts of violence, 26, 53
Raise Up (Thomas), 51, *51*
Ramallah (Palestine), *134*
Rankine, Claudia, 42
rape, 60–61, 82–83, 91. *See also* sexual harassment/assault
Reconstruction, 58
redemptive narrative, 42–43, 67, 222n9
Rego Park, Queens (New York City, New York), *147*, 148
Replacement: conspiracy theory, 60; fear of in Jim Crow era, 61
Republican National Convention, 73

Reynolds, Diamond "Lavish," 90
Rhodes, Tommy, 52
Riefenstahl, Leni, 124
Rigney, Ann, 8
Ringelblum Archives, 156
Rivera, Diego, 226n32
Roof, Dylan, 57, 74
Ruscha, Ed, 96
Russia. *See* Soviet Union
Russian Suprematism, 125

Saar, Betye, 87
Sabbagh family, 136
Sacramento, California, 71
Safdie, Moshe, 127
Said, Edward, 74
Saltzman, Lisa, 87
Sawyer, Drew, 95
Sayre, Daniel, 55
Sayre, Anthony, 54
Sayre, William, 55
Scanlan, Joe, 89
Schiavo, Terri, 225n23
Schneemann, Carolee, 96
Schneider, Gregor, 125
Schrödinger, Erwin, 162
school segregation, 45, 47, 70. *See also* segregation efforts, racial
Schulz, Bruno, 2
Schutz, Dana, 7, 12, 79–83, *79*, 83–94, 96, 97, 225n23
Scott, Dread, 96
Seals, Darren, 28
seeing, importance of, 89–94, 102, 180
Seeing Through Race (Berger), 25
segregation efforts, racial, 42, 45, 47, 49, 58, 70
selective breeding, 38
self, memory and construction of, 4, 5; 175–184
Selma, Alabama, 38
Sensation exhibition (Brooklyn Museum), 87
sexual harassment/assault, 9–10, 60–61, 91–92, 186. *See also* rape
shame: essentializing whiteness and, 86; inherited guilt and, 53; lynching and, 56, 86; monuments and, 65; political pressure and, 24; trauma and, 2
Shapiro, Dani, 213
sharecropping, 41

Sheikh Jarrah home evictions. *See* Palestine.

Sharon, Ariel, 127, 133

Sherman, Cindy, 96, 179–180

Sims, James Marion, 38, 207

"slave castle," Ghana, 49, 51

slavery: as cause of Civil War, 35, 37, 52; domestic slave trade, 37, *37*; as Hitler's inspiration, 73; injustice of, 41; legacy of, 41–61; museums (*see* Legacy Museum: From Enslavement to Mass Incarceration; National Memorial for Peace and Justice); public confrontation with history and legacy, 52–57; 219n7; white supremacist memory, 87

Slavery! Slavery! (Walker), *88*

slave trade, 37, *37*, 42. *See also* slavery

Smith, Roberta, 86, 87, 93, 225n23

Smithsonian's National Museum of African American History and Culture, 81

Sobibór death camp, 109

social class, 59, 72, 82, 216

"socialism or barbarism" slogan, 216, 231n3

socialist realist, 86

So Help Me Hannah (Wilke), 178

solidarity, 81–83

Solnit, Rebecca, 55

Soundsuit costumes, 74

South Dakota, 156

Southern Poverty Law Center (SPLC), 38: Civil Rights Memorial Center, 38

Souza, Aruna D', 88, 92–93

Soviet Union, 143, 156, *157*

Spector, Buzz, 1–2, *3*, 5, 11, 198

Spence, Jo, 230n4

Spiegelman, Art, 148

SPLC. *See* Southern Poverty Law Center

Stalin, Joseph, 86, 94, 117, 118

states' rights, 52

Stein, Ben, 30

sterilization practices, 73–74

Sternberg, Harry, 93

Stetson, Carla, *45*

Stevenson, Bryan, 39, 49, 52, 61

St. Louis, Missouri, 25

Stone Mountain Confederate Monument (Georgia), 57, *58*

Strange Fruit (Meeropol), 86

"Stranger Fruit" (documentary film), 221n16

Street of Crocodiles (Schulz), 2

subjective dissociation, 220n14

Sugar, Harry, 187

suicide, as response to emotional and psychological toll of resistance, 28–29, 221n10

Sundance Film Festival, 30

Support Foundation Comfort (Wilke), 178

SXSW film festival, 221n16

syphilis (Tuskegee experiment), 38, 207

Taliban, 86

Tallahatchie River (Mississippi), 80, 81, 97–98, 101

Tassi, Agostino, 91

Taylor, Henry, 89, 90–91, *90*

Tel Aviv, Israel, 121, 122

Tembeck, Tamar, 184

Terms of Endearment (movie), 162

Theresienstadt concentration camp, 61

Thomas, Clarence, 86, 150

Thomas, Hank Willis, 51, *51*

three-fifths rule, 41

Till, Emmett, *78*: controversial painting, 6, 7, 12, 79–80, *79*, 83, 225n23; exhumation, 81, 224n4; killing of, 30, 77–94, 101, 225n19; publication of funeral photographs, 77, *78*, 80–81, 84–85

Till, Mamie, 77, *78*, *80*, 83, 84–85, 87–88, 90, 93

Timbuktu, 64

Time magazine, 23, 84

THE TIMES THAY AINT A CHANG-ING, FAST ENOUGH! (Taylor), 89, *90*

TM13 (Cave), 74, *75*

Tito, Josip Broz, 118

To You With Love (video; Halabi), 124

trauma theory, 9, 220n14. *See also* memory, traumatic/trauma studies

Trigg, Dylan, 101

Tripoli, Libya, 102

Trotsky, Leon, 2, 12, 94, 117–118, 119

Trotskyist Spartacist League, 7

Trump, Donald: appeal to base, 59; contempt for immigrants and people of color, 81–82; credited by Duke for Unite the Right rally, 72–73; global authoritarianism, 6; immigration policy, 60, 67, 69, 97, 143–144, 229n4; opposition to removal of Confederate monuments, 76; parallels between Hitler, 73–74; racist views, 8, 55–56, 96–97; sexual predator, 61; support for Israeli government, 136

Trump, Fred, 72–73, *73*
Tuskegee experiment, 38, 207
Twin Towers (New York City, New York), 63
Tylko Polska (Only Poland; right-wing newspaper), 114
Tyson, Timothy, 86, 225n19

Ukeles, Mierle Laderman, 146
United Daughters of the Confederacy, 59
United Nations: Middle East Peace Process, 136; Relief and Rehabilitation Administration (UNRRA), 143; Relief and Works Agency (UNRWA), 131–132
United States Holocaust Memorial Museum (Washington, D.C.), 156, 229n4
Unite the Right rally, 8, 58, 72, *72*
UNRRA. *See* United Nations, Relief and Rehabilitation Administration
UNRWA. *See* United Nations, Relief and Works Agency
Untitled (Emmett Till River Bank) (Mann), 98
The Untold Story of Emmett Till (Beauchamp), 81, 224n4
Urban League, 73
U.S. Border Patrol: Central Processing Center (McAllen, Texas), *56*
U.S. Civil Rights Trail, 81
U.S. Justice Department, Civil Rights Division, 73

Venice Biennale (Piazza San Marco, Italy), 125
Vicksburg, Mississippi, 37
Vienna, Austria, 64, 101, 117–119, *118*
Vietnam Veterans Memorial (Washington, D.C.), 20, 63
Vine, Richard, 182
Vineland, New Jersey, 106, 113, *154*, 156–156
voting rights, 6, 38, 42, 54–55, 59

Wagner, Hans, 149
Walke, Anika, 229n4
Walker, Kara, 87, 88, 91–92, 96
Wall and Tower (Bartana), 123
Waller County, Texas, 700–71, *71*
War Culture and the Contest of Images (Dora Apel), 123
war on drugs, 29
Warsaw, Poland, 113, 123, 153, 156

Washington, George, 41
Washington Post, 21, 56
Wayne State University (Detroit, Michigan), 128, 213–214
Weiss, John, 2
Wells, Ida B., 82, 225n10
western medicine, 185
What to Expect When You're Expecting (Murkoff and Mazel), 150
white empathy, 79–80, 82, 85, 89, 90–91
white extinction anxiety, 60, 67
white genocide, 60
white nationalism. *See* white supremacism/supremacist
whiteness, concept of, 7–8
white racial anxiety, 25, 30
Whiteread, Rachel, 63–65, *64–65*, 67
white replacement conspiracy theory, 60
white supremacism/supremacist: appeal to working class, 59; Confederate monuments, 52, 186; creation of climate of fear, 29, 69–74, 75, 82, 93–94; mainstreaming, 67–69; memory of slavery, 87; movement, 82; narrative of racial difference, 55–56, 96; organizations, 57; replacement conspiracy theories, 60, 96–97; rise of, 6; role of women, 8, 12, 59, 94; sense of shame, 65; suppression of black civil rights, 59. *See also* Trump, Donald
Whitewalling (D'Souza), 88
Whitney Biennial, 12, 79, 82–83, 85, 89, 96. *See also* Schutz, Dana; Till, Emmett
Whose Streets? (documentary film), 30
Wideman, John Edgar, 85
Wilke, Hannah, 13, 175–184, 229n1
Williams Museum, Hank, 52
Wilson, Darren, 22–23, *22*
Wilson, Fred, 222n9
Winant, Carmen, 11, 145–147, *146*, *147*, 155
Windmuller-Luna, Kristen, 94–95
Withers, Ernest C., 84
witness. *See* seeing, importance of
Wittkopp, Gregory (author's husband), 105, 119, 127, 130, 134, 136, 159–166, *170*, 171: author's breast cancer, 185–214; birth of daughter, 150–152, 154–155, 189
Wittkopp, Patty (author's sister-in-law), 202–203
Wittkopp, Rachel Apel (author's daughter), 105, 119, 127, 128, 130, 134, 159–160,

164,*170*: author's breast cancer, 193–194, 197, 202, 210–211, 214; birth of, 151–155; visit to Auschwitz-Birkenau, 115

Wittkopp, Roger (author's brother-in-law), 202–203

women: active complicity in lynching, 10; gendered nature of Holocaust experience, 9–10, 141–155; gender roles, 59, 60, 82–83, 94, 186; gynecological surgical techniques performed on African Americans, 38; jurisdiction over body, 55; as perceived by white supremacists, 8, 12, 60, 96; reproductive health, 60; suffrage movement, 59; threat to white status, 61; victimization of black women, 70. *See also* sexual harassment/assault

Women in the Holocaust, 9

Woolford, Donelle. *See* Scanlan, Joe

World Conference of Jewish Scholars, 13, 130

World War II, 108–119. *See also* Holocaust

Wrocław, Poland, 113

Yale University, 71

Yanez, Jeronimo, 226n30

Yehuda, Rachel, 153

YIVO Digital Archive on Jewish Life in Poland, 153–154

Young, James, 67, 158

YouGov poll, 24

Yushchenko, Viktor, 225n23

Zamość, Poland, 112–113

Zamość uprising, 113

Zimmerman, George, 57, 74

Zionists, 105

Zoll, Timothy, 21

Zorn, Jacob, 82

Zubrzycki, Genevieve, 113

Zyklon-B, 73, *116*

ArtScroll Series®

Rabbi Nosson Scherman / Rabbi Meir Zlotowitz

General Editors

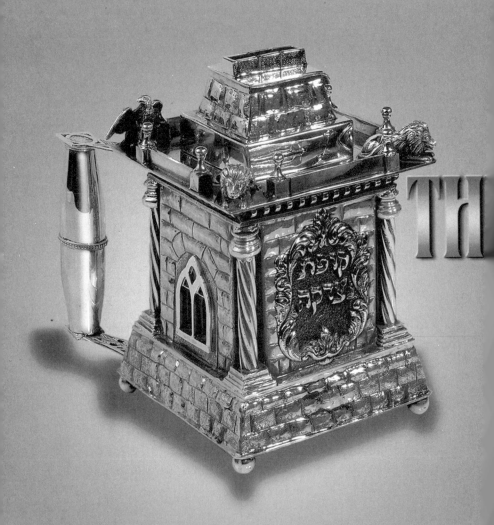

קופה של צדקה

TH

Published by

Mesorah Publications, ltd

TZEDAKAH

TREASURY

An anthology of Torah teachings on the
mitzvah of charity — to instruct and inspire

by

RABBI AVROHOM CHAIM FEUER

edited by Rabbi Menachem Davis

FIRST EDITION
First Impression . . . November 2000
Second Impression . . . December 2000
Third Impression . . . July 2001

Published and Distributed by
MESORAH PUBLICATIONS, Ltd.
4401 Second Avenue
Brooklyn, New York 11232

Distributed in Europe by
LEHMANNS
Unit E, Viking Industrial Park
Rolling Mill Road
Jarrow, Tyne & Wear NE32 3DP
England

Distributed in Australia & New Zealand by
GOLDS WORLD OF JUDAICA
3-13 William Street
Balaclava, Melbourne 3183
Victoria Australia

Distributed in Israel by
SIFRIATI / A. GITLER — BOOKS
6 Hayarkon Street
Bnei Brak 51127

Distributed in South Africa by
KOLLEL BOOKSHOP
Shop 8A Norwood Hypermarket
Norwood 2196, Johannesburg, South Africa

Typography by Compuscribe at ArtScroll Studios, Ltd.

Printed in the United States of America by Noble Book Press
Bound by Sefercraft, Quality Bookbinders, Ltd. Brooklyn, N.Y.

Dedicated in honor of our parents

Adele and Jules Bernstein

and

Renee and Andrew Weiss

*F*rom their humblest beginnings,
they taught, by word and deed,
the essentials of Yiddishkeit,
including the most important values of Tzedakah:

It is important to give;
it is more important to give properly;
it is most important to view giving
not as a burden but as a privilege.

We pray that we have imbued our children
Michelle, Jamie, Jesse and Nicole
with all of these Torah values.

Vivian and Stanley Bernstein
New Rochelle, New York

Table of Contents

Acknowledgments v

☙ Overview

An Overview/*Tzedakah*: The Mitzvah of a Lifetime xi

☙ Introduction to *Tzedakah*

Chapter One: A Delicate and Difficult Mitzvah 33
Chapter Two: Sensitivity at the Source 42
Chapter Three: Rambam's Eight Levels of Charity 55

☙ The Value of Giving

Chapter Four: Charity Protects From All Harm 63
Chapter Five: The Privilege of Giving 82
Chapter Six: Charity Is the Best Investment 92
Chapter Seven: Redemption Through Charity 100

☙ What to Give

Chapter Eight: The Poor Man's Portion
 Is on Deposit With the Rich 109
Chapter Nine: *Maaser*: Giving a Tenth 122
Chapter Ten: *Chomesh*: Giving a Fifth 147
Chapter Eleven: The Blessing of *Maaser* 155

☙ How to Give

Chapter Twelve: The Right Way to Give 171
Chapter Thirteen: To Comfort the Poor 210
Chapter Fourteen: Pledges to *Tzedakah* 219

☙ When to Give

Chapter Fifteen: Giving at All Times 229
Chapter Sixteen: Prayer and Charity 260

Chapter Seventeen: Repentance and *Tzedakah* 272
Chapter Eighteen: You *Can* Take It With You 276

⋙ Givers of *Tzedakah*

Chapter Nineteen: Great *Baalei Tzedakah* 285
Chapter Twenty: Collector of Charity — *Gabbai Tzedakah* 329
Chapter Twenty-One: Women and Charity 355

⋙ Recipients of *Tzedakah*

Chapter Twenty-Two: Prioritize Your Giving 367
Chapter Twenty-Three: Support of Torah 384
Chapter Twenty-Four: *Hachnassas Kallah* 393
Chapter Twenty-Five: Non-Jews 406
Chapter Twenty-Six: Worthy and Unworthy Recipients 414

⋙ Summary of Halachah

Chapter Twenty-Seven: Summary of Halachos
of *Tzedakah* and *Maaser* 435

Acknowledgments

I offer profound gratitude to Hashem for granting me the tremendous *siyata d'Shemaya* I needed for every word and thought in this *sefer*. This work is the thirteenth volume I have published under the guidance and encouragement of my dear friends Rabbi Meir Zlotowitz and Rabbi Nosson Scherman who are masters of scholarship, leadership, and loyalty. I thank them for inviting and encouraging me to write this work, which is a tribute to their patience, perseverance and professional standards.

The impetus for the creation of this work came from its dedicators, Mr. and Mrs. Stanley Bernstein of New Rochelle, New York. Themselves generous and thoughtful supporters of needy individuals and worthy causes, Mr. and Mrs. Bernstein perceived the necessity to both inspire and inform their fellow Jews regarding the importance of generosity and the halachah of how to exercise it. The Talmud teaches that one who persuades others to perform kind deeds is greater than one who merely performs them. The Bernsteins do both. May this work be a constant source of merit for them and their families.

In the course of the twenty three years that I have worked with *Artscroll/Mesorah* I have been involved in many difficult projects. However, the production of the present volume, *The Tzedakah Treasury*, proved to be an unprecedented challenge. The sheer magnitude of this *mitzvah* and the enormous mass of Torah literature dealing with it was daunting. More difficult than anything else was the organization of the finely-nuanced halachos of *tzedakah* and *maaser*, which required detailed and delicate consideration. Additionally, the application of the halachos to contemporary situations required much research and review. I was most fortunate to be able to review most of the halachos in this *sefer* with R' Tzvi Spitz of Yerushalayim, author of *Responsa*

Minchas Tzvi, Hilchos Maaser Utzedakah, and an accepted halachic authority in *Eretz Yisroel.*

My new *chaver* and esteemed colleague, Rabbi Menachem Davis, painstakingly edited this volume with utmost diligence and dedication. Reb Menachem's talent and Torah knowledge have significantly enhanced every aspect of this work. I am deeply grateful to him for his meticulous devotion to this arduous and time-consuming task.

The art and graphics of this volume are the final products of the consummate skill and genius of the entire Artscroll staff. All gave generously of their time and talents to assure the beauty of this book. I thank them for skillfully guiding this *sefer* to completion.

For the past seven years I have been most fortunate to serve as the Rav of Kehillas Bais Avrohom of Monsey, New York which is not only a *Bais Tefillah* and a *Makom Torah,* but an *Otzar Tzedakah* as well. The overwhelming magnanimity of the *entire* membership of our *kehillah* is simply awe-inspiring. Whenever the call goes out to come to the aid of the individual or the institution in distress, the *kehillah* responds with an outpouring of generosity that seems to know no bounds. I can certainly say that the shining example of my big-hearted *baalei battim* inspired me to write this volume on charity and kindness. Furthermore, over the past year, a great deal of my time has been consumed by the production of this *sefer,* thus making me less available to serve my constituents. I deeply appreciate their patience and forbearance throughout this extended period.

I have the privilege of delivering *shiurim* at *Yeshivas Ohr Someach* of Monsey, New York to wonderful *talmidim.* My total involvment in this *sefer* forced me to take a leave of absence from the Yeshiva for the past half year. I am deeply grateful to my esteemed *chaverim,* R' Yisroel Rokowsky, *Rosh HaYeshiva* and R'Avrohom Braun, *Menahel,* for their unstinting cooperation and warm encouragement for this project, despite the inconvenience it caused them.

I take this opportunity to acknowledge the many individuals who have contributed to this volume in a host of ways. My thanks to my cherished friends, R' Avraham and Etty Poznanski, who have opened their hearts and their home to my wife and me at all times, especially

during this project. Their perpetual devotion to *tzedakah* has given me a new appreciation of the term *nedivei lev,* 'generous of heart.'

In the course of writing this work, I made a new friend, R' Avrohom Nachman Wolfson, who has spent much time with many contemporary *gedolim* discussing the intricacies of *hilchos tzedakah.* R' Avrohom graciously shared his vast fund of knowledge and information with me, and gave me a heightened appreciation for the value of this great *mitzvah.*

In order to produce this very complicated and detailed manuscript, I finally had to become computer literate. I thank my dear *talmid* at *Yeshivas Ohr Someach,* Bezalel Juricek, for spending countless hours patiently teaching me the skills of word-processing.

It is my fervent hope and prayer that this *sefer* should be a *zechus* for a *refuah sheleimah* for my beloved father-in-law, HaGaon R' Mordechai Gifter, שליט״א. Together with him, may Hashem grant my dear mother-in-law שתחי׳ many years of good health and happiness to enjoy the great *Yeshiva* they built *and* the beautiful family they raised and inspired.

My precious parents שיחי׳ have always motivated me to discover new ways to serve Hashem with enthusiasm and energy. I know that it is in the *zechus* of their incessant *tefillos* on my behalf that I enjoy the gift of *siyata d'Shemaya.* May they share together many more years of vitality and wellbeing, and see much *Yiddishe nachas* from all of their offspring.

Last to be mentioned, yet foremost in mind, is my wife Luba Rochel. I conclude with a prayer that Hashem grant us *Yiddishe nachas* from our children and grandchildren as they grow in Torah and *yiras Shomayim.*

<div align="right">Avrohom Chaim Feuer</div>

Monsey, New York
18 MarCheshvan 5761/ October 16, 2000

Overview

An Overview/
Tzedakah: The Mitzvah of A Lifetime

It was taught in the name of R' Elazar: What is the meaning of that which is written: וַיִּלְבַּשׁ צְדָקָה כַּשִּׁרְיָן, *And He donned charity like a coat of mail* (*Isaiah* 59:17)? [Why is charity compared to a coat of mail?] To tell you that just as with mail, each metal scale combines [with the others] to form a large coat of mail, so with charity, each perutah combines [with the others] to comprise a large sum.

R' Chanina says: The principle [can be derived] from this verse: וּכְבֶגֶד עִדִּים כָּל צִדְקֹתֵינוּ, *All our charitable acts are like a garment* (ibid. 64:5). Just as in this garment, each thread combines with the others to form a large garment, so with charity, each perutah combines [with the others] to comprise a large sum (*Bava Basra* 9b).

With charity, each perutah combines with the others to comprise a large sum.

I. An Ongoing Metamorphosis

Maharal observes that the Talmud's comparison of charity to a coat of mail or to a garment implies that charity is different from all other commandments. When other commandments are performed more than once, it is considered as two separate good deeds. One who dons *tefillin* today and again tomorrow has performed two separate commandments. Not so *tzedakah*.

A Coat of Mail

If you give something to one person today and to another person tomorrow, the second gift is related to the first one, and **both** contributions merge into one large act of kindness. Thus, all the thousands upon thousands of charitable gifts a person distributes throughout his lifetime are inseparably bonded into one huge, lifelong mitzvah (*Nesivos Olam, Nesiv Hatzedakah*, Ch. 4).

All the charitable gifts a person distributes throughout his lifetime are bonded into one lifelong mitzvah.

Maharal does not explain why charity is unique, but he concludes his remarks with an enigmatic observation: "When you comprehend the difference between *tzedakah* and all other mitzvos, you will see how extraordinary this matter is." What indeed is the difference?

The two hundred and forty-eight commandments of the Torah correspond to the two hundred and forty-eight limbs and organs of the human body. Each mitzvah refines and elevates a specific part of man. *Tzedakah,* however, does not deal with the part; it addresses the whole. *Tzedakah* enables a person to undergo a comprehensive transformation, and to assume an entirely new identity. If one is dissatisfied with one's old, egotistic self, and yearns to break out of one's cocoon of callous indifference, *tzedakah* is the medium of metamorphosis. When performed properly, it affords a person the opportunity to perform a "personality transplant"; a total makeover.

Such change does not come about all at once; it is a lifelong project of incessant personal growth. Every time we open our hearts and hands to the poor, we combat our own self-centeredness. Indeed, whenever we make a contribution, we bestow upon ourselves a far more precious gift than the one we give away, the gift of freedom. Heretofore we were slaves to ourselves, unable to share the feelings of another. The coin of charity, however small, is a tool that picks the lock and opens the gates of liberty. In a sense, every charitable deed is an act of autoemancipation.

Every time we open our hearts and hands to the poor, we combat our own self-centeredness.

When the Torah exhorts us to charitable giving it speaks in repetitive form: פָּתוֹחַ תִּפְתַּח אֶת יָדְךָ, *Open,*

you shall open your hand (Deuteronomy 15:8); נָתוֹן תִּתֵּן
לוֹ, *Give, you shall give to him (ibid.15:10).* In the plain
sense, as *Rashi* explains, this teaches that one should
give again and again. In addition, it implies that the
purpose of *tzedakah* is twofold: open your hand today
so that the needs of the poor will be satisfied; and
also, open your hand today so that you will condition
yourself to open your hand again tomorrow — even
wider!

When you don *tefillin* today, it is not a preparation
for tomorrow's *tefillin.* One act is unrelated to the
other. But today's act of *tzedakah* is meant to train
your hand to open up more readily the next time. And
tomorrow's *tzedakah* influences you to give again the
next day.

Today's act of tzedakah is meant to train your hand to open up more readily the next time.

This is the meaning of the Rabbinic teaching that all
the charitable gifts combine to comprise a large sum.
And this is why *Maharal* taught that the thousands
upon thousands of charitable gifts a person distributes
throughout his lifetime are inseparably bonded into
one huge, lifelong mitzvah. The very essence of charity
is to interlink one selfless act with another so that
slowly but surely the giver is transformed into a kind,
giving person.

Once the Satmar Rav made an appeal for a charita-
ble cause, to which his disciples responded generously.
Shortly thereafter, the Rav made a second appeal to the
very same group of followers. One of them complained
that he was burdening them too frequently. The
Satmar Rav persisted and said, "To the contrary! This is
how it must be! מִצְוָה גּוֹרֶרֶת מִצְוָה, *One mitzvah leads to
another mitzvah*" (*Avos* 4:2).

This is especially true of the mitzvah of *tzedakah.*
The performance of one charitable act initiates a
spiritual chain reaction leading to countless new
opportunities for benevolence. If a person performs an
act of charity properly it *must* lead him to a second
charitable act, and then to a third and a fourth. The
Torah alludes to this by repeating, *For you shall open
and continue to open your hand to him [the pauper].*

If a person per-forms an act of charity properly it must lead him to a second charitable act.

Not Selfless but "Self-more"

יוֹתֵר מִמַּה שֶׁבַּעַל הַבַּיִת עוֹשֶׂה עִם הָעָנִי THE SAGES TAUGHT, הָעָנִי עוֹשֶׂה עִם בַּעַל הַבַּיִת, *The poor man does more for the rich man than the rich man does for the poor* (*Vayikra Rabbah* 34:8). What outstanding benefit does the poor man provide for the wealthy one?

The Sages taught that the commandments were given so that man could refine his nature and transcend himself, as the prophet admonished, זְרְעוּ לָכֶם לִצְדָקָה קִצְרוּ לְפִי חֶסֶד, *Sow charity for yourselves and you will reap according to kindness* (*Hosea* 10:12). A planted seed disintegrates, and then a bit of it revives, spreads, and grows, until it realizes its potential. So too, the giver of charity is himself like a seed. Man himself is like a seed and all the earth is his garden. If he surrenders to his surroundings and sheds his external properties, he will uncover the inner core from which his greatness and destiny will emerge. Indeed, the first man, Adam, was named for the earth, *adamah,* because he was planted, as it were, on earth to achieve his destiny.

He will uncover the inner core from which his greatness and destiny will emerge.

By nature, man is selfish and self-centered; God wants him to become selfless and world centered. This is not accomplished by destroying the self, because a person stripped of his ego is lacking in his humanity. To the contrary, to reach his destiny, man must expand his ego by developing a new self-image, a new sense of who he is and for Whom he toils.

We love only those to whom we give.

We think that we give things to the people we love. In truth, however, we love only those to whom we give. If I give of myself and my wherewithal to you, I have expanded my definition of "self" to embrace you. If I claim to love you, it means that I have unlocked myself and opened my limited, confining borders to you — not to control you, but to care for you. Not to conquer you, but to comfort you. This is not an "ego-trip," nor an "ego-trap," rather it is an "ego-triumph." It is an indication of maturity, like a seed bursting forth with creative energy and expansive vitality. To be mature is to have the ability to nurture others, to have a new appreciation of the soul and of one's relationship with

To be mature is to have the ability to nurture others.

others. Heretofore, I had myopic eyes for myself, alone. Now I realize that, indeed, my soul is a fragment of God; and just as God is without limit, so too, my soul can grow, expand, and encompass more and more people.

Man is born with a shrunken, shriveled soul. A newborn infant is like a limp balloon, shapeless unless inflated. God Himself blew the first breath of life into Adam's nostrils, and then said, as it were, "Henceforth, you will breathe life into yourself — by breathing life into others whose poverty and pain wrenches the very life force from their lungs. As you breathe new life into others, you will merge their lives with your own."

As you breathe new life into others, you will merge their lives with your own.

Tzedakah is a lifelong process of self-actualization. As I sustain the life of another person, a new breath of life comes into me. As I share my portion, I realize new proportions. *Tzedakah* is an ongoing personal expansion.

Prior to the *tzedakah* experience, we are trapped within the narrow confines of our self-contained selves, filtering events through the constricting lens of egocentricity, viewing social existence as an endless conflict between competitors, each struggling to protect his sliver of private turf. After we surrender to the will of the Creator, we are richly rewarded with a new perspective of ourselves; as we enjoy the exhilarating flavor of genuine freedom we are freed from the tyranny of our self-contained selves. By submitting ourselves to God, we have connected ourselves with the wholeness of His creation.

By submitting ourselves to God, we have connected ourselves with the wholeness of His creation.

AS I SHARE MY ASSETS WITH THE NEEDY, I SHOW THAT I AM inseparable from them. *Tzedakah* is not merely giving, it is sharing, bonding, relating and connecting. *Tzedakah* weaves a new fabric of human relationships. As man shares himself with others, he removes layers of his rigid self-image, and his true Divine Image emerges from within.

Transfer Leads To Transformation

As man shares himself with others, his true Divine Image emerges from within.

The *Tanya* observes that although their bodies are separate, all Jews are one on the soul level, for they share the same spiritual source. The Torah teaches us to focus on the needs of our soul and to make its

When Jews
make the soul
their priority,
their bodies
cease to divide
them and broth-
erhood reigns
supreme.

enrichment our predominant objective. When Jews make the soul their priority, their bodies cease to divide them and brotherhood reigns supreme. When we see dissension among Jews, it is proof that these fractious people have made their material needs their top priority, that their bodies, not their souls, rip them apart (*Likutei Amarim* Ch. 32).

Sharing one's material resources through *tzedakah* breaks down the barrier of body and demonstrates our common bond of soul. As we refine ourselves, we redefine ourselves. Before *tzedakah*, I was an isolated resident in my own private world; after *tzedakah*, I share my existence with others. When reaping the rewards of *tzedakah*, I am a table heaped high with a cornucopia, beckoning the hungry to eat their fill. I am a flowing fountainhead, spreading life-giving waters in every direction. Man does not live in a vacuum. As he sustains others, so is he sustained. As he shares his blessings, he is blessed. As he gives of himself, he discovers himself.

Surely, we now have a deeper appreciation for the words, צְדָקָה תַּצִּיל מִמָּוֶת, *charity rescues from death* (*Proverbs* 10:2). Death means to be severed from the force of life. But charity connects the giver to the source of life.

II. Tzedakah: Representatives of a Caring God

כִּי אָמַרְתִּי עוֹלָם חֶסֶד יִבָּנֶה,
For I said: The world is built with kindness
(*Psalms* 89:3).

Rav Assi said: "The commandment to give charity is equivalent to all the other commandments combined" (*Bava Basra* 9a).

The mitzvah of
tzedakah is a
sure sign that
one is a tzaddik,
a righteous
descendant of
the seed of
Abraham.

The obligation to be scrupulously careful with the mitzvah of *tzedakah* is so important because it is a sure sign that one is a *tzaddik*, a righteous descendant of the seed of Abraham, about whom it is written: כִּי

יְדַעְתִּיו לְמַעַן אֲשֶׁר יְצַוֶּה אֶת בָּנָיו וְאֶת בֵּיתוֹ אַחֲרָיו וְשָׁמְרוּ דֶּרֶךְ ה' לַעֲשׂוֹת צְדָקָה וּמִשְׁפָּט, *For I [God] have loved him [Abraham], because he commands his children and his household after him that they keep the way of Hashem, doing charity and justice (Genesis 18:19).* Only by virtue of charity is the throne of Israel firmly established and the true faith upheld, as it is written: בִּצְדָקָה תִּכּוֹנָנִי, *Establish yourself through charity (Isaiah 54:14).* Furthermore, the final redemption of the Jewish people will come about only in the merit of charity as it says: צִיּוֹן בְּמִשְׁפָּט תִּפָּדֶה וְשָׁבֶיהָ בִּצְדָקָה, *Zion will be redeemed through justice, and those who return to her through charity (Isaiah 1:27)* (Rambam, Hilchos Matnos Aniyim 10:1).

Establishing the Throne of Israel

AMONG THE ADVANTAGES REALIZED THROUGH *TZEDAKAH,* Rambam states: *"Only by virtue of charity is the Throne of Israel firmly established and the true faith upheld."* What exactly is this "Throne of Israel"? How does charity impact upon it so powerfully?

The Talmud (*Pesachim* 118a) teaches that the Holy One, Blessed is He, dwells in the heights of the universe, yet distributes food to sustain every creature. Consequently, we believe with perfect faith that He personally provides for and sustains every animal and organism. In the morning prayer, עֶזְרַת אֲבוֹתֵינוּ, *Ezras Avoseinu,* we declare: בְּרוּם עוֹלָם מוֹשָׁבֶךְ וּמִשְׁפָּטֶיךָ וְצִדְקָתְךָ עַד אַפְסֵי אָרֶץ, *At the zenith of the universe is Your dwelling, yet Your justice and Your charity extend to the very ends of the earth!* The themes of charity and justice are intertwined, because the Almighty's care, concern and sustenance of His creatures is His absolute, unswerving commitment to maintain His Creation.

We believe with perfect faith that He personally provides for and sustains every animal and organism.

However, in providing for the needs of man, God decreed: "I will provide some men with more than they need. In turn, these men of means are My representatives to distribute their surplus funds and resources to the poor. They are more than mere administrators of My charity fund — they are My equal partners in the sustenance of My universe!"

Thus, we have arrived at the definition of the term,

the "Throne of Israel"; the throne which *Rambam* said is established by charity. The Throne of Israel is nothing less than the celestial throne of God, from where He alone provides for all of His creations — with one notable exception — the poor! In providing for them, God, so to speak, makes room on His throne for the Jewish people to join Him in distributing the funds and supplies that the indigent need.

Rising to the Challenge

Man, created in God's image, reaches the most perfect resemblance to his Maker when he shares God's responsibility to provide for those in need.

THE CREATOR WANTS HUMAN BEINGS TO BE HIS PARTNERS in bringing the world to perfection. Man, created in God's image, reaches the most perfect resemblance to his Maker when he shares God's responsibility to provide for those in need. King David sings: אֲנִי בְּצֶדֶק אֶחֱזֶה פָנֶיךָ, אֶשְׂבְּעָה בְהָקִיץ תְּמוּנָתֶךָ, *I — through charity — shall behold Your face, upon awakening I shall be sated by Your image* (Psalms 17:15). Only through acts of charity will man behold the image of God's face reflected upon his own mortal features. Only *tzedakah* will awaken the Divine spark lying dormant within man, and lead him to the fulfillment of his Godlike potential.

The sustenance of the poor man has been breached. You, the charitable man, filled the breach for Me.

The Midrash teaches: The prophet says: וְתָפֵק לָרָעֵב נַפְשֶׁךָ וְנֶפֶשׁ נַעֲנָה תַּשְׂבִּיעַ . . . וּבָנוּ מִמְּךָ חָרְבוֹת עוֹלָם . . . וְקֹרָא לְךָ גֹּדֵר פֶּרֶץ, *If you offer your soul to the hungry, and satisfy the afflicted soul . . . ancient ruins will be rebuilt through you . . . and they will call you "repairer of the breach"* (Isaiah 58:10,12). Says the Holy One, Blessed is He: "The sustenance of the poor man has been breached, and it was My responsibility to repair it and make it whole. You [the charitable man] rose to the challenge and filled the breach for Me . . ." Furthermore, the poor person sits and complains [against God]: "Why is my lot so different from that of the [rich man]? He sleeps on his bed while I sleep here. He sleeps in a house, while I sleep here." Then you stepped forward and gave him [charity].

By your life, I consider it as if you made peace between Me and him!" (*Vayikra Rabbah* 34:16).

In this vein, R' Nochum Cohen of Jerusalem told me that his Rebbi, R' Elya Roth, was wont to say: "People think that when they give *tzedakah* they are uplifting the poor. In truth, they are lifting up Almighty God Himself — as it says: בְּכָל צָרָתָם לוֹ צָר, *In all of their troubles, it is He Who is troubled* (Isaiah 63:9).

People think that when they give tzedakah they are uplifting the poor. In truth, they are lifting up Almighty God Himself.

Earthly Charity and Heavenly Charity

IN THE NARRATIVE OF CREATION WE READ: וַיַּעַשׂ אֱלֹקִים אֶת שְׁנֵי הַמְּאֹרֹת הַגְּדֹלִים אֶת הַמָּאוֹר הַגָּדֹל לְמֶמְשֶׁלֶת הַיּוֹם וְאֶת הַמָּאוֹר הַקָּטֹן לְמֶמְשֶׁלֶת הַלַּיְלָה, *And God made the two great luminaries, the greater luminary [the sun] to dominate the day, and the lesser luminary [the moon] to dominate the night* (Genesis 1:16). According to *Tikkunei Zohar* (p. 84), this verse introduces the concept of charity. The great luminary, the sun, represents the rich people, and the lesser luminary, the moon, represents the poor. Just as the moon receives its light from the sun, the poor have nothing of their own and exist from the blessing that the wealthy bestow upon them. This relationship of the celestial luminaries set up a universal pattern of symbiosis spreading throughout all of creation, wherein the Creator established givers and takers who coexist together.

There are two distinct levels of charitable distribution. The lower level may be described as "earthly charity," which is when the philanthropist is filled with pity over the material poverty of an indigent, and resolves to alleviate his suffering. This level of *tzedakah* may be sporadic and short lived, because it depends on the emotions of the giver, whose feelings may be fickle, unpredictable, and impulsive.

The higher level of *tzedakah*, "heavenly charity," is that of a mature philanthropist, whose soul has heard the Divine call to join the Creator on His Heavenly Throne, to participate in His constant concern for His needy people. Heavenly charity engenders a level

of ongoing, unshakable commitment. The true *baal tzedakah* takes responsibility for this world! His Divinely attuned sense of justice is offended by the disparity between the haves and the have-nots. He takes upon himself the responsibility to see that all human beings are provided for. His sense of justice and his sense of charity are inseparable.

This higher level of tzedakah is not merely an act of philanthropy; it is an act of faith.

This higher level of *tzedakah* is not merely an act of philanthropy; it is an act of faith. Such a benefactor acknowledges God's benevolence to him, and says, "I believe with perfect faith that God Himself consistently lavishes His great bounty upon me. Therefore, I do not hesitate to commit a portion of my bounty upon those who are not so blessed. No! God blesses the needy, too — but He sends their blessings through me!"

The story is told about a *Chassid* who presented a long list of requests to R' Shneur Zalman of Liadi, the founder of Chabad *Chassidus*. After studying the list, the Rebbe said to his disciple, "It is apparent that you have given much thought to your needs on earth. Have you given equal thought to why you are needed on earth?" The *baal tzedakah* understands that he is needed on earth to help those who are less fortunate.

It is apparent that you have given much thought to your needs on earth. Have you given equal thought to why you are needed on earth?

This is the essence of man. Man was not created for himself; only to help others as much as he finds he is capable of doing.

In his introduction to his father's classic *Nefesh HaChaim*, R' Yitzchok of Volozhin relates: "My father, the renowned *gaon* and *tzaddik*, would soundly rebuke me when he saw that I did not sufficiently empathize with the suffering of another person. Father would constantly remind me: 'This is the essence of man. Man was not created for himself; only to help others as much as he finds he is capable of doing!' "

Imitate God — Follow His Ways

IN TWO PLACES IN HIS *YAD HACHAZAKAH*, RAMBAM SPEAKS of the obligation to be kind and charitable. In *Hilchos Aveil* (Chapter 14:1) he gives a long list of acts of kindness that one should perform for his fellow, concluding that the obligation to do so is of Rabbinic origin, but is alluded to in the verse, וְאָהַבְתָּ לְרֵעֲךָ כָּמוֹךָ, *Love your fellow as yourself* (*Leviticus* 19:18).

Elsewhere, however, in *Hilchos De'os* (Chapter 1:5-6),

Rambam teaches that there is a Torah obligation to imitate the conduct of the Almighty, as it is written, וְהָלַכְתָּ בִּדְרָכָיו, *and you shall follow in [God's] ways* (Deuteronomy 28:9). *Rambam's* first illustration of this obligation is, "As God is described as compassionate, you too shall be compassionate; as God is described as merciful, you too shall be merciful, to demonstrate that the ways of God are good and straight, and everyone is obligated to conduct himself according to God's ways and to imitate Him to the very best of his ability."

In his two formulations — that acts of kindness are both Scripturally and Rabbinically ordained — *Rambam* is speaking of two separate levels of benevolence. The elementary level is "earthly kindness," which is motivated primarily by pain and pity for the plight of the person in dire need or distress. If the benefactor's prime purpose is to provide for the beneficiary's earthly needs, he fulfills the Scriptural commandment to *love your fellow as yourself.* However, the advanced, supreme level of benevolence, "Heavenly kindness," is attained when the benefactor has a loftier goal in mind. He achieves this when his objective is to imitate God and to be God's agent in caring for the needs of His creatures. The benefactor who makes this his aspiration fulfills the *mitzvah* alluded to in the words, *And you shall go in His [God's] ways.*

"Earthly kindness" is motivated primarily by pain and pity for the plight of the person in dire need or distress.

"Heavenly kindness" is attained when his objective is to imitate God.

THE TALMUD RELATES: R' YITZCHAK SAID, WHAT IS THE meaning of the verse רֹדֵף צְדָקָה וָחָסֶד יִמְצָא חַיִּים צְדָקָה וְכָבוֹד, *He who pursues opportunities to perform acts of charity and kindness will find life, charity and honor* (Proverbs 21:21)? This verse teaches that if one pursues opportunities to do charity, the Holy One, Blessed is He, provides him with ample funds to use for charity [and he will earn the rewards of life and honor and prosperity] (Bava Basra 9b).

Maharal (Nesivos Olam, Nesiv Hatzedakah, Ch. 1) explains, in a manner similar to the way the *Rambam* was explained above, that there are two types of *tzedakah;* reactive and proactive. The 'reactive' philanthropist

The Proactive Pursuit of Charity

If one pursues opportunities to do charity, the Holy One, Blessed is He, provides him with ample funds to use for charity.

only gives in response to the heart-wrenching pleas of the needy. His kindness is based on the primary human instinct of compassion for the pain of those who suffer. In a sense, his giving is somewhat selfish, because he himself cannot bear to witness the suffering and deprivation of others. Therefore, he gives his hard-earned money to remove the painful sight of poverty which he finds so troubling and offensive.

On the other hand, the 'proactive' benefactor does not wait to be asked. He seeks out opportunities to give. His *tzedakah* is based not on mere human instincts, but on traits resembling the Godlike and Divine. The 'proactive' giver has attached himself to the Creator, the Source of All Life, so he is bursting with a desire to share the Divine 'gift of life' with the 'lifeless' poor who lack the wherewithal to live properly.

The 'proactive' giver feels as if he overflows with vitality and life. He resembles a fountainhead gushing forth an endless torrent of living water; flowing forever with a mighty, invincible power, overwhelming every obstacle in its path. King Solomon promises that this "pursuer of charity" will be granted every resource and advantage that will aid in his charitable distribution.

Stretching One's Spiritual Stature

A person who performs acts of charity with the proper attitude has elevated his entire level of spirituality to the loftiest heights.

MAHARAL COMMENTS THAT A PERSON WHO PERFORMS acts of charity with the proper attitude has elevated his entire level of spirituality to the loftiest heights, approaching a truly Divine level. The key to attaining this high level, he explains, is consistency and dependability. This is indicated by the verse: אַשְׁרֵי שֹׁמְרֵי מִשְׁפָּט עֹשֵׂה צְדָקָה בְכָל עֵת, *Praiseworthy are those who maintain justice, who perform acts of charity in every time (Psalms 106:3).*

As evidence of this, *Maharal* cites the following incident from the Talmud (*Bava Basra* 10a): While climbing a ladder, Rav Pappa slipped and nearly fell. Reflecting on the near tragedy, he said, "Now, if an accident had indeed occurred and someone had fallen to his death, the punishment would be the same one prescribed for those who desecrate the Sabbath and

for idol worshipers" [who are thrown down from a high place and stoned. Clearly, Rav Pappa did not understand why he deserved this particular brush with death].

Chiya bar Rav, from the city of Difti, said to Rav Pappa: "Perhaps a pauper came to you and you did not sustain him with a gift of charity, for it was taught in a Baraisa: R' Yehoshua ben Karchah says: If anyone averts his eyes from giving charity, it is as if he worships idols." [Thus one who spurns the opportunity to give charity may incur a punishment analogous to stoning, which is the punishment for idolatry.]

Maharal explains that giving charity properly is like climbing a ladder leading to celestial heights. From His celestial throne, God acts as a *mashpia,* an overflowing source of sustenance for all who must be sustained. Similarly, one who gives *tzedakah* faithfully and consistently resembles God, for he, too, is a *mashpia,* who sustains others. However, a *mashpia* must be absolutely consistent, as is God himself. If he should allow himself to slip even once, he will have forfeited his exalted position and have "killed" his Godlike identity, until he repents and starts his ascent anew (*Nesivos Olam, Nesiv Hatzedakah* Ch. 2).

One who gives tzedakah faithfully and consistently resembles God, for he, too, is a mashpia, who sustains others.

III. The Charity of Abraham

Rambam (*Hilchos Matnos Aniyim* 10:1) emphasizes that we are obligated to be more meticulous with the mitzvah of *tzedakah* than all other positive mitzvos, "Because the performance of charitable actions is a sure sign that one is a *tzaddik,* a righteous descendant of the seed of Abraham about whom it is written: כִּי יְדַעְתִּיו לְמַעַן אֲשֶׁר יְצַוֶּה אֶת בָּנָיו וְאֶת בֵּיתוֹ אַחֲרָיו וְשָׁמְרוּ דֶּרֶךְ ה' לַעֲשׂוֹת צְדָקָה..., *For I [God] have loved him, [Abraham] because he commands his children and his household after him that they keep the way of Hashem, doing charity ...* (*Genesis* 18:19)."

Filling a Spiritual Void

What was unique about the charity of Abraham?

Compassion for those who suffer is a basic human trait that virtually all people share. Any person with stable, healthy emotions will want to give a helping hand to someone in need. Indeed, the instinct to assist others is not exclusively human. Countless nonhuman species of animals, birds, fish, and insects bond together for mutual provision and protection.

The charitable nature of Abraham's offspring, which our Sages praise so highly, far surpasses ordinary philanthropy and common kindness. Jewish *tzedakah* provides far more than food, drink, and clothing for the flesh. *The desperate cry of the lonely spirit rings louder than the call of the craving, hungry body*, for the suffering of one with a void in his soul far surpasses the anguish of one with empty pockets.

When Abraham lovingly welcomed a lonely stranger into his home, he tended to more than physical needs. Abraham served his guests as God's representative, telling them: "*It is not me whom you must thank for this hospitality. All gratitude should go to the Maker of heaven and earth*, Who provided me with the resources I shared with you, and Who taught me to make every homeless person a member of my household. As hungry as you are for bread, you should be hungrier for God. As thirsty as you are for water, you should be thirstier for the closeness of your Father in Heaven."

Abraham was nurturing their souls. "Lonely wayfarers! Even if you are pagans, idolaters, alien to the living God, accept this bread. But if you think you are taking it from **my** hand, you will merely fill your mouth and belly for a fleeting moment. If, however, you recognize that your sustenance comes from the living God, you will nourish your soul and replenish it far into the future."

Escorting Guests

THE REWARD FOR ESCORTING ONE'S GUESTS AS THEY depart surpasses everything else. Escort is the rule of courtesy that Abraham introduced, and this mitzvah embodies the way of kindness that he always practiced.

He would feed wayfarers, and give them drink, and then escort them on their way. Taking in guests is greater than greeting the Divine Presence — and escorting them afterwards is even greater than welcoming them (*Rambam, Hilchos Aveil* 14:2).

The mitzvah to escort is truly representative of Abraham's unique approach to benevolence. He crafted his generosity to answer the needs of the empty soul. His was a world of spiritual orphans, a mass of humanity oblivious to their Father in Heaven. Abraham graciously welcomed them all to his home, and showered them with love and kindness in the Name of their Heavenly Father. As his guests departed his home, Abraham proclaimed, "My brothers, this is not the end of your encounter with your Maker; it is only the beginning! I am escorting you, directing you, and watching over you even as you turn your backs to me, to demonstrate that God, Whom I serve, will be with you forever. He will always protect you and provide for your needs."

As his guests departed his home, Abraham proclaimed, "My brothers, this is not the end of your encounter with your Maker; it is only the beginning!"

All this provides us with a more sublime appreciation of what *tzedakah* really is. For the poor, charity provides more than a slice of bread; it rejuvenates their souls with an ample supply of faith in a caring Father in Heaven, Who has appointed His agents to provide for the needs of His children on earth. And for people of means who share with the poor, *tzedakah* imbues them with a new, Divine self-image.

IN *BIRKAS HAMAZON*, THE GRACE AFTER MEALS, WE PRAY, וְנָא אַל תַּצְרִיכֵנוּ ה' אֱלֹקֵינוּ לֹא לִידֵי מַתְּנַת בָּשָׂר וָדָם וְלֹא לִידֵי הַלְוָאָתָם כִּי אִם לְיָדְךָ הַמְּלֵאָה הַפְּתוּחָה הַקְּדוֹשָׁה וְהָרְחָבָה שֶׁלֹּא נֵבוֹשׁ וְלֹא נִכָּלֵם לְעוֹלָם וָעֶד, *Please, Hashem our God, make us not needful of the **gifts of human hands,** nor of **their loans,** but only of **Your Hand,** that is full, open, holy, and generous, so that we not feel inner shame nor be humiliated for ever and ever.*

God's Out- stretched Hand

The Chassidic master R' Moshe of Kobrin, in his *Ohr Yesharim,* explains that this passage describes three very different types of charitable donors. The first

Three very different types of charitable donors:

group is comprised of the arrogant men who actually take credit for the money they earn, so that when they give to the poor, the recipient feels that he has received *a gift from human hands.* The second group includes those who realize that they deserve no credit for the money they earned, because everything is a gift from God — we do not *make a living,* we *take a living* from the Almighty. Nevertheless, these donors expect credit for their charitable distributions, and feel that the poor are beholden to them. Because they expect something in return for their *tzedakah,* even as little as a thank-you, their *tzedakah* is more like a *loan* than a pure gift.

1) The recipient feels he has received a gift from human hands.

2) Their tzedakah is more like a loan than a pure gift.

The third level of benefactors consists of those who know full well that God has entrusted the portion of the poor in their hands. Quite accurately, they understand that they are like surrogates who distribute money on deposit with them. Indeed, they feel privileged to be God's agents and they appreciate that the poor are doing more for their welfare than they are doing for the poor. Such philanthropists are described as *Your Hand,* an extension of God's own hand. A poor person fortunate enough to receive his portion from such agents will not *feel inner shame nor be humiliated for ever and ever* (*Tiferes Banim, Kitzur Shulchan Aruch,* Part I, p. 256).

3) They understand that their charity is directly from the hand of God, disguised behind a mask of flesh and blood.

Such was the charity of Abraham; charity directly from the hand of God, disguised behind a mask of flesh and blood.

Loving-kindness: The Final Merit

GOD PROMISED THE PATRIARCHS THAT THEIR DESCENDANTS would remember them at the commencement of every prayer service, which is why we begin *Shemoneh Esrei* by addressing God as אֱלֹקֵי אַבְרָהָם אֱלֹקֵי יִצְחָק וֵאלֹקֵי יַעֲקֹב, *God of Abraham, God of Isaac, and God of Jacob.* The Talmud observes: "We might think that since all three Patriarchs are mentioned at the opening of this blessing, we should also conclude the blessing by mentioning them all. Therefore, the Torah states, וֶהְיֵה בְּרָכָה, *and you [Abraham] shall be a blessing* (*Genesis* 12:2), which implies that God said: "We conclude the

blessing only with you, Abraham, and not with the others." Therefore, the blessing concludes, בָּרוּךְ אַתָּה ה׳ מָגֵן אַבְרָהָם, *Blessed are you, Hashem, Shield of Abraham* (*Pesachim* 117b).

R' Shimon Shkop explains that in every generation, one path of Divine service seems to be more effective in perpetuating the survival of Judaism than others. Some generations saw a resurgence of intense piety and penitence, reflecting the reverent and disciplined service of the Patriarch Isaac. Other epochs witnessed a renaissance of intense Torah study, stressing the truth of the Patriarch Jacob. Which motif will predominate in the era that heralds the advent of the Messiah? God Himself answered the question when He declared, "We conclude the blessing with you, Abraham!" Your charitable influence will be predominant in the final era.

At that time, when the dark night of exile draws to an end, the gentile world will be engulfed by a self-centered culture, glorifying narcissism and dedicated to self-gratification. In response to this general decadence, the Jewish people in exile will rebel against the culture of their captors and be inspired by the example of Abraham to practice kindness on an unprecedented scale. This may well be the clearest sign that the Messiah's arrival is imminent.

May we see this resurgence of *tzedakah* in our days, so that our own eyes may witness the fulfillment of the Messianic promise that צִיּוֹן בְּמִשְׁפָּט תִּפָּדֶה וְשָׁבֶיהָ בִּצְדָקָה, *Zion will be redeemed through justice, and those who return to her through charity* (Isaiah 1:27).

THE TZEDAKAH TREASURY

Introduction to Tzedakah

CHAPTER ONE

A Delicate and
Difficult Mitzvah

Rambam (*Hilchos Matnos Aniyim* 10:1) writes: **We are obligated to be more meticulous with regard to fulfilling the mitzvah of** *tzedakah* **than we are with fulfilling any other positive Torah commandment.**

Rambam teaches us that of all the mitzvos of the entire Torah, *tzedakah* is the one we must exert ourselves for the most! *Rambam* makes it clear that there is a singular obligation to be especially scrupulous with the distribution of charity.

It is fascinating to note that *Rashi* (commentary to *Shabbos* 156a, s.v. *tzadkan b'mitzvos*) states an important rule: Whenever the unqualified word '**mitzvah**' is used in the Aggadic literature, it refers to one mitzvah in particular — *tzedakah*. *Tzedakah* is in a league of its own; no other mitzvah is like it, both because of *tzedakah*'s magnitude and because of its complexity.

When we contemplate this mitzvah we begin to realize why the proper performance of *tzedakah* is unique — no two acts of charity are alike. Not so with other mitzvos. Once a scribe has mastered the fine art and the detailed halachos of writing a *Sefer Torah*, he may duplicate his accomplishment many times and produce scroll after scroll without making any changes. Once a person has learned how to blow the *shofar*, he may blow in the exact same way for the rest of his life. The woman who properly kindles the Shabbos candles once may repeat this very same act in the very same way forever.

Not so with *tzedakah*. There is no such thing as a "standard donation." Every poor person or worthy cause that cries out for help

presents us with a new set of challenges. Every request for assistance demands individualized research and serious analysis. To give properly, the donor must make a comprehensive evaluation of the poor supplicant's situation. The serious donor should take into consideration a vast array of financial, social, medical and emotional factors, which impact on each case.

Moreover, the circumstances of every poor person are in a constant state of flux. The tragic facts that made him a prime candidate for assistance a week ago may have changed dramatically, and now this pauper's needs may not be quite so urgent or may be even more so. Additionally, the personal fortunes and the unique obligations of the donor are critical factors in making a decision of how much to give. Here too, nothing is static; everything is subject to change.

❧ Adjustment and Alignment

The very term, *tzedakah*, which literally means 'justice,' suggests that this is not merely almsgiving or compassionate benevolence. *Tzedakah* means equity and balance. It is a reapportionment of resources that realigns the scales of society so that the distance between the 'haves' and the 'have-nots' is not divided by such a wide chasm.

The donor of *tzedakah* must begin to take himself more seriously. No longer may he view himself as an insignificant, private citizen who is merely dropping a few coins into the needy person's hands. As he determines how and how much to dispense to the indigent, the donor transforms himself into a public personage invested with the awesome responsibility of caring for the lives of the poor whom he now supports. The donor becomes a person of *tzedakah*, of justice — 'a justice of the realm,' a magistrate charged with jurisdiction over God's world and His creations.

❧ When Cruelty Is Charity

I once asked R' Dovid Feinstein if he would share with me his general attitude and approach to the distribution of *tzedakah*. In response, he related the following anecdote which illustrates the delicate balance of this precept.

There was once a very charitable man who was approached aggressively by a man in need. The philanthropist was moved by the poor man's story and gave a large gift, far more than he usually gave. The poor man, however, was not satisfied and continued to badger the donor for a still larger gift. The philanthropist stood firm and refused to add to his already generous gift. Finally, the beggar was so exasperated that he screamed at the rich man and said: "You are an *achzor*, a cold-hearted, cruel person!" Calmly, the kindhearted philanthropist responded, "You are so right, my friend! I *am* an *achzor*; and if anyone should be happy about it, it should be you! Because, if I were not 'cruel,' then I would have already given all of my money away to the poor man who solicited me just before you came, and I would have had nothing left over to contribute to your cause!"

✑ He Distributes Freely and Carefully

The delicate equilibrium that the true *baal tzedakah* strives to achieve is described in *Tehillim* (*Psalms* 112:9) where King David praises the proper philanthropist, saying: פִּזַּר נָתַן לָאֶבְיוֹנִים, צִדְקָתוֹ עֹמֶדֶת לָעַד, *He distributed freely and carefully gave to the destitute, his charity endures forever.* King David teaches us that in order to accomplish *tzedakah* perfectly so that the merit endures forever, one must have two qualities: 1) פִּזַּר, *He distributed freely,* and 2) נָתַן, *He carefully gave.* Each of these qualities has a positive and a negative. Some people scatter their money around and love to throw it away. They have no desire to hoard money and they would much rather enjoy it immediately by spending it or sharing it with others. This is a positive attribute because such people *distribute freely* to charity. But there is a downside as well, because they did not make any sacrifice to give away their money; it just fell out of their pockets effortlessly. Other people have the exact opposite nature. They love money and delight in counting, saving, and hoarding their cash resources. This characteristic has a negative dimension, because it is difficult for such people to part with their precious money and distribute it to charity. But there is a positive side as well, because when such a person does force himself to open his pockets and *he carefully gives,* it is an intentional mitzvah act fulfilled with total concentration, and it is an act of true self-sacrifice.

The ultimate *baal tzedakah* whose *charity endures forever* is the person who blends the best of both traits. He scatters charity freely and generously like a person who is by nature an open-handed squanderer, and at the same time appreciates the value of money and performs this mitzvah carefully and scrupulously with a sense of heavy responsibility. (R' Yechezkel Sarna in his eulogy for R' Boruch Zeldovitz; see about R' Boruch in *Great Baalei Tzedakah.*)

~§ A Balancing Act

The following story demonstrates the incessant struggle to achieve a charitable 'balance.'

R' Naftoli of Ropshitz once revealed an amazing memory to his close followers. "My earliest recollection," he said, "goes back to when the angel was teaching me the entire Torah while I was still inside my mother's womb. I remember that he concluded his lesson with a list of seven topics where the Torah sources seem to be contradictory. For instance, in one place the Sages exhort us to emulate the humble nature of Abraham, who said, אָנֹכִי עָפָר וָאֵפֶר, *I am but dust and ash* (*Genesis* 18:27). Elsewhere, the Sages say: Every man is obligated to say: 'The entire world was created just for me' (*Sanhedrin* 38a).

"Another apparent contradiction: In one place the Talmud (*Kesubos* 66b) says: 'The only salt which preserves money is to deplete it through charity.' Yet elsewhere, the Talmud (*Kesubos* 50a) says that one who wishes to be lavish in giving charity is forbidden to give more than one fifth of his money away lest he become impoverished.

"Before the angel could reconcile these contradictions, I abruptly felt myself dropping down a dark chute, and suddenly I heard someone scream, 'Mazel Tov!' I was born into this world.

"I realized then, that my purpose in life was to reconcile these contradictions and to strike a balance, a middle road, between all extremes!"

~§ Follow Your Heart

When I consulted R' Avrohom HaKohen Pam, Rosh Yeshiva of Mesivta Torah Vodaath, on this subject, he offered me the following advice on how to distribute *tzedakah* properly: "After all is said

and done, every person is drawn to certain individuals and institutions which for some reason seem to grab his heart. This is how it should be. A person must follow his heart in his service of Hashem.

"This concept is explained at length by the *Netziv of Volozhin*, in his commentary *Haamek Davar* (*Numbers* 15:41), who observes: In *Koheles*, King Solomon says: וְהַלֵּךְ בְּדַרְכֵי לִבְּךָ וּבְמַרְאֵה עֵינֶיךָ, *Follow the path of your heart and the sight of your eyes* (*Ecclesiastes* 11:9); meaning that the service of Hashem is highly individualized and no two people are alike. One person is immersed in painstaking toil in the study of Torah all day long, while another puts tremendous effort into prayer and supplication, and yet a third person throws himself heart and soul into acts of charity and kindness. All of them are sincerely dedicated to glorifying the Name of God, each in his singular way. Even in the quest for Torah knowledge, no two scholars are alike; each has a unique methodology and approach to his studies. Likewise, in the pursuit of mitzvos, everyone has a preference for certain good deeds over others. And in the practice of philanthropy no two benefactors follow the same path.

"Therefore, if a person comes to ask for advice, 'What area of Divine service should I emphasize?' the only answer is to paraphrase the words of King Solomon, הַלֵּךְ בְּדַרְכֵי לִבְּךָ, *Follow the path of your heart*; if your heart is attracted to a certain mitzvah it is because your celestial soul has recognized this as the mitzvah which is bonded to the root and essence of your being."

◆§ Look to the Eternal — Not the External

Very well, follow your heart! But is the heart to be trusted? The heart is quite fickle and easily fooled. Of course, I could follow my heart if it were selfless and unsullied. But who would dare lay claim to such purity?

As will be explained in the next chapter, "Sensitivity at the Source," *tzedakah* is much more than an 'action mitzvah'; it is not merely the transfer of currency from hand to hand. If one fails to accompany his *tzedakah* 'action' with the proper thoughts and feelings, and with comforting words, then it may be rendered worthless, and even sinful. This is where this mitzvah becomes highly personalized. *Middos*, or personality traits and quirks of character, play a large role in determining

the amount of charity we give and how we give it. Even for the same collector and donor the outcome may be different, based on the times and circumstances.

Very often, the donor's decision whether to give and how much to give is determined by the *wrong* criteria. For no good reason the donor may be 'turned off' by all kinds of misleading externals factors. He may be repulsed by the poor man who looks too shabby, or by the one who looks too slick. He may deem the collector to be too meek, or he may consider him too aggressive. The more modern donor may be prejudiced against those who look 'too fanatic' because of their more traditional Jewish garb. Or he may harbor some hidden resentment against people who cannot speak English very well or not at all. Ashkenazic Jews may be apathetic to Sephardic causes and collectors — and vice versa. The list goes on and on, and we leave it to the reader to recall or imagine countless scenarios where charitable gifts were made based on powerful presentation, peer pressure, politics, pride and prejudice — rather than purely on the merit of the cause at hand.

With the commandment of *tzedakah* the Torah summons us to rise above all these perverse and petty considerations. The Almighty demands of us to scale the heights of honesty, humility and humanitarianism and to bestow kindness with an unbiased heart. He Who has bestowed wealth upon us expects us to distribute that bounty to His dependents, the poor. And He expects our distribution to be based on *eternal* criteria of *halachah* and *mussar,* not *external,* ephemeral considerations.

In short, it is through the poor that God makes us pure!

⋖§ A Charitable Atitude

Attitude plays an enormous role in the mitzvah of *tzedakah*. Some people only donate after they are vigorously solicited and cajoled into giving. This is what may be described as 'defensive *tzedakah*' — such people give in order to protect themselves from outside pressures. For these people, charity is a nuisance, and they feel that they could well do without it. Charity is relegated to the periphery of their busy lives, which are devoted to their selfish, personal agendas. At the very best, we might give such people the title of *nossnei tzedakah,* givers of charity.

Others, far more generous and kind hearted, are always on the lookout for good causes to which they can contribute. This *tzedakah* variety may be called 'dynamic *tzedakah*' — the charity of those who aggressively pursue philanthropic opportunities and consider this mitzvah to be a great privilege and merit. For such souls, charity enjoys a prominent position at the very epicenter of their lives. They well merit the title of *baalei tzedakah*, 'masters of charity,' or *rodfei tzedakah*, 'pursuers of charity.'

⋊§ The Enormity of This Mitzvah

Finally, we take pause to ponder the enormity of the mitzvah of *tzedakah*. It is truly the most all· pervasive and predominant of mitzvos. It is a mitzvah which must be performed at any time of day or night, each and every day of the year, by men and women and children (in training) alike. One never knows when a request for *tzedakah* will appear out of nowhere. The poor are authorized to solicit us at all times. For every other mitzvah there is time to prepare in advance. This mitzvah may take us by surprise at any time. Perhaps the best illustration of the boundless opportunities for kindness is the story of the Tzalka Rav who was determined to give *tzedakah* before *davening* even while in a concentration camp. Every day he broke off a bit of his meager bread ration and gave it away to a starving bunkmate before he began to pray (see "Prayer and Charity").

Moreover, *tzedakah* is probably the most expensive of all mitzvos. It commands a large part of our income. Minimally, a tenth of our earnings should be designated as the tithe, optimally we should give away a fifth (20 percent) of our income, and sometimes even more. These are very hefty sums. And the giving never stops. From the moment we possess our first penny until the day we die, we must give, and continue to give, until we breathe our final breath and leave this world. The only thing we take with us is our *tzedakah*!

⋊§ A Mitzvah of Checks and Balances

The purpose of this work is to attempt to demonstrate that there are few hard and fast rules for the disbursement of *tzedakah*. What is

appropriate and commendable in one situation may well be totally unacceptable under different circumstances. Sometimes it is right to give lavishly, other times it is best to give sparingly. Some paupers we should pity, others we should avoid. Sometimes we should give in utmost secrecy, at other times it is a mitzvah to give or pledge in public. At times we should follow the advice of the *Rambam* who says that one thousand small donations are better than one large one. Other times it is best to concentrate all of our resources upon one very important poor person or project. The list of apparent 'contradictions' goes on and on.

We must become truly proficient and well versed in the vast body of Torah teachings on the subject of *tzedakah* in order to learn how to adjust and fine-tune our philanthropy so that we achieve a proper sense of balance and proportion. When one strives to become a true *baal tzedakah,* he must go beyond the study of the halachah. For, as R' Avrohom Pam reiterates, *tzedakah* is a mitzvah which is more influenced by the pull of the heart than the head. Then again, the heart is fickle and easily fooled, so it must be controlled and guided by the halachah as studied by the head. Therefore, this *tzedakah* treasury draws both upon the halachah *and* a wealth of anecdotal material, particularly illustrations and examples from the lives of our revered Rabbis who demonstrated incredible sacrifice and sensitivity in their pursuit of this mitzvah.

✑ The Battle for Balance Rages Forever

The Chofetz Chaim noticed an odd phenomenon: Paupers from the big city of Warsaw traveled hundreds of miles to roam the streets of little towns like Radin to beg for charity, while indigents from towns like Radin made the arduous journey to places like Warsaw to collect alms. Why didn't everyone just stay home? The Chofetz Chaim explained: Satan, the Evil Inclination, has a Divinely ordained mission that is to attempt to corrupt the Jewish people. There is nothing that Jews are better at than giving charity. Really Satan would love nothing more than to take this entire mitzvah away from us, but he knows that is impossible because *tzedakah* is as dear to us as life itself. Therefore Satan must content himself with sullying our mitzvah. "Let them give all the charity they want!" says the Evil One, "I will see to it that they

do it all wrong! I will do my best to push them to give to the wrong people in the wrong places in the wrong amounts and in the worst possible fashion. I will confuse them. Instead of giving the most and the best to their neighbors and relatives and Torah scholars who deserve priority, I will inspire them to give more to unworthy strangers who deserve the least." (As related by Rav Y. Y. Ruderman, Rosh Yeshivas Ner Israel of Baltimore, to his nephew, R' Sheftel Neuberger.)

With this lesson in mind, this work was conceived. Undoubtedly, *tzedakah* is ingrained in the genes of the Jewish people. The problem is: *How to do it right?* How do we dispense charity to the right people in the right way in the right amount? For this we must turn to our Torah and to the wisdom of our Rabbis to guide us. Hopefully, with the help of Hashem, this volume will present a clear and accurate view of their teachings.

CHAPTER TWO

Sensitivity at the Source

The purpose of this entire volume is to demonstrate the complexity of the mitzvah of *tzedakah*. It is often assumed that *tzedakah* is primarily an *action* mitzvah, where the main focus is upon the transferring of money from the giver to the needy taker. In truth, the thoughts, attitudes and words which accompany the act of giving are of critical significance and can 'make or break' the mitzvah.

We present in this chapter the Scriptural sources for this mitzvah, together with a brief selection of commentaries to convey just how sensitive and careful one must be in order to give charity properly.

✎§ Lessons From *Shemittah* — The Seventh Year

The theme of charity and kindness finds expression in countless verses throughout the entire Torah. However, the basic commandment to dispense charitable gifts to the poor is found in *Parshas Re'ei* (*Deuteronomy* 15:7-11). There, charity is introduced in conjunction with the laws of *shemittah,* the seventh or Sabbatical year, at the end of which all outstanding monetary debts are automatically canceled. The Torah warns that we dare not allow ourselves to be deterred from making free loans to our needy brethren out of concern lest the loan be canceled at the conclusion of the *shemittah* year. The Torah goes on to say that we must show compassion not only by lending our money despite the risks involved, but we should also make outright charitable gifts to the poor at all times.

The Torah juxtaposes the laws of charity to the laws of the *shemittah* year, because the many regulations of the seventh year are designed

to emphasize one essential theme. Man owns absolutely nothing. Almighty God is Master of everything. The holy Land of Israel that God *gave* to the Jewish people is not permanently theirs. Once in every seven years God takes back His land and declares that it and its produce are 'free for all.' Furthermore, the money which a man has earned by the sweat of his brow and by dint of his investment savvy and skill, this too, remains the property of the Creator of heaven and earth. As a reminder of this, all monetary loans (subject to certain halachic criteria) are automatically canceled at the end of the *shemittah* year. Thus, the *shemittah* concept sets the tone for the underlying theme of *tzedakah:* everything one 'possesses' remains the property of God. The larger portion He allows us to utilize for ourselves; the lesser portion He has entrusted with us to distribute to His dependents, the poor.

◈§ The Verses

VERSE 7:

כִּי יִהְיֶה בְךָ אֶבְיוֹן מֵאַחַד אַחֶיךָ בְּאַחַד שְׁעָרֶיךָ בְּאַרְצְךָ אֲשֶׁר ה׳ אֱלֹקֶיךָ נֹתֵן לָךְ לֹא תְאַמֵּץ אֶת לְבָבְךָ וְלֹא תִקְפֹּץ אֶת יָדְךָ מֵאָחִיךָ הָאֶבְיוֹן.

If there shall be a destitute person among you, from any of your brethren in any of your cities, in your land that Hashem, your God, gives you, you shall not harden your heart or close your hand against your destitute brother.

VERSE 8:

כִּי פָתֹחַ תִּפְתַּח אֶת יָדְךָ לוֹ וְהַעֲבֵט תַּעֲבִיטֶנּוּ דֵּי מַחְסֹרוֹ אֲשֶׁר יֶחְסַר לוֹ.

Rather, you shall open, and continue to open, your hand to him; you shall lend him his requirement, whatever is lacking to him.

VERSE 9:

הִשָּׁמֶר לְךָ פֶּן יִהְיֶה דָבָר עִם לְבָבְךָ בְלִיַּעַל לֵאמֹר קָרְבָה שְׁנַת הַשֶּׁבַע שְׁנַת הַשְּׁמִטָּה וְרָעָה עֵינְךָ בְּאָחִיךָ הָאֶבְיוֹן וְלֹא תִתֵּן לוֹ וְקָרָא עָלֶיךָ אֶל ה׳ וְהָיָה בְךָ חֵטְא.

Beware lest there be a heretical thought in your heart, saying, "The seventh year approaches, the remission year," and you will look malevolently upon your destitute brother and refuse to give him — then he may call out against you to Hashem, and it will be a sin upon you.

VERSE 10:

נָתוֹן תִּתֵּן לוֹ וְלֹא יֵרַע לְבָבְךָ בְּתִתְּךָ לוֹ כִּי בִּגְלַל הַדָּבָר הַזֶּה יְבָרֶכְךָ ה׳ אֱלֹקֶיךָ בְּכָל מַעֲשֶׂךָ וּבְכֹל מִשְׁלַח יָדֶךָ.

You shall give and continue to give him, and let your heart not feel bad when you give him, for in return for this matter, Hashem, your God, will bless you in all your deeds and in your every undertaking.

VERSE 11:

כִּי לֹא יֶחְדַּל אֶבְיוֹן מִקֶּרֶב הָאָרֶץ עַל כֵּן אָנֹכִי מְצַוְּךָ לֵאמֹר פָּתֹחַ תִּפְתַּח אֶת יָדְךָ לְאָחִיךָ לַעֲנִיֶּךָ וּלְאֶבְיֹנְךָ בְּאַרְצֶךָ.

For destitute people will not cease to exist within the land; therefore, I command you, saying, "You shall open, and continue to open, your hand to your brother, to your poor, and to your destitute in your land."

Verse 7

✒§ Establishing Priorities

כִּי יִהְיֶה בְךָ אֶבְיוֹן מֵאַחַד אַחֶיךָ בְּאַחַד שְׁעָרֶיךָ בְּאַרְצֶךָ, *If there shall be a destitute person among you, from any of your brethren in any of your cities, in your land.*

From the opening words of this verse, the sages derive the order of priorities one should follow in dispensing charity. First comes an אֶבְיוֹן, *a destitute person,* someone who is desperately poor. Next comes אָחִיךָ , *your brethren* — the closer the relative, the greater the obligation. Next in line is, בְּאַחַד שְׁעָרֶיךָ, *in any of your cities* — the poor of your own city take precedence over the poor of other cities. Finally, בְּאַרְצֶךָ, *in your land,* comes to teach that the needs of the poor of *Eretz Yisrael* come before the needs of the poor of other lands (*Rashi* from *Sifrei*).

ﻹ Two Warnings Concerning Charity

לֹא תְאַמֵּץ אֶת לְבָבְךָ וְלֹא תִקְפֹּץ אֶת יָדְךָ מֵאָחִיךָ הָאֶבְיוֹן, *You shall not harden your heart or close your hand against your destitute brother.*

Here, the Torah issues two different warnings because it addresses two kinds of people. To one who cannot decide whether to give or whether to keep his money, God says, *You shall not harden your heart;* to someone who initially feels the desire to give a charitable donation but at the last moment changes his mind and pulls back his hand, God says, *You shall not close your hand.* The verse closes with an implied threat to those who remain callous toward the needy. Remember that the man facing you is *your destitute brother* — if you spurn his entreaties, *you yourself* may well become his brother in poverty (*Rashi*).

Thus, according to *Rashi,* if a person has, for any reason, unequivocally decided not to give any charity at all, to anyone or to this particular pauper, he *would not* transgress the aforementioned prohibitions. The prohibition only applies when one is seized by an initial proclivity to give and then suppresses it.

A similar idea is put forth by R' Eliezer of Metz in his *Sefer Yereim* (202): *You shall not harden your heart:* The Torah warns a person that if his heart feels inclined to be merciful, he should not twist his heart away and forcibly harden his heart to feel no mercy. *You shall not close your hand:* This refers to the person who already opened his hand and was prepared to give and then closes it.

Rambam, however, understands the two warnings as being one all-inclusive prohibition not to ignore the needs of the destitute. He writes: Whoever sees a poor man asking for help, and averts his eyes from him (ignores him) and does not give him charity, transgresses a negative commandment as it says: *You shall not harden your heart or close your hand against your destitute brother* (*Hilchos Matnos Aniyim* 7:2.)

In *Sefer Hamitzvos* (Negative Commandment 232), *Rambam* writes: We have been warned not to withhold charity and generosity from our destitute brethren, whose poverty *we are aware of* and whom we have the ability to support. This is as is stated in Scripture, *You shall not harden your heart or close your hand against your destitute brother* (*Deuteronomy* 15:7). This serves as a warning to take care not to

acquire the negative traits of stinginess and cruelty, which would prevent us from doing what is proper.

According to *Rambam*, then, even if someone was not personally solicited by the beggar, as long as he sees the beggar going around and asking for help, he is obligated to come to his aid. *Rashba* (commentary to *Shavuos* 25a), however, cites the opinion of the Tosafists of France who hold that one is not obligated to give charity until he is personally solicited by the poor man in need.

⊷§ Do Not Look Down at the Poor

The *SMAK* (*Sefer Mitzvos Kattan* 20) provides yet another interpretation of the two warnings of this verse. *You shall not harden your heart:* Do not say to yourself, "Why should I help this individual who is asking for charity? If only he would motivate himself to go to work, he could earn more than he needs!" Do not entertain such negative thoughts, because if you do, you have transgressed a Torah prohibition. Furthermore, *You shall not close your hand:* Do not say to yourself, "If I give a penny to the poor, it will undermine my financial security; it will be better for me if I don't give anything!"

In his commentary on the Torah, *R' Yosef Bechor Shor* provides yet another example of the perverse thinking which may enter the mind of the person who does not wish to give charity. *You shall not harden your heart:* Do not let this evil idea lurk in the depths of your heart, "The reason this unfortunate pauper is plagued with poverty is that he is a sinner and consequently God despises him. Therefore, I should not give this beggar anything." To counter this perverse thinking, the Torah admonishes: *You* are obligated to deal kindly with your destitute brother. What God chooses to do is His own business. Indeed, God may be subjecting this pauper to poverty because He loves him, as it says, כִּי אֶת אֲשֶׁר יֶאֱהַב ה' יוֹכִיחַ וּכְאָב אֶת בֵּן יִרְצֶה, *For Hashem admonishes the one He loves, and like a father, He mollifies the child* (Proverbs 3:12). Often, when God loves someone, He causes him or her to suffer in *this* world in order to cleanse him or her of the slightest trace of impropriety, so that they will be absolutely flawless when they enjoy the rewards of the Hereafter. Conversely, God often showers prosperity upon the wicked in this world, so that they will have no claim to reward in the Afterlife. Therefore, the man enjoying prosperity should not

dare to condemn the pauper in his heart, because by doing so he transgresses the prohibition of *You shall not harden your heart.*

⌐§ Words of Comfort

Finally, *Rabbeinu Bachya* in his Torah commentary describes how it is possible for a person to actually give charity with an open hand yet with a closed heart. He says that one transgresses the prohibition of *You shall not harden your heart,* when he or she gives a peremptory donation to the poor man but fails to offer him words of consolation or encouragement together with his gift.

⌐§ Two Separate Categories of Poor People

R' Naftoli Tzvi Yehudah Berlin (*Netziv*), in his commentary (*Haamek Davar*), demonstrates that based on this verse, the halachah divides the poor into two distinct categories, each one to be dealt with in a different fashion.

כִּי יִהְיֶה בְךָ אֶבְיוֹן, *If there shall be a destitute person among you,*

מֵאַחַד אַחֶיךָ, *from any of your brethren (or)*

בְּאַחַד שְׁעָרֶיךָ בְּאַרְצְךָ אֲשֶׁר ה' אֱלֹקֶיךָ נֹתֵן לָךְ, *in any of your cities, in your land that Hashem, your God, gives you,*

לֹא תְאַמֵּץ אֶת לְבָבְךָ, *you shall not harden your heart or*

וְלֹא תִקְפֹּץ אֶת יָדְךָ מֵאָחִיךָ הָאֶבְיוֹן, *close your hand against your destitute brother.*

In the *first* part of this verse the Torah presents two distinctly different types of people in need; in the *second* part the Torah instructs us how to deal appropriately with people from each of the two groups. The *first* category of needy is described as *any of your brethren,* referring to someone you know or clearly recognize to be a respectable citizen who once earned an honorable livelihood but has fallen on hard times. Despite his difficult situation, this person attempts to maintain his self-respect and refuses to go begging from door to door. Therefore, he still is considered *your brother,* your equal and peer, who is struggling to maintain his reputation as a normal, self-sufficient member of society. In reference to this *brother,* the

second half of the verse instructs us: *you shall not harden your heart,* meaning that not only must you supply this person with his needs, but you should also open your heart to him, feel his pain and empathize with him. You must become emotionally involved with this person and shower him with genuine concern and consolation.

The second category of the needy is someone who is not considered to be your brother. Rather, he is a complete stranger to you, whom the Torah describes as, *in any of your cities* — an itinerant beggar who travels from city to city, shul to shul, door to door, begging for alms. This stranger just happened to enter your gates in the course of his wandering. Here, the Torah is concerned lest you disregard this person or treat him with contempt and disdain. Regarding this type of collector the Talmud (*Bava Basra* 9a) teaches: One is not obligated to give more than a minimal donation to he who collects from door to door, in fulfillment of the verse: אַל יָשֹׁב דַּךְ נִכְלָם, *Do not turn away empty handed he whose spirit is crushed, lest he be put to shame* (Psalms 74:21). Thus, generally speaking, one is not required to open his home and his heart to such a person, only a small gift from hand to hand is required, so the Torah warns: *you shall not close your hand against your destitute brother.* Every Jew is surely your brother, albeit a distant one, and you must help everyone who begs for alms. Nevertheless, not all brothers are alike. The one who has not been forced to stoop to beggary is your complete brother and you must take *full* responsibility for him and try your best to provide for all his needs in the most dignified and discreet fashion. But for the one who is merely *your destitute brother,* while he should not be ignored, a minimal donation will suffice.

◆§ No Two Paupers Are Alike

Similarly, the *Gaon* of Vilna explains the meaning of the words, *you shall not close your hand against your destitute brother.* When the hand is held open, with the fingers outstretched, one can clearly see that not all fingers are alike. But when the hand is closed and clenched into a fist, the four digits look exactly the same size. Therefore the Torah warns, when considering how to give charity, do not evaluate the destitute like the fingers of a closed hand, where all fingers look equal. Evaluate the poor like the fingers of an open hand and realize that no two paupers are alike.

Verse 8

◄§ Never Lose Patience

כִּי פָתֹחַ תִּפְתַּח אֶת יָדְךָ לוֹ, *Rather, you shall open, and continue to open, your hand to him.*

The compound verb tells us to give again and again, many times over (*Rashi*), and not lose patience or become tight fisted after giving once or twice.

Rambam (*Sefer Hamitzvos*, Positive Commandment 195) writes: We have been commanded to practice acts of charity — to strengthen the weak and to be generous with them. This commandment has been phrased in a number of different ways in the Torah, such as, *You shall open, and continue to open, your hand to him* (*Deuteronomy* 15:8); *You shall strengthen him* (*Leviticus* 25:35); *Let your brother live with you* (ibid. v. 36). However, the theme of all these verses is the same — we are responsible for helping the poor and supporting them as much as they need.

וְהַעֲבֵט תַּעֲבִיטֶנּוּ, *You shall lend him his requirement.*

The Torah directs that if the needy man is too proud to accept charity, you should lend him what he needs (*Rashi*).

◄§ Give Him What He Lacks

דֵּי מַחְסֹרוֹ אֲשֶׁר יֶחְסַר לוֹ, *Whatever is lacking to him.*

Although you are not obligated to make the supplicant rich, you should make an effort to give him what he lacks, according to his individual needs. Someone who was once wealthy and lost everything cannot subsist on what would be sufficient for someone who was always poor (*Rashi*).

Verse 9

❧ God Guarantees His Blessing

הִשָּׁמֶר לְךָ פֶּן יִהְיֶה דָבָר עִם לְבָבְךָ בְלִיַּעַל לֵאמֹר קָרְבָה שְׁנַת הַשֶּׁבַע שְׁנַת הַשְּׁמִטָּה וְרָעָה עֵינְךָ בְּאָחִיךָ הָאֶבְיוֹן וְלֹא תִתֵּן לוֹ, *Beware lest there be a heretical thought in your heart, saying, "The seventh year approaches, the remission year," and you will look malevolently upon your destitute brother and refuse to give him.*

The impending seventh year can be frightening to many lenders, for if the borrower cannot pay in time, the loan will be canceled at the conclusion of the *shemittah* year. The Torah warns that such fears are sinful and heretical because they betray a lack of faith in God. For even if the loan becomes a total loss, God Himself guarantees His blessing — surely much more valuable than whatever the loss may be.

❧ Do Not Arouse Divine Wrath

וְקָרָא עָלֶיךָ אֶל ה׳ וְהָיָה בְךָ חֵטְא, *Then he (the supplicant) may call out against you to Hashem, and it will be a sin upon you.*

Even if the rebuffed pauper will register no complaint to God against you, God's wrath will be aroused by your lack of kindness. But if the pauper does cry out to God against you, it will incite Divine retribution to strike you more swiftly (*Rashi*).

Verse 10

✑ Beware of an Angry Face and a Jaundiced Eye

נָתוֹן תִּתֵּן לוֹ, *You shall give and continue to give him.*

Even one hundred times (*Rashi*).

וְלֹא יֵרַע לְבָבְךָ בְּתִתְּךָ לוֹ, *And let your heart not feel bad when you give him.*

When giving charity, one must display a smiling face, and give with joy and a happy heart. The donor should attempt to feel the poor man's pain and share in his anguish. He should offer the pauper words of comfort. However, if the donor gives his alms with a nasty, angry face, he has forfeited his entire merit (*Shulchan Aruch, Yoreh Deah* 249:3) Even if the donor gave the poor man a large and generous gift, he loses the entire merit of the mitzvah and transgresses the negative command of *And let your heart not feel bad when you give him* (*Shach* ibid.).

Ramban (*Sefer Hamitzvos,* Additional Prohibitions 17) says that the admonition, *And let your heart not feel bad when you give him,* teaches that it is forbidden to give *tzedakah* with a jaundiced eye, feeling that the donation has caused a financial loss. Rather, the donor should consider the opportunity to give as a reward and a privilege and a very profitable investment that will reap rich rewards. For the Almighty will surely repay us many times over for everything we give away to the poor.

After you have given alms to the poor do not feel bad about it and regret it. Rather, you should rejoice over your good deed (*SMAK, Sefer Mitzvos Kattan* 21).

⊷§ To Emulate God
Is the Greatest of Blessings

כִּי בִּגְלַל הַדָּבָר הַזֶּה יְבָרֶכְךָ ה' אֱלֹקֶיךָ בְּכָל מַעֲשֶׂךָ וּבְכָל מִשְׁלַח יָדֶךָ, *For in return for this matter, Hashem, your God, will bless you in all your deeds and in your every undertaking*.

In truth, the greatest blessing of all is to imitate God's Divine attributes and to become godly oneself. The following passage expresses this idea most eloquently: *R' Samson Raphael Hirsch* (*Horeb* p. 427) writes: "Look around you in the great house of your [Heavenly] Father — Everything sustains and is sustained, everything takes and gives and receives a thousandfold in giving — for it receives life instead of mere existence. And do you alone wish only to take and not to give? Would you be as a stream which dries up in the arid sand and fails to give back to the sea that which it has received? Once you have pondered upon the thought — that you are nothing so long as you exist only for yourself, that you only become something when you mean something to others — that you have nothing so long as you have it only for yourself, that you only possess something when you share it with others — that even the penny in your pocket is not yours until you spend it for a blessed purpose; only then will you rejoice in the great task to which God has summoned you."

—— Verse 11 ——

⊷§ Make Yourself Feel Rich
When You Give to the Poor

כִּי לֹא יֶחְדַּל אֶבְיוֹן מִקֶּרֶב הָאָרֶץ, *For destitute people will not cease to exist within the land:*

This thought provides an additional incentive to give charity or to extend loans. Poverty is a constant phenomenon and today's

magnate may be tomorrow's pauper. The charity a person dispenses today may well be returned to him in the future if his fortunes are reversed (Ralbag).

Seven verses earlier in this chapter, in verse 4, Scripture seems to contradict this statement, because it says, אֶפֶס כִּי לֹא יִהְיֶה בְּךָ אֶבְיוֹן, *However, there shall be no destitute among you.* Chasam Sofer (Toras Moshe) explains that verse 11 refers to the recipients of charity, of which there will always be an ample supply, and they *will not cease to exist within the land.* Verse 4, however, describes the man who is giving the charity. No matter what his economic status really is, while a person is dispensing *tzedakah* he should feel as if he is a wealthy man, and should disburse his funds with a generous heart and a jovial countenance. The Torah's philanthropist, whether rich or poor, must banish from his heart any sense of economic inferiority or disadvantage. Then he will fulfill the command, *there shall be no destitute among you* — i.e., within your own heart.

⊸§ Regard the Poor Man's Plight as Your Personal Problem

עַל כֵּן אָנֹכִי מְצַוְּךָ לֵאמֹר פָּתֹחַ תִּפְתַּח אֶת יָדְךָ לְאָחִיךָ לַעֲנִיֶּךָ וּלְאֶבְיֹנְךָ בְּאַרְצֶךָ, *Therefore, I command you, saying, "You shall open, and continue to open, your hand to your brother, to your poor, and to your destitute in your land.*

The Torah describes the needy as '**your** *brother,*' '**your** *poor,*' '**your** *destitute,*' to emphasize that it is not enough to give to the needy in a casual fashion, without paying them much attention. One must truly take responsibility for the poor and accept their burden as his personal burden, and their plight as his own plight.

Rambam (Matnos Aniyim 10:2) exhorts us in the strongest terms to take responsibility for our destitute brethren, saying: "All of Israel and all who join them are like brothers . . . and if a brother will not take pity on his own brother, who then should take pity on him? And to whom should the poor of Israel turn their eyes in expectation of help? Should they turn to their enemies who despise and persecute

them? Obviously the poor have no one to turn to other than their own Jewish brethren!"

Indeed, the Sages teach us time and again that God deposited the sustenance of the poor man with his rich brother. Moreover, the only reason why God made some men poor is to give the man of means the merit of the mitzvah of *tzedakah.* Let the rich man be ever mindful that the indigent is literally '**your** *poor';* his suffering is for *your* sake.

CHAPTER THREE

Rambam's Eight Levels of Charity

◄§ The Eight Levels of Charitable Giving

Rambam, in the last chapter of his *Laws of Gifts to the Poor,* presents a comprehensive hierarchy of the preferred ways of distributing charity. Altogether, *Rambam* lists eight levels of charitable giving, which we present here with brief commentary and illustrations.

— Rambam: Hilchos Matanos Aniyim — Chapter 10

◄§ Level One: A Helping Hand

HALACHAH 7:

שְׁמוֹנֶה מַעֲלוֹת יֵשׁ בַּצְּדָקָה – זוֹ לְמַעְלָה מִזּוֹ. מַעֲלָה גְדוֹלָה שֶׁאֵין לְמַעְלָה מִמֶּנָּה – זֶה הַמַּחֲזִיק בְּיַד יִשְׂרָאֵל שֶׁמָּךְ וְנוֹתֵן לוֹ מַתָּנָה אוֹ הַלְוָאָה אוֹ עוֹשֶׂה עִמּוֹ שֻׁתָּפוּת אוֹ מַמְצִיא לוֹ מְלָאכָה כְּדֵי לְחַזֵּק אֶת יָדוֹ עַד שֶׁלֹּא יִצְטָרֵךְ לַבְּרִיּוֹת לִשְׁאוֹל. וְעַל זֶה נֶאֱמַר "וְהֶחֱזַקְתָּ בּוֹ גֵּר וְתוֹשָׁב וָחַי עִמָּךְ" – כְּלוֹמַר הַחֲזֵק בּוֹ עַד שֶׁלֹּא יִפֹּל וְיִצְטָרֵךְ, **There are eight levels of charity — each one higher than the next. The greatest form of charity, which is unsurpassed by any other, is to give a helping hand to a Jew who is on the verge of financial ruin. This may be accomplished by giving him a gift or a loan, by**

entering into a partnership with him, or by providing him with gainful employment. Any of these efforts should be undertaken to strengthen this person before he would have to ask for charity. This is what Scripture had in mind when it said: [וְכִי יָמוּךְ אָחִיךָ וּמָטָה יָדוֹ עִמָּךְ וְהֶחֱזַקְתָּ בּוֹ גֵּר וְתוֹשָׁב וָחַי עִמָּךְ], *[If your brother becomes impoverished and his means falter in your proximity] you shall strengthen him — proselyte or resident — so that he can live with you (Leviticus 25:35).* In other words, support him before he falls and becomes needy.

Upholding a poor person (to save him from falling below his level) has priority over supporting a wealthy person from slipping from his level of prosperity, even if the wealthy person is a neighbor or a relative (*Ahavas Chesed* 1 note 25).

The Chofetz Chaim (*Ahavas Chesed,* 21:1) says that the conclusion of this verse, וָחַי עִמָּךְ, *so that he can live with you,* can be explained by reference to the verse: עָשִׁיר וָרָשׁ נִפְגָּשׁוּ עֹשֵׂה כֻלָּם ה', *The rich man and the pauper meet; Hashem is the maker of them all (Proverbs 22:2).* The Sages expound: "When the poor man approaches the rich man and pleads, 'Support me!' — if the rich man supports the poor, well and good. If not, then *Hashem is the maker of them all.* The very same God Who made this man rich can turn around and make him poor!" Thus, says the Chofetz Chaim, whenever a poor man approaches you, you should imagine that your own finances are also insecure. And it really is so, because if you do not respond positively to the pauper, your financial position may collapse like his, heaven forbid. If, however, you do help him to stabilize his position, both of you together will endure and prosper, thereby fulfilling the Scriptural pledge, *so that he can live with you.*

Sefer Chassidim (1035) writes that an excellent form of charity is when the poor man attempts to sell an article that no one wants to buy, but the rich man nevertheless purchases it from him. This is a supreme act of charity because the pauper does not feel that he has received alms.

Not only was R' Yeshaya Muskat of Prague a great *baal tzedakah,* he also developed unusual sensitivity for the real needs of the poor. Once, a blind pauper came to Prague and made an effort to support himself by selling cakes and cookies. The blind man set up his humble business right next to the home of R' Yeshaya, where he sat all day

with a basket full of baked goods and hawked his wares to every passerby. The blind man's situation was miserable indeed, because he sat all day, in every kind of weather, exposed to the elements. In addition, such peddling was illegal, and the blind man was constantly filled with fear that the authorities would harass or even arrest him. Sure enough, one day, a policeman caught him and confiscated all of his merchandise. The blind man wailed bitterly over his misfortune and R' Yeshaya Muskat heard his heartrending cries. The kindhearted Rabbi gave the blind pauper enough money to cover his loss. From then on, R' Yeshaya would wait for the blind man every morning. The minute he set up his little stand, R' Yeshaya would come by and purchase all of his wares. The neighbors saw what was going on and asked R' Yeshaya: "We see that you are supporting the blind man single-handedly. So why don't you just give the pauper one lump sum, a monthly stipend, and save him from the burden of dragging his basket and setting up his stall every morning, and save yourself the effort of going through this daily charade?" R' Yeshaya firmly rejected their proposal: "Don't you see how much pride the blind man takes in his enterprise? Don't you see how he considers himself to be a successful businessman and not a helpless beggar? If this poor man's eyesight has been taken away from him, shall we also take away from him his self-respect and sense of accomplishment?"

✑§ Level Two: Double Anonymity

HALACHAH 8:

פָּחוֹת מִזֶּה – הַנּוֹתֵן צְדָקָה לָעֲנִיִּים וְלֹא יָדַע לְמִי נָתַן וְלֹא יָדַע הֶעָנִי מִמִּי לָקַח. שֶׁהֲרֵי זוֹ מִצְוָה לִשְׁמָהּ. כְּגוֹן לִשְׁכַּת חֲשָׁאִים שֶׁהָיְתָה בַּמִּקְדָּשׁ שֶׁהָיוּ הַצַּדִּיקִים נוֹתְנִין בָּהּ בַּחֲשַׁאי וְהָעֲנִיִּים בְּנֵי טוֹבִים מִתְפַּרְנְסִין מִמֶּנָּה בַּחֲשַׁאי. וְקָרוֹב לָזֶה – הַנּוֹתֵן לְתוֹךְ קֻפָּה שֶׁל צְדָקָה. וְלֹא יִתֵּן אָדָם לְתוֹךְ קֻפָּה שֶׁל צְדָקָה אֶלָּא אִם כֵּן יוֹדֵעַ שֶׁהַמְמֻנֶּה נֶאֱמָן וְחָכָם וְיוֹדֵעַ לְהַנְהִיג כַּשּׁוּרָה כְּרַבִּי חֲנַנְיָה בֶּן־תְּרַדְיוֹן, The next level, a step lower, is to give a charitable gift to the poor in such a way that the donor is unaware of the identity of the recipient, nor does the recipient know his benefactor. This is pure charity [lishmah] performed for its own sake. An example of this was Lishkas Chashoim, 'The Chamber of the Discreet,' in the Temple. The tzaddikim would deposit money into it quietly, and the

poor sons of good families supported themselves from it discreetly (*Mishnah, Shekalim* 5:6). The closest thing to this [today] would be the community charity chest. However, one should not contribute to the community charity chest unless he knows that the person in charge of it is as trustworthy and wise and capable of administering it properly as Rabbi Chananya ben Teradyon (*Bava Basra* 10b).

⊰ Level Three: Incognito Benefactor

HALACHAH 9:

פָּחוֹת מִזֶּה – שֶׁיֵּדַע הַנּוֹתֵן לְמִי יִתֵּן וְלֹא יָדַע הֶעָנִי מִמִּי לָקַח ... , The next level, a step lower, is when the donor knows to whom he is giving, but the poor man is unaware of the identity of his benefactor ...

This means that when a *gabbai tzedakah* is not available to serve as a middleman and the donor must personally allocate the charity, he should still attempt to deliver it in secrecy. He can, for example, throw the money into the poor man's house or send it with a messenger or a mailman who will not divulge who sent the money. The Talmud (*Kesubos* 67b) relates how Mar Ukva was accustomed to secretly placing a sum of money on a poor man's doorstep every day. One day the poor recipient decided to discover the identity of his mysterious benefactor. The man waited behind his front door until Mar Ukva and his wife approached. When the poor man flung open the door, Mar Ukva and his wife fled at top speed lest their identity be discovered. In order to elude the poor man who was running after them, they both dashed into a burning furnace to hide, saying that it was preferable to throw oneself into an inferno than to embarrass a poor recipient.

⊰ Level Four: Unknown Recipient

HALACHAH 10:

פָּחוֹת מִזֶּה – שֶׁיֵּדַע הֶעָנִי מִמִּי נָטַל וְלֹא יָדַע הַנּוֹתֵן. כְּגוֹן גְּדוֹלֵי הַחֲכָמִים שֶׁהָיוּ צוֹרְרִים הַמָּעוֹת בִּסְדִינֵיהֶם וּמַפְשִׁילִין לַאֲחוֹרֵיהֶם וּבָאִין הָעֲנִיִּים וְנוֹטְלִין כְּדֵי שֶׁלֹּא יִהְיֶה לָהֶם בּוּשָׁה, The next level, a step lower, is

when the recipient knows from whom he is receiving, while the giver is unaware of the identity of the recipient. This was the practice of certain great Sages who would wrap money in their cloak and throw it over their shoulders behind them so that the poor could take the money without being seen, thus avoiding embarrassment.

Another example of this level of giving is described in the Talmud (*Berachos* 58b) regarding R' Chana bar Chanilai who left bags of grain outside his home every night during years of famine for the benefit of those indigents who were too embarrassed to personally beg for food in the daytime.

This level of giving is a degree lower than the preceding one because here the poor person feels somewhat embarrassed and beholden to his patron. This method is, however, preferable to the following level, because the poor man is spared the need to confront his benefactor face to face.

⋖§ Level Five: Giving Before Being Asked

HALACHAH 11:

פָּחוֹת מִזֶּה – שֶׁיִּתֵּן לְעָנִי בְּיָדוֹ קֹדֶם שֶׁיִּשְׁאַל, The next level, a step lower, is for the donor to present the money directly to the poor man, but to give it to him before he asks.

When a confrontation between the donor and the poor recipient is unavoidable, one should make a special effort to enhance his mitzvah by giving before being asked. With this sensitivity and kindness one emulates the ways of the Almighty Who says: וְהָיָה טֶרֶם יִקְרָאוּ וַאֲנִי אֶעֱנֶה, *And it will be that before they call, I will answer* (Isaiah 65:24).

⋖§ Level Six: A Generous Response

HALACHAH 12:

פָּחוֹת מִזֶּה – שֶׁיִּתֵּן לוֹ כָּרָאוּי לִיתֵּן לוֹ אַחַר שֶׁיִּשְׁאַל , The next level, a step lower, is to give an appropriate amount to the poor after being asked.

❧ Level Seven: Bestowing Words of Comfort

HALACHAH 13:

פָּחוֹת מִזֶּה – שֶׁיִּתֵּן לוֹ פָּחוֹת מִן הָרָאוּי בְּסֵבֶר פָּנִים יָפוֹת, The next level, a step lower, is to give the poor man less than the appropriate amount, but to give with a smile and a pleasant disposition.

Sometimes, even a person who is usually a generous donor is incapable of giving a generous amount. Embarrassed by his inability to respond in a dignified way, this donor may feel that it is better to give nothing at all. That is incorrect. Better to give a small amount with sincere apologies and regret than to give nothing at all, thus losing the mitzvah and depriving the poor of everything.

Even if a person is unable to give anything because of his own poverty, he can still offer encouraging words of comfort to the unfortunate collector. The Talmud (*Bava Basra* 9b) teaches that when a person offers kind words, even without any financial aid, heaven bestows eleven blessings upon him. Encouraging the poor man should be a primary objective in giving *tzedakah*.

❧ Level Eight: Giving With Misgivings

HALACHAH 14:

פָּחוֹת מִזֶּה – שֶׁיִּתֵּן לוֹ בְּעֶצֶב, The next level, a step lower, is to give charity with sadness.

The very lowest level of *tzedakah* is to give with hidden, unexpressed feelings of reluctance. If the donor *openly* expresses his annoyance and dislike of giving, then he loses the entire merit of his *tzedakah*, even if he gave a large, generous amount. This type of callous contribution is not even considered among the *Rambam's* eight levels of charity, for it is actually a sin. The giver transgresses the prohibition, וְלֹא יֵרַע לְבָבְךָ בְּתִתְּךָ לוֹ, *Let your heart not feel bad when you give him* (*Deuteronomy* 15:10).

The Value of Giving

Charity Protects
From All Harm

~§ Charity Saves From Death

לֹא יוֹעִילוּ אוֹצְרוֹת רֶשַׁע וּצְדָקָה תַּצִּיל מִמָּוֶת, *Treasures of wickedness will not avail, but charity rescues from death (Proverbs 10:2).*

לֹא יוֹעִיל הוֹן בְּיוֹם עֶבְרָה וּצְדָקָה תַּצִּיל מִמָּוֶת, *Wealth will not avail in the day of wrath, but charity will rescue from death (Proverbs 11:4).*

There is nothing in the entire world which protects and delivers from death as effectively as acts of charity (*Vilna Gaon, Proverbs* 10:2). Obviously, this is measure for measure. For providing the needy with the essentials of life, he himself deserves to be rescued from mortal danger.

The Talmud (*Bava Basra* 10a) notes that King Solomon said *twice* that charity rescues from death. This signifies that charity rescues its donor from two different kinds of death: 1) *from an unnatural death,* and 2) *from the terrible punishment of Gehinnom after death.* The charity of the first verse quoted above (*Proverbs* 10:2) is the one that rescues from unnatural death; it refers to charity given anonymously, neither the donor nor the recipient knowing the identity of the other.

God Repays Those Who Restore the Poor to Life

Midrash Tanchuma (*Parshas Mishpatim* 15) teaches: מַלְוֵה ה׳ חוֹנֵן דָּל וּגְמֻלוֹ יְשַׁלֶּם לוֹ, *One who is gracious to the poor has lent to Hashem, and He will pay him his reward* (*Proverbs* 19:17). One who helps the poor is considered as if he has helped God Himself. One may think that if he gives a penny to the poor, God will give him a mere penny in return. Instead, God says: "This poor man was in the throes of death, brought on by his hunger. You nourished and revived him. By your life, I shall restore a life to you in return! Tomorrow, your son or your daughter may be ill or near death. I shall remember what you did for the poor man, and I will save your child from death for your sake. I will repay a life for a life!"

A Change of Fate

The Talmud (*Shabbos* 156b) recounts an incident from which the sage Shmuel derived that charity saves even from death itself. Shmuel and the Persian astrologer Avleit were sitting as a group of workers were walking towards a swamp. Avleit pointed to one worker and predicted, "That man is going out but will not return; a snake will bite him and he will die." Shmuel responded, "If he is a Jew, he will go out and return" [for a Jew is not controlled by the stars and his fate can be changed by prayer or *charitable deeds*]. When the worker returned alive, Avleit examined the man's knapsack and found a poisonous snake cut in half. (Apparently, as this worker was cutting reeds, he chopped this dangerous snake in two without realizing what he had done.) Shmuel said to the worker, "What have you done that might have made you worthy of escaping death?" The man explained that each day his group collected everyone's food into one basket, and then ate together. That day one of the men had no food to contribute. To avoid embarrassing him, the worker volunteered to collect the daily food and pretended to take from the man who was empty handed as well. Later the kind worker shared his own portion with the man (*Rashi* ad loc.). Thus, his charitable deed saved him from death.

✑ Saved From a Deadly Snake

The Talmud (ibid.) relates a second incident to illustrate the same point. Chaldean astrologers warned Rabbi Akiva that a serpent would kill his daughter on her wedding day. Naturally, R' Akiva was very concerned as his daughter's marriage date approached. On her wedding night, his daughter removed her golden pin and stuck it in a hole in the wall, unwittingly piercing the eye of a snake poised to attack her. In the morning when she removed the pin from the wall, the dead snake came trailing with it.

"What good deed did you do today?" her father asked. "A poor man came to our door in the afternoon," she replied. "Since everyone was so busy at the wedding banquet that there was no one to give him food, I gave him my portion." Then Rabbi Akiva went out and publicly proclaimed, "*Charity saves from death!* And not just from an abnormal death, but even from death itself." [Do not say that the most charity can do is if a person is supposed to die, the merit of his charity will ensure that he dies a normal death of usual causes. Rather, charity can actually spare a person from death itself and give him life (*Rashi*).]

Maharsha (ibid.) notes that the Talmud in *Bava Basra* (10a) seems to differ. There the Gemara *does* interpret this verse to say that charity can only save from unusual death but not from death itself. *Maharsha* reconciles the two passages in this way: If a person has lived out his allotted time and he must die, the merit of charity will only protect him from dying an abnormal death. However, if his preordained time has not yet arrived [but his life is threatened by an unusual danger], charity will rescue him from death itself and grant him the opportunity to live out his years fully.

✑ Cast Your Bread Upon the Waters

Avos D'Rabbi Nassan (Chapter 3:9) relates: There was a *Chassid* who was extremely charitable. Once, as he was traveling on a ship, a tempest came and sank the ship at sea. Rabbi Akiva witnessed this calamity and went to the *Beis Din* to testify that this *Chassid* had drowned so that his wife could remarry. Just as Rabbi Akiva rose to testify, the *Chassid* himself entered the court. Rabbi Akiva exclaimed,

"Did I not see you drown in the sea?" "Yes, indeed!" the *Chassid* replied. "So how were you rescued from the watery depths?" Rabbi Akiva asked. "The *tzedakah* which I performed lifted me from the depths!" the devout man explained. "How are you sure that it was your *tzedakah* which saved you?" queried Rabbi Akiva. The *Chassid* replied, "As I was sinking to the depths I heard a tremendous roar as the waves cried out to one another, 'Let us run to lift this man out of the sea for he has performed *tzedakah* all of his days!' "

At that moment, R' Akiva exclaimed, "Blessed is our God, the God of Israel, Who chose the words of the Torah and the words of our Sages which are so true and everlasting! We have just witnessed the fulfillment of the verse, שַׁלַּח לַחְמְךָ עַל פְּנֵי הַמָּיִם כִּי בְרֹב הַיָּמִים תִּמְצָאֶנּוּ, *Send your bread upon the waters, for after many days you will find it* (*Ecclesiastes* 11:1), and further it says, צְדָקָה תַּצִּיל מִמָּוֶת, *Charity rescues from death* (*Proverbs* 10:2).

⋖§ A Lifesaving Defense

The Talmud (*Bava Basra* 11a) also tells of a woman who appealed for charity to Binyamin the *Tzaddik* who was a *gabbai* in charge of communal charity disbursements. He had to refuse her request because the communal funds had been completely exhausted. In despair the woman cried that she and her seven children would die of hunger. Hearing her desperate plight, Binyamin the *Tzaddik* supported the entire family from his own pocket. Some time later, when Binyamin became sick and lay dying, the ministering angels themselves pleaded his case before the heavenly tribunal, arguing that someone who had personally saved eight lives did not deserve to die at a young age. Immediately, the decree was annulled and twenty-two years were added to Binyamin's life in the merit of his charity.

The Vilna Gaon explains the significance of these twenty-two years. The Talmud (*Sotah* 20a) teaches that in general a mitzvah merit can protect a person for up to three months. The Talmud (*Bava Basra* 9b) promises that he who gives a gift to the poor is blessed with *six* merits, but he who adds words of consolation and encouragement to his gift earns a total of *eleven* mitzvah merits. Thus for every one of the souls Binyamin saved and encouraged he gained eleven extra three-month

periods of life, or thirty-three months. Since he saved *eight* souls, he merited a total of 33 x 8 = 264 months, which equals exactly twenty-two years.

◄§ Tzedakah Protects From the Evil Inclination

Ahavas Chesed (Chapter 5) emphasizes that *tzedakah* is also highly effective in rescuing man from the clutches of his evil desires. As the Talmud states (*Avodah Zarah* 5b): Blessed are the people of Israel, for when they occupy themselves with acts of Torah, charity and kindness, they master their Evil Inclination and their Evil Inclination does not master them!

Ahavas Chesed explains that man's Evil Inclination strives to overwhelm him in two ways. First, it makes every effort to divert man's attention away from the service of God by filling him with desire for all kinds of worthless, mundane pursuits. Second, the Evil Inclination seduces man to actively sin and rebel against the will of God.

However, when someone concentrates on acts of *tzedakah,* he shifts the focus of his life away from self-gratification and personal pleasure. This is the ultimate conquest of the Evil Inclination which represents ego and selfishness.

◄§ Why We Love Money So Much

Rabbi Meir Tzvi Bergman explains why God ingrained in men such an insatiable love for money. It is for our good. If we love money as much as life itself, then when we do give it away, it is as if we gave away life itself. Therefore, this sacrifice has tremendous value in the eyes of God. This is the reason why, צְדָקָה תַּצִּיל מִמָּוֶת, *Charity saves from death* (*Proverbs* 10:2).

◄§ The Dream Which Averted a Nightmare

R' Aryeh Levin, renowned as "The *Tzaddik* of Jerusalem," was well known for his many acts of *tzedakah.* The *tzaddik* passed away

in 1969. Exactly one year later, on his first *yahrzeit,* he appeared in a dream to his oldest great-grandson. "Passover is coming soon," he told him, "and it is a tradition to give the needy *maos chittim* (special funds to cover the Passover expenses). Here are 20 liras," and in the dream he handed his great-grandson 20 Israeli liras. "Please give 10 liras to family A and 10 liras to family B," naming two families whom his great-grandson knew.

When he awoke in the morning the young man remembered the dream vividly, but, of course, did not find 20 Israeli liras lying around, and he dismissed the dream from his mind. However, later in the day he visited his grandfather, Reb Aryeh's son, who suddenly took 20 liras from his wallet and gave them to him. "Here," he said, "This money is for *maos chittim.* It's time for you to get involved in this important mitzvah. Please see that it gets to people who need it for Pesach."

The young man was amazed as his dream returned to him vividly. He went to his father and related the entire matter to him. His father was astounded. He told his son, "Mr. A [whom R' Aryeh designated in the dream] came to see me just this morning. He just lost his job and asked me to try to find him some other employment. He was particularly concerned about his many Pesach expenses. Your great-grandfather certainly had good reason to ask you to help Mr. A for Pesach!"

Despite all of these clear indications of the veracity and urgency of the dream, the young man did not rush to fulfill his great-grandfather's wishes. He himself was very busy with his own Passover preparations, and he had just recently become a father with his first child and his hands were full. He kept postponing his obligation until it was forgotten.

Two or three days before Pesach, this young man's child took sick. Despite the doctor's best efforts, the infant's condition grew worse and worse, to the point where the doctor wanted to have the child hospitalized. The young mother sat by her baby's crib wracked with worry. All of a sudden, she looked up at her husband and asked, "Isn't there a tradition in your family that when someone is sick, you give a donation to *tzedakah* to help him get well?"

The young man froze in shocked remembrance. Then, without a word, he left the house and went to the two families that R' Aryeh had specified in his dream. He informed both families of his great-grandfather's instructions as he left 10 Israeli liras with each.

To the two families, more important than the money they received was the knowledge that, even far away in heaven, R' Aryeh still

remembered them and was aware of their plight. The news of the dream made their holiday a happy one. R' Aryeh's great-grandson found happiness too; for when he returned home, he found his infant on the way to full recovery! (*A Tzaddik in our Time*, p. 348).

⋴§ The Chicken Which Saved a Child

R' Yechiel Michel Gutfarb of Jerusalem is well known as a *gabbai tzedakah par excellence* who distributes enormous sums to the poor under the guidance of the leading Torah authorities of the holy land. Recently, he related the following story that demonstrates the enormous protective power of *tzedakah.*

A destitute woman banged on the door of a *Kollel* scholar in Jerusalem, and begged the man to give her a piece of chicken to eat. This man barely eked out a meager living for his wife, himself and their fourteen hungry children who usually subsisted on next to nothing. He tried to explain to the needy woman that all he had in his refrigerator were two small chickens that he had purchased to feed his family on the upcoming *Yom Tov*. If he were to give her some chicken there would not be enough to feed his family. But the poor lady would not budge from the doorway. "I'm famished!" she cried out pitifully, "Only a piece of real meat, or at least some chicken, will still my terrible hunger!"

Seconds ticked by as the bewildered young man pondered this woman's unyielding request. He said to himself, "This lady must be desperate if she is not ashamed to stand by my door and beg me incessantly for a piece of chicken. I don't think she's crazy, so if she is pleading so much she must really be at the end of her endurance. Okay, so my kids won't have a piece of chicken for *Yom Tov* — it's not the end of the world."

The moment the young man realized how badly this woman needed his chicken, the mitzvah assumed an air of urgency. He rushed to the old refrigerator in his kitchen to bring her some chicken. He whipped open the door and a cry of terror burst from his throat! Inside the fridge he found his 3-year-old son who had playfully hidden in the nearly empty refrigerator and became locked in when the door slammed shut behind him. The toddler was already blue from the cold and from lack of air. Miraculously, the *Hatzalah* medics who raced to the scene were

able to revive him as he was rushed to the hospital for emergency treatment. The medical report issued later stated that had the child been inside the refrigerator for just another thirty seconds, he would definitely have been beyond help, heaven forbid!

There was no reason for anyone in the family to open the nearly empty refrigerator at that time of day. It was only the mitzvah of *tzedakah* that saved this boy's life. You never lose anything from giving *tzedakah;* you only gain. By giving away a piece of chicken you get back a whole child. It is a very worthwhile deal (*Tuvcha Yabiyu, Parshas Re'ei*).

✑§ Enough Money to Survive the War

The Klausenberger Rebbe, R' Yekusiel Halberstam, suffered enormously from the ravages of the Holocaust, losing his entire family. The Kapishnitzer Rebbe, R' Avrohom Yehoshua Heschel, was more fortunate, as he managed to escape to America when the war broke out. After World War II these two Rebbes met and the Klausenberger asked the Kapishnitzer, "By virtue of what good deed did you merit to save your entire family from Hitler and the Nazis?" In his humility, the Kapishnitzer initially hesitated to give a clear response, but finally said, "I was living in Vienna, Austria in 1938 when the German Nazis occupied the country. They immediately began to plunder, persecute and torture the Jews. Alarmed and very concerned for my well-being, one of my *Chassidim* gave me an enormous sum of money, saying, 'Dear Rebbe! It is clear that terrible times of war and suffering are in store for us. Here is enough money to survive the war.' This put me into a terrible dilemma, because it was always my custom, as it was the custom of my holy forebears, never to go to sleep at night with a penny in the house. Any funds we have available on any day must be distributed immediately to those in need. Now this well-wisher gave me enough money to support me for many years, but keeping the money even over one night would be a violation of my custom. What a quandary! Finally, I decided not to deviate from my way. That very day I distributed that whole fortune to charity. But I really did not deviate from that man's wishes either, because I have no doubt that in the merit of that charity my entire family survived the war!"

R' Zishe Heschel, the Kapishnitzer Rebbe's son, related the above

story to me personally and added this note: "The situation rapidly grew desperate. My father was one of the Nazi's prime targets because he was such an important Jewish leader. With tremendous effort we arranged for a special plane to take my father out of the country by himself because he was in such danger. But we didn't have a penny to pay for it. At the last minute, two of my father's admirers, a couple named Blauoig, came to say goodbye and asked if my father had money for his expenses. My father sort of blushed and shrugged and finally confessed that he was penniless. Without a moment's hesitation, Mrs. Blauoig removed her jewelry and gave it to my father. At the same time she made him promise that this time he would really use the money for his escape. He assured her that he would."

R' Yaakov Greenwald relates that he once entered the Kapishnitzer Rebbe's room on Erev Shabbos and the Rebbe's face was absolutely radiant — he was bubbling with joy. The Rebbe cried out, *"Ich bin rein! Mamash rein! Oisgeleidikt!"* "I feel clean, really clean! Absolutely cleaned out!" The Rebbe explained that just as he could not go to sleep at night leaving even one penny in the house, so too he could not enter into Shabbos leaving a cent to his name. "Today," the Rebbe said, " I am especially fortunate. Here we are a few hours before the holy Shabbos and I just gave away my last coin to *tzedakah.* Now I really have plenty of time to prepare for Shabbos with empty pockets and a clean heart!"

⋖§ Rattle the Pushka or Rattle the Saber

A young man who was about to be drafted into the Austrian army came to R' Chaim Sanzer for a blessing to be saved from this terrible danger. The Rebbe instructed him to take pains to always be the one who goes around the shul with the *pushka* collecting for *tzedakah.* R' Chaim explained: "Since we are dealing with gentiles, we have to defend ourselves with the language of the gentiles. In the German language the word for a gun is *biks.* A charity box, a *pushka,* is called something similar: a *biksen,* or a small box. Young man! If you will join God's army of charity collectors and you will go around with the small *biks,* the *pushka,* then I assure you that you will be spared from carrying around the large *biks,* the soldier's gun which he carries with him to war" (*Tiferes Banim* Vol.III, p. 171).

✑ Charity Will Save America

Akiva Chill was a young man from the United States studying in the Mirrer Yeshiva in Poland when the Second World War broke out. Akiva traveled to Vilna to seek the advice of R' Chaim Ozer Grodzenski. The diligent student yearned to continue his Torah studies in the yeshiva despite the many dangers threatening from all sides, but his family pleaded with him to return to America.

R' Chaim Ozer agreed with Akiva's family, saying, "Hitler may very well succeed in conquering all of Europe; however, I do not believe that he can vanquish America. The American Jews are great *baalei tzedakah* and we are taught, *Charity saves from death*" (*Proverbs* 10:2).

✑ Charity in the Concentration Camps

A Holocaust survivor, R' Shimon Zucker, relates the following tale of Jewish generosity and heroism.

"During World War II, I was a prisoner in a slave-labor camp near Kamenetz. Many of my fellow Jewish prisoners were dying of malnutrition and starvation. I knew that if only they could get a little more food it would keep them alive. But there was not an extra morsel of food to be had in that Nazi purgatory.

"Then something amazing happened. In honor of their holiday season, our cruel taskmasters decided to give each worker a double portion of food for one day. All of a sudden, as I stood on line with my fellow workers to pick up this bonanza, I had a great idea. *Tzedakah!* Even in a slave-labor camp we have an opportunity for *tzedakah!* If every one of the workers who was receiving an extra portion would donate just a small part of it to his starving brethren, many would be saved from a miserable death.

"I stood atop an empty barrel and made a public appeal. I cried out, 'Partners in suffering! A tremendous opportunity has come our way. We have a chance to save many of our brethren from death. All they need is a little extra food to avert starvation. Let every one of us contribute just a bit of the extra ration we are receiving tonight to our undernourished brothers.' Many were inspired to share their food and we had a successful 'Emergency Relief Campaign.'

"The next day I was summoned to the headquarters of the camp commandant to stand trial for my criminal activities. I was charged with the terrible offense of organizing 'Communist activities' because I had encouraged my comrades to share their wealth with others. For this high crime I was condemned to die. I attempted to defend myself by explaining to the commandant that my sole motivation was a desire to save my brethren from certain starvation. Much to my surprise, my defense seemed to have softened the Nazi's heart, because he dismissed me and my case with but one word, 'Out!' But my good fortune didn't end there. By the time I returned to my barracks the news was spreading: not only had the commandant miraculously pardoned me, but he also had decided to elevate me to the coveted position of 'Jewish Elder.'

"The next day I was summoned to headquarters once again to be officially installed in my new position. The commandant placed a whip in my hands, and gave me my orders: 'With this whip you shall beat those Jews, and I want you to beat them hard! From this moment onward you are officially the Elder of the Jews.'

"Hearing this, I was appalled. I felt more miserable than I had felt the previous day when I was condemned to death. I turned to the commandant and said, 'Sir, I assure you that I will do everything in my power to faithfully discharge my new duties to enforce all the rules and regulations of this camp. But one thing I cannot do, and that is to whip my fellow inmates, my suffering brethren.' The Nazi just stared at me with bewilderment. Finally, he barked, 'Get out of here, you Jewish filth!' And that is how I was saved from two calamities; the threat of a death sentence, and the worse threat of having to whip my fellow Jews" (*Olam Chesed Yibaneh;* Part II, p. 313).

⧽ Charity on Behalf of the Sick

The Talmud (*Rosh Hashanah* 16b) states: There are four different merits that can nullify a harsh heavenly decree against a person: 1) charity, 2) intense prayer, 3) a change of name, 4) dramatic change of conduct.

Midrash Talpios (p. 149) writes: When people pray for the recovery of a sick person, the custom is that every one of the supplicants donates charity on behalf of the one who is ill. The charity is divided into seven parts and distributed to seven different causes.

◄§ Financial Assistance for the Sick

It is a great merit to give charity on behalf of sick people, so that in the merit of this good deed they should be cured. It is certainly a great mitzvah to give financial assistance to the poor person who is sick and needs to pay for medical expenses. The *Chofetz Chaim* in *Ahavas Chesed* (Part 3, Chapter 3) elaborates on this theme. He reminds us that the poor person who is bedridden has not been able to work for a while and so is probably in desperate need of funds just for the general support of the family. In addition, sick people usually incur great medical expenses that they certainly cannot afford. The ill also have special dietary needs which must be provided and paid for. When visiting the sick, a person should inquire about all these matters and try to be of assistance. One who is sensitive to the special needs of the sick breathes new life into a broken, crestfallen soul and literally brings the sick person back to life. He who ignores the sick is as if he sheds their blood.

◄§ Thanksgiving for Recovery

When the sick recover from their illness they should give thanks to Hashem and show their gratitude to the Almighty by giving charity according to their means. He or she should say: "I am hereby donating this money to charity, and by the grace of God may it find favor before Him, and may He consider it as the equivalent of the *korban todah*, the thanksgiving offering, that I would have been obligated to bring in the time when the Holy Temple stood." It is especially appropriate to undertake a project that will benefit the entire community (see *Zichron Meir* on *Aveilus*, Chapter 2, p. 46).

◄§ Sickness Shall Not Step Over Your Threshold

A delegation of communal leaders of the city of Satmar once approached their Rav, R' Yoel Teitelbaum, with a revolutionary

idea. "It's such a waste of time and effort to have all these beggars and collectors going around from door to door. This system is not good for anyone. The poor have to trudge from house to house in all kinds of weather, and they are often too sick or old to do this. Not only is begging humiliating, but the householder may not even be home or may be unavailable. Even when available, the householder is often annoyed at being interrupted and solicited time after time. Let the Rav therefore decree that collectors should cease all house calls! Instead, our committee will determine how much charity every householder will give every year and the funds will be deposited in a central fund to which all those in need will turn. They will receive one lump sum from the entire town all at once. Guaranteed satisfaction for one and all— no hassle, no embarrassment, totally efficient."

The Satmar Rav did not hesitate for a moment and replied: "I will not even consider this proposal until you tell me who is the author of this 'revolutionary idea.'" Sheepishly, the group of leaders admitted that this new system was the brainchild of an outsider, a rich man of low character. They were actually embarrassed to even mention the man's name in the presence of the holy Rav.

"Just as I thought!" cried the Satmar Rav. "I was certain that the idea didn't come from a holy source, because it is so alien to Torah values. Our Rabbis teach us that when the needy step over our threshold they bring a tremendous blessing into our home, as we find in the Midrash (*Shir HaShirim Rabbah* 6:17): Rabbi Levi taught: 'The door that is not opened for mitzvos [of charity] will instead be opened for the doctor!'"

[As heard from R' Yehoshua Heshel Hershberg who heard it from R' Aron Pollak who was the Satmar Rav's personal attendant (*hoiz bachur*) and witnessed the event.]

◆§ The Chofetz Chaim

The son of the Chofetz Chaim wrote in his memoirs: In my youth, my mother of blessed memory told me that when my siblings and I were little she hardly ever called upon the services of a doctor. If any one of us took sick, as delicate children are wont to do, my father would immediately advise my mother to distribute a pound of bread

to the poor while he would closet himself in the seclusion of our attic and pray to Hashem. The illness would quickly disappear! (*Sketches From the Life of My Father*, p. 26).

⊸§ A Yerushalmi Cure

My dear friend, R' Moshe Krauss of Battei Ungarin in Jerusalem, told me the following story which he heard from its source, an acquaintance of his named R' Yaakov. Once, when R' Yaakov was collecting funds to marry off a poor bride, he came to the home of a man in Meah Shearim who responded to his request in an unusual manner. The man brought out a large box brimming with all kinds of currency — big bills, little bills, large coins, small change. The man poured the contents of the box on the table and asked R' Yaakov to please take it all. R' Yaakov was amazed by this large contribution given in such an unusual fashion. The man explained: "Whenever a member of my family gets sick, I know that there are two doctors to whom I can turn. I can call upon a flesh and blood physician, submit to his painful ministrations and pay him a hefty fee. Or I can turn directly to the Almighty, Healer of all flesh, and beg Him to cure with His gentle and compassionate methods. Now don't think that I am looking for bargains. Remember that the Talmud (*Bava Kamma* 84a) teaches: 'A cure that costs nothing is worth nothing!' God also must be paid a fee, and that is a donation to His cause: *tzedakah*. Therefore, whenever a member of my family takes ill, I estimate how much a doctor's visit would cost and I immediately place that amount into this special charity box. I usually empty out my pockets and deposit an assortment of bills and coins into the box. The next person that asks me for help receives the entire contents of my special box, for he surely was heaven sent to receive Hashem's fee. I follow this procedure and the illness always goes away; I never call upon a human doctor!"

Charity Saves From Losses

ᴇ§ When to Cry Over Spilt Milk

Rav Isser Zalman Meltzer, Rosh Yeshiva of Yeshivas Eitz Chaim in Jerusalem, was extremely scrupulous with charity. The winter of 1952 was a very difficult time. Food was in short supply in *Eretz Yisrael* and milk was particularly hard to come by. Milk was rationed with meticulous care; every drop was precious. One very cold winter day, while R' Isser Zalman was learning at home with his student, R' Mordechai Shapiro, he asked his wife, Rebbetzin Baila Hinda, to bring him a cup of warm milk which was essential for his health. A few minutes later, the Rebbetzin came to the door of the study with tears streaming from her eyes. "What's wrong?" asked her husband, alarmed. Sobbing, the Rebbetzin explained, "The entire cup of milk that I just heated up for you spilled on the floor. There is not a drop of milk left in the house and there is nowhere to get any more!"

"Perhaps a poor man asked you for money today and you failed to give him anything?" queried R' Isser Zalman. The Rebbetzin stared back at her husband with wonder in her eyes and said, "Indeed that's exactly what happened! A poor man came to the door, and I searched high and low for something to give him, but I couldn't find even one penny in the house, so he left empty handed."

"AHA!" cried R' Isser Zalman, and he returned to his studies with his young partner (as related by R' M. Shapiro in *B'Derech Eitz Hachaim* p. 352).

ᴇ§ Charity Saves From Poverty

Masechta *Derech Eretz Zuta* (Chapter 9) teaches: Let the doors of your home always be open wide, especially when you sit down to the table for dining and drinking, because it is these very doors which bring you to poverty or wealth. If you invite hungry, poor people to share your meal, then you will enjoy long life in this world and eternal life in the World to Come.

←§ Give to the Gabbai or the Government — The Choice Is Yours

The Talmud (*Bava Basra* 10a) relates: R' Yehudah the son of R' Shalom expounded: Just as a person's sustenance for the coming year is apportioned for him from Rosh Hashanah, so too a person's losses for the coming year are apportioned for him from Rosh Hashanah. If one merits good fortune, he will give the amount he must lose to the poor, in compliance with the verse: הֲלוֹא פָרֹס לָרָעֵב לַחְמֶךָ, *You will break your bread for the hungry* (Isaiah 58:7). But if he did not merit good fortune, the government will confiscate the amount he is supposed to lose, in fulfillment of the [end of the] verse (ibid.), וַעֲנִיִּים מְרוּדִים תָּבִיא בָיִת, *and miserable poor* [corrupt government officers] *you will bring to your home.*

An illustration of this concept is found in the case of the nephews of Rabban Yochanan ben Zakkai. Once, Rabban Yochanan saw in a dream [on the night following Yom Kippur] that his nephews were required to lose 700 dinars during the coming year. Therefore, over the course of the year, Rabban Yochanan would prevail on them to donate money to charity. Eventually he took from them most of the 700 dinars for charity. However, by the end of the year, 17 of the original 700 dinars remained in their possession.

When the eve of Yom Kippur arrived, the Roman government dispatched officers, who confiscated 17 dinars from Rabban Yochanan's nephews. The nephews were frightened that the officers would return to take even more, so Rabban Yochanan therefore reassured them: "Do not be afraid of losing more money. They took from you the last 17 dinars you were destined to lose; hence no more will be taken." The puzzled nephews asked Rabban Yochanan: "From where did you know that precisely 17 dinars were taken?" Rabban Yochanan then revealed to his nephews that at the beginning of the year he had seen a dream which foretold that they would lose 700 dinars that year, and he calculated how much remained to be lost.

Realizing now why Rabban Yochanan had been urging them to give so much charity throughout the year, the nephews said to their uncle: "Why didn't you inform us that we were required to lose 700

dinars this year so that we would have given the entire amount to charity? What a pity to have even a small part confiscated by the Romans." Rabban Yochanan replied: "I said to myself, It's better not to inform you, so that you would perform the mitzvah of *tzedakah* for its own sake. If you had known that you were destined to lose a certain sum of money anyway, your intent in giving would be simply to avoid its confiscation, and not to benefit the poor or to do the will of God."

This incident teaches an important lesson. Although the amount of charity given by the nephews was less than they were destined to lose, Rabban Yochanan felt that it was better for them to give a smaller amount with the proper intent than to give the larger sum with an ulterior motive.

⋙ Charity Saves From Taxes

The Chasam Sofer (*Drashos* p. 187b) referred to the story of R' Yochanan when he was rebuking his *baalei battim* in Dresnitz for failing to give enough money to charity and for the support of Torah. He told them that every single penny they withhold from *tzedakah* will eventually be confiscated by the gentile tax collectors. Indeed, says the Chasam Sofer, if the Jews would give *tzedakah* properly, the gentile authorities would not levy heavy taxes on them in the first place!

⋙ When the Poor Pursue You — No One Else Will!

I heard the following story of how *tzedakah* protects from many different problems from the grandson of the philanthropist involved.

A wealthy magnate, who was noted for his extraordinary generosity, once became completely overwhelmed by the endless requests for assistance inundating him from all sides. He decided to travel to the town of Radin where the Chofetz Chaim resided, to consult with this wise and holy man. Just as the philanthropist entered the Chofetz

Chaim's humble home, the *tzaddik* 'happened' to be speaking about King David's personal request in the book of *Tehillim*, אַךְ טוֹב וָחֶסֶד יִרְדְּפוּנִי כָּל יְמֵי חַיָּי, *May only goodness and kindness pursue me all the days of my life (Psalms 23:6).*

The Chofetz chaim explained: "No man can expect to live out all the days of his life in perfect tranquility. Everyone is destined to be harassed by some sort of worrisome bother that will disturb his equanimity. Such is life! Often, the worries are serious, such as when one is pursued by debilitating disease, or by bitter enemies, or by the police, or by bill collectors. Fortunate is the man who discharges his 'pursuit quota' by suffering from those who pursue him for charity! Rejoice when the countless collectors hound you day and night, because they are sparing you from much worse.

"This is what King David had in mind when he beseeched God, *May only goodness and kindness pursue me all the days of my life.* When goodness and kindness pursue a person he is absolved from pursuers who are far worse."

The magnate who 'happened' to enter just in time for this lesson understood that the words of the Chofetz Chaim were meant for him. He returned home reassured, and intensified his charitable efforts.

≈§ Sharing and Shearing

In the Talmud (*Gittin* 7a-7b) we read: Rav Avira taught: If a person sees that his income is rigidly measured according to his needs — he has the exact amount of money he needs to support himself with nothing to spare — he should nonetheless give some of his money to charity. It goes without saying that he should give from his income if it is plentiful.

In the academy of R' Yishmael they taught: Whoever shears some of his possessions and donates them to charity is saved from the judgment of *Gehinnom*. This is analogous to two sheep that were passing through a body of water. One of the sheep was shorn and one was not. The shorn sheep passed through safely, while the one that was not shorn did not pass safely.

People attempting to go through life with *all* their worldly possessions are analogous to sheep laden with all their wool attempting to

cross a river. Just as a sheep can only cross over the river safely when it is shorn and not weighed down by its own soggy wool, so too a person will pass safely through life and avoid punishment in the next world only if he unloads himself and gives away a portion of his possessions to charity (*Rashi*).

The Privilege of Giving

As explained in the Overview, the intent of *tzedakah* is not merely to supply the needs of the poor 'taker,' rather its primary purpose is to refine the character of the 'giver.' It is therefore essential for the 'giver' to develop a healthy, positive attitude towards charity. Lacking this proper attitude, a person may give *tzedakah* lavishly all his life, yet do so begrudgingly, considering the poor to be a burden and a nuisance, maintaining the false impression that he has done the poor a great favor for which they shall forever remain in his debt.

In this chapter we hope to demonstrate the truth of the teaching of our Sages (*Vayikra Rabbah* 34:8): "The pauper who accepts charity does more for the rich man than the rich man does for him." When the opportunity to give charity presents itself, it is a gift sent from God, a Divinely orchestrated privilege — and the wise man will not hesitate to seize this opportunity.

✥ Privilege or Pain?

Two men, confronted with the very same situation, may view it in an entirely different light. Both are surrounded and besieged by a throng of beggars. The selfish, tight-fisted man desperately attempts to avoid or get rid of these nuisances. He feels threatened and under assault. Derisively, he regards these collectors as a 'bunch of schnorrers,' a pack of parasites and pests. On the other hand, the

generous man thanks the Lord for sending him so many opportunities to help his fellow men and to fulfill the will of the Almighty. This is what the Psalmist had in mind when he said: רַבִּים מַכְאוֹבִים לָרָשָׁע וְהַבּוֹטֵחַ בַּיהוה חֶסֶד יְסוֹבְבֶנּוּ, *Many are the agonies of the wicked, but the one who trusts in Hashem, kindness surrounds him* (*Psalms* 32:10). While the man who trusts in Hashem feels that the beggars who surround him are a kindness and a gift from above, the wicked, selfish man, sees these solicitors as *'many agonies'* and a terrible nuisance to be avoided.

⊷§ Just Keep On Giving

The wisest of all men, King Solomon, said (*Koheles* 11:6): בַּבֹּקֶר זְרַע אֶת זַרְעֶךָ וְלָעֶרֶב אַל תַּנַּח יָדֶךָ כִּי אֵינְךָ יוֹדֵעַ אֵי זֶה יִכְשָׁר הֲזֶה אוֹ זֶה וְאִם שְׁנֵיהֶם כְּאֶחָד טוֹבִים, *In the morning sow your seed and in the evening do not be idle, for you cannot know which will succeed: this or that; or whether both are equally good.* The Midrash (*Bereishis Rabbah* 61:3) comments: R' Yehoshua said: If a poor man comes to you in the morning — give him! If he comes to you again in the evening — give him! Because you never know which of the two mitzvos will be recorded for posterity (perhaps only one of the times the beggar was truly needy, or perhaps you gave with pure intentions only one time); and perhaps both are equally good and worthy of eternal reward!

⊷§ The Distribution Never Ends!

King Solomon said: תֶּן חֵלֶק לְשִׁבְעָה וְגַם לִשְׁמוֹנָה כִּי לֹא תֵדַע מַה יִּהְיֶה רָעָה עַל הָאָרֶץ, *Distribute portions to seven, or even to eight, for you never know what calamity will strike the land* (*Ecclesiastes* 11:2). *Rashi* comments: Even if you have distributed portions of food and drink to seven needy souls, continue to distribute generously to the eight beggars who approach you right after them, and never say, "I have given enough!" You never know what kind of a calamity may strike you in the future; maybe you will need the merit of *all* of these charitable acts to save you then! So seize the opportunity to give now, for if not now, when?

⊷§ How Much Is Enough?

R' Moshe Wolfson, Mashgiach of Yeshiva Torah Vodaath and Rav of Emunas Yisroel, relates: There was a village in Europe where the custom was that when a poor stranger came to town the Rav himself took him around to collect from the *baalei battim*. Since this was a tiny, out-of-the-way hamlet, the Rav usually did not have to make such rounds more than once or twice a week. One day, however, this little village was inundated with collectors.

The first one arrived in the morning and the Rav gladly took him around. When the second pauper arrived in the afternoon, the Rav once again was delighted to help him raise funds. At dusk, a third indigent appeared and the Rav did not hesitate to approach the same donors for the third time in one day. This time, however, one of the *baalei battim* was irate and flung a question at the Rav, "Rebbe, please! Everything has a limit! How many times can you solicit from us in one day?" The Rav responded: "You are asking an excellent question. Every sick person may ask, 'How much medicine must I take today? How many pills should I swallow?' The only one who has the answer is the doctor. As much medicine as the doctor prescribes, that's exactly how much you need, not a drop more, not a drop less. Likewise, when it comes to charity we are all sick and in mortal danger. The only remedy for all the dangers that constantly threaten us is *tzedakah,* as it says, וּצְדָקָה תַּצִּיל מִמָּוֶת, *Charity saves from death* (*Proverbs* 10:2). Each and every time a beggar knocks on our door it is a reminder from the Divine Doctor that we need to take a dose of medicine to either immunize or cure us from an illness. If today three charity cases came our way, it means that the *Ribbono Shel Olam* knows that today we need not just one, or two, but three teaspoons of "*Tzedakah* Remedy.""

⊷§ How the Merit System Works

It may happen that a person is in danger and needs Divine assistance. Unfortunately, he does not have enough merits to earn him the assistance he requires. What does our Compassionate God do for this man? He sends him an opportunity to gain merits by giving *tzedakah*

or by doing some other act of kindness. This is the deeper meaning of the verse, וּלְךָ אֲדֹנָי חָסֶד כִּי אַתָּה תְשַׁלֵּם לְאִישׁ כְּמַעֲשֵׂהוּ, *And Yours, my Lord, is kindness, for You reward each man in accordance with his deeds* (Psalms 62:13). God has a great treasury in heaven, filled with opportunities for men to do kindness. When someone needs more merits, God sends him one of these opportunities. If the man seizes it, God will now be able to reward him by sending him the salvation he needs, as the verse concludes, *for You reward each man in accordance with his deeds* (Toldos Yaakov Yoseif, Vayikra p. 270).

⋖§ It's Not a Burden

Every year, R' Chaim Mordechai Katz, the *Rosh HaYeshiva* of the Telshe Yeshiva in Cleveland, Ohio, made a fund-raising trip to New York City on behalf of his renowned Torah institution. One of the highlights of the trip was the *Rosh HaYeshiva's* visit with the Bobover Rebbe, R' Shlomo Halberstam *zt'l* who was always delighted to make a generous donation to the yeshiva with a warm heart and a generous hand.

On January 1, 1963, Telshe Yeshiva suffered a tragic blow when the old wooden mansion which served as its main dormitory burnt to the ground, leaving hundreds of young students without a roof over their heads. Immediately thereafter, Rav Katz traveled to New York on an emergency fund-raising mission to rebuild the dormitory. Ever the generous supporter of Torah, the Bobover Rebbe doubled his annual pledge and told the *Rosh HaYeshiva* that he would give him one half of the amount on the spot, but the other half would not be available until a week before Pesach. For the convenience of the *Rosh HaYeshiva,* the Bobover Rebbe asked him to send one of his students who lived in Boro Park to come pick up the money before Pesach. One week before Pesach, a Telshe *talmid* entered the Bobover Rebbe's study, conveying warmest personal regards from the *Rosh HaYeshiva.* "Also," said the student, "I am here to collect the *chov*, the obligation, which the Rav has to the yeshiva." Ever so gently, the Bobover Rebbe corrected the young yeshiva *bachur,* "*Nein, mein kindt,* no, my dear child; for me, fulfilling this pledge is not a *chov*, it is truly a *zechus*, a great privilege!"

❧ Never Enough Merits

In 1948, following the War of Independence, the economy of the State of Israel was in a shambles and desperate poverty stalked the land. R' Chaim Kreiswirth (now the Rav of Antwerp, Belgium) expended tremendous effort to raise money on behalf of the poor of the Holy Land. He traveled to Brooklyn, New York, and approached the president of one of the wealthiest synagogues in Boro Park, asking him to make an appeal for this urgent cause. The president adamantly refused to make any appeals. R' Kreiswirth begged him, pleading and cajoling, "Please, you must help these desperately poor people! I assure you that it will be a tremendous *zchus* (merit) for you if you do this mitzvah!" The stubborn president turned to R' Kreiswirth and said, "Rabbi, believe me, I have enough *zchusim*! I really don't need any more *zchusim*!" And the appeal was never made.

Rav Kreiswirth went away both crestfallen and shocked. He would have understood if the man had simply said that he did not want to be bothered with yet another appeal. But how can anyone say that they have enough merits? Who knows how many merits one needs to survive?

Rav Kreiswirth was even more shocked when he received the terrible news, just a few days later, that this man was killed in a tragic airplane crash! Who knows if the merit of that *tzedakah* appeal might have saved him, because צְדָקָה תַּצִּיל מִמָּוֶת, *Charity saves from death (Proverbs 10:2)*.

Rav Kreiswirth related this tragic story to me when I met him in Jerusalem in Elul 5760. He added that he later found out that the doomed airplane had been delayed several times. As time dragged on, most of the passengers left and made other arrangements. Only a few of the passengers stubbornly insisted on waiting to take this plane that took them to their bitter fate.

Rav Kreiswirth observed that a person needs special merit to be able to sense and interpret God's subtle messages. The Talmud (*Chullin* 95b) relates that the great Sage, Rav, "used to regard the ferryboat as a sign." If the ferryboat arrived on time he took it across the river, but if he had a hard time finding it he considered it to be a heavenly omen telling him not to take this ride (*Rashi*). When a person trains his heart

to be open and sensitive to the plight of the poor he merits that his heart will be sensitive and receptive to the messages that God sends to protect us from harm.

⊷§ How to Read God's Messages

Rabbi Chaim of Volozhin frequently emphasized that a person must be alert to messages sent to him from heaven. Once R' Chaim happened to meet one of the wealthiest Jews of Vilna at an inn in Horodna. This influential person served as a representative of the Jewish community to the Russian government. In the course of their conversation, the man mentioned to R' Chaim that he had also been in Horodna the previous month on account of his communal responsibilities. While walking along the street a woman had approached him and asked him for a donation for a needy bride. He had generously offered her a fifty-ruble note, but she refused his offer. He then offered her one hundred rubles, but she still declined. She insisted that he take upon himself to provide the full amount needed for the dowry. He did not feel that he was obligated to that degree and refused her.

"Just today," continued the wealthy man, "I was confronted by the same woman with the same unreasonable request. I still didn't feel I could meet her demands, so I sent her away."

R' Chaim shook his head. "I think you acted wrongly. Your government meetings generally take place in Vilna. But twice within one month Providence brought you to Horodna, and both times you met this particular woman. This is a clear sign that Heaven is granting you the wonderful merit of helping her."

⊷§ The Poor at the Door Are a Gift From God

Rabbi Yehudah taught: How fortunate is a person when a poor man comes to him. Because that poor person is a gift sent from the Holy One, Blessed is He. Fortunate is he who welcomes this gift with a joyous, smiling countenance. Behold! He who has mercy on the poor and helps the pauper to restore himself, the Holy One, Blessed is He, considers it as if his act created the pauper (Zohar Vayakhel 198a; Sulam edition 61-62).

These words of the *Zohar* give new meaning to these verses from Tehillim: אוֹדֶה יהוה מְאֹד בְּפִי וּבְתוֹךְ רַבִּים אֲהַלְלֶנּוּ: כִּי יַעֲמֹד לִימִין אֶבְיוֹן לְהוֹשִׁיעַ מִשֹּׁפְטֵי נַפְשׁוֹ, *I will thank Hashem exceedingly with my mouth, and amid the multitude I will praise Him. For He stands at the right of the destitute, to save him from the condemners of his soul* (Psalms 109:30-31). David realized that when a poor man appeared at his door he did not appear by chance. Rather, it was God Himself Who stood beside the pauper and guided him to his door as a gift and a privilege — to give David a merit to save himself from those forces that were *condemners of his soul*. David vowed to thank God publicly and profusely for this gift.

❧ Stand Up for the Pauper

Pela Yoetz (*Ma'areches Kavod Habriyos*) cites a Midrash which states that one must stand when a poor man passes by, in acknowledgment that the Almighty Himself accompanies the poor, as the Psalmist says, כִּי יַעֲמֹד לִימִין אֶבְיוֹן, *For He stands at the right of the destitute* (Psalms 109:31). Similarly, the author writes that one should carefully avoid even subtle discrimination against men of lesser means. In personal celebrations, he advises, one should avoid allowing seating arrangements to reflect class distinctions.

❧ The Pauper Is as Precious as an *Esrog*!

The *Beis HaLevi* (*Terumah*) observes that the pauper is the rich man's 'ticket to eternity.' Realizing this, the rich man should honor and treasure the destitute who approach him. Moreover, the rich man should treat the poor man like a precious mitzvah object no less important than an *esrog*, which everyone treats so carefully and respectfully lest it be bruised or damaged. The *esrog* is but a simple citron fruit, and has no sanctity or status; nevertheless, at the time when a person actually uses this fruit for a mitzvah, the fruit is endowed with sanctity and significance. How much more so is the pauper, created in the image of God, to be exalted to the level of a sacred entity which must be treated with reverence and awe, at the moment when the rich man performs an act of charity through the pauper — certainly not abused and scorned.

✍ The Thread of Mercy

Rabbi Elazar taught: Come and see the kindness of the Almighty. Even when He must bring punishment upon the world, He gives the righteous people whom He loves an opportunity to be delivered from destruction. For we have learnt that when God loves someone, He sends him or her a gift. And what is that gift? A poor beggar! And when God's loved one is wise enough to accept this gift and gives the poor man charity, God draws a special 'thread of mercy' from His right side and attaches it as a Divine marker on His loved one. When the forces of destruction are unleashed on this world they wreak havoc everywhere, but when they see the man of charity identified with this 'thread of mercy' they respect his virtue and they leave him alone without harm (*Zohar, Vayeira*, p. 104a quoted by *Yesod Veshoresh Ha'avodah*, Tenth Gateway, Chapter 4 and *Me'il Tzedakah* 131).

✍ Let Everyone Share in the Mitzvah

R' Yankele Leizer, the Pshevorsker Rebbe of Antwerp, related this story to his followers:

I will tell you about an incident which happened in Cracow, Poland in the time when the *Rama*, R' Moshe Isserles, was the Rav of that great city. There lived in Cracow a very simple Jew who was called, 'Moshe the shlepper,' because he eked out his meager living by carrying freight and furniture from place to place. Some also called him by two other nicknames — 'Moshe the *shikker* (drunkard)' and 'Moshe the Shabbos'nik' — and these require some explanation. It seems that this Moshe developed a personal custom in welcoming the Sabbath in his own unique way. All week he would scrimp and save from his meager earnings so that he could afford a special treat. Every Friday afternoon, before immersing himself in the mikveh in honor of the holy Shabbos, Moshe would go to the local tavern and order a tall glass of honey mead which he drank with relish. As Moshe sipped the intoxicating beverage he would heartily sing the words "Shabbos! Shabbos! Shabbos!" with such unusual fervor and gusto that some unkind people were misled to think he was drunk from the fermented honey mead when in reality Moshe was intoxicated by his love for Shabbos.

For many, many years Moshe never deviated from his holy custom, until one Friday afternoon when things abruptly changed. As Moshe made his way to the tavern for his honey mead, he noticed a neighbor of his watching him from her window and murmuring bitterly in an audible voice: "*Oy vey!* Moshe is going to treat himself to a drink and I don't even have the few pennies needed to purchase candles for Shabbos!" Overhearing the unfortunate woman's plaint, Moshe found himself in a terrible quandary. In his hand he held the few coins for which he had toiled so hard and which he saved with such self-sacrifice — should he give them away to this heartbroken woman? Or perhaps he had no right to deviate from his holy *minhag* of drinking and singing in honor of the Shabbos? Finally, Moshe decided that there was no question that he must help this woman fulfill her obligation to light Shabbos candles. He gave her the few pennies he had and hurried off to immerse himself in the mikveh without his customary drink.

A little while later, right before Shabbos, Moshe suddenly died. The Chevra Kadisha guarded his lifeless body in a special room adjacent to the *Rama's* Shul so that they could prepare and purify Moshe for his burial as soon as Shabbos was over. Meanwhile Shabbos came and hardly anyone knew about or noticed the passing of the simple Jew, 'Moshe the shlepper.'

As soon as Shabbos ended Moshe appeared in a lifelike vision before the *Rama* and said: "I have come as a messenger from the *bais din shel maalah*, the heavenly tribunal, to warn the Rav that in heaven they are displeased with him and he is in danger!" Taken aback, the *Rama* cried out to him, "Moshe! You are a *shikker*. Go right home and sober up and stop this nonsense!" Try as he might, Moshe failed to convince the *Rama* that he was really a dead man whose spirit had been allowed to return to earth in order to warn the *Rama* of the danger threatening him. Finally, the *Rama* was informed of Moshe's demise and he gave his full attention to this celestial messenger.

"Tell me, R' Moshe," said the *Rama*, "Why are they angry at me in heaven?"

"Because," R' Moshe replied, "the Rav is not fulfilling the mitzvah of *tzedakah* properly!"

"How can that be?" cried the *Rama*, "I always go around personally to collect money for the poor!"

"Yes, you do. However, when you go around collecting you only go to the homes of the rich and dignified people where you are assured an honorable welcome and a sizable donation. The poor and lower-

class people you ignore. You never give them a chance to participate in the mitzvah!"

Terribly shaken by these words, the *Rama* asked, "What shall I do to rectify my wrongdoing?"

The spirit of R' Moshe replied: "Henceforth the Rav must commit to collecting charity from the *entire* city, even from the poorest, lowest classes — no matter how difficult and demeaning it may be."

The *Rama* accepted this advice and then asked R' Moshe, "How did you merit to become a messenger of the Heavenly Court so quickly, even before your burial? How did you merit to teach us such an important lesson about charity?"

R' Moshe related to the *Rama* how he had sacrificed his greatest personal desire, his precious Shabbos drink, in order to give charity to a brokenhearted woman in her time of need. This merit was so great that it outweighed all of his sins and tipped the scales of justice in his favor. "However, the heavenly court, in their compassion, feared that if I should continue my regular way of life on earth I would probably sin and undermine the great merit I had acquired. For my own good, in order to protect me, they decided to immediately have me return my soul to heaven. From the moment my soul left my body it has been escorted and protected by this extraordinary mitzvah of charity and by virtue of this I merited to represent the Heavenly Tribunal to teach the Rav this essential lesson about collecting charity" (*Tiferes Banim* on *Kitzur Shulchan Aruch,* Vol. I p. 250-252).

Charity Is the Best Investment

⋙ Reaping Tzedakah's Rewards

The nature of *'the man of wealth'* is to feel safe and secure when he feels his pockets full and sees his ledgers overflowing with black ink. The nature of *'the man of faith'* is to experience a sense of genuine security when he turns his fortune over to the hands of God Who provides for all his needs forever.

What is the process whereby one transfers his assets to the Divine Asset Manager? The Almighty has a 'family,' which represents His interests on this earth. God's 'kith and kin' are none other than the poor and needy who must come to their better-off brethren for help. When men of means transfer an appropriate portion of their resources to the indigent, they are actually placing these funds in the hands of God.

Tzedakah is the best investment possible. Nothing surpasses it. The investment is absolutely safe, guaranteed to remain in the investor's account forever — both in this world and in the eternal Hereafter. Funds invested in God's 'family,' the poor, belong to the donor forever. Moreover, this investment accrues lavish, undreamed-of dividends, both in this world and the next.

In this chapter we will present but a few examples of the amazing rewards one reaps from his acts of *tzedakah*.

⋙ Charity Increases Our Wealth

Ramban (*Sefer HaMitzvos*, Additional Prohibitions 17) says: "The Torah forbids us to become angry or upset when we give charity to the poor. We may not give it with a bad eye, feeling that we are

suffering a loss through giving charity. To the contrary, we should feel that every *tzedakah* opportunity is a [Divine] reward and a benefit for us, *because charity actually causes our wealth to increase* as the Blessed God pays back everything we give away many, many times over."

✑ Charity Is Better Than Real Estate

M aseches *Kallah* (Chapter 2) relates:
R' Tarfon was a very wealthy man, but he did not give charity in proportion to his means. Once R' Akiva asked him, "Would you like me to buy you a city or two?" R' Tarfon eagerly accepted the investment offer and gave R' Akiva four thousand golden coins, which R' Akiva immediately distributed among the poor.

After a while, R' Tarfon met R' Akiva and asked him, "Where are the cities which you purchased for me?"

R' Akiva took R' Tarfon to the study hall, where took a *Book of Psalms* and opened it in front of them. They recited from the text until they arrived at the verse, פִּזַּר נָתַן לָאֶבְיוֹנִים צִדְקָתוֹ עֹמֶדֶת לָעַד, *He distributed widely to the destitute, his charity endures forever* (Psalms 112:9). R' Akiva exclaimed, "This is the enduring real estate which I purchased for you!"

R' Tarfon arose and kissed R' Akiva, exclaiming, "My Rabbi! My mentor! My Rabbi in Torah wisdom; my mentor in proper conduct!" R' Tarfon then gave R' Akiva an additional sum of money to distribute among the poor.

The Chofetz Chaim (*Ahavas Chesed*, Part II; Chapter 14) explains that when R' Akiva originally approached R' Tarfon and offered him a real estate investment of "a city or two," he was not being deceptive, because R' Akiva knew full well that the person who gives charity creates for himself a celestial reward which will endure for all time. He who gives charity in this world builds himself a magnificent 'Palace of Kindness' in heaven, populated by legions of fiery angels who were created by each and every coin the philanthropist gave to the needy! It was precisely this awareness that made the difference between these two great Rabbis. Without a doubt, R' Tarfon was always a generous giver of *tzedakah;* but he did not see the eternal reward of *tzedakah* as vividly and realistically as R' Akiva did. To R' Akiva no real estate could be more "real" than the celestial structures created by *tzedakah*.

ᴥ§ As You Give Out, So Shall It Flow in

King Solomon observed: מַתָּן אָדָם יַרְחִיב לוֹ וְלִפְנֵי גְדֹלִים יַנְחֶנּוּ, *A man's gift expands him and places him in the presence of great people* (*Proverbs* 18:16).

Alshich explains that the wealthy person who enjoys a surplus of riches has clearly been appointed by heaven as a trustee to distribute his extra funds to the poor. The man of wealth resembles a funnel which has a wide mouth on top and a narrow spigot on bottom. A proportionate balance must be maintained between the influx above and the outflow below. If the spigot opening below is too narrow then there will be a backup at the funnel's mouth and the liquid poured into the top will overflow and go to waste. God uses the rich man as His funnel to distribute alms to the poor people who are lower on the financial ladder. As the rich man opens up his 'spigot' and generously distributes alms to those beneath him, God proportionately increases the level of his income, which flows down from above. If, however, the rich man is stingy and decreases the philanthropic flow from his pockets, then the Divine blessing from above will diminish or it will go to waste. The rich man has complete control of his income! The formula is simple, "Exactly as you give it out, so shall it flow in!"

ᴥ§ He Who Robs the Poor Robs Himself

The Chofetz Chaim used a parable to illustrate this point. A coarse, illiterate farmer used to come to town periodically to sell his sacks of wheat to a local grain merchant. By mutual agreement they kept track of the number of sacks unloaded from the farmer's wagon by making a check on the wall for every sack. After the wagon was unloaded they counted all the checks to determine how many sacks the farmer delivered.

After a while, the farmer became uncomfortable with this agreement. "Who knows," he said to himself, "maybe the merchant is secretly erasing some of those checks from the wall when I'm not looking?" So the farmer suggested an alternate method of keeping account. For each sack of grain he delivered, the farmer asked the merchant to put a small coin into a plate. When the delivery was

completed they would count the coins to determine the actual size of the delivery.

Soon after they introduced this new accounting method, the farmer found himself falling prey to temptation. Whenever the merchant turned his back and was not watching, the farmer could not control his greed and pilfered a few coins from the plate and hid them in his pocket. The merchant, of course, paid him according to the number of coins that remained in the plate.

The lesson is obvious. We often think that we are stealing from others, while in reality we are stealing from ourselves. The greedy think they will profit by depriving the poor of some charity coins. Little do they know that they are only robbing themselves, because for every penny we drop into the poor man's plate down below, God showers us with a fistful of coins from above.

✺§ How to Add by Subtracting

R' Avuhu said: If you see a person generously distributing his money to charity, rest assured that his wealth will surely increase, for it is written (*Proverbs* 11:24): יֵשׁ מְפַזֵּר וְנוֹסָף עוֹד, *There is a man who scatters [his wealth] and more is added* (*Midrash Mishlei*).

✺§ What You Give Is What You Take

In the beginning of *Parshas Terumah* we read: וַיְדַבֵּר יהוה אֶל מֹשֶׁה לֵּאמֹר: דַּבֵּר אֶל בְּנֵי יִשְׂרָאֵל וְיִקְחוּ לִי תְּרוּמָה . . . , *Hashem spoke to Moses, saying: "Speak to the Children of Israel and let them **take for Me** a portion . . ."* (*Exodus* 25:1-2). Since Hashem was asking the Jewish people to make a contribution, the proper wording should have been, וְיִתְּנוּ לִי תְּרוּמָה, *"let them **give for Me** a portion."* The Beis HaLevi (*Parshas Terumah*) explains that Hashem is teaching the Jewish people a fundamental lesson: The only thing you take with you is that which you give away.

The man of wealth can be compared to a fly locked up inside a canister with a large sugar cube. The fly can nibble at the delicious cube as much as its heart desires, but it can not take the cube out of the container; the fly itself is imprisoned within the canister and will not leave the container alive. The foolish fly may glory in his

imaginary 'wealth', but, in truth, he is a miserable prisoner getting his 'last licks.' Similarly, the man who has amassed great wealth in this world has no more control over it than the fly has over his sugar cube. The only thing one truly possesses and enjoys for eternity is the charity one gives away in his lifetime!

◆§ Why Charity Is So Difficult

R' Aryeh Leib Shteinman was once asked why it is so hard to give tzedakah properly. He answered that he once heard the following explanation from the Chazon Ish. The Talmud (Yoma 69b) teaches that at the beginning of the Second Temple, the Sages destroyed the yetzer hara for idol worship because the Jewish people could not withstand this overwhelming temptation. But since the yetzer hara has a mission — to test and challenge us — we cannot remain without a struggle. Therefore, a new yetzer hara for money had to take the place of the one for idolatry. This is why so many people put their faith and trust in their money, almost worshiping it as a god! It is because of this yetzer hara that people find it so hard to give their money to charity.

◆§ Money Worship Is Idol Worship

The Talmud (Bava Basra 10a) states: R' Yehoshua ben Karchah says: "If anyone averts his eyes from giving charity it is as if he worships idols." R' Elchonon Wasserman explains (Kovetz Shiurim 51): The person who worships idols believes that this lifeless statue can actually hurt him or help him, independently of God Almighty. Similarly, the person who ignores his tzedakah obligations does so because he loves his money and puts his full faith in his wealth. He too believes that his money, independently of God's will, determines his quality of life. Thus, money worship is tantamount to actual idol worship.

In reality, the opposite is true. When God decrees pain, punishment or discomfort upon a person, no amount of money can avert the Divine decree. On the other hand, when a person exerts himself to collect charity and suffers embarrassment in gathering for others, this mitzvah will surely save him from toil, travail, and humiliation elsewhere.

⇜ Charity Saves Steps

R' Eliyahu Roth used to say in the name of his Rebbe, Reb Shlomke of Zhvil: Every single step a person takes to help another saves him from taking a thousand steps on his own behalf!

⇜ A Merit for Outstanding Children

The Talmud (*Bava Basra* 9b) teaches: R' Yehoshua ben Levi said: Anyone who habitually performs acts of charity will have sons who possess wisdom, wealth, and knowledge of the Aggadah [homiletic discourse] as it is written: רֹדֵף צְדָקָה וָחָסֶד יִמְצָא חַיִּים צְדָקָה וְכָבוֹד, *He who pursues charity and kindness will find life, charity, and honor* (*Proverbs* 21:21).

The Chofetz Chaim (*Ahavas Chesed*, Part III, footnote to Chapter 5) makes a remarkable observation: "It is amazing that people search high and low for all sorts of *segulos* (actions with reputed benefits through either natural or supernatural causes) in order to bear children and they neglect the greatest *segulah* of all which is clearly set forth by our Sages. People lavishly squander fortunes of hundreds and thousands [of rubles] upon these *segulos,* but they pay no attention to the pledge made in the Talmud that one who gives habitually and generously to charity will be blessed with extraordinary offspring! But for this *segulah* to work the key is consistency. One must devote himself to *tzedakah* on a constant basis, and take responsibility to support specific poor people from his own resources and to raise money from others as well. Not only does the genuine *baal tzedakah* care for the material needs of the poor, but also he devotes himself to providing a solid Torah education for children from underprivileged, impoverished homes. Naturally, he who is concerned for the welfare of other families and their children will merit wonderful children himself."

⇜ Tzedakah Is Like Planting Seeds; There Is No Loss, Only Gain

In the first blessing of the Shema, recited every morning, we praise God in eight different ways. One of them is that God is זוֹרֵעַ צְדָקוֹת,

zorei'a tzedakos, *He sows the seeds of charitable deeds*. *Sefer Chassidim* (321) explains that the reward for *tzedakah* is different from the reward for other mitzvos whose reward is stored in a celestial treasury where it is locked up, so to speak, for eternity. God Himself sows the seeds of reward for human charity inside the Garden of Eden, where the '*tzedakah* trees' flourish every year and give forth an abundant crop of wondrous fruits and flowers, as King Solomon said: וְעַל פְּתָחֵינוּ כָּל מְגָדִים חֲדָשִׁים גַּם יְשָׁנִים דּוֹדִי צָפַנְתִּי לָךְ, *At our doors are all precious fruits, both new and old, I have hidden for You my Beloved* (*Song of Songs* 7:14).

R' Dovid of Novaradok in his classic work *Galya Masechta* (*Drushim* p. 91) vividly demonstrates how foolish it is for anyone to think that he is suffering any loss whatsoever by giving from his wealth to charity. This is illustrated by contrasting the following two scenarios. First is a man who lost one thousand dollars and desperately searched everywhere for his lost wallet. In the course of his search this man found a money clip containing ten thousand dollars and he was overjoyed by his good fortune. Yet, as happy as he was over his windfall, this man always felt bad over his original loss of one thousand dollars. In the second case we have a farmer who purchased one thousand dollars worth of prime seeds and sowed them in the furrows of his well-plowed land and then buried these expensive seeds with piles of soil and fertilizer. Later, the farmer is ecstatic when he harvests a bumper crop worth ten thousand dollars. His joy is not marred by any sense of loss over the expensive seeds which he buried in the earth, because the seeds were a normal investment, the only natural way to create an agricultural abundance. Similarly, the only natural, guaranteed way for a person to earn and enjoy enduring wealth is to first make a capital investment of charitable giving. Only then will one's capital realize permanent gains without losses.

R' Dovid of Novardok concludes: The Talmud teaches (*Bava Basra* 12b) that whenever there is a dispute between two parties where one side will enjoy an advantage without causing the other party any loss, the rule is כּוֹפִין עַל מִדַּת סְדוֹם, we coerce people not to emulate the selfish traits of the inhabitants of Sodom. We force the second party to allow the first party to enjoy his benefit and advantage. Thus, the Talmud describes a selfish person as one who emulates the people of Sodom; the selfishness is manifest where he will not lose, but he nevertheless prevents others from gaining. However, on the surface, the description appears inaccurate. We know that the people of Sodom

were notorious for refusing to practice *any* form of charity or benevolence, and in the practice of charity the poor man's advantage results, seemingly, from the donor's loss and depletion of funds. In fact, this was precisely the mistake of the Sodomites. They justified their refusal to give charity by asserting that they could not bear the loss involved and they refused to believe the basic principle that giving charity is all gain and incurs no loss whatsoever! This is exactly what the Torah means when it makes this proclamation for charity: נָתוֹן תִּתֵּן לוֹ וְלֹא יֵרַע לְבָבְךָ בְּתִתְּךָ לוֹ כִּי בִּגְלַל הַדָּבָר הַזֶּה יְבָרֶכְךָ יהוה אֱלֹהֶיךָ בְּכָל מַעֲשֶׂךָ וּבְכֹל מִשְׁלַח יָדֶךָ, *You shall give and continue to give to him, and let your heart not feel bad when you give him, for in return for this matter [of charity], Hashem, your God, will bless you in all your deeds and in your every undertaking (Deuteronomy 15:10).*

CHAPTER SEVEN

Redemption Through Charity

ᴥᔈ Charity Brings Redemption

The Talmud (*Bava Basra* 10a) teaches: R' Yehudah says: Charity is great because it brings the redemption closer, as it is written: כֹּה אָמַר ה׳ שִׁמְרוּ מִשְׁפָּט וַעֲשׂוּ צְדָקָה כִּי קְרוֹבָה יְשׁוּעָתִי לָבוֹא וְצִדְקָתִי לְהִגָּלוֹת, *Thus said Hashem: Observe justice and perform charity, for My salvation is soon to come, and My charity to be revealed (Isaiah 56:1).*

The Talmud (*Sanhedrin* 98a) teaches: Ulla said: Jerusalem will not be redeemed except through charity, as it is stated: צִיּוֹן בְּמִשְׁפָּט תִּפָּדֶה וְשָׁבֶיהָ בִּצְדָקָה, *Zion will be redeemed through justice, and those who return to her through charity (Isaiah 1:27).*

Rambam (*Hilchos Matnos Aniyim* 10:1) also uses the above verse to assert: "The final redemption of Israel shall only come about in the merit of charity as it says: צִיּוֹן בְּמִשְׁפָּט תִּפָּדֶה וְשָׁבֶיהָ בִּצְדָקָה, *Zion shall be redeemed through justice and her returnees through charity.*

ᴥᔈ Circumcision of the Heart

The *Baal HaTanya* writes (*Iggeres Hakodesh,* Chap. 4): Enveloping the innermost core of the heart are both a thick, crude covering and a thin stubborn membrane, representing the desire for both the gross and the subtle pleasures of this world, which stifle the love the heart has for the Almighty. This sheath is called עָרְלַת הַלֵּב, 'the foreskin of the heart,' and it must be 'circumcised' and thrown away. The most effective way to make this 'circumcision' of the heart'

is to detach oneself from the material object which a person loves exceedingly — his money!

This is especially effective for the poor person whose subsistence is limited and who is hard pressed for funds. When the poor man who toils to eke out his daily bread gives his money away to charity he is truly touching the innermost core of his heart. Every day he pours his heart and soul into his work, as his very life depends on it. When such a man distributes the fruits of his labor to please God, and distributes charity with joy and gladness, he redeems the inner sanctum of his heart from its state of exile and estrangement.

Giving charity also accomplishes the second stage of circumcision called פְּרִיעָה, *priah,* which removes the thin membrane covering the heart. *Priah,* which literally means 'paying a debt,' is needed because after devoting his desires and ambitions to the material world, he became indebted and subjected to alien desires which held his heart captive. This is the real meaning of the verse: צִיּוֹן בְּמִשְׁפָּט תִּפָּדֶה וְשָׁבֶיהָ בִּצְדָקָה, *Zion will be redeemed through justice, and her captives* (those whose hearts were captivated by lust for the material world) *through charity (Isaiah 1:27).*

⊰ Nowadays Charity Has Top Priority

The *Baal HaTanya (Iggeres Hakodesh,* Chapter 9) writes further:
Nowadays, in the pre-Messianic era known as עָקְבְתָא דִּמְשִׁיחָא, 'the footsteps of the Messiah,' the primary form of serving God is through charity, as our Rabbis taught, 'Israel will be redeemed only through charity.' The teaching of the sages (*Shabbos* 127a): וְתַלְמוּד תּוֹרָה כְּנֶגֶד כּוּלָם, 'The study of Torah is equivalent to all other mitzvos,' refers only to the times of the Sages. They were totally immersed and preoccupied with intensive Torah studies and that is why they became the outstanding Tannaim and Amoraim. However, in this pre-Messianic period when we have fallen from their level, it is different. Today, the only way to truly embrace the Almighty and to transform the darkness of exile into the Divine light of redemption is to force oneself to open his heart and his hand to give *tzedakah.* One who shatters his selfish nature in this way will surely merit the prophet's promise: כִּי עַיִן בְּעַיִן יִרְאוּ בְּשׁוּב ה' צִיּוֹן, *With their own eyes they will see that Hashem returns to Zion (Isaiah 52:8).*

◄§ Nothing Left but Tzedakah

While we languish in the depths of exile we are like the dead. There is nothing in the world that can revive us and inject even a minute dose of vitality into our systems other than *tzedakah*. Without charity the Jewish nation in exile is dead and totally buried. But when a benefactor resurrects his impoverished brother with *tzedakah*, he introduces a life-giving force into all of Israel (*Chasam Sofer, Drashah for Ches Teves*, p. 90).

◄§ Humility Brings Redemption

The Chofetz Chaim observed: "In our times we have seen an increase of poverty and economic hardship, because this is God's way of humbling pride and arrogance, and this is how it must be before the final redemption" (*Sichos Chofetz Chaim*).

◄§ The Covenant of Kindness

Tanna D'Vei Eliyahu (Chapter 23) says that when the enslaved Jews sought salvation from the terrible Egyptian bondage, they assembled as one and entered a solemn covenant to act kindly and charitably towards one another. This interpersonal compassion between Jews aroused God's compassion for them and He redeemed them from slavery. This is as we read in the Song at the Sea, נָחִיתָ בְחַסְדְּךָ עַם זוּ גָּאָלְתָ, *With Your kindness You guided this people that You redeemed* (*Exodus* 15:13).

◄§ The Past Provides a Glimpse of the Future

The *Beis Halevi* (*Responsa Part II, Drush* 16) explains that our deliverance from the Egyptian exile over three thousand years ago

was far more than just a salvation for the downtrodden Israelites of that generation. In fact, God used that opportunity to give the Jewish people a preview of the final Messianic Redemption of the future.

As the prophet *Michah* (7:15) proclaims: כִּימֵי צֵאתְךָ מֵאֶרֶץ מִצְרָיִם אַרְאֶנּוּ נִפְלָאוֹת, *As in the days of your deliverance from the land of Egypt, I will show you wonders [in the future].* The Talmud (*Bava Basra* 9a) teaches that the Messianic Redemption will come about by virtue of Israel's dedication to performing charity, as the prophet says: כֹּה אָמַר ה׳ שִׁמְרוּ מִשְׁפָּט וַעֲשׂוּ צְדָקָה כִּי קְרוֹבָה יְשׁוּעָתִי לָבוֹא וְצִדְקָתִי לְהִגָּלוֹת, *Thus said Hashem: Observe justice and perform charity, for My salvation is soon to come and My charity to be revealed* (Isaiah 56:1). Therefore, on the night of Pesach, in addition to reminiscing over our historical deliverance from Egypt in days of yore, we express our yearning for the day of final redemption. As part of that expression of yearning we also declare our dedication to the principles of charity and kindness toward others, which serve as the vehicles through which we may merit that redemption. That is why we preface the entire Haggadah recitation with a statement of concern for the poor and needy.

Beis Halevi adds: When we give careful thought to our situation in exile we realize that today it is nearly impossible to fulfill any mitzvah in all its details, because we are not living in the Holy Land and many things are lacking. Even Sabbath observance is incomplete, because when the Temple stood, special Sabbath *mussaf* offerings were sacrificed in honor of this holiest of days.

The exception to this rule is *tzedakah.* Instead of detracting from our observance of charity, the exile experience provides even greater opportunities to be kind to our brethren. When our people were safe and secure on their own soil, prosperity was the norm and poverty was the exception. Today, the opposite is true. Opportunities for charity abound and one can be busy with *tzedakah* every minute of the day. For a few pennies of charity a person can save lives, and ransom captives. Make no mistake; this is not by chance. Do not attribute this widespread poverty to random social or economic factors. These incessant charitable opportunities are a Divine gift, which the Almighty showers upon us in His abundant kindness. It is this charity alone and nothing else, which will bring about our long-awaited redemption from this exile.

≈§ Tzedakah: A Jewish Self-Portrait

The *Beis HaLevi* continues: The prophet tells the Jewish people in the name of God that even when they will wander in the darkest exile they will never lose their Jewish identity: וְנוֹדַע בַּגּוֹיִם זַרְעָם וְצֶאֱצָאֵיהֶם בְּתוֹךְ הָעַמִּים, כָּל רֹאֵיהֶם יַכִּירוּם כִּי הֵם זֶרַע בֵּרַךְ ה׳, *Their offspring will be known among the nations, and their descendants amid the peoples; all who see them will recognize them, that they are the seed that Hashem has blessed* (*Isaiah* 61:9). When the Jewish people heard this they responded (ibid. 61:10): שׂוֹשׂ אָשִׂישׂ בַּה׳ תָּגֵל נַפְשִׁי בֵּאלֹקַי כִּי הִלְבִּישַׁנִי בִּגְדֵי יֶשַׁע מְעִיל צְדָקָה יְעָטָנִי, *I will rejoice intensely with Hashem, my soul will exult with my God, for He has dressed me in the raiment of salvation, in a robe of charity has He cloaked me.*

This can be understood through the teachings of the *Zohar* which explains that all of the Torah which one studies and all the mitzvos one performs become a spiritual garment, a robe of heavenly light, which clothe the soul in this world and the next. But these garments may not be permanent, for when a person sins he is stripped of his garments of glory.

This can be compared to the crown prince, the beloved only son of the king. The king had special clothing made for his son — a magnificent uniform bedecked with royal insignia and medals. Even if the crown prince were to be in the middle of a huge crowd of people he would stand out because of his special attire. However, one day the prince rebelled against his father and the king threw him out of his palace and sent him into exile. The king stripped his son of his royal uniform and medals of honor and dressed him in rags. Later, the king regretted the harsh punishment and sent his guards out to find his banished son. The guards said, "But, Your Majesty, how can we find him if he is dressed in rags like thousands of other beggars? How will we recognize him?" The king replied, "I may have stripped him of his clothes and medals, but he is still my son and his face looks just like mine. Study all the faces carefully and you will be able to identify my son."

Similarly, says the *Beis HaLevi*, when the Jews were in the holy land of Israel and they obeyed God, their Father and King, and scrupulously fulfilled all the mitzvos, they were clothed in spiritual raiment and bedecked with mitzvah medals that identified them as children of the great King, God. But when they sinned and rebelled against God,

they were stripped of all these wondrous clothes and they were banished from the royal realm, condemned to wander among the gentile nations. In exile, the Jews became so assimilated that it seemed that there is no way to recognize them anymore. Yet there is one identifying birthmark that can never be taken away from the Jews because it is etched in their flesh and carved into the contour of their faces. And that is the charitable nature of the Jews. This can never be removed from them and this outstanding feature is their salvation.

This is what Isaiah meant when he said: *Their offspring will be known among the nations, and their descendants amid the peoples; all who see them will recognize them, that they are the seed that Hashem has blessed.* How indeed will the Jews be recognized among the nations? They themselves proclaim: *I will rejoice intensely with Hashem, my soul will exult with my God, for He has dressed me in the raiment of salvation, in a robe of charity has He cloaked me* (Isaiah 61:9-10).

Therefore, the redemption of Israel can only come about by virtue of charity, צִיּוֹן בְּמִשְׁפָּט תִּפָּדֶה וְשָׁבֶיהָ בִּצְדָקָה, *Zion will be redeemed through justice, and those who return to her through charity* (Isaiah 1:27).

What
to Give

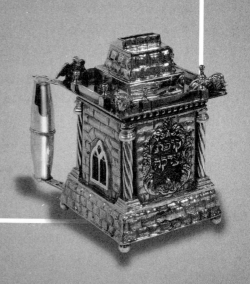

The Poor Man's Portion Is on Deposit With the Rich

⋖§ Economic Disparity Provides Opportunities for Charity

God Almighty has no lack of resources. He could easily have created a world of universal wealth, wherein everyone was wealthy and no one was poor. Why did not He do so? This question was posed to God by King David. The Midrash (*Shemos Rabbah* 31:5) records the following dialogue based on a verse in *Psalms* 61:8. David said to the Holy One, Blessed is He, יֵשֵׁב עוֹלָם, "*Equalize Your world!* Why must there be such a huge economic disparity between the rich and the poor?" God replied: "If I make all men economically equal, חֶסֶד וֶאֱמֶת מַן יִנְצְרֻהוּ, *who will practice kindness and charity?*"

R' Yerucham Levovitz of Mir explained: God did not create the precept of charity because he saw that there were poor people in the world who needed help. Rather, the exact opposite is true. God purposely created poor people in order to give men of means an opportunity to fulfill the mitzvah of *tzedakah*. A world devoid of opportunities to show kindness to others is inconceivable; compassion is the purpose of this world.

⋖§ The Wealthy Man Is a Treasurer

The Torah introduces the mitzvah of *tzedakah* in these words: כִּי יִהְיֶה בְךָ אֶבְיוֹן מֵאַחַד אַחֶיךָ בְּאַחַד שְׁעָרֶיךָ, *When there shall be in your midst*

a poor person, from one of your brothers in one of your cities . . . (Deuteronomy 15:7). The *Ohr Hachaim Hakadosh* notes that the phrase בְּךָ, *in your midst*, is superfluous, and attempts to explain its meaning. First of all the phrase teaches us that we should never look down condescendingly at poor people and treat them as inferior ne'er-do-wells. We must remember that the reason they suffer poverty is for our sake! Since the Almighty wished to provide you with the opportunity to gain the merit of charity, He purposely made some people poor and strategically placed them בְּךָ, *in your midst*, so that you could easily perform this mitzvah. Always remember that the charity you give is far more for your own sake than for the pauper's. Never forget that as shabby and miserable as the poor man looks he is nevertheless מֵאַחַד אַחֶיךָ, *from one of your brothers* — not merely a plain brother, but from *one* of your outstanding brethren, who is only suffering poverty for your sake.

A second explanation of the phrase, *in your midst*, is that the wealthy man should not view the pauper as a stranger who is begging to receive money which is not his. To the contrary, the rich man is the treasurer into whose hands the poor man's portion has been deposited for safekeeping.

Ohr Hachaim Hakadosh (commentary to *Exodus* 22:24) elaborates on this subject and makes it clear that any extra money which a rich man has beyond his actual needs is definitely not his own and was not given to him to hoard and save. This money belongs to the poor and the Almighty has merely accorded him the privilege to be His agent to disburse the money to those who need it and 'own' it. God did not give the money to the pauper directly because he is being punished for his misconduct; he must suffer the degradation and deprivation which is the lot of the poor. Thus, the concept of charity has two benefits: It brings merits to the rich and effects atonement for the poor.

◄§ God Has Made the One to Parallel the Other

The Midrash (*Vayikra Rabbah* 34:5) states: R' Tanchum Bar Chiya began, בְּיוֹם טוֹבָה הֱיֵה בְטוֹב, וּבְיוֹם רָעָה רְאֵה, גַּם אֶת זֶה לְעֻמַּת זֶה עָשָׂה הָאֱלֹקִים, *Be pleased when things go well, but in a time of misfortune, reflect: 'God has made the one to parallel the other'* (*Koheles 7:14*). When you observe that your friend has fallen upon hard times while you

continue to prosper, reflect that there is surely a relationship between the two events and that God is offering you an opportunity to gain merit by supporting your fallen friend. R' Tanchum bar Chiya learned this lesson from his mother. Whenever she went out to the marketplace to buy him a pound of meat, she always purchased not one, but two; one pound of meat for her son, and an equal amount for the poor. She fully realized that, *'God has made the one to parallel the other.'* He only made some people poor so that others could have the privilege and merit to support them!

⚜ It All Belongs to God

The *Tur* writes in his introduction to the Laws of *Tzedakah* (*Yoreh Deah* 247): Never allow your mind to entertain the perverse thought, 'I can't afford to give charity to others, it will diminish what I have for myself!' Because one must never forget that his money does not belong to him in the first place — it all belongs to God, Who has temporarily deposited His money with you for safekeeping. When a poor person asks for help it is as if God is requesting you to pay out *His* money into the hand of this needy representative. Indeed, the most precious part of your wealth is what you give to the poor, as it says: (*Isaiah* 58:8) וְהָלַךְ לְפָנֶיךָ צִדְקֶךָ, *And your charity shall go before you* [to your eternal reward].

⚜ Money Is a Divine Gift

The Midrash (*Bamidbar Rabbah* 22:7) teaches: "This is the absolute rule: Three outstanding gifts were put into this world. If a person is fortunate enough to be endowed with any one of them, he has acquired the most precious treasure in the world. He who is blessed with wisdom has everything! He who is blessed with extraordinary strength has everything! He who is blessed with wealth has everything! When are these gifts a blessing? When they are bestowed by heaven and earned through the merit of Torah. But the strength and wealth acquired by mortals of flesh and blood are worthless. Furthermore, when these gifts do not come from the Holy One, Blessed is He, they will not endure and are destined to be abruptly terminated. There were two fabulously wealthy

men — one a Jew, Korach; the other, a gentile, Haman — and both were utterly destroyed. Why? Because their wealth was not a gift from the hand of God; rather, they grabbed their money for themselves!"

The explanation of this Midrash is as follows: Everything that we possess comes to us from the hand of God. What is the difference between the 'gift-taker' and the 'grabber'? The 'gift-taker' humbly and gratefully acknowledges that God bestowed everything he owns, whereas the proud and foolish 'grabber' deludes himself and attributes his prosperity to his own efforts. Vast sums of money pass through the hands of the bank teller every day, yet he is well aware that not a penny of this belongs to him; he is merely part of a distribution system which gives out the money to its rightful owners. Similarly, the humble 'gift-taker' controls large sums of money but fully realizes that God put the money in his hands for him to distribute to the worthy recipients who are its rightful owners. Like the humble bank teller, the 'gift-taker' takes only a modest salary for himself. The 'grabber,' however, credits himself for his success and therefore selfishly hoards his hard-earned wealth. Therefore, his prosperity will be short lived, and others will grab it from his hands.

⋅§ Learn a Lesson From the Heart

King Solomon wisely noted the relationship between charity and the heart: חַיֵּי בְשָׂרִים לֵב מַרְפֵּא, וּרְקַב עֲצָמוֹת קִנְאָה: עֹשֵׁק דָּל חֵרֵף עֹשֵׂהוּ, וּמְכַבְּדוֹ חֹנֵן אֶבְיוֹן, *A tender heart brings healing of the flesh, but envy brings rotting of the bones. One who robs the poor disgraces his Maker, but he who is gracious to the destitute honors Him (Proverbs 14:30,31).*

Alshich explains the lesson contained in these verses: The heart is called 'the king of all organs' because it pumps essential, life-giving, blood to every part of the body. Why did the Creator design the body in this fashion that one organ should control the fate of all the others? In order for men to learn the lesson of *tzedakah* from their own flesh!

The man who possesses wealth resembles the heart. It is clear that the blood which the heart pumps all over the body is not its own — it belongs to the entire body. Similarly, the extra money which the rich man has beyond his personal needs is not his at all. His function is to act as a pumping station to circulate and distribute the money to all that need it. Furthermore, just as all the limbs and organs of the body

are not ashamed to receive the blood the heart pumps to them because it is rightfully theirs, so too, the poor should not be embarrassed when they receive their rightful portion from the rich.

This is the deepest message of the aforementioned verses: *A tender* [generous] *heart brings healing* [blood] *to the flesh* [all other limbs and organs], *but envy* [selfishness and stinginess hold back the vital flow of blood and] *brings rotting of the bones.* [Similarly, the rich man who refuses to circulate his wealth is] *One who robs the poor* [and] *disgraces his Maker* [because he repudiates God's welfare system], *but he who is gracious to the destitute honors Him.*

❦ When You Have More Than Enough

Chovos Halevovos (*Shaar Habitachon,* Chapter 5; 'The Fourth Advantage of Faith') explains how a man of true faith acts differently with his money: The man who sincerely trusts in Hashem knows that every penny he receives comes directly from the hand of God for a specific purpose. When he finds that he has more money than he needs for his expenses, he knows that God has given him this surplus for a good reason. He does not stash the money away and save it for the proverbial 'rainy day.' Rather, he enthusiastically gives the money away to others who are in need. He divests himself of these 'extra' funds with a generous spirit and a joyous heart, because he knows that this is why God gave him a surplus and that this distribution will be pleasing in the eyes of the Almighty.

However, the man of meager faith never has enough. You could give him the entire world and the fullness thereof and yet he would feel that he does not have enough for all his needs. He fails in fulfilling his obligations to God and to his fellow man because he would rather hoard his money than share it. Ultimately, he will lose his wealth and nothing will remain. All this is summed up in the wise words of King Solomon who said: יֵשׁ מְפַזֵּר וְנוֹסָף עוֹד, וְחוֹשֵׂךְ מִיֹּשֶׁר אַךְ לְמַחְסוֹר, *There is one who scatters* [his wealth to charity] *yet he gathers more* [wealth than he gives away], *and there is one who refrains from giving what is proper, only to realize a loss* (*Proverbs* 11:24).

Chovos Halevovos (*Shaar Yichud Hamaaseh,* Chapter 5) offers a vivid description of how the Evil Inclination makes every effort to discourage a person from giving charity: 'when you want to give money to the

poor, the Evil Inclination will make an all-out effort to convince you that this donation will put you in grave financial danger. He will conjure in your mind images of abject poverty and he will show you how miserable you will look when you yourself are reduced to penury. The Evil Inclination will attempt to convince you that any donation is simply beyond your means. The only way to refute his arguments is to remember the rule: If God has given me extra money which I have no use for right now, then most probably God wants me to give it away to charity.

✑ What Terrified the Chofetz Chaim

R' Naftoli Neuberger of Yeshivas Ner Yisroel of Baltimore told me the following story:

Once someone noticed that the Chofetz Chaim was fasting on a regular weekday, which was out of character for him despite his extraordinary piety and holiness. This individual pressured the *tzaddik* to explain why he was fasting. The Chofetz Chaim explained that it was a *Taanis Chalom,* a fast in response to having a bad dream. The man continued to pressure the Chofetz Chaim to reveal more details. "Rebbe, what was so bad about your dream that you are doing something so drastic as to fast on account of it?" The Chofetz Chaim felt compelled to reveal the dream's content. "It was really a *shrecklicher cholom,* a terrifying nightmare! I actually dreamt that I became a rich man!" The curious questioner continued to ask, "*Nu,* Rebbe, what is so terrible about becoming a rich man?" "*Oy vey!*" cried the Chofetz Chaim, "Being rich is an awesome responsibility! If I have a lot of money that means that I must distribute a great deal of *tzedakah.* Do you have any idea how hard it is to distribute *tzedakah* properly? And do you realize how much time and effort it takes? It would take me so much time that I would hardly have any time left for Torah study! Believe me, for me, wealth is a nightmare."

The Chofetz Chaim paused for a moment and added, "The truth of the matter is that there was something even more terrifying about that dream. The Gemara teaches that we dream at night about the things we think about by day. If I dreamt about money at night that means that I've been thinking about money all day! Woe unto me that it is money and not Torah that is occupying my thoughts throughout my waking hours!"

⊷§ The Responsibility of the Rich

R' Yisroel Salanter considered the possession of money a great responsibility. Therefore, when R' Yisroel's wife once purchased a lottery ticket, he immediately summoned two men to be witnesses, and he made a formal statement to his wife in their presence: "I hereby declare that I have nothing to do with your monetary acquisitions or with any interest which accrues to it forever."

R' Yisroel did this because he was concerned lest his wife win the lottery and become wealthy. "When Hashem grants riches to someone," explained R' Yisroel, "it is not exclusively for that man's personal benefit. The wealth makes its owner into a *gabbai tzedakah*, responsible for sharing it with the poor. Who can accept such a heavy burden? It requires searching every corner of the city to discover whether someplace there is a pauper in distress or a youngster whose family lacks the funds to hire a teacher to teach him Torah. Who can find them all?"

Unwilling to face the tremendous challenge and obligation of wealth, R' Yisroel hastened to free himself from all rights to his wife's potential lottery winnings! *(R' Ephraim Zaitchik, Hameoros Hagedolim).*

⊷§ Caring and Sharing With Others

R' Yisroel Salanter expressed his wonder that people do not realize what an immense obligation they have to help others. Many people worry about helping their friends do a mitzvah , but do not care about their material well-being. "Many times," said R' Yisroel, "I have seen a person pass a shul, and the people inside call out to him, '*Kedushah! Kedushah!* Please come in and join us!' But I have yet to see a person pass by a house where a *seudah* [a meal] is being served, and the people eating at the table call out to the passerby, '*Seudah! Seudah!* Please come inside and join us!'" *(Hameoros Hagedolim).*

⊷§ Share Everything With the Poor

Charity is not limited to sharing money or material resources with the poor. One must share everything he has with the needy in order to improve their lot.

A pauper once poured his broken heart out to R' Yisroel Salanter. His cupboards were bare and there was nothing for his family to eat. He decided that the best way to support himself would be to become an itinerant *maggid,* a public speaker who travels from town to town inspiring and entertaining people with his clever sermons. The only problem with this plan was that the pauper had absolutely no experience or expertise in public speaking! What did R' Yisroel do? He devoted a few hours of his precious time to this man and taught him a number of good sermons for his repertoire. He practiced them over and over again with the pauper until he was satisfied that he could say over these sermons very well *(Hameoros Hagedolim).*

⋄§ Please Do Not Make Me Rich!

The famous Maggid of Jerusalem, R' Sholom Mordechai Hakohen Schwadron, once related an interesting story about R' Yisroel Salanter. On a certain occasion, R' Yisroel remarked that he thanked Hashem for not having made him a rich man.

"Wealth is a heavy burden," R' Yisroel said. "I have a neighbor who lives in abject poverty. During the winter he trembles with cold, day and night. His children walk around wearing torn shoes. His wife, after childbirth, requires several glasses of milk every day, but there is nothing. If they will ask me in the heavenly court why I did not help this family enough, I will have a partial excuse: *I, too, do not have a penny.*

"No, it is not a full excuse. But it is a partial one, and even half an excuse is better than none. If I were rich, however, I would undoubtedly get a sharp rebuke: 'Your neighbor is drowning in anguish, and you are hiding your gold under your floorboards?' How would I respond to such a simple accusation?"

As he finished relating this story, R' Sholom grew emotional. He went on to describe, vividly and at length, the great responsibility that the rich bear. Suddenly, he raised his voice, "Ah, ah, R' Yisroel Salanter was right!' and continued to expound on the truth of R' Yisroel's words. Then he lifted his eyes heavenward and cried out, *"Ribbono Shel Olam* — don't make me rich!"

R' Sholom was silent for a moment. Then he smiled and said, "You're a smart one. If I were to ask you right here and now, to say

what I just said, out loud — to ask *HaKadosh Baruch Hu* in front of this entire group not to make you rich — you would refuse to do it. Why? Because you would be afraid that Hashem might actually grant your request. But I, I am not afraid!" He raised his voice once again and cried out, "*Ribbono Shel Olam, don't make me rich!*" (*Voice Of Truth*, p. 246).

⋲ The Rich Are Addicted to Their Money!

The Chofetz Chaim would caution the poor not to judge the rich too harshly when they failed to give charity properly. The kindly Sage of Radin had this to say in their favor: "Once I witnessed this scene while I was in Vilna. I saw a man lying dead drunk right in the middle of the street. All the little street urchins were dancing around this pitiful figure and mocking him for his despicable, drunken state. One adult passed by and saw the drunken man sprawled out in the public thoroughfare and addressed him with a smile on his face: "Woe unto you, my friend, you have no idea what your intoxication has done to you! If I would get drunk, I would at least attempt to salvage my self-respect! I would make sure not to drop down dead drunk in the middle of the street!" The critical passerby fails to realize that once a person is drunk, he has no control over his actions.

"Similarly," said the Chofetz Chaim, "many people accuse the wealthy of terrible stinginess, and claim that if only they were rich they would certainly donate huge amounts to charity. However, these people forget that they are making these generous claims now, when they are still poor, and their hearts are soft and sensitive. Little do these folks realize that the minute they become rich their hearts undergo a dramatic transformation and they become hard and tough. Their open hands close and they become tight fisted. Why? Because wealth can easily become addictive, just like alcohol! You will never comprehend why rich men act as they do until you become rich yourself!"

⋲ He Who Makes Him Poor Can Make Him Rich

The Midrash (*Vayikra Rabbah* 34:4) warns: When the poor man stands before the rich and begs, "Please give me!" and the man of

means refuses to give, remember — He Who made this man poor can make him rich, and He Who made this man rich can make him poor! Beware, lest the rich man scorn the impoverished man and say, "Why don't you go out to work and earn a living? Just look at yourself! What thick thighs you have! What strong feet you have! What a fat belly you have! You are big and strong — go to work!" Says the Holy One, Blessed is He, "Not only didn't you give him anything to live on, you cursed him with your evil eye! Therefore, your punishment shall be two-fold. The money you selfishly hoarded for yourself will be lost, and you will never bequeath it to your children. Moreover, because you begrudged the poor man his good health and strong body, therefore, your health and strength will be sapped from you."

◄§ Bad Money Destroys the Good

The Talmud (Kesubos 66b) teaches: Once Rabban Yochanan ben Zakkai was riding on a donkey leaving the city of Jerusalem and his students were walking behind him. He saw a young woman who was gathering barleycorns from the dung-droppings left by the animals of Arabs. When this impoverished young woman saw the great sage, she respectfully covered her face with her hair and approached him with a plea, "O Rabbi, please sustain me!" Rabban Yochanan asked her, " My daughter, who are you?" She replied, "I am the daughter of Nakdimon ben Gurion." The Rabbi continued to inquire, "My daughter, the wealth of your father — where has it gone?" She responded, "Rabbi, do they not say this proverb in Jerusalem: 'The only way to salt money is to give it away? The only way to guarantee that you will keep your money is by giving your money to charity!'" [But Nakdimon ben Gurion did not disburse charity properly and therefore he lost all of his money.] Rabban Yochanan persisted in his questioning: "But you had money not only from your rich father, but also from your wealthy father-in-law, what happened to that?" Sadly, the young woman replied, "Rabbi, the bad money was mixed together with the good money and destroyed it!" She continued: "Rabbi, do you remember when you signed on my kesubah, my marriage contract?" Rabban Yochanan turned to his students and related, "Indeed, I remember when I signed on her kesubah and read that her father gave her one million golden dinarim in addition to the enormous sum given by her father-in-law."

The Talmud concludes: How can anyone say that Nakdimon ben Gurion did not give charity? Have we not learnt in a *Baraisa*: "They would say about Nakdimon ben Gurion that when he walked from his residence to the House of Study they would roll out an exquisite silk runner before him and he would allow the poor to walk behind and pick up the expensive material for themselves." The Talmud offers two possible answers as to why Nakdimon's charity was wanting. "If you wish, you may say that all the charity Nakdimon gave was only for the sake of his own honor; or if you wish, you may say that even if he gave charity with the proper intention, he did not give enough for a person of his tremendous means; as the folk saying goes: "According to the camel, the load."

≈§ Cursed and Unkosher Money

The Chofetz Chaim (*Ahavas Chesed*, Part II, chapter 7) says that Nakdimon's tragic fall proves that even if a person does perform some charity with his money, but not in accordance with his means, not only will he lose his wealth, but a curse will be attached to it. If other people engage in a business venture with him, their money will also be lost.

R' Meir Bergman of Bnei Brak observes that this story teaches us that whenever a person earns any amount of money he should literally consider it as unkosher, unfit for any personal use, until it is properly tithed and the appropriate amount of charity is separated from it. Moreover, untithed money is like 'treif' meat to the point that when untithed money is mixed together with tithed money it actually contaminates the 'kosher' money, deprives it of blessing, and poisons it with a curse! The only way to secure money is to share it.

See *Giving Properly* for an additional story about Nakdimon regarding giving for glory.

≈§ Selfish Money Smells

Meor Einayim (*Parshas Matos*) writes that anyone who has developed a spiritually sensitive sense of smell can easily discern money which has not been properly tithed. It gives off a most

offensive odor like rotten, putrid meat which was not properly salted! "How foolish and misguided are those who hoard their money in order to feel secure. They are afraid to give away money for *tzedakah* lest this 'loss' deplete their 'nest egg.' Without charity their money is like unsalted meat which will surely go to waste. But the more they give away to charity the better preserved and protected their money is."

✍ God Invented Charity in Order to Save Us From Gehinnom

The Talmud *(Bava Basra* 10a) teaches: R' Meir used to say: The advocate of evil has an argument to discourage Jews from giving *tzedakah* by saying, "If your God is truly a lover of the poor, why does He not sustain them on His own? Since God does not provide for them, they must have fallen into His disfavor; hence you Jews certainly should not assist them with gifts of charity!" However, the Jews may refute this evil argument by explaining, "God does not cause the poor to suffer because they are wicked; rather, He impoverishes people so that we may be saved, through giving them charity, from the judgment of Gehinnom. Thus the poor may even be more righteous than we are. They suffer poverty for *our* benefit!"

The wicked Turanus Rufus, the cruel Roman governor of the conquered land of Israel, asked this very same question of R' Akiva: "If your God is a lover of the poor, for what reason does He not sustain them?" To this R' Akiva replied: "God makes people needy in order that, through our giving them charity, we may be saved from the judgment of Gehinnom.

Turanus Rufus said to R' Akiva, "On the contrary! This giving of charity is what actually condemns you to be punished in Gehinnom! I shall illustrate this concept for you with a parable. To what is this matter similar? It is analogous to a human king who was angry at his servant. He had the servant incarcerated in a dungeon and ordered that no one feed him or give him drink. Subsequently, one man defied the king's orders and fed the imprisoned servant and gave him to drink. When the king hears about this man's actions, is he not angry at the man? You Jews are called servants of God, as it says, כִּי לִי בְנֵי יִשְׂרָאֵל עֲבָדִים, *For unto Me the Children of Israel are servants! (Leviticus* 25:55). Hence, by giving charity you actually violate the edict of God, your

King, and so through charity you incur the judgment of Gehinnom."

R' Akiva said to Turanus Rufus: "I shall illustrate the situation for you with a different parable. To what is this matter of giving charity similar? It is analogous to the case of a human king who was angry at his son. He had the son incarcerated in a dungeon and ordered that no one feed him or give him drink. Subsequently, one man defied the king's orders and fed the imprisoned son and gave him to drink. When the king hears about this man's actions, does he not send the man a gift? Although the king imprisoned his son, we know that he did not want his son to die, for no normal father ever desires to kill his child. Thus, although the son's misconduct may have compelled the king to imprison his son, he would undoubtedly reward anyone who sustained his child. And we Jews are called sons of God, as it is written, בָּנִים אַתֶּם לַה׳ אֱלֹקֵיכֶם, *Sons are you to Hashem, your God* (*Deuteronomy* 14:1). Thus, although we are imprisoned in exile, the Jews are still God's children, and one who sustains the poor among them with gifts of charity earns God's gratitude and is thus absolved from the judgment of Gehinnom.

Turanus Rufus objected to this explanation and said to R' Akiva: "You Jews are called God's 'children' in one verse and are called His 'servants' in another verse. The explanation for this seeming discrepancy is that at the time that you fulfill the Omnipresent's will you are called His 'children' and it is appropriate to give charity to the poor among you. But when you do not do the will of the Omnipresent, you are called His 'servants,' and do not merit charity. And now, at this present time, you are obviously *not* doing the will of the Almighty, for He has subjugated you to the Romans! It is therefore improper for you to give charity to the poor at this time."

R' Akiva, however, countered this argument of Turanus Rufus and said to him: "Behold, Scripture states: הֲלוֹא פָרֹס לָרָעֵב לַחְמֶךָ, וַעֲנִיִּים מְרוּדִים תָּבִיא בָיִת, *you will break your bread for the hungry, and the wailing poor you will bring to the house* (*Isaiah* 58:7). When does the verse *and the wailing poor you will bring to the house* apply? Certainly it refers to the present situation when the Roman government impoverishes us and makes us miserable with unbearable taxes. And yet the verse states that even in such difficult times *you will break your bread for the hungry!* Scripture thus teaches that God desires us to give charity even when we have earned His condemnation because of our transgressions."

CHAPTER NINE

Maaser: Giving a Tenth

⋖§ Third of a Shekel

So far, we have described the mitzvah of *tzedakah*, the Torah obligation to give charity to the poor. The mitzvah of *tzedakah* does have a minimum amount, as codified in *Yoreh Deah* (249:2): "A person may not give away anything less than one third of a shekel *annually*, because if he gives less than that he has not fulfilled the mitzvah of *tzedakah.*" *Derech Emunah* (*Matnos Aniyim*, Chapter 7, 30) explains that the Biblical shekel consists of 768 perutos so that one-third shekel is 256 perutos. The shekel is equivalent to from 14.16 to 19.2 grams of pure silver. *Minchas Tzvi* (Vol. III, Chapter 1:7) values one-third shekel as four dollars (in 1990 US currency).

⋖§ Haphazard Charity or Precision Tithing

The mitzvah of *tzedakah* is really only half of the story of charity distribution. The second half of the story is a separate mitzvah called *maaser*, tithing, which serves to define and delineate the parameters of charity by determining exactly how much should optimally be given away.

A person who distributes *tzedakah* haphazardly, without specifically setting aside *maaser*, has earned only the mitzvah of *tzedakah*. One who carefully sets aside *maaser* and distributes it charitably has gained two mitzvos, both *maaser and tzedakah*.

Every penny a person distributes to the poor is a fulfillment of the mitzvah of *tzedakah*. However, it must be understood that a person might give away tens of thousands of dollars to charity, indeed, he may give away as much as half or even all of what he possesses to the poor, yet he has only fulfilled the mitzvah of *tzedakah* but *not* the mitzvah of *maaser*. In order to fulfill this second mitzvah, one must keep a careful record of all his earnings and profits, and scrupulously set aside at least 10 percent of these earnings for charitable distribution. (See the next section for an explanation of this statement.)

There are two ways to keep track of one's *maaser*. Some set up a separate banking or checking account into which they deposit one tenth of every sum of money that they earn. Others find it more convenient to merely keep an account book upon which they record the amount of money they 'owe' to *maaser* based on their earnings and/or their *realized* profits. Every time they give some money to *tzedakah* they deduct the amount from the accrued *maaser* debt as recorded in their ledger.

In this chapter we will describe in detail the laws and proper practices for fulfilling the mitzvah of *maaser kesafim*.

ᴥᔥ *Tzedakah* Exalts Everything We Own

When a person separates a part of his wealth and designates it for charity, he not only sanctifies the actual funds earmarked for *tzedakah,* but he also elevates the status of the money left over for his personal use. Before tithing, the money was merely *his* money, the product of *his* toil and effort. By separating a charitable portion for God, one demonstrates that everything is a present from God, and even that which remains for personal use is truly God's gift (*Kedushas Levi, Parshas Re'ei*). In a deeper sense, when one tithes, he demonstrates that he has no absolute power over his possessions and all that he owns is in partnership with Hashem.

This explains the difference between distributing *tzedakah* at random and scrupulously separating the tithe. If one distributes haphazardly, according to the needs or whims of the moment, even if he has met or exceeded the minimum amount required, he has not designated a specific portion for God, so the remainder of his

resources has not been elevated. Only when the full amount of at least 10 percent is specifically set aside for God does the merit of the tithe exalt all the remainder of a person's resources!

For this reason some authorities advise that even if a person is so poor that he really is exempt from giving away any of his meager earnings to charity, he should nevertheless separate a tithe from his income and then keep this tithe for himself! To those who do not understand the importance of *maaser* this might appear to be a farce — who is the pauper fooling? In truth, the poor man is accomplishing a great deal by tithing, because *maaser* is a mitzvah that stands on its own — separate from *tzedakah* — and brings a significant blessing in its wake. By tithing, the poor man is acknowledging that his income does not belong to him; it belongs to God Who dictates how one's wealth should be allocated. The same God Who commanded him to separate a tithe also decreed that the tithe should be distributed to the poor according to a precise system of priorities. The highest priority in that system is for a person to support himself and his family; therefore, this pauper is duty bound to give his tithe to himself!

✎§ The Tradition of Our Forefathers

R' Yehoshua ben Korcha says: Abraham was the first person to tithe. He took *maaser* from all of the property of Sodom that he retrieved (from the four kings), and *maaser* from the property of his nephew, Lot, and gave it all to Shem the son of Noah (Malkitzedek), as it is written (*Genesis* 14:20): וַיִּתֶּן לוֹ מַעֲשֵׂר מִכֹּל, *and he gave him a tenth from everything* (*Pirkei D'Rabbi Eliezer,* Chapter 27).

Not only Abraham, but each of the *Avos*, the Patriarchs, practiced *maaser* — tithed their assets and income for *tzedakah*. As stated above, Abraham gave a tenth of the spoils of battle to Malkitzedek, the High Priest of Jerusalem (*Genesis* 14:20). Isaac tithed the wealth he amassed from his fields and other enterprises every year (*Rashi* to *Genesis* 26:12). Jacob pledged to God, וְכֹל אֲשֶׁר תִּתֶּן לִי עַשֵּׂר אֲעַשְּׂרֶנּוּ לָךְ, *And whatever You will give me, I shall surely tithe to You* (*Genesis* 28:22).

The Talmud (*Taanis* 8b-9a) states: R' Yochanan said: What is the meaning of that which is written: עַשֵּׂר תְּעַשֵּׂר, *Tithe, you shall tithe* (*Deuteronomy* 14:22)? What is the message of this double expression?

It teaches: Tithe so that you will become wealthy [this homiletic interpretation relates the word תְּעַשֵּׂר, t'aser, to עֹשֶׁר, osher, wealth].

Tosafos (ibid.) says: The *Sifrei* interprets the verse, עַשֵּׂר תְּעַשֵּׂר אֵת כָּל תְּבוּאַת זַרְעֶךָ הַיֹּצֵא הַשָּׂדֶה שָׁנָה שָׁנָה, *Tithe you shall tithe the entire crop which you plant, the produce of the field, year by year (Deuteronomy 14:22).* From the simple reading of this verse it would appear that only agricultural produce must be tithed. How do we know that tithing applies also to monetary transactions and business profits? Because the verse could have stated simply, תְּעַשֵּׂר אֵת תְּבוּאָתֶךָ, *You shall tithe the crop.* Why was it necessary to add the word, כָּל, *entire?* *Entire* comes to include business profits that must also be tithed.

Similarly, *Midrash Tanchuma (Parshas Re'ei 18)* teaches: עַשֵּׂר תְּעַשֵּׂר, *Tithe, and you shall continue to tithe.* Tithe so that you may become wealthy; tithe so that you will not suffer financial losses. This is a lesson to merchants and to those who sail overseas to trade that they should separate one tenth of their profits for those who toil over the study of Torah.

∙§ Give a Tenth of Everything

Based on Jacob's pledge to God, וְכֹל אֲשֶׁר תִּתֶּן לִי עַשֵּׂר אֲעַשְּׂרֶנּוּ לָךְ, *And whatever You will give me, I shall surely tithe to You (Genesis 28:22),* R' Moshe Feinstein would stress that one is obligated to share with others one tenth of *everything* he possesses; not only one's money, but time and energy as well! Thus, one who knows how to learn Torah should volunteer one tenth of his time to study with others who need his help.

∙§ Maaser: It Is Hard to Get a Handle on Its Halachos!

The *Rama (Yoreh Deah 331:146)* takes note of the fact that R' Yosef Karo deletes all of the laws of tithing to the poor from his *Shulchan Aruch*, and *Rama* is puzzled by the omission, because we can learn a great deal about how to distribute charity properly from the laws of tithing to the poor. The renowned halachic authority, R' Shlomo

Zalman Auerbach, observed that since there is no section of the *Shulchan Aruch* exclusively devoted to the laws of *maaser kesafim*, tithing of money, it is difficult to render clear rulings on this subject. Therefore, he based his decisions in this area on the responsa of more recent authorities and upon his own logical and well-considered conclusions.

⋙ Commandment or Custom?

The precise halachic status of this *maaser* tradition is the subject of discussion among the authorities throughout the ages. Some assign this tradition the status of an absolute Torah obligation, on a par with mitzvos like *tefillin* and *tzitzis* (*Turei Zahav* as understood by *Aruch Hashulchan, Yoreh Deah* 249:5; and *Maharil* as cited in *Responsa Chasam Sofer, Yoreh Deah* 232. See *Tosefos Chaddashim* quoted and refuted by R'Akiva Eiger in gloss to *Peah* 1:1).

Other authorities, noting that there is no explicit commandment in the Torah to tithe one's monetary assets (only agricultural crops), consider this mitzvah to be a Rabbinically imposed obligation.

Yet a third view, adopted by the majority of *poskim* (*Bach, Yoreh Deah* 331; *Responsa Chavos Yair* 224; *Responsa She'elas Yaavetz* 1:3, 2:119; *Chasam Sofer, Yoreh Deah* 331), is that *maaser kesafim* is neither a Torah nor a Rabbinic obligation at all; rather it is a time-honored custom, a *minhag,* which should be adopted by Jews (see *Pischei Teshuvah* to *Yoreh Deah* 331:12 and *Iggros Moshe, Even Haezer* Vol. III, 43).

⋙ Customizing the Custom

According to the opinion that *maaser* is only an important custom, there are significant leniencies in a number of practical areas. One lenient ruling regards the rules for distributing one's *maaser* funds. There are opinions that rule that *maaser* funds are the exclusive property of the poor and cannot be used for anything else. But if we fulfill the laws of *maaser* only because it is a *minhag*, then one may use the funds to pay for other mitzvos. Thus, one can use *maaser* money to help build a shul or a *mikveh* or an *eruv* or a hospital. One

can donate *maaser* funds to support *Bikkur Cholim, Hatzolah,* or *hachnassas kallah.*

All of the aforementioned examples are mitzvos that are general community obligations. However, mitzvos, which are a personal obligation such as *tefillin, tzitzis, matzah* or *sukkah,* cannot be purchased with *maaser* funds, just as a person cannot use *maaser* money to repay the personal financial debts he has incurred.

In general, a *minhag,* or custom, that one practices several times assumes the status of a *neder,* a binding oath, which entails many halachic stringencies. To avoid this complication, it is advisable that one make a clear stipulation that he is accepting the *custom* of *maaser,* but unequivocally *does not* want his practice to assume the status of a binding *neder.*

⋑ Paying for Honors and Aliyos

The *Turei Zahav (Taz, Yoreh Deah,* 249:1) makes the difference between obligatory and discretionary mitzvos very clear in the following ruling:

Question: May a person pay for honors and *aliyos* in the synagogue with his *maaser* money?

Answer: If at the time he voluntarily purchased the honors he had in mind to pay for them with *maaser* money, he may do so. This is because *maaser* money may be used for all *discretionary* mitzvah causes, not just for charity. Even though the donor has gained a personal advantage, it is permissible. However, if at the time he purchased the honor, he *did not* have in mind to pay with *maaser* funds, the payment is now considered his personal debt, and one may not repay his debts or personal financial obligations with *maaser* money.

⋑ Giving Business to a Poor Man

The concept that one may not pay for his personal obligations with *maaser* is the key to solving the question raised in *Responsa Maharam Shick (Yoreh Deah* 238). There are two stores in town which sell the same item. However, store A charges more than store B. The

owner of store A is a very poor man who qualifies for charity, and the customer is willing to pay more to buy this item from store A in order to help a man in need. The question is whether he may consider the extra money he is paying at store A as *tzedakah* so that he can deduct the sum from his *maaser* obligation.

Later authorities offer the following solution: If one purchased the item from the poor storekeeper without realizing that he was paying a higher price, then he may not deduct the difference from *maaser*, because once the customer obligated himself to pay that price, he cannot discharge any part of his business obligation with *maaser*. But if the customer originally was aware of the discrepancy between the two prices and had in mind to patronize the poor man and pay him the higher price as an act of *tzedakah*, then this becomes a voluntary commitment to help a poor man and may be paid with *maaser* money.

R' Feivel Zimmerman reports that a similar question was posed to the *Beis Din* of Khal Adas Yeshurun in Washington Heights, New York. An individual who wanted to buy a *Sefer Torah* was shown two scrolls which were of equal quality written by two different scribes. The asking price for one of the scrolls was a few thousand dollars higher than the other, but the *sofer* who wrote it was a very poor man. The customer was ready to purchase the more expensive scroll from the poor scribe provided that he could deduct the extra amount he was paying him from his *maaser* obligation. The *Beis Din* ruled that if he has this in mind *before* making the deal, and he enters the deal as an act of charity, he may deduct the extra amount from *maaser*.

⋲§ Do Poor People Give Maaser?

The general rule is that one's own life takes precedence over all others. Therefore, *Rama* (*Yoreh Deah* 251:3) rules that a poor person is not obligated to give any *tzedakah* until he has enough money to support himself. However, some authorities rule that even though a poor person is exempt from *maaser*, it is preferable that he should separate 10 percent of his earnings as *maaser* and then keep it for himself (*Minchas Yitzchak*, Vol. VI, 101).

R' Moshe Shternbuch quotes the Brisker Rav, R' Velvel Soloveitchik, who said that anyone who is scrupulous to avoid luxuries and lives frugally, yet finds himself in such difficult circumstances that he must

accept help from others, should *not* give *maaser*. Rather, such a person should keep his own *maaser* money for himself. A *ben Torah* in particular should not take money from others if using his *maaser* money for himself will allow him to avoid accepting from others (*Taam Vodaas, Parshas Vayeitzei* p. 140; *Am HaTorah Journal,* Vol. II, 5, p. 36).

What is the definition of 'poor'? This is a person who only earns enough for the barest subsistence of plain 'bread and water'; only the basic necessities of food, clothing and shelter (*Aruch Hashulchan, Yoreh Deah* 251:5 and *R' Shlomo Zalman Auerbach, Maaser Kesafim,* p. 21). *Iggros Moshe* (*Yoreh Deah* 2, 112) posits that someone who has the basic sustenance to maintain himself for even a day or two is required to give *maaser*.

In the section, "The Blessing of Maaser," we read the story of R' Chaim of Volozhin who originally kept his own *maaser* for himself and was severely punished for this. When it comes to delicate monetary matters such as these, one should not trust himself and should seek Rabbinic guidance from reliable, unbiased halachic authorities.

✥§ The Accounting System

How does one compute his *maaser* obligation? *Ahavas Chesed* (18:2) offers the following detailed guidance on how to set up an accurate *maaser*-accounting system.

1. The businessman should keep a special account book in which he enters his net earnings [after deducting his business expenses].
2. A specific date should be designated which will mark the end of an accounting period, at which time "the books will be closed" and the calculations will be made. This should be done at the very least, once a year, and more frequently, if that is convenient.
3. At the time of accounting the person will calculate his annual profits from his dealings, and calculate his losses as well. The losses are deducted from his gains, and the remainder is the amount he must tithe.
4. During the entire accounting period, he should carefully record all of the sums he dispensed as charity. Even the smallest amount disbursed to the beggars who came to his door should be included. These charitable donations are deducted from his *maaser* obligation.

5. If, after balancing his accounts, one discovers that he still owes money to *maaser,* he should immediately set aside the amount he still owes and distribute it without delay. If there are no poor people at hand to whom he can distribute the money, he may hold on to the balance of the *maaser* until the proper occasion for *tzedakah* presents itself. In the meantime, he may use this money for his own purposes and needs. When a poor person solicits him, however, he must give him some of that *maaser* immediately. If he has no money available at that time, he is obligated to borrow money from elsewhere in order to respond to the request of the poor at once. {Author's note: The obligation to borrow in order to give charity pertains to a person who *does* have money to give away, but is not carrying it on his person at this time. Additionally, it may pertain to a person who has already disbursed all of his *tzedakah* money but has more money coming in soon in the form of his usual salary or steady investment income. Obviously, the indigent who is so poor that he is exempt from giving any of his income to *tzedakah* should not borrow from others in order to give charity. This is discussed in *Derech Emunah,* Chapter 7:8 and in *Tzedakah Umishpat* Chapter 1 fn. 3.}

6. Sometimes, at the time of accounting, one discovers that his charitable donations throughout the year or the accounting period exceeded the amount he owed to *maaser;* he actually gave more than he was obligated to give. Some authorities allow him to carry the balance forward to the next year. He may deduct the amount of charity he gave this year in excess of his *maaser* debt from the amount he will owe to *maaser* in the following year. Others (see *Responsa Nodah BiYehudah, Tinyana, Yoreh Deah* 198) render a stricter ruling and do not allow that procedure. Therefore, it is advisable that when one initially sets up his *maaser* account he should clearly stipulate that he may deduct from his *maaser* obligations, at all times, any charitable donations he makes at any time he desires.

The Chofetz Chaim concludes that the procedure outlined above is appropriate for businessmen whose profits are obtained in lump sums at specific intervals. It is almost impossible, however, for a store-keeper to record the minute profit he earns on each individual sale in his shop. The shopkeeper should periodically take stock of his inventory and his bills and his accounts receivable. Then he can

calculate his net income. He should also take care to stipulate, when he first embarks on the mitzvah of *maaser* (or, if he forgot, at the outset of a new accounting period), that he be permitted to rely on his own best estimates; thus, absolving himself of the burden of making precise calculations which may be well-nigh impossible.

⋙ Calculating Losses

It should be carefully noted that the losses that are calculated in determining one's *maaser* liability are *business-related losses*, not personal ones. If one deals in real estate, and during this *maaser*-accounting period he sold one property for a gain and another for a loss, he may deduct the loss from one business deal from the gain on another, even though they are unrelated. The same would apply, for example, to one's stock portfolio, where one deducts from the gains in one investment his losses from a different one.

Additionally, one may deduct his stock market losses from his real-estate gains. Or, if he earns a salary, he may deduct his stock-market losses from his salary gains. For instance, if one earned an annual salary of $100,000 (the tithe of which is $10,000) and during that same annual period he realized actual stock-market losses of $30,000, then we deduct this loss from the sum of his salary gains and he only is obligated to tithe from the $70,000 realized gain (the tithe of which is only $7,000).

However, if the financial loss is entirely unrelated to one's business dealings, it cannot be deducted from the net-profit appraisal. Thus, if a person loses his wallet filled with money, or rips his coat or crashes his car it has absolutely no relationship with his *maaser* obligation and such losses are not included in the accounting.

⋙ Stock-Investment Portfolio

If a person invests in the stock market, the rules are as follows: Any gains or losses "on paper" are meaningless, until the stock is actually sold. Even after the sale, it depends on what is done with the money realized from the sale. When the investor actually withdraws his funds from the stock market and uses them for something else,

then he calculates his profits or losses in reference to his *maaser* liability. However, as long as he intends to keep "playing the market" with these funds (even though they are temporarily lying idle in his account and could be used elsewhere), the loss or gain from the previous sale has no impact on his *maaser* calculations even though these very same losses or gains *are* calculated for tax purposes by the Internal Revenue Service (R' Tzvi Spitz; author of *Minchas Tzvi*, noted *posek* from Jerusalem, and R' Moshe Heinemann).

⋙ Deducting Business Expenses

All expenses one incurs in the course of running his business are deducted from his gains when calculating the *maaser* obligation. This calculation can become very detailed. For instance, if one travels on a business trip and eats in restaurants all the time, can he deduct the cost of these meals from his profits? *Responsa Beis Din Shel Shlomo* rules that the *additional* price of food above and beyond how he usually eats at home may be considered a legitimate business expense. Similarly, if one must purchase a special uniform for his job or special equipment for his profession, he may deduct this from his profit line.

One should be scrupulous to deduct only the added expense which actually results from engaging in business. Thus, *Responsa Minchas Yitzchak* (Vol. V, 34) rules that if one usually buys inexpensive suits, but now needs to buy a better suit in order to make a better impression in his business, he may deduct the additional amount he paid for a better suit as a legitimate business expense. But the basic amount that he always pays for a simple suit may not be deducted since that would have been spent anyway for his personal use and is not a business expense.

Tzedakah Umishpat (5:8,35) rules that if a working woman must hire domestic help because of her absence from her home, she may deduct the cost of the help from her income when calculating her *maaser* obligation. However, if the domestic help saves the family money by doing chores that the homemaker herself never would do, then that amount should be taken into consideration. For example: If the hired maid launders the shirts which otherwise would have been sent out to a laundry service, the amount saved by this is factored into the

equation. Thus, if the working wife earns $500 per week (liable to $50 tithe) from which she deducts $120 paid to the maid, she would have $380 in *maaser*-liable earnings ($38 tithe). But since the maid's laundering of shirts saves them $20 per week, only $100 of the maid's salary may be deducted from the $500 earnings, leaving her with $400 of income of which the tithe is $40.

৵ Corporate Liability

Corporations, public or private, have in the eyes of the law a legal identity independent of their shareholders who are entitled only to such profits as the directors declare as dividends. Since *maaser kesafim* is a personal liability, the corporation itself has no tithing obligation. Individual shareholders are responsible for tithing from their own dividends, or from profits from the sale of appreciated shares of stock (*Maaser Kesafim*, Chapter 2:8).

৵ Deducting Taxes From *Maaser*

Iggros Moshe (*Yoreh Deah*, Vol. I, 143) addresses the following problem:

QUESTION: When calculating one's earnings and profits in order to determine one's *maaser* obligation, which taxes, if any, may be deducted from the total income?

ANSWER: The amount a person pays as income tax is considered like money a person never earned in the first place; it is as if he was working and earning this amount for the government. Thus, if a person earned $50,000 per annum and his income-tax debt is $10,000, he only has to tithe 10 percent of $40,000, which are his net earnings. Similarly, the Social Security tax deducted from a person's paycheck is considered a business expense — money that he never earned, and is therefore not liable to *maaser*. When one retires and begins to receive Social Security payments, he must tithe them. However, if one voluntarily invests in a retirement fund or an IRA account, those funds are considered as money earned and then put in savings and are therefore liable to be tithed.

~§ Cost of Production Versus Cost of Consumption

The above rule only applies to taxes levied on one's *initial earnings;* because income tax and social security payments are considered as *costs of production;* these taxes are what the government charges you for producing your salary or your business profits. *Costs of production* may be deducted from one's income when determining how much to tithe. However, there are many other taxes, such as a sales tax, which are *costs of consumption,* and are therefore considered personal expenses. Therefore, if a person purchases clothing or appliances or gasoline, the sales tax attached to the price of the goods is part of the cost and *cannot* be deducted. Similarly, the property taxes one pays on his home is actually a payment to the local government for the services it provides, whether a person needs them or not. Thus, a homeowner may pay $5,000 a year in school taxes even though he has no children in the public schools. Nevertheless, this is considered the price he must pay to the local community for the right to own a home and live in this municipality.

However, if one owns property for the sake of producing an income, such as commercial real estate, or residential property that he rents out, the property taxes he pays on these investments are considered a business expense (*cost of production*) that may be deducted from the sum of his profits.

An interesting footnote to this rule is the cost of paying the interest on the mortgage for one's private residence. As long as one resides in his own home, his entire monthly mortgage payment, both principle and interest, are the price he must pay in order to live in this house. These payments fall under the category of *costs of consumption* and are personal expenses, which cannot be deducted from *maaser.* However, when one sells his home and realizes a profit due to its appreciation in value, the home is now transformed into a commercial item that is producing a new income, the profit. R' Tzvi Spitz rules that the owner may now deduct from his profit the full amount of interest he paid on the mortgage for the entire period he lived in the house. That interest has become a legitimate business expense that contributed to the present profit realized when selling the house.

⋐ Inflation and Cost of Living

R' Moshe Feinstein (*Iggros Moshe, Yoreh Deah* Vol. II, 114) rules that when computing one's *maaser* liability, one should take inflation and changes in cost of living into account. Thus, if a person purchased a home for $100,000 and sold it ten years later for $200,000, it would seem that his gain is $100,000 of which he must give $10,000 as his tithe. However, if the annual rate of inflation was 5 percent for each of the last ten years, for a total of 50 percent, then the house has really only appreciated by 50 percent, and the real gain to the owner is only $50,000, not $100,000. Therefore his *maaser* liability would only be $5,000. Note that this *maaser* liability is independent of whether you intend to use the proceeds of the sale of your home to purchase a new home. This is different from the sale and purchase of property as part of a real-estate business, as discussed above.

In addition to inflation, some say that we should factor in the interest cost of carrying the mortgage, because this is tantamount to a business expense, as explained in the previous section, "Cost of Production Versus Cost of Consumption."

⋐ Tithing Tax Refunds

QUESTION: Based on his earnings, a person owes a certain amount of income tax. However, because of the charitable contributions he made, the amount he owes to the IRS is lowered. Does the amount of money he saved belong to *tzedakah* since it was acquired by virtue of his charitable donations? For example, a person whose tax bill was originally $10,000 had his taxes lowered to $8,000 because of his charitable contributions. Does the $2,000 saved belong to *tzedakah*?

ANSWER: This money definitely belongs to the earner and not to *tzedakah*. He earned this money in the first place. The charity, which he also gave from his own money, merely provided him with a legal means of exempting more of his own earnings from taxes; therefore, the money belongs to him. In our example, the person who earned $50,000 had $10,000 in estimated taxes withheld from his salary in the course of the year. He was obligated to tithe 10 percent of

his $40,000 take home pay, or $4,000. At the end of the year, the IRS, in recognition of this person's charitable contributions, refunded him $2,000 of the $10,000 originally withheld. The $2,000 belongs to the earner, but he must give 10 percent of it or $200 to *maaser*. Of course, if the IRS sends him a refund for any other reason, this money must also be tithed. [See *Minchas Yitzchak*, Vol.V, 34:9 about taxes and *maaser* liability.]

⤚§ Nonmonetary Profits

Not only must one give *maaser* from money he earns himself, he must also tithe a gift of money that someone' else gives him. However, the proper procedure of tithing an object or a service that is *nonmonetary* is the subject of detailed halachic discussion.

INHERITANCE: The consensus of opinions is that when one inherits any nonmonetary item, he need not tithe one tenth of its value. Even if the inheritance is income-producing real estate or a thriving business, one is not obligated to sell the property in order to give a tithe to charity, nor must he tithe from his own funds one tenth of the value of his inheritance. Of course, the heir must give away a tenth of all future profits he himself realizes from this income-producing property. If and when the heirs sell the business or the property or the heirloom they inherited, then they must tithe the money they gain on the sale (*Tzedakah Umishpat*, Chapter 5, fn. 27).

GIFTS: There is a vast array of opinions concerning the tithe on nonmonetary gifts. R' Tzvi Spitz (author of *Minchas Tzvi* on *Hilchos Maaser Kesafim*) told me in a personal interview that the predominant and prevailing opinion is that there is no *maaser* obligation from such gifts. This is based on the fact that the majority of opinions hold that the entire institution of tithing money is no more than a custom, and the custom is restricted to actual monetary gain and nothing more. R' Moshe Feinstein also ruled that a *nonmonetary* gift is *exempt* from *maaser* (R' Moshe Heinemann).

Other authorities disagree. *Tzedakah Umishpat* (5:5, fn. 27) is of the opinion that the nature of the present and the recipient's relationship to it determine whether or not it is required to be tithed. The formula is simple: If the object or service one received as a gift is something he

would have purchased anyway with his own funds, then he should consider the value of the present as a monetary gain which enhances his net worth. He must tithe the purchase price of this gift article. However, if the gift is something the recipient had no intention of purchasing for himself, then it is not considered a gain for *maaser* calculations.

⊷§ Monetary Gift for a Specific Purpose

Another common question arises when someone gives a monetary gift to another and the money is earmarked by the donor to be used exclusively for a specific purpose, such as to purchase a specific item. *Minchas Tzvi* rules that here too, there is *no maaser* obligation because the donor does not want his money to be used for anything other than his specified purpose.

In *Derech Emunah* (*Tziyun Halachah* 67) R' Chaim Kanievsky cites the decisions of his uncle, the Chazon Ish, on this subject. He rules that one is *not* obligated to tithe the nonmonetary gifts one receives. On the other hand, one who receives a gift of money must give *maaser* from the full amount, *even if the money was earmarked by the donor to be used exclusively for a specific purpose!* The Chazon Ish explained that the donor would not usually object if the recipient used some of the gift money for charitable purposes. However, if the donation of *maaser* to charity will hinder the recipient from fulfilling the wishes of the donor who gave the money for a specific purpose, then the recipient should purchase the article or property which the donor had in mind and postpone his donation to *maaser* until a later date when he has liquid assets. Ideally, in this situation, the recipient should immediately give as much *maaser* as he can afford from the gifted sum of money, and record the remainder in his account books as a debt he owes to *maaser*.

⊷§ Paying Someone's Bills or Debts

Most authorities rule that if someone pays someone else's bills or debts, that is *not* a profit which is liable to be tithed. The payment is not considered a material gain, only a saving from a debt payment,

which is a loss — *mavriach ari,* chasing away a lion. This is the accepted, prevailing custom (R' Tzvi Spitz). There are, however, various other opinions on this as we shall see in the rulings of R' Shlomo Zalman Auerbach.

The following is a list of questions asked to R' Shlomo Zalman Auerbach concerning *maaser* obligations, and his halachic responses as recorded in the journal *Kol HaTorah* (Vol. 39; Tishrei 5756).

1. What is the law in the case of a Torah scholar who eats one meal a day in the dining room of his yeshiva and thereby saves himself, over the course of a full year, over $1000 in food expenses? Must he give *maaser* from the amount of money he saved? Answer: There is clearly no *maaser* obligation.

2. What is the law of a couple living in a rented apartment where someone else pays their rent for them [directly to the landlord]? Is the amount they save considered income that is liable for *maaser?* Answer: Yes, there is a *maaser* obligation.

3. What if no one pays the rent for them, but the landlord lets them live in his apartment for free? Must they determine what the market value of such an apartment would be and give *maaser* from the amount they are saving? Answer: Yes, they are obligated to do so.

4. What if a person works for a company that provides him with the fringe benefit of paying for his medical insurance? This is worth approximately $3000 per annum. Must he give *maaser* from that amount? Answer: If the worker would have purchased a health-insurance policy on his own if his company would not have provided one, then this is pure profit and he must tithe it. However, if he is the kind of person who never buys health insurance for himself, then there is no monetary gain for him and he need not tithe the $3000 paid by the company on his behalf.

R' Tzvi Spitz (*Minchas Tzvi*) sets down a general rule for determining which 'fringe benefits' are liable to *maaser* obligation. Whenever the company or school owes the employee a certain amount of money, but instead of paying the employee directly they pay various bills for him such as medical insurance, or children's tuition, etc., then this is truly a monetary debt owed to the employee which he may legally demand from the company in a *Beis Din.* This is just like money and is liable to *maaser.*

✑ The Poor Tithe to One Another

The Steipler Gaon (based on *Yoreh Deah* 251:12) ruled that two poor people who experience serious financial hardship can and should give their *maaser* money to support one another. However, this arrangement must be in a voluntary, spontaneous manner — they should not legally or officially make a reciprocal exchange agreement which makes each one's tithe dependent on the other. Similarly, a father may give his *maaser* to his hard-pressed (independent) children, and they may give him their *maaser* in return. Two needy brothers or other relatives may do the same (*Orchos Rabbeinu* Vol. I, p. 302).

A person who receives a stipend from the *kupas hatzedakah*, the community charity chest, falls under the category of the poor who are exempt from charity. However, if the indigent wants to fulfill the mitzvah of *maaser*, he can separate 10 percent of his charity grant and give it back to the very same charity fund which gave it to him. *Tzedakah Umishpat* (Chapter 5, fn. 27) compares this to the situation of two poor people who give their tithes to one another.

✑ Supporting One's Children With Maaser Money

The Talmud (*Kesubos* 49b) teaches that a father is legally obligated to support his children until they are 6 years of age; however, when they are above 6 years of age the obligation is only a moral one. Therefore, the Gemara (*Kesubos* 50a) expounds on the verse, אַשְׁרֵי שֹׁמְרֵי מִשְׁפָּט עֹשֵׂה צְדָקָה בְכָל עֵת, *Praiseworthy are the guardians of justice, who perform charity at all times* (Psalms 106:3). Is it possible to perform charity at every moment? Our Rabbis in Yavneh therefore expounded, and some say it was R' Eliezer who expounded: This refers to one who sustains his sons and his daughters when they are minors.

This refers to older minors (above the age of 6) who are still dependent on their parents. Their parents consistently provide for all their needs all the time, day and night, so they are praised as those *who perform charity at all times.*

Shach (*Yoreh Deah* 149:3) cites the Maharam of Rothenburg who

rules that the funds spent on such children is genuine charity (and may be paid with *maaser* money). *Turei Zahav, Taz* (ibid.), strongly disagrees and asks, "Although the *Psalmist* calls this the performance of charity at all times, how could anyone possibly think that one can use his *maaser* money to support his own children!"

Minchas Tzvi (Chapter 4) rules that under ordinary circumstances one should certainly *not* use his *maaser* money to support his dependents. However, if one cannot possibly pay for some of his children's essential needs on his own, he may rely on the Maharam of Rothenburg and provide for children over 6 with his *maaser* money. It is surely preferable to do this than to take charity from others.

The extent and duration of a parent's moral obligation to support an older child is determined by the prevailing social norms in Jewish society. Generally, the moral obligation ends at the age when children generally can go out to work to support themselves. Many contemporary decisors say that today the moral obligation ends at the time when children graduate from high school. In the post-high-school years, there is much more room for leniency for parents to deduct from *maaser* the costs of helping their older children.

✑ Using *Maaser* Money for Tuition

A parent is personally responsible to provide his child with a proper education. Therefore, a parent may not use *maaser* money to pay for his children's tuition. One is not allowed to use *maaser* funds to pay his personal debts or to discharge his mitzvah obligations. This applies to the tuition for both boys and girls (*Iggros Moshe, Yoreh Deah*, Vol. II, 113).

R' Moshe explains that since the law of the land requires every parent to send his daughter to school, a Jewish father is obligated to send his daughter to a Torah school in order to escape the negative influence of public school where her belief in God and her dedication to Torah and mitzvos are in great danger. Therefore, a father must pay to rescue his daughter from public school and he cannot use *maaser* funds to discharge his personal obligations.

An important footnote to this discussion is found in *Responsa Achiezer* (Vol. III, 79:6) where R' Chaim Ozer Grodzinsky permits a Jewish community to divert surplus funds which were originally

earmarked for boys' education to be used for the local *Bais Yaakov* girls school. He writes: "It is a great mitzvah to support the *Bais Yaakov* which instills in its students faith in Hashem and fear of heaven and educates them in the traditional manner."

✺ Tuition for Older Children

A father is obligated to provide his son with a comprehensive Torah education. A full Torah education is divided into two levels. The elementary level is known as *Torah She'Biksav,* the Written Torah. This encompasses all of Scripture, the twenty-four books of *Tanach* (*Torah, Neviim, Kesuvim*). Ideally, a father should personally teach his son. If he cannot do so, the halachah obligates him to pay for this elementary education. Following the rule that one *may not* pay for any of his absolute obligations with *maaser* money, a father may not use *maaser* for tuition to pay for teaching his son the written Torah.

The second level of Torah education is the Oral Law, *Torah She'Baal peh.* The father must also teach this to his son, if not personally, then through a teacher. However, the father *is not obligated to pay* for this second level of schooling. Therefore, there is more room for leniency for a father to dedicate a portion of his *maaser* money to pay tuition for his son's advanced Torah studies (*Minchas Tzvi*). Similarly, R' Moshe Feinstein, who ruled that today a girl's Jewish education is an absolute obligation in order to secure her *Yiddishkeit,* would agree that advanced education on the post-high-school seminary level is not an absolute obligation and, if necessary, *maaser* money may be applied towards tuition (see *Responsa Minchas Yitzchak,* Vol. X, 85).

Tzedakah Umishpat (6:14) discusses the concept that when a father is no longer obligated by halachah to continue to teach his son Torah he may deduct the cost of advanced yeshiva education from his *maaser* account. However, he does make it clear (6:35) that according to the *Shulchan Aruch* a father is obligated to educate his son until he reaches the level of proficiency where he is capable of studying Torah *independently.*

Tzedakah Umishpat also points out that the fees charged by a yeshiva or seminary pay for more than Torah education. A very substantial part of the tuition bill is applied towards noneducational expenses such as room and board. A parent should calculate how

much it would cost to feed and board his child at home. That amount *may not* be deducted from *maaser*. The extra amount that it costs to cover room and board at the yeshiva or seminary *may* be deducted from *maaser*.

◄§ Factoring in Scholarships

Today, the fact is that yeshivos provide both full and partial scholarships to parents who can prove that they cannot afford full tuition. In many institutions, the tuition structure is set up in such a way that the parents who do pay full tuition are subsidizing those who cannot; the parents in a higher income bracket are charged more than the actual cost of education for their child, so that the extra money they give helps to offset some of the scholarship burden. This extra amount is certainly *maaser* deductible.

Before signing a tuition contract, the parent should ascertain what part of his obligation is actual tuition and what part is an 'add-on.' He should clearly stipulate that the additional amount will be paid as a donation and then he may consider this a *maaser*-deductible charitable donation. {The fact that the Internal Revenue Service may *not* recognize this as a charitable tax deduction has no bearing on the halachah of *maaser* here.}

If a school tuition committee assesses a parent's financial obligation to be more than the parent feels he can actually afford, then the parent may use *maaser* money to pay that amount which he honestly considers to be beyond his true ability. Moreover, this obligation to cover tuition costs takes precedence over distributing *maaser* to other charities.

◄§ Raffles for Tzedakah

Today, many charitable institutions sell raffles in order to raise funds. If the only reason why a person is purchasing this raffle is because he wants to make a contribution to this charitable cause, then he may deduct the entire cost of the raffle from *maaser*. If this person wins the raffle, he should refund the full purchase price of the raffle to his *maaser* account, and he should also give one tenth of the raffle prize

back to the Torah institution that sponsored the raffle (*Iggros Moshe, Orach Chaim* Vol. IV, 76).

Tzedakah Umishpat (Chapter 1, fn. 85) discusses the subject of raffles in great detail and cites opinions (*Derch Emunah* and others) which rule that if one uses charity money to buy a raffle and wins, the prize belongs to charity!

ᵌᴥ Free Loan Fund

The Chofetz Chaim (*Ahavas Chesed* Part II, Chapter 18) says that when a person tithes his income, he should designate two thirds of his funds for outright gifts to the poor, while retaining one third to be used for giving the needy free loans. After a while, he will find that his free-loan fund has grown significantly. When it reaches the point that his fund has enough money to cover the needs which can be anticipated in his community, then he can stop setting aside a third of his charity money for free loans and he can give his *maaser* to charity outright.

ᵌᴥ Deducting a Bad Loan

QUESTION: Someone lent money to a poor man with the full expectation that the loan would be paid back. Later, the poor man reneges on the loan and says that there is no way that he can pay it back. May the lender now consider the full amount of the loan as a charitable donation to the poor man and deduct the amount from his *maaser* obligation?

ANSWER: *Responsa Nodah BiYehudah* (*Tinyana, Yoreh Deah* 199) rules that such a deduction is only valid if the following three conditions are fulfilled:

1. The lender must inform the needy borrower that he is converting the loan into an outright charitable gift, and the poor man must agree to accept it as *tzedakah*.

2. The poor man must be someone to whom the lender is already accustomed to giving his *maaser* money, so that the current 'gift' is in line with the normal pattern of the lender's *maaser* distribution.

3. Finally, the amount of the loan, which is now to be forgiven, is a

sum similar to the amount which the benefactor usually gives to this poor man.

There are many variables and intricate details to this complex halachah and they are discussed at length in *Minchas Tzvi* (Chapter 9) and in *Tzedakah Umishpat* (Chapter 5, fn. 45-50).

ᥲᔆ Payment of Maaser in Nonmonetary Manner

One may fulfill his obligation to *maaser* with things other than money. Any object or service of commercial value can be donated to the poor and deducted from one's *maaser* liability.

R' Shlomo Zalman Auerbach explained this in detail. A merchant purchased an item wholesale for $100 and he usually sells it retail for $200. Now, rather than selling the item to a retail customer, he donates it to charity. He calculates the monetary value of his *tzedakah* contribution as follows: $100 which he paid wholesale for the item, plus the $100 normal profit, minus 10 percent of that customary $100 profit (*maaser*); for a total of $190.

ᥲᔆ A Charitable Gift of Work or Services

If a craftsman or a professional donates his services to a charitable institution he may deduct the full amount of his customary fee or wages from his *maaser* debt, minus one tenth of that fee which he would have to tithe anyway.

There are those who say that one can only take such deductions if he was fully employed or booked solid with patients. Thus, if the professional took an hour away from his profitable practice and donated his services gratis to a poor man, he has made a true contribution. But if the professional was not fully booked and this hour was uncommitted anyway, it does not have a dollar value and he may not deduct its alleged value from *maaser.* R' Tzvi Spitz rules that it makes no difference whether the professional is booked or not. As long as his time and services have a dollar value he may deduct that value from his *maaser* if he donates to a needy person or a charitable cause.

However, one should be careful to differentiate between personal acts of kindness and professional services. Thus, if a doctor takes an hour off from his office hours to attend to the medical needs of an indigent, the monetary value of his "billable" time is *maaser* deductible. But if he uses that hour to go grocery shopping for a poor family or to baby-sit for them, this is a personal *chesed* and no monetary value should be assigned to it.

⋙ Discounts for the Poor

If one sells an item at a discount to the poor, or works for the poor at a discounted rate of payment, he may deduct the amount of the discount from his *maaser*. Similarly, if one rents a dwelling to a needy family and deducts a portion of the usual rental fee in order to help them, this is considered *tzedakah* and may be deducted from *maaser* (*Minchas Tzvi,* Chapter 3:11 based on *Responsa Maharil Diskin* 24).

⋙ Paying *Maaser* Debt With Voluntary Services

R' Yaakov Kanievsky, the Steipler Gaon, was asked the following question: Teachers in the *Chinuch Atzmai* school system are required to volunteer to teach two hours every week gratis. Can they consider the value of the wages they ordinarily receive for two hours of teaching as a charitable donation to these Torah schools and deduct this amount from their *maaser* obligation?

The Steipler Gaon answered that if these hours were truly voluntary, their cash equivalent could be deducted from *maaser*. However, in this case, they are not really voluntary, because whenever the system hires a teacher they stipulate that the teacher must donate two hours a week of free teaching in order to get the job. Therefore, it is as if a person were hired to do 26 hours of work for 24 hours of pay. Similarly, if an employer would tell his worker, "If you give a charitable donation to a certain poor person, then I will hire you for this job," this definitely is not considered charity; it is merely a fee that the worker is paying in order to get a job (*Orchos Rabbeinu,* p. 304).

❧ Minors and Dependent Children

The *Shulchan Aruch* (*Yoreh Deah* 248:4) rules that collectors of *tzedakah* should only accept a small, token donation from minors who apparently have no independent source of income other than their parents. The collectors must refuse any sizable gifts from children because they must be concerned lest the money was stolen, because where else would an unemployed minor get money from — if not from a parent's pocket?

R' Y. Y. Bloi (*Chanoch Lanaar,* Chapter 2, fn. 12) writes that it is appropriate for a father to give small change to his young children to train them in the practice of distributing *tzedakah.*

❧ Maaser for Minors

A child under the age of bar mitzvah received a monetary gift from his parents. Later, when he comes of age and is responsible for mitzvos, should he tithe the money he received as child? R' Shlomo Zalman Auerbach was asked this question and he answered: "Certainly! Why not?"

However, *Responsa Yashiv Moshe* (*Yoreh Deah, Hilchos Tzedakah*) quotes R' Elyashiv as ruling that even a boy after bar mitzvah age is exempt from all *maaser* obligations as long as he is fully dependent on his father for all of his support. As long as the child is dependent on his father, everything he acquires really belongs to his father. Therefore, the bar mitzvah boy is not obligated to tithe the money gifts he receives, unless his father specifically states that he wants his son to give *maaser* from it.

CHAPTER TEN

Chomesh: Giving a Fifth

The Talmud (*Kesubos* 50a) teaches: "The Sages enacted in Usha that one who lavishes money on charity should not lavish an amount which exceeds one fifth of his income. It was also taught thus in a Baraisa: One who lavishes money on charity should not lavish more than a fifth of his income, lest he [impoverish himself and] become dependent on other people for his support. And there was an incident involving one [distinguished] individual who sought to lavish on charity more than one fifth of his wealth, and his [Rabbinic] colleague did not allow him to do so."

Tosafos (based on *Yerushalmi*) explain the ruling to mean that a person may give a lump-sum donation of up to a fifth of his total wealth, and thereafter he may make an annual contribution of one fifth of his profits.

Shulchan Aruch (*Yoreh Deah* 249:1) rules: The amount to be given to charity is as follows: If one has sufficient resources, he should give charity according to the needs of the poor. If his resources do not extend so far, he should give up to one fifth of his money for an *ideal* fulfillment of *tzedakah*, one tenth for an *average* fulfillment, anything less is considered giving *ungenerously*, with a bad eye.

R' Avrohom Hakohen Pam told me that in times such as ours, when in the United States of America, as well as in many other countries, the Jewish people are sharing with the general population an unprecedented level of prosperity, it is appropriate, even for the average, middle-class person, to consider giving *chomesh* in recognition of and with gratitude for the amazing bounty which God is showering upon us.

❧ Easy Money, Tougher Tithing

The Shiniver Rav (*Divrei Yechezkel, Parshas Lech Lecha*) notes an apparent inconsistency in the conduct of the *Avos*. Jacob made a solemn promise to the Almighty as he set out to the house of Lavan: וְכֹל אֲשֶׁר תִּתֶּן לִי עַשֵּׂר אֲעַשְּׂרֶנּוּ לָךְ, "*Whatever You will give me, I will return a double tithe unto You*" (Genesis 28:22). Abraham, on the other hand, gave Malchizedek *a tenth of everything* (Genesis 14:20) that he captured in the battle with the four kings. Why did Jacob promise two tithes — *chomesh*, or 20 percent — while Abraham was satisfied with *maaser* or 10 percent?

The difference, however, is that Abraham's financial gain was the result of great effort on his part. He had fought a hard and dangerous battle with the enemy. Therefore, the standard donation of one tenth was sufficient. Jacob, on the other hand, was the beneficiary of a miraculous windfall profit from the extraordinary number of lambs born to Lavan's flocks, for which he had expended a minimum of effort. Therefore the appropriate donation for him was not one, but two tenths of his supernatural gain.

The Shiniver Rav concludes: "This insight teaches us that in actual practice a person should indeed be scrupulous to give a *chomesh*, a fifth, to charity whenever he makes an easy profit!"

❧ Proper Separation of the Fifth

Ahavas Chesed (Part II, footnote to chapter 19:3) says that the proper way to give 'chomesh' is not to give the full fifth all at once. Rather, it is better to give the tithe *twice*! This is derived from the fact that the Talmud ascribes the Scriptural source for 'chomesh' to Jacob's vow, וְכֹל אֲשֶׁר תִּתֶּן לִי עַשֵּׂר אֲעַשְּׂרֶנּוּ לָךְ, *And whatever You (God) will give me, I shall tithe and tithe again to You* (Genesis 28:22). Jacob clearly did not pledge to give one fifth of his wealth to God; rather, he promised to tithe two times! Indeed, the custom of tithing one's monetary income today is based on the agricultural tithes, where the Jewish people actually separate *two* tithes from their annual harvests.

The Chofetz Chaim (ibid.) also says that if a person wants to give

more than 10 percent to charity, but less than the full 20 percent which is *chomesh,* he should first allocate a precise 10 percent of his income for the mitzvah of *maaser;* the rest he should distribute as plain *tzedakah.* Thus, if one decides to give away 17 percent of his income to charity, he should first separate 10 percent as *maaser* and afterwards distribute the additional 7 percent as plain *tzedakah.*

⊷§ Exemptions to the One-Fifth Limitation

The one-fifth limit does not apply to one who is dying; he may donate more than a fifth of his wealth to charity, as the Talmud (*Kesubos* 67b) states, and as *Rama* rules (*Yoreh Deah* 249:1): "When a person is on his deathbed he may donate to charity as much money as he wishes." Obviously, the concern that he might become dependent on charity does not apply to a man who is about to die. Nevertheless, according to the Chofetz Chaim, it is preferable that even a dying man should not give away more than a third or a half of his property (*Ahavas Chesed* 20:1).

Ahavas Chesed lists several other exceptions to this one-fifth limitation. 1) This concern does not apply to an extremely wealthy person. 2) Some authorities rule that the one-fifth limit only applies where the donor seeks, of his own volition, to find needy people and to distribute charity among them. However, when hungry and indigent people approach the donor and beseech him for help, he is duty bound to feed and clothe them. 3) Also, the limitation is inoperative where danger to life is involved. Thus, if a captive is in danger of being killed, or a hungry person may die of starvation, one may donate far more than a fifth of his money to save a life. 4) The one-fifth limit applies only to charity in general. *Shittah Mekubetzes* (*Kesubos* 50a) takes the view that the support of Torah study is not included in the restriction. The reason may be that the one who sponsors Torah study receives a share of the reward of the Torah scholar whom he supports. Thus, he who supports Torah is not "lavishing" money and giving it away; he is investing it wisely in order to ultimately reap great profits.

Another exemption is cited in the commentary of the *Bach* (*Orach Chaim* 656) who observes that the Talmud (*Sukkah* 41b) relates that

Rabban Gamliel, the *Nasi* of Israel, spent the fabulous sum of 1,000 zuz to purchase a *lulav,* and this amount was apparently more than one fifth of his worth. However, since Rabban Gamliel was a leader of the Jewish community, the Sages taught elsewhere that the community has an obligation to support him generously at all times. The reason why a person may not lavish more than a fifth of his income on charity or on mitzvos is that it may impoverish him. Therefore, important communal Rabbis would be exempt from the prohibition, because their financial solvency is guaranteed by the Jewish community.

≈§ Joyous Giving Is Unbounded

R' Yisroel Baal Shem Tov lavished far more than a fifth of his income on *tzedakah.* He explained the one-fifth restriction only applies to a person who gives begrudgingly. However, if a person shares all he has with utmost joy, and money truly means nothing to him compared to the delight of giving *tzedakah,* he is bound by no limitations. This is why the Talmud (*Kesubos* 50a) uses an uncommon verb to describe excessive giving — הַמְבַזְבֵּז, *hamevazbeiz* — because this word is cognate with בִּיזָה, *bizah,* which means plunder. If the giver gives lavishly under duress and feels that his wealth is being 'plundered,' then he may not give more than a fifth (*Baal Shem Tov Al HaTorah, Parshas Re'ei*).

≈§ Men of Faith Give More

A wealthy man approached Rav Yitzchok Silberstein, Rav of Ramat Elchonon, Bnei Brak, Israel, with the following question: "I am blessed with a great deal of money. I receive steady support from my pension fund and I have many valuable, income-producing properties. For a long time I have donating a fifth of my income to *tzedakah.* Now I want to change things around. Henceforth, I would like to provide for my family and myself with that *chomesh* of my income, and to give the other 80 percent to *tzedakah.* May I do so?"

Rav Silberstein responded, "I am deeply impressed by your generosity and by your intense faith in Hashem, but I don't see any

way we can ignore the ruling of our Sages that a person shouldn't give away more than a fifth of his resources to charity." However, the man would not give up. He pleaded and pleaded with the Rav to find some leniency on this matter. Finally, Rav Silberstein sent him to ask R' Shlomo Zalman Auerbach in Jerusalem. When the man returned from his trip to Jerusalem he reported to Rav Silberstein, "At first, Rav Auerbach was reluctant to allow me to give more than a fifth. But after I pleaded with him repeatedly, he gave me permission."

That very same day Rav Silberstein 'happened' to go to Jerusalem to visit his great father-in-law, R' Yosef Shalom Elyashiv, and he went to hear his daily *shiur* in *Beis Midrash Tiferes Bachurim*. The *shiur* 'happened' to be on the Gemara in *Sotah* (48b) where the Talmud bemoans the fact that nowadays it is almost impossible to find אַנְשֵׁי אֲמָנָה, 'Men of Genuine Faith,' because these are people who really put their trust in the Holy One, Blessed is He. *Rashi* (ibid.) explains: "These are people who spend money lavishly in order to beautify a mitzvah and to give charity and to pay for the expenses of celebrating Shabbos and *Yom Tov*."

Rav Elyashiv elaborated: "Who is the *baal tzedakah* that the Talmud is referring to here? If it refers to a Jew who is extravagant and gives one fifth of his income to charity, why does it say that nowadays such people are almost impossible to find? Many people do give *chomesh* in our times. Rather, the Gemara is describing someone who gives much more than a fifth of his income to *tzedakah;* he is 'The Man Of Genuine Faith.' But you will ask, don't the Sages strictly prohibit giving away more than a fifth to charity? The answer is that the prohibition is only for the plain people, but one who qualifies for the special title, 'Man Of Genuine Faith,' has full permission to give more."

Who qualifies for the title, 'Man Of Genuine Faith'? A king of flesh and blood has many loyal subjects, but there are always a select few, the elite, who are chosen as his personal bodyguards. These are the selfless soldiers who value the king's life far more than their own, and would gladly sacrifice their all for the sake of fulfilling the wishes of their beloved monarch. So too with the King of kings, the Holy One, Blessed is He. Many are those who have faith in the Almighty, but only a select handful unconditionally surrender themselves and all they possess to their Maker. Such people may certainly give much more than one fifth of their wealth to charity and mitzvos (*Tuvcha Yabiyu, Parshas Re'ei*).

◄§ The Vilna Gaon's Instructions

While attempting to journey to the land of Israel, the Vilna Gaon wrote an ethical will to his family who had stayed behind, in the form of a personal letter which has become a source of guidance and inspiration for all of the Jewish people. Among other things, he writes, "For the sake of God, I entreat you to give one fifth to charity as I have instructed, and, as I have warned you; do not give anything less. Because if one gives less than one fifth to *tzedakah*, then every minute of his life he is transgressing several positive and negative commandments of the Torah, and he is considered as if he has denied the whole of the holy Torah, heaven forbid!"

◄§ The Chofetz Chaim and the Steipler

Ahavas Chesed (Part II, footnote to Chapter 19) says that the Vilna Gaon's strong admonishment to give *at least one fifth* is only referring to a situation where one is solicited by needy paupers who are begging for alms. When the need is so desperate, then one is obligated to give at least one fifth of his income to charity, and he may give even more as an act of piety (*Midas Chassidus*).

R' Chaim Kanievsky said: "My father, the Steipler Gaon, told me that his brother-in-law, the Chazon Ish, told him that he gives far more than a fifth of his income to *tzedakah.* However, as for himself, my father said that in principle he gives only the 10 percent tithe, but in practice, I know that my father very often gave 20 percent and even more."

In the year 5725 [1965] the Steipler Gaon discussed the Vilna Gaon's statement in his famous letter to his family. The Vilna *Gaon* wrote very firmly that it is an obligation to give *chomesh*, 20 percent to charity, and if one gives any less, then every minute he is transgressing a number of negative commands of the Torah. The Steipler said the Vilna *Gaon* only meant this ruling to apply to great *tzaddikim* who are on a very high level (*Orchos Rabbeinu*).

৵§ A Guarantee for Success

Kesser Rosh (*Hilchos Tzedakah and Maaser* 123) quotes R' Chaim Volozhin who said: My master, the Vilna *Gaon*, said that whoever keeps the mitzvah of *maaser* is guaranteed that he will never suffer any damage whatsoever, and one who gives away one fifth of his income is guaranteed to enjoy great financial success. By means of this mitzvah a person firmly implants in his soul the quality of *bitachon*, absolute trust in God. If every single Jew would fulfill the mitzvah of *maaser* we would witness the fulfillment of the Divine promise, אֶפֶס כִּי לֹא יִהְיֶה בְּךָ אֶבְיוֹן, *May there be no destitute among you* (*Deuteronomy* 15:4).

৵§ Tzedakah Lessons From the Hebrew Letters

Maharal (*Nesiv HaTzedakah*, Chapter 2) observes that the four Hebrew letters which comprise the word *tzedakah*, {צ, *tzadi*, ד, *dalet*, ק, *kuf*, and ה, *hei*} are actually two sets of 'fraternal letters,' because they appear side by side in the Hebrew alphabet; *tzadi and kuf* are written one after the other, as are *dalet and hei*. This juxtaposition is no mere coincidence. Rather, Hashem purposely designed the word this way to demonstrate that the performance of *tzedakah* is based on a sense of brotherhood, which bonds one Jew to another. Therefore, A Jew must always 'close ranks' with his brother and walk side by side with him; shoulder to shoulder, arm in arm.

Furthermore, observes *Maharal*, each pair of letters demonstrates a different level of charitable giving. The numerical value (*gematria*) of the צ, *tzadi*, is 90, while the value of the ק, *kuf*, is 100; symbolizing that the lesser level of giving is the tithe of 10 percent whereby the donor keeps 90 out of 100 dollars for himself, and gives away 10 to the poor. The preferred level of giving is expressed in the relationship between the letter ד, *dalet*, which has a value of four, and the letter ה, *hei*, which has a value of five. This alludes to the mitzvah of *chomesh* whereby the donor keeps four fifths of his earnings for himself, and gives away one fifth or 20 percent to charity.

Maharal concludes by calculating that the numerical value of all four Hebrew letters of צְדָקָה, *tzedakah,* equals 199, which alludes to the Mishnah (*Peah* 8:8) which teaches that if a person possesses 200 zuz he is not eligible to receive charity [because that was the amount that could cover a person's annual expenses]. However, one who owned 200 zuz minus just one — 199 zuz — was considered a pauper, eligible for *tzedakah.*

CHAPTER ELEVEN

The Blessing of Maaser

◆§ Tithing Earns a Special Reward

The Talmud (*Taanis* 8b-9a) states: R' Yochanan said: What is the meaning of that which is written: עַשֵּׂר תְּעַשֵּׂר, *Tithe, you shall tithe* (*Deuteronomy* 14:22)? What is the message of the double expression? It teaches: Tithe so that you will become wealthy. [This homiletic interpretation relates the word תְּעַשֵּׂר, *t'aaser*, to עוֹשֶׁר, *osher*, wealth.]

Tosafos (ibid.) cites *Midrash Tanchuma* (*Re'ei* 10) which elaborates on the rewards of tithing: There was once a pious man whose fields would bring him one thousand measures of grain each year. From this he would set aside one-tenth as *maaser*.

On his deathbed he summoned his son and warned him, "My son, be very careful to observe the laws of tithes, because it is in the merit of the tithe that I have become wealthy."

The first year after taking over his inheritance the son set aside a tithe of one hundred measures from the one thousand measures that the fields had produced. But at the end of the second year he said to himself, "Why should I give away so much?" He set aside only ninety measures for the tithe.

The following year the fields only produced nine hundred measures of grain. The son again set aside a tithe that was ten measures less than what it should have been. The following year the fields again produced one hundred measures less than the year before.

This went on year after year. Finally it reached the point where all of the fields, which once produced one thousand measures per year, gave forth only one hundred measures. The son was distraught.

His relatives came to visit him dressed in festive clothing. He said to

them, "Are you here to mock me that you are dressed in such finery? You should have come in a somber mood to console me for my losses!"

The concerned family members replied, "Why shouldn't we rejoice? The Almighty is demonstrating that He cares for you enough to teach you a vital lesson. At first, you were the owner of the fields and the Holy One, Blessed is He, was the recipient. You kept nine hundred measures of grain for yourself while you gave out one hundred measures for His tithe. But now God is the owner Who keeps nine hundred measures for Himself, while you are the recipient who merely receives the tithe of one hundred measures. You brought all of your misfortune upon yourself by failing to give the appropriate *maaser*."

➳§ Selfishness Leads to Self-Destruction

Midrash Tanchuma (*Re'eh* 12) relates an even more severe example of how one who does not observe the mitzvah of *maaser* destroys his own wealth: It happened that there was a man who hoarded vast stores of wine and oil, but failed to set aside the proper tithes. All of a sudden, a spirit of madness seized him. In his crazed state, he grabbed a stick and began to smash all of the precious jugs and casks he had so carefully preserved. His son yelled at him to stop. Instead of stopping, the crazed man aimed the stick at his own son and beat him over the head.

His son was then also overcome with madness and cried out, "Give me the stick and I too will smash these casks!" The father gave his son the stick and they took turns smashing the precious storage casks until every last one was destroyed.

Who was to blame for this devastation? It was the fault of the selfishness of this man in failing to tithe properly!

➳§ Permission to Test God

The Talmud (*Taanis* 9a) continues: R' Yochanan met the young son of Reish Lakish. R' Yochanan said to him: "Recite to me the verse you are currently studying." The boy answered him, עַשֵּׂר תְּעַשֵּׂר, "*Tithe,*

you shall tithe. " The youngster then asked R' Yochanan, " What is signified by the double expression: עַשֵּׂר תְּעַשֵּׂר, *Tithe, you shall tithe?*" R' Yochanan answered him, עַשֵּׂר בִּשְׁבִיל שֶׁתִּתְעַשֵּׁר, "Tithe so that you will become wealthy." The boy asked R' Yochanan, "From where do you know this?" R' Yochanan responded, "Go and test it; take tithes and see whether you become wealthy or not." The boy then asked, "Is it permitted to test the Holy One, Blessed is He? Is it not written *(Deuteronomy 6:16):* לֹא תְנַסּוּ אֶת ה' אֱלֹקֵיכֶם, *Do not test Hashem?*" R' Yochanan answered him, "Thus said R' Hoshaya: This case of separating tithes is an exception to the general prohibition against testing God, for it is explicitly stated in Scripture, הָבִיאוּ אֶת כָּל הַמַּעֲשֵׂר אֶל בֵּית הָאוֹצָר וִיהִי טֶרֶף בְּבֵיתִי, וּבְחָנוּנִי נָא בָּזֹאת אָמַר ה' צְבָאוֹת, אִם לֹא אֶפְתַּח לָכֶם אֵת אֲרֻבּוֹת הַשָּׁמַיִם, וַהֲרִיקֹתִי לָכֶם בְּרָכָה עַד בְּלִי דָי, *Bring all the tithes to the storehouse, so that there may be food in My House [for those who serve in the Holy Temple], and you may test Me now through this, says Hashem, the Master of Legions, if I will not open for you windows of the sky, and pour out blessings for you without limit"* (Malachi 3:10):

Sefer HaChinuch (Mitzvah 424) explains that usually one is forbidden to perform a mitzvah with the intention of seeing whether or not he will be rewarded for it. Since the primary location for receiving reward is in the World to Come, one cannot expect reward in this world. However, since the above verse clearly sets forth a challenge to test God to see whether a reward will be forthcoming for separating tithes, evidently an exception is made here to the injunction against testing God. One is guaranteed financial reward for the fulfillment of this mitzvah, regardless of any sins or transgressions one might have committed.

◆§ Tithing Is Not Testing!

Ordinarily, we may not perform mitzvos for the sake of reward, nor may we test God to see if He will fulfill His promises. Why is tithing and giving charity the only exception to this rule? Because the blessings which the Torah promises for observing all other mitzvos are a supernatural reward, whereas the blessing of prosperity which the Torah guarantees for charity is a reality, an incontrovertible fact of life. When a farmer plants a seed there is no doubt that under normal

circumstances grain will soon sprout forth. Similarly, when one gives his money to charity, it is a predictable phenomenon that wealth and prosperity will grow out of this charitable gift.

Thus, the Torah actually encourages a person to perform charity in order to be rewarded. Because when the *baal tzedakah* will prosper it will publicly demonstrate to one and all that the bounty one reaps from his charity is as predictable as the harvest the farmer gathers from his planting.

As scripture emphasizes: נָתוֹן תִּתֵּן לוֹ וְלֹא יֵרַע לְבָבְךָ בְּתִתְּךָ לוֹ, כִּי בִּגְלַל הַדָּבָר הַזֶּה יְבָרֶכְךָ ה׳ אֱלֹקֶיךָ בְּכָל מַעֲשֶׂךָ וּבְכֹל מִשְׁלַח יָדֶךָ, *You shall surely give him, and let your heart not feel bad when you give him, for in return for this matter, Hashem, your God, will bless you in all your deeds and in your every undertaking* (Deuteronomy 15:10). It was with this in mind that R' Yochanan proclaimed, "Tithe so that you will become wealthy!" The philanthropist should train himself to feel that there is no loss involved in tithing — it is all guaranteed gain! It is not merely *permissible* to look forward to riches as a result of charity, it is an *obligation!*

This teaches us that there are two purposes in the mitzvah of *tzedakah*. The first is to help the poor. The second is to intensify one's own faith in the power of this mitzvah to bring abundant blessings. (*Matnas Chaim, Tzedakah* Chapter 5).

Tosafos (*Taanis* 9a) cites the *Sifri* which derives from the double expression, *tithe, you shall tithe,* that one must separate the tithes not only from the agricultural products which the verse is actually talking about, but even from nonagricultural income. See *Yoreh Deah* 331:146 and *Pischei Teshuvah* (ibid.) for a discussion of the basis for this law.

According to *Mishnas Chachamim* only prosperity — the reward specified in the verse — may be expected as a reward for tithing. One may not expect other rewards, such as health. Furthermore, the authorities dispute whether or not one is permitted to expect a reward at all for tithing nonagricultural income (see *Yoreh Deah* 247:4, *Pischei Teshuvah* ibid. 1,2).

◅§ Take God as Your Business Partner

In the early part of the 20th century, there was a very wealthy Jewish philanthropist living in New York City whose name was Harry

Fischel. Mr. Fischel made his fortune in Manhattan real estate and he distributed vast sums to *tzedakah*. Whenever anyone asked him for the secret of his success, Mr. Fischel was only too eager to share his 'secret' formula. He would say, "I left Eastern Europe as a penniless young man. But before I embarked upon my long journey to America, I went to Radin to receive the blessing of the Chofetz Chaim. The holy man said to me, 'If you want to succeed in business, you must take God Himself as your partner in every endeavor. Before you enter into any investment or project, try to make an accurate estimate of how much profit you stand to make in the undertaking. Then calculate how much the tithe of your projected profit will be and write a check for that amount to be eventually deposited in your *tzedakah* account. Turn to Hashem in fervent prayer and say: "*Ribbono Shel Olam*, Master of the Universe, it is my privilege to invite You to be my partner in this endeavor. If, heaven forbid, I fail to realize a profit, I will have nothing to share with You, my partner. However, if I successfully realize my anticipated profit, then the ten percent I have set aside for *tzedakah* is Yours." When one takes God as his partner from the outset, he is guaranteed success!'

◆§ Maaser Is Your Mazel

I found the following idea in a venerable work called *Derech Moshe* (lesson for day eighteen): The Torah says, עַשֵׂר תְּעַשֵׂר, *Tithe, you shall tithe* (Deuteronomy 14:2). This phrase can be interpreted homiletically as "you shall separate עֶשֶׂר, ten percent, from the word תְּעַשֵׂר, and you will discover your good fortune." The first letter of תְּעַשֵׂר, *t'asseir*, is ת, *tav*, which has a numerical value (*gematria*) of 400. One tenth of 400 is 40, which is the numerical value of the letter מ, *mem*. The second letter of *t'asseir* is ע, *ayin*, which equals 70. One tenth of 70 is 7, the value of the letter ז, *zayin*. The third letter, שׂ, *sin*, equals 300, one-tenth of which is 30, the numerical value of the letter ל, *lamed*. The fourth letter, ר, *reish*, has a value of 200, ten percent of which is 20, the numerical value of the letter כ, *chof*. Thus the *tithe* of the word *t'asseir* yields the letters מ, *mem*, ז, *zayin*, ל, *lamed*, כ, *chof*, which spell the word מַזָּלְךָ, *mazalchah, your fortune*. In other words, a person's fortunes, for good or bad, are dependent upon how scrupulously he separated his tithes.

ᴥᔒ Zorei'a Tzedakos:
Not a Reward — A Reality!

The *Mishnah* (*Avos* 1:5) teaches : Yose ben Yochanan, leader of Jerusalem, says: "Let your house be open wide; treat the poor as members of your own household; and do not converse excessively with a woman."

R' Chaim of Volozhin (*Ruach Chaim* 1:5) explains how charity differs from all other mitzvos. The blessings which the Torah promises for observing all other mitzvos are a supernatural reward, whereas the blessing of prosperity which the Torah guarantees for charity is a reality, an incontrovertible fact of life. When a farmer plants a seed there is no doubt that under normal circumstances, grain will soon sprout forth. Similarly, when one gives his money to charity, it is a predictable phenomenon that wealth and prosperity will grow out of this charitable gift. This is precisely what the prophet meant when he said: זִרְעוּ לָכֶם לִצְדָקָה קִצְרוּ לְפִי חֶסֶד, *Plant for yourselves charity, and you will harvest according to your kindness* (Hosea 10:12). The farmer who takes perfectly good grain and buries it in dirt might appear, to the ignorant bystander, to be wasting his resources. But anyone with even a rudimentary understanding of agriculture realizes that whatever you plant will grow back many times over, yielding a plentiful harvest. Similarly, the distribution of charity unconditionally brings back material prosperity.

R' Chaim develops this idea even further: "In truth, planting seeds of charity is more profitable than planting grain. Because when grain is planted, the actual kernel that is placed in the earth decomposes and is lost; whereas with charity, not only does the mitzvah bring back a bumper crop of blessing and wealth, but even the original gift is not lost. To the contrary, the actual amount, which one gives to the poor, is immediately gathered up by the Almighty and stored in heaven as the donor's portion in the World to Come. In addition, that charity causes an abundant yield in this world. This is what the prophet (Hosea 10:12) meant when he said: זִרְעוּ, *Plant* — invest in *tzedakah* — and the results will be twofold. 1) לָכֶם צְדָקָה, *for yourselves charity* — the actual money donated to the poor remains in heaven for yourselves only; it is your personal, eternal reward. In addition 2) קִצְרוּ לְפִי חֶסֶד, *you will harvest according to your kindness —*

you will be blessed with abundant wealth in this world.

R' Chaim concludes: "This is the meaning of the Mishnah's three teachings: 1) "Let your house be open very wide" — the more you open up your home for the poor, the wider the gates of prosperity will be opened for you and your family. 2) "Treat the poor as members of your household" — It is not enough to merely give the poor entry into your home, you must let them into your heart as well. You must treat them as members of your own family and talk to them with the same love, concern, compassion and generosity as you do to your own children. 3) "And do not talk excessively with a woman" — despite the great responsibility you have to treat the poor like family, nevertheless, you must take care not to become overly friendly and familiar with any woman, notwithstanding her desperate circumstances. Beware! Do not become emotionally involved with any woman no matter how tragic her plight!

◄§ Expanding the Circumference of the Self

One of the most outstanding Eastern European *Roshei Yeshivah* of the first half of the 20th century was R' Shimon Shkop, who, in the fifty-six years of his career as a teacher of Torah, taught thousands of young scholars in the great yeshivos of Telshe, Maltsch, Brynsk and Grodno. R' Shimon's *magnum opus* was his classic work שַׁעֲרֵי יוֹשֶׁר, *Shaarei Yosher,* which elucidates some of the most challenging Talmudic topics. In his introduction to this masterpiece, R' Shimon offers thanksgiving to the Almighty for all the great fortune he experienced throughout a lifetime of Torah dissemination. He attributes his success to the fact that he was meticulous to *tithe* both his time and his energy toward helping others grow spiritually.

He proceeds to explain why tithing is the only mitzvah which comes with a guaranteed reward of wealth. This is because a person must always bear in mind that any advantage he enjoys was only granted to him for the sake of sharing it with others. Thus we say in the *Shemoneh Esrei* of Shabbos morning, יִשְׂמַח מֹשֶׁה בְּמַתְּנַת חֶלְקוֹ, כִּי עֶבֶד נֶאֱמָן קָרָאתָ לוֹ, *Let Moses rejoice in the gift of his portion, because You [God] called him a faithful servant.* The only justification for Moses to rejoice over the special gifts and talents that You have endowed him with is that he is aware that he is merely Your servant and that

everything he possesses was meant to be shared with others.

However, this attitude is not easily acquired. It would seem that man's instinctive self-love and the love he is supposed to have for others are mutually exclusive rivals that cannot coexist. The secret for reconciliation of these contradicting emotions is in the proper definition of *self*. Indeed, to the coarse, vulgar person, obsessed with self-gratification, the definition of *self* is limited to his own body and its needs. To one who is more spiritually inclined, the *self* transcends the confines of the flesh and includes the spirit and the soul. The person who is more sensitive includes his close family and relatives inside his concept of *self* and shows heightened concern for their welfare as if it were his own. The gentleman with a more generous soul extends his *self* to include his neighbors and even the citizens of his own town.

←§ Trustee of the King's Treasury

Rav Shkop continues: The Jew who lives according to the Torah broadens his definition of *self* to encompass the entire nation of Israel in his notion of who he is and whom he is here for. The Jew whose worldview has thus expanded sees himself as one small, but essential limb integrally bound up to a whole body. He envisions the Jewish people as a huge, complex machine in which the smallest screw and the shortest wire plays a crucial role. Thus, he possesses a healthy self-image, humbly acknowledging that he is no more than a tiny cog, yet, because his component is essential to the operation of the entire mechanism, also feeling that he is the whole machine.

When the mechanic oils a screw, he is not merely oiling one screw; he is oiling the entire machine. Similarly, he whose *self* has expanded to embrace all of Israel feels a profound sense of trusteeship towards his people. He knows that any bounty God has bestowed upon him is meant as a blessing for the whole nation, and he shares it accordingly.

Moreover, whenever a trustee demonstrates his honesty and responsibility, he is entrusted with ever-larger sums to disburse. As the treasurer proves that he is honest and diligent in controlling the royal funds he will be put in charge of more and more of the king's finances.

This is the explanation of the Torah's promise, *Tithe so that you will*

become *rich*. It really cannot be otherwise, for it makes perfect sense, measure for measure. The man who scrupulously tithes his wealth is not merely giving *tzedakah,* he is acknowledging that his wealth belongs to God, and he is merely a treasurer. And the nature of the world is that the king continually places more and more wealth in the hands of the loyal treasurer.

Rabbi Shkop concludes his observations with a guarantee that the blessing of *maaser* goes beyond the tithing of money and extends to the sharing of any of our resources. This explains the well-known statement of our Sages (*Taanis* 7a) that more than one learns from his teachers and colleagues, he learns from his own students. Why? When studying with teachers and colleagues, one is *taking* knowledge from them. However, when teaching students, the devoted teacher is unstintingly *giving,* sharing his time and energy and knowledge with his pupils. Therefore, the teacher is guaranteed that he will be repaid in kind; measure for measure, his fund of knowledge will be enriched.

⇥ Contentment Is True Wealth

M eor Einayim (*Parshas Re'ei*) advances a more exalted interpretation of Hashem's promise: עֲשֵׂר בִּשְׁבִיל שֶׁתִּתְעַשֵּׁר, *Tithe so that you will become rich* (*Taanis* 9a). He argues that this cannot refer to material wealth because, in fact, the more wealth a person accumulates the more needy he becomes! As the Sages taught, "One who has amassed one hundred wants two hundred, and one who has amassed two hundred wants four hundred" (*Midrash Koheles Rabbah* 1:34). Therefore, "No man ever leaves this world with even half of his desires in his possession" (ibid.). Rather, the wealth that is the reward for tithing is that described in the Mishnah: "Who is rich? He who is happy with his lot" (*Avos* 4:1). The real reward for giving away wealth to others is to acquire the wonderful trait of הִסְתַּפְּקוּת, *histapkus,* the ability to be happy with less. Non-Jewish culture measures success by *how much* a person takes from this world. Jewish culture measures success by *how little* a person takes from this world. Therefore, the reward of the person who decreases his substance by tithing is that God will decrease and diminish his lust for material things and replace it with genuine contentment! (cf. *Chasam Sofer* and *Beis Yisroel of Gur,* ibid.).

✑ Different Definitions of Prosperity

R' Tzvi Spitz of Jerusalem asked Rav Elyashiv: "How do we explain the fact that so many people are meticulous with tithing yet they have not been blessed with material wealth?" The great Rav answered: "There are many different types of wealth other than financial prosperity. Some people are rewarded with a great deal of *nachas* from their children. Others experience an abundance of energy and robust health. All of these may be considered as a reward for the mitzvah of *maaser.*"

In a similar vein, the *Rama* (*Yoreh Deah* 265:11) says that the one who is a *sandak* at a *bris* will be rewarded with wealth. The Steipler Gaon, who had been a *sandak* for hundreds of children, was asked why he never was rewarded with financial wealth. The Steipler looked at the questioner incredulously and said, "What? You don't think that I am wealthy? The many dozens of volumes of my *sefer, Kehillos Yaakov* on all of the Talmud, which I have been privileged to publish is nothing to you? And to merit to have a son like my R' Chaim, a true *gaon* and *tzaddik,* you don't consider that to be wealth?"

✑ Maaser or Mice!

The Jerusalem Talmud (*Demai,* Chapter 1:3) records the following incidents, which illustrate the power of tithing.

The great Tanna, R' Pinchas ben Yair, visited a certain town and all of its residents came to him with a bitter complaint: "The mice have infested all of our granaries and they have eaten up all the stores of grain!" R' Pinchas ben Yair issued a command for all the mice to gather around him, and behold, every single mouse in town came to the meeting with the *tzaddik.* The mice were chattering and squeaking. R' Pinchas asked the amazed townsfolk if they understood them and they said that they could not understand a thing the mice were saying. R' Pinchas said, "The mice are telling me that you deserve to take a loss because you have not tithed your grain! If you promise to tithe your grain it will be protected from the mice." The people asked the great rabbi to teach them how to tithe properly, and from that moment on their granaries were free of mice!

Another time, R' Pinchas ben Yair came to a farm settlement and the people complained that they lacked an adequate water supply for themselves and their fields. R' Pinchas immediately suggested, "Perhaps you are not tithing properly?" the farmers replied, "Rabbi, teach us how to tithe and we will do whatever you say!" The moment they started tithing properly, the small trickle, which dripped from their well, began to gush forth as a powerful fountainhead.

The great Tanna, R' Chanina ben Dosa, was renowned for his piety and extreme devotion to God. Once, as he was sitting down to his Shabbos table on a Friday night, the entire table collapsed. "What is happening here?" the Tanna cried out. His righteous wife responded, "I just remembered! Right before Shabbos, I ran out of spices to season the food and I borrowed some spices from my neighbor. I forgot to take the tithe from these spices." R' Chanina performed the conditional tithing procedure appropriate for Shabbos and immediately the table reassembled itself and miraculously stood up on its own feet!

⋅§ The Psak Beis Din in Keristier

R' Moshe Neuschloss, the Rav of New Square, related this incident to me when I visited him in his home on the third night of Chol HaMoed Pesach, 5755-1995:

The holy Chassidic Rebbe, R' Shayele Keristierer, passed away seventy years ago, in 1925, but I had the privilege of meeting him when I was very young. I also made a point of visiting a grocery store in that town run by a certain Mr. Engel, in order to see firsthand something very unusual. Hanging prominently on the wall of the grocery store was an official document, a *Psak Beis Din*, issued by the local Rabbinical Court, signed by the Rav of Keristier, Rav Ginzler, and by two other Rabbinical judges and by R' Shayele Keristierer himself.

It seems that Mr. Engel, the proprietor of the store, was extremely meticulous about giving his *maaser* tithe. At the end of every week he made a precise calculation of how much money he owed to charity and paid up his *maaser* immediately. If he was unable to pay his *maaser* debt with cash, he paid it with groceries or produce. He would send his *maaser*, funds or food, to R' Shayele for him to distribute as he saw fit.

One day, Mr. Engel discovered that mice were devouring his inventory. He ran to R' Shayele, who sent him to the local *Beis Din.* The first question that the *Beis Din* asked him, of course, was whether he gave *maaser,* because of the well-known statement in the Jerusalem Talmud that he who is lax with *maaser* will suffer losses through mice. Mr. Engel assured them that he was most scrupulous with *maaser* and R' Shayele confirmed his statement. The *Beis Din* decided that the mice in Mr. Engel's store needed a reminder. They wrote a *Psak Bais Din* addressed to the mice: "You are hereby ordered to leave Mr. Engel's grocery store because he fulfills his *maaser* obligations!" Mr. Engel hung this document in his store and the mice promptly disappeared!

Two days later, Mr. Engel's next-door neighbor, a gentile shopkeeper, ran into the grocery store in a state of frenzy. He cried out, "I don't know what happened! All of a sudden my shop was overrun with mice! Where did they all come from?"

✽§ R' Chaim of Volozhin

R' Chaim of Volozhin, the revered founder of the great Volozhiner Yeshiva, was scrupulous with the mitzvah of *maaser.* Early in his life he saw clear proof of the special power of this mitzvah. As a newly wed, young man without any position or income, R' Chaim was supported exclusively by the revenues from his wife's fabric store. Since this revenue was meager, R' Chaim was confronted with the question of whether it was permissible for him, a Torah scholar learning diligently day and night, to use his *maaser* money to support his own learning. For some reason, he was unable to pose this serious question to his master, the *Gaon* of Vilna, so R' Chaim had to decide this question for himself. After much study and research he determined that it was indeed permissible to use the *maaser* for himself.

Shortly thereafter, the revenues from his wife's fabric business plummeted disastrously and the young couple found themselves bankrupt. Realizing that the blame for the decline in business could not be attributed to his wife's lack of business acumen, R' Chaim concluded that the fault must lie in the fact that he was keeping his *maaser* money for his own use. R' Chaim immediately desisted from this practice and also began setting aside a small sum of money every

month to repay the *maaser* money which he had used for himself. Within a short while his wife's business revived and prospered.

One day, as R' Chaim was making his calculations to determine his *tzedakah* obligations, he could not decide whether a particular sum should be added to his *tzedakah* account. After deliberation, he decided that he did not owe *tzedakah* the amount in question. He finished his accounting and returned to his Torah studies.

R' Chaim's learning was soon interrupted by a knock on the door. The gentile youth who drew water from the village well for R' Chaim was at the door with bad news. "I have lost both your bucket and your axe," the boy cried. "While I was drawing water, the bucket slipped from my hands and fell into the well. I tried to draw it out with your long axe, but that too slipped from my hands into the well and both are lost!"

R' Chaim realized that accidents like this do not 'just' happen so he pondered what he might have done wrong to deserve this monetary loss. In his mind he calculated the value of the lost bucket and axe, and he realized that the amount was exactly equal to the sum that he had just withheld from *tzedakah*!

After sending the boy on his way, R' Chaim immediately added that exact sum to his *tzedakah* chest. A few minutes later, there was a knock on the door. The young boy was back, jubilantly waving the lost bucket and axe. "A miracle just happened," he exclaimed. "I went back to the well and I found these two items floating near the surface!"

To R' Chaim the lesson was clear. Once the *maaser* money was returned to its proper place, there was no need for R' Chaim to suffer any further financial loss. R' Chaim would always comment on this episode: "If people would regularly review their personal actions for any trace of error or sin and would rectify any wrongdoings, they would be safe from all loss or harm!"

◆§ Withholding the Tithe Thwarts God's Blessings

Once, R' Chaim Brisker traveled to Minsk in order to raise urgently needed funds for the Volozhiner Yeshiva. He asked each of the yeshiva's three *gabbaim* to raise one third of the money needed. One

of the *gabbaim* succeeded in raising the entire amount before the other two had finished collecting their part. His partners were so upset at him for grabbing the entire mitzvah for himself that they actually summoned him to a *din Torah* and sued for the privilege to have a share in the mitzvah. (See the section on R' Boruch Zeldovitz in the chapter *Great Baalei Tzedakah* for full details of this story.)

When R' Chaim's close disciple, R' Isser Zalman Meltzer heard this story he was inspired to an insightful interpretation of the words of the prophet who records Hashem's complaint against the Jewish people: הֲיִקְבַּע אָדָם אֱלֹקִים כִּי אַתֶּם קֹבְעִים אֹתִי, וַאֲמַרְתֶּם בַּמֶּה קְבַעֲנוּךָ, הַמַּעֲשֵׂר וְהַתְּרוּמָה. הָבִיאוּ אֶת כָּל הַמַּעֲשֵׂר אֶל בֵּית הָאוֹצָר וִיהִי טֶרֶף בְּבֵיתִי, וּבְחָנוּנִי נָא בָּזֹאת אָמַר ה' צְבָאוֹת, אִם לֹא אֶפְתַּח לָכֶם אֵת אֲרֻבּוֹת הַשָּׁמַיִם, וַהֲרִיקֹתִי לָכֶם בְּרָכָה עַד בְּלִי דָי, *Can a person steal from God, as you steal from Me? And you say, "How have we stolen from You?" [The answer is] By withholding the tithes and the priestly gifts! Bring all the tithes into the storage house, and let it be sustenance in My Temple. Test Me, if you will, with this, says Hashem. Master of Legions, [see] if I do not open up for you the windows of the heavens and pour out upon you blessing without end. (Malachi 3:8,10).*

Hashem obviously has no need for the tithe of our agricultural products nor for our money. What He really yearns for is the opportunity to pour His blessings upon us. Nothing could make Him happier. But He can only shower us with His *berachah* after we have given away our tithes. When we withhold the tithes, we frustrate God, so to speak, because we deprive Him of the opportunity to bless us.

That is why the *gabbaei tzedakah* were so upset when the other *gabbai* grabbed the whole mitzvah for himself. They truly believed that this deprived them of a tremendous opportunity to be showered with Hashem's blessings (*B'Derech Eitz Hachaim*, p. 347).

How
to Give

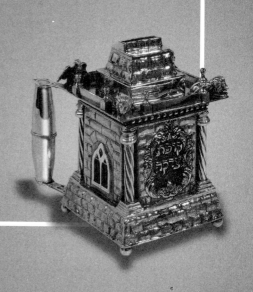

CHAPTER TWELVE

The Right Way to Give

◆§ Charity Is Rewarded According to Its Kindness

The Talmud (*Sukkah* 49b) teaches: The prophet says: זְרְעוּ לָכֶם לִצְדָקָה
קִצְרוּ לְפִי חֶסֶד, *Sow for yourselves charity and you will reap according
to kindness* (Hosea 10:12). R' Elazar taught: *Tzedakah* is rewarded only
according to the kindness with which it is performed.

Rashi (ibid.) explains: "The actual giving of money or an item of
value is classified as *tzedakah,* but the effort one extends in the
pauper's favor is counted as kindness, *chesed.* This may manifest itself
in several ways: *Chesed* is when the donor does not wait for the poor
man to pick up the money, but brings it to the poor man's home
himself. Or *chesed* is when the donor brings him freshly baked bread
or a ready-made garment to enjoy immediately. *Chesed* is when the
donor carefully plans his giving so that it coincides with the time when
grain is in abundant supply so that the poor man can buy it for the best
price and get the maximum return for his money. In each of these
cases, the benefactor engages his heart and mind to arrive at what is
best for the pauper."

◆§ Filling the World With Kindness

The Talmud (*Sukkah* 49b) teaches: R' Elazar said, "Whoever per-
forms even a small amount of charity in a manner which is right
and proper is regarded as though he filled the whole world in its
entirety with kindness, as it says אֹהֵב צְדָקָה וּמִשְׁפָּט חֶסֶד ה' מָלְאָה הָאָרֶץ,

One who loves charity and gives it according to what is right causes the earth to be full of Hashem's kindness (Psalms 33:5).

Benayahu defines this as charity given with the utmost joy, yet with a humble spirit and with the awareness that he gives not from his own property but from the property of God. Also, he says, one must give the maximum amount of which he is capable. A person who gives charity in this ideal way, then even if the actual amount he gives is objectively small, he is nevertheless considered as if he gave all the charity in the world.

In a deeper sense, the Talmud is teaching us that when one gives charity with gladness, his benevolence has a ripple effect that radiates throughout the world. When a man gives a coin to a pauper in Los Angeles with joy, he creates a positive force which spreads worldwide so that a few moments later, a Jew in London is moved to give more *tzedakah* than he ever gave before and with unprecedented enthusiasm.

ᴥᴥ Four Types of Donors

The Mishnah (*Avos* 5:16) teaches: There are four types of donors to charity:

1) One who wishes to give himself but wants others not to give, he begrudges others;
2) that others should give but that he should not give, he begrudges himself;
3) that he should give and that others should give is pious;
4) that he should not give and that others should not give is wicked.

Two of the four types described in the Mishnah do not want to give any charity; then why does the Mishnah classify all four types as 'donors to charity'? R' Moshe Alshich provides an insightful answer: This Mishnah teaches us that every Jew is, at heart, kind and charitable; as the Talmud states (*Yevamos* 79a): *Every Jew possesses three essential character traits; they are merciful, bashful, and they do acts of kindness.* Therefore even the two types who do not want to give are suffering from temporary, selfish resistance, but deep in their hearts, their essence is charitable. Thus, the question facing the Jew is not whether to give charity; but rather it is how to give, how much to give, and to whom to give.

The following story about one of the greatest of our Rabbis demonstrates how the teachings of the Mishnah are applied to actual situations:

Two collectors approached Rabbi Yechezkel Landau, Rav of Prague and author of the Responsa Noda B'Yehudah, and asked for his help for a very urgent tzedakah cause. He asked them how much was needed, and when they told him the amount, he immediately gave them the entire sum minus a small amount.

"Since the Rav contributed such a large sum, why doesn't he simply complete the mitzvah and donate the full amount?" the collectors asked.

"You forgot a clear teaching of the Mishnah," the Rav told them. "In Pirkei Avos we are taught that if someone wishes to give charity himself, but does not want others to give, he begrudges others. I want others, as well, to share in the mitzvah."

s When a Smaller Gift
Is a Greater Kindness

Once a desperately poor man approached the Satmar Rav for assistance. He poured his heart out to the Rav, and described how he was drowning in enormous expenses that he had no way of paying. The Rav asked him how much money he needed to ease his financial burdens. The poor man responded, "Oh, if only I would have $20,000 I would be able to manage." The Satmar Rav promptly had a check made out to the man for $19,900.

The desperate man was now relieved and elated by the Rav's generosity and he left the Rebbe's room with a big smile. Later, the Rav's gabbbai, who witnessed the entire incident, asked him, "Rebbe! If you were prepared to give this man such a large amount, why didn't you give him the full $20,000?" The Rebbe replied, "Had I given this man the full amount he requested, I would actually have made him sad. The man would have regretted not asking for more, thinking that I was ready to give him any amount he wanted. By giving him less than he requested, I actually made him happier!"

✦ Give With a Smile

In the Mishnah (*Avos* 1:15) we are taught: "Welcome all people with a cheerful face." *Avos D'Rabbi Nassan* (chapter 13) observes: This teaches that if one gives his fellow man all of the gifts in the world but with a downcast face, it is considered as if he gave him nothing at all. But if one welcomes his fellow man with a bright and cheerful face, even though he is unable to give him anything, it is considered as if he gave him all of the most valuable gifts in the world.

This is codified in the *Shulchan Aruch* (*Yoreh Deah* 249:3): A person should give charity with a happy, joyful face. He should attempt to comfort the poor and make every effort to alleviate their sorrow. If someone gives charity, but gives it with a frown or an angry face, he loses the merit of giving.

✦ Never With a Nasty Face

Our Sages taught that the fourth of the seven terrible levels of Gehinnom, known as *tit hayevein*, oozing quicksand, is reserved as a place of punishment for all those who responded to the pleas of brokenhearted poor with brazen arrogance (*Zohar Chadash, Rus,* cited in *Derech Emunah, Hilchos Matnos Aniyim,* Chapter 10, 16).

✦ Give Cheerfully or Tearfully — The Choice Is Ours

R' Dovid of Lelov frequently traveled to his revered Rebbe, the Chozeh of Lublin. When R' Dovid traveled he was accompanied by one of his admirers, a wealthy man who served as his "treasurer" and paid all of his expenses. Whenever a poor person asked R' Dovid for charity, he would give away as much as he had. After R' Dovid exhausted his own meager resources he would turn to his wealthy friend for help with the mitzvah. The wealthy man would eagerly join R' Dovid in his charity distribution. However, much to his

chagrin, by the time they arrived in Lublin, the rich man would not have even a kopeck left.

So it was every year until finally the wealthy man thought of a method to assure that he would be able to save enough to pay his expenses in Lublin and also to have some money to give to the holy Chozeh. Before he left Lelov, the rich man sewed a valuable golden ruble into the lining of his overcoat with the intention of hiding it from R' Dovid until they arrived at their destination. As usual, as the journey wore on, R' Dovid's funds ran out, and the ready cash in his companion's pockets was also depleted. Poor people continued to beg them for money but the rich man turned out his pockets and showed that he did not have a penny left.

As the travelers neared Lublin, they were attacked by a band of Cossack robbers who demanded all of their money. Seeing that the rich man was dressed so well, the Cossacks refused to believe that he was penniless. They beat and whipped him mercilessly until he bled. Finally he revealed the secret of the precious golden ruble he had sewn in his coat. The Cossacks ripped open the coat, grabbed the coin, and galloped away. However, the robbers were so frenzied by their plunder that they rode recklessly and the saddlebag in which they stuck the precious coin fell off the horse. After the Cossacks were out of sight, the rich man retrieved his ruble and handed it over to R' Dovid and asked him to distribute it to *tzedakah.*

R' Dovid turned to his bruised and bleeding friend and said to him gently, "Indeed, we have just learned a great lesson. The alms that we owe to the poor we will ultimately end up giving to them. That is unquestionable. The only question is *how* we will give it. If we are wise, we give it cheerfully and voluntarily. If not, God will force us to give the poor that which they are due, even through the violent blows of a Cossack!"

↝ See No Evil

The great Rav and Chassidic master R' Shmelke of Nikolsburg taught: "When a poor man approaches you for assistance, do not use his personal faults as an excuse for not helping him. Rest assured that if you look for *his* shortcomings, Hashem will find *your* own blemishes. Always bear in mind that the poor man's sins have been atoned for through his poverty, while yours remain with you."

⊸§ Go Against Your Nature

R' Nachman of Kossov observed that if you give a poor man a charitable gift and he returns it with a request for a larger amount, your positive response to his bold request will bring you great reward. It is human nature to be annoyed and upset by such behavior. Thus, by acquiescing to his entreaty, you are going against basic human behavior and elevating yourself above it. Since this is very difficult, such conduct brings a person great merit *(Esser Tzichtzachos,* p. 66).

⊸§ Do Not Emulate Sodom and Gomorrah

There have always been people who are annoyed by the beggars who walk the streets in search of alms. They are bothered by the poor people who disturb their prayers in shul and who knock on the doors of their homes at the most inconvenient times.

There is a well-known story about the reaction of the great *Shaagas Aryeh* to such people. When he assumed the prestigious post of Chief Rabbi of the city of Metz, the leaders of the community informed him that their custom was that when a new Rav was installed they would honor him in the following manner. The community kept a *Pinkas HaKahal,* a special memorial book in which they recorded all of the important events and *takanos* or improvements that were introduced into the city throughout its long history. To celebrate the advent of the new Rav, the leaders would come up with an original *takanah* to enhance Jewish life, and they would give the Rav the honor of affixing his signature to this new enactment. They invited the *Shaagas Aryeh* to endorse the following enhancement to communal life: "Henceforth, no beggars will be allowed to beg in the city of Metz. Instead, they will come to the office of the Jewish Community to receive a fixed stipend." The *Shaagas Aryeh* declined this honor, explaining that, in reality, this enactment was not at all an original one because it had already been introduced (with disastrous results) in the ancient cities of Sodom and Gomorrah!

❧ Place No Restrictions on the Poor

In his classic *Ahavas Chesed* (Part II; Chapter 17), the Chofetz Chaim vehemently condemns those who would prevent the poor from begging. The following is an extract of some of his salient statements on this issue:

Recently we have heard that the poor are being prevented from visiting homes to collect alms; thus, no one is concerned with rescuing them from hunger.

Those in charge have a ready answer, claiming the best of intentions. According to them the increased number of beggars harms the lower middle class, making it impossible to provide help for them. Therefore, they have forbidden the poor to collect alms, and a small collection has been taken up to assist the lower middle class.

They are seriously in error! Does the existence of one group of poor justify the total denial of support to the rest? True, we need not give an itinerant beggar a large sum, but we must still give him something (*Yoreh Deah* 250:3). Heaven forbid that we should refuse him entirely and cease to sustain him. The Talmud even cites an opinion that a person may not build a protective fence or wall around his front yard if it will prevent a beggar from knocking on the door.

Even beggars from other cities should not be treated callously. Even if the leaders would give itinerant beggars a small gift from a special aid fund, their policy of forbidding begging would be unacceptable. Many of the wandering beggars are collecting not only to sustain themselves, but they have families, wives and children back home who depend on them. By making their rounds to beg, they can gather enough to bring back to their families and save them from starvation.

True, the Talmud states: "The poor of your own city take precedence over those who come from elsewhere." However, that rule does not apply here; it is addressed only to the person who wishes to give *tzedakah* but who knows that right now he only has enough money in his hand for one needy person. For this individual the law is that he must give to the poor of his own city. But it is unheard of to presuppose that everyone in an entire city can only afford to give one donation to one poor person, thus shutting the door on all other indigents!

Furthermore, upon closer examination, we find that the major

impetus behind this decree originates with the wealthy who are well able to give *tzedakah* to more than one individual.

If we were to limit our charity to one periodic donation to a central fund it would be detrimental in a host of ways. Here is a list of some of the harms that would ensue:

1. The Mishnah in *Avos* (chapter 3:19) teaches: וְהַכֹּל לְפִי רוֹב הַמַּעֲשֶׂה, *Everything is determined by the frequency of our deeds.* The *Rambam* in his commentary explains: "Man does not acquire virtues through the *magnitude* of his good deeds, but rather through the *number* of good deeds he performs. Refined character is achieved through the frequent repetition of good deeds, not by performing one isolated, outstanding action. Thus, if someone gives one thousand gold pieces to one needy person and nothing to another, his single outstanding action is not as effective as giving one gold coin each to one thousand needy people. If he opened up his hand again and again one thousand times, the trait of giving becomes a part of him. When he merely gives a thousand coins once, the impulse for generosity wells up in him only one time and then it disappears." If every Jew in the city would give one fixed amount to *tzedakah* every week and no more, our city would be deprived of thousands of good deeds every day!

2. Because of this decree the amount of *tzedakah* given in the city will decrease dramatically. When the pauper collects personally, people are often moved to give generously. Sometimes the pauper's plea arouses extra compassion; sometimes they give from a sense of duty. Often, the householder gives more than money. He gives extra food, old clothes, and others items he does not need but which are of value to the poor.

⊷§ He Who Chases Away the Poor Chases Away God

The Chofetz Chaim continues to list many other serious disadvantages of preventing the poor from begging.

The truth is that a person should make himself as accessible as possible to the poor. In *Avos D'Rabbi Nissan* (Chapter 7) we read: A man's house should be open to everyone from every direction. The

poor will thus not be put to the trouble of circling the entire house in search of the door. Whoever comes from the north or the south will be able to enter directly, and so with the east and west.

In Tractate *Derech Eretz Zuta* (Chapter 9) we read: Be certain that the doors of your house are not locked at mealtime. Otherwise, they may become the cause of your impoverishment!

Similarly, we are taught (*Taanis 20b*): When Rav Huna sat down to his meals, he would open his door and say, "Whoever is in need of food, let him come and eat!"

Moreover, our Sages said (*Shabbos 63a*), "When a person keeps an angry, threatening dog in front of his home, it is as if he is preventing his home from displaying any kindness!" *Rashi* explains that the dangerous dog does not allow beggars to come to the door. Now consider this: The owner of a mean dog *unintentionally* discourages beggars (because his main purpose is for the guard dog to chase away burglars). How much worse, how much more shameful it is, when the entire community *deliberately* adopts a policy to drive beggars out of the city. As a result of this ban, the level of compassion in the city will gradually decline because there will be fewer opportunities to show compassion. The evil of this will be most apparent in the future generations, for they will not have an opportunity to see poor people with their own eyes; nor will they be grateful for their own material blessings, for they will never see anyone suffering from want!

Eventually, the beggars will be so unwelcome that if one does appear in town in defiance of the ban, he will be given over to the gentile authorities who will abuse and beat him. Thus the Jews will sink to the level of miserable informers who hand their Jewish brothers over to our enemies. What an enormous sin this is!

Remember! When you chase the poor man from your home, you are chasing God Himself out of your home! Always remember the teaching of R' Avin (*Midrash Vayikra Rabbah*, Chapter 34:9): The poor man stands at your door, and God stands on his right, as it says, כִּי יַעֲמֹד לִימִין אֶבְיוֹן, *For He stands at the right of the destitute* (*Psalms* 109:31). If you give the poor man something, be aware that He Who is standing at his right hand shall surely reward you. If you give him nothing, be aware that He Who stands at his right hand shall surely punish you. That is why the above verse concludes, לְהוֹשִׁיעַ מִשֹּׁפְטֵי נַפְשׁוֹ, *to save him from the condemners of his soul.*

In summation, a Jew must be firmly convinced that *tzedakah* will never bring him any financial loss as the Sages taught (*Midrash Shemos*

Rabbah, Chapter 36:3): When a Jew wishes to perform a mitzvah his good and evil impulses are in conflict. The evil inclination cries, "Why perform this mitzvah and lose your property? Before you make a donation to others, give the money to your own children!" The good inclination counters this, saying, "Invest in the mitzvah! Bear in mind the teaching of the Torah, כִּי נֵר מִצְוָה וְתוֹרָה אוֹר, *For a commandment is a lamp, and the Torah is light (Proverbs* 6:23). When a single lamp is lit, it can kindle a million other candles, losing nothing itself thereby. Similarly, he who invests his wherewithal in a mitzvah shall lose nothing!

✑ Charitable Advice for Our Times

The Chofetz Chaim dedicated an entire volume named *Ahavas Chesed* to the subject of charity and kindness. In the epilogue to that work he writes:

I know full well that today many people are under the impression that the practice of charity and kindness has become so wide spread that it is not necessary to say any more about it. To this argument I offer three replies:

1) The practice of charity is not the same in every time and place. Its urgency and quantity is relative to the needs of the poor. In earlier times, the needs of the indigent could be easily satisfied by some small gift. Today, clothing, shoes, housing and other daily, basic necessities are so much more expensive. One need only calculate his own personal expenditures and he will realize that today the price of everything has doubled and quadrupled. Hence, the obligation to satisfy the needs of the poor also requires much larger sums.

Giving is also relative to the donor, since the obligation to give charity depends on a person's circumstances. The obligation of the well to do is greater than that of the poor, and the duty of the rich surpasses that of those who are merely well to do. As for the extremely wealthy person, his responsibility exceeds all others. Actually, two people may perform exactly the same act of charity. One is praiseworthy and receives reward; the other is condemned and loses his money. If a person fails to give in accordance with his means, he will lose his fortune as we see from Nakdimon ben Gurion (*Kesubos* 67b).

2) In former times people subsisted on a very low standard of living

and only spent money on basic necessities. They could offer significant assistance to others in their time of need with a modest sum of money. Circumstances have changed. People spend so much of their money on luxuries and pleasures, expensive clothes and homes, on domestic help and the like. Therefore, the level of a man's charity should certainly not be less than the level of his indulgence in these luxuries — especially since *tzedakah* affects a person's life in this world and the eternal life of his soul. Indeed, the Sages taught: "In the future every man will be rebuked in relation to his particular circumstances!"

Consider this: When we ask someone how he manages his household expenses, because we notice that he lives on the scale of a wealthy man, spending more than his income allows, he has a ready answer that it is impossible to reduce these expenditures by any amount. With religious fervor he announces that he has absolute faith that God will help him! Yet when this very same man is approached for charity, he hardens his heart and clenches his fist and tries to give the impression that he is poor and impoverished. He refuses to contribute according to his means. King Solomon had him in mind when he said: יֵשׁ מִתְעַשֵּׁר וְאֵין כֹּל מִתְרוֹשֵׁשׁ וְהוֹן רָב, *Some pretend to be rich and have nothing, but others act poor and have great wealth* (Proverbs 13:7).

3) It is well known that charity and kindness can transform the Divine Attribute of Strict Justice to mercy and compassion, as the Talmud teaches: "Whoever has mercy on others will be granted mercy from heaven" (*Shabbos* 151b). In our times we see with our own eyes how the Attribute of Strict Justice intensifies from day to day. All kinds of maladies and unnatural deaths abound. Each day seems to be more cursed than the day which preceded it. Undoubtedly, we must intensify our practice of charity and kindness. Perhaps in this way we will soften the severity of the Strict Judgment and the entire world will be filled with mercy!

⊷§ Vaad HaTzedakah — Community Charity Research

Responsa *Minchas Tzvi* (Vol. III, Chapter 10) addresses one of the most essential, contemporary charity issues and offers a valid

halachic solution. Here is a digest of his words:

In our times many communities find themselves besieged by throngs of beggars who [by virtue of their strange demeanor and coarse behavior] are highly suspect of being 'unworthy recipients' of *tzedakah*. People are very concerned lest they be giving their charity money to fraudulent paupers and thereby have not accomplished any mitzvah of *tzedakah* with their money. This atmosphere of suspicion and doubt seriously undermines the efforts of worthy charity collectors — both individuals and institutions — because people do not know whom to trust.

In response to this problem, many communities have established a *Vaad HaTzedakah,* which operates under the authority and guidance of the local Rabbinate. The personnel of the *Vaad* are specially trained individuals who check the credentials and stories of those who come to collect *tzedakah* in a particular city or neighborhood. If the inspector concludes that the cause and the credentials are legitimate, he issues an official document attesting to his findings. Often this document will have a picture of the collector and other forms of identification, together with a brief description of the cause or the institution.

This system is halachically approved and praiseworthy because its goal is to *facilitate and increase* the distribution of *tzedakah,* not to impede it. When the community is properly informed they will give charity with greater confidence and generosity. Even the Chofetz Chaim who denounced any attempt by the community to control or curtail the beggar's right to collect from door to door (see previous section in detail) would encourage and endorse this *Vaad HaTzedakah* system because it helps the poor. Of course, the community may only encourage the poor to take advantage of the *Vaad's* documentation service for their benefit, but they may not rule that any collector who does not want to receive documentation is prohibited from collecting on his own. Obviously, the collector lacking documentation does so at his own risk because he will certainly be subject to suspicion, but we have no right to prevent anyone from collecting independently.

∽§ Do Not Desert Your Post!

The Chofetz Chaim had this to say to a wealthy and charitable person who decided to scale down his business so that he could dedicate himself to Torah study: "In wartime, if an officer decides on his own

that he can do more for the common good by leaving his post behind the lines and fighting in the front, he will be court-martialed. A loyal soldier must obey orders and stick to the position assigned to him. Your responsibility is to make money to give to the poor and to support Torah study. By terminating your business success, you are jeopardizing the cause you were assigned to defend. You are a deserter!"

◆§ No Two Paupers Are the Same!

The Talmud (*Kesubos* 67b) relates two stories about charity:
The first story:

> There was a certain pauper who came to R' Nechemyah to be fed. R' Nechemyah said to him, "On what are you accustomed to dine?" He said to him, "On fatty meat and aged wine." R' Nechemyah said to him, "Are you interested instead in joining me in eating a meal of lentils?" Having no choice, the pauper joined him in his meals of lentils. But eventually the pauper died. R' Nechemyah said in response, "Woe unto this pauper whom Nechemyah killed!" The Gemara asks: To the contrary, he should have said, "Woe unto Nechemyah who killed this pauper." The Gemara answers: R' Nechemyah was not responsible for his death. Rather, the pauper caused his own demise since he should not have pampered himself so much. He should not have ingrained within himself such an intense dependence on delicacies!

The second story:

> There was a certain pauper who came before Rava to be fed. Rava said to him, "On what are you accustomed to dine?" He said to him, "On fattened hen and aged wine." Rava responded to him, "Are you not concerned about imposing a burden upon the community who would be paying for your expensive tastes?" The pauper said to him, "Am I then eating from that which is theirs? I am eating from that which belongs to the Merciful One! For we learned in a Baraisa: The verse states: עֵינֵי כֹל אֵלֶיךָ יְשַׂבֵּרוּ וְאַתָּה נוֹתֵן לָהֶם אֶת אָכְלָם בְּעִתּוֹ, *The eyes of all look to You with hope, and You give them each their food in his time* (Psalms 145:15). It does not say in the plural, בְּעִתָּם, *b'ittam, in their time,* but in the singular, בְּעִתּוֹ, *b'itto, in his time.* This teaches that the Holy One, Blessed is He, furnishes the provisions for each individual in his proper

time. At that point, Rava's sister, who had not seen him for thirteen years, came by and brought for him a fattened hen and aged wine. Rava, noting this extraordinary turn of events, exclaimed, "What is this that has happened before my eyes?" Rava turned to the pauper and said to him, "I said too much when I criticized you; rise and eat."

The Ozorover Rebbe in *Be'er Moshe* (*Parshas Beshalach, Maamar IV:4*) points to the glaring contradiction between these two stories. In the first story R' Nechemyah claims that the pauper was responsible for his own death because he had no right to pamper himself with delicacies. In the second story, God Himself sends the pauper the expensive delicacies he has grown accustomed to.

The Ozorover Rebbe explains that each and every individual, even the beggar who lives off others, has the right and the power to determine his own, personal standard of living — provided that he has full faith in God that He will provide him with the wherewithal to maintain that standard of living. In the second story, the pauper had unswerving faith that it was God Himself who provided his luxuries and he even had Scriptural references to prove it. Therefore, this pauper's benefactors were required to make an effort to provide him with his customary fare. But in the first case, the pauper did not believe that Hashem would guarantee his high standard of living, and compromised his standard. He told R' Nechemyah that he would be satisfied with the cheapest meal of coarse lentils. For that very reason, he was not supplied with the high-quality food he had accustomed himself to, and he was held responsible for his own death! (See *Kehilas Yitzchak, Pirchei Nissan to Parshas Behar* and R' Chaim Shmulevitz, *Sichos Mussar 5732 #30* for similar explanations.)

❧ With the Right Hand

When a person gives a gift to a poor man, it is appropriate to give it with the right hand which is the more important one. By doing so, the donor acknowledges how important the pauper is in the eyes of God, because the Almighty Himself stands at the right side of the beggar, as it says: כִּי יַעֲמֹד לִימִין אֶבְיוֹן לְהוֹשִׁיעַ מִשֹּׁפְטֵי נַפְשׁוֹ, *For He stands at the right of the destitute, to save him from the condemners of his soul* (*Me'il Tzedakah Vol. II, #515*) (*Psalms 109:31*).

·§ Standing Up

It is preferable to stand up when giving charity (*Magen Avraham; Orach Chaim* 51:7). *Pela Yoetz* (*Maareches Kavod Habriyos*) cites a Midrash that states that one should stand up whenever a poor man passes by, in acknowledgment that the Almighty Himself accompanies the poor. Similarly, the author writes that one should carefully avoid even subtle discrimination against people of lesser means. In personal celebrations, he advises, one should avoid allowing seating arrangements to reflect class distinctions.

·§ No Blessing Before Giving Charity

The Sages ordained that a blessing be recited before the performance of many mitzvos. Why then is no blessing said before giving *tzedakah*? *Tshuvos HaRashba (18)* explains that as a rule the Sages never required a blessing for any mitzvah *bein adam l'chaveiro*, between man and his fellow man, such as visiting the sick, honoring parents, etc., because in every interpersonal mitzvah the entire obligation is predicated upon the will of the recipient. Should the recipient change his mind at the last minute and refuse to receive the service or kindness from his benefactor, then the entire mitzvah disappears. Thus, it may occur that the benefactor will recite a blessing just before he gives the poor man charity and suddenly the poor man will have a change of heart and announce that he does not wish to accept *tzedakah*, and the blessing will be for naught!

The great Chassidic master, R' Menachem Mendel of Rimanov, told his disciples that he had found in a very old volume that the reason we do not recite a blessing over *tzedakah* is that it is extremely difficult to fulfill this mitzvah properly. The real mitzvah of *tzedakah* is not just to give to the poor; it is to give with genuine joy! The Sages realized that the vast majority of people do not give with joy, so they did not want to establish a blessing on a deficient mitzvah! (*Meor V'Shemesh, Parshas Pinchas, s.v. Bnei Gad*).

◌ঌ The Privacy Rights of the Poor

The Talmud (*Chagigah* 5a) discusses the verse: כִּי אֶת כָּל מַעֲשֶׂה הָאֱלֹקִים יָבֹא בְמִשְׁפָּט עַל כָּל נֶעְלָם, אִם טוֹב וְאִם רָע, *For God will judge every deed — even everything hidden — whether good or evil* (*Ecclesiastes* 12:14). We understand that God will judge and condemn a person for a *bad* deed, but why will one be judged and punished for a *good* deed? They taught in the academy of R' Yannai: This refers to one who gives charity to a poor person in public. An incident actually occurred where R' Yannai saw a certain man who gave a *zuz* (a small coin) to a poor person in public. R' Yannai said to him: It would have been better not to give him the charity than to give him charity in public and embarrass him. [Obviously this would not apply to people who solicit charity in public; such people are not embarrassed by a public response to their request.] Thus, we see clearly how one can be brought to judgment even for performing a good deed, because the merit of the charity was outweighed by the sin of embarrassing one's fellow.

The Gemara offers another example of an improperly performed good deed: In the academy of R' Shila they said: The above verse refers to one who gives charity to a woman in a concealed place, for this brings her under suspicion of impropriety. *Eitz Yosef* explains that those who were unaware of her previously destitute situation — and see her enter a secluded area and then notice an increase in her means — will erroneously conclude that the money was given to her in payment for immoral acts.

◌ঌ Charity in Secrecy

The Talmud (*Kesubos* 67b) relates the following story about the great sage, Mar Ukva. He gave charity to a poor man in his neighborhood in absolute secrecy. Every day, Mar Ukva would sneak up to the poor man's door and stuff some money into a hole in the threshold and quickly disappear from sight. One day the pauper's curiosity got the best of him and he said to himself, "Today I will be on the lookout to discover the identity of my benefactor." On that day, Mar Ukva came home very late from the house of

study, so his wife accompanied him on his charitable mission in the late hours of the dark night. When the pauper saw a figure placing something on his threshold, he swung open his door in order to see who it was. Mar Ukva and his wife turned and ran away. The poor man ran after them relentlessly. Desperately, they searched for a hiding place. They saw a furnace from which the coals had been removed, but which was still burning hot. Without a moment's hesitation they both jumped into the furnace and shut the door. Mar Ukva felt his feet burning from the scorching furnace. His wife said, "Just put your feet on top of my feet and you won't feel a thing." Mar Ukva thus realized that his wife's merit surpassed his own because she was totally impervious to the heat and this puzzled him. His wife explained, "When it comes to charity, we, the housewives, have mitzvah opportunities not available to the men. We are home at all times so we are far more accessible to the poor. Additionally, we give the poor and hungry prepared foods which supply them with immediate benefit, whereas the men give the poor money which they must exchange for food and its benefit is not immediate."

⋖§ Strategies for Secrecy

In the Lithuanian town of Slabodka there was a wealthy leather tanner named R' Shraga Frank who was a man of exceptionally high caliber. He lived his life under the influence of R' Yisroel Salanter and his disciples. When R' Shraga heard of a poor Torah scholar who was embarrassed to accept charity, he would fill sacks with food and leave them outside the poor scholar's home in the dark of night.

He also developed other clever methods to help people. R' Shraga would approach a man in need and ask him for a favor. He would claim that he had a large sum of money in his possession, but that he was afraid to leave it in his own home because robbers like to break into the homes of wealthy people. Therefore he was asking the poor man to hold the money for him. He would stipulate that meanwhile the poor man could use it as he wished. After the poor man acquiesced to this arrangement, R' Shraga would 'forget' the deal or push off the time of repayment with various ingenious excuses (*Tnuas Hamussar*, Vol. III, p. 38).

⊸§ Caught Red-handed

Rabbi Naftali Riff served for many years as the Rav of Camden, New Jersey. The Rav had a place in his heart for every Jew. He would actively seek out the poor in his area and strive to assist them to the best of his ability.

Late one night, he went to a nearby neighborhood to slip an envelope containing money under a poor person's door. A policeman drove by and saw R' Riff bending down at the door. Not knowing the Rav, the officer suspected him of attempting to break in. Before R' Riff could explain himself, the poor man, who had heard the commotion, opened the door. R' Riff knew that his explanation would cause the poor man some embarrassment. Therefore, he remained silent.

It did not take long for the poor man to figure out what had happened. He asked the officer to step aside with him so that he would be out of the Rav's earshot. The poor man explained to the officer, "This man is a rabbi; all he wanted to do was help me out by slipping some money under my door. In fact, if you will look over your shoulder, you'll notice that he's trying to drag the money back with his foot so that it won't be discovered."

The officer looked over his shoulder, then apologized to R' Riff and drove off.

⊸§ Volumes of Kindness

R' Yitzchok Silberstein, the Rav of Ramat Elchanan in Bnai Brak relates: "My neighbor, R' Shmuel Tzvi Kovalsky had an incredible 'nose' for kindness. He had a unique way of 'sniffing out' other people's needs, and he invented countless new ways of doing favors for others.

"For instance, whenever he found out that a *talmid chacham* was deeply immersed in a particular Torah subject — a specific tractate or certain special halachos — he would buy all of the books which pertain to that subject in order to help the scholar. Rav Kovalsky would innocently approach the *talmid chacham* and say, 'I see that this subject interests you. It just so happens that I have many important texts pertinent to this topic and I really have no use for them. Please

do me a favor and take them off my hands for as long as you need them?' I know of cases where R' Kovalsky lent out books in this manner and they stayed with the borrower for over ten years.

"Sometimes, the Torah scholar didn't agree immediately, and he would protest, 'How can I take these rare and precious *sefarim* from you? These are hard to find volumes and I am sure you will need to look them up in the near future.' To this R' Kovalsky's response invariably was, 'What are you talking about? I have no need whatsoever for them. They are sitting and collecting dust. They are taking up precious space on my crowded bookshelves. Please do me a favor — do these poor neglected *sefarim* a favor — and put them to good use, so that I can at least take part in your mitzvah of Torah study!'

"Sometimes, R' Shmuel Tzvi didn't even bother to go through the charade described above. On more than one occasion I discovered specialized *sefarim* on my bookshelf dealing with the subjects I was studying at that time; these were 'phantom' books that I never owned or purchased but just appeared out of nowhere! After thorough investigation, I discovered that somehow Rav Kovalsky had clandestinely slipped these volumes onto my shelves.

"One last detail remains vividly etched into my memory from the time when I lived in close proximity to R' Kovalsky. Once, I was honored by a visit from my illustrious father-in-law, R' Yosef Shalom Eliashiv. We were engrossed in a discussion about a certain Torah topic, when suddenly we heard someone knocking at my door. It was none other than my neighbor, R' Kovalsky, holding a pile of *sefarim* in his arms, all relating to the very subject we were discussing. We were truly bewildered. How did he know what we were discussing? We weren't shouting or even talking very loud. And even if he somehow heard us, how did he put together such a vast array of materials in so short a time? It was truly an enigma, and that's how it remained."

✥ The Secret of the Unmarked Boxes

In every Jewish community there is a *Chevra Kadisha* (literally, 'the Sacred Society'), which is dedicated to performing the final purification rituals for the deceased and providing a dignified burial. The *Chevra Kadisha* of Khal Adath Jeshurun of Washington Heights, New York, goes a step further and provides for the needs of the living as

well as of the deceased. These provisions are made in the most discreet and sensitive manner and represent the epitome of *matan b'seiser,* the hidden gift. Sometimes, the fact that the family must observe *shivah* the seven-day-long period of mourning when they may not go out to work, poses a serious economic hardship. In order to alleviate this problem, the *Chevra Kadisha* has a few identical, unmarked boxes, one of which is delivered to the house of mourning at the onset of the *Shivah* period. An envelope is attached to the box containing a letter with the following text:

> *The community is obligated by Jewish Law to insure that those in mourning may observe the* shivah *without economic worries. Our* Chevra *wishes to fulfill this noble obligation in a discreet way within our Congregation.*
>
> *To this end, $250 are being handed to the mourners in each instance, regardless of their economic condition. If there is no cause to make use of this help the monies can be returned to the* Chevra *by placing them in the accompanying box.*
>
> *On the day after the* shivah, *the box is picked up by the* Chevra.
>
> *In view of the fact that we have a number of identical boxes and the boxes are only opened periodically, you can be assured that complete anonymity is maintained.*
>
> הַמָּקוֹם יְנַחֵם אֶתְכֶם בְּתוֹךְ שְׁאָר אֲבֵלֵי צִיוֹן וִירוּשָׁלָיִם
>
> *May you be comforted among the rest of the mourners of Zion and Jerusalem.*

<div align="right">

Chevra Kadisha
K'HAL ADATH JESHURUN

</div>

◆§ Sometimes Sensitivity Supersedes Secrecy

In the opening piece of this chapter, we quote the Talmud (*Sukkah* 49b) which teaches: "*Tzedakah* is rewarded only according to the kindness with which it is performed," meaning that the donor should make every possible effort to give the charity in the way that the poor man will derive the most benefit from it. R' Yeshaya Pinto (*Rif*) in his commentary to *Ein Yaakov* (ibid.) observes that sometimes a direct charitable gift, which is given with words of advice and

encouragement, surpasses the concealed gift which lacks this sensitive, personal touch. In every *tzedakah* situation it is up to the donor to decide what is the best approach at that particular time.

◄§ Decorate Yourself First

A young man was sent to R' Shlomo Zalman Auerbach to obtain his signature on an appeal for *tzedakah* to finance an operation abroad for a child whose life was in danger. After inquiring about the case, R' Shlomo Zalman agreed to give his endorsement, and the young man thanked him and left.

When the young man was already halfway down the stairs, R' Shlomo Zalman called him back. "The Talmud (*Sanhedrin* 19a) teaches us," he said, " 'Decorate yourself before you decorate others.' How can I encourage others to contribute to such an urgent matter with consequences of life and death if I don't first contribute myself?" He handed the young man a sizable amount of money and asked him to give it to the needy family. "*Now,*" he said, "you can publicize the appeal with my signature on it."

◄§ Share the Bread Which Is Yours to Give

The prophet says: הֲלוֹא פָרֹס לָרָעֵב לַחְמֶךְ, *Surely you should break your bread for the hungry* (Isaiah 58:7). R' Yehuda observed, "The prophet doesn't say, '*break bread,*' he is careful to say, '*break* **your** bread.*' This means that the bread of charity should be obtained honestly; it should not come from stolen, ill-gotten gains. Not only is *tzedakah* from stolen money not a merit or a mitzvah, it actually arouses God's fury because it reminds Him of the sins of the thief!" (*Zohar, Parshas Vayakhel,* 198a).

◄§ Do Not Be Generous
With Other People's Money

The Midrash (*Vayikra Rabbah* 3:1) teaches: R' Yitzchok expounded upon the verse, טוֹב מְלֹא כַף נָחַת מִמְּלֹא חָפְנַיִם עָמָל וּרְעוּת רוּחַ, *Better is*

one handful of pleasantness than two fistfuls of labor and vexation of the spirit (*Koheles* 4:6). Far better is he who goes out and does honest labor and earns a modest income and gives charity from it than he who robs and steals and gives generously to charity with other people's money! There is a folksaying that describes such a person: A crooked philanthropist is like the harlot who sells her services and takes apples as her fee. Then she goes to visit the sick and presents them with her apples. Similarly, this thief toils to earn the title "Man of Charity" while causing frustration and aggravation to others.

◄§ Stolen Money for Charity

The Talmud (*Kesubos* 67a) describes how all of Nakdimon ben Gurion's wealth was lost, despite his charity, because he distributed *tzedakah* ostentatiously for the sake of his own honor. *Maharsha* (ibid.) explains that although the Talmud (*Pesachim* 8a) states that one who gives charity in order to gain personal benefit is still considered perfectly righteous, and one may test God and expect a reward for tithing (*Taanis* 9a), nevertheless, to give charity for the sake of personal glory is far worse [see *Kovetz Shiurim* for explanation]. *Maharsha* concludes: Many people in this generation amass great wealth dishonestly and with much desecration of God's Name. They cheat and rob the gentiles and then publicly show off their generosity by making large donations in the synagogue and lavishly paying for 'me shebeirach' blessings at the reading of the Torah. Such people delude themselves. They think they are doing a good deed, but they are really sinning. Their ill-gotten gains will not stay with them for long and they will surely lose their fortunes.

◄§ Don't Waste a Pauper's Precious Time

Many people are annoyed when a poor person interrupts their work, because their time is precious and 'time is money'! They have no qualms about keeping a poor man waiting for a long time, for they regard the indigent with disdain and consider the poor man's time to be worthless. The Torah seems to have a different view on this matter.

The Torah (*Leviticus* 1:15) describes how the Kohen deals with the

bird offering brought to him by a poor man. He slaughters the bird by a method known as מְלִיקָה, melikah, whereby the priest cuts the back of the neck of the bird with his sharpened thumbnail instead off using the customary knife. *Sefer HaChinuch* (*Mitzvah* 124) explains that this teaches us that whenever a person does something for the benefit of a poor man he should do it with all possible speed. If the offering of the poor man had to be slaughtered in the conventional fashion, with a knife, the priest might not have one available at the moment the poor man approaches him. The priest might have to spend a few minutes searching for a proper slaughtering knife. Meanwhile the pauper will be kept waiting and his precious time is being wasted! Also, when a bird or an animal is slaughtered in a conventional, kosher fashion, the ritual slaughterer must turn the animal over to access the throat. *Melikah*, however, is performed at the nape of the neck, in a place which takes much less time to locate, so that the poor man's needs can be attended to with utmost speed and alacrity.

⋗ Speed Is of the Essence!

The *Tanya* (*Iggeres Hakodesh* Chapter 21) explains that although speed is an important factor in the performance of all mitzvos, it is essential for the mitzvah of *tzedakah*. Why? Because all other mitzvos gain a person *zechusim*, merits for good life, whereas charity is life itself! One should swiftly complete one act of *tzedakah* so that he can immediately undertake a second act of *tzedakah*! There is simply no time to waste. The *tzedakah* cycle must go on and on and on.

A principle of our faith is that every man is judged every minute of his life by the Almighty Judge Who determines whether this man will continue to live (*Rosh Hashanah* 16a). A truly God-fearing person constantly feels that his entire existence hangs precariously in the balance every moment of his life. He humbly acknowledges that he must perpetually draw a new infusion of animation and spirit from the celestial treasury of life lest his vital spirit disappear. The person who never stops giving charity demonstrates that his life is not taken for granted, for וּצְדָקָה תַּצִּיל מִמָּוֶת, charity will rescue from death (*Proverbs* 11:4).

This is why *Rambam* (commentary to *Avos* 3:19) emphasizes that it is far better to distribute one thousand coins to *tzedakah*, one coin at a time, than to give a lump sum all at once. The apparent reason is, as

Rambam himself explains, that the frequent repetition of giving to others will transform man's naturally selfish nature into a generous one. The deeper reason, however, is as explained above: *Tzedakah* is the fuel source that energizes life. It is the only guaranteed way to renew our lease on life.

❧ Don't Leave Home Without It!

Tzedakah L'chaim (*Ma'areches Dalet* 119) makes a point of encouraging everyone to always be prepared to give charity. A person should never leave his home without at least some small coins in his pocket so that the minute a pauper solicits his help he can immediately dip into his pocket and give him something. He observes: "The man who sniffs snuff never leaves home without his snuffbox, so that when he gets the urge to sniff, he has his snuff close at hand. And the man who smokes cigarettes never ventures forth without a pack of cigarettes to satisfy his addiction. Similarly, no one should leave home without an ample supply of coins on his person so that he may respond to any and all charitable requests with alacrity! Moreover, the person who is careful to always carry his *tzedakah* equipment with him is protected by the most potent security system possible; for charity protects from all harm and is more effective than all amulets and charms."

Me'il Tzedakah (1071) also encourages everyone to always be sure to carry coins for charity on their person. He says that this is what Job had in mind when he said, צֶדֶק לָבַשְׁתִּי וַיִּלְבָּשֵׁנִי, *I dressed up with charity, and it suited me* (Job 29:14) — just as I would never leave home without being properly attired with the right kind of clothing, similarly, before I stepped outside *I dressed up with charity*, and made sure I filled my pockets with money for *tzedakah*.

Also, the Midrash (*Shemos Rabbah* 31:3) states: "Fortunate is the man whose hand is forever outstretched to the poor." *Me'il Tzedakah* (1597) explains that this is a reference to one of the Sages in the Talmud (*Berachos* 58b) who always kept his hand inside his coin purse so that if he were approached for *tzedakah* by a sensitive person he could give a donation instantly without fumbling around for a few moments to open his purse. In this way he saved the pauper from even the slightest discomfort or embarrassment. Such a caring benefactor deserves extra blessings and special good fortune.

❧ A Jar Full of Quarters

In R' Moshe Feinstein's home there was a large jar filled with quarters. Before leaving for a public function, the *Rebbetzin* would reach into the jar and give her husband a handful of coins so that he would be able to give something to every solicitor he would meet at the door. In general, R' Moshe never refused a request for *tzedakah*. Even if a number of children would solicit for the same cause in *shul*, R' Moshe would give each of them something. This he did for *chinuch*, to provide for them a good example, so that the children would learn not to refuse the requests of others when they grow older and are in a position to give (*Reb Moshe; ArtScroll/Mesorah*, p. 175).

❧ The Grudging Donation

The great Chassidic Master, R' Shlomo of Radomsk, was once approached by a notoriously stingy, rich man who offered him a large donation to *tzedakah*. The Radomsker Rebbe, however, refused to take anything from this man. The *Chassidim* were puzzled by the Rebbe's refusal and later they asked, "Rebbe, why did you reject this man's donation?"

The Rebbe replied, "If you would have seen the joyous look on his face when he took back his money you would not have to ask me why I did not accept it!"

❧ Coins Have a Cheerful Character

R' Elya Roth, one of the holy men of Jerusalem in the early part of the 20th century, was a *gabbai tzedakah*. He said that when he went around collecting he felt much greater pleasure when people gave him small coins than when they handed him larger bills. The reason for this, he explained, is that people hand out small change with joy and a full heart. Large bills, however, are often only given under duress (*Tiferes Banim*, vol. III, p. 238).

✑§ Give the Best

R' Sholom Schwadron, the renowned Maggid of Jerusalem, loved the mitzvah of giving *tzedakah* with all his heart. "To give to others gave him a special joy," his son-in-law relates and he told of an interesting incident:

One *Erev Yom Tov* a poor man knocked on R' Sholom's door asking for alms. His son-in-law had just arrived to spend the holiday and was putting his belongings in his room. Suddenly he heard a soft cry emerge from the front room, and saw one of R' Sholom's daughters wringing her hands. "*Oy!* Look what Abba is doing! Why is he doing that?"

The son-in-law went to the front door where he saw R' Sholom unfolding a brand-new shirt before the poor man's happy eyes. It was a fine shirt he had purchased in England many months earlier, which had been put away, waiting to be opened in honor of *Yom Tov!*

After he had shown the poor man how beautiful the shirt was, R' Sholom refolded it and returned it to its wrapping. "Take it! Take it! You should have a new shirt. *Good Yom Tov!*"

The poor man accepted the shirt and left. Turning back inside, R' Sholom met his daughter's reproachful eyes. "Abba! If you had no money and had to give him a shirt, why give him the special shirt from England? Why?"

R' Sholom saw her pain and was silent. A moment later he summoned his son-in-law over to the bookcase, where he removed a volume of the *Rambam* and opened it up to the laws of sacrifices (*Hilchos Issurei Mizbeiach* 7:11).

"Listen to the *Rambam's* language. 'One who wishes to offer a sacrifice for his own merit should suppress his evil inclination and bring of the best quality there is of the type he is offering. This is the law with everything. If one builds a House of Prayer, it should be more beautiful than his dwelling place. When feeding the hungry, he should give of the best and sweetest food on his table. When dressing the naked, he should offer his finest clothing.' "

R' Sholom finished reading this passage leaving his family with a profound lesson in *tzedakah* which has accompanied them to this very day (*Voice of Truth*, p. 215).

✑ Follow Your Heart (I)

R' Avrohom HaKohen Pam, *Rosh Yeshivah* of Mesivta Torah Vodaath, offered me the following advice on how to distribute *tzedakah* properly: "After all is said and done, every person is drawn to certain individuals and institutions which for some reason seem to grab his heart. This is how it should be. A person must follow his heart in his service of Hashem. This concept is explained at length by the *Netziv of Volozhin* (*Haamek Davar, Numbers* 15:41): King Solomon says: וְהַלֵּךְ בְּדַרְכֵי לִבְּךָ וּבְמַרְאֵה עֵינֶיךָ, *'Follow the path of your own heart and the vision of your own eyes'* (*Ecclesiastes* 11:9), meaning that no two people can serve Hashem in the same way. One person is immersed in the study of Torah all day long, while another puts tremendous effort into prayer and supplication, and yet a third person throws himself heart and soul into acts of charity and kindness. All of them are sincerely dedicated to glorifying the Name of God, each in his singular way. And even in the pursuit of Torah studies, no two scholars are alike, and each has a unique methodology and approach to his studies. Similarly, in the pursuit of mitzvos, everyone has a preference for certain good deeds over others. And in the practice of philanthropy no two benefactors follow the same path. So if a person comes to ask advice, "What area of Divine service should I emphasize?" The only answer is to listen to the words of King Solomon, *Follow the path of you own heart;* if your heart is attracted to a certain mitzvah it is definitely because your soul has recognized this as the mitzvah which is bonded to the very core and essence of your being."

Similarly, R' Yosef Myer of Boro Park was told by R' Shlomo Zalman Auerbach that, *"Mir darfen gebben vu der hartz tseeyt,* one should give to the causes and individuals that tug most at his heartstrings!"

✑ Follow Your Heart (II)

R' Heshy Parnes of Boro Park told me: "Many years ago I was deeply involved in supporting many excellent Torah institutions. However, as time went on many worthy individuals who needed assistance approached me, but I was unable to help them significantly because all of my money was committed to *mosdos* (institutions). I

approached R' Moshe Feinstein and told him of my change of heart. Was I allowed to divert *tzedakah* money previously earmarked for Torah to help needy people with their personal problems? R' Moshe assured me that I had every right to change my *tzedakah* disbursement, for there is no *chazakah*, or 'permanently established privilege,' regarding charity, and no individual or institution can claim that since I gave them in the past I am forever obligated to continue to give them. Moreover, R' Moshe actually commended and encouraged me to get involved with downtrodden individuals. He said, 'There are so few people who have the patience, empathy, and sensitivity to listen to other people's woes! If you feel capable of this, you are one of the blessed few and your services are sorely needed!' "

⋉§ Chazakah: Do Not Deprive the Destitute

Note, though, that a statement in *Yalkut Shimoni* (*Mishlei* 960) appears to support the view that the poor *do* have some rights of *chazakah*. King Solomon says: אַל תִּגְזָל דָּל כִּי דַל הוּא, *Do not rob the destitute because he is destitute* (*Proverbs* 22:22). The Midrash asks: The destitute man has nothing, so what can be robbed from him? Rather, this serves as a warning to the person who has steadily supported a poor person not to change his mind and terminate his assistance, saying, "How long am I going to continue to support this one?" If you do this, it is as if you robbed the destitute. King Solomon concludes his solemn warning to the one who cuts off support: וְאַל תְּדַכֵּא עָנִי בַשָּׁעַר. כִּי ה' יָרִיב רִיבָם וְקָבַע אֶת קֹבְעֵיהֶם נָפֶשׁ, *And do not oppress the poor man in the gate of judgment. For Hashem will take up their grievance; He will steal the soul of those who would steal from them* (*Proverbs* 22:22-23).

However, it appears that the warning of the Midrash only pertains to the benefactor who abruptly stops his support of a particular pauper because he has lost his patience with this poor man's plight and rejects him out of arrogance and disdain. This is terribly wrong, because the poverty of the pauper is not his fault; it is the result of a Divine decree. As long as the Almighty has decreed that this man must suffer penury, that is how long he is worthy of support. The benefactor should consider it a privilege to help this poor man who was sent to him as a gift from God so that he should enjoy the constant merit of *tzedakah*. It would be a crime to drop the poor man for no reason.

But if the philanthropist has a change of heart due to a valid reason, then he is not inextricably bound to his earlier beneficiaries. If, after careful consideration, the donor decides to direct his *tzedakah* funds to a different individual or cause which he now feels needs and deserves his support more than the first, he may do so. This is in accordance with Rav Pam's motto, "Follow your heart!"

See *Tzedakah Umishpat* (Chapter 3, 6) for a detailed discussion of the laws of *chazakah* in relationship to charity.

◄§ Make a Lasting Contribution

R' Heshy Parnes also told me that he once asked R' Eliezer Shach for guidance on how to distribute his *tzedakah* money. Rav Shach advised him that a man of means should undertake significant projects which 'make a difference' either to a poor individual or to a worthy Torah institution.

For instance, if you are approached to help a poor Torah scholar who needs an apartment in Israel, try to give or raise the full amount so that you have really helped a worthy person in a significant and lasting manner. Better to give $100,000 to buy this one apartment than to give $1,000 each to 100 people who need apartments. The same idea would apply where someone with a large family requires a lump sum to add another desperately needed room to an existing home or apartment. Undertake the entire project if possible. Similarly, it is preferable for a man of means to help a yeshiva in a permanent way by giving it a new building or completely renovating and enlarging an old one. This is better than giving many smaller donations to many yeshivos.

Rav Shach cited the example of the wise *tzedakah* investments of the philanthropists who built homes for needy *talmidei chachamim* in Jerusalem: Battei Natan, Battei Ornshtein, Battei Rand and the like. They helped needy people in a tangible, large way; and their charity endures for generation after generation.

Author's note: Earlier in this chapter, in the section, *Place No Restrictions on the Poor* (p. 178), we cite the well-known words of the *Rambam* who observes that giving one thousand coins to one needy person is not as effective as giving one coin each to one thousand people. The *Rambam* states that when one opens his hand again and

again to one thousand paupers, the trait of giving becomes ingrained in him. This appears to contradict Rav Shach's advice that it is preferable to undertake one large, significant project than to give several smaller gifts. Really, there is no contradiction. *Rambam* is teaching us that repetitive, piecemeal giving is most effective for transforming the selfish character of the philanthropist, *the giver of charity*. Rav Shach gave advice on what is the most beneficial way to utilize charity money so that the giver will derive the maximum *zechus*, merit, from the mitzvah. That is to do one significant project for one specific *taker of charity*.

Of course, there are situations where it is more important to provide piecemeal primary support to the indigent than to build large edifices. This is demonstrated by God's displeasure with King David for hoarding the riches he amassed to build the Temple in Jerusalem and refusing to distribute these funds to feed the starving people during the terrible famine which raged for three years [see chapter, *Time to Give/Chanukah*]. The main guiding principle is that the donor must put God's wishes before his own; he must attempt to distribute his money in a fashion that would please and honor Hashem the most in every situation.

⋙ This Pauper Was Custom Made for You

In the years between the two world wars, the great industrial city of Lodz, Poland was home to thousands of Gerrer *Chassidim*. Once, a poor Gerrer *Chassid* rented an apartment from a wealthy landlord who was also a follower of the Gerrer Rebbe, the Imrei Emes. The poor tenant became so mired in poverty that he could not pay his rent. The landlord promptly sent the poor tenant formal notice that if he did not pay his rent quickly, he would be evicted.

Word of this terrible threat reached the ears of the Gerrer Rebbe. When the wealthy landlord came to Ger on the Shavuos holiday, the Rebbe sternly rebuked him and warned him that he had no right to evict the destitute tenant even if he failed to pay his rent, because he was worthy of *tzedakah*. The landlord did not accept this ruling easily and complained, "Why should the burden of supporting this pauper fall on my shoulders only? There are thousands of Gerrer *Chassidim* in Lodz who should participate with me."

The Rebbe refused to accept this argument. "Don't you understand?" said the Rebbe, "If the Holy One, Blessed is He, went out of His way to set up the circumstances which sent this poor man to your property, it's a clear sign from Heaven that this mitzvah is earmarked for you alone! Do not waste a moment — quickly grab this custom-made *tzedakah* opportunity!" *(Rosh Golas Ariel).*

⋅§ A Test of Character

A poor man once approached R' Shlomo of Zhvil and asked for some food. R' Shlomo told him that all he had was some bread and jam. The pauper responded brazenly, "That kind of food you can eat yourself; it's not for me!" A half-hour later, the same pauper returned and requested food. Once again, R' Shlomo told him that all he had was bread and jam, and again the pauper insolently shot back, "That kind of food you can eat yourself; it's not for me!" Another half-hour elapsed and the pauper approached R' Shlomo for the third time, but this time he said he would like some bread and an egg. R' Shlomo granted his wish. Then the pauper asked for some bread and jam, and R' Shlomo graciously fulfilled his request.

Later, R' Shlomo explained that the entire episode was a special Divine test designed to determine whether he would lose his temper with the pauper, which would have been a great sin. The pauper himself was really a very fine man of sterling character who, under ordinary circumstances, would never speak with *chutzpah*. But in this case, he was merely a pawn in the hands of celestial forces that aroused him to speak brazenly to me in order to put me to the test *(Tiferes Banim,* Vol. III, p. 246).

⋅§ Ulterior Motives

The Talmud *(Pesachim* 8a-8b) states: If a person says: "This coin is donated to charity so that my son shall live in the merit of this mitzvah," or if he says, ". . . so that I shall be one who merits a portion in the World to Come," this type of donor is a completely righteous person.

Rashi explains that he is considered completely righteous with respect to this particular mitzvah. His ulterior motive does not detract from his intent to fulfill God's will. Primarily, he gave charity because God commanded him to do so, and his intent for personal benefit was merely ancillary (see *Ahavas Chesed* II 23:2 and gloss there). This concept only applies in a case where the donor would not regret his donation if his wish were not granted, e.g. his son did not recover (*Tosafos* here and *Rashi* to *Bava Basra* 10b. See also *Chiddushei HaRan* here and *Responsa of Beis HaLevi* II, *Drush* 1).

✑ Let the Pauper Feel He Is Doing You a Big Favor

R' Mordechai Banet offered a novel interpretation to this statement. The Talmud chooses its words carefully. It does not rule that, " A person who *gives* charity so that his son should live is completely righteous," rather it states, "If a person *says*: 'This coin is donated to charity so that my son shall live,' he is completely righteous." We are referring here to a person who is giving alms to an indigent without any interest in his own personal benefit. However, in order to make the poor man feel good, the donor says, "Please, do me a favor and take this money from me because I desperately need the merit of the mitzvah of *tzedakah* so that my dangerously ill son should live or so that I should have some virtue that will get me a portion in the World to Come." The person who goes to such lengths, to make the pauper feel that he is giving rather than receiving, truly is completely righteous.

✑ Publicizing One's Charity

One of the most challenging questions concerning *tzedakah* is whether or not to publicize one's charitable actions. The majority of sources indicate that it is best to give charity secretly and not to talk about it. There are, however, situations where it is appropriate to publicize one's charity, such as during an appeal or other fundraising events. We present here many of the sources and arguments for both sides of this complex issue.

‌ Do Not Publicize Your Charity

Rama in his gloss to *Shulchan Aruch* (*Yoreh Deah* 249:13) states: Under no circumstances should a person glorify himself with the charity which he gives. And if he does glorify himself with it, not only does he forfeit all of the reward for the mitzvah, but he will even be punished for his bragging.

The Vilna Gaon (ibid.) cites the source of this halachah as the Talmud (*Bava Basra* 10b) where Rabban Gamliel says that: "Any act of charity or kindness that idolaters perform is a sin for them, for they perform a good deed only to glorify themselves through it."

R' Avrohom Pam says that this very harsh punishment is reserved for the person who gives charity exclusively for the sake of showing off and has absolutely no philanthropic purpose in mind. However, if a person means well and gives *tzedakah* for the right reasons, only that in addition to the proper reasons he also has in mind to boast of his generosity, that will not ruin his mitzvah and he certainly will not be punished for it.

The precise wording of the Talmud (*Bava Basra* 10b) cited above supports Rav Pam's point. When Rabban Gamliel disqualified the charity of the idolaters, he specified "for they perform a good deed *only* to glorify themselves through it."

R' Chaim Kanievsky (*Derech Emunah, Hilchos Matnos Aniyim.* Chapter 10, *Tziyun Halachah* 90) cites the opinion of *Chadrei Deah* who says that the only way that one who glorifies himself with charity loses his merit and is punished is if the donor does it in order to hurt or embarrass someone else, or if he gives in a way that humiliates the poor recipient.

‌ Don't Throw Your Charity to the Dogs!

From the simple reading of the halachah cited above, one could have the impression that 'glory-seeking' is prohibited only if that is what the donor has in mind at the time that he is actually giving the *tzedakah*. However, if one donates *tzedakah* with pure intentions, but later brags about his good deeds, that is not blameworthy. The following story makes it clear that that is not the case.

R' Aharon Roth (*Maamarei Tzedakah* p. 63) elaborates on this: The very lowest level of charity is when one gives and then boasts about his own generosity. Unfortunately, almost every giver of charity makes this terrible mistake, some more and some less, but they all take pride in their giving and thereby lose the mitzvah. What a tragedy — because a person has to struggle so much to overpower his selfish nature and to give away his hard-earned wealth, and then he forfeits all his gains by bragging about himself!

The story is told about the great *gaon* and Chassidic master R' Yuda Tzvi of Stretin who once heard of a very wealthy man who gave to charity generously and had an open house for poor guests whom he treated royally. However, this fine man would always talk about his good deeds and bragged about his philanthropy.

The holy Rebbe of Stretin was filled with pity for this kind man who was unwittingly destroying himself, so he decided to make the long journey to his hometown in order to set him straight. The Rebbe waved his kerchief over the man's face and asked the man what he now saw. The man said, "I see before me a big dog with its mouth opened wide as if it is swallowing something." The Stretiner Rebbe said to him, "Indeed, I wished to demonstrate to you that all of the deeds of charity and kindness that you perform so painstakingly are devoured by this big dog as a result of your showing off!" Shocked by this revelation, the man deeply regretted his mistake and resolved never to repeat it.

⋖§ A Scrap of Glory Tears Tzedakah to Shreds

The Talmud (*Kesubos* 66b) describes the fabulous wealth of Nakdimon ben Gurion who was one of the wealthiest men in Israel. Yet, in the end, all of his wealth was tragically lost and his family suffered the direst poverty. Not that he didn't give charity, explains the Talmud, but that he gave it for his own glory. Whenever he walked from his home to the *Beis Hamidrash,* his servants rolled out expensive silk runners before him, and the poor people followed after him and were allowed to pick up the precious material for themselves.

R' Chaim Shmulevitz (*Sichos Mussar, Vayigash* 5732, *Shleimus Hamaaseh)* observes that elsewhere, the Talmud (*Taanis* 20a) brings dramatic and irrefutable proof that precisely this benevolent man, Nakdimon ben Gurion, practiced kindness without seeking personal

glory. One year, masses of pilgrims arrived in Jerusalem for the festival but there was no water supply for them. Nakdimon convinced a gentile aristocrat who owned twelve huge cisterns filled with water to allow the pilgrims to use up all his water reserves. Nakdimon promised him that by the end of the year God would send an abundant rainfall to replenish the cisterns; otherwise, he would be personally responsible to pay the aristocrat an enormous sum.

At the very last moment before the end of the year, Nakdimon prayed before the Almighty and proclaimed, "Master of the Universe! It is clearly known before You that I did not do this for my personal honor, nor did I do this to enhance the glory of my father's house. Rather, I did it exclusively for Your glory, so that water be available for the festival pilgrims." Immediately, the sky became overcast with clouds, and rain fell until the twelve cisterns borrowed from the nobleman were filled to overflowing with water.

Thus, God Himself corroborated Nakdimon's declaration of total selflessness. How then do we understand the Talmud in *Kesubos* which condemns him for selfish glory-seeking? We must conclude that the downfall of Nakdimon demonstrates how careful one must be when giving charity. Undoubtedly, Nakdimon concocted the scheme to leave behind the silk runners for the poor in order to distribute *tzedakah* in an honorable fashion. Let the poor think that Nakdimon abandoned the silk and didn't care about it. Thus, they wouldn't feel they were accepting charity, but rather that they were earning a living by collecting and reselling unwanted discards! Nevertheless, this scheme was ostentatious, and a tiny shred of glory stole into Nakdimon's heart. He tasted the forbidden fruit of pride, which poisoned all of his charity and all his wealth! Such is the level of altruism that God demands of great philanthropists. [Precisely because Nakdimon had originally acted exclusively for God's glory with the twelve wells, he was expected to be totally selfless in his future charity.] Charity is an act of 'giving,' the donor may take nothing for himself — no glory, no advantage, no personal benefit — nothing! Personal gain poisons charity.

Others say that in reality, Nakdimon did *not* lose his heavenly reward for all the charity he gave even if he did not give enough or he entertained some feelings of self-glory. What the Talmud wants to teach us is that in a time of disastrous calamity one has to have a pure mitzvah of the highest caliber in order to be protected from the all-encompassing tidal wave of destruction which may engulf the

THE RIGHT WAY TO GIVE ᘓ 205

Jewish nation. The Talmud observes that Nakdimon's charity could not protect his family because it was relatively flawed and impure (R' Avrohom Nachman Wolfson).

◆§ Giving Charity to Receive Honor

Maharsha (Commentary to *Kesubos* 67a) notes that the Talmud (*Pesachim* 8b) rules that if a person gives charity so that in its merit his son should live, he is considered a perfectly righteous man. This proves that even if a person gives charity for an ulterior motive it does not detract from his mitzvah. Why then does the Talmud here disparage Nakdimon ben Gurion who gave charity for the ulterior motive of increasing his own glory?

R' Elchonon Wasserman (*Kovetz Shiurim* 224) explains that doing a mitzvah to gain honor and recognition is much worse than any other ulterior motive, because *Chovos Halevavos* (*Shaar Yichud Hamaaseh*, Chapter 5) teaches that the 'people-pleaser' who ingratiates himself to others in order to curry their favor is tantamount to an idol-worshiper! A Jew must firmly believe that no one and nothing in the world controls his fortunes other than Almighty God. So the person who gives charity in order to gain prestige and advantage from mortals of flesh and blood denies the omnipotence of the Creator. In this vein the Talmud (*Bava Basra* 10a) states: Scripture says, וְחֶסֶד לְאֻמִּים חַטָּאת, *The kindness of the gentile nations is a sin* (*Proverbs* 14:34). This means that any charitable acts which the heathen nations perform is considered as a sin for them, for they perform such good deeds only in order to increase their self-glory.

◆§ The Path of Glory Leads to Oblivion

Sefer Chassidim (503) writes: "Whoever performs good deeds in order to be remembered will not be remembered! There was a man who dedicated himself to building a magnificent synagogue. Many members of the community wanted to contribute to this fine project in order to share in the mitzvah; but this man turned them away, because he was determined to do this mitzvah single-handedly so that it would serve as an eternal memorial to himself and his children after him.

In the end, all of his children died and there was no one left to memorialize! (*See Magen Avraham* to *Orach Chaim* 155, 23.)

In this vein, the *Zohar* (*Genesis* 25b) writes: Woe unto those who build massive synagogues and Houses of Study for the sake of showing off their wealth and increasing their glory! They fill these splendid buildings with Torah scrolls and place crowns upon them. But they do all this for their own prestige and not for the sake of God. These glory-seekers are just like the wicked men who built the Tower of Babel who said: הָבָה נִבְנֶה לָּנוּ עִיר וּמִגְדָּל וְרֹאשׁוֹ בַשָּׁמַיִם וְנַעֲשֶׂה לָּנוּ שֵׁם, "*Come, let us build a city, and a tower with its top in the heavens, and let us make a name for ourselves*" (*Genesis* 11:4).

‎⊰ When Publicity Is Proper

Yoffe L'lev (Part III, *Yoreh Deah* 249) rules that there are times when it is appropriate for a person to broadcast his good deeds in order to inspire others to follow his good example. An illustration of this is found in the Talmud (*Kiddushin* 31b) which tells of R' Tarfon who honored his old mother in a most extraordinary fashion and later went to the House of Study and boasted to his colleagues about his outstanding devotion to this mitzvah. Their response to R' Tarfon was, "As much honor as you have given her, it is not even half of what a child should do for a parent!"

The Jerusalem Talmud (*Horiyos* 3:4) relates: Once R' Chiya conducted an appeal in the great *Beis HaMidrash* in Tiberius and one individual publicly pledged the munificent sum of an entire liter of gold to the cause. R' Chiya took the man and sat him next to him in the place of honor. He proclaimed that this generous donor personifies the words of King Solomon, מַתָּן אָדָם יַרְחִיב לוֹ וְלִפְנֵי גְדֹלִים יַנְחֶנּוּ, *A man's gift broadens access for him, and leads him before the great* (*Proverbs* 18:16).

‎⊰ Commemorative Plaques

R' Shlomo Ben Aderet (*Teshuvos HaRashba* 581) discusses an individual who donated his home to become a synagogue and wishes to install a plaque to commemorate his gift to the community. Some people wanted to prevent this, but *Rashba* rules that not only is

this permissible and appropriate, it is actually a hallowed custom from times of old. Indeed, he argues, this is the way of the Torah, for Scripture openly praises those who perform meritorious deeds in countless places. For example, he cites how the Torah praises Reuven for saving Joseph from death at his brothers' hands. If this is the way the Torah itself acts, should we not emulate the conduct of our Holy Scripture, whose ways are perfect and pleasing?

This ruling is accepted as the halachah by the *Rama* (*Yoreh Deah* 249:13), who, after denouncing those who give charity in order to glorify themselves, adds: "However, one who dedicates a specific object to a charitable institution may inscribe his name on it so that it should be an [eternal] remembrance for him, and it is appropriate to do so. The Vilna Gaon (ibid.) concurs and supports this ruling with the words of the Midrash (*Yalkut Shimoni Ruth* 604) which says that in days of old when someone performed a mitzvah wholeheartedly it was publicly recorded for posterity in Scripture. Nowadays, a great mitzvah is inscribed in a special book by Elijah the Prophet and the Messiah, and God Himself places His seal of approval on it!

Such publicity seems to contradict the Torah ideal of concealing one's good deeds. In his introduction to *Responsa Divrei Malkiel*, the author addresses this problem and explains the true reason for *Rashba's* ruling. "Great *tzaddikim*, even though they performed vast amounts of mitzvos in the course of their lifetime, are forever reluctant to leave this world even though they will pass on to their eternal reward, because death deprives them of further opportunities to produce good deeds. So the *tzaddikim* hit upon a scheme to 'defy' the ravages of death! They invest their resources in a building or an institution, which will survive them, and they publicly commemorate their contribution so that others will be inspired to follow their example and undertake long-lasting projects, which will outlive them. In this fashion a person insures that his donation will produce rich dividends long after he dies."

Thus we arrive at the following conclusion: The regular mitzvos for which every Jew is responsible certainly should be performed in a modest fashion and one should not boast about them — and *tzedakah* most of all. However, when someone exerts himself to do something extraordinary, and he sincerely feels that his example will encourage others to follow his ways, then it is highly appropriate to publicize this action.

✑ Have No Fear for Ayin Hara

R' Moshe Sternbuch notes that when an appeal for charity is conducted, it is proper for everyone to publicly announce their pledge so that others will see how important the cause is and be inspired to participate. Some people are loath to pledge publicly because they are afraid of attracting attention and bringing an *ayin hara*, an evil eye, upon themselves or their families or their wealth. This is incorrect. Nothing bad will result from performing a mitzvah. This situation is analogous to God's promise to those people who were reluctant to make the festival pilgrimage to Jerusalem because they were afraid that their gentile neighbors would cast an envious eye on their property in their absence. The pledge God made to them applies to our situation as well, וְלֹא יַחְמֹד אִישׁ אֶת אַרְצְךָ בַּעֲלֹתְךָ לֵרָאוֹת אֶת פְּנֵי ה' אֱלֹקֶיךָ שָׁלֹשׁ פְּעָמִים בַּשָּׁנָה, *No man will covet your land when you go up to appear before Hashem, your God, three times a year* (Exodus 34:24).

CHAPTER THIRTEEN

To Comfort the Poor

⛤ Encouraging Words Are Better Than a Contribution

R' Yitzchak said: Anyone who gives even a *perutah* [a small copper coin] to a pauper is blessed with six heavenly blessings. And one who comforts a pauper with kind words is blessed with eleven heavenly blessings *(Bava Basra* 9b).

Maharsha (ibid.) explains that these eleven blessings are reserved for the person who has no money to give, for otherwise one cannot fulfill his obligation to assist the poor by merely offering words of comfort without material help. Nevertheless, he who has *nothing* but kind words to offer the poor is more richly blessed than he who *only* donates money to the indigent; the comforter gives of himself (a much more meaningful act of charity), while the donor merely parts with his money.

Tosafos observes that one who succors the poor *both* financially and emotionally will receive the first six blessings *plus* eleven more for a total of seventeen blessings.

⛤ Offer Your Soul to the Hungry!

The Midrash *(Vayikra Rabbah* 34:15) teaches: The prophet cries out, הֲלוֹא פָרֹס לָרָעֵב לַחְמֶךָ וַעֲנִיִּים מְרוּדִים תָּבִיא בָיִת . . . וְתָפֵק לָרָעֵב נַפְשֶׁךָ וְנֶפֶשׁ נַעֲנָה תַּשְׂבִּיעַ, *Surely you should break your bread for the hungry, and bring the moaning poor to your home . . . and offer your soul to the*

hungry, and satisfy the afflicted soul (*Isaiah* 58:7,10). R' Levi said: If you have no money to give the poor man, at least offer him words of consolation. Tell him, "I feel your pain. I would give my life for you, if only that would get you some food!"

If you relieve the pauper's pain with such words then you will shine with the radiance of the sun at noon, for you are emulating the ways of the Creator. The Creator Himself will come to your assistance and He will protect you from any harm in the future and give you comfort.

⋳ Compassion's Reward

The Talmud *(Shabbos* 151b) teaches: It has been taught in a *Baraisa:* Rabban Gamliel bar Rebbi says: "Scripture states: וְנָתַן לְךָ רַחֲמִים וְרִחַמְךָ, *He will bestow upon you* [the attribute of] *compassion and show compassion to you* (*Deuteronomy* 13:18). From this we learn that whoever is compassionate toward God's creatures is shown compassion by heaven, and whoever is not compassionate toward God's creatures is not shown compassion by heaven."

⋳ To Soothe the Pain

R' Boruch Ber Lebowitz, the Rosh Yeshiva of Kamenetz, was one of the greatest Torah luminaries of the 20th century. He was renowned not only for his Torah wisdom but for his piety and fear of heaven which even surpassed his great wisdom. A student of his, R' Avrohom Pinkus, relates the following incident:

"Once while we students were sitting around the Rosh Yeshiva's table as he delivered a Talmudic lesson to us in his home, a beggar walked in and asked for *tzedakah.* The Rosh Yeshiva interrupted the lesson, searched through every one of his pockets, but not a kopek was to be found. So R' Boruch Ber humbly asked the beggar if he would be so kind as to go to the kitchen where his wife, the Rebbetzin, was, and ask her for some money. The beggar quickly went to the kitchen but immediately returned empty handed, explaining that the Rebbetzin was not home.

"The Rosh Yeshiva then turned to us and inquired whether any of us had some change to lend him. Every one of us made a thorough

search of our pockets but there was not a coin to be found in the entire student body. To his great consternation, the Rosh Yeshiva had no choice but to gently ask the beggar to please come back later in the day when the Rebbetzin would be home. Then they would surely find some money for him.

"As the beggar turned away and shuffled toward the door, the Rav got up from his chair at the head of the table, ran over to the pauper, and accompanied him to the front door. There he parted from the beggar with sincere words of hope and encouragement and showered blessings and warmest best wishes upon him.

"When the Rebbi returned to us, his students, he noticed a look of bewilderment on our faces. We had never seen the Rosh Yeshiva go to such extremes to honor a common beggar. The Rosh Yeshiva explained: 'You must realize that when someone comes to beg for alms he feels very uncomfortable and deeply ashamed. What makes this distasteful experience bearable? The alms that the pauper receives make him feel better about himself and eases his pain. In this instance, however, the pauper lowered himself to beg for help and got nothing in return. He was leaving my home feeling worse than when he came. Therefore, I felt that these unusual circumstances demanded of me to at least try harder to cheer him up with special words and acts of kindness and respect!'" (*Uvdos L'Beis Brisk,* Vol. I, p. 46).

ঙ R' Moshe Feinstein — The Essence of Charity

R' Moshe Feinstein was supposed to attend his first meeting as the newly appointed chairman of the *Moetzes Gedolei HaTorah of Agudath Israel of America.* The meeting was scheduled right after his regular *shiur* and *Minchah* in his yeshiva, Mesivtha Tifereth Jerusalem. A car was waiting for him outside the yeshiva and as soon as *Minchah* was over, the students surrounded their Rosh Yeshiva to escort him outside without a moment's delay, since many of the other distinguished members of the *Moetzes* would already be there waiting for him. As he was about to get into the car a poor man asked him for charity. R' Moshe reached into his pocket and gave the man a few coins, but the beggar was not finished. He began a conversation with R' Moshe while the waiting driver and the students became more and

more impatient. A few attempted to tell the poor man that R' Moshe was in a hurry, but R' Moshe waved to them to go away. After ten minutes, R' Moshe excused himself, shook hands with the beggar and finally got into the car.

One of the students gathered up the courage to ask his *Rebbi* why he had not simply given the man the money and said that he had no time to talk.

R' Moshe replied, "You must understand that to that man the conversation meant more than the money. My mitzvah of *tzedakah* included showing him that I care about what he thinks and that I am not too busy to speak to him."

R' Moshe's older son, R' Dovid, remarked, "My father never wasted a minute, but if a poor or troubled person — or even a *nudnik* — took an hour to pour out his heart, my father could spare an hour" (*Reb Moshe*, ArtScroll/Mesorah; p. 176).

◄§ The Wheel of Fortune

The Talmud (*Shabbos* 151b) teaches: R' Elazar Hakappar says: "A person should always ask God for mercy regarding this fate, poverty. That is, one should pray that he does not become poor, for every family becomes poor sooner or later. If he himself does not become poor, his son may become poor, and if his son does not become poor, his son's son may come to be, for it is stated: נָתוֹן תִּתֵּן לוֹ וְלֹא יֵרַע לְבָבְךָ בְּתִתְּךָ לוֹ כִּי בִּגְלַל הַדָּבָר הַזֶּה יְבָרֶכְךָ ה' אֱלֹקֶיךָ בְּכָל מַעֲשֶׂךָ וּבְכל מִשְׁלַח יָדֶךָ, *You shall surely give him [the poor person], and let your heart not feel bad when you give him, for in return ['biglal'] for this matter [of charity] Hashem, your God, will bless you in all your deeds and in your every undertaking.* (Deuteronomy 15:10). In the academy of Rabbi Yishmael they taught that the word בִּגְלַל, *biglal*, 'in return,' is cognate with the word *galgal*, 'a wheel.' Financial status is like a wheel of fortune which constantly revolves in the world; as one man's fortunes rise, another man's fortunes sink. Thus, poverty is a cyclical phenomenon, never permanently removed from any individual or his descendants.

R' Chiya said to his wife: "When a poor person comes to our door, be quick to offer him bread, so that others will be quick to offer bread to your children when they are beggars." She said to him: "Are you

cursing our children that they should become poor?" R' Chiya responded: "It is not I but Scripture for it is written in the verse, כִּי בִגְלַל הַדָּבָר הַזֶּה, for in return ['biglal'] for this matter [of charity], and a Baraisa has been taught in the academy of R' Yishmael: Poverty is like a גַּלְגַּל, wheel, that revolves in the world; sooner or later everyone becomes poor. Thus it is quite possible that our children may be paupers."

◄§ Wealth Insurance

The Talmud (Zevachim 113b) states that the wealth of the affluent families in Babylonia did not endure for three generations. Rashi (ibid.) explains the reason: "It is because they had no compassion for their fellow men." Maharsha explains that poverty is ordained to strike one of every three generations (see Shabbos 151b) but one may avert this fate through sincere prayer.

Masechta Derech Eretz Zuta (Chapter 9) counsels: "Always love the poor so that your own children will not suffer their fate! Let the doors of your house always be wide open [to welcome the poor] and that will protect your income from being diminished. Be careful lest the doors of your home be locked while you are dining or drinking, because the locked doors of one's home bring him to poverty!"

Aruch Hashulchan (Yoreh Deah 247:5) records: "I personally have received a tradition that when an individual goes from door to door to collect charity for others, this merit will save his children and future generations from becoming beggars."

How foolish are the people who spend their lives amassing fortunes in order to 'insure' their children's future financial security. They fail to realize that the only 'wealth insurance' is to give money away to charity and to collect charity for others.

◄§ Someday Soon You Will Be a Giver

R' Yisroel of Rizhin made the following observation: The Torah concludes the section which deals with charity with this verse: כִּי לֹא יֶחְדַּל אֶבְיוֹן מִקֶּרֶב הָאָרֶץ, עַל כֵּן אָנֹכִי מְצַוְּךָ לֵאמֹר, פָּתֹחַ תִּפְתַּח אֶת יָדְךָ לְאָחִיךָ לַעֲנִיֶּךָ וּלְאֶבְיֹנְךָ בְּאַרְצֶךָ, For destitute people will not cease to exist within

the land; therefore I command you, saying, "You shall surely open your hand to your brother, to your poor, and to your destitute in your land" (*Deuteronomy* 15:11). R' Yisroel noted that the Hebrew word לֵאמֹר, *saying*, appears to be unnecessary and therefore should more correctly be translated as *to say*. God is telling us that it is not enough just to contribute money to the needy; rather one must comfort them by saying to them, "Don't feel bad because you are on the receiving end. It won't be this way forever. The wheel of fortune is forever turning. The day will come, in the not-so-distant future, when you will be the wealthy giver and the tycoons of today will be the takers of tomorrow!" Thus, the verse is read: *Therefore, I [God] command you [the donor] to say [to the beggar], "You yourself shall [soon] surely open your hand to your brother. . ."*

⊷§ The Poor Are Not to Blame

R' Aharon, the son of the Chofetz Chaim, writes (*Dugmaos,Midarkei Avi* p. 38): My father was extremely careful with the beggars who went around collecting alms and took great pains not to hurt or upset them in any way. This was no mean feat because these beggars would sometimes say or do things that were very disturbing and one had to exercise great self-control not to reply to them in a sharp, hurtful way. Father explained that his diligence was based on the verse, כָּל אַלְמָנָה וְיָתוֹם לֹא תְעַנּוּן, *You shall not cause pain to any widow or orphan* (*Exodus* 22:21). *Mechilta* (ibid.) explains that this warning extends to all people who are broken hearted and it is prohibited to cause them even the slightest pain.

I remember that Father once remarked, "The problem is that people misjudge the poor and look at them with a jaundiced eye. People are wont to say that these beggars are lazy good-for-nothings who would rather beg than put in a hard day's work. Nothing could be further from the truth. Often the poor are not to blame; they are victims of a Divine curse! For the Sages of the Talmud (*Niddah* 16b) teach that before a soul descends to earth a heavenly decree proclaims, 'So-and-so will be rich, so-and-so will be poor!' In order to make that decree come true, heaven above pumps tremendous ambition and energy into the man who is predestined to be rich so that he is motivated to toil incessantly to make more and more money. Heaven

bestows so much vitality upon this person that he never seems to grow fatigued and he can work day and night without a stop. On the other hand, the one predestined to be poor is prevented from accomplishing anything. In other words, the heavenly decree is not, 'Let this man be penniless!' Rather it is, 'Let this man be listless!' In Yiddish they say, 'Fun himmel, mehn gist eim uhn mit blei' — 'From heaven they fill him up with molten lead' which weighs him down, saps his strength and prevents the pauper from doing anything to improve his lot. The pauper is not indolent by choice, but because of a curse. We should be filled with pity for these poor souls and do all we can to alleviate their suffering."

ᴖ A Stone Off My Heart

Under ordinary circumstances, the Gerrer Rebbe did not give private audiences to women. However, when the petitioner was a lonely, heartbroken widow, the Rebbe made an exception in order to comfort the brokenhearted. Once, a poor widow came to the Rebbe with a desperate plea for money to marry off her daughter. The Rebbe promised to send a generous sum to her home through his gabbai. When the gabbai returned from his mission he described to the Rebbe how elated and relieved the widow was when she received the awaited funds. She actually cried out in Yiddish, "Ah shtein is arup fuhn mien hartz!" — "A heavy stone has been lifted from my heart!" In a whisper, the Rebbe responded to the gabbai, "Fuhn vemen's hartz?" — "From whose heart?" Her desperate plight had been weighing more heavily on the Rebbe's heart than on her own!

ᴖ Care Wisely for the Poor

King David exhorts us to think carefully before we give charity and to perform the deed with the proper attitude and sensitivity. He says: אַשְׁרֵי מַשְׂכִּיל אֶל דָּל, Praiseworthy is he who cares wisely for the impoverished (Psalms 41:2). The great Amora R' Yonah observed, "The Psalmist uses his words most judiciously. He does not say, Praiseworthy is he who gives to the impoverished, rather, Praiseworthy is he who cares wisely for the impoverished. One must analyze this

mitzvah of *tzedakah* very carefully to come up with the best strategy for its fulfillment."

How did R' Yonah himself put his dictum into practice? When he learned of an upstanding person who had lost his wealth, he would approach the man with a proposal. "My son, I just heard that you are about to inherit a great fortune from a relative in a faraway place. Here, take this sum of money from me now and you can pay me later when you actually take possession of your inheritance." In this way the recipient accepted the money with his pride intact. Later, R' Yonah would visit the beneficiary and tell him, "Just in case the inheritance doesn't come through, I am giving you the money as a gift; forget about any payment" *(Jerusalem Talmud; Peah 8:8)*.

ᴥ The Poor Get Double

The Talmud (*Niddah* 16b) teaches that before the embryo is formed, the angel appointed over conception brings the parents' seed before God and asks, "What will be the nature of the child who will emerge from here? Will the child be strong or weak? Wise or foolish? Rich or poor?" Human existence is a test, and everyone is tested differently. One person's purpose in the universe may be fulfilled by overcoming the trials and tribulations of poverty, while another may achieve his ultimate perfection by withstanding the tests and temptations of wealth and luxury.

Which test is preferable? Viewing success from the vantage point of this materialistic world, the answer would be, 'riches.' But if we evaluate life from the perspective of the next world, as the Rabbis did, we would view things differently.

The Midrash (*Shemos Rabbah* 31:3) teaches: Fortunate is the man who withstands his personal test, for there is no creature whom God does not test. God tests the rich man to see if his hands will open generously to the poor. He tests the poor man to see if he will bear his afflictions patiently without complaining against God's ways. If the rich man withstands his test and gives charity, then he will eat the fruits of his wealth in this world while the principal will be conserved for his enjoyment in the Hereafter. If the poor man withstands his afflictions and doesn't rebel against God, he will be rewarded with a *double portion* in the World to Come."

Why does the poor man merit a 'double reward'? *Michtav MeEliyahu* (Vol. I, p. 152) explains this in light of the Midrash (*Vayikra Rabbah* 34:8): "The poor man does more for the rich man than the rich man does for the poor." The rich man merely gives the poor man some money. The poor man, however, gives the rich man a mitzvah for eternity. Thus, the poor man has a double mitzvah: 1) The poor man suffers the misery of poverty without complaint. 2) He gives the rich man an opportunity to do charity. Therefore, the poor man has earned his double reward in the World to Come.

CHAPTER FOURTEEN

Pledges to *Tzedakah*

◆§ Do Not Delay

The Torah warns, כִּי תִדֹּר נֶדֶר לַה׳ אֱלֹקֶיךָ לֹא תְאַחֵר לְשַׁלְּמוֹ, *When you make a vow to Hashem, your God, you shall not be late in paying it* (*Deuteronomy* 23:22). One who does not fulfill his vow to bring an offering to the Temple before the passage of the next three *regalim* (pilgrimage festivals) is in violation of this negative commandment (*Rashi* ibid. based on *Rosh Hashanah* 6a). But in regard to vows to charity, Rava rules (*Rosh Hashanah* 6a) that immediate payment is required, since poor people are always available and their urgent needs must be met without delay.

Rava's opinion is codified in the *Shulchan Aruch* (*Yoreh Deah* 257:3): "Donations to charity fall into the category of vows. Therefore, if one says, 'I take upon myself the obligation to give a certain amount to charity' or he says, 'This coin is allocated to charity,' he is obligated to give it to the poor immediately. If he delays, he transgresses the negative command, בַּל תְּאַחֵר, *bal t'acher, You shall not be late in paying it,* because he is able to pay his pledge immediately and the needy people are available. If no poor people are available, he should set aside this sum of money and leave it until he comes across people in need."

The *Shulchan Aruch* there concludes: "The obligation to pay a pledge immediately only applies to someone who designates money for charity without defining specific conditions. However, a person may stipulate that he intends to keep the money he is separating for charity under his own control in order to give it out a little at a

time to a variety of poor people as he sees fit."

Based on this ruling, R' Shlomo Zalman Auerbach recommends that when a person begins his personal *maaser* fund, he should explicitly stipulate that he reserves the right to give out the funds piecemeal over a period of time so that the laws of *bal t'acher* should not apply to his distribution.

Rama in his gloss to *Shulchan Aruch* (ibid.) notes that *bal t'acher* does not apply to pledges made in the synagogue or elsewhere which are meant to be collected by a *gabbai tzedakah,* a community charity collector. In such cases, one can hold on to his money as long as the *gabbai tzedakah* has not asked for payment, even though the poor people or the charitable organization needs the money immediately. If one made a pledge to an organization, but the *gabbai tzedakah* responsible for that cause is unaware of the pledge, the person is obligated to inform the *gabbai* of what he vowed so that the *gabbai* can come to collect it.

⊷§ Holding Back the Rain

The Talmud *(Taanis 8b)* teaches: R' Yochanan said: Rainfall is withheld only because of those who pledge charity in public and do not pay, as it is said: נְשִׂיאִים וְרוּחַ וְגֶשֶׁם אָיִן, אִישׁ מִתְהַלֵּל בְּמַתַּת שָׁקֶר, *Clouds and wind, but no rain [falls], when a man is praised for a false gift* (*Proverbs* 25:14).

The lesson is clear: When a person delays payment of his vows, God also delays the blessings He had in store for him and for those close to him.

⊷§ Bli Neder

It is preferable not to make a vow to charity since there is always the concern that a person may forget to honor his vow or he may not be able to do so. However, if circumstances warrant making a pledge to *tzedakah,* then one should add, בְּלִי נֶדֶר, *bli neder* i.e., 'without a vow.' In this way a person declares that his pledge was not a vow, but merely an indication of intent (see *Yoreh Deah* 257:4).

◆§ Serve the Poor Promptly

Responsa *Dvar Avrohom* (Vol. II, 2 in footnote) writes: I heard in the name of the great *gaon* and *tzaddik,* our master, R' Yisroel Meir HaKohen of Radin (the Chofetz Chaim), that if one invites a poor man to dine at his Sabbath table, then the host must begin his meal immediately upon his arrival from shul without any delay. The Talmud (*Rosh Hashanah* 4a) teaches that when one makes a pledge to charity, he must distribute the money to the poor immediately, if there are poor people around. If he delays, he transgresses the negative commandment of *bal t'acher*: *You shall not be late in paying your vow* (*Deuteronomy* 23:22). Inviting a pauper to dine at one's Shabbos table is tantamount to vowing to give him charity. As such, the vow must be paid in full immediately. In fact, the essence of this concept was recorded by the Chofetz Chaim himself in his *Mishnah Berurah* (*Shulchan Aruch, Orach Chaim* 639, in *Shaar Hatziyun* 67).

◆§ Extreme Care to Honor Pledges

A large crowd gathered in Jerusalem to hear eulogies in memory of R' Leib Cheifetz, a pious Torah scholar. At the conclusion of the eulogies, the cantor chanted קֵל מָלֵא רַחֲמִים, *Keil Malei Rachamim,* the prayer for the deceased. The moment the cantor finished the prayer, R' Yehoshua Leib Diskin went over to the synagogue's *gabbai tzedakah* and gave him a sum of money for charity. The Rav explained that he was giving the money on behalf of all those who were present when the cantor recited the memorial prayer. In the text of the memorial prayer it says that all the assembled people will give charity for the merit of the deceased. It was as if the cantor made a charitable vow for the entire assemblage. R' Yehoshua Leib wanted to make sure that no one would be guilty of violating the vow to give charity, so he gave charity on their behalf (*Amud Aish,* p. 155).

◆§ Additional Laws of Pledges to Charity

1) A pledge to charity is a binding *neder,* vow, which must be fulfilled under all circumstances. The only way out of the vow is if a Rabbi

annuls the vow (*Yoreh Deah* 258:6). However, under ordinary circumstances a Rabbi should never annul a charitable vow because he is causing a monetary loss to the poor; a Rabbi who does this should be punished *(Radvaz* cited by *R' Akiva Eiger* and *Pischei Teshuvah* ibid.). Once the pledge has been redeemed and the money has been handed over to the *gabbai tzedakah,* the vow can no longer be nullified, and the donor can make no more claims on his money.

2) The following financial commitments are considered to be charitable vows even though no mention was made of charity: A) A person who promises a personal, friendly gift to a poor friend (*Yoreh Deah* 258:12). B) A person who hires a poor man to do work for him and promises to pay him a salary which exceeds the normal pay scale in order to give him charity in an honorable way (*Ketzos Hachoshen, Choshen Mishpat* 264:4).

3) If someone made a vow and said, "If so-and-so who is deathly ill will be cured, I will donate such-and-such an amount to *tzedakah,*" and then the sick person died, the person is exempt from fulfilling his vow because it was clearly conditional (*Rama, Yoreh Deah* 220:15). However, if one pledged *tzedakah* in the *hope* of a recovery for a sick person, but did not verbalize any conditions to his pledge, the pledge must be honored even if the person died (*Tzedakah Umishpat,* 4:10).

4) Ordinarily, a person must verbalize a vow in order for it to become an obligation. A mere thought has no halachic significance. In regard to charity the law is different. Although it is true that if one merely thinks about giving a gift to a poor person or an institution, but has made no firm decision, this mental consideration is not binding; nevertheless, once a person has made up his mind to make a charitable gift and has assumed a firm mental commitment, this thought is binding and the mental pledge must be fulfilled (*Rama, Yoreh Deah* 158:13)! *Mishnah Berurah (Orach Chaim* 694:2) concurs with this ruling and explains (in the name of *Beis Yosef* and *Hagahos Ashri*) that a charitable vow is like *nidrei hekdesh,* a pledge to the Holy Temple, where even a mental commitment is binding.

5) A common situation where this halachah comes into practice is when a person sees a pauper going around collecting in the synagogue during prayers and he casually thinks to himself that if the poor man comes to him he will give him something. However, the poor man leaves without soliciting this individual. This casual,

conditional thought is *not* a vow to charity because it is human nature to come up with an idea and then to change one's mind. A thought is only considered a binding vow when one makes a firm mental commitment to follow through under all circumstances (*Magen Avrohom* to *Shulchan Aruch, Orach Chaim* 562 section 11 and *Machtzis Hashekel* ibid.).

6) There is an opinion that holds that even a firm mental commitment to charity is *not* considered to be a binding vow, except in a situation where a person *did* verbally pledge to give money to charity but *did not* verbally specify the amount he would give or the cause to which he would donate. Later, this person makes up his mind as to the amount and the cause. Only in such a case is his mental commitment binding, because it was preceded by a verbal (albeit unclarified) statement (*Responsa Dos Aish* cited in *Pischei Teshuvah, Yoreh Deah* 258:13 and *Gilyon Maharsha* ibid.).

7) R' Moshe Sternbuch explains that according to the *Rambam* the only vows which become binding with thought alone are vows to offer sacrifices to the altar of God, as it says, וְכָל נְדִיב לֵב עֹלוֹת, *And all those with generous hearts brought burnt-offerings* (*II Chronicles* 29:31). For all other vows, thoughts of the heart are not binding. However, when one provides a destitute person with his basic, primary life support, this is tantamount to offering a sacrifice of flesh and blood to God, and so even the thought to give such charity is binding. Similarly, a thought to give a donation to support Torah study is like bringing an offering to the Almighty. But other types of *tzedakah,* such as providing for nonessential, secondary needs of the poor, are not tantamount to an offering and only verbal vows are binding in such cases (*Taam Vodaas, Devarim* 23:24).

≈§ Public Pledges Are Preferable

Tosefta *(Peah,* 4:17) says: "Whoever pledged to give charity and gave it is granted a double reward — both for his pledge and for his charitable deed."

The Chofetz Chaim (*Ahavas Chesed,* Part II, footnote to Chapter 16) notes that from here we learn that a person should always make a verbal commitment to fulfill every mitzvah he intends to do, because his devout words make a profound impact in heaven above and

significantly enhance the sanctity of the mitzvah act (see *Nedarim* 8a). This is especially the case regarding charitable appeals, where everyone who makes a public pledge reinforces the resolve of others to follow his generous example. There are certain 'pious' people who excuse themselves from participation in public appeals saying that they do not want to make a vow and they do not want to publicize their charity. The *Tosefta* cited above proves how wrong they are. The public pledge, which inspires others, is part and parcel of the mitzvah. And if they are concerned about making a vow, which is indeed a serious matter, let them say, *bli neder,* after they utter their verbal pledge.

A note of caution: Sometimes, a well-intentioned person will participate in a public appeal by making a sizable pledge which he has no intention of paying in full or at all. He only makes this impressive pledge in order to encourage others to participate generously. *Responsa Minchas Yitzchok* (Vol. III, 97) rules that such a practice, however well intentioned, is absolutely forbidden.

✥ Beyond Any Shadow of Doubt

R' Moshe Sofer of Pressburg was presented with the following dilemma *(Responsa Chasam Sofer, Yoreh Deah* 240): A man was honored with an *aliyah* to the Torah and afterwards made the customary pledge to *tzedakah.* In that particular city there were quite a few charitable causes to which people would usually dedicate their *aliyah* pledges — the yeshiva, *hachnassas kallah, bikkur cholim,* etc. The man was sure that when he made his pledge he did have one specific cause in mind, but afterwards he forgot which cause he had designated. Should he donate the full amount that he pledged and have it divided equally among all the local charities, or must he give the full amount of his pledge to each charity in town?

The *Chasam Sofer* rules that when it comes to paying a *tzedakah* pledge one must always adopt the stricter position in order to fulfill his pledge beyond any shadow of a doubt. Therefore, he must donate the full amount of his pledge to each and every charity in town.

The following is a list of similar situations where a person is in doubt as to his *tzedakah* obligations:

1. *Shulchan Aruch (Yoreh Deah* 258:3) rules that one who pledged a certain amount to a *tzedakah* but later finds that he is unable to

recall the amount is obligated to contribute the largest amount a person like himself would normally give this charity.

2. A person who borrowed money from a charity but is unable to remember how much he borrowed must repay a sum which is undoubtedly equal to or more than the amount he originally took as a loan (*Tzedakah Umishpat*, Chapter 7:34).

3. If one inadvertently mixed his personal funds with charity funds, he must repay the *tzedakah* fund a sum which is beyond any doubt at least as much or more than the amount originally belonging to the charity (*Yoreh Deah* 259; *Pischei Teshuvah* 13).

⋙ Open Now Before It Is Too Late

The Torah states: וְלֹא תִקְפֹּץ אֶת יָדְךָ מֵאָחִיךָ הָאֶבְיוֹן. כִּי פָתֹחַ תִּפְתַּח אֶת יָדְךָ לוֹ, *Nor shall you close your hand against your destitute brother. Rather, open, and continue to open your hand to him* (Deuteronomy 15:7,8). What is the significance of the repetition, *open, and continue to open your hand*? This can be explained with the words of the Midrash (*Koheles Rabbah* 5:21): R' Meir observed, "When a person comes into this world as a baby, his fists are clenched, as if to say, 'The entire world is mine and I intend to hold on to it!' But when a man dies and leaves this world his hands are open and outstretched, as if to say, 'Nothing I acquired is really mine, for I must leave everything behind!' This is as King Solomon said: כַּאֲשֶׁר יָצָא מִבֶּטֶן אִמּוֹ עָרוֹם יָשׁוּב לָלֶכֶת כְּשֶׁבָּא וּמְאוּמָה לֹא יִשָּׂא בַעֲמָלוֹ שֶׁיֹּלֵךְ בְּיָדוֹ, *As he emerged from his mother's womb, naked will he return, as he had come; he can salvage nothing from his labor to take with him* (Koheles 5:14).

This is alluded to in the repetition פָּתֹחַ, *open*, unclench your fists while you are still alive and can give charity, because inevitably, תִּפְתַּח, *you will continue to open your hand*, on the day you die; you cannot take your money with you (*Me'il Tzedakah*, Vol. II, 551).

⋙ Wills and Estates

1. If a person dies and leaves a written will which states that he pledged money or property to charity while he was alive, the will

must be honored. Moreover, even if this written statement was not recorded in the form of a formal will and was not signed by witnesses, but was merely found among the deceased's papers, we must fulfill the promise and we need not be concerned lest the deceased changed his mind and regretted his written commitment before he died (*Aruch Hashulchan, Yoreh Deah* 247:7).

2. If a person made a verbal pledge to *tzedakah* but died before it was redeemed, his heirs are obligated to fulfill this vow and give the amount pledged to *tzedakah*. However, they are only obligated to pay the pledge from the money left over in the estate of the deceased, not from their personal funds (*Beis Lechem Yehudah, Yoreh Deah* 248. See *Tzedakah Umishpat,* Chapter 4:28,29 at length).

3. If an individual set aside money for charity without designating a specific cause and he passed away, the executors of the estate should contribute the money to the best cause, which is the support of Torah study (*Daas Torah, Yoreh Deah* 259).

When
to Give

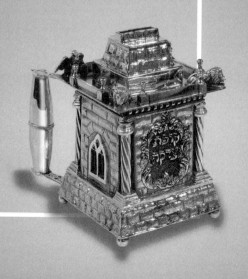

CHAPTER FIFTEEN

Giving at All Times

✑ *Tzedakah* Opportunities Unlimited

There are a host of reasons and unlimited opportunities to give *tzedakah* all day and all night, every day of the year, at every special occasion. אַשְׁרֵי שֹׁמְרֵי מִשְׁפָּט עֹשֵׂה צְדָקָה בְכָל עֵת, *Praiseworthy are those who maintain just standards, those who perform charity at all times* (*Psalms* 106:3). In this chapter we will attempt to demonstrate the vast scope of the mitzvah of *tzedakah*.

✑ Give *Tzedakah* Every Day

The Chofetz Chaim (*Ahavas Chesed*, Part II; Chapter 12) writes:
One should be very careful not to be remiss in practicing acts of kindness even for a single day, in the very same way that one is scrupulous to set aside fixed times for daily Torah study. I found in the *Sefer Hakedushah* of R' Chaim Vital that, every day, one should bemoan: "Woe unto me! I have allowed another day to pass by without Torah and acts of kindness!" The deeper meaning of this is as follows: The Mishnah (*Avos* 1:2) teaches: *The world stands on three things — on the Torah, on the sacrificial service in the Temple, and upon acts of loving-kindness.* Since the Temple was destroyed on account of our many sins, the sacrificial service has been denied to us; therefore, we must put greater effort into the remaining pillars of Torah and kindness.

In truth, acts of charity and kindness secure atonement as effectively as Temple sacrifices as we learn from this passage (*Avos D'Rabbi Nassan*, Chapter 4): Once, R' Yochanan ben Zakkai and R' Yehoshua were

leaving Jerusalem. They noticed the Temple lying in ruins. R' Yehoshua cried out, "Woe to us that the place where we sought forgiveness for our sins is destroyed!" R' Yochanan ben Zakkai responded, "My son, do not be upset. We still have a means of achieving forgiveness which is equal to the Temple service — acts of kindness, as the verse states: כִּי חֶסֶד חָפַצְתִּי וְלֹא זָבַח, *For kindness — not sacrifice — was My desire.*" (*Hosea* 6:6). Since everyone commits some sins every day, the Temple altar was never without sacrifices every day. And since charity and kindness take the place of sacrifices today, we must take care to practice kindness every day of our lives! (See the section, "Prayer and Charity," for details of the obligation to give *tzedakah* before every prayer.)

✑ *Tzedakah at Every Meal*

The Talmud (*Sanhedrin* 92a) teaches: Whoever does not leave over bread on his table after his meal will never see a sign of blessing. This is codified as the halachah in *Shulchan Aruch, Orach Chaim* (180:2) where *Mishnah Berurah* explains that food should be left over after the meal so that it will be immediately available for consumption by the hungry paupers who come by.

Mishnah Berurah also quotes the *Shelah Hakadosh* who says: "The proper way is to give the poor the very best food on the table, particularly if the pauper is a distinguished person, because in this way the poor man will feel welcome and respected. Moreover, I reserve special praise for those communities, whch feed poor yeshiva students all year long. Individual families 'adopt' one or more *bachurim* and treat them like their own sons and they always eat at ther table. Thus, the hosts earn a double mitzvah; first, the mitzvah of *tzedakah* for feeding the poor. Second, they earn the mitzvah of speaking words of Torah at the table, because what else would a *yeshiva bachur* talk about at the table other than Torah? Families who have such guests every morning and every night are considered as having offered the two daily sacrifices in the *Beis HaMikdash.*"

✑ *Charity Helps Torah Study*

The holy *Arizal* advised that if one is having difficulty understanding his Torah studies, he should give a coin to charity and in the

merit of opening up his hand the gateways of wisdom will be opened wide before him. *Pnei Yitzchak (Parshas Re'ei)* says that the Talmud *(Shabbos* 104a) alludes to this when it discusses the meaning of the letters of the Hebrew alphabet. The *Gemara* explains that the first two letters, *aleph beis,* stand for 'Aluph Binah,' learn understanding. The second two letters, *gimmel dales,* stand for 'Gemol Dalim,' be kind to the poor. The reason why Hashem arranged the alphabet in this order is to teach us that if a person is having difficulty with fulfilling the mandate of the first two letters, to 'learn understanding,' he should immediately follow the mandate of the second pair of letters and 'be kind to the poor'! [See *Shomeia Tefillah;* Chapter 76].

Chida (Chadrei Beten, p. 161) explains this further. The reason why one experiences excessive difficulty in comprehending the Torah may be that his sins create an impediment that separates between himself and the holy Torah. Therefore, the *Arizal* advises that the most effective way to eliminate this unholy interference is to cleanse the soul with tearful prayer and pure charity.

◆§ *Times of Distress*

Our forefather, Jacob, fled from the Holy Land, fearing lest he be slain by the hand of his brother, Esau. וַיִּדַּר יַעֲקֹב נֶדֶר לֵאמֹר, אִם יִהְיֶה אֱלֹקִים עִמָּדִי וּשְׁמָרַנִי בַּדֶּרֶךְ הַזֶּה אֲשֶׁר אָנֹכִי הוֹלֵךְ... וְהָאֶבֶן הַזֹּאת אֲשֶׁר שַׂמְתִּי מַצֵּבָה יִהְיֶה בֵּית אֱלֹקִים, וְכֹל אֲשֶׁר תִּתֶּן לִי עַשֵּׂר אֲעַשְּׂרֶנּוּ לָךְ, *Then Jacob took a vow, saying, "If God will be with me, and guard me on this way that I am going,.. then this stone which I have set up as a pillar shall become a house of God, and whatever You will give me, I shall repeatedly tithe to you" (Genesis* 28:20,22).

The Midrash *(Bereishis Rabbah* 70:1) says that Jacob was speaking to all future generations. He meant to set an example that in times of danger or distress, one should make a vow to charity, which will be a source of merit to rescue one from trouble. This rule is codified in *Shulchan Aruch, Yoreh Deah* 203:5. *Tosafos (Chullin* 2b, s.v. *'avol')* makes it clear that although halachah discourages a person from making vows under ordinary circumstances, it is meritorious to make vows in times of distress.

In a time of danger or distress, a person is being judged according to the Divine Attribute of Strict Justice. Therefore, it is advisable to

arouse the Divine Attribute of Mercy by being merciful to the poor and dispensing charity to them (*Taam Vodaas, Parshas Vayishlach* 32:21).

✒️ An Antidote for Distress

Ritva (Commentary to *Nedarim* 9a) writes: Throughout the ages the Jewish people have followed the example of their father, Jacob, so that whenever someone is sick or in distress, or finds his children in a dangerous situation, they customarily make a vow, stating, "I hereby commit myself to donating such and such an amount to charity if I will be saved from harm." Furthermore, there are certain communities where the custom on Rosh Hashanah and Yom Kippur is to make special pledges to charity, as well as pledges to supply the oil to illuminate the synagogue . These awesome days are considered to be an עֵת צָרָה, a 'time of distress,' because the Books of Life and Death are open before God and He sits in judgment to decide the fate of man for the coming year. Therefore, people make pledges to *tzedakah* as an extra merit to be saved from strict judgment, and they are scrupulous to pay these vows on the very next day following the holiday.

✒️ Nighttime

According to *Arizal* one should not give *tzedakah* at night, because charity is meant to arouse the Divine Attribute of Mercy and the night is designated as a time of strict Divine Judgment, so the two are incompatible (*Birkei Yosef, Orach Chaim* 235:1 and *Yoreh Deah* 247:1). This opinion is supported by the *Yerushalmi* (*Shekalim* 5:4).

Many *tzaddikim* held that the *Arizal's* restriction only applied to a voluntary charitable gift offered at night. However, if someone is solicited by a person in need at night, then he certainly must respond to this request immediately. [See *Shemiras Haguf V'Hanefesh* Chapter 257 for a comprehensive discussion of this issue.]

Responsa Maharsham (Vol. II, 43) says that this restriction only applies to giving in public, but one may certainly give a *mattan b'seiser*, a private donation, even at night. This was the practice of the *Chasam Sofer* as well.

◆§ Before Sleep

Sefer Zechirah (Inyanei Olam Hazeh, p. 105) advises that it is an excellent idea to place a *pushka*, a *tzedakah* box, near one's bed so that immediately before one goes to sleep he can give charity. When a person sleeps, his soul ascends heavenward to give an account of his daily activities, and it is very beneficial to have the merit of charity precede it as it climbs on high, as it says: צֶדֶק לְפָנָיו יְהַלֵּךְ וְיָשֵׂם לְדֶרֶךְ פְּעָמָיו, *Charity will walk before him, and he will set his footsteps on the way* (Psalms 85:14).

R' Kolman Krohn of Lakewood, New Jersey would periodically travel to Manchester, England to spend time with the great Rosh Yeshiva, Rabbi Yehuda Zev Segal. Often he would stay in Rav Segal's home, carefully observing his pious customs and mode of daily living.

Late one evening, R' Kolman noticed that as Rav Segal was about to go to sleep, he took out a coin from a drawer, walked over to a *pushka*, prayed for a few moments with great intensity, and then placed the coin into the collection box. His curiosity aroused, R' Kolman asked Rav Segal about the purpose of the *tzedakah* and the prayer.

"Kolman," the Rosh Yeshiva said softly, "I am about to go to sleep. How do I know that I will get up? What guarantee do I have that the *Ribbono Shel Olam* will return my soul to me tomorrow morning? So I give *tzedakah*, because וּצְדָקָה תַּצִּיל מִמָּוֶת, *Charity redeems from death* (*Proverbs* 10:2, 11:4)!"

"And the prayer before giving?" R' Kolman asked.

"I pray to the *Ribbono Shel Olam*," said the Rosh Hayeshiva, "that I gain from my sleep all that I am supposed to, that I wake up refreshed so that I can learn with a clear mind, and that my body be refreshed and healthy so that I may serve *HaKadosh Baruch Hu* as I should." (*Along the Maggid's Journey*, p. 164).

◆§ Pregnancy and Childbirth

Shelah Hakadosh (Maseches Tamid, Ner Mitzvah 103) writes that when a women enters into her ninth month of pregnancy, she and her husband should designate a day of voluntary fasting, prayer and repentance. As the fast day draws to an end they should intensify their prayers for a safe birth and a healthy baby and they should make generous contributions to worthy poor people.

Me'il Tzedakah (Vol. II, 384) explains that charity is essential at this time because even though the Almighty has many angels who are His agents to control many aspects of nature, God takes care of certain things Himself. One of them is the opening of the mother's womb at childbirth (see *Taanis* 2a). This is such a dangerous and delicate moment that it requires God's most intense involvement and compassion. Those who care for God's 'family,' the poor, are considered as if they did God a personal favor, as it says, מַלְוֵה ה' חוֹנֵן דָּל, וּגְמֻלוֹ יְשַׁלֶּם לוֹ, *One who is gracious to the poor has lent to Hashem, and He will pay him his reward* (Proverbs 19:17). Thus, by giving charity right before the time of birth, the pregnant woman assures that God Himself will have mercy on her and open her womb at the right time in the proper way.

⊷§ Before Embarking on a Journey

It is good to give *tzedakah* before one embarks upon a journey, as it says צֶדֶק לְפָנָיו יְהַלֵּךְ וְיָשֵׂם לְדֶרֶךְ פְּעָמָיו:, *Charity will walk before him, and he will set his footsteps on the way* (Psalms 85:14) (*Eliyahu Rabbah, Orach Chaim* 110:4).

⊷§ Chanukas Habayis

When R' Rephael Soloveitchik and his wife moved into their new apartment after they were married, he asked his father, the Brisker Rav, if he should make a *chanukas habayis,* a special celebration to consecrate a new dwelling. The Brisker Rav answered that for the first meal he eats in his new home he should invite a poor person to be his guest and share in the meal. That was how R' Rephael celebrated the *chanukas habayis.*

⊷§ Shabbos

Many sources encourage giving *tzedakah* on Friday in preparation for Shabbos. Indeed, the *Maor Veshemesh* (*Parshas Vayakhel* p. 287) explains the Talmudic dictum, "He who toils and prepares on the

eve of the Sabbath will have what to eat on the Sabbath" (*Avodah Zarah* 3a), in the context of *tzedakah*. The *Gemara* intends that whenever a person toils to earn money throughout the week, he should have two motives in mind. Number one: his need to earn money in order to buy all that is necessary for Shabbos. Number two: his need to have money in order to give *tzedakah*. When a person has kept these motives in mind as he worked all week, and gives charity right before Shabbos in order to greet the Shabbos with the fruits of a whole week of toil, he certainly will experience the highest level of sanctity and joy.

⇜ Kindness Increases the Candlelight

Many woman follow a time-honored custom of placing a *tzedakah pushka* near their Shabbos candelabra so that they can make a gift to charity just before they kindle their Shabbos *licht*. While placing their gift into the *pushka*, they recite special personal supplications in addition to the poignant prayers that freely flow from their hearts as they light the Shabbos candles.

⇜ The Charity of a Butcher

In the ancient cemetery of Worms, Germany, lies buried the great Rav of German Jewry, the *Maharil* (R' Yaakov HaLevi Mollin, 1365-1427). Right next to him is the grave of the town butcher. What did this 'simple' man do to deserve such an honor? The answer is inscribed on the butcher's tombstone which says that every Friday morning this butcher would add up his own weight and that of his wife and his children. Then he would take meat of equivalent weight and distribute it to the poor for Shabbos!

⇜ Glorifying the Shabbos or Glorifying Oneself

The Talmud (*Beitzah* 16a) teaches: "All of a person's income is fixed each year from Rosh Hashanah until Yom Kippur, with the

exception of expenditures for the Sabbaths and Festivals." The Dubno Maggid *(Ohel Yaakov, Parshas Behar)* uses a parable to explain why this statement should be a powerful incentive to be charitable and care for the needs of the poor before Shabbos.

There was once a very wealthy man who was celebrating the most joyous moment in his life. He was finally marrying off his youngest and dearest son. He knew that the wedding feast to which he invited everyone would be an opportunity for him to display his fabulous wealth and grandeur.

In a faraway city this man had two other sons. One son was successful and quite proud of it, the other was a pauper who failed in all he undertook and lacked for everything. The father sent a letter to the capable son with these instructions: "Hire a fine carriage and bring all members of the family to the wedding. Dress and outfit everyone lavishly in a manner that will reflect glory upon me, the head of the family. Spend as much as you wish, for when it comes to my honor and eminence money is no object! I will gladly reimburse you for everything you spend to add luster to my name!"

The rich son promptly had the finest tailors sew the finest clothes for him, his wife, and children. They were outfitted in the most magnificent garments.

When the day came to journey to the wedding, the rich man's wife and children were impeccably prepared for the majestic event. As the splendid carriage made its way out of the city, the rich brother passed by the squalid hovel of his poor brother and told him to join him on the carriage immediately for their father had commanded that the entire family join him for the great wedding.

At the grand wedding event, the old father was mightily pleased when his successful son made his grand entrance accompanied by his entire family so splendidly outfitted. However, the proud father's spirit was utterly crushed when his impoverished son made his appearance in filthy tatters and rags.

When the festivities finally came to an end, the successful son came to take leave of his father, and he presented him with a long list of expenses he had incurred at his father's behest. Much to the son's shock and dismay, his father vehemently refused to reimburse him for anything he spent, explaining, "I made it very clear that I would pay you back for every last penny you spent *for my glory!* How dare you claim that you bedecked yourself in finery for my glory, when you humiliated me by allowing your poor brother to appear in filthy rags! The fact that

you completely ignored your brother, who is also my son, proves that everything you lavished upon yourself was intended only to enhance your own glory, not my glory!"

Similarly, all Jews are equally children of the Almighty God Whose Name is' glorified when *all* of His children sit at His Sabbath table dressed in finery, provided with their every need. But when the rich provide for all of their own Sabbath and holiday needs and ignore their poor brethren who are also God's precious children, it proves that the money they spent was not a Shabbos expenditure but a selfish personal expense for which God makes no reimbursement.

✑§ A Clean Heart for Shabbos

R' Yaakov Greenwald relates that once when he entered the Kapishnitzer Rebbe's room on Erev Shabbos the Rebbe's face was absolutely radiant; he was bubbling with joy. The Rebbe cried out, *"Ich bin rein! Mamash rein! Oisgeleidikt!"* "I feel clean, really clean! Absolutely cleaned out!" The Rebbe explained that just as he could not go to sleep at night leaving over even one penny in the house, so too he could not enter into Shabbos leaving over a cent to his name. "Today," the Rebbe said, " I am especially fortunate. Here we are a few hours before the holy Shabbos and I just gave away my last coin to *tzedakah*. Now I really have plenty of time to prepare for Shabbos with empty pockets and a clean heart!"

✑§ Pledging and Planning on Shabbos

Shulchan Aruch (*Orach Chaim* 306:6) rules that although it is prohibited to discuss monetary matters and business affairs on Shabbos, such talk is permissible when one is discussing the performance of a mitzvah or pledging to charity. One may also make monetary pledges to the synagogue on Shabbos and may commit himself to donating specific items to it, such as a *Sefer Torah* or Torah ornaments (*Mishnah Berurah,* ibid. 27).

ᴥᔆ Holidays

The Torah clearly describes how we should celebrate our holidays: וְשָׂמַחְתָּ לִפְנֵי ה' אֱלֹקֶיךָ, אַתָּה וּבִנְךָ וּבִתֶּךָ וְעַבְדְּךָ וַאֲמָתֶךָ וְהַלֵּוִי אֲשֶׁר בִּשְׁעָרֶיךָ, וְהַגֵּר וְהַיָּתוֹם וְהָאַלְמָנָה אֲשֶׁר בְּקִרְבֶּךָ, בַּמָּקוֹם אֲשֶׁר יִבְחַר ה' אֱלֹקֶיךָ לְשַׁכֵּן שְׁמוֹ שָׁם *You shall rejoice before Hashem, your God — you, your son, your daughter, your slave, your maidservant, the Levite who is in your cities, the convert, the orphan, and the widow who are among you — in the place where Hashem, your God, will chose to rest His name there (Deuteronomy 16:11). Rashi,* citing the *Sifrei,* observes that the verse lists four members of a person's household — his son, daughter, servant, and maid. It also lists four outsiders who are needy — the Levite, the convert, the orphan, and the widow. God says, "If you will take care of My four dependents, I will take care of your four!"

ᴥᔆ Celebrate With Open Doors

After describing how each person should find means to make the festival enjoyable, *Rambam (Hilchos Yom Tov* 6:18) writes: While a person is eating and drinking, he is obligated to feed the convert, orphan, and widow, along with the other unfortunate poor. But one who locks his courtyard doors and eats and drinks with his wife and children, but does not give food and drink to the poor and embittered — this is not the joy of a mitzvah, but the joy of his stomach. Of such people it is said, זִבְחֵיהֶם כְּלֶחֶם אוֹנִים לָהֶם, כָּל אֹכְלָיו יִטַּמָּאוּ כִּי לַחְמָם לְנַפְשָׁם, *Their offerings are like the bread of mourners for themselves, whoever eats them will be contaminated for their food is for selfishness (Hosea* 9:4). Such a celebration is a disgrace for them, as it is said, וְזֵרִיתִי פֶרֶשׁ עַל פְּנֵיכֶם, פֶּרֶשׁ חַגֵּיכֶם, *I shall fling filth in your faces, the filth of your festival offerings (Malachi 2:3).*

ᴥᔆ Provide for the Poor With a Good Eye

Yesod Veshoresh Ha'avodah (The Ninth Gateway; Chapter 7) cites the *Zohar* which speaks forcefully on this subject: R' Shimon taught: "Whoever rejoices on the festivals but fails to give God His proper

portion is a person with a very bad eye who will suffer many sorrows and will eventually be driven out of this world. What is God's portion? It is to make the needy people happy for the holiday by providing them with everything they require.

"When the festival arrives, whom does God visit first? He goes to the hovels of the poor and says, 'Let Me see how these shattered vessels are faring! These are My primary concern!' If God sees that their cupboards are bare and they do not have the wherewithal to celebrate His holiday, He cannot rejoice Himself because He weeps bitterly over their lot. He ascends to heaven and wants to rain destruction down upon the world [if not for the angels of mercy who, with utmost difficulty, assuage God's wrath].

"Similarly, Satan, the accuser, inspects every holiday feast. If the householder has made sure to provide for the poor before he sits down to his own lavish table, then Satan leaves him alone. But if Satan sees the householder enjoying a sumptuous repast without any poor people as guests and without any provisions having been sent to the poor, then he disrupts the festivity and causes aggravation to reign in place of selfish joy!"

Sukkos

◄§ Prepare a Table for Exalted Guests

The *Zohar* teaches that for dwelling faithfully in their *sukkos*, the people of Israel merit the privilege of welcoming the *Shechinah* [God's Presence] and the seven "faithful shepherds" who descend from their heavenly abode in Gan Eden to enter the *sukkah* as *ushpizin ila'in kadishin*, exalted holy guests.

The *Zohar* (*Emor* 103b) elaborates: "When Rav Hamnuna the Elder would enter the *sukkah* he used to stand inside the door and say, 'Let us invite the exalted guests and prepare a table. . .' One must also gladden the poor, because the portion of those exalted guests that he invited belongs to the poor. Furthermore, one should not say, 'I will first satisfy myself with food and drink, and from what is left over I will give to the poor,' rather the first of everything should be reserved for

the אוּשְׁפִּיזִין, *ushpizin*, the exalted guests, and in their stead must be given to one's poor guests. If one gladdens his poor guests and satisfies them, God Himself rejoices with him. Abraham, Isaac, Jacob and the other righteous shower him with blessing. Happy is the man who attains all this!"

Thus, following the *Zohar*, it is proper to invite poor guests to the *sukkah*. If this is impossible, one should at least provide meals or money for meals, so that the poor can rejoice in their own *sukkah*. (*Shelah Hakadosh, Maseches Sukkah*).

⋄§ Find Shelter Under Charity's Wings

The *Arizal* writes that one should be scrupulous about giving charity lavishly on Erev Sukkos. *Bnei Yissaschar* (*Chodesh Tishrei, Maamar* 10) offers a number of explanations for this.

1) The Rabbis (*Tanna D'vei Eliyahu*, 23) taught that the downtrodden Jewish slaves in Egypt entered into a covenant of loving-kindness with one another and in that merit they were redeemed from bondage. The connection between charity and liberty may be explained according to the Midrash (*Rus Rabbah* 5:4) which states: Come and see how great is the power of the righteous and how great is the power of their charity and how great is the power of their acts of loving-kindness, for those charitable people find their refuge *not* under the wings of the dawn and *not* under the wings of the earth and *not* under the wings of the sun, rather they find their refuge under the protective shelter of the One Who spoke and created the world, as it says: מַה יָּקָר חַסְדְּךָ אֱלֹקִים, וּבְנֵי אָדָם בְּצֵל כְּנָפֶיךָ יֶחֱסָיוּן, *How precious is Your kindness, O God! Mankind takes refuge in the shelter of Your wings* (Psalms 36:8).

Sukkos commemorates the clouds of glory that sheltered the Jewish nation in the wilderness. Because the Jews had a covenant of loving-kindness between themselves they merited this miraculous opportunity to *take refuge in the shelter of God's wings*. Therefore, on Erev Sukkos we do more than build a booth of wooden boards, we also create a spiritual cloud-cover for ourselves by giving charity lavishly.

2) Yom Kippur is the day when God forgives and erases our sins. This spirit of amnesty overflows into the days following Yom Kippur

until the first day of Sukkos, which is called *"Rishon Lecheshbon Avonos,"* the first day of the new, strict accounting of sins. If they are many and severe, sins can sometimes even wipe away a person's mitzvah merits. The only mitzvah impervious to all threats is *tzedakah,* as it says: פִּזַּר נָתַן לָאֶבְיוֹנִים, צִדְקָתוֹ עֹמֶדֶת לָעַד, *He distributed widely to the destitute, his charity endures forever (Psalms 112:9).* Therefore, it is appropriate to begin our new celestial account of merit and demerit with charity, the enduring mitzvah that can never be erased.

⋅§ Ornaments of Charity

The holy Rebbe, Rav Chaim of Sanz, would always wear his finest Yom Tov clothing, including his festive shtriemel, on the week-days between Yom Kippur and Sukkos, for these days bridged between the purity of the tenth of Tishrei and the festivity of the fifteenth. Once, during this exalted time Rav Chaim sat at his table and groaned. This strange behavior caused both wonder and ap-prehension to his family and followers who were accustomed to seeing him in the highest of spirits at this time. Then Rav Chaim called in a group of his wealthy *Chassidim* and said: "Rosh Hashanah has passed by, Yom Kippur has passed by, and I still have not repented! Woe unto me! How will I look entering the holy *sukkah*?" These words shook and dismayed the *Chassidim.* The holy Rav continued, "I desperately need two thousand rubles for charity so that I can properly repent. Please lend me this sum and I will pay you back in a few weeks." As soon as the sum was in the *tzaddik's* hands the gloom lifted from his brow and a glorious festive light radiated from his face. On the first night of the Sukkos holiday the Rebbe joyously entered his *sukkah* and proclaimed: "Rosh Hashanah passed by, Yom Kippur passed by, and I still had not repented. How do I dare to enter the *sukkah*? But now — now it's different: אֲנִי בְּצֶדֶק אֶחֱזֶה פָּנֶיךָ, *And I — because of charity — shall behold Your face (Psalms 17:15)."*

On a different occasion Rav Chaim said: "Most people beautify their *sukkah* with all sorts of splendid decorations and ornaments, but not I. Charity! That is my ornament! Every penny to the poor comes back to light up my *sukkah* with a celestial glow."

Pesach

≈§ Maos Chittim

Rama on *Shulchan Aruch* (*Orach Chaim* 429:1) states that the custom is to buy wheat for the poor in anticipation of their need for Passover matzah. *Mishnah Berurah* (ibid.) says that in Eastern European communities the custom is to provide the poor with flour because it saves the poor from the expense and effort of grinding the wheat into flour. The general rule of charity is that we try to help the poor in a fashion that allows them to benefit from our gift in the quickest and easiest way. Of course, if the indigent have other Passover needs, we are obligated to help them to obtain everything necessary to celebrate the holiday properly.

Ramo says that the obligation to contribute to the *Maos Chittim Fund* is incumbent on the resident only after he has lived in the town for a full twelve months. Some hold that it is enough to have been in residence for only thirty days. *Mishnah Berurah* seems to accept the opinion that once a person has taken up permanent residence in a community, he is immediately obligated to contribute his fair share to the *Maos Chittim Fund.*

Similarly, the primary obligation is to provide for the poor of one's own city, and this privilege is reserved for those who have resided in town for at least thirty days. Others say that once a poor person or family has taken up permanent residence in a city or town, the community is immediately obligated to help them.

Mishnah Berurah rules that everyone must contribute to this special Pesach Fund, even the Torah scholars who are usually exempted from other communal taxes. Ideally, the community should assess each individual based on his income. Otherwise, everyone should give according to his means. Anyone who shirks his obligation to give *Maos Chittim* commits a very grave sin, for the needs of the poor are acute before Pesach and they really depend on the *Maos Chittim Fund.* Without these funds the poor will be left with hardship, heartache and real hunger.

✑ The Covenant of Kindness

By what merit were the Jewish people redeemed from Egypt? *Tanna
D'vei Eliyahu* (23) states that the downtrodden Children of Israel
saw that their only hope to survive the bitter bondage was to help one
another. To this end they assembled and ratified a mutual covenant of
loving-kindness wherein they pledged to be kind and charitable to one
another. This is the meaning of the verse in the 'Song of the Sea,' נָחִיתָ
בְחַסְדְּךָ עַם זוּ גָּאָלְתָּ, *With Your Attribute of Kindness You guided [to safety]
this people that You redeemed* (Exodus 15:13). According to *Tanna
D'vei Eliyahu,* the Jewish people's dedication to kindness aroused the
Divine Attribute of Kindness which guided them out of bondage. [This
is one explanation why there is such an emphasis on *tzedakah* in
preparation for Pesach.]

✑ Everyone Shall Eat Matzos

The Torah introduces the mitzvah of eating matzah on Passover in
two consecutive verses. First it says: שִׁבְעַת יָמִים תּאֹכַל מַצֹּת, *For
a seven-day period shall you eat matzos* (Exodus 13:6). Afterwards,
it repeats itself in an apparently redundant statement: מַצּוֹת יֵאָכֵל אֵת
שִׁבְעַת הַיָּמִים, *Matzos shall be eaten throughout the seven-day period*
(Exodus 13:7). The Vilna Gaon explains that the first verse speaks of a
Jew's personal obligation to eat matzah himself. The second verse
teaches that every Jew is responsible to assure that '*Matzos shall
be eaten*' by all other Jews, especially those who are too poor to
buy matzos on their own. Additionally, the Vilna Gaon observes that
in the first verse, the Hebrew word מַצֹּת, *matzos*, is spelled deficiently,
without the letter *vav*, whereas in the second verse which addresses
the needs of the indigent it is spelled out in full (מַצּוֹת) with the
letter *vav*. This teaches that one is obligated to provide fully for the
matzah and Passover needs of the poor — even more than for his own
needs.

Finally, the Vilna Gaon observes that the letter '*tzaddik*' in the word
matzos stands for *tzedakah*. If we remove this letter from the word
מַצּוֹת, *matzos*, we are left with the word מָוֶת, *maves*, death; to teach us
that the only merit which saved the Jews from death at the hands of

their Egyptian oppressors was the charity they generously gave out to others.

All this explains why there is such concern for *tzedakah* in preparation for Passover.

◆§ A Search for Matzah

R' Yoseif Dov Soloveitchik, the Rav of Brisk, was wont to say before Passover, "At this time of the year, most people are preoccupied with their search for *chametz*, leavened bread, which one cannot keep in his possession during this holiday. Day and night, they go about searching and saying, '*Chametz, chametz*, where is the *chametz*?' I am just the opposite. All I am preoccupied with in anticipation of Pesach is my search for matzah. 'Matzah! Matzah! Does every poor family in Brisk have matzah and all the other Pesach necessities? Each and every Jew, especially the Rav, is obligated to search through each and every hut and hovel in this city to make sure that not even one poor family is left out!"

◆§ The Past Provides a Glimpse of the Future

The recitation of the Haggadah on the night of Passover begins with a well-known proclamation: הָא לַחְמָא עַנְיָא . . . בְּנֵי חוֹרִין, "This is the poor bread which our ancestors ate in the land of Egypt. Whoever is hungry — let him come in and eat! Whoever is in need — let him come and partake of the Pesach! Now we are here; next year may we be in the Land of Israel! Now we are slaves; next year may we be free men."

This entire statement seems out of place here. Charity and hospitality are mitzvos that apply all year-round; why are they mentioned specifically here, as an introduction to the *Seder*? Why is an official invitation extended to the poor on Pesach night more than on any other holiday? Furthermore, the *Rama* (*Orach Chaim* 429:1) mandates that every Jewish community must follow the custom to make a special collection of *Maos Chittim*, "wheat money," for the needy in advance of Pesach to ensure that no Jew should find himself unable

to fulfill the night's mitzvos because of lack of funds. Of all the holidays then, Passover is the least likely time of year to find people who are in need when the festival begins. This makes the recitation of this invitation to the poor at this time even more difficult to understand.

The *Beis Halevi* (*Responsa* Part II, *Drush* 16) explains that our deliverance from the Egyptian exile over three thousand years ago was far more than just a salvation for the Israelites of that generation. In fact, God used that opportunity to give the Jewish people a preview of the final Messianic redemption of the future. As the prophet *Michah* (7:15) states: כִּימֵי צֵאתְךָ מֵאֶרֶץ מִצְרָיִם אַרְאֶנּוּ נִפְלָאוֹת, *As in the days when you left the land of Egypt, I will show it* (in the future) *wonders.* The Talmud (*Bava Basra* 9a) teaches that the future Messianic redemption will come about by virtue of Israel's dedication to performing charity, as the prophet says: כֹּה אָמַר ה' שִׁמְרוּ מִשְׁפָּט וַעֲשׂוּ צְדָקָה, כִּי קְרוֹבָה יְשׁוּעָתִי לָבוֹא וְצִדְקָתִי לְהִגָּלוֹת, *Thus said Hashem: Observe justice and perform charity, for My salvation is soon to come and My righteousness to be revealed* (Isaiah 56:1). Therefore, on this night of Pesach, in addition to recounting our historical deliverance from Egypt in days of yore, we express our yearning for the day of final redemption. As part of that expression of yearning we also declare our dedication to the principles of charity and kindness which serve as the vehicles through which we may merit that redemption. Therefore we preface the entire Haggadah recitation with a statement of concern for the poor and needy.

◆§ Seize Every Opportunity for *Tzedakah* Now!

Chasam Sofer (*Drashos L'Shabbos HaGadol*, p. 253) explains that there is a special reason that we preface the *Seder* of Passover, The Festival of Redemption, with an invitation to the poor. The Talmud (*Pesachim* 50a) says that in the messianic era poverty will disappear; אֵין כַּאן עָנִי, *'ein kann oni'* — there will no longer be any poor folk. On the Festival of Redemption, our yearning for the future messianic redemption intensifies which helps hasten its arrival. Therefore the Sages warned us: "Quick! Seize this opportunity to invite the poor to your table tonight, because the moment the Messiah arrives you will be unable to give *tzedakah* again!" Thus: *Whoever is hungry — let him*

come and eat! Whoever is in need — let him come and partake of Pesach! Do you know why it is urgent now? Because, *Right now, we are here [in exile] but next year we hope to be in the [redeemed] Land of Israel! Right now, we are still slaves [to poverty and need], but next year we hope to be free men [and forever released from the bondage of poverty].*

Shavuos

◄§ The Book of Ruth

Midrash *Lekach Tov* asks: Why is the Book of *Ruth* read on Shavuos, on the anniversary of the giving of the Torah? Because it is written: תּוֹרַת חֶסֶד עַל לְשׁוֹנָהּ, *The Torah of kindness is on her tongue,* (*Proverbs* 31:26), and this entire book is permeated with charity and kindness.

First we read of the terrible punishment meted out to Elimelech, who was the leader of the Jewish nation, but shirked his responsibilities by fleeing from the country during a time of famine.

However, the Sages taught: *During a time of famine, set your feet in motion and flee the land as quickly as you can!* Why then was Elimelech punished? Because he caused the Children of Israel to lose heart! Elimelech was one of the outstanding personalities of his time, as well as one of the country's leading economic providers. However, when the years of terrible famine set in, he bemoaned, "Now all of Israel will gather at my gates! One will come collecting with his box, the other will come begging with his basket!" To avoid them, Elimelech picked himself up and ran away from all of them (*Yalkut Shimoni, Megillas Rus* 598).

R' Mordecai Gifter demonstrates from other Midrashic sources that in reality, Elimelech was not selfish and tight fisted. Before he fled he did, in fact, give away most of his wealth to feed the starving populace. Elimelech's sin was that he did not want to be bothered by the poor. He refused to participate in their pain. He did not want to be disturbed time and again by this collector and that "schnorrer." "Here, take all of my money!" he cried out. "Just leave me alone!" This was a terrible sin because it is incumbent upon the man of wealth not only to support

the poor but also to encourage and uplift them. By running away from their sorrows and sighs and groans, Elimelech crushed the people's spirit and for this he was condemned to die.

And where did Elimelech flee to, with his wife Naomi and his two sons, Machlon and Kilyon? To the land of selfishness and unkindness, the land of Moab. Moab was the son of Lot, the nephew of Abraham. It was the self-seeking Lot who spurned the charitable influence of Abraham to live in the selfish city of Sodom.

The Sages asked: What caused Machlon and Kilyon to marry Moabite wives? Like Ammon and Moab they acted out of selfish motives, as it says, לֹא יָבֹא עַמּוֹנִי וּמוֹאָבִי בִּקְהַל ה׳. . .עַל דְּבַר אֲשֶׁר לֹא קִדְּמוּ אֶתְכֶם בַּלֶּחֶם וּבַמַּיִם בַּדֶּרֶךְ בְּצֵאתְכֶם מִמִּצְרָיִם. . . לֹא תִדְרֹשׁ שְׁלֹמָם וְטֹבָתָם כָּל יָמֶיךָ לְעוֹלָם, *An Ammonite or Moabite shall not enter the congregation of Hashem. . .because they did not greet you with bread and water on the road when you were leaving Egypt. . .You shall not seek their peace or welfare, all your days forever. (Deuteronomy 23:4-5,7).*

Ruth was the exact opposite. She was a princess of Moab who ripped herself away from her selfish roots and selflessly sacrificed herself in order to care for the needs of her elderly mother-in-law, Naomi. Ruth made one of history's greatest declarations of love and selfless devotion: כִּי אֶל אֲשֶׁר תֵּלְכִי אֵלֵךְ, וּבַאֲשֶׁר תָּלִינִי אָלִין, עַמֵּךְ עַמִּי וֵאלֹקַיִךְ אֱלֹקָי. בַּאֲשֶׁר תָּמוּתִי אָמוּת וְשָׁם אֶקָּבֵר, כֹּה יַעֲשֶׂה ה׳ לִי וְכֹה יֹסִיף כִּי הַמָּוֶת יַפְרִיד בֵּינִי וּבֵינֵךְ, *For where you go, I will go; where you lodge, I will lodge; your people are my people, and your God is my God; where you die, I will die, and there I will be buried. Thus may Hashem do to me, and so may he do more, if anything but death separates me from you! (Ruth 1:16-17).*

When Ruth comes to gather the pauper's gleanings in the fields of Boaz, he recognizes her and offers her words of encouragement: יְשַׁלֵּם ה׳ פָּעֳלֵךְ וּתְהִי מַשְׂכֻּרְתֵּךְ שְׁלֵמָה מֵעִם ה׳ אֱלֹקֵי יִשְׂרָאֵל, אֲשֶׁר בָּאת לַחֲסוֹת תַּחַת כְּנָפָיו, *May Hashem reward your deed, and may your payment be full from Hashem, the God of Israel, under whose wings you have come to seek refuge (Ruth 2:12).*

R' Avin observed: How great is the power of those who perform acts of charity and loving-kindness, for they shelter not in the shadow of the wings of earth, nor in the shadow of the wings of morning but under the shadow of the Holy One, Blessed is He, as it is written: מַה יָּקָר חַסְדְּךָ אֱלֹקִים, וּבְנֵי אָדָם בְּצֵל כְּנָפֶיךָ יֶחֱסָיוּן, *How very precious is Your loving-kindness, O God, and the children of man take refuge under Your wings." (Psalms 36:8) (Midrash Rus Rabbah 5:4).*

From Ruth came forth King David who was born on the festival of

Shavuos and departed from this world on Shavuos as well. King David declares: חַסְדֵי ה׳ עוֹלָם אָשִׁירָה, לְדֹר וָדֹר אוֹדִיעַ אֱמוּנָתְךָ בְּפִי. כִּי אָמַרְתִּי עוֹלָם חֶסֶד יִבָּנֶה, *Of Hashem's kindness I will sing forever, I will make Your faithfulness known to every generation with my mouth. For I said, "The world is built upon loving-kindness"* (Psalms 89:2-3).

✣ Elul

Chayei Odom (137:1) writes that one should intensify his charitable activities during Elul, the final month of the Jewish year, in preparation for Rosh Hashanah, the great day of judgment. He finds an allusion to this in the Book of *Esther* (9:22) where we are told to observe Purim by sending gifts to one another and to the poor. The initial letters of the Hebrew words, אִישׁ לְרֵעֵהוּ וּמַתָּנוֹת לָאֶבְיוֹנִים, spell אֱלוּל, *Elul*.

Based on this verse, R' Moshe Vorhand of Makova (*Ohel Moshe*) observed that before one gives *tzedakah*, one must be certain that his money is honestly earned — that it really belongs to him and not to someone else. The verse reads, אִישׁ לְרֵעֵהוּ, *every man to his friend*. First pay back what you owe to your friends and creditors; only after those debts and obligations are satisfied can you come to מַתָּנוֹת לָאֶבְיוֹנִים, *gifts to the poor*. This is what the prophet meant when he cried out, בִּצְדָקָה תִּכּוֹנָנִי רַחֲקִי מֵעֹשֶׁק, *Fortify yourself through charity, distance yourself from cheating* (Isaiah 54:14).

✣ Rosh Hashanah

Rama (*Orach Chaim* 581:4) cites the custom of praying at the graves of *tzaddikim* on Erev Rosh Hashanah and distributing charity to the poor.

In the High Holiday prayers we say: וּתְשׁוּבָה וּתְפִילָה וּצְדָקָה מַעֲבִירִין אֶת רֹעַ הַגְּזֵרָה, *And penitence and prayer and charity turn aside the severity of God's strict judgments*. Rambam (*Hilchos Teshuvah* 2:4) states: "Among the methods of *teshuvah* are: The penitent should continually call out to Hashem, with weeping and intense prayer; and he should distribute charity according to his means."

Rambam (*Hilchos Teshuvah* 3:4) adds: "Because of the critical nature

of this matter [to repent properly] it has always been the custom of the entire Jewish people to increase their charity and good deeds and mitzvah observance in the days between Rosh Hashanah and Yom Kippur even more than the rest of the year."

⋟ *Mishloach Manos* on Rosh Hashanah

One Erev Rosh Hashanah, a young man came to the home of the Satmar Rav, R' Yoel Teitelbaum, and requested an audience with the Rebbe so that he could give him *mishloach manos*. The young men who overheard this strange request were highly amused by this absurd request to give Purim gifts on the eve of the awesome Day of Judgment, Rosh Hashanah. From inside his room, the Rebbe also heard what was going on and he said, "Let the young man in! There is indeed a sacred source for the custom of distributing *mishloach manos* on Erev Rosh Hashanah. The great halachic authority, the *Pri Megadim* (*Shulchan Aruch,Orach Chaim* 581:1) writes: I personally follow the custom of sending out *manos*, portions of prepared foods, to the poor and needy on Erev Rosh Hashanah as per the instructions of the Jewish leaders, Nechemiah and Ezra, who decreed to the populace of Jerusalem on the eve of this great day: וַיֹּאמֶר לָהֶם לְכוּ אִכְלוּ מַשְׁמַנִּים וּשְׁתוּ מַמְתַקִּים וְשִׁלְחוּ מָנוֹת לְאֵין נָכוֹן לוֹ, כִּי קָדוֹשׁ הַיּוֹם לַאֲדֹנֵינוּ . . . וַיֵּלְכוּ כָל הָעָם לֶאֱכֹל וְלִשְׁתּוֹת וּלְשַׁלַּח מָנוֹת וְלַעֲשׂוֹת שִׂמְחָה גְדוֹלָה, *Go, eat rich foods, and drink sweet beverages, and send portions of food to those who have nothing prepared, for today is sacred to our Lord. . . .So all the people went to eat and to drink and to send portions [to the needy] and to engage in great rejoicing (Nechemiah 8:10,12).*

⋟ *Erev Yom Kippur*

It is customary to distribute charity on the afternoon before Yom Kippur. *Mateh Ephraim* (607) writes: In most communities it is the custom to distribute *tzedakah* to the poor as one walks to the synagogue for the *Minchah* prayer. Also, those responsible for the various *tzedakah* funds in the community sit in the forechamber of the synagogue and there the members of the congregation give *tzedakah*, each man according to his ability.

In many shuls today, numerous plates or special *pushkas*, each designated for a different charity, are laid out on the *bimah* at *Minchah* time. This affords everyone the opportunity to fulfill the mitzvah of *tzedakah* numerous times in preparation for the *Yom HaKadosh*.

➳ Candy Coated Charity

R' Yechiel Michel Tucazinsky of Jerusalem writes in his *luach* (calendar) that in certain *kehillos* there is a unique custom for Erev Yom Kippur: The *minhag* is that the *gabbai* gives a piece of candy to everyone in shul and tells them, "This is the time of year when God determines everyone's annual financial status. Just in case a heavenly decree was issued that this year you will have to take charity from others, let that decree be fulfilled with this candy that you are now taking from me!" The Chief Rabbi of Jerusalem, R' Eliyahu David Rabinowitz-Teomim, traced the source of this custom to the Jerusalem Talmud (*Peah* 8:8) which says that there were certain pious elders who would accept whatever charity was given to them in the days between Rosh Hashanah and Yom Kippur, but the rest of the year they would never accept *tzedakah*. Clearly the reason they took charity during this short period was in order to fulfill any possibility of a Divine decree for poverty.

➳ Kapparos

Rama (*Shulchan Aruch, Orach Chaim* 605) records the custom of offering כַּפָּרוֹת, *kapporos*, on Erev Yom Kippur. This time-honored custom entails designating a chicken for every member of the family — roosters for the males and hens for the females — and slaughtering them. *Mishnah Berurah* explains that this has a dramatic effect on everyone and arouses him or her to sincere repentance, because they say to themselves, "The bloody death which befell this bird should really have befallen me as a result of my many sins."

The custom is to give the slaughtered chickens to the poor as charity, or to keep the chickens for oneself and to give their monetary equivalent to the poor. *Mishnah Berurah* observes that it is preferable to give money and not the chicken to the poor, lest the pauper be

humiliated and insulted by this gift. He may say to himself, "This rich man dumped all of his sins on the head of this chicken and now he is giving this sin-laden creature to me!" But if one is sure that the poor man will not be insulted by this gift, it is better to give him the actual slaughtered chicken, because he can cook it and enjoy it immediately with little effort. If a person decides to exchange the chicken for money, he should not take this money from his *maaser* account, rather it should come from his regular funds.

Rama concludes that the custom is to visit the cemetery on Erev Yom Kippur and to distribute charity lavishly there.

⮜§ Memorial Pledges

The custom is to make pledges to charity on Yom Kippur for the benefit of departed souls. Additionally, we recite *Yizkor*, a memorial prayer, because the souls of the deceased also achieve atonement on Yom Kippur, the Day of Atonement (*Shulchan Aruch, Orach Chaim* 621). *Mishnah Berurah* explains: "The reason why the pledge to charity helps the deceased is because we may assume that if the dead people were alive, they would undoubtedly give charity themselves on Yom Kippur. Even if the deceased were poor and penniless, we can assume that their pure hearts would certainly yearn to contribute. According to this logic, a charitable pledge cannot help for wicked people because we cannot say with assurance that they would have wanted to give *tzedakah*. But if the sinners at least recited the *viduy* confession before death, then we can say that they sincerely repented in their final moments and died like *tzaddikim*. Therefore, a charitable pledge will benefit them as well. Furthermore, if a son makes a pledge in memory of his own father or mother, it is always beneficial because the Sages taught (*Sanhedrin* 104a): "The son's good deeds always bring merit to his parents' souls (even if a parent was a sinner)."

Mishnah Berurah also notes that the Torah often refers to this sacred day in the plural, Yom HaKippurim, the Day of Atonements, alluding to the notion that this day offers atonement to two different groups of people — both the living and the dead!

Midrash Tanchuma (*Parshas Haazinu* 1) writes: It says in the Torah: כַּפֵּר לְעַמְּךָ יִשְׂרָאֵל אֲשֶׁר פָּדִיתָ, *Atone for Your people Israel,* this refers to the living; *that You have redeemed* (*Deuteronomy* 21:8), this refers to

the deceased. This teaches us that the living can redeem the dead (from the suffering of Gehinnom). This is why we conduct a *Yizkor* memorial service for the dead on the Day of Atonement, and pledge charity in their memory.

The custom for relatives to make pledges to charity in conjunction with the *Yizkor* memorial service is an ancient and time-honored practice and it bestows great benefit upon the souls of the deceased (*Rama* to *Shulchan Aruch, Yoreh Deah,* 249:16 in the name of the *Rokeach* 217).

✌§ Chanukah

Mishnah Berurah to *Shulchan Aruch* (*Orach Chaim* 670:1) cites the *Magen Avraham* who cryptically says: "There is a special custom for the poor to go from door to door collecting alms on Chanukah, and there is a reason for it." We will attempt to explain why the theme of giving alms to the poor is not merely a peripheral custom but rather an essential lesson of Chanukah.

✌§ Givers and Grabbers

The first Greek to conquer the land of Israel was Alexander the Great. This selfish, power-hungry young man was obsessed with an ambition to conquer the entire world. For ten long years, from the age of 23 until he died at 33, he relentlessly drove his huge armies to march on and on in order to swallow up empires and continents which he would never live to enjoy. In his classic, *Michtav Me'Eliyahu* (Vol.I, p. 49), Rav Dessler calls Alexander, *melech hanotlim,* "the king of the grabbers. Indeed, the Hebrew name for Greece, יָוָן, *Yavan,* literally means "quicksand," which is a substance which swallows up everything which comes in contact with it.

Therefore, when the *Chashmonaim* rose up to break the yoke of Greek rule over Israel, they had to do much more than free themselves from the military and political power of Greece; they had to overthrow the prevailing Hellenistic attitude of selfishness and hedonism. In the history book *Yosiphon* (chapter 20), the author vividly describes how Judah the Maccabee celebrated his extraordinary victory over the

vastly greater Greek forces. So confident were the Greeks of their victory over the Jews that they invited slave traders to stand at the rear of their battle lines with large sacks full of gold coins, so that when the Greek heroes would capture masses of Jewish captives they could immediately take them to the traders at the rear of the battle lines and sell them. When the victorious Jewish forces seized these sacks filled with coins, what did they do with the booty? They donated it all to the poor!

Furthermore, writes *Yosiphon,* there were masses of bodies of slain Greek soldiers strewn all over the battlefield. Judah commanded that all the expensive armor and wealth plundered from them be sent to Jerusalem to be distributed amongst its impoverished citizens.

◆§ The Needs of the Poor Take Precedence

Indeed, this acute sensitivity to the needs of the poor was represented in the most prominent symbol of the Chanukah miracle, the Menorah itself. The Talmud (*Menachos* 28b) states that the original Menorah of the *Chashmonaim* was made of the most inexpensive material: First they constructed the Menorah from iron rods plated with tin. When they became wealthier, they made a new Menorah for the Temple out of silver. When they became even wealthier, they made the Menorah out of gold.

How could it be that the *Chashmonaim,* with the rich spoils of war, could not afford to make a Menorah out of precious metal? The answer clearly lies in the report of *Yosiphon* cited above: They did indeed have great wealth, but they decided that it would be better to give it to the poor than to use it for an ornate Menorah! As great a mitzvah as it is to glorify the House of God, it is an even greater mitzvah to elevate the downtrodden people of God, the hungry and the poor. Thus, when the Talmud says that when they became wealthier they made a finer Menorah, it is not referring to the wealth of the Temple treasury; rather it refers to the wealth of the Jews who were originally at the poverty level. As the fortunes of the paupers improved, and their urgent needs were satisfied, then the Temple treasurers and the sages decided that they could use community funds to embellish the Menorah.

Therefore, Chanukah is a most auspicious time to give more *tzedakah* because the entire holiday celebrates the triumph of the Jewish "givers" over the rapacious Greek "grabbers."

◄§ Learning From King David's Mistake

Apparently, the *Chashmonaim* learned this lesson from King David's mistake. He put the needs of the Temple before the needs of the poor — with tragic results.

Scripture (*I Kings* 7:51) relates that after King Solomon finished construction of his magnificent Temple in Jerusalem he brought all of the silver and gold and precious vessels which his father, King David, had sanctified in his lifetime and put them into a special treasury in the House of God.

Rashi cites the *Midrash* (*Yalkut Shimoni* ibid.) which explains that although David had spent his entire reign preparing enough money and material to build the entire Temple and that this was his greatest dream and desire, his son, Solomon, refused to use these resources. Solomon said, "There was a terrible famine in the days of my father which devastated the land for three consecutive years; my father should have expended this wealth in order to sustain the poor people of Israel!"

When David ignored the cries of the starving poor, The Holy One, Blessed is He, proclaimed: "My beloved children are dying of starvation and you, David, are piling up heaps of silver and gold to build a building! By your life, your own son, Solomon, will not use any of your money for this mitzvah!"

◄§ Purim: *Mattanos L'evyonim*

On Purim we are obligated: לַעֲשׂוֹת אוֹתָם יְמֵי מִשְׁתֶּה וְשִׂמְחָה וּמִשְׁלֹחַ מָנוֹת אִישׁ לְרֵעֵהוּ וּמַתָּנוֹת לָאֶבְיוֹנִים, *To observe them [the days of Purim] as days of feasting and gladness, and for sending food portions to one another, and gifts to the poor* (*Esther* 9:22). This special mitzvah of Purim charity, called *mattanos l'evyonim*, entails giving two separate gifts of money or food to at least two different paupers, a separate gift to each (*Orach Chaim* 694:1).

Rambam (*Hilchos Megillah* 2:17) writes: It is far better to give more gifts to the poor than to spend more on one's Purim feast or on sending portions to one's friends, for there is no great and glorious joy like the joy of gladdening the hearts of poor people, orphans, widows,

and converts. One who gladdens the hearts of these unfortunate people is comparable to the Divine Presence as it is said: לְהַחֲיוֹת רוּחַ שְׁפָלִים וּלְהַחֲיוֹת לֵב נִדְכָּאִים, *[God acts] to revive the spirit of the lowly and to revive the heart of the oppressed (Isaiah 57:15).*

Furthermore, *Shulchan Aruch* (*Orach Chaim* 694:3) rules that on Purim one should not investigate whether someone requesting alms is really needy. Rather, כָּל הַפּוֹשֵׁט יַד נוֹתְנִים לוֹ, *Whoever stretches out his hand to receive, we give him.*

Although one can discharge his obligation by giving a single penny to each of two paupers, one should strive to give with an open hand, increasing both the quality and the quantity of his charity. Even if no one asks us for alms on Purim, we must search for two people to give them gifts.

One living in an area where there are no poor people is not absolved of this mitzvah. He should set aside two sums of money to be given to a poor person when the opportunity presents itself (*Orach Chaim* 694:4), or he should send a messenger to deliver the money on Purim (*Kitzur Shulchan Aruch* 142:3). Many authorities maintain that when there are no poor people in town the money can be placed into a regular charity box earmarked for distribution to the poor.

It is interesting to note that R' Meir Shalom of Porisov would make it a point to distribute money to the poor on the day *after* Purim. He explained that since there is a special obligation to give gifts to the poor on Purim, and people do give lavish amounts on this day, they are somewhat negligent with charity on the day after. Therefore, it is especially important to perform this neglected mitzvah (*Derech Tzaddikim*, p. 363).

⪦ How to Beautify the Mitzvah

R' Eidel Horowitz was well known as one of the elite of Bnei Brak, who served Hashem with unique devotion and scrupulous attention to every halachic detail. He usually spent his time either praying in shul or studying in the *Beis HaMidrash,* and carefully avoided the mundane environment of the marketplace.

It was, therefore, somewhat of a surprise to find him standing on line in the bank on the day before Purim. When his turn came, he approached the teller with a pile of paper currency and asked, "Would

you be so kind as to change these old, worn-out banknotes for crisp, new ones?"

The teller was somewhat bewildered by this unusual request and responded, "What difference is there between a crumpled ten-shekel banknote and a crisp one? They are both worth the exact same amount and it makes no difference to any shopkeeper whether you pay with fresh notes or faded ones. Why in the world would anyone waste his time standing on a long line just to exchange some banknotes?"

"Yes, there is a big difference between old and new notes," responded R' Eidel. "You see, tomorrow is Purim and I hope to distribute money to the poor to fulfill the mitzvah of *mattanos l'evyonim,* gifts to the needy. Whenever one fulfills the wishes of his Creator he should make every effort to beautify the mitzvah as much as possible, and therefore I would like to use crisp, clean banknotes to distribute to the poor" (*Tuvcha Yabiyu,* Vol. I, p. 229).

◁§ Be Patient With the Poor

Purim is the most hectic of days for every Jew — how much more so for the great leader of his generation, R' Chaim of Volozhin. R' Chaim was besieged all day long by lines of paupers who stretched out their hands for *mattanos l'evyonim.* Every poor person received his gift with gratitude and promptly left the Rabbi's home to run elsewhere for more gifts. But there was one pauper who lingered around the house and then came back again to ask for another gift.

Often, people become annoyed by this kind of behavior, especially on Purim when they may feel beleaguered by the onslaught of a seemingly endless flow of solicitors. Not so R' Chaim of Volozhin. He graciously gave the pauper a second monetary gift and even spent a moment talking to him. The world-famous Rav and Rosh Yeshivah asked the poor man if perchance he had a *gut vort,* a nice Torah idea about Purim to share with him.

The pauper responded, "The Midrash says that Mordecai knew that the heavenly tribunal agreed with Haman's decree to harm the Jews because they had to be punished for their sins. However, the tribunal has two different ways of sealing its decrees. If the decree is sealed with a seal of blood, it is permanent and can't be rescinded. But if the decree is sealed with a clay seal, then there was still a last chance for

the Jews to repent and thereby shatter the clay seal. Mordecai was deeply concerned lest the decree was sealed in blood. When he met Elijah the Prophet who informed him that the decree was only sealed with clay, Mordecai was overjoyed because there was still hope for the salvation of the Jews.

"I would like to know, honored Rabbi, whether there is some *remez* or hint of this concept in the text of the *Megillah* itself."

Before R' Chaim could reply, the pauper continued and demonstrated a textual derivation of this idea from the Book of *Esther* (3:9), where it says לְהַשְׁמִיד לְאַבְּדָם , *it shall be written down to destroy them.* The Hebrew word לְאַבְּדָם, may be broken into two words to read, לֹא בְּדַם, *lo b'dam,* not with blood. Simply inserting a space in the verse describing Haman's decree reveals this key fact about the hidden Divine decree.

The next time R' Chaim visited his teacher, the Vilna Gaon, he repeated this *gut vort* to him. The Vilna Gaon's response was, "The very same Elijah the Prophet who brought this good news to Mordecai in Shushan many centuries ago revealed this Scriptural proof to you on Purim."

This incident teaches us how important it is to be patient with the poor. If R' Chaim had been impatient with the pauper when he approached him the second time, and had rejected his request, then R' Chaim would have forfeited his opportunity to have *gilui Eliyahu,* a revelation of Elijah the Prophet. Beware! You never know who is knocking at the door (*Tuvcha Yabiyu,* Vol. II, p. 278).

⊷§ Weddings: The Poor People's Feast

S*eder Hayom* writes: The greatest joy possible at a wedding feast is to feed the poor, the orphans and the widows. The underprivileged are God's family, his personal household — they are the ones He loves and cares for most. When the needy are happy, God Himself is happy. But if the host lavishes his attention on his well to do, prestigious guests who have plenty to eat anyway, what pleasure or benefit does Hashem have from this frivolous feasting? Unfortunately, we see that in our times people try to exclude the poor from their weddings because they are embarrassed to put such "low-class" guests together with the wealthy "dignitaries." Fortunate is he who does not allow

himself to be corrupted by such warped thinking and makes the poor his most honored guests. Especially if they are Torah scholars, it is the poor who should be seated up front in the place of honor.

Sefer Nissuin K'hilchaso observes that over time the custom has changed somewhat. The reality is that at the wedding meal proper the host is usually preoccupied with countless details and he takes pains to greet and seat all of his many guests from near and far. The host cannot provide his needy guests with the undivided attention they deserve. Therefore, there evolved a custom to make a special banquet exclusively for the poor on the night preceding the wedding. This is known as the *Orima Chasunah,* the poor people's wedding.

Darkei Chaim V'Sholom (*Hilchos Nissuin* 1049) tells how the Munkatcher Rebbe made a lavish *Orima Chasunah* on the night preceding his daughter's wedding, to which he invited all the poor people of his city. The Rebbe himself donned his Shabbos finery and personally served the poor. Later he sat at the table with them and rejoiced together with his indigent guests. After the meal the Rebbe honored one of these paupers with the privilege of leading the *bentching.* Finally, the Rebbe handed out substantial monetary gifts to every poor man who attended this *Orima Chasunah.* Today, this beautiful custom is continued by many Chassidic courts such as Viznitz, Rizhin, Chabad, Skver and Biala.

Whenever the Rebbe of Ziditchov married off a child or a grandchild, he also helped an orphan to get married. He would spend as much money on the orphan as he would on his own child or grandchild (*Sifsei Tzaddikim Hachadash,* p. 16).

◄§ A Wedding Appeal

Mr. Harry Hershkowitz was a great supporter of many charitable causes, including Yeshiva and Mesivta Torah Vodaath, whose building bears his name.

As Director of the Internal Revenue for the southern district of Manhattan, Mr. Hershkowitz worked closely with judges, lawyers and other prominent people in New York City. When Mr. Hershkowitz married off a daughter, many dignitaries were in attendance.

In the middle of the wedding meal, Mr. Hershkowitz asked the band to stop playing for a few minutes. He took the microphone and said,

"Friends, though I have married off a child tonight, my happiness is not complete. How can my heart be filled with joy when I know that in this very city, there are Jewish fathers and mothers who do not have the money with which to feed and clothe their young children? Please, I ask you to come forward and to contribute generously to help these unfortunate families."

⊷§ Taanis: The Day of Fasting

The Talmud (*Berachos* 6b) teaches: Mar Zutra said, אַגְרָא דְתַעֲנִיתָא צִדְקָתָא, *The primary merit one receives from a fast day is from the charity he distributes.* [It was customary to give food on the night following a fast day to the poor people who had fasted that day. (*Rashi*)].

Tosafos (*Megillah* 21a) explains that on a fast day we read the *haftarah* at *Minchah* late in the afternoon because we read the words of the prophet (*Isaiah* 56:1): *Thus said Hashem, Observe justice and perform acts of charity.* Since it is customary to distribute alms to the poor late in the fast day so that they will have a good meal after the fast, we read the exhortation to charity after the charity has been distributed.

The Talmud (*Sanhedrin* 35a) teaches: R' Elazar said in the name of R' Yitzchak: On any fast day that they delay giving charity until morning, they [who are in charge of distribution] are considered as if they shed blood, for it says (*Isaiah* 1:21): *It [Jerusalem] was full of strict judgment; charity was delayed overnight, and now they are murderers* [since the poor would depend on receiving food from generous benefactors to break their fast, if the contributions are delayed until the next morning, the poor would go hungry and might possibly die of starvation (*Rashi*)].

The *Shelah Hakadosh* (*Masechta Taanis*) writes in the name of his father that a person should distribute to the poor all of the food that he usually eats but did not eat on the fast day, or its monetary equivalent. Otherwise, it appears as if the only reason he fasted was to save on his personal food expenses!

A similar idea is found in the *Sefer Chareidim* (*Teshuvah;* end of Chapter II) where he adds that the letters of the word תַעֲנִית, *taanis,* may be transposed to read תֵּת עָנִי, *teis ani,* or give to the poor.

Prayer and Charity

◁§ *Tzedakah* Before Prayer

The Talmud (*Bava Basra* 10a) teaches: Rabbi Elazar would first give a *perutah* and then pray, as the Psalmist says, אֲנִי בְּצֶדֶק אֶחֱזֶה פָנֶיךָ, *And I — because of charity — shall behold Your face* (*Psalms* 17:15).

R' Dostai ben R' Yannai taught: Come and see how different the ways of God are from the ways of flesh and blood. When a man brings a large gift to a mortal king of flesh and blood there is first a doubt whether or not the king will accept the gift. Even if the gift is accepted, it still remains doubtful whether the petitioner will be granted the privilege of a royal audience. With Almighty God it is not so! A man gives a gift of a mere penny to a pauper and he is assured of beholding the Divine Presence, as it is written, *And I — because of charity — shall behold Your face* (*Psalms* 17:15).

◁§ Charity Unlocks Prayer's Potent Powers

Kav Hayashar (Chapter 88) writes that the relationship of *tzedakah* to prayer is comparable to the relationship between seasoning and food. Just as spices and seasonings bring out the real flavor locked inside the food, so does charity bring out the tremendous power locked up inside words of prayer. Therefore, it is most effective to give some money to charity before praying.

Meiri (Commentary to *Bava Basra* 10a) observes that the charity

one gives before prayer serves as an advocate between man and his Father in Heaven and prepares the way for God to accept one's prayers favorably.

◈§ The Poor Man's Prayer

King David taught that when one stands in prayer before Almighty God he should feel like the helpless beggar pleading for his alms, fully aware that he is at the mercy of his benefactor. תְּפִלָּה לְעָנִי כִי יַעֲטֹף וְלִפְנֵי ה' יִשְׁפֹּךְ שִׂיחוֹ: ה' שִׁמְעָה תְפִלָּתִי וְשַׁוְעָתִי אֵלֶיךָ תָבוֹא, *A prayer of the poor man when he grows faint, and pours forth his supplications before Hashem: "Hashem, hear my prayer, and let my cry reach You!"* (*Psalms* 102:1-2). This concept is reflected in the words of *Shulchan Aruch* (*Orach Chaim* 98:3) which rules that: "One should adopt a submissive posture while praying, as if he were a pauper begging at the door." *Shaarei Teshuvah* (*Orach Chaim* 66:13) adds to this: "Even if one is extremely wealthy he should still consider himself to be a pauper as he prepares to pray. Because even if he is financially secure, he should consider himself to be impoverished in his Torah knowledge and performance of mitzvos which is *genuine* poverty. Moreover, the rich man should picture in his mind what he will look like in the grave, stripped of all his possessions."

By giving charity to the poor in preparation for prayer, one reminds himself how prayer is similar to a helpless person pleading for mercy and kindness.

◈§ Awakening the Divine Attribute of Mercy

Olellos Ephraim (Section 502) explains why charity is so effective before prayer. When one prays he should never make demands of God and tell Him that He must fulfill the supplicant's requests because he is worthy and deserving. To the contrary, prayer is only effective when one humbly throws himself before God and begs for mercy. One should beseech God for a *matnas chinnam,* an unearned and undeserved gift — pure charity. Therefore, by giving charity before prayer, the supplicant arouses God's Divine Attribute of Charity!

◄§ Giving Guarantees That God Will Answer

Midrash Tehillim (Psalms 65:4): Ben Azai and R' Akiva say: Anyone who engages in acts of charity and kindness may be assured that his prayers will be answered, as it says: וַאֲנִי תְפִלָּתִי לְךָ ה' עֵת רָצוֹן, אֱלֹקִים, *As for me, may my prayer to You, Hashem, be at an opportune time; O God, in Your abundant kindness, answer me with the truth of Your salvation* (Psalms 69:14).

◄§ Before They Call, God Will Answer

The Rebbe of Izbitze (*Dor Yesharim* p.114) observes that *Rambam* (*Matnos Aniyim* 10:10) says that one of the most sublime levels of charity is to give even before the poor man asks. Therefore, it is very effective to voluntarily distribute charity before prayer before anyone asks, and by virtue of this, God will act, measure for measure, and answer our prayers even before we ask! This is as the prophet says: וְהָיָה טֶרֶם יִקְרָאוּ וַאֲנִי אֶעֱנֶה, *It will be that before they call I will answer* (Isaiah 65:24).

◄§ The Poor of the Land of Israel

The Munkatcher Rebbe, the *Minchas Elazar,* writes that when he visited the community of Stolin he found an old manuscript which recorded the custom of the great R' Aharon of Karlin who would specifically give charity to the poor of the land of Israel before reciting his prayers and he would deposit his donation in a *pushka* designated for R' Meir Baal Haness. He explained that in this way one's prayers anywhere in the world will be channeled through the Holy Land and they will be much more effective (*Tiferes Banim* Vol. II, p. 104).

◄§ Charity in the Shadow of Death

The Tzalka Rav, R' Yoel Tzvi Roth, was confronted with a dilemma. Here he was, incarcerated in a brutal Nazi concentration camp,

stripped of every possession. Now it was time to recite his morning prayers, but he could not prepare himself properly for prayer. The fact that he had no *siddur* did not bother him much, for he could recite the *tefillos* by heart. But what about the halachah which bids us to distribute charity before *davening*? What could he give for *tzedakah* in this death camp where he had no money and no belongings? Yet he found a solution. Each day, the Tzalka Rav would break off a portion of his meager bread ration and give it to a fellow prisoner to enjoy. Only then could he begin his prayers, having fulfilled the mandate, אֲנִי בְּצֶדֶק אֶחֱזֶה פָנֶיךָ, *And I, — because of charity — shall behold Your face* (*Psalms* 17:15).

⋅§ Squeeze Out the Best

R' Meir of Premishlan used to say: "If one were to give a *kvetch*, a good squeeze, in an attempt to extract the true intent and purpose of every Jewish prayer, he would discover that at the core of every supplication is an overriding desire for money. However, if one were to *kvetch* and squeeze out all Jewish money in order to extract the real reason why Jews want so much money, he would discover that Jews yearn to have a lot of money to do charity and good deeds."

This provides us with a new insight as to why we give charity before prayer. It is as if the supplicant is admitting: "It is true, dear God, that when I pray for all kinds of things, what I really want is money. But please remember that above all else, the reason I need money is because my first priority is charity."

⋅§ He Sustains the Living With Kindness

The Chofetz Chaim writes (*Ahavas Chesed,* Part III, Chapter 6): How can a person dare to lift up his face in prayer to the Holy One, Blessed is He, and ask: שִׂים שָׁלוֹם טוֹבָה וּבְרָכָה חֵן וָחֶסֶד וְרַחֲמִים, *Please grant us peace, goodness, blessing, grace, kindness and mercy,* if he fails to deal with his neighbors with compassion and kindness? Similarly, how does a person who fails to practice charity and kindness recite the prayer, מְכַלְכֵּל חַיִּים וָחֶסֶד, *He sustains the living with kindness?*

However, the person who constantly pursues the virtue of kindness and charity can rest assured that his prayers will be answered by God, as the Rabbis (*Midrash Shochar Tov,* Chapter 65,4) taught: Whoever bestows loving-kindness upon others may rest assured that when he prays to God he will be answered — he will receive the good news that his request has been fulfilled.

≈§ Everything Belongs to God

Shulchan Aruch (*Orach Chaim* 92:10) rules: It is good to give to charity before one prays. *Mishnah Berurah* cites the *Pri Megadim* who records the custom of some communities where everyone puts a gift into the *tzedakah* box when they recite the words, וְהָעשֶׁר וְהַכָּבוֹד מִלְּפָנֶיךָ וְאַתָּה מוֹשֵׁל בַּכֹּל, *Wealth and honor come from You, and You rule everything* (I Chronicles 29:12). Similarly, *Magen Avraham* (*Shulchan Aruch, Orach Chaim* 51:7) cites the custom in the name of the *Arizal.*

The great Chassidic master, R' Pinchas of Koretz (*Midrash Pinchas* p. 14, #32), used to say, "If all Jews would realize the tremendous importance of giving *tzedakah* when reciting the verse, *and You rule everything,* and they would all give charity at that time — then *Mashiach* would already be here!"

≈§ When Not to Give

In many shuls, especially the busy ones in the big cities, many beggars come to ask for alms during the prayer services. This is a good opportunity for them to approach many people in one place and at a time when the people want to give out charity. However, there are parts of the *tefillah* which require intense concentration; therefore, it is improper to interrupt those parts even to give *tzedakah*. Obviously, one should not give *tzedakah* while he is reciting the silent *Shemoneh Esrei*, the *Amidah*; but he may respond to the beggar's request while he is listening to *chazaras hashatz*, the repetition of the *Shemoneh Esrei*.

One may not give charity while reciting the first paragraph of

the *Shema*, but he may do so during the second paragraph beginning with וְהָיָה אִם שָׁמֹעַ, *vehaya im shamoa* (*Beis Baruch on Chayei Adam* 21:27 based on *Mishnah Berurah, Orach Chaim* 63:18).

Mishnah Berurah (*Orach Chaim* 92:10) observes that in some places the custom is to collect *tzedakah* during the reading of the Torah. This, he says, is wrong, because it distracts people from giving full attention to the reading and interferes with their responding properly to the blessings on the Torah.

R' Chaim Kanievsky (*Derech Emunah, Hilchos Matnos Aniyim*, Chapter 10, *Tziyun Halachah* 96) observes that one may be exempt from giving charity throughout the entire prayer service because of the dictum (*Bava Kamma* 56b, *Rashi* s.v. *d'lo*) that הָעוֹסֵק בְּמִצְוָה פָּטוּר מִן הַמִּצְוָה, *one who is occupied with the performance of one mitzvah is exempt from the performance of other mitzvos* (See *Siddur Ishei Yisroel* p. 194, footnote 83).

In Elul 5760 I personally discussed this matter with R' Chaim Kanievsky and he explained that usually it is very distracting for a person to be confronted with the solicitation of the collector while he is trying to concentrate on the words of prayer and keep up with the pace of the congregation. The slightest disturbance can confuse a person immersed in fervent prayer. It is also distracting to grope to find the right amount of change to give while *davening*. Therefore, a person may ignore all collectors from the very beginning to the very end of his prayers because of the rule that 'while someone is engrossed in one mitzvah he is exempt from another.' However, R' Chaim suggested (and several other *gedolim* concurred) that one prepare money in advance in a convenient place so that one can easily give something to collectors who make their rounds during the services without significant distraction.

Tiferes Banim (Vol. III on *Kitzur Shulchan Aruch, Siman* 17:6) cites much anecdotal information both pro and con regarding giving *tzedakah* during the paragraphs of the *Shema*. He concludes: "I heard in the name of R' Yosef Shalom Eliashiv that nowadays it is prohibited to interrupt one's prayers at any time in order to give alms. Since there is an inordinate number of impostors collecting, it is doubtful whether one will fulfill the mitzvah of *tzedakah* anyway, so it is not worthwhile to disturb one's prayers."

◌§ When Disturbance Becomes
an Enhancement

One may view the distraction of the collection during *davening* in a more positive light. My Rebbe and father-in-law, the Telzer Rosh HaYeshiva, R' Mordecai Gifter told me that when he was learning in Lithuania he heard the following story: Over two hundred years ago a group of *baalei battim* in Vilna became upset with the numerous beggars who inundated them with aggressive solicitations throughout the prayer services. Even while they were trying to concentrate on the recital of the *Shema*, their thoughts were disturbed by the countless solicitors who stuck their hands in front of their eyes or forcefully tugged at their clothing in order to gain their attention. The community leaders decided to put an end to these disturbances by issuing a ban against all solicitations during times of prayer. However, they would not dare to put the ban into effect without the approval of the revered *Gaon* of Vilna.

When he was informed of the proposed ban, the *Gaon* was vehemently opposed to it. "What!" he cried out, "you want to ban *tzedakah* solicitation because it disturbs your *krias Shema*? Rest assured that nothing will improve and enhance your *krias Shema* as much as the merit of *tzedakah,* because the best way to accept the yoke of God's sovereignty is to accept the burden of our impoverished brothers!"

◌§ The Clatter of Charity Silences Satan

There is also a Chassidic story which sheds a positive light on the commotion engendered by collecting during *davening*. Once, on Erev Yom Kippur, in the town of Mezhibuz where the Baal Shem Tov resided, the *gabbaim* of the shul decided to do away with the age-old custom of having rows of metal bowls lined up in the middle of the shul for the people to give *tzedakah* before *Minchah*. They argued that the noise of the coins being thrown into the metal bowls disturbed the intense concentration of the people who came to *daven* this last *Minchah* before Yom Kippur, with its special *viduy,* confessional prayer.

The Baal Shem Tov told them, "The noise and clatter drowns out and confounds our adversaries who are busy in heaven accusing us. Put back the metal bowls!"

Finally, my good friend, R' Yossel Friedman (a renowned *gabbai tzedakah* from Monsey, New York) told me that he goes out of his way to *daven* in a *shul* where there are many collectors going around throughout the services. Why? Because he is afraid of the day of Final Judgment!

"Just imagine," says R' Yossel, "when I come before the Heavenly Tribunal after 120 years, and I tell them that I avoided or ignored the charity collectors during *davening* so that they wouldn't disturb my intense concentration on my prayers. They will make a laughing stock out of me! "You call that *kavana*, concentration?" they will cry out to me. "Even as you pretended to focus so intently on your *tefillos*, your mind was flying around, thinking about one hundred different things!"

"Therefore," says R' Yossel, "I prefer to be disturbed by all sorts of charity collectors, so that I will have a good excuse for my lack of proper concentration."

◄§ Pray for the Privilege to Give

K*av Hayashar* (Chapter 24) encourages a person to pray for the privilege of giving *tzedakah*: "Beware! If you feel that your heart is as hard as steel and refuses to allow you to share your wealth with the poor, you need help! If you know that the only passion that consumes you is an overwhelming lust to eat and drink and pamper your flesh, then you are cursed with a terrible evil. This situation must force you to pray to the All-Merciful King and beseech Him to replace your tough heart with a soft and tender one. Ask for a heart that can hear the pleas of the poor and is sensitive to the cries of the needy. And more than anything, one should ask for a heart that cares for the impoverished Torah scholar and makes a special effort to support him — even if he is not a close relative!"

A person should always pray to be an open-handed *vatran* with his money and not, heaven forbid, a tight-fisted *kamtzan*.

The *Zohar* teaches that there is an evil that is worse than poverty and that is to *have* money but to be unable to enjoy it! Yes — sometimes

the Almighty punishes a person and casts an evil spirit over him which actually paralyzes him, in a way, by not allowing him to spend his own money! King Solomon alluded to this: יֵשׁ רָעָה חוֹלָה רָאִיתִי תַּחַת הַשָּׁמֶשׁ, עשֶׁר שָׁמוּר לִבְעָלָיו לְרָעָתוֹ, *"There is a sickening evil which I have seen under the sun; riches hoarded by their owner to his misfortune"* (Koheles 5:12). This man has money in the bank, yet his cupboard is bare, his stomach is empty, his wife and family go around in ragged clothes and he suffers every sort of deprivation. The only decent thing this person will take from this world are the shrouds in which he will be buried! All this is because of a heavenly decree that someone else who is more worthy will enjoy all his wealth! In yet another verse (Koheles 6:1-2), King Solomon bemoans this curse: יֵשׁ רָעָה אֲשֶׁר רָאִיתִי תַּחַת הַשָּׁמֶשׁ, וְרַבָּה הִיא עַל הָאָדָם. אִישׁ אֲשֶׁר יִתֶּן לוֹ הָאֱלֹקִים עשֶׁר וּנְכָסִים וְכָבוֹד וְאֵינֶנּוּ חָסֵר לְנַפְשׁוֹ מִכּל אֲשֶׁר יִתְאַוֶּה, וְלֹא יַשְׁלִיטֶנּוּ הָאֱלֹקִים לֶאֱכל מִמֶּנּוּ, כִּי אִישׁ נָכְרִי יֹאכְלֶנּוּ, *"There is an evil I have observed beneath the sun, and it is prevalent among mankind: a man to whom God has given riches, wealth and honor, and he lacks nothing that the heart could desire, yet God did not give him the power to enjoy it; instead, a stranger will enjoy it."*

Yesod Yosef (Chapter 23) writes: If you know that your heart is as hard as iron and you cannot be moved to feel the plight of the poor, then arouse yourself to cry out to your God, and pray with all your heart and soul that the King of Mercy should soften your heart so that it will hear the cries of the unfortunate!

⋅§ Penitence and Prayer Pave the Way for Charity

In the High Holiday prayers we proclaim: וּתְשׁוּבָה וּתְפִלָּה וּצְדָקָה מַעֲבִירִין אֶת רֹעַ הַגְּזֵרָה, *And penitence and prayer and charity turn aside the severity of God's strict judgments.* The Satmar Rav explained that the order of this list is precisely calculated so that charity is mentioned last, preceded by penitence and prayer. In order to disburse charity properly and to merit the privilege of giving to worthy recipients, one must first purify himself with penitence and invoke Divine assistance with fervent prayer. Only then is there hope that one may give *tzedakah* properly (*Divrei Yoel, Moadim, Rosh Hashanah* 73).

✑ Pray to Give Properly

Sefer Chassidim (61) writes: King Solomon advises: טוֹב מְלֹא כַף נָחַת מִמְּלֹא חָפְנַיִם עָמָל וּרְעוּת רוּחַ, *Better is one handful of pleasantness than two fistfuls of toil and mean spirit* (Ecclesiastes 4:6). This means that it is preferable to give a relatively small amount of charity, a mere *handful*, to righteous, God-fearing people who have fallen upon hard times than to give a large amount, *two fistfuls*, to bad people who will use the charity money in ways which defy the will of the Almighty. Therefore a person should always pray that Hashem send him worthy paupers with whom he may fulfill the mitzvah of *tzedakah* properly.

Another explanation of the above verse as it relates to *tzedakah*: It is better to give a large amount of charity to one person [*one handful*] if this will satisfy all of his needs than to divide this sum into five smaller parts and to distribute it to five individuals who will receive only minimal benefit from the smaller donations that will not cover their needs [thus the *two fistfuls* will **not** alleviate their *toil and mean spirit*]. But if others will join him in supporting the five paupers in a way that all the donations pooled together will cover all of their needs, then this is the best option of all.

✑ Pray While You Disburse Alms

Shelah Hakadosh (Megillah 26) writes that while it is inappropriate to put God to the test, one may make special prayer requests while he is disbursing charity to a beggar who goes collecting from door to door. The giver of charity may pray to God that neither he nor his children should ever be forced to beg. The prayer will be effective, because charity protects from poverty and the most auspicious time to pray is when disbursing charity.

✑ God Pays His Debts With Mercy

Rabbeinu Bachaye (Introduction to Va'eschanan) elaborates on the relationship between charity and prayer.

King Solomon taught: מַלְוֵה ה׳ חוֹנֵן דָּל, וּגְמֻלוֹ יְשַׁלֶּם לוֹ, *One who is*

gracious to the poor has lent to Hashem, and He will pay him his reward (*Proverbs* 19:17). God loves the poor far more than He loves the rich, because the poor are totally dependent upon the Almighty, as King Solomon notes: גַּם לְרֵעֵהוּ יִשָּׂנֵא רָשׁ, וְאֹהֲבֵי עָשִׁיר רַבִּים, *A poor person will be hated even by his companion, but the lovers of the rich will be many* (ibid. 14:20). And he repeats this idea: כָּל אֲחֵי רָשׁ שְׂנֵאֻהוּ, אַף כִּי מְרֵעֵהוּ רָחֲקוּ מִמֶּנּוּ, *All a pauper's brothers hate him, surely his friends withdraw from him* (ibid. 19:7).

When friends and relatives spurn the pauper, he has nowhere to turn but to God. Inadvertently, by abandoning the indigent, they drive him toward the warm embrace of the Almighty. The unfortunate soul who casts himself entirely upon the mercy of God has chosen wisely, because now God will gather him in and take full responsibility for his welfare, as the prophet said: כִּי ה׳ יִסַּד צִיּוֹן וּבָהּ יֶחֱסוּ עֲנִיֵּי עַמּוֹ, *For Hashem has established Zion and in it the poor of His nation take shelter* (*Isaiah* 14:32). The poor are God's personal charges, His dependents, *His nation.* Therefore, whoever supports the poor is actually discharging God's obligation and God is indebted to this benefactor. When the man of charity turns to God in prayer, God feels compelled to respond positively to his requests. God says: "You gave my poor dependents a gift, even without their earning it; similarly, I will shower you with Divine gifts even if you are undeserving!"

◆§ The Poor Man's Prayer Is Precious

A *rvei Nachal* (*Parshas Va'eschanan*) writes that because the poor are so close to God, they perform a great service for the Jewish people. There are times when Hashem is angry with the Jewish people because of their sins and he refuses to accept their prayers with favor. The prayers of the indigent, however, are always precious to God. For they have every reason to complain against Him, yet they pour out their hearts before Him with love and devotion. No obstacle, no accusing angel, nothing stands in the way of the poor man's prayer which soars heavenward and is welcomed before God's celestial throne. So powerful and all encompassing is the poor man's prayer that it sweeps up all of the lost and rejected prayers of the Jewish people and carries them up to the presence of God. This is the meaning of the verse, תְּפִלָּה לְעָנִי כִי יַעֲטֹף וְלִפְנֵי ה׳ יִשְׁפֹּךְ שִׂיחוֹ, *A prayer of*

the poor man when he envelops all others, and pours forth his supplications before Hashem (Psalms 102:1).

Therefore, he who gives charity to the poor before he prays is merging his supplication with that of the pauper, infusing it with tremendous merit and power!

CHAPTER SEVENTEEN

Repentance and *Tzedakah*

⇜ Charity Rectifies Sin

In the High Holiday prayers we say: וּתְשׁוּבָה וּתְפִילָה וּצְדָקָה מַעֲבִירִין אֶת רֹעַ הַגְּזֵרָה, *But repentance, prayer and charity remove the evil of God's decree.*

Rambam writes (*Hilchos Teshuvah* 2:4): Among the methods of *teshuvah* are: The penitent should continually call out to Hashem, with weeping and intense prayer; and he should distribute charity according to his means.

Rambam writes (*Hilchos Teshuvah* 3:4): Because of the critical nature of this matter [to repent properly] it has always been the custom of the entire Jewish people to increase their charity and good deeds and mitzvah observance in the days between Rosh Hashanah and Yom Kippur even more than the rest of the year.

Me'il Tzedakah (1263) writes that if a person sinned with his hands [for example, if he touched someone or something he should not have touched] then he can rectify his sin by repenting and by using his hands to give *tzedakah*. Scripture alludes to the fact that the sinner's hand is 'locked into' his sin until he redeems it with charity, for it says: פָּתֹחַ תִּפְתַּח אֶת יָדְךָ לוֹ וְהַעֲבֵט תַּעֲבִיטֶנּוּ דֵּי מַחְסֹרוֹ אֲשֶׁר יֶחְסַר לוֹ, *Open your hand [for charity] and you will surely open your hand [and release it from the grip of sin]* (Deuteronomy 15:8).

⇜ *Tzedakah* Is Better Than a Sacrifice

R' Chaim Palagi writes (*Tzedakah L'Chaim* 297) that when one seeks Divine forgiveness, charity is more effective than sacrifices in the

Holy Temple. For animal sacrifices only atone for unintentional sins, whereas *tzedakah* brings God to forgive a person even for intentional acts of defiance against His will. This concept is stated by King Solomon who said: עֲשֹׂה צְדָקָה וּמִשְׁפָּט נִבְחָר לַה׳ מִזָּבַח, *Performing acts of charity and justice is preferable to Hashem than a sacrifice* (*Proverbs* 21:3).

⇜ *Tzedakah* Is Not a Bribe

The Talmud (*Bava Basra* 10a) teaches that charity saves the donor from the harsh judgment of *Gehinnom*. R' Elchonon Wasserman (*Kovetz Shiurim* 52) asks: This statement apparently contradicts the established rule that God does not take bribes; even mitzvah acts cannot change His decrees. Thus, if a person sinned and fears Divine retribution, the good deeds he does in order to mollify God are to no avail; they will not cancel out his transgressions. He will still have to suffer the consequences of his misdeeds, and he will be rewarded appropriately for his mitzvah actions. So how can the Talmud teach that charity will rescue a man from the punishment of *Gehinnom*?

The proper understanding of this concept may be based on the teachings of Rabbeinu Yonah in his *Shaarei Teshuvah* who explains that when King Solomon said, בְּחֶסֶד וֶאֱמֶת יְכֻפַּר עָוֹן, *Through kindness and truth iniquity will be forgiven* (*Proverbs* 16:6), he meant *after repentance!* There are many sins which are so serious that repentance alone will not suffice to erase them; rather the sinner must also suffer in order to eradicate his wrongdoing. It is in reference to such sins that King Solomon said that if the penitent gives charity, the charity can take the place of suffering and anguish, and the penitent needs no additional affliction.

⇜ Collect Lifesaving Merits

Rav Huna taught: If a person stumbled and committed a sin for which the penalty is death at the hands of heaven, what should he do to merit a reprieve? Let him increase his study of Torah. If he

was accustomed to study one page of Torah per day, let him now study two. If he ordinarily studied one chapter, let him now study two. But what if he is totally unlettered and is incapable of studying even the most elementary texts, what should he do to live? Let him undertake community service or accept a position as a *gabbai tzedakah*, a charity collector, and he will be rescued from death! (*Vayikra Rabbah* 22:1).

ക് Protects From Sin

R' Tzvi Elimelech of Dinov, the author of the *Bnei Yissachar,* writes: I have received a tradition from holy *tzaddikim* that if by some chance, heaven forbid, a person's eyes stray and he finds himself gazing upon a sinful sight, or one feels that his mind is overwhelmed by a sinful thought, and the Evil Inclination ignites an uncontrollable passion for sin which rages within him, he should make a vow to give any amount of money to *tzedakah* and this merit will save him from sin and weaken the grip of the Evil Inclination (*Igra D'pirka* 104).

ക് Whatever a Man Has He Would Give Up for His Life

The *Baal HaTanya* (*Igeres Hakodesh,* Chapter 10) posits that the prohibition of lavishing more than one fifth of one's income upon charity only applies to a perfectly righteous person who needs to give charity only for the sake of fulfilling the mitzvah of *tzedakah.* But if a person has tainted himself with iniquity and his soul is afflicted with the malady of sin, then he must give charity lavishly in order to repent and cure his soul. In such a case there are absolutely no monetary limits. Wouldn't a person suffering from a physical ailment spend all of his money in order to find a cure? Doesn't Scripture say, וְכֹל אֲשֶׁר לָאִישׁ יִתֵּן בְּעַד נַפְשׁוֹ, *whatever a man has he would give up for his life (Job* 2:4)? Moreover, the most potent penitence is when a sinner commits his entire being to imitate the ways of Hashem. Since God's kindness and charity are without limit, the penitent, too, must give charity without any limit (see *Igra D'pirka* 187).

▸§ Have Pity on My Poor Soul!

Every day of his life, R' Chaim Sanzer gave away every penny he had to charity. He never went to sleep if there was even a single coin left in the house. Everything had to be distributed among the poor. When he was told that the wealthy have strongboxes in which they save their money, he responded in wonderment, "How can they sleep at night?"

The Sanzer Rav's son once gently reminded him that the halachah dictates that one should not give away more than one fifth of his assets to *tzedakah.* His father's reaction was painful. "Woe unto me, that I have lived to have a child who has no mercy on me!

"I am not giving *tzedakah* merely as a mitzvah," said the Sanzer Rav. "I am doing acts of kindness in order to atone for my many sins! Anyone would give away all he owns in order to save his own life. The halachah places no limits on how much one may spend to save his own life.

"What value does my learning have? What meaning do my prayers have? Every mitzvah I perform is tainted with imperfection. *Tzedakah* is the one mitzvah that does not require perfection in order to have merit. As long as the poor have food to eat and clothes to wear as a result of my charity, then I have earned some genuine merit. So you see that the only mitzvah I can perform acceptably even in my pitiful state of sinfulness is *tzedakah;* and you, my own child, begrudge me this!"

▸§ The Price of Penitence

R' Moshe Feinstein in (*Iggros Moshe, Orach Chaim,* Vol. I, 175) offers the following guidance to a couple who made a serious error in the laws of family purity and asked for a formula for penitence. He advises them that fasting is the most effective form of purification. But whether they can fast or not, they must certainly increase their charity significantly, for *Rambam* (*Hilchos Teshuvah* 2:4) emphasizes the power of *tzedakah* to inspire genuine penitence.

The extra money the penitents donate to charity should be above and beyond their customary *maaser* contributions, and is therefore not deductible from their *maaser* obligation. [Additional details are enumerated in the full responsum.]

CHAPTER EIGHTEEN

You Can Take It With You

⇜ Charity Is a Man's Best Friend

King Solomon says: אִישׁ רֵעִים לְהִתְרֹעֵעַ, וְיֵשׁ אֹהֵב דָּבֵק מֵאָח, *There is a man with many friends who will be broken but there is a beloved friend who is closer than a brother* (Proverbs 18:24). The Vilna Gaon (ibid.) observes that in this life everyone has three primary 'close' relationships. First, man is closely related to his money and property. Second, a person is close to his relatives and neighbors. Third, man is related to his charity and good deeds.

Thus, King Solomon says: Most people feel secure because they rely on two of their friends to come to their aid in time of need — their money, and their relatives and influential social contacts. But when a person is on his deathbed he will discover that these 'friends' can do little to help him recover. And after one passes over the threshold from this world to the Hereafter, these 'friends' will abandon him to his eternal fate. It is precisely at these times of need that a person discovers that he has a friend whom he hitherto failed to appreciate; a relative whom he never thought of relying upon. Now, on the day of death, one discovers that his closest relative, closer than his own brother, is his *tzedakah*. Only *tzedakah* can save him from all danger in this life, and will accompany and protect him in the Afterlife as it says, בְּהִתְהַלֶּכְךָ תַּנְחֶה אֹתָךְ, בְּשָׁכְבְּךָ תִּשְׁמֹר עָלֶיךָ, וַהֲקִיצוֹתָ הִיא תְשִׂיחֶךָ , *As you go forth* [during your lifetime] *it will guide you, as you recline* [in the grave] *it will guard you, and when you awaken* [for final judgment] *it will empower you with* [defensive] *speech* (Proverbs 6:22; Rashi).

�'§ Open Now Before It Is Too Late

Scripture states: וְלֹא תִקְפֹּץ אֶת יָדְךָ מֵאָחִיךָ הָאֶבְיוֹן. כִּי פָתֹחַ תִּפְתַּח אֶת יָדְךָ לוֹ, *Nor shall you close your hand against your destitute brother. Rather, open, and continue to open your hand to him (Deuteronomy 15:7,8).* What is the significance of the repetition, *open, and continue to open your hand?* This can be explained with the words of the Midrash (*Koheles Rabbah* 5:21): R' Meir observed, "When a person comes into this world as a baby, his fists are clenched, as if to say, 'The entire world is mine and I intend to hold on to it!' But when a man dies and leaves this world, his hands are open and outstretched, as if to say, 'Nothing I acquired is really mine, for I must leave everything behind!' This is as King Solomon said: כַּאֲשֶׁר יָצָא מִבֶּטֶן אִמּוֹ, עָרוֹם יָשׁוּב לָלֶכֶת כְּשֶׁבָּא, וּמְאוּמָה לֹא יִשָּׂא בַעֲמָלוֹ שֶׁיֵּלֵךְ בְּיָדוֹ, *As he emerged from his mother's womb, naked will he return, as he had come; he can salvage nothing from his labor to take with him (Koheles 5:14).*

This is alluded to in the repetition: פָּתוֹחַ, *open,* unclench your fist while you are still alive and can give charity, because inevitably, תִּפְתַּח, *you will open your hand* on the day you die; you cannot take your money with you (*Me'il Tzedakah,* Vol. II; 551).

�'§ Last Will and Testament

The Talmud (*Kesubos* 67b) relates that before Mar Ukva died, he asked that his charity accounts be brought to him. He saw that he had given 7,000 dinars. "I am about to embark upon a long journey [in the eternal Afterlife], but the provisions I have set aside [charitable deeds] are insufficient!" Stirred by this thought, Mar Ukva proceeded to give away half of his assets to charity.

The Talmud questions his actions: "How could he give away half of his money, since in the city of Usha the Sages enacted a regulation that a person should not give to *tzedakah* more than a fifth of his possessions?" The Talmud answers that this restriction only applies during a person's lifetime, but not at the time of his death.

Rama (*Yoreh Deah* 249:1) states: The restriction of giving no more

than one-fifth to *tzedakah* only applies throughout a person's lifetime, but before a person dies he may donate all he wants to charity.

There are, however, different versions of the text of the above Gemara. R' Akiva Eiger (gloss to *Yoreh Deah* ibid.) cites the text of the *Sheiltos* which says that Mar Ukva merely gave one third of his wealth to charity on his deathbed. *Pri Megadim* (*Orach Chaim* 656) says that the proper reading of the text should be that Mar Ukva gave away one half of his wealth to charity.

The consensus is that before death, one should not give away more than 50 percent of his resources to charity and he should leave at least 50 percent for his heirs. However, if one is extremely wealthy, he may give more than 50 percent of his wealth to *tzedakah* as long as the smaller percentage he bequeaths to his family is enough to support them in a dignified manner.

The *Aruch Hashulchan* (*Yoreh Deah* 249:1) explains that giving half one's assets to charity at the time of death is equivalent to splitting one's estate between himself and his heirs: half of the wealth is designated for the benefit of one's soul and the second half is reserved for his heirs.

R' Moshe Feinstein (*Iggros Moshe, Choshen Mishpat*, Vol. II, 50) endorses the concept of a person caring for his soul by giving *tzedakah* lavishly before he leaves this world. If a person fears that he will suffer in *Gehinnom* for his sins, *tzedakah* will certainly protect him. And even if *Gehinnom* is not one's concern, he would be doing a great eternal service to his soul by giving charity in order to increase his merits in the Afterlife.

The best practice of all is for the person to distribute all that he wishes to leave to charity while he is still alive. In this way, he will be immediately protected from the initial suffering in the grave [*chibut hakever*] and his charity will accompany him as he ascends to appear before the heavenly tribunal for final judgment. Also, it is best for a person to depend on himself and not his executors or heirs. Who knows what complications may arise after one leaves this world? Who can be sure that his instructions will be fulfilled scrupulously and punctually? Why be left to the mercies of others when you can take care of yourself? (*Responsa Minchas Tzvi*, Vol. III, 11).

See also the section on *Wills and Estates* in the chapter *Pledges to Tzedakah*.

✺ Preparing to Leave This World

It is very worthwhile for the sick person who feels his life drawing to an end to give charity for the benefit of his own soul (*Maavar Yabok* Chap. 10; *Ahavas Chesed,* Part III, Chap. 3 and Chap. 4 in the name of the *Shelah Hakadosh*). *Gesher Hachaim* (p. 36) writes: What a great privilege it is for a person to merit to give charity as he departs from this world. As long as a person is still alive, he can give charity from his own money while he is in full possession of his property. After death, all of the heirs will come to grab their portion of the estate, so why shouldn't the sick person, the real owner, grab a piece of the estate for the eternal benefit of his or her own soul?

Some authorities advise a person to designate some of his or her estate for a project which will benefit the entire community [*tzarchei rabbim*] because the Talmud (*Bava Basra* 165a) teaches that in the course of a lifetime almost everyone is guilty of some type of theft. Elsewhere, the Talmud (*Bava Kamma* 94) teaches that if someone knows that he stole but cannot remember from whom he stole, he should contribute a sum equal to the amount he stole, to a project which will benefit the entire community (*Choshen Mishpat* 366). By contributing to such a cause, a person assures atonement for any monetary infractions (*Ramat Rachel,* Chapter 27).

The Midrash (*Koheles Rabbah* 3:22) states: Whoever gives charity just before death demonstrates that the measure of his or her lifetime's charity was almost complete and that all that was missing was that final contribution. With this deathbed bequest, the entire quota of charity has been completed.

Before the dying person recites the final *viduy* confession, it is appropriate to contribute at least 26 pennies to charity, or 91 or 112. These numbers represent the *gematria* values of different names of God — and have kabbalistic significance (*Gesher Hachaim* p. 35).

✺ Funeral

It is customary to give out charity during a funeral ceremony to demonstrate the power of charity upon the soul of the departed. The *Pesikta* says: "Great is the power of charity because it saves a person

from the judgment of *Gehinnom"* (see *Responsa Rashba,* Part 7; 539). Furthermore, in *Pirkei D'Rabbi Eliezer* we learn that "R' Yehoshua ben Korcha said that it is the merit of charity that resurrects the dead, for we see that the prophet Elisha brought the son of the Shunamite woman back to life by virtue of the kindness and charity she did for him." For this reason it is customary to give out charity at a funeral for in this merit the deceased will come back to life (*Menachem Aveilim* p. 35b). The greatest Rabbis such as the renowned R' Akiva Eiger made known before they died that charity should be distributed for them at their funeral.

Scripture says: וְהָלַךְ לְפָנֶיךָ צִדְקֶךָ, כְּבוֹד ה' יַאַסְפֶךָ, *And your charitable deeds shall go before you and the glory of Hashem will gather you in* (*Isaiah* 58:8). This means that the holy angels a person created whenever he gave charity throughout his lifetime will precede him as his soul ascends heavenward after death. There is a time-honored custom in many communities that during the actual funeral procession, as the deceased is carried towards the grave, the *shamash* goes in front of the body with a charity box in hand and cries out, צְדָקָה תַּצִיל מִמָּוֶת, *Charity saves from death!* This serves both as a prayer for the deceased that by virtue of this charity he will be saved from eternal death and also it inspires the living to protect themselves from harm by intensifying their charity while still alive.

Maavor Yabok writes that if a person finds that extenuating circumstances prevent him from participating in a funeral he should at least offer prayers on behalf of the deceased and donate charity in his memory at the estimated time of burial. (See *Zichron Meir* on *Aveilus,* Part I Chapter 17 for details about charity at the funeral.)

ᴇ§ Yahrzeit

The great Chassidic master, R' Tzvi Hirsch of Ziditchov (1763-1830), once forgot to observe his mother's *Yahrzeit.* That night she appeared to her son in a dream and told him that she forgave him for forgetting to learn *Mishnayos* in her memory, and she also forgave him for not leading the prayers and reciting the *Kaddish* for the elevation of her soul. But she could not excuse him for neglecting to serve all who came to pray in the synagogue the customary *tikkun* of cake and drinks in her memory.

An illustrious descendant of the first Ziditchover Rebbe, the Rebbe of Sanz-Klausenberg explained that the *tikkun* served after prayers is very meaningful. Since many poor people partake of these refreshments it constitutes an act of public charity. In the Mishnah (*Avos* 1:2) we learn: "The whole world stands upon three things — on the Torah, on the service of God, and upon acts of loving-kindness." On the day of the *Yahrzeit* we wish to dedicate the three pillars of the world to the blessed memory of the deceased. Before prayers, one purifies himself in the *mikveh* and learns Torah for at least an hour and thereby dedicates the first pillar. Then one dedicates the second pillar, that of service to God, by standing in devout prayer before the Almighty. At the conclusion of the prayers, one completes the third pillar, that of loving-kindness, by setting out refreshments from which the poor will get immediate benefit (*Shefa Chaim,* Vol. II, p.119).

Givers
of
Tzedakah

CHAPTER NINETEEN

Great *Baalei Tzedakah*

◆§ The Quality of Leadership

Throughout the ages, the Jewish people has been blessed with leaders who have guided them conscientiously in their service of Hashem. The two most common qualities that Jews demand from their leaders are outstanding piety and scholarship. However, when we study the biographies of our Rabbinic leaders carefully, it becomes apparent that inevitably these two qualities bring out a third which eventually becomes their predominant quality — dedicated care and deep concern for each and every Jew and his needs. Our great leaders were all men of charity and kindness, *baalei tzedakah vachesed.*

The higher a great man has ascended, the lower he knows how to stoop. My teacher, the Telzer Rosh HaYeshiva, R' Chaim Mordechai Katz, would say: "Only small people say that something is too small to care about. For truly great people, nothing is too small!" When the outstanding scholar sits by his *Gemara*, he racks his brains to solve the Talmud's questions. And with the same total concentration, the pious leader studies the face and the heart of the pained Jew who pours out his or her plea before him, and has no rest until he finds a solution to their problem.

In this vein, R' Yisroel Salanter would say, *"Yenem's gashmiyus iz mein ruchnius,* another person's material problems become my spiritual opportunity."

It may very well be that charity and kindness are the litmus test which proves the sincerity and purity of one's Torah study and mitzvah observance. The leaders who have demonstrated their selflessness

by generously giving away both their spiritual and material resources to help others have merited extraordinary Divine assistance, *siyata d'Shmaya*, in their quest to achieve high levels of Torah and *yiras Shamayim*. When you will read about the incredible charity of R' Chaim Brisker, who shared everything he owned with the poor, you will realize why Hashem blessed him with such extraordinary success in his Torah studies — studies worthy of being shared with the entire Jewish world, not just in his generation, but for all generations to come!

However, outstanding devotion to *tzedakah* is not the exclusive realm of Torah giants. Throughout our history, many *ordinary* people have displayed extraordinary devotion to the mitzvah of charity. Perhaps it was the example and the influence of the *giants* which inspired men of lesser stature to aspire to higher levels of charity. This is our goal in presenting a selection of stories of great *baalei tzedakah* from the annals of our history, presented in chronological order.

Stories From the Talmud

⧉ Rabbi Elazar of Bartosa

The Mishnah (*Avos* 3:8) teaches: R' Elazar of Bartosa says: Give Him (God) from His Own, for you and your possessions are His. And so has David said: בִּי מִמְּךָ הַכֹּל וּמִיָּדְךָ נָתַנּוּ לָךְ, *For everything is from You, and from Your Own we have given You* (I Chronicles 29:14).

Man must realize that all that he has belongs to God; hence, what he gives to charity is not his own, but is merely returning to God what is His (*Rav*).

This is a call against stinginess in matters of charity or expenditures for mitzvos. Realizing that he is spending God's money and not his own, man should give happily and magnanimously (*Meiri*).

All of a man's wealth is given to him by God for safekeeping. But unlike human depositors, God allows man to use part of the deposit for his personal needs; however, the rest must be used only according to the Divine Depositor's instructions (*Rabbeinu Yonah*).

As a practical matter, this Mishnah advises us to separate charity funds from our income immediately and earmark them for *tzedakah*.

Thus, when the poor or representatives of institutions come to solicit, one will not be reluctant to part with the funds since he already considers them the property of the poor (*Pri Chaim*).

For this reason, many people follow the commendable practice of keeping a separate *maaser* (charity tithe) account, and depositing a tenth of their earnings in it as soon as they are paid. Then, when they write out their charity checks, they are truly *giving Him from His Own*.

✥ A Race for Charity

The Talmud (*Taanis* 24a) describes the great thirst for giving charity that characterized R' Elazar of Bartosa:

Whenever the administrators of the charity funds would see him coming they would go and hide from him, because if he would encounter them he would give them whatever he had with him for whatever charity they were then collecting. One day he was going out to the market to buy a trousseau for his daughter. The administrators of the charity saw him coming and hid from him. Seeing this, he ran after them and found them. He said to them: "I insist you tell me, for what charity are you now involved in collecting money?" They answered him, "To marry off an orphan boy to an orphan girl." He said to them: "By the Temple service, they come before my own daughter!" He took all the money he had with him and gave it to them.

He was left with one *zuz*. He bought with it some wheat, and brought it home and tossed it in his granary. His wife came and said to her daughter, "What did your father bring home?" She said, "Whatever he brought home, he tossed in the granary." She went to open up the door of the granary, and saw that the granary was filled with wheat, to the extent that it was coming out through the hinges of the door and the door would not open because of the wheat that was pressing against it. His daughter went to the house of study and said to her father: "Come and see what the One Who loves you has done for you." He said to her: "By the Temple service, this grain shall be like consecrated property to you, and you have no more share in it than any other poor person in Israel."

Rashi (ibid.) explains that the pious R' Elazar did not wish to benefit from a miracle, so that it would not detract from his merits in the World to Come. Instead, he donated the miraculous wheat to charity.

ᵜ§ Nochum Ish Gamzu

R' Elazar of Bartosa provides an example of how one should pursue *tzedakah* with all speed. The story of Nochum Ish Gamzu illustrates the high standards to which truly great men hold themselves accountable. Nochum was an eminent sage; indeed he was one of the earliest teachers of Rabbi Akiva. He was a man of exceptional piety and philanthropy. Yet, on one chance encounter, when he inadvertently failed to respond to the needs of a famished pauper with sufficient speed, he accepted full responsibility for the tragedy which ensued.

The Talmud (*Taanis* 21a) relates this story: They said of Nochum Ish Gamzu that he was blind in both eyes, missing both hands, missing both legs, and his entire body was covered with boils. ... And he was lying in a dilapidated house. His disciples sought to remove their bedridden teacher from the house first, and then remove the rest of the furniture. Nochum told them, "First remove the furniture and then remove my bed, because you may be assured that as long as I am in the house, the house will not collapse."

The students removed the furniture and then removed his bed — the house then collapsed. His disciples said to him, "Our master, since you are obviously a completely righteous person, why must you endure such suffering?"

Nochum replied, "My children, I brought this upon myself. For I was once traveling on the road to the house of my father-in-law with three donkeys — one laden with food, one with drink, and one with various delicacies. A poor man came and stood before me on the road and said to me, 'My teacher, sustain me!' I said to him: 'Wait until I unload some food from the donkey.' However, before I had a chance to unload the donkey, the poor man died of hunger! I went and fell down near the dead man's face and cried out, 'Let my eyes, which took no pity on your eyes, become blind; let my hands, which took no pity on your hands, be cut of; let my legs, which took no pity on your legs, be cut off!' And my mind did not rest until I said, 'Let my entire body be covered with boils!'"

"Woe to us that we have seen you like this," cried the disciples. Nochum replied, "Woe to me had you not seen me like this! (— had I not received my punishment in this world)."

Ben Yehoyada explains that Nochum blamed himself for not looking closely enough at the man to discern the gravity of his condition. This failure led him to dismount from his donkey, remove a sack and untie it in orderly fashion. Instead, he should have leaped from the donkey, pulled down a sack and torn open its binding to get a piece of food for the dying man. Because his delay contributed to the man's death, Nochum decreed upon himself that the eyes that failed to observe should be blinded, that the legs that did not spring from the donkey should be severed, and that the hands that did not tear at the sack's bindings should be severed as well.

Nevertheless, the *Maharsha* comments, this was merely the slightest trace of a sin, since Nochum had no reason to suppose that the man was so near death that the extra minute or two would prove critical. Thus, his students were astonished that he should receive such severe punishment for such a slight infraction. However, it is the desire of perfect *tzaddikim* to bear their punishment for even the slightest infraction in this world, and to arrive in the next world totally free of blemish.

R' Shimon Shkop (Introduction to *Shaarei Yosher*) explained Nochum's drastic behavior by comparing the situation to that of a superior officer who failed to live up to the responsibilities of his high position. Being a man of honor and integrity, this officer would resign from his commission on his own accord for his failure to discharge his obligations properly. Nochum understood that his arms and legs were merely agents to fulfill God's will. When these limbs failed in their duty to respond to the will of God, they quite literally resigned!

✒ Barbuhin

Once the Rabbis were collecting funds for their yeshiva and they came to the home of a man named Barbuhin. As they neared Barbuhin's residence, they overheard him instructing his son to buy some cheap, shriveled vegetables for supper. The Rabbis were certain that such a penny-pinching person would not give them a generous donation, so they decided to approach Barbuhin last, after they finished approaching all of the other donors. When they finally did solicit from Barbuhin, he said, "Go tell my wife to give you a measure of gold pieces."

His wife asked the Rabbis, "Did my husband say that the measure should be level or heaped?"

The Rabbis told her that her husband had not given specific instructions. She told the Rabbis that she would make the contribution with a heaping measure of gold; and if her husband would be adverse to this, she would allow him to deduct the extra amount from her dowry. Later, Barbuhin confirmed that his wife had acted correctly, for he had intended to donate a heaping measure of gold coins. When Barbuhin asked why they had not come to him sooner, the Rabbis revealed that they had been reluctant to solicit from him because they heard how he scrimped when buying food for his family.

"I have the right to be economical for my personal needs," he replied, "but not when it comes to fulfilling the wishes of my Creator" (*Midrash Esther Rabbah* 2:3; *Yerushalmi Pesachim* 4:9).

R' Yosef Chaim of Bagdad derives an essential lesson from this story: When it comes to giving charity a person has no right to think small — he must think big, very big! No matter what a person's economic level, he has to imagine that he is a multimillionaire who is capable of making significant contributions and accomplishing great things. In that way, when he ultimately calculates what he really can afford he will overcome the natural inclination to be stingy and he will give the maximum! This idea is conveyed in the verse describing the generous nature of those who merited to contribute to the construction of the Tabernacle: וַיָּבֹאוּ כָּל אִישׁ אֲשֶׁר נְשָׂאוֹ לִבּוֹ וְכֹל אֲשֶׁר נָדְבָה רוּחוֹ אֹתוֹ הֵבִיאוּ אֶת תְּרוּמַת ה' לִמְלֶאכֶת אֹהֶל מוֹעֵד, *Every man whose heart inspired him came; and everyone whose spirit motivated him brought the portion of Hashem for the work of the Tent of Meeting* (*Exodus* 35:21).

Another advantage of this positive frame of mind is that when one feels the enormity of the privilege of giving to a worthy cause he will not be filled with pride over his contribution; rather he will be humbled by the merit he has earned to be able to participate in some small way (*Aderes Eliyahu, Parshas Vayakhel*).

◆§ King Munbaz

The Talmud (*Bava Basra* 11a) relates the story of King Munbaz, a gentile potentate who became a sincere convert to Judaism near the end of the era of the Second Temple. In a time of severe famine,

Munbaz distributed the entire royal treasury to the poor. His family said to him, "Your fathers kept adding to the treasures that their fathers had amassed. But you did the opposite — you squandered away your own wealth and the fortunes amassed by your fathers."

Munbaz replied: "My fathers hoarded treasures below on the earth, but by giving charity I have stored treasures in heaven above. My fathers stored their treasures in a place where others could take it from them, but I stored my treasures in a safe place where no human hand can reach. My fathers stored treasures of money, but I stored treasures of souls. My fathers stored treasures for others, but I stored treasures for myself. My fathers stored treasures for this world, but I stored treasures for the World to Come."

⋑ R' Pinchas Ben Yair

Sometimes, when a person performs great acts of charity, he is not merely acting under the inspiration of the outstanding *baalei tzedakah* of the past, but his act of charity may forge a spiritual link with those great *baalei tzedakah*.

R' Shmuel Uzida, author of *Midrash Shmuel* on *Pirkei Avos*, was a close disciple of the holy *Arizal*. One time, he visited his master, and the *Arizal* showered extraordinary honor upon him. First he stood up before him. Then he sat R' Shmuel at his side in the position of highest distinction. The *Arizal's* foremost disciple, R' Chaim Vital, was amazed by this most unusual conduct, and after R' Shmuel took his leave, he humbly asked his master for an explanation. The *Arizal* replied: "You should know that it was not for my dear student R' Shmuel that I stood up. Rather, I stood up for the holy Tanna, R' Pinchas ben Yair, who entered the room together with him." Upon hearing this, R' Chaim Vital ran after R' Shmuel and asked him, "What special mitzvah did you perform today which might have earned you great merit?" R' Shmuel reluctantly revealed what had transpired early that morning: "I was passing by a house and I heard heartrending crying and wailing coming from within. Upon inquiry, the members of the household told me that their home had been broken into that night, and the robbers had stripped the house bare of every last item. The robbers had even stolen the clothing off their backs. I didn't hesitate for a moment and I gave them the clothing off my back in order to

calm them down! I then ran home and put on my Shabbos clothing, which, as you can see, I am wearing right now." R' Chaim Vital went back to his master, the *Arizal,* and related this story to him. The *Arizal* observed, "Now you can understand why the spirit of R' Pinchas ben Yair accompanied R' Shmuel today, because R' Pinchas excelled in acts of kindness, charity, and ransoming captives; so his soul is attracted to those who follow his example" (*Shulchan Hatahor, Shaar Tzedakah,* Chapter 2).

Stories From the
Last Three Centuries

——— R' Zusya of Hanipoli ———

⋖§ Business Is Business, and
Tzedakah Is Tzedakah!

R' Zusya's wife once asked him for money for a new dress. "I am ashamed to go among people in rags," she said. And when this righteous woman referred to her clothes as rags she was not referring to perfectly good garments, which had merely gone out of fashion. She meant that her one dress was threadbare with multiple patches.

Impoverished as he was, R' Zusya responded positively to his wife's request. He borrowed some money and his wife purchased material for the dress.

For a while there was peace and contentment in R' Zusya's home. One day, however, R' Zusya noticed that his wife was dejected. He asked her why her spirits were so low.

"I went to the tailor to pick up my new dress," she said, "but when he handed it to me he groaned deeply, and his tired eyes welled up with tears. I asked him why he was so depressed, and he informed me that he was marrying off his own daughter in a few weeks. He was very poor and he had nary a penny saved up for the event. All of his meager

earnings were used up feeding his large family. He could not afford a wedding dress for his daughter, and the young bride was very sad because of this.

"One day his daughter walked into the shop, and saw her father finishing the work on my new dress. She jumped to the conclusion that this was actually her wedding dress with which her father was going to surprise her. She asked to try on the dress, and it fit her perfectly. She was overjoyed until her father reluctantly told her that in truth the dress was not for her, but was made for a customer. The tailor told me that the poor girl became depressed and was talking about not wanting to get married, even wishing to break the engagement.

"I simply couldn't bear to see the tailor's pain," R' Zusya's wife continued, "so I told the tailor to give the dress to his daughter."

R' Zusya was overjoyed with his wife's act of kindness. "Thank God you were strong enough to overcome your personal desires," he said. "You have done one of the most selfless mitzvos possible. But tell me, did you pay the tailor for his work?"

"Pay him?" R' Zusya's wife exclaimed. "I should pay him? Isn't it enough that I gave away the dress I have been waiting for for so long? You want me to pay him for the dress I never got?"

R' Zusya gently explained his reasoning: "I am certain that this poor tailor counted on these wages to support his family. You contracted for a dress, and the tailor did his work skillfully, just as you had stipulated. You owe him the money you promised him for his work. The fact that you were moved to do an act of extraordinary kindness and gave him the dress for his daughter does not absolve you from your obligation to pay him for his work. Business is business, and *tzedakah* is *tzedakah*!"

R' Zusya borrowed additional money, and saw to it that his wife paid the tailor the wages he deserved.

⊷§ Genuine Charity

A pauper once knocked on R' Zusya's door, asking for alms. R' Zusya, who was penniless himself, had nothing to give the man, and was very upset over this. He searched all over his ramshackle hut for something of value which he might give him, and he finally found, tucked away in back of a drawer, the headpiece which his wife had worn at their wedding. There were several pearls sewn into the

headpiece and R' Zusya carefully removed them and gave them to the beggar.

No sooner had the beggar left R' Zusya's hut when his wife walked in and discovered what her husband had done. She shouted at him, "You gave away those pearls? Those are not imitation pearls! They are genuine!"

R' Zusya immediately ran after the pauper. "Listen!" he cried out. "Those pearls I gave you, they are genuine! Don't sell them cheaply!" (*Generation to Generation* p. 149-50).

——— Reb Meir Premishlaner ———

⋙ The Value of the Mitzvah of Tzedakah

R' Meir of Premishlan or, as he was fondly known, R' Maer'l, was renowned for his devotion to *tzedakah*. Any gifts he received from his *Chassidim* he immediately distributed to the poor. He explained himself in this way:

"Maer'l once went up to heaven in a dream and observed what happened to people as they came to heaven after they died.

"The first to appear by the celestial gates was a great Torah scholar, who was not granted immediate entry into heaven. Instead, he was politely asked to wait outside a while so that the angels could determine whether his studies were pursued with pure intentions or in order to be recognized and praised for his great wisdom.

"The second soul to appear before the gates was that of a *tzaddik* who devoted his life to leading and advising his flock in their search to serve Hashem. He too was cordially asked to wait outside while his motives were thoroughly investigated.

"The third to arrive was a poor innkeeper, who accepted all guests into his inn. If someone had money to pay for his room and board, the innkeeper would graciously accept it. However, if the person were too poor to pay, the host would gladly provide hospitality free of charge. The angels immediately decided that he should be ushered into the presence of Hashem without any delay. They had no doubt that his charity was pure because he had not done it for recognition and he helped the poor without expecting any reward in return.

"From this dream Maer'l learnt the enormous importance of *tzedakah* and decided to become a *gabbai tzedakah* to distribute Hashem's money among the poor."

ᴥᔓ Why R' Maer'l Could Not Sleep

R' Maer'l was so scrupulous with the mitzvah of *tzedakah* that he insisted that no money which could be distributed to the poor remain in his house overnight.

One night he could not fall asleep. He awakened all the members of his household and asked them to search the entire house to see if they could find any money which should not be there. Not a single kopek could be found. Still R' Maer'l could not rest. He insisted that there must be some money belonging to him somewhere.

The Rebbe then sent his *gabbai* to search through the town to see if anyone might have come with a *pidyon* for him. The *gabbai* searched all the local inns until in one he found a man who had arrived late in the evening. Before this traveler had departed from his hometown a woman had given him a *kvittel* and a *pidyon* to give to R' Maer'l to pray for her sick child. The *gabbai* urged this man to bring the request and the donation to the Rebbe immediately. Since the woman had designated this money for R' Maer'l it was as if it were already his. It was this money which would not allow the Rebbe to rest until he had distributed it among the poor.

—————— Rav Chaim Sanzer ——————

ᴥᔓ "I Love the Poor Because God Loves Them"

The Sanzer Rav, R' Chaim Halberstam (1793-1876), was one of the outstanding Chassidic leaders of the 19th century. Profound Torah scholar, renowned author of the classic Responsa *Divrei Chaim,* and revered leader of thousands of devoted disciples, he found the time

and wherewithal to care for the needs of the poor and destitute. His incredible kindness and mercy place the Sanzer Rav among the great masters of *tzedakah* who have graced the Jewish people throughout the ages.

The Rebbe was the central Chassidic leader of Galician Jewry at a time when those Jews were mired in poverty and dire want; every penny was hard to come by. The only exceptions were a few rare individuals, and these men of means were overburdened by *tzedakah* obligations. The Rebbe of Sanz was like a great minister of finance, under whose auspices huge sums flowed from the purses of the wealthy *negidim* into the hands of the poor.

R' Chaim himself derived no benefit whatsoever from his *tzedakah* activities; not a penny donated for *tzedakah* was used for his own needs or those of his family. His own home was bare of furniture, and his personal income was a few gulden a month; yet, thousands of gulden flowed through his fingers on a monthly basis.

Twice a day, every day, at set times in the morning and evening, the Rebbe would distribute charity lavishly. As he entered the *Beis HaMidrash* every morning for prayers, he always found hundreds of the needy of Sanz waiting for him. They surrounded him on all sides as he would give each one his allotted amount. When his funds were exhausted, they would still tug on his coat from every side. He did not become angry, but only pleaded with them that he simply had no more money. They refused to leave him alone until he gave more. He would go again and again to his wife, the Rebbetzin, to request that she lend him a few gulden, until she too could give no more. Then he would send out his *gabbai* to borrow from one of the local householders. In this fashion, every morning he would distribute at least eighteen gulden, and sometimes twice that amount, depending on the situation. After his prayers the Rebbe would return to his private room and again he found waiting for him poor youths with various urgent requests. This one desperately needed shoes, and that one needed another item of clothing, and so on.

At night, following the evening prayers, the Rebbe would give out money to the needy *yoshvim*, his disciples and followers who came from far and wide to spend an extended period of time in the court of the Rebbe and to benefit from his teachings and holy influence. These included men of Torah and accomplished scholars. The Rebbe also provided them with a good meal by holding a *tish* for them every day.

The Rebbe found no rest for his soul until he had fulfilled the needs

of all who required his help. He used to say, "I love the poor. Do you know why? Because *HaKadosh Baruch Hu* loves them."

∽§ The Finest Merit for a Departed Soul

His furniture and tableware were of the simplest kind. He never wanted to buy new clothes for himself. "The poor come first," was his constant refrain. He wouldn't even purchase a necessary *sefer* for himelf, explaining that *tzedakah* was far more important than buying holy books, for *sefarim* can always be borrowed. The moment a penny reached his hands, he would immediately give it away. And when he had nothing left to give away, he would pawn his personal possessions. The only household items of sufficient value to borrow on were the Chanukah *menorah,* the *Kiddush* cup, and the Shabbos candlesticks. The Chanukah *menorah* was pawned as security for loans from one Chanukah to the next; the *Kiddush* cup, from Shabbos to Shabbos; and as for the candlesticks — if the Rebbetzin didn't manage to hide them from his view — they too would be pawned for *tzedakah* needs.

A wealthy follower of the Rebbe, who had died without a son, bequeathed to him a splendid golden *Kiddush* cup, which the Rebbe would use on Shabbos and *Yom Tov.* Once, when R' Chaim was very pressed for charity funds, he decided that the soul of his departed benefactor would gain far more merit if he would use the golden cup as collateral for a loan and use the money for the poor. From then on, the golden cup was no longer seen on the table of the Rebbe. In its place the *tzaddik's* old silver goblet reappeared — and that, too, would be held as security for *tzedakah* loans from one Shabbos to the next.

∽§ A Gaon in Tzedakah

Before Sukkos, the Rebbe was especially involved in *tzedakah* and distributed tremendous sums to the poor. One Erev Sukkos R' Chaim sent his sons out to borrow several thousand gulden on his behalf and he immediately distributed the entire amount to those in need. As he was entering his *sukkah* that evening, R' Chaim turned to his sons and said with great joy and excitement: "Tonight our *sukkah*

is exceptionally beautiful because we have adorned it with the precious mitzvah of *tzedakah*. Others may decorate their *sukkos* with exquisite art and ornaments, but that is not my way. *Tzedakah* is the most magnificent adornment of the *sukkah*; that is its grace and splendor."

One Sukkos, a few minutes before sunset and the beginning of the festival, a messenger from the Rebbe came to one of the wealthy men of Sanz (who was involved in the Rebbe's charitable endeavors) requesting an immediate loan of a large sum of money. The man promptly fulfilled the Rebbe's request, but his curiosity was aroused. He knew that the Rebbe had already distributed enormous sums to *tzedakah* well before Sukkos, so what *tzedakah* need was so urgent now? Furthermore, it was so late in the day that the recipient could not put it to use for this *Yom Tov* anyway, so what was the money for?

The rich man followed the messenger and noted that he delivered the money to a poor family whose holiday needs the Rebbe had already provided. The curious man then approached the Rebbe and asked him why this extra gift was necessary.

The Sanzer Rav responded, "Are you going to teach me how to give *tzedakah*? Here, let me teach you something!

"Of course I already gave this family adequate provisions for the *Yom Tov*. But the head of the family is deeply mired in debt. How can he possibly enjoy his holiday when he knows that immediately after *Yom Tov* his creditors will hound him? Is food and drink sufficient to provide *Yom Tov* joy to this man? Is it not my responsibility to enable the entire family to have true joy on this great holiday? Now that this man has some money from which he can make payments on his debts right after *Yom Tov,* he and his family will be able to experience genuine *Yom Tov* joy!"

No wonder the Sanzer Rav's grandson, R' Shlomo, the first Bobover Rav, used to comment: "The Sanzer Zeide is generally considered to have been an outstanding genius, a *gaon,* in Talmudic scholarship and a righteous *tzaddik* in his *tzedakah*. What people don't realize is that he was an outstanding genius in his approach to *tzedakah* as well."

⊷§ Enough for All Their Needs

Although the Rebbe and his family made do with the bare minimum, the Sanzer Rav dealt towards others with incredible

generosity. One incident illustrates this most vividly. A local merchant once tried to sell the *Rebbetzin* a goose in honor of Shabbos, but she turned down the offer because of the high price the merchant was asking. Much to her consternation, the Rebbetzin later discovered that this same goose had ultimately been purchased by one of the impoverished families regularly supported by a stipend from her husband.

The Rebbetzin was incensed by this flagrant abuse of charity funds and went to complain to her husband, saying, "Just look at the 'needy ones' you support! I myself passed up that goose because it was too expensive, yet that family, which benefits from your charity funds, went out and bought it!"

Her husband, the Rebbe, responded: "Thank you so much for this crucial information, for I had no idea that this poor family needs goose meat on Shabbos. From now on I shall add to their allotment so that they will have enough for all their needs."

◄§ He Uprooted the Desire for Money From His Heart

The Rebbe related how he had traveled great distances to visit with great *tzaddikim* to learn their noble character traits and adopt their holy ways. In the course of these journeys he stayed with R' Hirsch of Rimanov, from whom he learnt about *tzedakah* which R' Hirsch practiced to perfection. When R' Hirsch had money, he would dispense all of it to the poor, leaving nothing for himself; and when he did not have anything to give, he was just as joyful as if he had had money and had given it to the poor. This was obviously how Hashem wanted it to be, R' Hirsch would explain. "I am different," R' Chaim would say in self-criticism, "if I have nothing to give to *tzedakah,* my very flesh withers and melts from my bones."

R' Aharon Roth writes (*Shulchan Hatahor, Shaar Hatzedakah,* Chap. 3): I heard that R' Chaim Sanzer said that originally he had an extraordinary love of money and he was exceedingly stingy. However, he worked on himself mercilessly to change his nature and he literally uprooted the desire for money from his heart. His success was evident because he became a philanthropist such as had not been seen in many generations.

~§ The Soloveitchik Dynasty

In the final decades of the 18th century, an extremely wealthy magnate named R' Moshe Soloveitchik lived in Lithuania. He made his fortune from the lumber cut from the vast forest which he owned. R' Moshe was renowned for his philanthropy; he gave lavishly to everyone in need and to every worthy cause.

Suddenly one day, terrible news spread like wildfire: R' Moshe Soloveitchik was bankrupt. His entire fortune was lost! This news was especially painful and perplexing to everyone who knew R' Moshe because no one could fathom why God would impoverish such a righteous and generous man.

Indeed, R' Moshe was held in such high esteem by the Rabbis of his generation that they convened a special Rabbinic court to investigate R' Moshe's terrible misfortune. The court was headed by the renowned R' Chaim of Volozhin who, together with other illustrious Rabbinic personalities, made a thorough examination of all of R' Moshe's financial records and business transactions in order to uncover any irregularities which might have caused his downfall. After an exhaustive investigation, the only 'crime' they uncovered was that R' Moshe had ignored the warning of the Sages (*Kesubos* 50b) that "He who lavishes his money on charity should not give away more than one fifth of his income." However, R' Chaim Volozhiner himself refused to accept this as the cause of R' Moshe's bankruptcy. He rejected the mere suggestion of this out of hand, saying, "What? Do you really believe that for such a 'crime' he deserves such a harsh punishment? Impossible!"

Meanwhile, R' Moshe himself was not wasting time agonizing over his tremendous losses. He discovered that although he had *lost* a great deal of money, he had *gained* a great deal of time! Now that his mind was no longer preoccupied with business affairs it was free to delve into the depths of Torah. R' Moshe concentrated his superior intellectual powers on his studies and steadily developed into a *talmid chacham* of note. Eventually, he grew so proficient in halachah that he was appointed to be a *poseik,* a halachic decisor in the city of Kovno. Moreover, his son, Yosef Soloveitchik, became such an outstanding *talmid chacham* that he was chosen by R' Chaim Volozhiner to be his son-in-law.

Years later, R' Chaim Volozhiner observed: "In retrospect, in light of

all that has happened since R' Moshe Soloveitchik's financial collapse, I see clearly the reason for all that transpired. In heaven they wished to reward R' Moshe for his extraordinary charity and kindness. There is no greater gift than to have generations of children and children's children who are great in Torah and fear of heaven. However, it is impossible for such a Torah dynasty to be cultivated in a home of luxury and wealth. Therefore, the heavenly tribunal decreed that R' Moshe's wealth should be lost so that he would be free to dedicate himself to Torah study and have a home where Torah was acquired through deprivation and dedication."

R' Chaim Volozhiner lived to see his prophecy about the Soloveitchik dynasty fulfilled. In his old age he saw his great-grandson, R' Yosef Dov Soloveitchik, the famed *Beis Halevi,* the future Rav of Brisk, as a child of 6 or 7, already showing signs of greatness in Torah (*Avi HaYeshivos,* Vol. II; p. 160).

⋞§ R' Yosef Dov Soloveitchik — The Beis Halevi

R' Yosef Dov (Yoshe Ber) Soloveitchik, the 'founder' of the Brisker Torah dynasty, was born in 1820 to his father, R' Yitzchok Zev. R' Yoshe Ber, who became one of the most illustrious Rabbis of his time, was renowned not only for his phenomenal Torah scholarship, but also for his charity and compassion for the poor and downtrodden. In fact, one of the most popular *tzedakah* stories of all time highlights R' Yoshe Ber's extreme sensitivity to the needs of the poor and his uncanny ability to read between the lines of their requests.

One Erev Pesach, a man came to R' Yoshe Ber asking if he could fulfill the mitzvah of drinking four cups of wine at the *Seder* by substituting milk for wine. R' Yoshe Ber did not hesitate for a moment. He turned to his wife and asked her to give the man 25 rubles to purchase wine. The man protested that he came to receive an answer to his halachic query, not to receive charity. Thereupon, R' Yoshe Ber informed him that the money was meant to be a loan — to be repaid when his financial situation improved.

After the man departed, the Rebbetzin asked her husband why it was necessary to give the man 25 rubles for wine when wine only cost three rubles. R' Yoshe Ber replied, "I understood from this man's

question that he had no meat for Pesach. Otherwise, how could he possibly have thought that he could drink milk for the four cups of wine? Clearly, this man needed money for wine, meat and the other Pesach necessities."

⊷§ Searching for Charitable Opportunities

Even as a youngster in *cheder,* R' Yoshe Ber showed great sensitivity to the pain of others. He would distribute whatever food his mother sent along with him to school to his poor hungry classmates whose parents could not afford to give them even one decent meal all day. When his mother expressed concern about young Yoshe Ber's going hungry in school, the little boy grabbed his *tzitzis* and exclaimed, "I assure you by the sanctity of these *tzitzis* that every time I see a poor boy satisfying his hunger with a piece of my bread, I feel as satisfied as if I myself had eaten!" During his free time he played with the poor children who were excluded from the wealthy children's games. His primary purpose was not to play for his own pleasure; his main intention was to gladden the hearts of the poor boys who were always left out.

In 1854, R' Yoshe Ber was appointed Rosh Yeshiva in the great Yeshiva of Volozhin where he assisted R' Naftoli Tzvi Yehuda Berlin in educating hundreds of the finest young Torah scholars in Eastern Europe. In 1865, he accepted the position as Rav of Slutsk in White Russia, where he personally supervised every aspect of Jewish communal life. Of course, as Rav, he thoroughly inspected the local Talmud Torahs of Slutsk where the younger boys studied. However, instead of examining the youngsters' Torah knowledge as was the norm, the first thing the new Rav checked out was their physical well-being. The Rav's first inquiry was whether all the boys had food for lunch. Finding that some the impoverished boys were starving all day, he gave his own money to buy them food. Then he saw to it that free daily meals be provided for the Talmud Torahs at communal expense.

R' Yoshe Ber's son, R' Chaim Soloveitchik, would remark, "What is the difference between me and my father? I assist the needy only after they approach me. My father didn't wait for the poor to approach him, but rather went knocking on people's doors to inquire whether they

needed assistance." R' Chaim compared his great father to Mordechai, who is praised in *Megillas Esther* (10:3) for being דֹּרֵשׁ טוֹב לְעַמּוֹ, searching for opportunities to benefit his nation.

R' Chaim Soloveitchik

⋖§ Master of Kindness

R' Chaim Halevi Soloveitchik, the Rav of Brisk, was world famous for his brilliant Torah scholarship. Today, almost a century after he left this world, R' Chaim's influence is felt more powerfully than ever wherever Torah is studied seriously. Yet, as awesome as R' Chaim's wisdom was, his fear of heaven was even greater, fulfilling the dictum of our Sages: *Anyone whose fear of sin takes precedence over his wisdom, his wisdom will endure* (*Avos* 3:11). R' Chaim literally trembled to fulfill the word of God properly in accordance to the halachah. This scrupulous and unswerving devotion to fulfilling God's will manifested itself in R' Chaim's incredible dedication to serving the needs of the poor.

R' Chaim Brisker passed away in 1918 and he is buried in the Jewish cemetery in Warsaw. The very first words at the top of his tombstone read: רַבֵּנוּ הַגָּדוֹל רַב הַחֶסֶד, *Rabbeinu Hagadol, Rav Hachesed*, 'Our great Rabbi, master of kindness.'

⋖§ Running After the Beggars

R' Michel Feinstein, the son-in-law of the Brisker Rav, R' Yitzchok Zev Soloveitchik, heard the following story from R' Isser Zalman Meltzer who was one of R' Chaim Soloveitchik's closest disciples: "Once I was sitting with my Rebbe in his home and there was a knock on the door. R' Chaim jumped up to open the door by himself (as was his custom at all times — to rush to open the door personally). A pauper was at the door collecting. My Rebbe searched his pockets and found them all to be empty. He asked the pauper to be kind enough to wait a few moments while he went to his drawer to get some money

for him. R' Chaim rushed into his room, fetched the money and ran back to the front door to give it to the beggar. Much to R' Chaim's dismay, the pauper was not there anymore! He had not had the patience to wait a few minutes and instead continued on his rounds.

"My master and teacher, R' Chaim, literally trembled with dread and fear. All color drained from his face and he turned all white. When the children saw their father's anguish and distress, they too went into a panic. They rushed out of the house in a frenzied search for the beggar in order to give him his alms! Why was R' Chaim so agitated? Because he had promised to give the pauper some coins and that constituted a charity vow, which is a very serious obligation and must be fulfilled. Furthermore, R' Chaim was concerned lest he had forfeited the fulfillment of the positive commandment, *You shall surely open your hand [to the poor]* (*Devarim* 15:8)."

When R' Michel Feinstein related this story to his father-in-law, R' Yitzchok Zev Soloveitchik, R' Chaim's son, his father-in-law, was not at all surprised and commented, "Such incidents were everyday occurrences in my father's home. If father ever suspected that he had not treated a pauper properly, or perhaps had not given him enough, he would send us children all over town to find the beggar and make amends!"

◄§ Kindness Without Limits

The Mishnah (*Avos* 1:5) says: *Yose ben Yochanan, leader of Jerusalem, says: "Let your house be open wide; and treat the poor as members of your household."* *Rabbeinu Yonah* and *Tiferes Yisroel* explain that one should make poor guests feel totally at home by showing them a happy face, thus minimizing their embarrassment at being dependent. One should give them free reign of his home.

R' Chaim Soloveitchik, the world-famous Rav of Brisk, took the teachings of this Mishnah to new heights. The kindness of R' Chaim Brisker knew no limits. He felt no sense of ownership over anything in the world. His home and all of his possessions were *hefker*, abandoned and free for all to use as they pleased. The hinges on the front door were purposely left unrepaired so that the door could never be closed. Any beggar could step over R' Chaim's threshold and immediately make himself at home without receiving any invitation or permission.

A poor man would come in, head straight for the kitchen where he lit a fire, boiled up a kettle of hot water for a soothing cup of tea, and rummaged through the cupboards to find something to eat. Finding something good to eat, the pauper would take out a pot, cook the food to his liking, set the table and sit down to a home-style meal. Feeling drowsy after his heavy meal, the pauper would go down the hallway and look through the bedrooms in search of an empty bed and lie down on the bed that suited him best. On winter nights, when the dirt floor was too cold to sleep on, the latecomers who could not find an empty bed would slip the doors off their hinges, put them down on the floor, and sleep on them.

Many times poor people would bang on R' Chaim's door in the dead of night and he would jump out of his bed, run to welcome them, and prepare a cup of tea to warm them. R' Chaim did it all so naturally and so calmly that no one ever felt embarrassed by the fact that they had caused the *Gadol Hador,* the leader of the generation, to take such pains on their behalf.

৵ His Home Belonged to the Public

The great American Rabbinic leader, R' Eliezer Silver, who was a student of R' Chaim Soloveitchik, recalled that in his Rebbe's home the activity never stopped, day and night. The place was literally a public thoroughfare. So much so, that shopkeepers, merchants and wagon drivers felt free to post their advertisements and announcements on the walls of the Rav's home because that was the best place for publicity. And R' Chaim saw his walls plastered with these posters and never said a word.

Entire families of indigents settled down in R' Chaim's home for months on end. R' Chaim forbade the members of his family to say a word or make a sound which might indicate that they felt annoyed or impatient with their guests.

The only things which R' Chaim kept for himself were the mitzvah objects such as the *lulav* and *esrog* on Sukkos and the matzoh of Pesach night, which according to the halachah must be one's personal property.

R' Chaim's son, R' Yitzchok Zev Soloveitchik, related that most of the time growing up in his father's home, he slept on a bench in some

corner of the house because his bed was always taken by a poor stranger. Once, he came home, exhausted from a full day of learning and fell into his 'own' bed. A short while later, a poor stranger aroused him from his slumber, saying, "This bed is mine. I already staked a claim on it earlier in the day!" The same thing often happened to R' Chaim himself, who would come home and find his own bed occupied by a stranger; he himself then slept on a hard wooden bench.

Small wonder that all these downtrodden souls felt like real family members. R' Chaim treated them with such genuine, brotherly love that they talked to him like a brother. Instead of referring to him as 'the Rav,' they merely called him "Chaim'ke."

≈§ Find Your Own Gemara

R' Yitzchok Zev (Velvel) Soloveitchik vividly described how his father's home was *hefker,* ownerless, to the poor.

Once, R' Chaim asked him to bring over a certain volume of the Talmud from the bookcase but it was missing. It turned out that one of their poor 'guests' was using it. R' Yitzchok Zev went over to the guest and told him that his father needed to use that volume. The poor man just looked at him and said, "Is there a lack of *Gemaras* in the local *Beis HaMidrash?* Go fetch one from there!"

Once, when R' Velvel was young, he was sitting at the table writing down some Torah. A distraught person rushed into the house and needed to write something. He went over and snatched the pen from R' Velvel's hand while he was in the middle of writing a word. No request, no excuse, no apology, no thank you! R' Velvel wanted to retrieve his pen from the interloper, but his father commanded him, *"Zie shtil,* Hold your tongue!"

Another intruder constantly 'borrowed' books from R' Chaim's library without asking permission. After a while, he amassed a sizable collection of R' Chaim's *sefarim,* but he had nowhere to store them. One day this person arrived at R' Chaim's home with a carpenter and a big wheelbarrow. The carpenter carefully dismantled R' Chaim's bookcase and put the pieces into the wheelbarrow. As the intruder was walking out with the wheelbarrow, he announced that since the Rav's bookcase was empty anyway, it might as well be placed in his own house. As usual, no one said a word! (*The Life of R' Rephael Soloveitchik,* p. 294).

⋖§ Who Will Worry About This Widow?

R' Yaakov Moshe Zimmerman, Rav of Krementzug, was a guest in R' Chaim's home for Pesach of the year 1911. He related the following incident that he witnessed.

At a very late hour on the night before Pesach, long after the search for *chametz* was over, a destitute widow knocked on R' Chaim's door. With tears streaming down her cheeks, she revealed her desperate plight. Here she was, the impoverished, widowed mother of thirteen orphans, on the night before Pesach, and she did not have a thing prepared for the coming holiday. Her cupboards were empty and bare.

Without hesitation, R' Chaim went over to the pantry closet where his wife stored all the Pesach food she had toiled for weeks to prepare. Indeed, she had prepared a lot of food because many guests would come to R' Chaim's home for the festival. R' Chaim emptied out the entire pantry, personally carried all the food outside, and loaded it on a wagon which delivered everything to the widow's home.

The next morning, the Rebbetzin awoke to make her final preparations for the holiday and, to her shock and dismay, discovered that all her Pesach food had disappeared! The news spread like wildfire; the entire city of Brisk was in an uproar. Imagine, the 'chutzpah' of a thief to break into the Rav's home the night before Pesach and rob him of every last morsel of food! The people of Brisk rose to the occasion and responded generously and sent the Rebbetzin some of their choicest Pesach delicacies. By the time the holiday arrived, R' Chaim's home was well stocked with ample supplies for his family and guests.

After the first *Seder* was over, R' Chaim 'confessed' to his wife that he himself was the thief. Bewildered, she asked, "But how could you take the chance of leaving your whole family and guests without food for the entire Pesach holiday?" To this R' Chaim replied, "I had no doubt that the people of Brisk would not let their own Rav go hungry for the holiday. As for the wretched widow and her thirteen orphans — who will worry about her if not the Rav?" (Many stories in this section are found in *Uvdos L'Beis Brisk*, Vol. I, II.)

✒§ Reb Boruch Zeldovitz

A man of both great wealth and genuine piety, R' Boruch Zeldovitz studied in his youth in the Yeshiva of Volozhin under R' Naftoli Tzvi Yehuda Berlin and R' Chaim Halevi Soloveitchik. R' Boruch was very close to R' Chaim and remained his disciple all his life. After the tragic closing of the Volozhiner Yeshiva by the Russian authorities, R' Chaim moved to Brisk where he eventually assumed the rabbinate in place of his great father, the Beis Halevi. His devoted student, R' Boruch, lived far away in a different city, Yet, whenever he found himself unable to fathom the meaning of a certain *Gemara,* R' Boruch would leave behind his thriving business and travel all the way to Brisk to ask his teacher R' Chaim to clarify the difficult section of the Talmud.

Not only was R' Boruch an accomplished Torah scholar, he was also an outstanding philanthropist. The doors of his home were always open to those in need, whom he helped generously. He was extremely open handed in his munificence to yeshivos and all Torah institutions, especially to Yeshivas Volozhin, to which he owed such a debt of gratitude for his own Torah study.

R' Boruch lived in the city of Minsk, and in time, he himself, together with two other worthy men, became the *gabbaim* responsible for the interests of the Yeshiva of Volozhin in that locale. Once, R' Chaim Soloveitchik himself traveled all the way to Minsk because of the yeshiva's desperate financial straits. He called together the three *gabbaim* of the yeshiva and urged them to make every effort to raise the sum of 30,000 rubles as quickly as possible. All three dropped their own affairs and immediately set out to raise the necessary sum.

Within a half-hour, one of the *gabbaim* returned with the full amount of 30,000 rubles. A few minutes later, the two other *gabbaim* returned, and each came with 10,000 rubles. R' Chaim thanked them warmly but informed them that he no longer needed their 20,000 rubles because the full sum had been raised by the first *gabbai.* The two *gabbaim,* however, were adamant, and insisted that R' Chaim had to take their money. They argued that since R' Chaim had sent all three out to raise the required sum, that meant that all three would share the mitzvah equally and each one would have the privilege of

raising a full 10,000 rubles. When the first *gabbai* refused to give up the full mitzvah, which he had grabbed for himself, the other two *gabbaim* promptly summoned him to a *Beis Din* in an all-out effort to obtain their rights! Such was the dedication of *gabbaim* in days of yore!

❧ Charity Counters the Revolution

During World War I, when most of the great yeshivos of Eastern Europe were forced into exile, R' Boruch personally took responsibility to support three of the greatest institutions, the yeshivos of Kamenetz, Slabodka and Novaradok. Later, in 1917, the rapacious Communists came to power during the Russian revolution. The Communists made the wealthy their first targets and after murdering them and their families in cold blood, they would plunder their wealth for themselves. R' Boruch Zeldovitz was one of the few who escaped with their lives. Indeed, his salvation was by virtue of his *tzedakah.*

The night before the Communists were to arrest and 'liquidate' R' Boruch, two Jewish young men came to warn him of the impending doom. Not only did they personally help R' Boruch to escape, they even gave him money to help him flee to *Eretz Yisrael.* Although these two young men were loyal Communist party members they felt they owed a debt of gratitude to R' Boruch because they and their families had benefited from his charity in times gone by.

❧ Earning a Degree in Philanthropy

On his way to the land of Israel, R' Boruch went through Brisk to take leave of his beloved Rebbe, R' Chaim Soloveitchik. R' Chaim was deeply pained to see how his beloved disciple was reduced to the level of a penniless pauper, a desperate fugitive fleeing for his life with only the shirt on his back. R' Chaim offered the following words of consolation and encouragement: "A prosperous merchant once came to me, weeping bitterly because he had just lost all of his wealth. He pleaded with me, 'Rebbe, please explain to me why I lost all my wealth.' I told him, 'Your situation can be compared to a father who presented his son with a beautiful pocketknife. A while later the father

noticed that the son was very careless with the knife and cut himself. Immediately, the concerned father took away the knife from his son in order to protect him from further damage. Similarly, our Merciful Father in Heaven bestowed wealth upon you as a gift. But when Hashem saw that you were mismanaging this gift and thereby were "cutting your hand," He had no choice but to protect you from your own carelessness and therefore he took your wealth away.'"

R' Chaim continued: "In your situation, R' Boruch, the explanation of your loss is entirely different. You know that when students attend the university they can only specialize in one field at a time. Only after they complete a full program and earn their degree in one field are they allowed to go on to earn a second degree. In a spiritual sense too, this world is one big university, which offers two major courses. The *Mesillas Yesharim* says that all men are tested in one of two ways. Some are tested through poverty and suffering, others are tested by wealth and glorious success. Until now, you, R' Boruch, have been tested with great wealth. God has challenged you in numerous ways but you have always placed generosity above greed and thus have earned your 'degree.' Therefore, Hashem is now sending you to a new course of studies, in order to challenge you with poverty. I sincerely hope and pray that you will overcome all tests and challenges in this area as well as you did with your wealth."

R' Sholom Schwadron related that he personally knew R' Boruch from the time he arrived in Jerusalem and he said, "I can testify that R' Boruch passed the test of poverty with outstanding success."

◆§ He Distributes Freely and Carefully

When R' Boruch passed away, the Rosh Yeshiva of Chevron, R' Yechezkel Sarna, eulogized him and said:

In *Tehillim* King David praises the philanthropist, saying: פְּזַּר נָתַן לָאֶבְיוֹנִים צִדְקָתוֹ עֹמֶדֶת לָעַד, *He distributed freely and carefully gave to the destitute, his charity endures forever* (Psalms 112:9). King David teaches us that in order to accomplish *tzedakah* perfectly so that the merit endures forever, one must have two qualities: 1) *He distributed freely,* and 2) *He carefully gave.* Each of these qualities has a positive and a negative. Some people scatter their money around and love to throw it away. They have no desire to hoard money and they would much

rather enjoy it immediately by spending it or sharing it with others. This is a positive attribute because such people *distribute freely* to charity. But there is a downside as well, because they did not make any sacrifice to give away their money; it just fell out of their pockets effortlessly. Other people have the exact opposite nature. They love money and delight in counting, saving and hoarding their cash resources. This characteristic has a negative dimension, because it is difficult for such people to part with their precious money and distribute it to charity. But there is a positive side as well, because when such a person does force himself to open his pockets and *he carefully gives,* it is an intentional mitzvah act fulfilled with total concentration, and it is an act of true self-sacrifice.

Rav Sarna concluded: The ultimate *baal tzedakah* whose *charity endures forever* is the person who blends the best of both traits. He scatters charity freely and generously like a person who is by nature an open-handed squanderer, and at the same time appreciates the value of money and performs this mitzvah carefully and scrupulously with a sense of heavy responsibility. No one exemplified these two traits as well as R' Boruch Zeldovitz who appreciated the value of money and yet let it flow out of his hands freely.

◆§ Rav Isser Zalman Meltzer

Rav Isser Zalman Meltzer exemplified a uniquely sympathetic attitude toward the poor. Whenever anyone would knock at his door, he would insist on personally answering the door, no matter what time of the day or night. At the slightest sound, he would rise from his *sefer* and rush to the door — ahead of his disciples who rarely managed to outrun him. When his students asked him why he made the effort to personally answer the door every time, he replied, "Who knows? Perhaps it is a poor man who is knocking."

"And what if it is a poor man?" the students persisted. "Why must the Rav answer the door in person every time a poor man knocks?" R' Isser Zalman answered, "Let me ask you: Do you think that I have merited to sit at the head of this large table solely by means of my wisdom, and that the beggars in the street are there solely because of their lack of wisdom? If so, you are terribly mistaken, for it is written, שַׁבְתִּי וְרָאֹה תַּחַת הַשֶּׁמֶשׁ כִּי לֹא לַקַּלִּים הַמֵּרוֹץ וְלֹא לַגִּבּוֹרִים הַמִּלְחָמָה וְגַם לֹא לַחֲכָמִים לֶחֶם

וְגַם לֹא לַנְּבֹנִים עֹשֶׁר וְגַם לֹא לַיֹּדְעִים חֵן, *Once more I saw under the sun that the race is not won by the swift, nor the battle by the strong, **nor does bread come to the wise, riches to the intelligent, nor favor to the learned*** (*Koheles* 9:11).

"Rather, the reason there are poor people in the world is that Hashem decreed long ago, כִּי לֹא יֶחְדַּל אֶבְיוֹן מִקֶּרֶב הָאָרֶץ , *For destitute people will not cease to exist within the land* (*Deuteronomy* 15:11). Hashem's ancient decree is immutable. Hence, when a beggar knocks at my door, my heart is filled with genuine gratitude toward him, for the beggar exempts me and all of my household from having to fulfill this decree of poverty ourselves. If he would not be poor, then someone else would have to take his place. Who knows? Maybe it would be my turn. Now do you understand why I cannot bear the thought of letting the poor wait for me at the door even one moment longer than necessary?"

☙ Why the Teacup Shattered

Once, on a cold winter day, R' Isser Zalman was learning with two young students who were his study partners. His devoted wife, Rebbetzin Bayla Hinda, made herself a hot cup of tea to warm herself from the cold which seeped into their poorly heated home. All of a sudden, for no apparent reason, the teacup fell out of her hands and shattered on the floor.

R' Isser Zalman lifted his head out of his *Gemara* and gently asked his wife, "Perchance, did a poor person stretch out his hand to you today, asking for *tzedakah,* and you failed to give it?"

The question shocked Rebbetzin Bayla Hinda because it was so accurate. She responded, "Indeed, when I was shopping in the market today a beggar approached me for alms. I took a large coin out of my purse and asked him for change. When the beggar said that he had no change I went over to one of the market-stalls and obtained change from a vendor. When I turned around to give the money to the pauper he was gone, nowhere to be found! That's how I lost out on an opportunity to give charity today."

R' Isser Zalman said casually, "It was absolutely clear to me that something of this sort happened, because teacups never shatter without a reason!" (*B'derech Eitz Hachaim, p.* 351).

—— Rav Chaim Ozer Grodzenski ——

"**I** have no greater pleasure in life than to help someone else"
(R' Chaim Ozer in a letter to R' Chizkiyah Y. Mishkowsky).

✎ My Charity Ledger Is My Passport to Heaven

R' Chaim Ozer Grodzensky was the Rav of Vilna for over forty years and authored the classic set of responsa, *Shaalos U'Teshuvos Achiezer.* For over forty years he was "the address of *Klal Yisrael*" and every communal matter, large or small, from every corner of the Jewish world, came before him for his advice and consent. However, R' Chaim Ozer saw his most important function as that of a *gabbai tzedakah* , an administrator of charity funds. The phenomenal scope of his activities was worldwide, yet he always had a place in his heart for every individual Jew.

In 1939, after the third volume of *Achiezer* was published, a relative asked R' Chaim Ozer why he did not devote more time to publishing his Torah novellae. R' Chaim Ozer replied, "When I was younger, I did think that the most important work for a person like me was to discover new insights and to write volumes of novellae. But now that I am older and more experienced, all that seems like child's play compared to the need to support widows, orphans, and Torah scholars. I used to think that my passport to *Gan Eden* was my magnum opus, *Achiezer.* Now I think my passport will be my ledger where I record my charity accounts!"

Over the years, millions of dollars in charity and other monies went through his hands. He was trustee for orphan's inheritances, dowries, and the like. Funds from worldwide campaigns for the sake of Russian Jewry were sent to him, as were countless donations from private individuals who wanted R' Chaim Ozer to distribute their *tzedakah* to worthy recipients. The *Va'ad HaYeshivos,* the Joint Distribution Committee, and the *Va'ad Hatzalah* (during World War II), as well as the Hafkine fund, the Rabbi Meir Ba'al HaNes fund for Israeli poor, Ezras Torah, and other organizations, all made use of one common address:

Reb Chaim Ozer's. He alone kept an exact record of the various funds he received and distributed.

He would say that for the misuse of even a minuscule amount of *tzedakah,* one could ruin his lot in both worlds. He lived up to these words. When a yeshiva student once came to him for money with which to buy a pair of shoes, R' Chaim Ozer handed him a generous sum while gently reminding him to return the change after his purchase.

⋖§ Assistance for Adversaries

A secularist once commented, "I'm not sure which R' Chaim Ozer loves more — the Torah or his fellow Jews."

It happened once that the president of the Jewish Society of the University of Vilna received a request from R' Chaim Ozer that he visit him at his home. Having never met the Torah sage and being a lifelong secularist, the gentleman found the invitation somewhat surprising. Nevertheless, he accepted it, and even purchased a hat for the occasion.

After being welcomed by R' Chaim Ozer, the man was served tea and cake and the two chatted for a while. Then R' Chaim Ozer revealed why he had asked to see his visitor. He had learned that a number of Jewish students at the university lacked the means to purchase matzah and other essentials for the upcoming Passover holiday. R' Chaim Ozer presented the society president with an envelope containing money for him to distribute among the needy students.

The man was stunned. He had never imagined that anyone would be so eager, of his own accord, to aid those whose views and way of life were in direct opposition to his own.

⋖§ A Small Request and a Larger One

Vilna was a center of medicine and, since R' Chaim Ozer was knowledgeable about many physicians both in and out of the city, people constantly sought his medical advice. Often, people came not only for medical advice but also for help in paying their medical bills. Their requests were never refused. When R' Chaim's iron *tzedakah* chest was empty, he would give away his personal money. When that too would run out, he would approach men of means in his community

to grant the person a loan for which he personally would serve as guarantor. Quite often, the borrower, hampered by illness and saddled with huge medical expenses, could not repay the loan. The responsibility of repayment then fell on R' Chaim Ozer's shoulders.

At the beginning of World War II, soon after Vilna had been occupied by Soviet Russian troops, the city's stores were emptied as a result of pillage and plunder. A group of wealthy men from Kovno (which had been spared from pillage) visited R' Chaim Ozer to discuss urgent communal matters. They asked the great leader if there was anything they could bring him from Kovno when they returned for their next meeting. "I have a small request and a large one," R' Chaim Ozer replied. "The small request is that perhaps you can find me a certain medicine unavailable here in Vilna. The large one is that my maid desperately needs shoes. My own are also torn, but I am an old man and rarely leave the house. However, with winter approaching and my maid constantly venturing outside, I would be very grateful if you could help her" (Beis HaMidrash, pp. 284-86).

◆§ Besieged by Tzedakah

People in need of tzedakah forever besieged him. He always gave of his own money and when the situation warranted it, he would write a note to the trustees of the Tzedakah Gedolah community fund, asking that they assist the individual.

He once mentioned parenthetically that there was a time when he had been giving half his earnings away to others.

Another time, he remarked, "All my life, I never worried over money. I loaned someone my entire dowry of 500 rubles — and the person was unable to repay me. It caused me no worry."

Small wonder that when R' Chaim Ozer passed away, he left not a penny behind.

◆§ Tzedakah Stands First on Line

R' Mordechai Dubin of Riga, Latvia was renowned throughout Eastern Europe for his tireless efforts for the welfare of his

Jewish brethren. A visitor to Riga observed that following the daily prayers on an ordinary weekday, it was not uncommon to have two hundred people lined up to present their personal problems to R' Mordechai. He personally involved himself with solving every dilemma with patience and love.

R' Mordechai once took a short break from his grueling schedule and spent a few days resting at a resort on the Baltic Sea. Immediately after the Tishah B'Av fast, he made preparations to return to Riga as swiftly as possible. He explained that he had important *tzedakah* matters to attend to and the needs of the poor could not wait. All the other vacationers were taken aback by the urgency with which R' Mordechai planned to 'escape' from the resort. "R' Mordechai," they pleaded, "it was such a long, hard fast. You must be drained. You have to preserve your strength. You have to look out for your health. Would it be so terrible if you made the trip home tomorrow and gave yourself a good night's rest?"

R' Mordechai responded with a story: "One year I had the privilege of spending Yom Kippur in Vilna in the proximity of R' Chaim Ozer. All day I prayed near him in the great synagogue, and when the solemn fast day was over, I accompanied him back to his apartment. When we walked through the door, there were already forty petitioners waiting impatiently for the great Rabbi, each one waiting to ask him for some sort of charity or help. The old Rabbi had not eaten or drunk for more than a day. He was exhausted. Yet, he set aside his personal needs and gave his full attention to every person and responded patiently and compassionately to their requests. Only after all forty petitioners had been satisfied did R' Chaim Ozer allow himself to break his fast!"

R' Mordechai concluded, "Now, after witnessing R' Chaim Ozer's exemplary dedication, how can I not return to Riga with all due haste in order to deal with the needs of my brothers?" (*Uvdos L'Beis Brisk*, Vol. III, p. 263).

⋇§ Beware! A Broken Heart!

R' Simcha Wasserman was present when someone asked R' Meir Karelitz to relate a "miracle" performed by R' Chaim Ozer. He told the following story: An important meeting of *Rabbanim* was in

progress in R' Chaim Ozer's home when a widow knocked on the door. The woman requested some *tzedakah* , which R' Chaim Ozer promptly gave her. She then asked for a note to the *Tzedakah Gedolah* for additional funds. R' Chaim Ozer gently explained to her that the community fund did not provide for her particular request. The woman adamantly insisted that she be given the note. One of the *Rabbanim,* seeing R' Chaim Ozer's precious time being wasted while the woman showed no signs of leaving, told her rather sternly to leave. R' Chaim Ozer placed his hand on the Rav's arm and admonished him, "No, Reb __, she is a widow!"

R' Meir Karelitz recalled that R' Chaim Ozer's "No . . . !" was said with the same intonation one would use when warning someone to beware of a protruding knife.

◦§ R' Binyomin Beinesh Dennis

R' Binyomin Beinish Dennis, the renowned philanthropist of Kharkov, was the great-grandfather of my wife, Luba. His daughter, Luba Rochel (my wife's namesake), married R' Shmuel Zalman Bloch, the *Mashgiach Ruchani* of Telshe Yeshiva in Lithuania. Their daughter, Shoshana Bloch Gifter, is my mother-in-law. Rebbetzin Gifter remembers her illustrious grandfather. After her parents were married in the year 1913, R' Binyomin Beinish single-handedly covered the entire budget of Telshe Yeshiva for two full years. The Rebbetzin relates how, during the Bolshevik revolution, the Communists stole everything from R' Binyomin Beinish, and he and his family fled, penniless, to Hamburg, Germany. Even there, in his drastically reduced circumstances, R' Binyomin Beinish continued his benevolence. He would walk the streets of the city searching for poor people in need of *tzedakah* or any other kindness. He would actually approach total strangers and ask if they needed a loan or other help.

R' Isser Zalman Meltzer, Rosh Yeshiva of Slutsk and Kletsk in Europe and Yeshivas Etz Chaim in Jerusalem, was very close to R' Binyomin Beinish. R' Isser Zalman once explained why R' Binyomin Beinish was so extraordinary. "Many philanthropists give and give until they reach a point where they grow tired of giving and then they don't wish to see any more collectors. Not so with R' Binyomin

Beinish! The more money he gives away the more he wants to give. It is clearly noticeable on his face that the mitzvah of *tzedakah* becomes more and more precious to him from minute to minute" (*B'derech Eitz Hachaim* p. 522).

My father-in-law, R' Mordechai Gifter, explained why R' Binyomin Beinish's attitude was unique: "Most *baalei tzedakah* burn out because they imagine that they are actually giving away their own money. They eventually get tired, because how much of yourself can you give away? Our Zeide Dennis never felt that the money he gave away was his own. No matter how long the money stayed in his vault or in his bank account or in his pocket, he always felt that this was God's money — he was never giving his own. Since Hashem has no limits, the Zeide's giving knew no limits!

"Additionally, many philanthropists, despite their generosity, regard their *tzedakah* as a secondary, albeit very important, aspect of their lives. To the Zeide Dennis, *tzedakah* was the very essence of his being, his purpose in life. Whatever he gave away endowed him with more life, because this was what his life was all about. He was not merely a giver of *tzedakah,* he was a '*rodeif tzedakah,*' one who chases after *tzedakah* as if his life depended on it!"

⊷§ Giving With Sensitivity

R' Binyomin Beinish was a man of great wealth, yet he insisted that the floors of the entranceway to his home and of the grand dining-room should not be covered with expensive carpeting as was the fashion of the wealthy in his days. He told his wife that she could have fine rugs and carpets in the private quarters of their home, but not in the areas where the poor people came in. In those places the floor would remain surfaced with plain wood. Then, if a pauper came to the door wearing muddy boots, he would not be afraid to step over the threshold, lest he soil the carpet, and the Sages warned us to make the poor feel at ease in our home. Also, since R' Binyomin always invited dozens of poor people to his Shabbos table (especially Jewish soldiers of the Russian army who had nowhere else to eat a kosher Sabbath meal) he wanted the dining-room floor to be bare so that no pauper would feel uncomfortable about sullying it. Additionally, every Friday night, R' Binyomin mysteriously made himself very clumsy.

Right before he made *Kiddush* for his many poor guests, he would 'accidentally' knock over the full wine cup and stain the beautiful white linen tablecloth. This was just another way in which he put his guests at ease so they should not be worried about staining the spotless tablecloth.

✺ Don't Show So Much Respect for My Riches!

Above all other charities, R' Binyomin's top priority was the support of Torah study, to which he contributed enormous sums. Once, the head of a large yeshiva came to his home to obtain his support. R' Binyomin gave him a generous contribution, yet the Rabbi was disappointed. He complained, "It is a matter of public knowledge that just recently the head of the Novaradok Yeshiva, R' Yosef Yoizel Horowitz, approached you for help and you gave him an enormous donation. I certainly appreciate your generous contribution to my institution, but I am truly puzzled why it is nowhere near what you gave to Novaradok."

R' Binyomin replied, "Indeed, your fine yeshiva is an extremely worthy institution and I am privileged to support it. But I will explain to you why I felt compelled to give Novaradok such a large sum. You see, when the Novaradoker entered my mansion I felt that he had absolutely no respect whatsoever for all of the luxurious furniture and interior designs in my palatial home. Indeed, I sensed that he had a loathing and genuine contempt for these mundane, material frills. His attitude was so pure and powerful that it inspired in me contempt for luxury and wealth. Since he made me feel that money was worthless, I gladly gave away as much as I could in order to get real value in the form of *tzedakah*. But when you entered my mansion, I noticed that you displayed respect for my wealth and my possessions. "Well," I said to myself, "if wealth is that important, I think I'll keep the bulk of it for myself and I won't part with it so quickly.""

The Kapishnitzer Rebbe

⊰ The Gadol Hador in Chesed

The relationship between R' Avraham Yehoshua Heschel, the Rebbe of Kapishnitz, and the outstanding luminaries of the Lithuanian Torah world was one of true love and deep admiration. The Rebbe was extremely close with the acclaimed leader of the yeshiva world in America after the Second World War, R' Aharon Kotler.

The Rebbe once said, "If R' Aharon would tell me to run a hundred miles, I would do it."

R' Aharon referred to the Rebbe as, "the *gadol hador* in *chesed* (leader of the generation in acts of loving-kindness)."

⊰ No Salvation From a Linoleum Floor

The Kapishnitzer Rebbe lived in a very modest apartment on the Lower East Side of New York City. The furniture was plain and the floor coverings were worn. He and his Rebbetzin had no need for more.

One day, the Rebbe's daughter asked her father, *"Tatte,* the linoleum in the dining room is old and worn. Could we perhaps replace it?" The Rebbe responded that they had no money at present for anything but necessities.

A few minutes later, the doorbell rang. A solicitor for a worthy *tzedakah* organization stood in the doorway. The Rebbe greeted the man warmly and handed him a generous donation. The Rebbe's daughter, who observed the scene, did not understand. Respectfully, she asked her father how he was able to give the man so much money when he had said only minutes before that there was no money for anything but necessities.

With warmth and understanding, the Rebbe explained, "My child, this money was given to me as a *pidyon* by a man who sought a blessing on behalf of a sick relative. In the prayers of *Shacharis* we say of Hashem: זוֹרֵעַ צְדָקוֹת מַצְמִיחַ יְשׁוּעוֹת, *He sows tzedakos, He*

makes salvations flourish. By using a person's *pidyon* for a charitable purpose, a Divine salvation may flourish, but can one expect a salvation to flourish from buying linoleum?" (*More Shabbos Stories*, p. 218).

⋖ You Only Own What You Give Away

I related the above story to R' Yaakov Greenwald, a devoted follower of the Kapishnitzer Rebbe, and he told me a beautiful story which proved this point.

Once, a very bitter and frustrated Rabbi in America came to the Rebbe and complained of his dire poverty and his inability to afford even basic necessities such as a new hat. He pointed to his head and cried, "Just look at this beat-up 'shmatta' that I am forced to wear!" The Rebbe's eyes lit up and he told the Rabbi, "Just stay right where you are. I will return momentarily!" He ran upstairs to his bedroom closet, took out a hatbox, ran downstairs with it, and placed it on the table in front of the Rabbi. Beaming with joy, the Rebbe opened up the box and took out a brand new Rabbinical-style hat and presented it to the Rabbi. The Rabbi was overwhelmed by the Rebbe's generosity but refused to accept the gift. "This is the Rebbe's new Shabbos hat!" he exclaimed. "How can I possibly take it away from him?"

The Rebbe was prepared for this refusal and immediately responded, "No! This is not my Shabbos hat; it is really my *Olam Habah* hat! Don't you want me to have a beautiful hat in the World to Come? Whatever I give away now, here in this world, will be mine forever in the World to Come. What I keep for myself now, in this world, will not be mine in the future!"

⋖ The Richest Rabbi in America

R' Zishe Heschel related the following story about his father, the Kapishnitzer Rebbe: Once my father visited *Eretz Yisrael* and the correspondent for the Yiddish newspaper, *The Morgen Journal* (his name was Dovid Flinka), reported his visit. Flinka wrote: Now visiting the Holy Land, staying in the Moriah Hotel, is the man reputed to be the richest Rabbi in all of rich America, the Kapishnitzer Rebbe.

Our family read this report in the paper and laughed bitterly, because, although the Rebbe did indeed distribute enormous sums to *others,* he kept nothing for himself or his family. When we showed father the article he commented, "You know — Flinka is right! I am the richest Rabbi in America and I may even be the richest man in the entire world! Of course, there are many that have much more money in the bank than I, but I am still richer, because they do not own their money, their money owns them! I truly own my money because I can do anything I want with it. I can give it away anytime to anyone, anywhere. When I make any decision it is based on the intrinsic merit of the person or situation, not on monetary expense. Others are slaves to their money — even if they make up their minds to give it away, their hearts won't let them part from their beloved money."

The Satmar Rebbe

⇜ A Child's Appeal for Charity

The Satmar Rebbe, R' Yoel Teitelbaum, introduced the Jews of America to new vistas of charity they had never before dreamed of. 'R' Yoelish,' as he was fondly called by all who knew and revered him, was born in the city of Sighet, Romania, before the turn of the 20th century. In childhood he already displayed an amazing care and concern for the destitute. From the tender age of 5 or 6 the Rebbe was already giving away everything he had for charity. His father, the famed *Kedushas Yom Tov,* was the Rav of the city and had many admirers, so his family lived comfortably. But young Yoelish could not bear the poverty of his classmates. He noticed that many did not eat even one decent meal a day. He gave away his lunch and snacks to them on a daily basis. He observed that many poor boys came to *cheder* in the rain, snow and freezing cold with ragged clothes and torn shoes. Their plight gave his warm heart no rest. Secretly, he called together all the boys who came from wealthy homes and made the first charity appeal of his lifetime. "My friends!" he cried, "My parents give me spending money and your parents give you spending money. But money is worthless! It has absolutely no value unless it is used for

charity to help the poor. Let us put together our pennies and collect a respectable sum for our ragged classmates." Little Yoelish's plea made a tremendous impact on the boys. They pooled their resources, and together they went to the local tailors and shoemakers, ordered new clothes and shoes for the underprivileged boys, and distributed the goods to their needy classmates.

৵ Borrowing to Give Tzedakah

At the tender age of 6, R' Yoel began his lifelong practice of borrowing money in order to care for the poor. He would go from door to door and from shul to shul begging and borrowing for tzedakah. And when the local sources of revenue were exhausted, little Yoelish would sit down and write personal letters to his father's followers and admirers, requesting long- and short-term loans to finance his ever-expanding charitable activities. Many decades later, the Rebbe established a vast network of Torah and charity institutions both in America and throughout the world. Often, the administrators would complain that they were mired in heavy debt which threatened to overwhelm them. The Rebbe would comfort them saying, "Look at me! I've been in debt for good causes since I was 6 years old and I have, with the help of Hashem, survived all these years and have even prospered. The Almighty has always paid all of my staggering debts and He will surely pay off all of your debts as well. Have no fear!"

৵ How to Choose a Rebbe

The Satmar Rav enjoyed repeating the following story which summed up his worldview. Once a *Chassid* visited the holy Sanzer Rav, the *Divrei Chaim*, who asked him, "Which great Chassidic master do you follow? Who is your Rebbe?" The man said, "I am a follower of your son, the Shiniver Rebbe." The Sanzer Rav asked, "What is so special about my son Yechezkel that he deserves to be your Rebbe?" The man responded, "His prayer and service to Hashem is performed with amazing fervor and passion!" "No!" cried R' Chaim, "That isn't enough reason! Every Jew must serve God with fire and passion." The

man cited another virtue of the Shiniver, "His Torah scholarship is extraordinary, who can compare to him!" But R' Chaim rejected this too for everyone must be great in Torah learning. And so it continued on and on. The *Chassid* enumerated his Rebbe's virtues and R' Chaim dismissed them. Finally, the *Chassid* cited the Shiniver's dedication to charity. "Once in the freezing winter, as the Shiniver was walking in the deep snow, he encountered a beggar making his rounds from door to door and noticed that the beggar had no boots to protect his feet. Right there, in the middle of the street, the Shiniver took off his own warm boots and gave them to the pauper as a gift. "Aha!" exclaimed R' Chaim, "If he knows how to take away from himself and give to others, then indeed he is a real Rebbe!" (From *Moshiyun Shel Yisrael,* Vol. I).

✂ Walk on Your Own Two Feet

The Rebbe always demanded of all his followers that they should get personally involved in collecting *tzedakah.* It is not enough, said the Rebbe, merely to put your hand in your pocket and give away a few coins or dollars. If someone is in need, get up and go around from door to door and raise money for him. Make an effort, exert yourself. Exhaust yourself for someone else. That is how the mitzvah is best done!

He showed no favoritism. He insisted that even the wealthiest, most distinguished people should personally act like common beggars and go around "schnorring." One of the Rebbe's wealthiest *Chassidim* was Mr. Getzel Berger of London. He would arrive from overseas to be close to the Rebbe for the High Holidays, but the Rebbe would send him out to collect for the poor. Once, when R' Getzel was an old man, the Rebbe told him that he needed a large sum for a needy person. R' Getzel gladly offered to give the Rebbe the entire amount from his own pocket, but the Rebbe refused to accept it, demanding that R' Getzel go around and collect it from others. The Rebbe sought to derive two benefits from this. First, the rich man would have a far greater mitzvah if he toiled over it. Secondly, this experience would give the wealthy givers a taste of what it is like to have to beg. They would learn to have far more empathy with the desperate plight of the destitute.

⋖§ Charity in the Curriculum

Likewise, the Satmar Rebbe established a rule in his yeshiva that every student was expected to go out periodically to collect charity. A special supervisor was appointed whose job it was to determine how much each boy was expected to collect within a certain time, and to receive from each boy the charity collected at the end of that time. Here too, there were boys from well-to-do families who attempted to pay off the full assessment from their own pockets in order to avoid this distasteful "*schnorrer* duty," but the Rebbe let no one shirk his responsibility. He felt strongly that this was an integral part of his students' Torah education: to train them to be personally involved in helping their fellow Jews. The Rebbe once commented, "You know, a man can go through all the years of his life and never once learn what it means to really do good for his fellow Jew!"

The Rebbe once sent his *gabbai* to ask two young married men to go around collecting for charity. They complained to the *gabbai* that since they were studying Torah diligently they were exempt from this mitzvah. When the *gabbai* returned to the Rebbe with their argument the Rebbe would not relent. "Go tell them that the purpose of Torah study is to bring to action," said the Rebbe, "and the ultimate action is to perform acts of charity and loving-kindness towards our fellow Jews."

⋖§ Don't Walk Barefoot in the World to Come

The Rebbe said in the name of R' Elimelech of Lizhensk that when a person goes around to all four corners of the city collecting charity he saves himself from all of the *"Arba Missos Beis Din,"* the four types of death sentences issued by the Jewish court.

The Rebbe related that the holy Shiniver Rav once had a dream in which he saw a great Torah scholar who died young. The *talmid chacham* was dressed in radiant white robes. His feet, however, were without shoes. The Shiniver asked his father, the holy Sanzer Rav, to explain the meaning of the dream vision. The Rav replied, "Since the

deceased was an outstanding Torah scholar, he deserved to be swathed in splendid celestial robes. But since he never went around on his own feet to collect charity, they did not merit any celestial garb and will remain bare forever!"

The Rebbe often said that for him the performance of *tzedakah* is a matter of life and death. He literally felt that he could not survive a day if he was not constantly involved in helping those in need. "For me," he would say, " charity is like the very breath of life. I can't live long without it."

R' Mendel Kaplan

◆§ Sympathize With the Pain of the Poor

R' Mendel Kaplan, a Rosh Yeshiva of the Yeshiva of Philadelphia, was not only a *gaon* in Torah, he was also a *gaon* in *tzedakah*. It was very difficult for him to ask people for money for *tzedakah,* but he overcame his nature in order to help others. Once he saw what a poor person needed, he could not take his mind off it.

R' Mendel would say to his students: "In reference to helping others, the Torah warns us to assist אֶת הֶעָנִי עִמָּךְ, *the poor person who is together with you* (*Exodus* 22:24). This terminology teaches that you, the benefactor, have to feel as if you yourself are a poor person mired in exactly the same position as the pauper! My mother once told us, 'You don't know who you are and you don't know who this beggar is. Maybe he is someone who did not sympathize with the pain of a poor person in a previous life, and was sent down to this world again as a beggar so that he would feel it.'

"What about Yankele, the beggar who comes here?" R' Mendel asked the students. "You don't care, you laugh at him and enjoy making fun of him. Can you imagine the pain he has in life? Do you think it couldn't possibly happen to you? No one is safe from anything in this world. Once I sat near Yankele in shul and he smelled so foul that I wasn't sure I was allowed to *daven* near him. Then after *davening,* I saw Dr. Askovitz greet him and embrace him with open arms like an old friend. {Dr. Shimon Askovitz, an ophthalmologist, was an

outstanding *tzaddik* who was close to the yeshiva community. He was held in awe by all of the *gedolim* of his time.} Later that morning I stopped at the doctor's home to pick up a pair of glasses, and who do I find there but Yankele. He was sitting at the table and Dr. Askovitz was serving him a meal like a distinguished guest!"

⋗§ In the Eyes of Hashem
No One Is Privileged

When R' Mendel lived in Williamsburg, he did not hesitate to take beggars into his house. Many smelled terribly because they had nowhere to bathe or wash their clothes. R' Mendel's children asked him how he could tolerate the foul odor and he would reply, "Do we look any better in Hashem's eyes? You have to absorb the smell of a poor person willingly. The bird offered as a sacrifice in the *Beis HaMikdash* by the poor man was burned together with its feathers — even though this gave off an offensive odor — because Hashem loves the smell of a poor man. In the eyes of Hashem no one is privileged — there are no upper and lower classes; with Him the big and the small are all equal."

Once, R' Mendel saw a poor old man picking up cigarette butts from the sidewalk. He ran into a nearby store and bought the man a pack of cigarettes. He was always eager to meet this fellow so that he could give him a few dollars for his needs. The day before R' Mendel passed away, he happened to see this poor man passing by his home; R' Mendel ran out and gave him a sizable donation.

R' Mendel made every effort to accommodate other people's needs even when they seemed eccentric to the rest of the world. In Chicago, he knew a man who was so obsessed with collecting newspapers that the man's landlord wanted to evict him together with his paper collection. When R' Mendel became aware of the situation, he rented a garage to store the man's newspaper collection, rented a U-Haul truck, and then personally transported everything to the garage. Other people found it strange that R' Mendel spent so much time and money on such an idiosyncratic fellow, but R' Mendel explained, "How can we make light of his feelings? His papers are as important to him as our furniture is to us!"

◆§ R' Yehuda Zev Segal of Manchester

The Rosh Yeshiva of Manchester was a great *baal tzedakah*. No sum was too large to raise for someone in need. Upon learning that a wedding was being delayed because both sides were penniless, the Rosh Yeshiva personally undertook to raise tens of thousands of pounds.

His many *tzedakah* projects sometimes forced him to obtain large personal loans, which he meticulously paid on time. When the Rosh Yeshiva heard of a *tzedakah* project which someone else had undertaken, he would contact the person and ask if he could participate, saying, "I would like to purchase a few 'shares' in your venture." Despite the ever-present need to raise funds for *tzedakah* projects, the Rosh Yeshiva was careful never to pressure anyone into contributing, or even to say anything that smacked of pressure.

The Rosh Yeshiva's reputation for benevolence brought many strangers to his door seeking his assistance. But his kindheartedness was complemented by a sense of fairness. When individuals who had already received a large sum would return within a short time expecting to receive a similar donation, the Rosh Yeshiva would give them less than they expected, explaining that there were others who needed help as well.

When providing an individual with monetary assistance, the Rosh Yeshiva did everything possible to ensure that the recipient not feel ashamed. He was careful not to send an emissary to the same recipient more than once, so that the emissary would not know how often the person received *tzedakah* from him.

Once, the Rosh Yeshiva assured a troubled caller that he would send a sizable sum that same day. The Rosh Yeshiva immediately phoned a confidant who lived near the first caller and asked that he provide the necessary sum. The person readily agreed. The Rosh Yeshiva then said, "Wait a few hours before delivering the money. This way the recipient will think that I sent you the money to deliver. He would be embarrassed if he knew that the money came out of your pocket."

Collector of Charity
— Gabbai Tzedakah

⋘ The Gabbai Is Greater
Than the Giver

The Talmud (*Bava Basra* 9a) teaches: R' Elazar said: גָּדוֹל הַמְעֲשֶׂה יוֹתֵר מִן הָעוֹשֶׂה, *The one who causes the performance of charitable deeds is greater than the one who actually performs the deed.* R' Elazar adduces support for his statement from the verse (*Isaiah 32:17*): וְהָיָה מַעֲשֵׂה הַצְּדָקָה שָׁלוֹם, וַעֲבֹדַת הַצְּדָקָה הַשְׁקֵט וָבֶטַח עַד עוֹלָם, *And those who effectuate the performance of charity will have perfect peace, while the work of (giving) charity will cause everlasting tranquility and security* (following *Rashi*). Since perfect *peace* is a greater blessing than *tranquility* and *security* (*Ritva, Maharsha*), R' Elazar derives that one who motivates another to perform an act of charity is the greater of the two.

There are many ways in which the collector of charity surpasses the giver of charity, as will be demonstrated in this chapter. Actually, the charity collector, known as the *gabbai tzedakah,* usually performed two functions: the gathering of *tzedakah* contributions from the givers and the distribution to the needy takers. The Talmud (*Shabbos* 118b) observes that equitable distribution of *tzedakah* is more difficult than its collection: R' Yose said: "May my portion be among charity collectors and not among charity distributors!"

Rashi explains that the ideal way to run the community charity fund is to have two men to collect the charity and three men, who

constitute a *Beis Din* or court, to distribute it. It is the responsibility of this court to examine the needs of each person who comes before them for financial assistance, and to disburse funds accordingly. Sometimes, however, the judgment of the distributors might be unfairly biased in favor of one person, to whom they would give more liberally, while another person with similar needs would not be given the appropriate amount.

In our time, when our community organization (the *kehillah*) does not have the authority to force people to give charity, all *tzedakah* donations are considered to be voluntary. When the donations are voluntary, it is not necessary to have two people collecting together, or three people for distribution. Any individual can assume the role of *gabbai tzedakah* and solicit funds from others for any worthy cause. People are allowed to give such individuals their *tzedakah* money (*Tzedakah Umishpat,* Chapter 7:6).

⊷§ Payment for a Pounding Heart

During the Nazi Holocaust, Rabbi Yechezkel Abramsky, head of the London Rabbinical Court, raised enormous sums of money to fund the rescue of as many Jews as possible. Dayan Abramsky once telephoned a wealthy Jew and asked him to donate the princely sum of £40,000 to the rescue effort. The man responded, "Rabbi, I would be privileged to contribute, but first you must answer a question which deeply perplexes me. As you well know the Sages of the Talmud taught that the collector of charity gets a greater reward than the giver. But that makes no sense! Here, lets look at this situation. You approached me for £40,000. Do you have any idea how much time and effort and worry I expended in order to earn that much money? And you, my dear Rabbi, just made one brief phone call for thirty seconds asking for this amount and if indeed I do give it, your reward will surpass mine? It doesn't make sense!"

Later, when R' Yechezkel related this incident, he said, "At first, I was dumb struck, because I really had no explanation. There was absolute silence from my end of the wire as I silently prayed to Hashem to enlighten me. All of a sudden I had a flash of insight. I said, "Reb Yid, when I had the audacity to ask you for such a huge sum, whose heart do you think was actually pounding harder, yours or

mine? Rest assured that my heart was racing wildly. The solicitor receives greater reward because of the terror he endures when he summons up the courage to make an audacious request!" (Heard from R' Yosef Hoffman of Monsey, New York; see another version in *Hamashgiach D'Kaminetz,* p. 291).

~§ As the Mitzvah Grows the Struggle Intensifies

The Chazon Ish, Rabbi Avrohom Yeshaya Karelitz, offered another insight to explain why the charity collector receives a greater reward than the donor. The person who undertakes to become a *gabbai tzedakah* transforms himself from a private individual into a public servant, who not only supports the poor but also brings tremendous merit and reward to his contributors. Therefore, the Evil Inclination does everything in his power to prevent or discourage him from making his rounds. It will fabricate every possible reason to convince the collector that he is wasting his time and toils for naught. The Evil Inclination argues, "Don't waste your time going to this house to collect, the owner is probably fast asleep, or he never will give you anyway, or, this cause isn't worth all of your effort. What about your own time for learning? etc." Since the collector has a far greater struggle than the individual donor, his reward is greater (*Hamashgiach D'Kaminetz* p. 297).

~§ Motivating Others Surpasses Giving Oneself

Rabbi Eliyahu Lopian once accompanied a friend who was collecting money for charity. As they were walking, Rabbi Lopian asked, collecting charity is greater than merely giving?

"Do you know why collecting charity is greater than merely giving? There are three reasons:

1. One who only gives charity does something for himself; one who influences people to give does something for others.

2. One who gives charity receives honor; one who goes around collecting from others often receives humiliation and disappointment.

3. One who gives charity only gives money; one who makes the rounds collecting charity gives away his time — and time is life!" (*Lev Eliyahu,* Vol. I, p. 30).

⊸§ Charity Collectors Will Shine Like the Stars

The Talmud (*Bava Basra* 8b) comments on the verse in *Daniel* (12:3) which describes the brilliant light which God will bestow upon the deserving at the time of the final reward: וְהַמַּשְׂכִּלִים יַזְהִרוּ כְּזֹהַר הָרָקִיעַ, *And the wise will shine like the radiance of the firmament;* this refers to a judge who renders an absolutely truthful judgment. וּמַצְדִּיקֵי הָרַבִּים כַּכּוֹכָבִים לְעוֹלָם וָעֶד, *And those who make the multitudes righteous will shine like the stars forever and ever;* this refers to the charity collectors.

Maharsha explains that just as the stars exert their influence both day and night but are visible only at night, so charity collectors care for the poor at all times but "shine" only at night — i.e. they distribute charity discreetly, so as not to embarrass the recipient.

The Talmud presents an additional view, that the above verse alludes to *both* the judge who renders an absolutely truthful judgment as well as to the charity collectors. *Rashi* explains that just as a judge must be wise to render accurate decisions, so must a *gabbai tzedakah* have wisdom to discern the needs of the poor.

⊸§ Never Lose Sight of the Needs of the Poor

Kav Hayashar (Chapter 91) writes that the misery of the poor makes their lives dark and gloomy. It is incumbent upon the *gabbai tzedakah,* the charity collector, to bring light and good cheer into their lives. He may not stand aloof from his suffering brethren, for he does not fulfill his duty by merely sending them money through an

intermediary in an impersonal way. The *gabbai* himself should descend into the dark world of the poor. He must go into their dimly lit hovels in order to unearth all the basic necessities which they need. In this way the devoted *gabbai tzedakah* is like the bright stars which illuminate the darkness.

Moreover, the dutiful *gabbai* keeps his eyes open to ascertain the maximum benefit for the poor, never forgetting that the gift one gives to the needy is like an offering to God Himself; nothing less than the best will do as it says: וְכֹל מִבְחַר נִדְרֵיכֶם אֲשֶׁר תִּדְּרוּ לַה', *And the choicest of your vow offerings that you will vow to Hashem* (*Deuteronomy* 12:11).

◢§ Around the Clock, Around the Calendar

Kau Hayashar (ibid.) bemoans the fact that some charity trustees are not diligent enough in discharging their duties. "I have observed great shortcomings in the charity system in Poland, where communities do not have a permanent *gabbai tzedakah.* Instead, they have a rotation system whereby every month a different individual serves as the charity administrator. Because of this, no one is prepared to take full responsibility for the poor. When one *gabbai* finds it too difficult to help the poor he vents his annoyance on the unfortunates and says, 'Why are you coming to me now? You should have come to last month's *gabbai;* he should have given you money for this month!' This problem achieves crisis proportions in the months of Tishrei and Nissan, when the poor have extra expenses for the holidays and for Passover. That is when the irresponsible *gabbaim* find excuses to shirk their duties.

"The proper way is for the trustees of the charity fund to be appointed to a permanent position, an office that preoccupies their thoughts and actions day and night, all day, every day of the year without interruption. Why should the position of *gabbai tzedakah* be any less than the position of a royal minister working in the service of the king? There is no such a thing as a part-time minister! A royal minister works diligently, round the clock. How much more should one be devoted to the service of God, the King of kings, and take total responsibility for God's most precious beneficiaries, the downtrodden and poor?"

‫ A Trustworthy Gabbai —
The Ultimate Act of Tzedakah

The Talmud *(Bava Basra* 10b) teaches that the finest form of charity is when the giver does not know to whom he is giving, and the recipient does not know from whom he has taken. This is the highest level of charity — for a pauper does not feel beholden to an unknown donor, and a donor cannot have a patronizing attitude toward an unknown recipient. Thus to preserve the dignity of the recipient and the good character of the donor, the Talmud recommends that one donate to the communal charity purse.

The Talmud, however, qualifies this recommendation: The communal charity purse is the highest form of charity only if the administrator is as honest as R' Chananya ben Teradyon! [Otherwise the Talmud would indeed recommend that the donor distribute the money personally.]

Tosafos (ibid.) explains that charity administrators need not be as *righteous* as the Tanna R' Chananya ben Teradyon, since he lived in the earlier times of the Mishnah and in the later times people no longer attained his level of piety. Furthermore, *Tosafos* explains that R' Chananya was chosen as the standard for honesty because when communal charity funds were once inadvertently misspent, R' Chananya voluntarily reimbursed the charity with his own personal money *(Avodah Zarah* 17b).

‫ No Resignations Accepted

Chachmas Adam (Klal 146:19) rules that once a person embarks on a *tzedakah* project in the capacity of a *gabbai tzedakah,* he may not resign until he brings the campaign to its successful conclusion (see *Tzedakah Umishpat,* Chapter 7, note 9 for details).

In the city of Lodz, Poland, one of the community officials whose duty was to collect and distribute *tzedakah* to the poor submitted his resignation to the Rav of the city, R' Eliyahu Chaim Meisel. He complained that he could no longer put up with the abuse he was taking from both sides.

"When I solicit money," said the frustrated man, "the donors are angry with me for imposing so heavily on them. The poor people to whom I distribute the funds I collect are also upset and blame me for not giving them enough."

"You have no right to resign," said the great Rav, "the Torah clearly forbids it!"

The man stared at the Rav, bewildered. "Where does it say in the Torah that a *gabbai tzedakah* cannot resign?"

R' Eliyahu Chaim answered, "In *Parshas Beha'aloscha* (*Numbers* 11:28) the Torah relates how Joshua, the most devoted disciple of Moses, felt that Eldad and Meidad had spoken irreverently about his master. Therefore, he said to Moses, אֲדֹנִי מֹשֶׁה כְּלָאֵם, *'My master Moses, destroy them!'* Rashi explains that Joshua actually asked Moses to impose the burden of public service upon these two men, and the pressure and stress involved with dealing with the public would eventually overwhelm them.

"But why would such public service destroy them?" asked R' Eliyahu Chaim. "The minute these men would feel overburdened by the friction and exasperation of their voluntary job, they could just resign? Apparently, the Torah is teaching us that people who accept the yoke of public service do not have the option of resigning their position, regardless of the aggravation it entails. The enormous eternal reward reserved for those who sacrifice themselves in this world for the public welfare requires of them a commitment that is unshakable and enduring."

⊸§ Unworthy Administrators

Maaser money should be given to organizations that conform to the laws of the Torah and whose administrators will distribute their funds according to halachah. Conversely, one should avoid making contributions if they will be used to subvert the ideals and causes of Torah Judaism (*Iggros Moshe, Yoreh Deah* Part II; 149).

⊸§ The Collector's Commission

Rabbi Moshe Heinemann relates that his Rosh HaYeshiva, R' Aharon Kotler, said that a professional fund-raiser is allowed to take up to

49 percent of what he raises as his commission. As long as the majority of the money (51 percent) goes to the institution, it is considered that he was raising funds for the institution and not for himself.

⋖§ A Charitable Influence

Rabbi Eliyahu Eliezer Dessler (*Michtav MeEliyahu,* Part III, p. 91) offers advice on how to collect *tzedakah.* The collector should feel, "My main concern is to *give* this donor an opportunity to perform a mitzvah." If the collector's primary concern is to *give* others an opportunity to *give,* then he infuses them with a *'giving spirit'* and they are likely to make a generous contribution. If, however, the primary interest of the collector is to *take* money — for himself or for his institution — then he will project this attitude of *'taking'* onto the person he is soliciting. Such solicitation is destructive because the collector himself unwittingly influences the donor to be a selfish *'taker'* and not a *'giver.'* R' Dessler contends that if one analyzes yeshivos or institutions which have closed down due to lack of funds, one will inevitably find that their downfall came about because they collected with a selfish attitude of *'taking.'*

⋖§ Why the Audience Was Tight Fisted

This idea was conveyed by a renowned Chassidic master, R' Mordechai of Chernobyl. He was an itinerant *maggid* preacher, who traveled from town to town, delivering inspiring lectures to the delight of his audiences, who showed their appreciation by lavishing generous gifts upon him.

Once, another *maggid* came to a town while R' Mordechai was there, and he was shocked by the contrast between the two of them. This *maggid* was a wonderful speaker who kept his audience spell bound for hours as they thirstily swallowed his every word. Yet, when the sermon was over, most people left without leaving a donation, and even those who gave grudgingly contributed only a few pennies.

The *maggid* asked R' Mordechai to unravel this mystery. The holy Rabbi of Chernobyl explained: "You see, you make your living from speaking, so as soon as you stand up in front of the audience your

mind is already on how much money you hope to receive. Since your mind is filled with love of money, you transfer that love to the audience, so that when you finish speaking they want to hold on to their money. But I despise money! My sole concern is to inspire people to embrace spiritual values. The audience absorbs my values, so that when I am finished they loathe their money and shower it upon me!"

⋖§ *A Shining Example Never Dims*

R' Zalman Ashkenazi of Williamsburg, Brooklyn, New York is a tireless *gabbai tzedakah* who raises millions of dollars a year for the indigent of Israel and America. I once asked him, "R' Zalman, you never cease to amaze me! Day and night, rain or shine, snow and ice, you are always on the run to help others. How do you do it? What keeps you going?"

R' Zalman is the humblest of men who never speaks about himself or his achievements, but this one time he let down his guard and revealed a glimpse of his past. He told me, "As a teenager I studied in the Satmar Yeshiva in Williamsburg. The Satmar Rav, R' Yoel Teitelbaum, had an enormous impact on all of his *talmidim,* whom he inspired to be charity collectors. One incident stands out vividly in my mind. In 1964, when I was 17 years old, I was collecting with a friend for *hachnassas kallah* for another poor friend who had no money for his wedding. I decided to do something a bit rash. I said to my friend, 'Wouldn't it be amazing if we could get a donation, a *berachah* and a letter of approval from the *gadol hador,* the great Rabbi of our generation, R' Moshe Feinstein, who lives so close to us, on the Lower East Side of Manhattan!'

"We went over the bridge to Mesivtha Tifereth Yerushalayim and approached R' Moshe just as he was about to begin his *shiur* to his students. But when he saw that we were collecting for *tzedakah,* he stopped and gave us his full attention, as if we were the most important people in the world. We told the Rosh HaYeshiva what we were collecting for and offered to show him supporting letters from leading rabbis in Williamsburg.

"The Rosh HaYeshiva just smiled at us with his sweet, angelic face, and said, 'I have no need to look at letters to prove the truth of your

cause. I can see it all over your faces!' With that, the Rosh HaYeshiva opened his drawer and took out a $20 bill, which was a large sum at the time, and handed it to us, saying, 'It's my *zechus* to be part of your mitzvah; I will give you my own letter of approval if you think it will help the cause!'

"I never met anyone with such a radiant face. I have never seen *tzedakah* given with such joy! Thirty-six years have elapsed since that very brief encounter, but I will never forget R' Moshe's bright face and encouraging words. Whenever things get rough and I feel discouraged, I have one thought that is guaranteed to boost my flagging spirits. How can I doubt whether I will succeed in my mission of mercy? How can I allow gloom to shroud my face? Didn't the holy Rosh HaYeshiva tell me that I am truly a *gabbai tzedakah;* didn't he tell me, 'I can see it all over your face!' "

ᴈ Caring for the Donor More Than the Cause

R' Shmuel Tzvi Kovalsky of Bnei Brak was a *gabbai tzedakah* for many varied causes, but his main responsibility was to sustain the *Kollel* of Sochatchov in his capacity of *Rosh Kollel.*

Once, when a wealthy man came to visit him, R' Kovalsky described the *Kollel* and the outstanding young scholars who studied there. He also explained with great passion the tremendous reward that awaits those who support the study of Torah. The wealthy man was so excited and impressed that he whipped out his checkbook and announced, "I am prepared to write a check for any amount you say, up to $20,000!" But R' Kovalsky remained silent.

"Please tell me what amount you want me to write on the check!" the man asked. "Whatever you wish," was R' Kovalsky's answer.

The man wrote out a check for $5,000. R' Kovalsky thanked him very warmly and the man left.

The bystanders who witnessed this incident were amazed. "With one word you could have made $20,000 for the *Kollel* — effortlessly! Just think how much time and energy you could have saved yourself! With just one word you could have given this wealthy man the merit of a gift of $20,000, instead of one quarter the *zechusim* for his gift of $5,000!"

R' Kovalsky replied, "Apparently you have forgotten a statement from the Talmud in Tractate *Kiddushin."* No one grasped what the Rav was referring to.

R' Kovalsky made himself clear. "This rich man's final actions revealed his original intentions — he never wanted to give more than $5,000 dollars. What happened? Momentarily he was overwhelmed by my beautiful description of the *Kollel* and he got so carried away by emotion that he felt a flash of generosity and proclaimed he was ready to give $20,000. I have no doubt that when he would have gone home, his exhilaration would have subsided and he would have regretted donating such a large sum.

"The Talmud (*Kiddushin* 40b) teaches that even if a man was a perfectly righteous *tzaddik* all his life, but in the end regrets the good deeds that he did, he loses his reward for those good deeds that he regrets. Therefore, if I had exploited my opportunity to the maximum, the *Kollel* would have gained $15,000 and I would have saved myself a lot of collecting — but this man, 'nebach,' would have forfeited all of his merit from this mitzvah. My primary responsibility as a fund-raiser is to recognize the debt of gratitude owed to the donors who help my cause, and my top concern is that they not lose the merit of the mitzvah they paid for so handsomely!"

◦§ Humiliation Increases Merit

A *gabbai tzedakah* should not be upset if his clients vilify him, for this humiliation only increases his merit and reward (*Yoreh Deah* 257:7).

The Vilna Gaon (ibid.) cites the *Jerusalem Talmud (Peah* 8:6) which relates that R' Elazar was responsible for feeding the poor. One day his family told him that in his absence they had fed a group of paupers who ate and drank and then prayed for his welfare. R' Elazar responded, "For this I will not get much of a reward." Another time, his family reported that they fed a second group of paupers. But after their meal, this group disparaged their host. R' Elazar responded, "Now I will merit a fine reward!" Similarly, the community asked R' Akiva to become their *gabbai tzedakah.* He explained that he first had to consult with his wife and family. The people were curious and followed R' Akiva home. They overheard his family

saying, "Yes accept the position; but only with the awareness that the poor will curse and disparage you, but you will refuse to be offended!"

◄§ Humiliation From a Mitzvah

R' Elchonon Wasserman visited London in the late 1930's to raise funds to support his yeshiva in Baranovitch. He was given the names of three well-to-do gentlemen who might be interested in helping the yeshiva. As R' Elchonon was preparing to visit them, a wealthy gentleman came to visit him, and R' Elchonon asked the visitor to accompany him as he solicited these three men. The wealthy man refused, saying, "I will be more than happy to give a generous donation to your yeshiva, but I would be terribly embarrassed to approach others for funds!"

R' Elchonon reassured the man, "Believe me, it is preordained from heaven exactly how much embarrassment a person will suffer at any given time; you can't suffer one iota more than is coming to you. If you fulfill your quota of shame and pain while collecting *tzedakah,* you will save yourself from suffering humiliation in other ways. You would be wise to get your disgrace while earning a fine mitzvah!" The rich guest was astounded by this revelation and asked the great Rosh Yeshiva, "Do you promise me that this is so?" R' Elchonon assured him that this statement was completely accurate. The rich man swallowed his pride and accompanied the Rosh Yeshiva on his collection rounds (Heard from R' Kasriel Hakohen of Bnai Brak).

◄§ One Who Suffers Deserves Special Help

One Friday, a poor man came to the home of Rabbi Yeshaya Brodky who was the Rav of the Ashkenazi community in Jerusalem in the early years of the 19th century. The pauper complained that he and his family had nothing to eat. The Rabbi said, "I myself have no money at all, but I will give you one of my two Shabbos candlesticks. Sell it for a good price and use the money to buy yourself food."

A few weeks later the very same man returned and once again

begged for help. R' Yeshaya gave him the second Shabbos candle-stick. Not long after this, the poor man came a third time. This time the Rav had nothing valuable to give away except for his own fur *shtriemel,* which he gladly gave away. The pauper flew into a rage. Instead of thanking the Rav for his great sacrifice, he contemptuously threw the *shtriemel* to the floor and cursed the Rav for not helping him enough.

"If a person behaves this way," thought the Rav, "he must be suffering so much that his mind is being adversely affected. He urgently needs help!" R' Yeshaya stood up and said, "Come, let us go to collect funds from the entire community." Together, the illustrious Rav of Jerusalem and the lowly pauper went from door to door until an appropriate amount was collected *(Midemuyos Yerushalayim,* pp. 54-55).

⇜§ Collect Money, Not Complaints

Rabbi Aharon Weitz, who now directs Ezras Cholim (ECHO) in Monsey New York, relates: In the early 1950's, Rabbi Alexander Linchner was raising funds to build Boys Town in Jerusalem. I had the privilege to accompany him to the office of a prominent businessman who was one of his supporters. In the reception area Rabbi Linchner met another fund-raiser who, he discovered, had been waiting for over two hours. When the businessman rushed out of his office to greet Rabbi Linchner whom he admired, Rabbi Linchner rebuked him: "Why did you keep this distinguished fund-raiser waiting so long?" Before the businessman could reply, the fund-raiser raised his voice in protest, "Please! Leave him alone! I didn't mind waiting. It's fine. It's really fine. Let me explain why:

"Once, the son of the *Chozeh* of Lublin took leave of his father before setting out to raise funds for *hachnassas kallah.* The *Chozeh* told his son, 'The main thing when you collect funds for charity is that you must always keep the right thoughts in mind. If you have the right attitude, there is no mitzvah greater than *tzedakah.* But if, heaven forbid, you should entertain the wrong thoughts, you will destroy the mitzvah and harm yourself.'

"The *Chozeh* continued: 'I learned this from my own experience. Once when I was collecting for charity on a burning hot day, I entered

a Jewish *kretchma* (inn) and asked the lady in charge for a glass of water. She began to run to the barrel to fetch the water for me, but her husband stopped her. They actually had two barrels of water; one barrel contained unfiltered water straight from the river full of contaminants and sediment. The other barrel held filtered water, purified for human consumption. When his wife was about to give me the filtered water, the husband objected, "Don't squander that precious water on a stranger! Give him the unfiltered stuff!" '

" 'I drank my murky glass of water and went outside into the burning sun. In the street I passed a gentile water carrier who was carrying two bucketsful of crystal-clear water from the well. The gentile called out to me, "You look like a man of God; It would be my privilege to have you drink your fill from my bucket!" I drank from the cold, crystal-clear well water and took out some coins to pay the water carrier. He adamantly refused to take a cent. I begged him to take the money; he walked away. I ran after him for many blocks, pleading with him to accept payment.'

" 'Why did I persist? Because I realized that in heaven there would be a terrible *kitrug,* accusation, against the innkeeper. He didn't want to give a fellow Jew a decent glass of water, while this stranger, this gentile, treated me with brotherly love.' "

"The moral of the story is that when we collect charity our sole intention is to help and bless our brothers, never to cause hurt. The collector must bear no resentment against those from whom he is collecting. He must not take umbrage even if they keep him waiting too long, give him too little, or speak to him harshly."

The fund-raiser concluded his story and said, "With the *Chozeh's* words in mind, I am prepared to wait and wait and it doesn't bother me at all."

◈§ Mr. Marianpolski Will Not Forgive

Rabbi Yosef Shlomo Kahaneman, the Ponevezher Rav, took great pleasure in recounting stories of generous charity givers. "I remember well," related the Rav, "how I was once startled very late at night by an urgent knocking at my door. I opened the door and standing before me was a group of the most distinguished members of my Ponevezh community. 'What is the emergency?' I asked.

"They replied, 'We just learned that one of the finest merchants in town, Mr. — has suddenly fallen on hard times and is in dire straits. He is about to lose everything he has!'

" 'What can we do for him?' I asked.

"The delegation replied, 'If we can obtain an emergency loan of 20,000 lit for him, there is a very good chance that his business can be saved.'

"I immediately picked up the phone and called the manager of the local Jewish bank and asked him to please come to my home right away. When he arrived, we explained to him the desperate situation and he responded, 'I would be delighted to make a loan for the entire amount, to be repaid at 500 lit per month over the next three and one half years. All I need is a reliable guarantor to back up the loan. If you can get Mr. Marianpolski of Kovno to co-sign the loan, then the deal is done.' Right then, in the dead of night, I called Mr. Marianpolski in Kovno, whom I knew quite well, and he agreed to guarantee the very large loan to save a fellow Jew from financial ruin.

"A few months later the bank manager paid me a surprise visit. He explained that the borrower had failed to make his payments. But that was not bothering the manager. What was the problem? Following established policy, the bank sent reminders to the borrower. When he failed to respond, the bank sent a notice to Mr. Marianpolski requesting monthly payments on the loan. But Marianpolski refused to make monthly payments. Instead, he paid the entire sum of 20,000 lit! 'Why did he do that?' asked the bewildered manager.

" 'Obviously, there is only one way to solve this mystery,' said the Ponevezher Rav. In a flash, I called Marianpolski and he explained it very simply and humbly. 'Rebbe,' he said, 'It's very clear to me that this poor man cannot pay his loan. Why stretch out the mitzvah and pay it out piecemeal in monthly installments when I am able to pay off the entire loan all at once!' "

During World War II, R' Yaakov Galinski, the Rosh Yeshiva of Chadera, met Marianpolski in a slave-labor camp deep in Siberia, where they were both exiled after the Russian takeover of Lithuania. The Communists, of course, had stripped Marianpolski of all his wealth and left him penniless. There, in the miserable Siberian wasteland, he poured out his bitter heart to Rabbi Galinski, saying, "I cannot forgive the rabbis of Kovno and Ponevezh. They were much too soft with me! Of course they asked me for *tzedakah* in the good

times, but they didn't demand enough. I was capable of giving much, much more but they didn't want to bother me. So what happened to my money in the end? The Communists plundered everything, and I have nothing to show for myself. Had my money been donated to *tzedakah* I would have enjoyed it for all eternity" *(HaRav MiPonevezh, Part II, pp. 245-246).*

◄§ Constant Vigilance

Rabbi Yosef Shlomo Kahaneman, the Ponevezher Rav, was a non-Chassidic Lithuanian to the core. He did, however, have one close encounter with the Chassidic world. When he was a young man visiting the town of Slonim, where the Slonimer Rebbe, known as the *Divrei Shmuel,* was living at the time, young Yosef Shlomo attended the Rebbe's *tisch* one Friday night, out of curiosity. Much to his own surprise, he was extremely moved by the Rebbe's profound words of Torah. Moreover, his soul was sent soaring by the fervor of the *zemiros* sung by the entire assemblage. The next Friday night, Yosef Shlomo felt himself drawn back to the Rebbe's *tisch* with a tremendous yearning. Once again, his entire being was deeply stirred by the experience. He said to himself, "Here my soul has found its place! This is where I belong! I will surely return next week, and I will adopt more of this ardent service of Hashem."

On the third Friday night, young Yosef Shlomo was moved as never before. He simply could not take his eyes off of the shining countenance of the Rebbe. But all of a sudden, in the middle of the *zemiros,* when everyone around the table seemed to be transported to a higher world, the Rebbe called over his *gabbai* and whispered in his ear, "Listen carefully. Are you sure the money is safe? Did you make sure to lock up the money carefully? Please, go check on the money to be certain that it's safe!"

Young Yosef Shlomo was shocked. "How could the Rebbe possibly have his mind on money at a time like this, on the holy Shabbos? At a time when everyone else seems to be soaring in celestial spheres of sanctity, how could the Rebbe be so mundane? Something isn't right here. I don't think this is the place for me."

Years went by, and many decades later, Yosef Shlomo, who had become the world-famous Ponevezher Rav, was conversing with the

present Slonimer Rebbe, R' Sholom Noach Berzovsky. The conversation turned to the earlier Slonimer Rebbe, the *Divrei Shmuel,* and R' Berzovsky remarked, "The *Divrei Shmuel* was a devoted *gabbai tzedakah* for the poor people of *Eretz Yisrael.* He used to collect enormous amounts of money to send to the needy of the Holy Land. His dedication to this cause was unbelievable. The Rebbe didn't care at all about his own money, but the funds collected for *Eretz Yisrael* he guarded like the apple of his eye! He didn't stop thinking about those funds for a second. As a matter of fact, there were times when he would summon his attendant in the middle of a *tisch* and grill him about the safety of the charity money, saying, "Are you sure the money is safe? Did you make sure to lock up the money carefully? Please, go check up on the money to be certain that it's safe!"

When the Ponevezher Rav heard this he realized that he had made a great mistake. He related to the Rebbe, R' Sholom Noach, the story of his brief encounter with *Chassidus,* and said wistfully, "What a shame that I made such a misjudgment. If not for my error, I would have stayed with the Rebbe and become a *Chassid!*" R' Sholom Noach responded, "Don't feel bad; it worked out for the best. You didn't become a *Chassid.* So what? There are plenty of other *Chassidim* in Hashem's world! Instead, you became a peerless rabbinic leader and Torah institution builder, the one and only Ponevezher Rav!" *(As told to me by R' Eliezer Eichler, the Boyaner Dayan, who heard this story directly from the Slonimer Rebbe, R' Sholom Noach Berzovsky).*

⋘ It's in Our Blood

My uncle, R' Izak Ausband, Rosh Yeshiva in Telshe, Cleveland, told me the following story which he himself heard from the Ponevezher Rav when he was a student in his yeshiva in the 1930's.

A wealthy man in town gradually lost all of his money, but his financial reverses were still a secret. Only the Ponevezher Rav was aware of the man's poverty.

Pesach was approaching and the Rav knew that the man would require a sizable sum for the holiday. He also knew that this man would never accept charity. With utmost discretion the Rav made a special collection for this man and put together a handsome sum. The

Rav then fabricated a story to induce the proud man to accept the money. He told the man, "Your rich brother in America somehow sensed that you could use a little bit of extra help before Pesach, so he secretly sent me a generous amount of money for you. He wants absolutely no thanks or acknowledgment of this gift."

The man accepted the money and immediately gave a large portion of it back to the Rav. He explained, "I am delighted to be able to give a large donation to the community *maos chittim* campaign as I always do every year. This is my most urgent Passover need — to help the needy!"

The Ponevezher Rav had no choice but to accept the donation. Years later, he commented, "*Tzedakah* is ingrained in the very essence of a Jew. It flows in his blood and is his breath of life. No matter how difficult the circumstances for himself, a Jew always thinks of others and contributes to the extent of his ability for their welfare."

∽§ The Amount to Be Collected Is Preordained

Rabbi Zusya of Hanipoli once came to a city to raise funds for charity. Two local young men were very eager to share in this great mitzvah by doing the legwork of going from door to door. There was a wealthy man in town who always gave a very generous donation to every good cause. They decided to approach him last, because his large donation was guaranteed. After a long hard day of knocking on doors, the two volunteers succeeded in raising nearly 50 rubles, a very respectable sum. Bone tired but very optimistic, they approached their final, affluent prospect, expecting him to match the entire amount they had amassed. How chagrined and shocked they were when he gave them only the few rubles necessary to round out the full 50 rubles. All of their pleas for a more generous contribution fell on deaf ears. They could not believe it! Why had this philanthropist's heart suddenly turned into stone?

The two collectors returned to R' Zusya and complained bitterly about their acute disappointment. The Rebbe silenced them saying, "My dear sons, there is no reason to be upset. At the very moment a supplicant arrives in a city, a heavenly decree pronounces how much money he will raise. Once the decree is issued, it cannot be changed.

The poor man will not take from this city a penny more or a penny less." R' Zusya continued, "The moment I set foot in this city I heard a celestial voice crying out that I would raise exactly 50 rubles for charity. Had you approached the rich man first, he would certainly have given you a lavish donation. However, since you saved him for last, he could not give you more than the few pennies you were shy of 50 rubles."

From this story, the Stretiner Rebbe derived an essential lesson in fund-raising. Often people discourage a fund-raiser, saying that a certain person or group of people have been solicited time and again and they are probably sick and tired of giving, or have exhausted their charity account. This is absolutely false. For every new cause a new heavenly decree determines how much will be raised. It makes no difference how many times these people were approached. As long as there are people willing to collect, the preordained sum will be raised. [In this vein, the Ponevezher Rav would say, "*Ess felt nit kein tzedakah gelt in der velt, ess felt nemers!* There is no shortage of charity funds in the world, there is only a shortage of collectors)!"] Nor should someone be upset when a donor gives a disappointing gift. It is very possible that that it was decreed that no more money could be donated to this cause (*Maamarei Tzedakah* by *Rabbi Aharon Roth*, p. 52).

⮜§ A Blessing for Long Life

Rabbi Avrohom Chaim Levinson of Jerusalem, a descendant of the famous *tzaddik*, Rabbi Hillel of Kolomaye, met a Jew in America who was 108 years old! The old man explained that his long life was due to a blessing he had once received from R' Hillel of Kolomaye. "When I was a young man, I was in the Rav's home when a grandson of R' Chaim Sanzer begged R' Hillel to help him raise funds in order to marry off his daughter. R' Hillel turned to me and said, 'This good man is in desperate straits and he needs someone to take him around to help him collect. Do me a personal favor and take charge of this great mitzvah!'

"When I heard the Rav's urgent plea I didn't hesitate. I immediately went around and spent the entire day collecting, and I gathered quite a sizable amount. Late that night I delivered all the money to the Rav

and he was very pleased. He turned to me and gave me a warm blessing: 'You have earned great merit because you didn't hesitate for a moment and you grabbed this mitzvah. Moreover, you gave away your precious time, an entire day, to help this desperate man. May you therefore be blessed with many, many more minutes, and many more days and may you live many long and good years!' "

◆§ R' Eliyahu Chaim Meisel

R' Elya Chaim Meisel, Rav of the great Jewish community of Lodz, was not only a *gaon* in Torah but also a *gaon* in *tzedakah*. (R' Elya Chaim was born in the week that R' Chaim of Volozhin died. He was named 'Eliyahu' after the *Gaon* of Vilna and 'Chaim' after R' Chaim of Volozhin.)

R' Elya Chaim was a very wealthy man in his own right and he gave away enormous sums to charity. In addition, he would borrow vast amounts of money in order to help the poor, and thus, he was always deep in debt. Once, at a meeting of the greatest rabbis in Eastern Europe to discuss an urgent communal matter, a certain Rabbi said disparagingly, "It's certainly true that the R' Elya Chaim is a great activist for the Jewish people, but, unfortunately this has taken a toll on his Torah learning. His devotion to *tzedakah* has made him waste a lot of time from studying!"

Rabbi Chaim Brisker responded angrily, "You should know, that someone who closes his *Gemara* to perform acts of kindness is regarded as if his *Gemara* is open before him. On the other hand, if someone refuses to close his *Gemara* in order to help other Jews, then even when his *Gemara* is open before him it is as if it is closed and sealed tight!" (*Uvdos L'Beis Brisk*, Vol. I, p. 60).

◆§ Give the Rich a Taste of Being Poor

One cold winter day, R' Elya Chaim was collecting money to buy firewood for the poor. He went to solicit the *gvir* of Lodz, the richest man in the city. The Rav stood in the outer corridor of the mansion and waited there as the servant announced his arrival. The magnate, wearing just a shirt, greeted the Rav in the unheated corridor

and invited him into the cozy warmth of the inner chambers. The Rav, however, did not budge. Instead, he began to describe the desperate needs of the impoverished Jews without even firewood.

The *gvir* was freezing, but out of respect for the Rav, he listened patiently. The Rav spoke very slowly, and the wealthy man's teeth started chattering from the cold.

"Please, Rabbi," he begged, "come inside the house where it is warm!" But R' Elya Chaim did not move.

"I have come to raise money to purchase firewood for the poor," was his only response.

The *gvir* gave the Rav a very generous donation, and then R' Elya Chaim entered the home.

"Tell me, dear Rabbi," queried the host, "why did you insist on standing so long in the cold when we could have taken care of the *tzedakah* here in the comfort of my warm home?"

R' Elya Chaim Meisel answered with a smile. "If I had entered into your cozy surroundings, you would not have been able to properly appreciate the desperate needs of the poor. But when you suffered in the cold, you were able to commiserate with those who need firewood, and you gave a truly handsome and appropriate contribution!"

⋖§ This Is My Profession

R' Nachum'ke of Horodno was a great *tzaddik* and *talmid chacham* who concealed his stature in the guise of a simple Jew, but he could not hide from other holy men who detected his true worth. Small wonder then that the Chofetz Chaim considered him to be one of his main teachers and kept R' Nachum'ke's picture with him. Among his many virtues, R' Nachum'ke was a dedicated *gabbai tzedakah*.

In his old age, he was sickly and in constant pain, but this did not deter him from going about, day and night, to collect *tzedakah* for the poor.

One night, as he was out collecting, his sickness overcame him and he fell down in great pain. It was very late and pitch dark as he lay on the ground, groaning in pain, but not a soul was around to help him. A Jewish wagon driver heard the groans and found R' Nachum writhing in pain, more dead than alive. The driver picked him up,

placed him in the wagon, and started driving him home. R' Nachum turned to the wagon driver and asked him to stop; he had to get off.

The wagon driver begged R' Nachum to stay on the wagon so that he could be taken home. "I'm sorry," said R' Nachum, "I have urgent matters to attend to. I must collect money for the poor."

"Rebbe," pleaded the wagon driver, "you're so sick, and it's late at night."

"Tell me," asked R' Nachum'ke, "why are you driving around in the dark so late at night?"

"What can I do, Rebbe? This is my occupation, and I have a wife and five children to support."

"That is precisely my point," argued R" Nachum. "If you, who have only six mouths to feed, are still working at this late hour, then I, who have hundreds of needy people depending on me, must certainly continue to toil even at this time!"

◆§ Pressuring Donors to Give

The Talmud (*Bava Basra* 8b) teaches: A *gabbai tzedakah* is authorized to seize collateral for an unpaid charity obligation, even on the Sabbath eve [when every Jew has an excuse that he is busy preparing for the Sabbath and therefore has no time to tender his contribution (*Rashi*)]. Is that really the law? Is it not written: וּפָקַדְתִּי עַל כָּל לֹחֲצָיו, *And I will visit evil upon all of their oppressors?* (*Jeremiah* 30:20). And the Rabbis taught: This means that God will punish even the charity collectors [because even though they generally do a great service to the community, they occasionally oppress the people by overzealously seizing their property for collateral. Thus we see that the collectors are forbidden to seize property as collateral for unpaid charity pledges].

The Talmud answers: There really is no difficulty. The law of seizing pledges applies when the contributor is wealthy. It is not considered oppressive to seize his property as collateral, since he is not harmed by the temporary loss. But to seize the property of a contributor who is not wealthy is considered oppressive because it may cause him financial loss. Rabbeinu Tam (cited in *Tosafos*, s.v. *achpei*) explains that even verbal coercion is considered an oppressive tactic for the man who cannot afford to give more charity.

Indeed, the Talmud concludes with an incident that illustrates that wealthy people are treated differently. This was the case of Rava, who while collecting for charity coerced Rav Nassan bar Ami, a wealthy man, and took 400 zuzim for charity from him. Similarly, collectors are permitted to seize collateral from wealthy donors.

The above teachings are codified in *Shulchan Aruch, Yoreh Deah* (248:1,2).

⤳ Taking in Order to Give to Others

The Jerusalem Talmud *(Peah 8:8)* relates: Nasty rumors were being spread about R' Zecharyah, the son-in-law of R' Levi, because he was collecting charity [apparently for himself] and everyone knew that he was not needy. After he died, his account books came to light and they proved that everything he collected was for others.

Sefer Chassidim (318) describes a similar situation: Once there was a Torah scholar who was not needy, but he collected charity, telling people, "Please help me out for I am in dire need!" In truth, he gave away every penny he collected to the poor. The only reason he went through this charade was because nothing else worked. When the paupers went around collecting for themselves, people paid no attention to them. When he himself went around on behalf of the poor, people also gave only a mere pittance. The only way he could raise a respectable sum was by saying that he was collecting for himself; so that is exactly what he did. He said, "I would rather humiliate myself and be treated like a beggar than to see the poor suffer deprivation." It is permissible for a *talmid chacham* to do this [because he feels the pain of others as if it would be his own, and so he is truly in need — for them!].

⤳ Halachos

1. Once a person hands over his money to the administrators of a charity fund, he relinquishes all power over his donation and the *gabbai tzedakah* may do with the money what is proper in the eyes of God and man *(Yoreh Deah 251:5)*.

2. We are obligated to feed the hungry before clothing the needy (ibid. 251:7). If stranger comes and asks for food, we do not investigate to ascertain his poverty. We must immediately provide him with food [lest he drop dead from hunger]. However, when a stranger asks for clothing, we must make sure that he is really needy. Once the virtue of his request has been ascertained, we immediately provide him with proper clothes (ibid. 251:10).

⊰ Lending Out Surplus Funds

Question: Often, a gabbai tzedakah will find he has surplus money. May he temporarily use these tzedakah funds to give free loans to those in need? May he invest this money in order to make a profit for this charitable cause?

Answer: It depends on the nature of the charity the money was originally designated for. If it is the type of charity where the poor constantly come to ask for their needs, then the money should always be available to them. It should never be tied up in loans or investments which render the funds even temporarily inaccessible. But if the charity fund is seasonal and there is a period of time when the money is not needed, then the trustees may invest the funds in safe, 'no-risk' investments. They may also make free loans from these funds to people whom they know and trust to repay the funds promptly (*Rama* to *Shulchan Aruch Yoreh Deah* 259:1 and *Responsa Chamudei Daniel* cited in *Pischei Teshuvah* ibid. 4).

⊰ The *Pushka* of *Tzedakah*

It is a time-honored custom for every Jewish home to have a few charity boxes placed in convenient locations where small donations may be made periodically. In all generations, righteous Jewish women filled these *pushkas* by putting in a few coins before every daily prayer and especially before kindling their Shabbos candles.

A question arises regarding the halachic status of these *pushkas*. The law is that if a person held an amount of cash in his hand and stated that this money is hereby given as a gift to *tzedakah*, he has not yet relinquished his control over the money. Under certain

circumstances he is allowed to annul his vow and get his money back. Also, if there are no collectors or poor people around to take the money from him, the donor may temporarily borrow the money and use it for his own purposes, with the understanding that he will immediately pay it back the moment a needy person or a collector appears to take it. But once the money reaches the hands of the poor or the *gabbai tzedakah* the donor forfeits all rights to the money.

If an individual makes or purchases his own personal *tzedakah pushka* which has not been designated for any specific cause, the money placed in the box certainly remains under the donor's control as explained above. However, most *pushkas* are produced and distributed by institutions and are clearly identified as their property. The halachic dilemma is this: Do we say that when someone puts money into the *pushka* it is as if he put it into the hands of the institution's *gabbai tzedakah,* thereby relinquishing all rights over the money? Or do we say that the inanimate *pushka* is not similar to a live *gabbai tzedakah* and since it is located on the property of the donor, the money inside it remains under his control?

Most authorities agree that once the money is deposited in the institutional *pushka* it becomes the institution's exclusive property (*Tzedakah Umishpat* 8:9 and note 25).

⊸§ Revealing Charity Sources

Question? Is it permissible for a charity collector to share information with other collectors by revealing the names of the people who gave him generous contributions?

Answer: R' Moshe Feinstein addresses this question in *Iggros Moshe* (Vol. III, *Yoreh Deah* 95):

The Talmud (*Arachin* 16a) teaches: R' Dimi said: What is the meaning of the verse: מְבָרֵךְ רֵעֵהוּ בְּקוֹל גָּדוֹל בַּבֹּקֶר הַשְׁכֵּים, קְלָלָה תֵּחָשֶׁב לוֹ, *If one blesses his friend loudly from early in the morning, it will be considered a curse to him (Proverbs 27:14)?* This verse refers to a guest whose host goes out of his way to treat him with extraordinary hospitality. The next morning the appreciative guest goes out into the public thoroughfare and publicly proclaims: "May God bless my wonderful host who went to such extraordinary lengths to make me feel at home!" The result of this apparent blessing will be a curse,

because all kinds of people will now besiege the benefactor for hospitality and favors and they will swiftly consume his wealth!

The commentaries (ibid.) elucidate that this teaching only applies when the beneficiary of the kindness praises his benefactor in an irresponsible way, in the presence of unprincipled people who are likely to abuse and exploit the philanthropist's kindness. However, it is perfectly appropriate to sing the praises of a good host in front of decent, upright people who are not suspected of misusing this information. Also, if it was already public knowledge that the host was a rich and hospitable person, then the grateful guest has done no harm by merely reiterating that which is already well known.

Another factor to consider is the teaching of the Talmud (*Bava Basra* 8b), which warns charity collectors not to pressure someone who is known to be softhearted and especially generous. It is considered a serious sin to exploit a gentle person's soft nature to squeeze charity money out of him. R' Moshe Feinstein says that this prohibition only applies to someone who is positively known to be embarrassed to turn down any request. The average person, however, is capable of defending himself and will not allow himself to be abused. Therefore, one may give out the names of normal charitable donors and need not be concerned lest they be exploited.

Moreover, if the donor is known to be a wealthy man, his name can be revealed even if he is known to be very softhearted and not able to refuse the request of a great Rabbi or an important fundraiser. The reason is that this wealthy man probably has not yet fulfilled his *maaser* obligations and it is a mitzvah to pressure him into doing so. Even if he has actually given his full tithe for this year, that is only the minimum amount. Ideally, everyone, especially the wealthy, should give one fifth of his or her income to charity. Thus, if a great Rabbi will pressure him to give a substantial donation in order to meet his *chomesh* quota, he will not be sinning at all; rather he will be doing the rich donor a favor. The rich man should actually thank the *gabbai tzedakah* for sharing his name with other collectors because this caused him to have so many new mitzvos and merits!

Women and Charity

◂§ The Value of Immediate Benefit

The Talmud (*Taanis 23b*) tells of a time when the world was in desperate need of rain and the Sages of Israel sent a delegation to the pious Abba Chilkiyah to pray for mercy. Abba Chilkiyah and his wife went up to the roof of their home in order to pray discreetly. The husband prayed in one corner while his wife prayed in another. Their fervent entreaties to the Almighty were soon answered. However, the Rabbis noticed an odd thing. When the rain clouds formed, they first appeared over the corner where the wife stood in prayer. The Rabbis asked Abba Chilkiyah to explain this phenomenon. He responded: "My wife's prayers were answered first because generally women have greater *tzedakah* merit than men. Why? Because they stay home and are readily accessible to the beggars who go from door to door. Additionally, the housewife gives bread and food to the poor and hungry, and the benefit of ready-to-eat food is immediate. Men, however, give money to the poor and the benefit is not immediate since the money must be exchanged for bread and other staples." A similar idea is found elsewhere in the Talmud (*Kesubos 67b*).

◂§ With Her Husband's Permission

One may not accept large donations from a married woman since her husband might not approve of her donating large amounts.

The amount that is permissible to accept is dependent on the financial situation of the particular family. This applies when the husband has not made an explicit statement concerning his wife donating money. If the husband specifically leaves it to his wife's discretion she may give as much as she wishes. If the husband protests, it is forbidden to accept any money at all from his wife (*Yoreh Deah* 248:4).

May we believe a woman who claims that her husband has granted her permission to give a large donation to a charitable cause? *Responsa Nodah BiYehudah Kamma* (*Yoreh Deah* 72) rules that she is to be believed.

Elsewhere, in *Responsa Nodah BiYehudah Tinyana* (*Yoreh Deah* 154) the author addresses the question of a woman who is aware that her wealthy husband is stingy and does not give charity according to his means. The woman runs her own successful business from her home and secretly gives *tzedakah* lavishly from her profits — enough to cover what her husband really should be giving. She knows that if her husband would realize this he would be upset and would protest. Is she doing the right thing?

The *Nodah BiYehudah* rules that according to halachah everything the wife earns belongs to her husband and she has no right to give it away without his permission. Anyone who accepts unauthorized charity from her is stealing from her husband! Even though the Jewish court has the right to force a man to give his fair share to charity, who gave his wife the authority to make that decision? Moreover, even when the *Beis Din* coerces a man to give charity, it is done with his full knowledge, albeit without his consent. No one has the right to seize another man's property without his knowledge. (See *Pischei Teshuvah to Yoreh Deah* 248:4.)

Aruch Hashulchan (*Yoreh Deah* 248:12,13) cites important authorities (*Yam Shel Shlomo* in the name of the *Raavan*) who say that nowadays women have much more of a say in their family's finances than in Talmudic times. Therefore, one may accept a larger charitable donation from a woman without her husband's approval. He also brings authorities who rule that when a wife earns money independently through a trade or profession she may spend the money as she wishes and certainly may contribute her earnings to *tzedakah*.

A husband must honor the *tzedakah* pledges his wife made before they were married (*Responsa Maharam Mintz* 7 cited in *Beis Lechem Yehudah, Yoreh Deah* 248).

‏ꞌꞬꞗ The Husband's Approval Is Mandatory

In a certain city in Hungary, a childless woman approached the local Rav to help her in her desperate plight. She gave the Rav the equivalent of $400 and requested that he send it to a renowned *tzaddik* of his choice to pray for her to merit bearing children. With her approval, the Rav sent the money and her request to R' Yosef Chaim Sonnenfeld of Jerusalem.

A few weeks later, the woman's husband stormed into the Rav's house and protested, "The Rav had no right to take such a large sum of money from my wife without my permission. I demand that you return the money to me immediately!"

The Rav found himself in a most uncomfortable predicament and offered to repay the money from his own pocket, although he would only be able to pay it out in small installments. While the two men were speaking, the mailman arrived at the Rav's house with a registered letter. The Rav opened the letter and to his surprise found inside the money he had sent to Jerusalem together with a note from Rav Sonnenfeld. Written on the note was the following message: "Since you wrote me that it was the wife, on her own, who asked you to give me this money, I am concerned that she might have done this without her husband's approval. I am therefore returning this money to you so that you can give it back to her. Rest assured that I will persist in praying on her behalf. May the Almighty fulfill her wishes!"

An eyewitness related that both the Rav and the husband were so overcome by emotion that they burst out in tears (*Amudah D'Nehora*, pp. 25-26).

‏ꞌꞬꞗ It Was Worth the Wait

When R' Isser Zalman Meltzer studied in the Yeshiva of Volozhin (where he was the youngest student), the yeshiva had no regular kitchen and the students ate with different families in town. Most of the families lived in great poverty and often did not have enough food for themselves, much less for the *bachurim*. Often the *bachurim* would simply go without food for one or more days of the week.

Once, R' Isser Zalman's sister Fruma Rivka (who was 18 years his senior and later became the mother-in-law of R' Eliezer Schach) sent him a package of sugar cubes. These cubes were a treasure because they could be used to sweeten hot water and provide some energy on the days when no meals had been arranged. Nevertheless, R' Isser Zalman left the package untouched for many months. When the next vacation period arrived, he went to visit his sister in Mir and brought the sugar with him.

Fruma Rivka was very surprised to see her gift still intact and asked her brother how it was possible that he had no need for such a precious commodity.

"I needed it very much," he answered. "But I knew that a wife is not allowed to give a generous gift without her husband's permission, and I thought that, given your circumstances, this might very well constitute a 'generous gift.' I wasn't sure whether your husband would consent to your sending such a gift."

"If so," she said, "why didn't you just write and ask me about it?"

"Since I didn't know if your husband knew about the present at all, I was concerned that my letter might fall into his hands and cause him to be upset with you. If so, I would have been responsible for causing a fight between the two of you. How could I repay your kindness to me by making problems for you?" (*The Rosh Yeshiva Remembers*, p. 252).

◆§ Accepting *Tzedakah* Without Her Husband's Knowledge

The *maos chittim* distribution committee was hard at work giving out food packages and monetary stipends to help poor families prepare for Pesach. There were quite a few families in Bnei Brak who desperately needed and eagerly accepted the help which was proffered to them in a most sensitive and dignified manner. However, much to the dismay of the dedicated committee, there was one penniless *talmid chacham* who declined the offer of special holiday assistance. He sincerely wished to live from the hand of Almighty God alone, and therefore refused to accept the gifts of flesh and blood. But the committee knew that Pesach was around

the corner and the cupboards were bare, so they tried to give the food and money to the scholar's wife without her husband's knowledge.

The woman approached R' Yitzchok Silberstein of Ramat Elchonon in Bnei Brak and poured her heart out to him. Of course she desperately needed the *maos chittim,* but how could she accept it. First, in the *Tennaim,* the prenuptial agreement made prior to their wedding, both bride and groom committed themselves that, *'lo ya'alimu zeh mizeh'* — they would hide nothing from one another. Second, how could she betray her husband by interfering with his noble aspiration to achieve an exalted level of faith and trust in the Almighty? "No!" she concluded. "There is no way that I can accept this assistance!"

Rav Silberstein presented this thorny question to his father-in-law, R' Yosef Shalom Eliashiv who refuted both of her arguments. In this case, accepting the charitable assistance does not violate the pledge not to hide anything from one another. That pledge applies only where the spouses are filled with a desire for money and comforts. Then they are obligated not to conceal from one another whatever they earn or whatever they spend. But in this instance, neither spouse is greedy for money. Rather, the impoverished, suffering wife merely wishes to have the means to make a proper Jewish holiday. She is allowed to take the stipend even without her husband's knowledge.

As far as the wife's concern lest accepting help from men will undermine her husband's efforts to reach total reliance on Hashem, here, too, there is no problem. At the moment the husband refused to accept the committee's offer and threw himself upon God's mercies, he achieved the exalted faith level that he aspired to. His wife's accepting the money without his knowledge will not affect his remaining on that lofty level.

Rav Eliashiv did, however, attach one condition to his ruling. We must carefully evaluate the character and temperament of the husband and surmise how he would react if somehow he would discover that his wife accepted the help of flesh and blood. If there are grounds to believe that he would be overly upset with her and this would lead to serious discord between them, then she may not accept the money under any circumstances. Nothing is more valuable than *shalom bayis,* domestic tranquility, and this must be protected at all costs (*Tuvcha Yabiyu, Parshas Re'ei*).

ও A Merit for Having Sons

Chasam Sofer Al HaTorah (Parshas Vayeira) promises that a woman who is a baalas tzedakah, heavily involved in charity, will give birth to male children. This is alluded to in the verse, אִשָּׁה כִּי תַזְרִיעַ וְיָלְדָה זָכָר, When a woman conceives [lit. makes seed] and she gives birth to a male (Leviticus 12:2). Giving tzedakah is often compared to planting seeds for the future. Thus, Scripture pledges that the woman who makes charitable seeds will give birth to sons.

ও The Reward for Charity Is a Good Wife

King Solomon said, טוֹב רָשׁ הוֹלֵךְ בְּתֻמּוֹ, Better is a pauper who walks in his innocence (Proverbs 19:1). The Midrash (ibid.) teaches: In the merit of the charity which our Patriarchs performed with innocent faith, they merited to marry righteous wives — the holy Matriarchs!

ও A Woman as Gabbai Tzedakah

Responsa Hisorrerus Teshuvah (Vol. II, 23) rules that a woman may not be an official gabbai tzedakah to collect money from men. However, a woman may certainly be an officer or a gabbai tzedakah in a charitable or mitzvah organization dedicated exclusively for women. Additionally, there are women who go around collecting money on their own for all kinds of good causes. This is permissible as long as they scrupulously adhere to the rule of tznius (see Tzedakah Umishpat, Chapter 7:11).

ও Rebbetzin Chana Klapperpantofil

R' Nisson Wolpin relates that he once visited the Boro Park home of R' Michael Munk, where he noticed a beautiful antique silver pushka which drew his attention. Rabbi Munk explained that this charity collection box was a family heirloom. "This pushka was pre-

sented to my great-grandmother, who was known in her community as Chana Klapperpantofil!"

He then elaborated: In the early 1800's, Rebbetzin Chana Munk lived in a small town outside the city of Danzig together with her husband, Rabbi Michael Leib Munk, who was the Rav of the community. In order to help the indigent, Rebbetzin Munk would walk around the town almost daily, collecting *tzedakah* for those in need.

She would knock on a door, and if the residents were home, they would slide open a wooden slat in the door to see who was there. When they saw that it was their distinguished Rebbetzin, they would welcome her and invariably give her a contribution.

One day it occurred to the Rebbetzin that people might feel pressured to contribute to her because of her status, and in a sense, she might be taking money from people who really were not able to give it.

So the Rebbetzin bought a pair of heavy wooden clogs and wore them every time she went collecting. The shoes would make loud thumping noises as they clunked on the wooden planks that lined the muddy, unpaved roads, thus signaling to each of the town's inhabitants that she was there before she knocked on the door. Anyone who did not wish to donate charity at that time would simply not come to the door.

In this way she lovingly became known as "Chana Klapperpantofil," German for "noise-making house shoes." In 1841, on her seventieth birthday, Rebbetzin Chana "Klapperpantofil" Munk was presented by her fellow townspeople with the silver *pushka* that her descendant, Rabbi Munk, displayed in his home in Brooklyn (*The Jewish Observer*, March 1999).

�298 Even the Simplest Actions Are Rewarded

Rav Yitzchok Zev Halevi Soloveitchik, the Brisker Rav, related a story connected with the Vilna Gaon which had been passed down in his family from the days of his ancestor, Rav Chaim of Volozhin:

The Vilna Gaon's wife and a close friend used to go door-to-door collecting *tzedakah* for poor families in Vilna. The two women made a solemn pact that whoever passed away first would come back in a dream to tell the other one what awaited her.

As it happened, the other woman passed away first. Some time later

she appeared to the *Gaon's* wife in a dream and said, "I'm not permitted to reveal to you what goes on in heaven, but because of our solemn pact, I have been allowed to reveal one thing to you.

"Do you remember the time the two of us went to collect *tzedakah* from a particular woman and did not find her at home? We went on to our other stops and later we saw that woman coming towards us on the other side of the street. You remarked that she was coming and lifted your finger to point her out to me, and we both crossed the street and asked her for a donation. Do you remember that?

"Know that the money we collected from that woman is recorded in both our names, since we both had an equal part in that mitzvah. Every step each of us took on our way to get her contribution is recorded equally for the two of us. But in addition to that, it is recorded in your ledger exclusively the fact that you raised your hand and pointed a finger to call my attention to her — even that small gesture has not been overlooked" (*The Rosh Yeshiva Remembers*, P. 34).

⋗ The Role of Women in Charity

The Midrash (*Yalkut Shimoni; Megillas Rus* 607) teaches: Whoever marries a worthy woman is considered as if he fulfilled entire Torah from beginning to end. Indeed, the redemption will only come about in the merit of the righteous women of the generation. Once there was a pious man who was married to a most worthy wife. Unfortunately, this man lost all of his wealth and property and was forced to hire himself out as a farmhand.

One day as he was plowing a field, Elijah the Prophet appeared to him in the guise of a simple Arab worker and said, "Six years of prosperity have been awarded to you. You can enjoy them immediately or you can save these blessed years for the end of your life. The choice is entirely up to you." Initially, the pious man rebuffed this offer because he could not believe that such an extravagant offer could be true. Finally, after Elijah returned to him a second and then a third time, he relented and said, "I must go home and seek my wife's advice." His wife's advice was to take the six years of prosperity immediately. At the very moment that the husband gave this reply to Elijah, his little children were playing in the dirt in front of his humble

abode and as they dug down they discovered a buried treasure chest which contained enough gold and gems to support them for six full years.

The worthy wife, a woman of valor, dealt with this windfall in a manner most wise. Said she, "God has been most kind to us. Let us not squander this gift. We will live frugally for the next six years and use only a fraction of this wealth for our personal needs. The bulk of this abundance we shall use for charity. Perhaps, in the merit of charity, the Holy One, Blessed is He, will extend our blessing beyond the six year limit." And so, as good as her word, the woman distributed charity generously every single day for the next six years. Additionally, she did something very clever; she appointed her young son to be the accountant for the family's philanthropy. He kept a ledger in which he recorded every penny his mother disbursed.

When the six-years came to an end, Elijah appeared once again to the devout man and said, "The time has come for me to take back the gift I gave you six years ago." The man responded, "Just as I only accepted this gift upon the good counsel of my wife, so too will I return it to you only with her counsel and consent." The man's wife advised her husband as follows: "Go back to the Arab who blessed you and tell him, 'If you can find people who will be more trustworthy with this money than we are, then by all means take it from us and let them disburse it!' "

The Holy One, Blessed is He, saw the truth of her sincere words and noted the generous charity they distributed, and therefore decided to prolong their blessing of wealth forever.

◄§ Chuldah the Prophetess

R' Azaryah said: To get a clear notion of the power of *tzedakah* come and see what happened to Shallum ben Tikvah who was one of the leaders of his generation and performed acts of charity every day of his life. What did he do? He would fill up a large barrel of fresh water and sit near the gateway to the city. Whenever a tired, thirsty wayfarer came through the gate, he would offer him a drink of water, which refreshed and revived his weary soul. In the merit of this charitable deed, Shallum merited that the spirit of prophecy enveloped his wife Chuldah, as it says: וַיֵּלֶךְ חִלְקִיָּהוּ הַכֹּהֵן . . . אֶל חֻלְדָּה הַנְּבִיאָה

אֵשֶׁת שַׁלֻּם בֶּן תִּקְוָה, *So Chilkiyah the priest. . . went to Chuldah the prophetess, the wife of Shallum ben Tikvah* (II Kings 22:14).

Originally, her husband was called 'Shallum ben Schorah.' After her husband died, the entire nation of Israel came out to pay him the final kindness of accompanying him to the grave. However, the huge funeral procession was attacked by a foreign army and everyone fled in terror. They just dropped Shallum's dead body on the nearest grave — that happened to be that of the great prophet, Elisha. The moment Shallum's corpse touched Elisha's grave, it came back to life! The miraculously resuscitated Shallum returned to normal life and sired a son named Chananel ben Shallum (*Pirkei D'Rabbi Eliezer,* Chapter 33).

Me'il Tzedakah (Vol. I, #726) asks: If Shallum was the one who excelled in charity, why was it that his wife, Chuldah, was the one who was blessed with the gift of prophecy? He answers that the key to understanding this episode is found in the fact that originally, Shallum was called '*ben Schorah*' which literally means, 'a man of merchantry.' Shallum was a rich and successful merchant who decided to give up his lucrative enterprises in order to be involved full time in doing charity and kindness. [Therefore, his last name was changed to *Tikvah,* hope, because his kind acts gave new hope to those unfortunate souls whose lives had hitherto seemed hopeless]. As great as Shallum's sacrifice was, his devoted wife, Chuldah, deserved equal credit because she encouraged him to go ahead with his bold plan even though it entailed great financial loss and forfeiting many comforts and luxuries to which she had grown accustomed. God wanted to reward Shallum, measure for measure. Because he had infused people with a spirit of hope, he merited a Spirit of prophecy. However, Shallum was unfit for prophecy because he wasn't a Torah scholar or an especially pious, spiritual man. But his helpmate, his wife, Chuldah, was steeped in spirituality and so it was she who was granted the gift of prophecy!

Recipients
of
Tzedakah

CHAPTER TWENTY-TWO

Prioritize Your Giving

⋖§ No Two Needy People Are Alike

The Torah introduces the mitzvah of *tzedakah* with these words: לֹא
תְקַפֵּץ אֶת יָדְךָ מֵאָחִיךָ הָאֶבְיוֹן. כִּי פָתֹחַ תִּפְתַּח אֶת יָדְךָ לוֹ, *You shall not close
your hand against your destitute brother. Rather you shall open, and con-
tinue to open, your hand to him* (*Deuteronomy* 15:7-8). The Vilna Gaon
explains that the Torah conveys the mitzvah of charity using the image
of the open hand to teach that alms must be distributed according to a
precise halachic protocol based on need, location, family relationship
and social standing — **not** all destitute are treated equally. The hand
illustrates this. When you make a fist and clamp your fingers into your
palm, all fingers look alike, and consequently, you will treat all charity
collectors alike. Only when you open your hand wide do you see that
every finger is of a different dimension. Just as you see no two fingers
alike so will you treat no two needy people alike (*Divrei Eliyahu*).

In a deeper sense this means that when a person opens his heart and
his hand to give generously he will be blessed with the privilege of
giving *tzedakah* properly to the right people in the right amount. But
if a person only gives begrudgingly with a closed heart and a tight fist
that must be pried open forcefully, he will not be privileged to give his
charity properly to those who are genuinely worthy.

⋖§ Give Him Everything He Needs

The Talmud (*Kesubos* 67b) records: The Rabbis taught in a Baraisa:
The verse (*Deuteronomy* 15:8) states with regard to helping the

poor: דֵּי מַחְסֹרוֹ, [and provide] for the full extent of his needs. This teaches that you are commanded regarding a pauper to provide him with his basic needs, but you are not commanded to make him rich. The verse continues: אֲשֶׁר יֶחְסַר לוֹ, whatever is lacking to him; even if he is lacking a horse to ride upon and a servant to run before him you must provide these for him. They said about Hillel the Elder that he once brought for a pauper from an aristocratic family a horse to ride upon and a servant to run before him. On one occasion Hillel could not find a servant to run before the pauper, so Hillel himself ran before him for three millin [approx. 2.3 miles]. The Rabbis taught in a Baraisa: There once occurred an incident with the people of the Upper Galilee that they purchased for a pauper from an aristocratic family from Tzippori a large amount of expensive meat each day.

The Talmud is teaching that even though, for the public at large, certain items would be considered a luxury, for certain individuals they are deemed a necessity, and the charity fund is obligated to provide for these expenses now that he is poor and can no longer afford them. However, regarding ordinary paupers who are not accustomed to such wealth, the fund should not provide them with extravagances.

Shittah Mekubetzes cites a view of the Geonim that these extravagant expenses are covered by the charity fund only as long as the current impoverished status of the formerly wealthy man is not a matter of public knowledge. Only in such a case will the charity fund assist him in maintaining his lifestyle so that the shame of his poverty will not be revealed. However, once it is known that he is a pauper, he is given no more than any other pauper.

According to Rama .(Yoreh Deah 250:1) no individual is initially obligated to provide the poor man with all his needs. Rather, the poor man should make an effort to get the entire community to help him with his sustenance. If that is not feasible, then the individual should help him as much as he can.

◆§ Letters of Recommendation

A highly effective tool for fund-raising is the presentation of a letter of recommendation exhorting the potential donor to support a needy individual or a worthy cause. Influential Rabbinic personalities

are besieged with requests to write or sign such letters of approbation or solicitation. It would appear that this is a perfect opportunity to make a significant contribution to a charitable cause in a nonmonetary fashion. But is one obligated to do this?

Baal Shem Tov identified a Scriptural source for this obligation. The Torah requires us to help the poor man, דֵּי מַחְסֹרוֹ אֲשֶׁר יֶחְסַר לוֹ, *[and provide] for the full extent of his needs, whatever is lacking to him (Deuteronomy 15:8)*. In the Hebrew text, the words are *dei machsoro asher yechsar lo*. The *initial letters* of these five words — ד, *dalet*, מ, *mem*, א, *aleph*, י, *yud*, ל, *lamed* — have a combined numerical value (*gematria*) of 85, which is the numerical value of the word פֶּה, *peh*, mouth. This teaches that you must try to help the poor man in any way you can. In addition to financial assistance, you should help him by using your *peh*, mouth, to speak to potential donors on his behalf. The *final letters* of these five words, — י, *yud*, ו, *vav*, ר, *reish*, ר *reish*, ו *vav* — have a combined numerical value of 422, which equals the numerical value of the word כְּתָב, *ksav*, a written document — alluding to the idea that if the man of influence is unable to use his *peh*, mouth, to help the poor man, let him, at least, provide the indigent with a *ksav*, a written document, to encourage donors to give (*See Divrei Yechezkel, Parshas Re'ei*).

﷼ Nowadays Charity Is Not What It Used to Be

*A*ruch Hashulchan (*Yoreh Deah* 249:3-5 and 250:7), writing in Novaradok Belorussia at the end of the 19th century, explains in detail that according to the original law of the Torah the man of means should take full responsibility to provide for all the needs of his impoverished Jewish 'brother,' fulfilling the dictum, דֵּי מַחְסֹרוֹ אֲשֶׁר יֶחְסַר לוֹ, *[and provide] for the full extent of his needs, whatever is lacking to him (Deuteronomy 15:8)*. That system was possible only as long as the nation of Israel flourished on its own land. The majority of Jews prospered and the paupers were few so that someone to was able 'adopt' one poor family and provide for all their needs.

However, this changed once the Jews were driven from their homeland. In exile, the vast majority are poor, while only a small minority have wealth. Even if the rich were to give away every penny,

they could not provide for all the needs of the poor masses. For many centuries we have wandered in exile, and our fortunes have sunk lower and lower. Most Jews have no solid, reliable means of support. We are *luftmenschen,* people who somehow coax a living out of thin air.

Therefore, the Sages reduced the amount one is expected to give for charity to *maaser,* 10 percent, as a minimum, or *chomesh,* 20 percent, maximum. They based this number on the agricultural tithes that were incumbent upon those who worked the land before the exile. But it should be clearly understood that *maaser* and *chomesh* are Rabbinical percentages and *not* Torah law.

❧ The High End and the Low End of Tzedakah: The Beggar Who Goes From Door to Door

It is important to understand that there are two distinct categories of the poor and hence two distinct ways one must respond to the poor. This concept was introduced in the earlier chapter, "Sensitivity at the Source," in the commentary of the *Netziv, Haamek Davar,* to *Deuteronomy* 15:7. The *Netziv* demonstrated how this polarity is clearly identified in the Scriptural text.

The 'high end' of charity is where the Torah requires the man of means to take full responsibility for the poor man and to load the poor man's burden upon his own shoulders. This only applies to a poor relative or neighbor who, despite his poverty, has not stooped to public begging. The Torah respects the right of the indigent to maintain his facade of dignity and this is not condemned as false pride. Therefore, the individual giver or the entire community should make an effort to do as much as possible to support this 'brother.'

The 'low end' of charity is summed up in the words of the *Rambam* (*Hilchos Matnos Aniyim* 7:7): The beggar who goes from door to door — we are not obligated to give him a sizable donation, but we do give him a minimal gift. It is forbidden to turn away empty handed anyone who begs for help. Rather, you must give him something, even if it is no more than a piece of dried fruit, because it says, אַל יָשֹׁב דַּךְ נִכְלָם, *Let not the oppressed turn back in shame* (*Psalms* 74:21).

Aruch Hashulchan (*Yoreh Deah* 250:7) sums up their status: Those who go begging publicly from door to door have removed the 'mask of shame' from themselves. Each person they approach may give them the smallest amount, because no single individual is responsible to support them. These people have the whole world to collect from and they have access to every door they knock upon. Indeed, the *gabbai tzedakah* who administers the community charity chest should not give these beggars anything, because they are soliciting from the entire community on their own. However, the halachah is that he *does* give them a token donation, because if he ignores the beggars, people may get the false impression that the *gabbai tzedakah* thinks they are unworthy of charity.

In practical terms, מַתָּנָה מוּעֶטֶת, *matanah muetes*, a minimal gift, is the smallest coin that can buy some food item at the market. In America a gift of a quarter is certainly acceptable, and some say that even a dime is sufficient. In Israel, Rav Y. Fisher of the *Beis Din Tzedek* (*Badatz*) ruled that a 10 *agora* coin qualifies as a *matanah muetes*.

◄§ Beggars in the Big City

The Steipler Gaon related that when, as a young man, he came to Vilna, he asked R' Chaim Ozer Grodzensky: "When I go to the synagogue here, there are many poor people sitting outside and begging. Am I obligated to respond to the entreaties of every one of these beggars? Due to my very tight financial situation this would be very difficult."

R' Chaim Ozer responded: "When I lived in a small town before I came to live in Vilna, I was very scrupulous to cheerfully greet every person I met on the street. But since I came to Vilna I stopped this practice, because in such a big city it's impossible to greet everyone. The same idea applies to *tzedakah*; in a big city you simply cannot give to everyone" (*Ashkavta D'Rebbe*, Part II; p. 166).

In Elul 5760 I discussed this story with the Steipler's son, R' Chaim Kanievsky, in Bnei Brak and he corroborated the statement and said it can be relied upon in actual practice. He explained that the rule of giving a 'small gift' only applies where there is *a limit* to solicitors. But when a person is besieged incessantly by throngs of collectors, as is the case on some very busy thoroughfares or at many *chasunos* and

even during *davening* in many large shuls, it becomes a situation of אֵין לְדָבָר סוֹף, *ein ladavar sof,* a never-ending collection. It is then no longer in the category of 'a small gift,' but rather balloons into a huge gift, from which the donor is exempt.

⊰§ Who Qualifies for Charity?

The *Shulchan Aruch* (*Yoreh Deah* 255:1-2) rules: A person should always refrain as much as possible from taking charity. It is preferable to live a life of suffering and deprivation than to ask others for support. In this vein the Sages of the Talmud (*Pesachim* 113a) taught: "Treat your Sabbath as a weekday, but do not be dependent on other people for aid!" Even if he was a dignified, distinguished Torah scholar who became impoverished, he should earn his income from some type of gainful work, even a demeaning job that is beneath his dignity, rather than become dependent on *tzedakah.*

Although a person should make every effort to avoid taking charity, if he cannot survive without it, his refusal to accept charity would be tantamount to taking his own life. Thus, a sick or elderly person who cannot possibly earn enough to live is obligated to accept charity (*Yoreh Deah* 255:2).

The story is related that when R' Yisroel Salanter was told that a poor person had died of hunger, he corrected the person who bore the tragic tidings. "No," said R' Yisroel, "he didn't die of poverty, he died of pride!" (*Chayei Hamussar*)

1. The general rule is that one is considered a pauper if he possesses less than '200 zuz,' or the amount necessary to cover all of his expenses for one full year. This rule only applies to a person who is old or disabled or for some other reason cannot earn a living. However, if a person has a steady income from a salary, commissions, or from sales profits, even though he never has in his hand at one time a full year's worth of money, he is not considered poor. Although he does not have the money in his hands, he does have the hands with which to make the money!

2. Someone whose money is tied up in investments from which he has no present income may accept *tzedakah* until he begins to realize a return on the money.

3. A person who does have money saved up, but needs it to repay his

debts that have come due, may accept *tzedakah* to pay for his current living expenses.

4. One who is traveling from city to city in order to raise funds is allowed to complete his planned itinerary and to continue to ask for charity all along the way even though the full amount of money he originally needed and planned to raise was collected *earlier* on his fund-raising journey (*Rama, Yoreh Deah* 253:1). The same rule applies to a person sending out a mass mailing. If he qualified for 'poverty status' at the time the mailing was sent out, he may keep all funds sent back by mail even after the amount he receives exceeds the '200-*zuz*' maximum.

◆§ Selective Poverty

It is important to remember that a person can make a good living which is sufficient to cover his ordinary expenses, yet, under extenuating circumstances, this person will have special needs which will temporarily render him eligible for *tzedakah*. Many regular wage earners are overwhelmed when confronted with extraordinary medical bills or the expense of marrying off one or many children in a relatively short period of time. They have the right to collect money for these needs (and others may collect on their behalf) and the donors may consider this to be *tzedakah*. Such 'temporary collectors' must continue to tithe their regular income, but many authorities exempt them from tithing the funds they collected for their special need. The people who gave them the money most probably wanted them to use the entire donation for the purpose it was collected for and for nothing else.

◆§ The List of Basic Priorities

The most fundamental priority for contributing to those in need is that a person is obligated to provide for his own needs and for those of his immediate family before he provides for anyone else. Indeed, the halachah definitely endorses the notion that "charity begins at home" (*Rama, Yoreh Deah* 251:3). After a person has provided for his own minimum needs, he must then begin to care for others according to the following list of priorities.

1. If one has parents who are unable to support themselves, the child's primary *tzedakah* obligation is to maintain his parents' standard of living. It is preferable that funds other than *maaser* money be used to support one's parents. However, if this is not feasible, one may use his *maaser* funds for this purpose, and he must give his parents priority in the distribution of these funds (*Responsa of Chasam Sofer, Yoreh Deah* 229).

2. The second priority is to assist relatives who are unable to support themselves. When providing for poor relatives, one may give approximately half of his *maaser* funds to them (*Responsa of Chasam Sofer, Yoreh Deah* 231).

 The order of priorities for poor relatives is as follows:
 a) Parents
 b) Children who may be supported by charity (see *Maaser: Giving A Tenth, Tuition for Older Children*," p. 141)
 c) Grandchildren
 d) Grandparents
 e) Brothers or sisters
 f) Other relatives.

3. The next priority is to provide for one's divorced wife who is unable to support herself with the arbitrated divorce settlement [which *cannot* be paid from *maaser* funds]. The divorced wife has the status of a 'relative' and must be supported before charity is donated to Torah institutions or to poor people (*Shach, Yoreh Deah* 247:1).

4. After providing for relatives, one should care for the needy. Here the top priority is to support 'amalei Torah,' those who are totally immersed in conscientious, dedicated Torah study. Since they are so involved in their studies, they cannot be distracted by pursuit of a livelihood. It is a great privilege to remove the financial burden from them so that they can learn with full concentration. Indeed, the Chofetz Chaim (*Ahavas Chesed*, Part II; Chapter #19) cites *Midrash Tanchuma* which says that the primary purpose of the entire institution of *maaser* was to support those who labor in Torah study.

5. After the needs of the 'amalei Torah' have been satisfied, the next priority is to help poor people in general, even if they are not Torah students.

6. Relatives come before close neighbors; close neighbors before residents of the same city; residents of one's city come before residents of all other cities (*Rama, Yoreh Deah* 251:3). The Vilna Gaon (gloss 5 ibid.) rules that to qualify for the status of a poor dweller of a city it is necessary to establish residence there for a minimum of thirty days.

7. *Aruch Hashulchan* notes that even when one category has precedence over another, some money should always be left over to help those in the lower category as well.

⋐ Additional Priorities

Within every category listed above, there is also a priority list. Feeding the hungry takes precedence over providing clothing for the naked (*Yoreh Deah* 251:7). Providing for the needs of a woman always takes precedence over taking care of a man (*Yoreh Deah* 251:8). *Shach* (ibid.) explains that it is appropriate for a man to beg from door to door whereas for a woman it is inappropriate and demeaning. Therefore, we give priority to the woman's needs in order to get her off the streets and to stop begging. Similarly, in fulfilling our obligation to help marry off poor orphans, the needs of an orphan girl take precedence over an orphan boy.

Another general rule is that the man who possesses greater Torah knowledge takes precedence over the man of lesser Torah knowledge. Moreover, the wife of a *talmid chacham* enjoys the same privileges as her husband. For those on the same level of scholarship the order of priorities is based on *yichus*, or family status, meaning that a *Kohen* comes first, then a *Levi* and then a *Yisrael*. If a person's Rebbe, his Torah teacher, is in need, then he takes precedence over all other Torah scholars, even those who surpass him in their knowledge (*Yoreh Deah* 251:9).

Rabbeinu Yonah (*Commentary to Avos* 1:2) states that part of the act of kindness is to carefully evaluate the status of the recipients and to give priority to those who are worthier due to their spirituality and refined character. Thus, the donor should be more considerate of the needs of the person who is more modest and God fearing.

◆§ The Private Donor
Enjoys Greater Discretion

R' Moshe Feinstein (*Iggros Moshe, Yoreh Deah,* Vol. I 144) rules that all of the priorities enumerated in the *Shulchan Aruch* only apply to a *gabbai tzedakah* who administers charity funds which have been collected from the public. However, an individual donor who is distributing charity from his own money has the right to divide his money as he wishes. This ruling is based on the concept of *Tovas Hanaah,* 'benefit of gratitude' (*Pesachim* 46b, et al.), which means that although the money a person separates for charity does not belong to him, the Torah allows him to retain one benefit — the privilege of selecting the person he prefers to give his money to, because he wishes to earn that person's gratitude.

"The donor has the right to give to any one person he chooses from among those who are eligible to receive charity, even if another person has a greater need. Thus he may give to the person who needs clothing even if another needs food. However, in regard to the community charity fund, neither the administrator nor the donors have 'benefit of gratitude' (see *Yoreh Deah* 251:5), and it is the duty of the community to see that justice is done in the eyes of God and man. The administrators are appointed by the community to distribute charity funds according to the priorities codified in *Shulchan Aruch,* such as the rule that the people with greater needs come first and that providing food is more urgent than supplying clothing. Likewise, when dealing with two paupers with equal needs and status, they may not prefer one over the other. This does not apply to the individual who is distributing his own charity. Even when confronted by two people of equal need, he has the right to select one and give him all of his available funds, and if their needs are different, he has the right to give his charity to the one who is less needy."

◆§ The Barren or the Blind
— Who Comes First?

R' Yitzchok Silberstein, the Rav of Ramat Elchonon in Bnei Brak, Israel, was approached with the following question by a man

who was blessed with a child after many years of being childless. The man, who was quite wealthy, wanted to give away one fifth of everything he owned (a very sizable sum) as a charitable donation to a hospital to help people with serious medical problems. The benefactor asked: Should he donate his money to the hospital's Fertility Clinic to help childless couples have children or should he give it to the Department of Ophthalmology to help save people's eyesight?

Rav Silberstein referred the question to his brother-in-law, R' Chaim Kanievsky, who resolved it with masterful simplicity. From the laws of Pesach we learn that whenever the Sages give us a list of options, the list is not made at random. Whichever option appears higher up on the list has halachic priority. Thus, when the Mishnah (*Pesachim* 39b) lists the five different types of bitter herbs which may be used for *maror* on Pesach night, whatever herb appears earlier on the list is preferable (*Shulchan Aruch, Orach Chaim* 473:5). Similarly, when the Talmud (*Nedarim* 64b) lists four people who suffer such anguish that they are considered 'dead': 1) the pauper, 2) the *metzora*, 3) the blind, 4) the childless, whatever appears earlier on the list is the more severe affliction. Since the plight of the blind is listed before that of the childless, it demonstrates that blindness is worse than childlessness, and it is more important to help save people's eyesight than to help people have children! (*Tuvcha Yabiyu, Parshas Shemos*).

⊰§ The Poor of the Land of Israel

The poor people of the land of Israel take precedence over the poor people of the Diaspora (*Yoreh Deah* 251:3). The Chasam Sofer (*Responsa, Yoreh Deah* 233,234) rules that the paupers of Jerusalem take precedence over the paupers of the rest of the Holy Land. However, this priority is only when everyone in the Holy Land is starving; then one should provide the poor of Jerusalem with a basic diet of bread and water before providing for the other parts of the country. But if the poor of Jerusalem have been provided with a subsistence ration of bread and water, but they ask for more money to buy clothing and other necessities, while the poor of the rest of the country do not even have a crust of bread, then one must provide basic bread and water rations for the poor of the entire land before providing Jerusalem's paupers with additional funds.

R' Shlomo Zalman Auerbach said that nowadays the poor of both the old city of Jerusalem and of the newly built areas enjoy the status of residents of the holy city.

⋙ Rabbi Meir Baal Haness

The Chasam Sofer (Collected Responsa 27) was asked the following question by a certain Jewish community: The custom in our kehilah was that whenever people became ill, they or their family members would make a charitable donation and say: "I am hereby making this donation as a merit for the soul of Rabbi Meir Baal Haness." They would then bring the money to the Rav of our city who would send it to the poor of the land of Israel. The Rav would usually wait until he had amassed a sizable amount of money before he would send one large sum to Eretz Yisrael. The Rav died suddenly and left over a large sum of this Rabbi Meir Baal Haness money. The trustees of the kehilah claim that the money should not be sent to the Holy Land, because the poverty in their own city has increased dramatically and they desperately need these funds to support the local poor. They have nowhere else to turn.

The Chasam Sofer replied: If the initial pledge which the people in distress made was for the money to go for the poor people of Eretz Yisrael, it would not be permissible to divert the funds elsewhere. However, this is not the case. They merely vowed to give charity as a merit for R' Meir, and any charity would be a merit. Actually, the best merit would be to donate charity to the best cause. Since Bach rules that one should support the poor of his own city before he supports the poor of the Holy Land, that should be top priority.

However, the poor of Eretz Yisrael should not be entirely neglected. Therefore, the major portion of the money should be distributed locally, while a substantial sum should be allocated for the poor of the Holy Land (see Responsa Ksav Sofer, Yoreh Deah 113 on this topic, and Sdei Chemed, Maareches Eretz Yisrael, 7).

⋙ Telephone and Mail Solicitations

The halachah is that one should never turn away any solicitor empty handed, even the beggar going around from door to door, because

the Psalmist warned, אַל יָשֹׁב דַּךְ נִכְלָם, *Let not the oppressed turn back in shame* (*Psalms* 74:21). What is the halachah when the solicitation is done in an indirect way, not in a face-to-face fashion? There are those who are of the opinion that a direct phone call is tantamount to a personal solicitation and should not be refused out of hand. However, when solicited by phone, the donor can ask the solicitor to send him a stamped and self-addressed envelope to facilitate his response. And, of course, the halachah here too is that he is only obligated to give a minimum donation — enough not to embarrass the solicitor by turning him away empty handed.

Today, we find ourselves inundated by mass mailings on behalf of needy individuals and worthy organizations. The average Jew probably receives no fewer than several hundred such mail solicitations every year. There are individuals and organizations that have amassed huge lists of 'good names' — donors who usually respond to mailings in various degrees of generosity. These lists are often sold or 'rented out' to solicitors who then pay special companies to send out mass mailings to tens of thousands of 'good names.' If as few as 5 percent of those solicited by mail respond to the postal appeal, the professionals consider the appeal a success.

It would be safe to say that despite some glaring abuses of the system, which occur sporadically, most of the causes are legitimate and worthy of support. However, it is nearly impossible for the average person to expend the time, effort, and money necessary to respond to these mailings.

Contemporary authorities, such as R' Avrohom Pam and R' Chaim Kanievsky, told me that one has the right to ignore *all* mass mail solicitations. This is not considered as *Let not the oppressed turn back in shame* because there is no direct solicitation and the 'mailers' expect most people to ignore them.

Additionally, if the organization sends you an unsolicited 'gift,' you may keep it and use it without making any payment whatsoever. The solicitor who mailed this 'gift' had precisely that in mind: to mass mail a gift to thousands of people in the hope that a sufficient percentage of them would express their appreciation of this 'gift' by making a donation to their cause. Also, if the mailers enclosed a return envelope to which they affixed a postage stamp, the receiver may ignore the solicitation and keep the stamp for his own personal usage.

The Debrecener Rav (*Responsa Be'er Moshe*, Vol. IV, 92) rules that any letter of solicitation, even from an important person, may be

disregarded. If, however, the letter comes from a *Beis Din* of repute or from a renowned, outstanding *tzaddik,* then one should treat the request more seriously. His reasoning is that the Torah disqualifies testimony of witnesses rendered in writing and it cannot be trusted. Therefore, a written solicitation has no validity. However, if the mail request comes with a recommendation from a highly trustworthy [and verifiable] source, then it should be acknowledged with a donation.

Finally, we have the question of a *personal* mail solicitation, when someone who actually knows you, even a relative or a friend, writes you a personal letter requesting *tzedakah.* Here there is room to say that to refuse or ignore the solicitation, albeit by mail, would be considered an act of rejection and humiliation. Nevertheless, R' Chaim Kanievsky personally told me that since the solicitation was not done face-to-face, it too may be ignored. Similarly, he ruled that a *personal* telephone solicitation, even when made by a close relative or good friend, may be turned down and one is *not* in violation of the verse, *Let not the oppressed turn back in shame,* which only applies to a live, face-to-face solicitation.

⊰ Spread the Wealth

Shulchan Aruch (*Yoreh Deah* 257:9) states that a person should not give all of his charity to one poor person. This is based on the Talmud (*Eruvin* 63a) which says that: "Anyone who gives all of his priestly gifts to a single *Kohen* brings famine to the world." The Torah teaches that there are twenty-four different types of donations, mainly from a person's produce or Temple sacrifices, which must be given to a *Kohen.* Each Jew has the right to give these gifts to the *Kohen* of his choice. It is preferable to distribute them to many *Kohanim. Chidushei Meiri* explains that in this way a person is motivated to help many people rather than just one.

⊰ Leftover Funds From a Charity Campaign

QUESTION: Fund-raisers collected money to pay for the medical expenses of a certain sick person, and they raised more than necessary, so that a surplus of money remains in the hands of the *gabbaim.* What should they do with this money?

ANSWER: If, for some reason, the entire medical procedure never took place, then all the money that was collected should be returned to the donors. If he cannot identify the donors, or such a return would involve great expense or difficulty, then the money should be used exclusively to pay the medical expenses of a different sick person, but not for a totally different type of charity.

NOTES: This question is addressed in the Mishnah (*Shekalim* 2:5): *The remainder of funds contributed for distribution to poor people is to be used for poor people; but the remainder of funds contributed for the sake of a specific poor man is to be given to that poor man.* This means that if money was collected for a specific need of some poor people, and there were leftover funds, the remainder should be used to help *other* poor people (*Tiferes Yisrael*) [or to fill a *different* need of the same group of poor people]. However, if the money was collected to fill a specific need for a particular poor person, such as to buy him clothing, the remainder should be used to fill some other need for *this* individual (*Bartenura*). This means that the money *may not* be used for another poor man. See *Yoreh Deah* 253:6.

Rashba in a *Responsum* (based on the words of the Jerusalem Talmud here) explains that the poor man retains his rights over *all the money* raised for him because he suffered great embarrassment when people were told that charity was being collected on his behalf; no one can deprive him of the money for which he paid such a painful price! Even if the poor man dies before the *gabbaim* give him the money they raised for him, they are obligated to hand over the money to the poor man's heirs. Understandably, this ruling only applies when the collectors revealed to the donors the name of the poor man they were collecting for. If they collected anonymously, the poor man suffered no humiliation and he has no claim over the money raised on his behalf. Even though the collector or a small collection committee knew the identity of the poor man, as long as his name was not revealed to the donors, he is not considered to have been publicly humiliated by the collection.

The Jerusalem Talmud (ibid.) explains that if money was raised for someone on the assumption that he was needy but they later discovered that he was *not* in need, then this individual and his heirs have absolutely no claims to this money. *Rosh* (*Responsa; Klal* 32:6) addresses the question of money raised to pay the doctor bills of a sick person who later had no use for the money either because he recovered

on his own without any help from the doctors or because he died before the doctors could begin their ministrations. *Rosh* argues that it was clearly the intention of the donors that their money be used for medical expenses and their intention was not fulfilled in any way at all. Therefore, the money should be returned to the donors. But if the donors are unknown or if the return would involve great expense, then the money should be used for a different person who needs funds to pay his doctor bills. This ruling is codified in *Yoreh Deah* (253:7).

The Steipler Gaon makes an important point: If collectors gather money for someone on the assumption that he is in need, and later it is discovered that there was a mistake and the need never existed, then they must return all the money to the donors. But if when they were collecting, the person was in need of this money, but by the time they collected the full amount and delivered it to him he had gotten whatever he needed from another source, then the money belongs to him. When the collectors took the money in their hands they acquired these funds on behalf of this person who *was* truly needy at *that* time (*Orchos Rabbeinu* Vol. I, p. 300).

Aruch Hashulchan (*Choshen Mishpat,* 243:1) holds that even when the name of the intended recipient was not mentioned, the monies cannot be diverted to someone else. See *Responsa Imrei Yosher* (Vol. I, 159) for a detailed discussion.

⊷§ A 'Serious' or a 'Casual' Gabbai Tzedakah

There is a difference between someone who is known to be a 'serious' *gabbai tzedakah* and a 'casual' *gabbai tzedakah.* The 'serious' *gabbai tzedakah* is someone who is appointed by the community to raise money for all kinds of charitable causes, or a self-appointed philan-thropist who volunteers to help raise funds for needy individuals and organizations and is known and trusted by the community. If a 'serious' *gabbai tzedakah* collected money for a specific cause (whose name was identified) and there was leftover money, then this *gabbai tzedakah* may use the leftover for an entirely different cause which he is also collecting for, if he has no other way to raise money for the second cause. This is because when people give money to this kind of a person they are giving not only for the sake of the particular cause but also for the sake of this particular person who is known and respected as representing

many good causes. So it is precisely the other causes he represents which helped to raise money for this individual. Therefore, in a difficult situation, it would not be inappropriate to use the leftover money for those causes (*Yoreh Deah* 153:6; *Beis Lechem Yehudah* ibid. and *Yoreh Deah* 156:4; *Shach* 7 ibid.).

If, however, the collector was a 'casual' *gabbai tzedakah* who volunteered to raise money for this one individual, then everything he raises is for this one poor man — even the surplus.

◆§ A Clothing Drive for the Poor

R' Moshe Feinstein writes a detailed response (*Iggros Moshe, Yoreh Deah,* Vol.I, 148) to R' Gedalya Schorr about a clothing drive sponsored by Agudas Israel for the benefit of destitute yeshiva students in war-torn Poland [in the year 1940]. The problem was that the political and military situation had so deteriorated that it was impossible to ship the clothes to the Nazi-occupied country. May the clothing now be given to the poor Jews of a different country? Also, since shipping costs had become prohibitive, was it allowed to sell these used clothes and use the proceeds for other charitable purposes? R' Moshe advised that the clothing be sent to the poor people of the land of Israel. Otherwise, the clothing may be distributed to poor people in America, providing that those responsible for this clothing drive have in mind that when the first opportunity arises, they will conduct a new clothing campaign for the benefit of the impoverished Torah students of Poland.

Support of Torah

In the preceding chapter, "Prioritize Your Giving," it was noted that the support of poor relatives is one's primary *tzedakah* obligation. Once that has been satisfied, the top priority is the support of those who study Torah.

A wealthy *baal tzedakah* once entrusted me with a very large amount of money to distribute on his behalf to all kinds of worthy causes. He told me that he left the distribution entirely to my personal discretion and I was free to do whatever I wished with the money. However, this philanthropist offered one observation, which left a lasting impression on me. He said, "I certainly want to help everyone in trouble — the poor and the sick — but my first and foremost concern is the support of Torah. Why? Because I firmly believe that the more Torah there is in this world, the more blessing it brings with it. If there would be more Torah in the world, there would be less poverty, and less sickness, and less suffering. So why should I help the poor in a roundabout way? I would rather address the problem right at the source! Increase Torah in the yeshivos — decrease poverty on the streets!"

◆§ The First Tenth Is Dedicated to Torah

Shulchan Aruch (*Yoreh Deah* 249:1) rules that the preferred way is to give 20 percent of one's income to charity. The Chofetz Chaim (*Ahavas Chesed* Chapter 19:3) says that one should not give all 20 percent at once. Rather, one should first tithe 10 percent of his income and give that to support Torah students and scholars. Afterward a

person should separate the second tithe to be used for poor relatives and all other charity and mitzvah purposes. However, if one only gives away 10 percent of his income (which is considered the minimum), then he should give precedence to his poor relatives, as they come before the support of Torah (*Shach, Yoreh Deah* 251:17 and *Ahavas Chesed* 19:1).

ᴥᔆ Torah Needs Support — Now!

R' Dovid Soloveitchik relates: It is well known that my grandfather, R' Chaim Soloveitchik, considered the mitzvah of saving a Jewish life to have top priority; he went to tremendous lengths for *pikuach nefesh*. However, a person once brought R' Chaim a very large sum of money and asked him whether he should use it to build a new hospital or to support Torah study. R' Chaim ruled that he should use the money to support Torah.

The reasoning behind this ruling is as follows: While it is true that the halachah is that 'saving lives overrides all other mitzvos of the Torah,' that rule only applies when the one whose life is in danger is here right now. The construction of a hospital is to save the lives of those who will be sick and in danger in the future, but are not here right now. Even if there were a person here in danger now, spending the money for a hospital would not help in time. Thus, the priority to saving lives does not apply at this moment. The paramount obligation to study and support Torah is constant and applies immediately. Therefore, it is more important to use the money for Torah study (*Uvdos L'Beis Brisk,* Vol. I, p. 66).

ᴥᔆ Which Comes First: Day School or Kollel?

R' Moshe Feinstein (*Iggros Moshe, Yoreh Deah* Vol.III, 94) addresses the question of priorities in supporting Torah students. What is more important — the support of accomplished scholars pursuing their advanced studies in yeshivos and *kollels,* or helping to educate young children in primary schools?

On the one hand, the Talmud (*Berachos* 8a) teaches that God loves the select academies where Torah is studied constantly with utmost

dedication by outstanding scholars even more than He loves the synagogues and ordinary study halls — for the elite academies are spiritual centers comparable to the holy Temple. On the other hand, the Talmud (*Shabbos* 119b) states that the Torah study of pure, innocent children has a great advantage over the study of even the greatest sages who have already been slightly tainted by sin. Therefore: *The world is sustained only in the merit of the pure breath emanating from the mouths of innocent children studying Torah.*

R' Moshe rules that the primary concern of the Jewish people is to produce outstanding Torah sages who can transmit the Torah's teachings to others and issue authoritative halachic decisions. Without such unique individuals our people cannot survive because our Torah tradition will be forgotten. It is a long and arduous process to produce a Torah luminary, for the Rabbis said: *From one thousand children who enter into elementary Torah education, only one individual will ultimately emerge as a Torah teacher and authority* (*Vayikra Rabbah* 2:1). Therefore, our primary *tzedakah* obligation is to support advanced Torah studies geared to produce such unique individuals. Once we are certain that this generation has produced enough of these individuals to teach and guide the Jewish people, then our top *tzedakah* priority becomes the support of elementary Torah education. (*See Tzedakah Umishpat* Chapter 3, fn.77 for more details on this decision and for dissenting opinions which rule that elementary education takes precedence over advanced scholarship.)

⋅§ The Yissachar-Zevulun Partnership

There is one significant mode of Torah support which should be mentioned. In his final blessing to the Jewish people, Moses said: שְׂמַח זְבוּלֻן בְּצֵאתֶךָ וְיִשָּׂשכָר בְּאֹהָלֶיךָ, "*Rejoice, O Zebulon, as you journey abroad, and Issachar in your tents*" (*Deuteronomy* 33:18). These two brothers enjoyed a unique partnership. Zebulon engaged successfully in maritime commerce and shared his profits with Issachar who devoted his time to Torah study as a teacher, judge, and cultivator of the spiritual treasures of the Jewish people. Although Issachar was older, Zebulon is mentioned first because it was he who made Issachar's Torah study possible (*Tanchuma; Rashi*). Over the years, many have emulated the tradition of this partnership.

Shulchan Aruch (*Hilchos Talmud Torah, Yoreh Deah* 246:1) rules: A person who cannot study Torah himself, because of his own ignorance or because he is so preoccupied that he has no time to learn, should support the studies of other scholars. To this *Rama* adds: In this way it will be considered as if the patron himself studied Torah. It is appropriate to make a formal agreement between the two parties stipulating that one will support the other who is studying Torah and the two will share in the reward for these studies.

The Chazon Ish drew up a special contractual agreement to be signed by both Yissachar and Zevulun partners in order to formalize their agreement to share their material and spiritual earnings. The difference between the Yissachar-Zevulun partnership and haphazard, sporadic donations to Torah scholars or institutions is that this long-term contractual agreement allows Yissachar, the Torah scholar, to learn with peace of mind in order to make great achievements in his studies.

⊷§ This Partnership Is Business — Not Charity

May Zevulun use his *maaser* money to fulfill his obligation to support his partner Yissachar? R' Moshe Feinstein (*Iggros Moshe, Yoreh Deah* Vol. 4, 37) addresses this topic at great length and firmly maintains that this partnership is a business transaction whereby the patron is purchasing a portion of the scholar's Torah. Therefore, the stipend **is not tzedakah** and **may not** be taken from *maaser* money. Indeed, R' Moshe holds that even if the Torah scholar is not impoverished and does not qualify to be a recipient of charity, nevertheless, it would appropriate for a Zevulun to support him generously in order to allow him to learn with more peace of mind. This is why *Shulchan Aruch* codifies this arrangement in *Hilchos Talmud Torah*, the laws of Torah scholarship, and not in *Hilchos Tzedakah*, the laws of charity, because this matter has nothing to do with *tzedakah*.

The Chofetz Chaim (*Ahavas Chesed*, Chapter 20) rules that the prohibition to give away more than one fifth of a person's income to charity does not apply to the general support of Torah scholars or to the financing of a Yissachar-Zevulun partnership. This is based on *Shittah Mekubetzes* (*Kesubos* 50a) who takes the view that support of

Torah is not included in the one-fifth restriction. The reason is that the one who sponsors Torah study receives a share of the reward of the Torah scholar whom he supports. Thus, he who supports Torah is not 'lavishing' money and giving it away; he is investing it wisely in order to ultimately reap great profits!

⋙ Kollel Scholars

R' Chaim Kanievsky writes (*Derech Emunah, Hilchos Matnas Aniyim, Biur Halachah,* Chapter 9): What is the halachic status of someone studying in a *kollel* or a yeshiva who receives a small but steady stipend which covers his minimal living expenses. Does he qualify as a *tzedakah* recipient?

Answer: Even if he receives this minimal stipend, the halachah would nevertheless place him in the category of 'a poor person' who is a worthy *tzedakah* recipient, as long as the administration of the *kollel* has made no formal contract or binding commitment to support him. That is, the *kollel* made it clear initially that they will only pay him a stipend if the money is available. Moreover, many *kollelim* reserve the right to terminate their obligation to their members at any time based on the sole discretion of the administration. A *kollel* scholar who finds himself in such a situation is considered 'poor' (even while he is still receiving his full stipend). Other people may supplement his income with their *tzedakah* funds, which he has every right to take. This scholar is exactly like the poor person in the time of the Mishnah who did not have in hand the 200 zuzim necessary for a full year of sustenance.

However, if the *kollel* or yeshiva administration committed themselves to the *kollel* scholar that they will pay him his weekly or monthly stipend under all circumstances and they also committed to support for at least one full year during which they cannot terminate the agreement, then the scholar is considered as having a full year's sustenance and is not eligible for *tzedakah.*

⋙ Endowment Funds

Interestingly, the Chofetz Chaim did not approve of tying up large amounts of capital in endowment funds that would 'assure' yeshivos

of a guaranteed, steady source of income. He said: "Invest the capital in expanding the existing yeshivos and creating new ones. You ask, 'How will (the present) yeshivos exist?' That is Hashem's problem." (*Michtav Me'Eliyahu*, Vol. I, p.186; *Strive for Truth*, Vol. II, p. 260). However, other Roshei Yeshiva, such as R' Eliezer Yehuda Finkel of Mir and R' Yosef Kahaneman of Ponevezh, encouraged the establishment of endowment funds or real-estate investments for perpetual support of existing Torah institutions.

⊸§ Purchasing Torah Texts

The Psalmist states: הוֹן וָעֹשֶׁר בְּבֵיתוֹ וְצִדְקָתוֹ עֹמֶדֶת לָעַד, *Wealth and riches are in his house, and his charity endures forever* (*Psalms* 112:3). How can one perform charity in such a way that his initial gift continues to generate benefit over and over again forever? This is accomplished by the person who writes texts of the Scriptures — *Torah, Neviim, Kesuvim* — and lends them out for others to use (*Kesubos* 50a).

Turei Zahav, 'Taz,' in his commentary to *Yoreh Deah* (249:1) rules that one may use *maaser* money to purchase Torah texts that he would otherwise be unable to buy. He may use these texts for his own studies but must also lend them to other students. However, warns the *Taz,* one should take care to write in these texts that they were purchased with *maaser* funds, so that his children will always be aware of this and continue to lend them out to others.

Aruch Hashulchan (ibid. 10) takes issue with this ruling and presents this argument: If we allow someone to purchase *sefarim* with *maaser* funds, then we should also permit him to buy a *talis* or *tefillin* with *maaser* money as long as he allows others to use them. Similarly, we should allow him to buy other mitzvah articles with *maaser,* such as a *shofar* or an *esrog* or a *sukkah*. Another point to consider is that if we allow him to purchase *sefarim* with *maaser* money, then he, the buyer, will be the primary beneficiary while others are at a disadvantage. Other Torah students can argue, "We don't want these *sefarim* to be kept in your house where they are inaccessible to us! We want them to be placed in the *Beis HaMidrash* where they will be available for anyone who wants to use them for his Torah studies." For these reasons *Aruch Hashulchan* holds that it is preferable not to use this leniency.

◆§ Purchasing an Unwanted Sefer

Someone asked the Chazon Ish the following question: "I purchased a *sefer* from a poor man only for the sake of giving him money in a dignified manner. I deducted the amount of the *sefer* from my *maaser* account. What shall I do with the *sefer* now?" The Chazon Ish ruled that he could keep the *sefer* for his own use and he is not required to give it away. However, it was the custom of the Steipler Gaon in such circumstances to give the *sefer* away to a *shul* or to a Torah scholar. Whenever the Steipler purchased a *sefer* with *maaser* funds he would write on the front page, "purchased with *maaser* money" (*Orchos Rabbeinu*, p. 303).

◆§ Dissemination of Torah Texts

Responsa Chasam Sofer (*Yoreh Deah* 244) rules that there is no mitzvah greater than to supply Torah texts to scholars and students. Therefore, he concludes that if someone bequeathed his entire library to a shul so that the books should be readily available to Torah scholars, they may not be sold for any reason. Even if the community wishes to sell the *sefarim* in order to use the money to build a *mikveh*, they may not do so. (See *Derech Emunah*, Chapter 7, 60, for further discussion of this topic.)

◆§ Sponsoring the Publication of Torah Literature: A Blessing for All Generations

A wealthy philanthropist approached R' Yaakov Kamenetsky with this important question: "Every year, I donate a large sum of money to support Torah study in yeshivos. I now have the opportunity to sponsor the publication of a significant work of Torah scholarship written in English. My charity funds are limited, so that if I use a serious amount of my money for this publication, I will be left with less money for yeshivos. What should I do?"

R' Yaakov responded: "The answer to your question can be found in the *hakdamah,* the introduction, of the *Ohr Hachayim Hakadosh* to his commentary on the Torah. The introduction is printed in the front of the standard *Mikraos Gedolos Chumash,* the *Chumash* used by students and scholars, in shuls and yeshivos, and found in almost every Jewish home worldwide. Go home and study the introduction and then come back next week and we will discuss it further."

The next week the man returned and R' Yaakov asked him if he had studied the introduction. The gentleman answered that he had studied it but did not find the answer to the question. R' Yaakov asked him patiently, "What did you learn from the introduction?" The man answered that it is a poetic description of the Torah and the commentary he was writing. "And what about the end of the introduction?" R' Yaakov asked. "That is where he thanks four patrons who generously funded the publication of his commentary," the philanthropist answered.

"Exactly!" R' Yaakov exclaimed. "The *Ohr Hachayim* describes the four sponsors as 'golden links in the chains upholding the Torah' and as 'the four royal kings of kindness with the living.' Without their support the great *sefer* could not have been written. Today, more than two hundred and fifty years since the *Ohr Hachayim* was printed, it remains a source of wisdom and scholarship for the entire Jewish people. I have no doubt that these four sponsors supported many Torah institutions and that their names appeared on plaques and panels in many sacred locations. Sadly, those places are gone and the memorials they held are forgotten. The only eternal memory that endures for all generations is the gratitude of the holy *Ohr Hachayim* inscribed in the introduction to his great commentary. That is their sacred legacy for posterity!"

The man was still a bit hesitant and asked again, "Is this the Rosh Hayeshiva's final *psak,* his final halachic ruling?" R' Yaakov emphatically replied, "A *vaddah*! Certainly! Publishing a necessary Torah work is *tzorchei rabbim,* a public necessity! Nothing surpasses it."

Later R' Yaakov reiterated this ruling to other interested parties and remarked: "And if my friend who sponsored a *sefer* thinks that by doing that he will have *less* money available to support yeshivos he is mistaken. By virtue of his good deed, he will be granted *more* money to support Torah study of the very books he published."

৪§ *Writing a Sefer Torah*

T *zedakah Umishpat* (Chapter 6, fn. 22) rules that if one wishes to write a *Sefer Torah* for himself, to fulfill the mitzvah, he certainly cannot use *maaser* money, because every Jew is responsible to write a *Sefer Torah*, and one may not pay for his personal mitzvah obligations with *maaser* money. However, if the entire congregation embarks on a campaign to write a Torah for the use of the shul, most authorities hold that one does not discharge his personal obligation to write a Torah by participating in such a partnership. Thus one may donate *maaser* money to this cause.

CHAPTER TWENTY-FOUR

Hachnassas Kallah

➳§ Hashem Himself Marries Off Brides

R' Yehudah bar Ilai said to his students: "Get involved in the mitzvah of marrying off brides, because we find that the Holy One, Blessed is He, involved Himself with the very first bride, Eve, as it is written (*Genesis* 2:22): וַיִּבֶן ה' אֱלֹקִים אֶת הַצֵּלָע אֲשֶׁר לָקַח מִן הָאָדָם לְאִשָּׁה וַיְבִאֶהָ אֶל הָאָדָם, *And Hashem God fashioned the rib that He had taken from the man into a woman, and He* [Himself] *brought her to the man* (*Avos D'R' Nassan*, 4).

The Talmud (*Berachos* 61a) derives from God's example that even one who is on the highest social level should involve himself or herself with marrying off brides who are on a lower level.

Moreover, this demonstrates how the essential theme of the entire Torah is benevolence, because the Torah begins with the story of God's kindness to Eve, fulfilling the mitzvah of *hachnassas kallah* with her (*Midrash Tanchuma, Vayeira* 1).

➳§ Don't Fail on the First Questions!

The Talmud (*Shabbos* 31a) provides a dramatic lesson about the importance of *hachnassas kallah.* Rava said: "When they escort a person to his final judgment in heaven, the heavenly tribunal will immediately ask him a list of fundamental questions: נָשָׂאתָ וְנָתַתָּ

בֶּאֱמוּנָה, Did you conduct your business transactions honestly? קָבַעְתָּ עִתִּים לַתּוֹרָה, Did you set aside fixed times for Torah study? עָסַקְתָּ בִּפְרִיָּה וּרְבִיָּה, Did you engage in procreation?"

Maharsha observes that the precise terminology of the third question — עָסַקְתָּ בִּפְרִיָּה וּרְבִיָּה, rather than קִיַּמְתָּ פְּרִיָּה וּרְבִיָּה — demonstrates that the issue of primary concern is not whether the person actually had children of his own. Rather, it is whether he *facilitated* procreation; that is, did he help orphans [and generally those less fortunate than he] find mates and get married?

∽§ *Hachnassas Kallah*

The Mishnah (*Kesubos* 67a) states: The administrator of the charity fund who marries off an orphan girl should not provide her with a dowry of less than 50 *zuz* [even if the charity coffer is empty, the *gabbai tzedakah* must borrow funds to supply the bride with this minimum amount for a dowry (*Shach, Yoreh Deah* 250:2)]. If, however, there are sufficient funds in the charity coffer, they should provide her a dowry as befits her honor [according to her social status and the status of her family (*Aruch Hashulchan, Yoreh Deah* 250:6)]. [The *Shach* (loc. cit. 3) explains that the fixed amounts of money in the Mishnah and Gemara are only relevant to their times; today the amount appropriate to our economic situation should be given.]

The Talmud elaborates: The Rabbis taught in a Baraisa: If an orphan boy and an orphan girl come individually before the administrators of a charity fund to obtain funds to get married (not to each other), we first marry off the orphan girl, and only afterwards do we marry off the orphan boy, for the shame of a woman is greater than the shame of a man.

The Rabbis taught in a Baraisa: When an orphan boy comes for charity funds in order to get married, we rent a house for him, we supply him with a bed and with all the furnishings required for his use. Afterwards, we pay the expenses of the actual wedding to marry him off properly. For it says with regard to assisting the poor, כִּי פָתֹחַ תִּפְתַּח אֶת יָדְךָ לוֹ, וְהַעֲבֵט תַּעֲבִיטֶנּוּ דֵּי מַחְסֹרוֹ אֲשֶׁר יֶחְסַר לוֹ, *Open up your hand to him and provide for all of his needs, whatever is lacking for him* (*Deuteronomy* 15:8).

‎‑§ Extravagance Is Relative

The Sadovner Rav, R' Yisroel Sekula was an extraordinary man of charity. The following story illustrates his incredible sensitivity to the psychological needs of the poor.

A good-hearted gentleman, whom we shall call R' Yitzchok, was asked to help a girl who had become engaged and was soon to be married. Her life had been laced with tragedy. She had been orphaned at a young age and had spent much of her childhood being transferred from one foster home to another. Finally, she had become engaged, but there was no money to pay for the wedding and all of the expenses of setting up a home.

R' Yitzchok did not know the *kallah,* but he undertook to raise the large sum of money needed for this most worthy cause. He approached friends and business acquaintances who responded warmly, but he was yet very far from his goal. Someone offered him good advice, "Have you ever heard of the Sadovner Rav? He is a *gaon* and a *tzaddik* who raises vast sums of money for such causes. He will surely help you."

R' Yitzchok went to visit the Sadovner Rav who lived in Boro Park, and told him about the plight of the young lady he was collecting for. R' Sekula immediately handed him $800. "Had I known you were coming," he said, "I would have prepared a larger sum. Please be in touch with me so that I can give you more."

However, a few days later, R' Yitzchok's collections came to an abrupt end. Someone informed him that the poor bride he was working so hard for was to be wed in an elegant catering hall. The dedicated collector was shocked. That very day he met with the bride and got straight to the point.

"How," he asked the young lady, "can you expect anyone to collect *tzedakah* for your wedding when thousands of dollars are being wasted on unnecessary extravagance? I personally would never spend money on such a lavish wedding hall for my own children even if I could afford it!"

By the time the lecture was finished, the girl's eyes were brimming with tears. She explained that she was very sorry to have upset him so, and that she understood why he was so aggravated. Nevertheless, she said emphatically, she still had her heart set on having her wedding in that special hall, and she was not going to change her mind. R' Yitzchok, too, was adamant, and he gave the bride all the money he

had collected while informing her that he would collect no more.

A few days later, the Sadovner Rav summoned R' Yitzchok to his apartment. "Where have you been?" he demanded. "When you were here last time, I told you that I wanted to give you a larger sum towards your worthy cause. Why haven't you returned?"

R' Yitzchok explained the situation to the Rav, certain that he too would be shocked by the revelation and grateful that he had not contributed more. However, Rav Sekula's reaction was not at all what Yitzchok had expected. The mild-mannered *tzaddik* grabbed him by the lapel and exclaimed, "You can't understand that brokenhearted girl? You can't understand why she fails to see things your way? Don't you realize where this poor soul is coming from? This child has not had a good day in her life, as you yourself told me! She was orphaned from both parents, went drifting from home to home, unwanted and uncared for — her lot was one of hopeless misery. At long last she is now engaged to be married and she is dreaming of her great moment of joy. Can't you understand why she might feel that she is entitled to a somewhat extravagant wedding? Do we have the right to pass judgment on her? Can we feel the pain she has endured? Dare we abandon her?"

The Sadovner Rav then handed R' Yitzchok $2,000. "Here is some more money toward her wedding. I hope that you will resume your collections without delay."

The Rav paused for a moment and then said with emotion, "Do you think that collecting *tzedakah* is a simple matter? To succeed at this mitzvah, one must see himself in the position of those for whom he is collecting, understand their situation, and feel their pain."

When R' Yitzchok related this incident after the Sadovner Rav's passing, he reflected, "What amazed me most is that in the course of his lifetime, the Rav had raised vast sums of money for hundreds, perhaps thousands, of needy individuals. Yet he still remained acutely sensitive to the particular needs of each individual and keenly felt that person's pain."

⇒§ Supporting a Poor Brother After His Marriage

R' Moshe Feinstein in his *Iggros Moshe* (*Yoreh Deah* Vol. I, 144) was asked the following question: Two brothers would like to help

their younger brother who will be ready to get married in one or two years. They would like to use their *tzedakah* money to support him while he continues his Torah study for several years after his wedding. However, they would like to start setting the money aside for their brother right now, in advance, long before his marriage, in order to be certain that there will be enough money available to him later when he needs it. The crux of the issue is this: While *Shulchan Aruch* (*Yoreh Deah* 251:3) clearly rules that giving charity to a poor brother takes precedence over other relatives and neighbors, perhaps that priority only applies to a brother who needs the money right now. In the case at hand, where the brother does not need the money until later and other poor people have desperate needs right now, perhaps they have priority?

R' Moshe answers that all of the priorities mentioned in *Shulchan Aruch* only apply to charity administrators who are distributing communal funds. A person who is disbursing his own money has total discretion to give as much as he wishes to anyone he wishes as long as they satisfy the halachic criteria of poverty. By the same token, someone has the right to set aside money for his close relative's *future* needs, even though there are poor people who have urgent, immediate needs.

When it comes to paying the expenses of marrying off children, even a person who normally earns an income which covers his expenses may well be considered a pauper. Therefore, even a person who is usually financially independent may accept help from a charity fund or individuals to help marry off his children. Moreover, one may collect or accept money toward *hachnassas kallah* for his children even *before* they are engaged so that he will have funds set aside in advance in anticipation of future needs.

Thus, the brothers who wish to support their younger sibling in the future may begin to set aside money for him long before his wedding. Further, what they set aside will immediately be considered as a charitable donation, as long as they deposit the money into a separate bank account designated as a trust fund dedicated exclusively to this purpose.

Finally, R' Moshe stipulates that the brothers should not give all of their *tzedakah* exclusively to this cause [or to any one cause] as is the rule stated in *Yoreh Deah* (257:9). Rather, they may give the lar- gest part of their *tzedakah* to their younger brother while distributing a

significant share of their charity to all other good causes in general and specifically to the support of institutions of Torah study.

❧ A Wedding Canopy Next to the Sickbed

A young man in Jerusalem who was orphaned from both his father and mother at a very young age was preparing for his wedding. All alone, he had no money and lacked even the barest necessities. The impoverished groom came to the Lelover Rebbe, R' Dovid Biderman, and shared with him his tale of woe. The Rebbe was deeply moved by the young man's plight and assured him, "Have no fear. With the help of Hashem, everything will be all right."

The Rebbe called a special meeting of his followers and told them of the orphan's desperate plight. In order to inspire the assemblage to dig deep into their pockets, the Rebbe shared with them an insight based on a statement of the Talmud (*Shabbos* 127a): "These are the good deeds whose fruits a person enjoys in this world but whose principal remains intact for him in the World to Come. They are: honoring his father and mother, acts of loving-kindness, early attendance at the house of study morning and evening, hospitality to guests, visiting the sick, marrying off a bride, escorting the dead, etc."

The Lelover Rebbe said: "The great Chassidic master, R' Yitzchok of Vorka, observed that the sequence of events in the above statement seems to be inaccurate, because, in many cases, 'visiting the sick' is followed by 'escorting the dead.' Why did the Sages insert the mitzvah of 'marrying off a bride' in between these two mitzvos? Rather, the Sages wished to teach us a great lesson: If you visit someone who is deathly ill and you wish to avert escorting him to the grave, give generously to the charity of *hachnassas kallah*, and that will interrupt between sickness and the grave!"

When the assemblage heard these words demonstrating the great merit of *hachnassas kallah*, they were inspired to donate enough to cover the poor orphan's wedding expenses. Only afterwards did it become known that the Lelover Rebbe himself was suffering from illness at that time, and after he involved himself in this mitzvah of *hachnassas kallah* he fully recovered from his ailment (*Tiferes Banim* Vol. II; p. 111).

✑A Gift of Gratitude

In the month of Elul 5760 I met with Rav Chaim Kreiswirth in Jerusalem and he related the following incident.

"Many years ago, I was deathly ill with a terrible disease. I asked the Steipler Gaon to pray for me, and I had a miraculous recovery. I have no doubt that his *tefillos* saved me. After I was fully recuperated from my surgery, I went to visit the Steipler Gaon and I said to him, "I owe a tremendous debt of gratitude to Hashem. During the Second World War, I miraculously escaped from the murderous Nazis. On more than one occasion they stood me before a firing squad, but somehow I was never shot. And now, once again, Hashem has delivered me from this dread disease.

"The Talmud (*Shabbos* 33b) relates how R' Shimon Bar Yochai escaped from the Roman Government which had sentenced him to death, and how he survived thirteen years hiding in a desolate cave. When he safely emerged from his harrowing ordeals, he said, "Since a miracle was performed to rescue me, I am obligated to make some improvement for the benefit of the community."

"Therefore, I asked the Steipler Gaon what mitzvah I should undertake for the benefit of the community? He told me to get involved with הַכְנָסַת כַּלָּה, marrying off brides, on a very large scale because it is this mitzvah that separates between בִּקּוּר חוֹלִים, 'visiting the sick,' and לְוָיַת הַמֵּת, 'escorting the dead,' in the list of precepts whose fruits a person enjoys in This World but whose principal remains intact for him in the World to Come, אֵלּוּ דְבָרִים שֶׁאָדָם אוֹכֵל פֵּרוֹתֵיהֶם בָּעוֹלָם הַזֶּה ... בִּקּוּר חוֹלִים, וְהַכְנָסַת כַּלָּה וּלְוָיַת הַמֵּת (*Shabbos* 127a; cf. *Siddur* Morning Blessings). The Steipler promised me that I would continue to enjoy good health as long as I continued to devote myself to *hachnassas kallah,* and, *baruch* Hashem, his promise has been fulfilled!"

✑ The Beis Aharon of Karlin

A brokenhearted woman once approached R' Aharon of Karlin with her tale of woe. She related that her daughter was engaged to marry a fine young man, but a number of years had already passed

and they could not get married for lack of funds. She had promised the young man a dowry, but she had no money to meet her pledge. Now the young man sent word that he could wait no longer and that if the money was not forthcoming in the next few days, he was removing himself from the marriage arrangement. R' Aharon asked the lady how much money she had promised the *chassan,* and upon hearing the amount, went to his money chest and gave the woman the entire sum.

A few days later the very same woman came back to the Rebbe and, her face awash in bitter tears, cried out: "Rebbe! How can I possibly marry off my daughter when I have no money to buy myself a new dress for the *chasunah!*" Once again, the Rebbe went to his money chest and gave the woman money for a new wedding dress.

R' Aharon's Rebbetzin could not restrain herself from asking: "When the woman approached you the first time and said that the *shidduch* was about to be broken for lack of a dowry, I could understand why you didn't hesitate to help her, because saving a marriage has the highest priority. But I cannot understand why you had to give her money for a new dress. The young man wasn't about to break the *shidduch* because his mother-in-law didn't have a new dress. Wouldn't this money have been put to better use if you had given it to some indigent man to feed his starving children?"

"Indeed, the exact same thought passed through my mind," exclaimed R. Aharon. "As I went to my money chest to give her the money for the dress, I was suddenly plagued by the very same doubt; maybe it would be better to give this money to poor, hungry children. But then I asked myself, 'Where does this wonderful idea come from? If it is my Good Inclination that makes me concerned with the plight of these poor children, why is he approaching me right now? Where was he yesterday; where was he an hour ago? Why is the allegedly Good Inclination giving me this fine idea just now at the moment when I want to cheer up this unhappy mother who doesn't want to be embarrassed in her worn, old clothes on the day of her beloved daughter's wedding? No! It must be that this sudden, unprecedented concern for starving children is not emanating from a good source. The voice I hear is none other than the Evil Inclination who wants to prevent me from doing what is right, and so I must ignore it and follow my original impulse to gladden this mother's heart!' "

⇜ How Easy It Is to Collect
for *Hachnassas Kallah*

R' Shmuel Tzvi Kovalsky was a *talmid chacham* of great stature; a
student of the great yeshivos of Bnei Brak and a close disciple of
the Chazon Ish. As *Rosh Kollel* of Kollel Sochatchov, it appeared as if
Torah study was R' Shmuel Tzvi's sole profession, but in reality he was
devoted, heart and soul, to acts of kindness and charity. Even in the
realm of charity, he had priorities, and *hachnassas kallah* was at the
top of the list.

The following story is recorded in the biography of R' Shmuel Tzvi,
Ana Avdah.

Once, R' Shmuel Tzvi heard of a widow in his area whose daughter,
an orphan, was just engaged to be married. Not only was the poor
widow penniless, but she was still in debt from the recent marriage of
her older daughter. R' Shmuel knew two fine young men, *kollel*
scholars, who were close relatives of the widow. He personally visited
them in their homes and exhorted them to collect money on behalf of
their relative, the unfortunate widow. R' Shmuel was absolutely
tenacious. He would not let them go. Every day he would badger them
and prod them to collect for the widow.

All this perplexed the two young men. They themselves had no
money. They had never collected money before. They had no rich
friends or relatives. What were they supposed to do? The most
perplexing thing of all was R' Shmuel's incessant involvement and
ironclad determination in this matter. He was not related to the widow,
nor was he in any way related to them; yet he gave them no peace! Day
in and day out, the refrain never ceased, "Collect! Collect! Collect!"

Little did they realize that this was only the beginning!

One night each of the two young men received a telephone call with
an invitation to come to Rav Kovalsky's home for an urgent meeting.
When they arrived, they mumbled some apologetic words, "We did a
little bit, we just haven't seen results. It's not so simple. It's not so easy
for us."

As they took their seats in R' Shmuel's apartment, he took out a
Gemara Berachos and read them the words of the *Maharsha* who
writes that when a person enters heaven, the very first question he is
asked will be, "Did you ever help to marry off a poor orphan girl?"

"Yes, indeed," sighed the Rav, "the obligation to marry off an orphan girl rests squarely on **everyone's** shoulders, and even more so on her own relatives! What have you been doing? What have you accomplished? Make no mistake, it is your responsibility!

"Just imagine the situation if it were now a day or two before *Sukkos* and you still hadn't acquired an *esrog*. Would you satisfy yourselves with some lame excuses like, 'We looked all around the market, we really couldn't find anything we liked. Too bad, I guess we can't do this mitzvah this year!' Or picture in your minds what it would be like a day before Pesach and you still were without proper *shemurah matzos* for the *Seder* and the week of Pesach! You would be absolutely frantic! You would not be able to rest for a moment! You would be overturning worlds to get the matzoh or the *esrog*.

"But just look how quiet you are now. How easily you throw up your arms in defeat and despair. 'It's too hard!' Is this mitzvah any less than the others? Marrying off a bride, an orphan bride, the lonely daughter of a poor widow! *Gevalt!* What an enormous mitzvah!

"You claim it is too hard; the task is too great for you; the sums required are overwhelming you. Sorry, that's no excuse. Every little bit counts and helps a great deal. It is not for us to do everything, but we surely must make every effort to do something.

"In all honesty, I must tell you that you are making a great mistake. You are simply oblivious to the most crucial factor which will determine your success, and that is *siyata d'Shmaya,* Divine intervention and assistance! Benefactors, who sincerely throw themselves into a mitzvah, heart and soul, merit extraordinary help from the Almighty. The Jewish people are amazing too. You just ask them and they give! Try it and you will see wondrous results!"

Awesome words, pouring out of a sincere heart, burning with passion for a mitzvah! And yet R' Shmuel Tzvi saw that these two young were not convinced. Still they hesitated. So he ended off his talk with one final statement.

"Sure, it's not pleasant to go around collecting; but according to the pain, the gain! The merit of one mitzvah earned with pain surpasses the merit of a hundred earned with ease! Prepare yourselves with two big purses — one to hold the money you will collect, and the other to hold the degradation you will surely suffer. But never forget that both of these purses will make way before you when you ascend heavenward after 120 years. And the purse filled with humiliation is much more valuable up there in heaven."

R' Shmuel Tzvi concluded: "Now I want to show just how easy it really is." He got up and presented them with a very handsome sum of $1500! He added, "I want you to know that this is my own money. It comes from my own personal funds, which I scraped together. Really, I had saved up this sum in preparation for my own daughter's chasunah, but I gladly give it to you, because I want to have a share in your tremendous mitzvah of marrying off a poor orphan. And this is only a down payment on my share in this mitzvah. I hope to give much more. But I give it on one condition, that you dare not reveal my gift to anyone! If you reveal my participation to anyone, then I absolutely regret my gift and the money will be stolen goods in your hands! I want to perform this mitzvah with absolutely no personal honor or gain, purely for the sake of heaven. And more than anything, I just want to demonstrate to you how easy it is to collect money for an important cause such as this!

"Get to work and you will succeed! Make sure you visit me at least once a week to report on your progress!"

So inspired were the two young men that they did get to work and they did report to R' Shmuel once a week. Whenever they came, R' Shmuel gave them a few hundred dollars for the cause. Furthermore, he mobilized his entire family and sent out his sons and sons-in-law to collect for the poor orphan girl. He gave detailed advice to every collector: names and addresses and pertinent information. He told them how to speak to each and every individual, and what their schedule was: when they were home, when they were not. He wrote letters of recommendation and personal requests. He told them about certain well-to-do men who would only respond to a request by a certain Chassidic Rebbe and had already arranged for the Rebbe's gabbai to let the collector have an audience with the Rebbe in order to get a letter of recommendation. In short, R' Shmuel did everything in his power to make this collection a huge success.

Their success was truly extraordinary. One of the young men once overheard a very wealthy man pouring his heart out before a group of friends: "Oy! One of my closest and dearest friends is deathly ill! I wish I knew how I could heal him." The young man spoke up and said, "I have a precious mitzvah for you, the mitzvah of marrying off a poor orphan. I am sure that if you grab this mitzvah it will be a great merit for your sick friend!" The rich man accepted this advice and donated $15,000 to the cause as a z'chus for his friend.

And the story still is not finished. During this period, Rav Kovalsky

was marrying off his own child. One of his own sons-in-law decided that just as his father-in-law helps everyone else, he wanted to help his father-in-law. Right in the midst of the Kovalsky *chasunah,* with the rejoicing reaching a crescendo, the son-in-law slipped a sealed envelope into his father-in-law's hands and whispered his purpose in his ear. That the envelope contained $500, the son-in-law did not say. R' Shmuel Tzvi thanked and blessed his son-in-law with all his heart, but even as his mouth flowed with words of gratitude, his eyes were scanning the hall to pinpoint the whereabouts of the two young men who were collecting for the orphan girl. Slowly, he made his way through the crowd, making sure that his son-in-law did not notice where he was going. He slipped the sealed envelope to one of them without ever opening it, without any idea of how much it contained. And with the envelope he gave them more words of encouragement, pushing them to continue to collect!

ᴇ§ Laws of Hachnassas Kallah

1) *Tzedakah* administrators, *gabbaei tzedakah,* who have charity money in their possession, should use it to marry off poor young girls, for there is no greater charity than this (*Shulchan Aruch, Yoreh Deah* 249:15).

2) It is preferable to use one's *tzedakah* money to marry off a poor orphan boy or girl than to use it for the purchase of a *Sefer Torah,* if the community already possesses a usable Torah scroll (*Rashbash Responsa,* 323).

3) The preferred way is to give the poor man enough money to cover all his needs. For example, if the poor man wants to get married, we help him with all the wedding expenses, we rent him a dwelling, and we furnish it with beds and with everything else the home needs (*Shulchan Aruch, Yoreh Deah* 250:1). If the bride or groom come from a more distinguished family, then the charity fund should make them a wedding on a higher scale, even though this will cost more money (*Maharsham, Responsa,* Vol. I, 45).

[Obviously, this is a very delicate question which must be approached with sensitivity and good judgment. On the one hand, the *gabbaim* must take the feelings of the bride and groom into consideration if a 'no-frill' wedding will really embarrass them.

They *may not* assume the attitude, "Look, you are a helpless charity case. How dare you tell us about your preferences. Take it or leave it!" On the other hand, both the young couple and the gabbaim should be careful not to squander charity funds on superfluous trifles (see *Tzedakah UMishpat,* Chapter 3, note 3).]

4) A person may use his *maaser* money for the mitzvah of *hachnassas kallah* (*Taz, Yoreh Deah,* 249:1; *Ahavas Chesed,* Chapter 19:2).

5) A poor man *should not* refuse to accept charitable assistance in order to marry off his children, especially one who has many daughters and is faced with overwhelming expenses. Indeed, if the pauper assumes an attitude of false pride and refuses to lower himself to accept assistance, it is as if he shed blood! (*Shach, Yoreh Deah* 255:1, based on *Yerushalmi* and *Smag*).

6) Moreover, even someone who usually is not in the category of a poor person in regard to general needs, because he has enough to support himself under ordinary circumstances, may accept help from charity sources if he is unable to afford the great expenses entailed in marrying off children (*Maharsham, Responsa,* Vol. I, 45 and *Tzedakah UMishpat,* Chapter 2, note 6). {See *Hanisuin K'hilchaso,* Chapter 1, 13-20 for more details on this subject}

Non-Jews

⋖§ Giving to Gentiles

The Talmud (*Gittin* 61a) teaches: We provide financial support to the gentile poor along with the Jewish poor, and we visit the gentile sick along with the Jewish sick, and we bury the gentile dead just as we bury the Jewish dead [but not in the same cemetery (*Rashi*)], because these are some of the ways that foster harmonious, peaceful coexistence.

This ruling is codified by the *Shulchan Aruch* (*Yoreh Deah* 151:12). *Shach* (ibid.) makes it clear that we support gentile beggars not only when they come together with a group of Jewish paupers, but even when they come on their own; we support the non-Jewish poor under all circumstances.

Responsa Avnei Yashpei (*Yoreh Deah*, Vol. I, 193) maintains that one may deduct charitable donations to non-Jews from his *maaser* obligation. However, he does suggest that the concept of *Darkei Shalom*, i.e. fostering harmonious, peaceful coexistence only applies when the non-Jew asks for Jewish aid. If the non-Jew does not request Jewish aid and does not expect it, there is no obligation to volunteer a contribution because there are sufficient non-Jews who can support those causes.

⋖§ Are Gentiles Obligated to Give Charity?

The prophet cried out: הִנֵּה זֶה הָיָה עֲוֹן סְדֹם אֲחוֹתֵךְ, גָּאוֹן שִׂבְעַת לֶחֶם וְשַׁלְוַת הַשְׁקֵט הָיָה לָהּ וְלִבְנוֹתֶיהָ, וְיַד עָנִי וְאֶבְיוֹן לֹא הֶחֱזִיקָה, *Behold, this was the*

sin of Sodom, your sister: She and her daughters were arrogant, they were filled with an overabundance of bread and enjoyed peaceful serenity, but she did not support the hand of the poor and the needy (*Ezekiel* 16:49). In his commentary to *Sanhedrin* (56b), *Rabbeinu Nissim* (*Ran*) proves from these words of admonition that even non-Jews, such as the citizens of Sodom, are obligated to support the poor and needy with charity.

R' Naftoli Tzvi Yehudah Berlin (*Netziv* of Volozhin) wrote an enthusiastic letter of approbation to the Chofetz Chaim for his masterpiece *Ahavas Chesed* [printed in front of the Hebrew version of this work]. The *Netziv* explains the words of the prophet Ezekiel quoted above as demanding that *all* men support the needy. Social welfare, he observes, is the very cornerstone of humanity, as the Psalmist sings: עוֹלָם חֶסֶד יִבָּנֶה, *The world is built on kindness* (*Psalms* 89:3). One of the most fundamental differences between man and beast is that all men share a sense of brotherhood which instinctively binds them to help one another. The Torah alludes to this in its precise description of the birth of the first two brothers, saying: . . . וַתֵּלֶד אֶת קָיִן. וַתֹּסֶף לָלֶדֶת אֶת אָחִיו אֶת הָבֶל, *And she* (*Eve*) *gave birth to Cain. . . And she continued to give birth* to *his brother*, *to Abel* (*Genesis* 4:1,2). It would have been sufficient to write, אֶת אָחִיו הָבֶל, *to his brother, Abel.* The second אֶת, *to,* is superfluous. Rather it comes to emphasize that from the very moment that Cain, the first child born, had a brother, Cain was instantly bound *to* him with bonds of brotherhood, which obligated Cain to be concerned for his brother's well-being.

⋖§ A Lower Level of Charity

The Talmud (*Bava Basra* 10b) states: Rabban Yochanan Ben Zakkai said to his students: My children! What is the explanation of that which Scripture said, צְדָקָה תְרוֹמֵם גּוֹי וְחֶסֶד לְאֻמִּים חַטָּאת, *Charity exalts a nation, but the kindness of the nations is a sin* (*Proverbs* 14:34)? [Rabban Yochanan found two difficulties in this verse: 1) Why is kindness considered a sin? 2) What is the difference between *a nation* and *the nations*?]

The Talmud lists the answers of each of Rabban Yochanan's numerous disciples. All agree that there is clear Scriptural proof that *a nation* refers to the chosen nation of Israel who are exalted through

tzedakah, whereas *the nations* refers to the gentile world. The essential difference between these two groups is that the Jew gives charity wholeheartedly, only to fulfill the will of God. The gentile, however, donates to charity for selfish reasons such as self-glorification or personal gain.

It appears that this fundamental difference in attitudes is based on the following point. The Torah trains the Jew to believe that he is not the master of his money; he is not the owner of his wealth. The bedrock of our faith is that we do not "make a living," rather, we "take a living" from the generous hands of Almighty God, Who furnishes us with all of our sustenance. Anything extra which He provides is surely not ours; but is the portion of the needy, which God has given us the privilege of distributing to them on His behalf. Therefore, the person imbued with the Jewish attitude toward charity has nothing to boast about, because the money he gives out is not his own. On the contrary; he is humbled by the privilege of being the representative of the Almighty!

The gentile attitude, however, is that man's brains and brawn have earned him his assets, and they are his rightful property. Does not the toiler deserve full credit for sharing his hard-earned gains with others? May he not take pride in sacrificing his assets for the pauper? Herein lies the erroneous attitude of the gentile nations. Thus, it is clear that if a gentile would sincerely adopt a Jewish attitude toward charity, he too would be exalted by charity.

◄§ The Wicked Do Not Deserve the Merit of Charity

In the fourth chapter of the Book of *Daniel* we read of the terrifying dream which Nebuchadnezzar, king of Babylon, dreamt. In his dream he saw a huge tree whose height reached the sky and was visible to the whole earth. Its branches were beautiful, its fruits were plentiful, and there was food for everyone on it. Then a voice came out of heaven and proclaimed: "Chop down the tree and destroy it!" The king's great Jewish adviser, Daniel, interpreted the 'dream of the tree' as presaging the dire punishment that awaited the wicked emperor as a punishment for his erecting a golden image of himself for all to bow down to. With that act the king demonstrated his arrogance and defiance of God's will. Then, apparently without being asked, Daniel

advised Nebuchadnezzar that the terrible retribution might be averted if the king undertook to dispense gifts of charity to the poor.

Daniel said (4:24): לָהֵן מַלְכָּא מִלְכִּי יִשְׁפַּר עֲלָךְ, וַחֲטָאָךְ בְּצִדְקָה פְרֻק וַעֲוָיָתָךְ בְּמִחַן עֲנָיִן, הֵן תֶּהֱוֵא אַרְכָה לִשְׁלֵוְתָךְ, "Nevertheless, O king, let my advice be agreeable to you. Redeem your error with charity, and your sin through kindness to the poor — perhaps there will be an extension to your tranquility." Rashi (ibid.) quotes the Midrash Tanchuma (Mishpatim 4) which says: "Do not let it enter your mind that under normal circumstances Daniel the tzaddik would have given such wonderful advice to the wicked Nebuchadnezzar who was an enemy of Almighty God. Rather, Daniel witnessed the terrible plight of his Jewish brethren, the exiles who had been plundered of all they possessed and now suffered from dire poverty. Deeply stirred by his compassion for them, Daniel said to Nebuchadnezzar, "These poor people whom you exiled from their homeland are starving and thirsty and naked. Open up your treasuries and sustain them; perhaps this merit will avert the harsh decree of your dream." In truth, Daniel was absolutely certain that, at best, Nebuchadnezzar would only follow his advice for a short time, and in the long run his selfishness and arrogance would not let him continue to help others.

At first, Nebuchadnezzar took Daniel's advice and for twelve months he opened up his treasure houses to sustain the impoverished Jews. But after twelve months he forgot his terrifying dream and his heart grew hard. One day, as he was strolling through his palace grounds, he heard the clamor of the throngs of paupers who crowded around his treasury to receive their stipend. He asked his entourage, "What is this din that I hear?" They answered, "This noise comes from the poor Jewish exiles who are clamoring for their stipend!" At that moment a mean spirit entered Nebuchadnezzar, and he looked upon the wretched Jews with an evil eye. עָנֵה מַלְכָּא וְאָמַר הֲלָא דָא הִיא בָּבֶל רַבְּתָא, דִּי אֲנָה בֱנַיְתַהּ לְבֵית מַלְכוּ, בִּתְקַף חִסְנִי וְלִיקָר הַדְרִי, The king exclaimed, and said "Is this not the great Babylon which I have built up into a royal house with my powerful strength and for glorification of my splendor?" (Daniel 4:27). Nebuchadnezzar thundered, "If not for all of my money how could I have built up such a vast empire? I cannot afford to squander any more money on these Jews!" Immediately he ordered that the distribution of charity cease. עוֹד מִלְּתָא בְּפֻם מַלְכָּא קָל מִן שְׁמַיָּא נְפַל, לָךְ אָמְרִין נְבוּכַדְנֶצַּר מַלְכָּא מַלְכוּתָה עֲדָת מִנָּךְ. וּמִן אֲנָשָׁא לָךְ טָרְדִין, While the words were still in the king's mouth, a voice fell from heaven: "To you, King Nebuchadnezzar, we say: The kingdom has departed from

you; and we are driving you from mankind" (Daniel 4:28-29). The Holy
One, Blessed is He, cried out to him, " O wicked one! What caused you
to enjoy this reprieve of twelve months of tranquility? Only the charity
which you performed!"

Midrash Tanchuma concludes: "If charity has so much power to
protect a non-Jew from punishment, how much more so can it save a
Jew from all harm!"

The Sages (*Bava Basra* 4a) fault Daniel for advising an idolater and
blasphemer like Nebuchadnezzar how to escape retribution (cf.
Rambam Hilchos Rotzeiach 12:15). According to one view, Daniel was
punished by being demoted from his high post at the royal court
during the reign of the Persians. According to another view, his ordeal
in the lion's den was punishment for his advice to the wicked king.

⊷§ Kindness Is a Safe Bridge Over a Raging River

The Chofetz Chaim (*Shem Olam,* Chapter 8) provides a deeper in-
sight into the story of Nebuchadnezzar and his downfall. Whoever
performs even one mitzvah acquires for himself a defense advocate,
who is actually the angel created by that very mitzvah. This advocate
seeks the welfare of its 'creator' in every possible way. Here on earth
the advocate saves him from sickness and suffering and brings him
every kind of goodness. After death, the protecting angel defends him
in order to save him from punishment and to bring him to eternal life.

On the other hand, whoever commits even a single sin creates his
own worst enemy, an adversary who seeks to destroy him physically
and spiritually, in this world and the next.

Nebuchadnezzar, through his many sins, surely had a vast army of
'adversaries' who sought his destruction and demanded that he be
punished in accordance with Strict Justice. Nevertheless, the moment
Nebuchadnezzar began performing acts of charity and kindness, the
good advocates he now created restrained the power of Strict Justice.
But the moment Nebuchadnezzar regretted his charity, his security
system disintegrated, and the floodgates of fury were flung wide open!

Kindness is like a long bridge spanning a raging river, supported by
sturdy pillars set deep in the earth. When the pillars are removed, the
entire bridge immediately collapses into the maelstrom below.

Benevolent actions create the angels who support us on the pathway of life. We must therefore be forever vigilant and never neglect our obligation to charity even for a moment, lest our callousness cause the very foundations of our existence to disintegrate.

◄§ Keeping Ahead of the Competition

Yesod Vshoresh Haavodah (*Shaar Hakollel,* Chapter 10) cites the words of the *Zohar Hakadosh* (*Parshas Pikudei*) which explains that there are destructive forces which travel from place to place all over the world. When a person encounters them he is in great peril. The only merit that can protect a person from harm is charity. If the Jewish people intensify their acts of kindness while the other nations ignore the poor, then the sacred forces will be strengthened. If, however, the other nations intensify their acts of charity and social welfare, while the Jewish people grow lax in their pursuit of charity, then the forces of impurity and destruction have the upper hand — Jewish people are in grave danger of being overwhelmed and crushed by these destructive powers. When the charity of the non-Jews surpasses that of the Jews, then all of the blessings which God sends down from heaven to the Jewish people are diverted toward the benevolent gentile nations.

In contemporary times, the nations of the world are involved in charity and welfare on unprecedented levels. In the United States as well as other countries there are countless government programs to assist people in every conceivable type of health crisis or financial difficulty. Many of our *gedolim* have given the United States the title of '*Malchus Hachesed,*' the empire of loving-kindness. But the *Zohar* indicates that precisely this *chesed* is cause for concern. For when our acts of charity lag behind those of the nations, the blessings originally earmarked for us will be diverted to them, and the forces of evil and destruction will leave them alone and attack the Jewish people.

◄§ Pity for the Poor Foils a Plot

R' Yechezkel Halevi Landau, author of the classic *Responsa Noda BiYehudah,* served as Rav of Prague from the year 1745 until his death in 1793, at the age of 80.

Shortly after the *Noda BiYehudah* came to Prague, he saw a boy crying bitterly in the middle of the street. It was a gentile youth whose stepfather, one of the bakers in town, had sent him to peddle a basket full of bread. The youngster had succeeded in selling all of his wares, but somehow had lost all the money he made. He was afraid to return home to his brutal stepfather, because of the merciless beating he could expect.

Upon hearing the story from this frightened child, the Rav was filled with pity for him and gave him the entire sum he was missing.

Late one night, many years later, the *Noda BiYehudah* heard a tapping at his door. When he opened the door he found standing there a gentile man about 40 years old.

"The esteemed Rabbi surely doesn't recognize me," the man said, "but perhaps you will remember an encounter with a young boy who was crying bitterly in the town square many years ago. With his generosity, the Rabbi saved me from a terrible beating at the hands of my cruel stepfather.

"Now I have come to return the favor," the gentile continued. "I have come to inform the Rabbi about a terrible plot that the bakers in town have schemed for your upcoming Pesach holiday. Every year, on the day after the holiday, the Jews come to buy bread from the gentile bakers. This year, all of the bakers in Prague have conspired to poison the bread they will bake for the Jews. Of course, the bakers are keeping this diabolic plot a closely guarded secret, and I would be in mortal danger if they discovered that I am revealing this to you. Nevertheless, in appreciation for what you did for me, I have come to warn you of this peril."

Throughout the entire Pesach festival the *Noda BiYehudah* kept this terrible secret to himself. But on the night of the eighth day of Pesach, announcements were made in all the shuls in Prague that the next morning, the last day of *Yom Tov*, only the Great Synagogue would be open. There, the Rav would give an important sermon that everyone must attend.

The city was in great suspense. It was clear that something very unusual had occurred. The next morning, the main synagogue was full to bursting.

"Mistakes can and will always happen," the Rav began. "We made a mistake this year in calculating the calendar and we actually began the Pesach holiday one day too early! This means that the holiday does not conclude tonight as expected. Rather, the holiday continues

for one more day, until tomorrow night. Therefore, we must all refrain from eating any bread or *chametz* until tomorrow night."

The Jews of the city of Prague had great respect for their esteemed Rav and therefore asked no questions about his strange, inexplicable ruling. The next day, the gentile bakers of the city were confounded when not a single Jew came to buy bread as they would every year.

Meanwhile, the *Noda BiYehudah* alerted the authorities to this murderous plot. The police raided the bakeries, confiscated the poisoned loaves, and threw the conspirators into prison.

Thus the actions of the *Noda BiYehudah* illustrate the truth of the words of our Sages (*Gittin* 61a): We provide financial support to the gentile poor along with the Jewish poor, because these are the ways that foster harmonious, peaceful coexistence.

(*Gedolei Hadoros,* Vol. I, p. 371).

Worthy and Unworthy Recipients

✑ Unworthy Recipients

Kindhearted and compassionate Jews are always eager to lavish *tzedakah* upon the poor. However, one of the main obstacles that deters them from giving as much as they should is the gnawing doubt whether they are being deceived by an unscrupulous solicitor. The customary system of charity collection lends itself to suspicion. First of all, most solicitors are total strangers who burst into our lives from out of the blue. Often, they appear at our doorstep recently arrived from a foreign land and from a different background. In many cases, they are requesting funds for individuals or causes that are entirely unfamiliar to us. Additionally, the extraordinary tales of tragedy and woe they share with us are at times hard to believe. Furthermore, even if the heartbreaking stories are true, it is difficult to gauge what level of assistance the solicitor deserves.

King Solomon captured our concern over misrepresentation in his wise words, יֵשׁ מִתְעַשֵּׁר וְאֵין כֹּל, מִתְרוֹשֵׁשׁ וְהוֹן רָב, *Some pretend to be rich and have nothing, but others act poor and have great wealth* (*Proverbs* 13:7).

✑ Pursue Charity With Honesty

The Mishnah (*Peah* 8:9) teaches:
Whoever does not need to take charity but does take will not

depart from the world until he does indeed become dependent on people. And anyone who is neither lame, nor blind, nor crippled, but makes himself appear like one of these, will not die of old age until he becomes like one of these; as it is said: צֶדֶק צֶדֶק תִּרְדֹּף, *Justice, justice, shall you pursue* (*Deuteronomy* 16:20).

Maharsha explains that this latter statement refers even to an authentically poor person who is worthy of receiving charity, but pretends to have physical defects in order to arouse greater sympathy for his cause.

Tosafos Chaddashim (ibid.) observes that the verse from *Deuteronomy* (16:20) quoted in the Mishnah can also be translated to mean, צֶדֶק, *Charity,* צֶדֶק תִּרְדֹּף, *shall you pursue justly.* Pursue it legitimately because of your true misfortune —your poverty — but do not pursue charity deceitfully by posing as disabled.

◆§ The Privilege of Giving to Worthy Recipients

The Talmud (*Sukkah* 49b) teaches: R' Elazar said, "Greater is the performance of *chesed,* acts of kindness, than the giving of *tzedakah,* charity, as it says: זִרְעוּ לָכֶם לִצְדָקָה קִצְרוּ לְפִי חֶסֶד, *Sow for yourselves charity and reap according to kindness* (*Hosea* 10:12). [Scripture identifies charity with sowing and kindness with reaping. Reaping is superior to sowing because] when a person sows, he might later enjoy the grown produce or he might not enjoy it. However, when a person reaps, the produce has grown already and he will surely enjoy it!" [This means that one cannot always be confident that one's charitable funds have reached the needy. There are some who pass themselves off as paupers but who are actually wealthy frauds. Acts of kindness, on the other hand, are always acts of kindness, whether they are bestowed on rich or poor (*Meromei Sadeh, Iyun Yaakov*).]

The Talmud (*Sukkah* 49b) continues: Perhaps you will say that whoever attempts to leap to the highest level of charitable giving may take one leap and he will be guaranteed success. Scripture therefore states: מַה יָּקָר חַסְדְּךָ אֱלֹקִים, *How precious is Your kindness, O God!* (*Psalms* 36:8). [Not always does one merit to dispense his charity in the desired manner and it is indeed a precious privilege to give to worthy, genuinely needy indigents. One must devote himself with

great effort to run after charitable opportunities in order to merit to give to worthy recipients (*Rashi*).] Perhaps one may think that this rule also applies to a God-fearing person [that he too may not merit the privilege of giving properly to worthy recipients]; Scripture therefore states: וְחֶסֶד ה' מֵעוֹלָם וְעַד עוֹלָם עַל יְרֵאָיו, *But the kindness of Hashem is forever and ever upon those who fear Him*. (Psalms 103:17). [Among those with genuine fear of heaven, the ideal performance of charity and kindness is far more prevalent because God Himself helps them to give to worthy recipients (*Ben Yehoyada*).]

⋘ Pray to Give Properly

Sefer Chassidim (61) writes: King Solomon advises: טוֹב מְלֹא כַף נָחַת מִמְּלֹא חָפְנַיִם עָמָל וּרְעוּת רוּחַ, *Better is one handful of pleasantness than two fistfuls of toil and mean spirit* (Ecclesiastes 4:6). This means that it is preferable to give a relatively small amount of charity, a mere *handful,* to righteous, God-fearing people who have fallen upon hard times than to give a large amount, *two fistfuls,* to bad people who will use the charity money in ways which defy the will of the Almighty. Therefore a person should always pray fervently that Hashem should send him worthy paupers with whom to fulfill the mitzvah of *tzedakah* properly.

⋘ Pray for Worthy Recipients

R' Aharon Roth writes (*Shulchan Hatahor; Shaar Hatzedakah,* Chap. 3): Every time a person sets aside money for charity he should pray to Hashem that this money should actually go to worthy recipients and not to people who are not needy at all. God Himself is the Great Distributor of charity and it is in His hands to direct our charity funds to the right people.

⋘ Be Grateful for Imposters

The Talmud (*Kesubos* 68a) teaches: Rabbi Elazar said: Come and let us show gratitude to swindlers (who pretend to be paupers in

order to solicit charity) for if it were not for them we would be sinning daily when we ignore the poor. [Now that there are swindlers, we have an excuse for our behavior. The swindlers cause us to distrust even the genuine poor (*Rashi*).]

The Jerusalem Talmud (*Peah* 8:8) relates similar incidents: When he was a youngster, the great Talmudic Sage, Shmuel, wandered between two shacks where the beggars lived. As he stood outside, he heard one beggar say to the other, "Which plates and tableware should we eat with today — our gold service or our silver service?" Young Shmuel ran home and told his father that he had uncovered fraudulent collectors! His father calmed him, saying, "We should be very grateful for these imposters; if not for them we would have no excuse for giving *tzedakah* improperly."

Once, the great Sages, R' Yochanan and Reish Lakish, were entering the hot baths in Tiberius when they were approached by a beggar who cried out, "Take care of me!" They told him that they would take care of him after they completed their therapeutic baths. Later, when they emerged from the baths they found the man dead. They said, "Since we didn't take care of him while he was alive, let us take care of him after his death." As they were preparing his body for burial they found a big purse stuffed with money hidden underneath his clothes. They remarked, "This demonstrates the truth of what R' Avuhu said in the name of R' Eliezer, 'Let us be thankful for the swindlers. If not for them we would be punished every time a pauper solicits us and we fail to give him immediately!' "

⋙ Kosher Money Goes to Kosher Hands

The Talmud (*Bava Basra* 9b) relates: "He who pursues *tzedakah* opportunities, the Holy One, Blessed is He, will extend to him coins with which to perform *tzedakah*. R' Nachman bar Yitzchok says the Holy One, Blessed is He, will extend to him upright people through whom to perform *tzedakah*, so that he will receive reward for his charitable act."

A person must merit the privilege of having his *tzedakah* go to proper recipients!

R' Avrohom Kahaneman, son of the Ponevezher Rav, approached a wealthy widow of advanced years for a sizable donation to the

Ponevezh Yeshiva in Bnai Brak. The woman responded generously to his request and remarked that she contributed to many such worthy causes. Rabbi Kahaneman knew that this woman, widowed for fifteen years, was without anyone to advise her where to contribute her money, and she herself was certainly not familiar with the makeup of the many charitable organizations and yeshivos that existed. Quite curious, he asked the lady which other causes she supported. The woman listed more than a dozen excellent causes to which she contributed handsomely. Rabbi Kahaneman asked in surprise, "May I ask who gave you the sound advice to support these worthy charities?" "No one," the widow replied. "The money my husband left me is 'kosher money'; all of it was earned honestly and none of it came through *chillul Shabbos*. I pray constantly that in his merit, my *tzedakah* should always end up in the right hands, and apparently my request is always granted!"

~§ Collecting for the Yeshiva of Volozhin

The following story about R' Chaim of Volozhin, which took place in the first decade of the 19th century, when R' Chaim was organizing financial support for his new yeshiva, illustrates a similar connection between the intent of the donor and the worthiness of the recipient. The Rosh Hayeshiva hired a collector, a *meshulach*, to travel on behalf of his institution. When the collector returned from his travels, R' Chaim would go over his ledgers. He noticed that a certain farmer was one of the yeshiva's most generous supporters. He would consistently give the *meshulach* a donation of 50 rubles, which was a tremendous amount in those days.

After a while, the *meshulach* suggested to R' Chaim a dramatic change in the collection system. Hitherto, the collector would travel with "public transportation," which was provided by wagon drivers who took a number of passengers from destination to destination at certain appointed times. The problem with this, explained the collector, was that often he would complete his rounds in a certain town in one day and he would sometimes have to wait for days until a wagon left for his next stop. This caused a great waste of time and a loss of revenue to the yeshiva. The collector suggested that it would be worthwhile for the yeshiva to purchase its own horse and wagon

and to engage the services of a permanent driver. This innovation would provide the *meshulach* with the opportunity to collect from many more people in a shorter period of time, thus increasing the yeshiva's income dramatically. R' Chaim approved this sensible idea and the new system was introduced in short order.

When the collector returned from his travels on his own wagon R' Chaim examined the ledgers and it was clear that the new system was indeed successful. Income had increased significantly. There was, however, one problem. R' Chaim noticed that on this trip the farmer who had been one of the yeshiva's staunchest supporters had not given anything at all. The *meshulach* told R' Chaim that he himself was shocked when the farmer refused to given him a penny, but the farmer minced no words when he explained his refusal. He said, "Since I see that the yeshiva now has its own horse and wagon, I will no longer give. It was my great privilege to donate money so that *yeshiva bachurim* could sit and learn. I was delighted to provide them with meals and lodging. But I will not waste my money to feed horses and pay the wagon driver. My money is dedicated exclusively to Torah and nothing but Torah! As a matter of fact, I am so upset at the yeshiva for buying a horse and wagon that I regret all the money I gave in the past and I wish I had not given it!"

Upon hearing this, R' Chaim was deeply pained that the farmer regretted his generous donations of the past. Therefore, R' Chaim said that he would like to accompany the collector on his next visit to the farmer.

⊷§ Mind Over Money

When R' Chaim arrived at the farmer's home, the simple man was amazed to see the Rosh Hayeshiva himself at his door. He greeted R' Chaim with reverence and awe. R' Chaim asked him if he had ever studied *Gemara*. His response was, "No." Had he ever studied *Mishnah*? "No." Had he ever studied *Chumash*? The farmer replied that once he had studied a bit of *Chumash*. R' Chaim leafed through the *Chumash* and showed the farmer a few verses in *Parshas Vayakhel*:

וַיֹּאמֶר מֹשֶׁה אֶל בְּנֵי יִשְׂרָאֵל רְאוּ קָרָא ה׳ בְּשֵׁם בְּצַלְאֵל בֶּן אוּרִי בֶן חוּר לְמַטֵּה יְהוּדָה. וַיְמַלֵּא אֹתוֹ רוּחַ אֱלֹקִים בְּחָכְמָה בִּתְבוּנָה וּבְדַעַת וּבְכָל מְלָאכָה. וְלַחְשֹׁב מַחֲשָׁבֹת לַעֲשׂת בַּזָּהָב וּבַכֶּסֶף וּבַנְּחֹשֶׁת, *Moses said to the Children of Israel, "See,*

Hashem has proclaimed by name, Bezalel, son of Uri, son of Hur, of the tribe of Judah. He filled him with Godly spirit, with wisdom, insight and knowledge, and with every craft — to think thoughts, to work with gold, silver, and copper (Exodus 35:30-32).

R' Chaim turned to the farmer and said: "Let's study these verses very carefully. First God informs Moses that Bezalel is endowed with the most sublime wisdom that a human being can comprehend. The Talmud (*Berachos* 55b) says that Bezalel knew the innermost mysteries and secrets of Creation and he knew the Divine formulas and the combinations of holy letters with which God created heaven and earth, as it says, *He filled him with Godly spirit, with wisdom, insight and knowledge.* If so, it's difficult to understand the ensuing praises that Bezalel knew how *to think thoughts, to work with gold, silver, and copper.* If Bezalel understood the secrets of Creation, it appears to be insignificant to say that he was a goldsmith and a silversmith. It's like saying that a great rabbi is a *gaon,* a *tzaddik,* a leader , and he also knows how to fix broken benches!"

R' Chaim then proceeded to give the deeper explanation of these verses. "The *Mishkan,* Tabernacle, had many different levels of sanctity. The highest was the Holy of Holies where the Holy Ark resided, with the Tablets inside and the golden Cherubs on top. Next was the *Heichal,* the Sanctuary. Then came the Courtyard, and so on. Naturally, every contributor wanted his money to go for the construction of the Holy of Holies or the Holy Ark or the Cherubs. But if every donor would have his way, there would be nothing left for the Sanctuary or the lesser environs. Therefore, the Torah reveals to us a new aspect of the amazing wisdom that only Bezalel possessed. He knew how *to think thoughts, to work with gold, silver, and copper.* This means that he could look at the precious materials donated to the Tabernacle and *think thoughts* — discern the true intentions of their donor. If the intentions of the donor were pure and holy, and his sole desire was to glorify the House of God, then his material was placed in the Holy of Holies. If his motivation was less pure, his donation was placed in a lesser position."

R' Chaim concluded his lesson to the farmer, "Nowadays, we no longer have a Bezalel to make these delicate determinations. But we have faith that the Almighty Himself directs all donations to their appropriate destinations. When a person, such as yourself, donates money to the yeshiva out of pure love for Torah and its students, he can rest assured that every penny he gives will be used to feed and

lodge the most diligent students and to illuminate the *beis hamedrash* so that they can study Torah. The person whose intentions are not so pure — his money will find its way to buy furniture for the yeshiva. And the person who gives under duress and has no interest in Torah study at all — his money will be used to buy a wagon and feed the horse!"

◈ The Privilege of Giving to Worthy Recipients

Sefer Chassidim (332) writes: Sometimes two people arrive in a town at the same time to collect charity — but they are very different from one another. One collector is a worthy person who deserves support. The other collector is unworthy. But then the townspeople give more money to the unworthy collector than to the worthy one. Let this not disturb you, for the townsfolk did not merit the privilege of supporting the worthy man. That is why, when the worthy man enters a town, Providence arranges that the unworthy one also comes, so as to divert people's attention from the man who truly deserves charity.

Secondly, it could be that the worthy man is being punished for the sins of his ancestors. Perhaps they were people of means who only gave charity when and where it brought them honor and glory. Therefore, they ignored worthy collectors and willingly gave to unworthy people if that brought them more recognition and honor. Measure for measure, their descendants will suffer for their misdeeds, and people will ignore them in favor of unworthy recipients. This is what King David had in mind when he cursed the descendants of the wicked, saying: אַל יְהִי לוֹ מֹשֵׁךְ חָסֶד, וְאַל יְהִי חוֹנֵן לִיתוֹמָיו, *May he have no one who extends him kindness, and may no one be merciful to his orphans* (*Psalms* 109:12).

◈ Ban the Wealthy Not the Poor

A beggar once came to the city of Kovno, Lithuania and collected a large sum of money from the Jewish community. Later, the

people discovered that this collector was an imposter; in reality he was a wealthy man. Everyone was so incensed that the trustees of the community decided to pass an ordinance prohibiting all beggars from collecting in the city of Kovno.

When R' Yitzchok Elchonon Spector, the illustrious Rav of Kovno, heard about the proposed ordinance, he came before the trustees and addressed them. He told the community leaders that although he sympathized with them, he had an objection to their proposal. "Who deceived you, a needy person or a wealthy one?" asked R' Yitzchok Elchonon. "You men know full well that you were duped by a wealthy man feigning poverty. If you wish to pass an ordinance, you should issue a ban against wealthy people from collecting alms. But why should you issue a ban against truly needy paupers?" (*Ethics From Sinai*, Vol. III, pp. 121-22).

❧ The Stumbling Block of Unworthy Recipients

Rava expounded: What is the (deeper) meaning of that which is written (*Jeremiah* 18:23): וְאַתָּה ה׳ יָדַעְתָּ אֶת כָּל עֲצָתָם עָלַי לַמָּוֶת, אַל תְּכַפֵּר עַל עֲוֹנָם וְחַטָּאתָם מִלְּפָנֶיךָ אַל תֶּמְחִי, וְיִהְיוּ מֻכְשָׁלִים לְפָנֶיךָ, בְּעֵת אַפְּךָ עֲשֵׂה בָהֶם, "*You, Hashem, know all their counsel against me for death; do not pardon their sin and do not erase their transgression from before You. Let them be made to stumble before You; at the time of Your anger, act against them!*" Jeremiah cried out before the Holy One, Blessed is He: "Master of the Universe, even when these wicked men perform acts of charity, make them stumble by sending them people who are not worthy of receiving charity, so that they will not receive a reward for their deeds" (*Bava Kamma* 16b).

Nimukei Yosef (ibid.) notes that a person is denied reward for giving charity only when he *knows* that the recipient is unworthy. If one does not recognize the recipient, one receives reward for giving him charity even if in fact he is not worthy, since one's intentions were good. This is borne out by the Gemara (*Bava Basra* 8a), which relates that during a famine Rabbi Yehudah Hanassi opened his food storehouses indiscriminately to the entire public and did not check to see if everyone was worthy.

⤽ Unworthy Donors Undermine the Yeshiva

Rabbi Yissochor Mayer, the *Rosh Yeshiva* of Yeshivas HaNegev in Netivot, Israel, related the following ruling to me in the name of his Rebbe, the Ponevezher Rav, Rav Yosef Kahaneman. One may accept donations to a yeshiva or a charitable cause from a nonobservant Jew as long as the donor sincerely desires to support Torah and to give *tzedakah.* In such a case this will be a real merit for this person and undoubtedly the mitzvah of *tzedakah* will bring him closer to God and to sincere repentance. However one should not accept charity or Torah support from a nonobservant Jew if he has no interest in the mitzvah and only gives because someone is putting pressure on him.

In this vein, the Ponevezher Rav related the following story about R' Chaim of Volozhin. Once, a nonobservant Jew offered him a donation for his renowned Volozhiner Yeshiva. R' Chaim refused to accept the gift saying, "I can't afford to take this money, it's much too expensive!" R' Chaim explained, "When the prophet Jeremiah cursed the sinners, he wished for them something terrible. He begged of God that even if these people should want to give charity they should give it to unworthy recipients. He asked God to engineer events so that money from unworthy people would go to support unworthy people. Similarly, if I take money for my yeshiva from unworthy people, God will see to it that unworthy students will come to the yeshiva so that the tainted money will go to them. These unworthy students will surely have a deleterious influence on the yeshiva and may even ruin it. So I simply can't afford to take money from unworthy donors for it will undermine everything I am trying to accomplish."

⤽ One Out of a Hundred

R' Chaim of Sanz had a different attitude towards fraudulent charity collectors. He said: "Some people are reluctant to give to one hundred genuine paupers out of fear lest one of them be a fraud. On the other hand, I feel that the merit of *tzedakah* is so great that I would gladly give to one hundred beggars even if only one was truly in need!" (*Darkei Chaim* p. 137).

⊱ The Danger of Being Overly Scrupulous

R' Chaim Sanzer lived for *tzedakah,* and gave out charity lavishly. Once he gave a sizable sum to someone who turned out to be an imposter. This upset his *Chassidim* very much, and they asked the Rebbe why he gave *tzedakah* to such an undeserving person.

"Let me tell you a story about the Rebbe R' Zusya of Hanipoli," said R' Chaim. "R' Zusya had an admirer who considered it his great privilege to help support his pure and holy Rebbe, and periodically he would give R' Zusya a generous sum of money. This open-handed *Chassid* achieved considerable success in his business ventures and prospered. Once this man came to Hanipoli and was told that R' Zusya had just left town in order to be with his own master, R' Dov Ber, the great Maggid of Mezritch. The *Chassid* said to himself, 'If the Maggid of Mezritch is R' Zusya's master, he obviously must be a greater *tzaddik* than R' Zusya himself. Why bother supporting the lesser disciple if I can go right to the top and support the supreme master himself!'

"However, from the very day he discontinued visiting R' Zusya, his business began to fail. The *Chassid* then returned to R' Zusya and admitted, 'I realize that it is not a coincidence, but I fail to understand why my fortunes took a turn for the worse when I became a devotee of your Rebbe, who you must admit is greater than you are.'

"R' Zusya responded, 'You see, my son, the Almighty deals with us according to how we deal with others. As long as you were willing to help support someone as undeserving as Zusya, Hashem dealt generously with you as well, whether or not you were worthy of His blessings. But once you began to be selective and were scrupulous to give your support only to the greatest of *tzaddikim,* then the Almighty reacted accordingly and became more selective in choosing only the worthiest recipients for His bounty."

"R' Zusya concluded: This explains the strange request of the prophet Jeremiah: *Master of the Universe, even when these wicked men perform acts of charity, make them stumble by sending them people who are not worthy of receiving charity,* **so that they will not receive a reward for their deeds** (*Bava Kamma* 16b). How could a holy prophet, a lover of all Jews, possibly wish ill for his brethren, even if they were sinners? The answer is that in heaven they always deal with people 'measure for measure.' If a person is scrupulous and demanding and only gives his charity to worthy people, heaven will only bestow its

blessings upon him when he is worthy. But if he gives charity even to the unworthy, heaven will be lenient and kind hearted toward him even when he is unworthy. Therefore, the prophet Jeremiah was actually blessing these wicked people, saying, 'Dear God, do these wicked people a favor and let their charity money go to unworthy people, so that You can be good to them even when they are unworthy! Thus, these wicked people will *not* receive the 'reward,' the appropriate punishment they deserve, for their [evil] deeds.'"

R' Chaim Sanzer concluded: "As long as I am not overly selective as to whom I give my *tzedakah,* then I can hope that Hashem will be merciful and generous even to someone as undeserving as I am. But if I will begin to be scrupulous and exacting and only give charity to those who are truly deserving, then what right have I to ask Hashem for anything for myself?"

◈§ Why Charity Resembles Scales of Armor

The Talmud (*Bava Basra* 9b) says: It was taught in the name of R' Elazar: "What is the meaning of that which is written: וַיִּלְבַּשׁ צְדָקָה כַּשִּׁרְיָן, *He donned charity like a coat of mail?* (*Isaiah* 59:17). Why is charity compared to a coat of mail? To tell you: Just as in the manufacture of this mail each and every metal scale combines with all the others to form a large coat of mail, so with respect to giving charity each and every penny one donates combines with all the others to comprise a large sum."

The comparison of charity to armor is very appropriate. Armor must cover every part of the body because the soldier never knows where the enemy arrow or weapon will strike him. Similarly one should be careful to give charity to all who ask, without being concerned lest this beggar is a fraud. Because if you give to everyone you will surely have given to at least one worthy indigent, and that charitable act may well prove to be the merit which will save the donor from harm.

◈§ Attitude Is Everything

King Solomon shares with us a foolproof method for unmasking a fraudulent collector. תַּחֲנוּנִים יְדַבֶּר רָשׁ וְעָשִׁיר יַעֲנֶה עַזּוֹת, *A pauper*

utters supplications, but a rich one responds with brazen words (*Proverbs* 18:23). The nature of the poor man is to be broken hearted and humble. He is not aggressive, loud and pushy. He softly pleads for compassion and makes no demands. On the other hand, the man who is not truly needy will betray himself by his demeanor and tone of voice. When he collects, he places tremendous pressure on those from whom he solicits and makes exaggerated demands of people who owe him nothing. Try as he may to hide his status, the imposter cannot disguise his brazen arrogance which will always show through.

✺ Do Not Be Gracious to the Ungrateful

The Steipler Gaon (*Bircas Peretz*, addendum to *Parshas Beshalach*) offers us a vital lesson in the distribution of charity. He bases his lesson on the words of the Talmud (*Sanhedrin* 92a): R' Elazar said: "If a person does not have understanding, it is forbidden to have mercy on him." And R' Elazar also said: "If one gives his bread to a person who has no understanding, suffering will come upon him [the misguided donor]."

The Steipler Gaon explains that '*a person who does not have understanding*' does not refer to a small child or a mentally retarded adult. To the contrary, he says, one must have tremendous sympathy for those who are mentally handicapped and one should give them special consideration. Rather, this designation refers to a person whose mental faculties are perfectly sound, but he lacks one of the most essential character traits — appreciation, *hakaras hatov*. Through the Talmud's description of the ungrateful person as '*a person who does not have understanding,*' the source of his ingratitude is being pinpointed. This person has a warped sense of reality and lacks a true understanding of who he is and who his benefactors are.

In his twisted mind, the ingrate entertains illusions of grandeur; he imagines himself to be an extraordinary human being who is entitled to special gifts and privileges. The ingrate is convinced that he is doing his benefactors a favor by accepting their money. After all, it is a unique honor and merit to support so illustrious a personage as he! Additionally, the ingrate has no respect for his benefactors and looks upon them with contempt and disdain. He does not recognize their

charity as an act of kindness, but rather looks down on his benefactors as weak 'pushovers' who cannot say no to his entreaties. In his heart, the ingrate gloats triumphantly, "Aha! Look at this new victim who has fallen into my clutches! Oh how I will suck out of him all that he is worth!" As far as the ingrate is concerned, this new victim is permanently entered into the list of those who are subservient to him and must fulfill his wishes.

Although it seems obvious why it would be unwise to help such an ingrate, the Steipler Gaon goes to the effort of listing *five* separate reasons why it would be harmful to do so.

1. One who is kind to such a misguided ingrate only feeds his illusions of grandeur and reinforces his arrogance and false pride.

2. The more one gives him, the less he appreciates! Thus, what you think is helping him is really harming him, because his character flaws become more deeply entrenched.

3. The ingrate is now caught in a terrible bind. He really does not appreciate anything his benefactor has done for him, yet how can he ignore his patron's kindness and self-sacrifice? This predicament forces the ingrate to fall to an even lower level of ignominious behavior and he now repays the good with bad. He makes outrageous demands of his benefactor, and when they are not met to his satisfaction, he makes believe that he has been deeply hurt and insulted by the benefactor's 'selfishness and insensitivity' in an attempt to pour guilt all over his hapless victim.

4. The ignoble conduct of the ingrate arouses the ire of his benefactor whose eyes are finally opened to the real nature of the person he helped. Now he is filled with deep contempt and loathing for this ingrate. This, in and of itself, is a major crime against the benefactor; because when a person practices charity, the result should be that he enjoys a heart brimming with joy and love for the beneficiary, but here, instead of love, the heart of the patron is poisoned with bitter resentment.

5. The nature of the ingrate is to ask for help again and again. And he does not merely ask for help — he demands it. It is coming to him. He has his rights; and his patron is forever duty bound to him! And when the donor refuses to give again, or attempts to give less than his original donation, the ingrate gets very angry and acts as if the donor is stealing from him.

This is why the Talmud juxtaposed the two warnings: "If a person

does not have understanding, it is forbidden to have mercy on him" and "If one gives his bread to a person who has no understanding, suffering will come upon him [the misguided donor]." Because, inevitably, whoever is kind to an ungrateful person is doomed to suffer from gross ingratitude, insults, quarreling, unwarranted guilt and animosity! Fortunate is he who follows the wise advice of our Sages!

⋙ The Scourge of Ingratitude

Sefer Chassidim (1026) writes: Never take pity on the cruel hearted, and never feel mercy for the person who has no mercy on himself, and have no compassion for the ingrate. The 'cruel hearted' is the person who cheats his fellow, and lies and steals and swindles and spreads evil tales. The one 'who has no mercy on himself' is the spendthrift who wastes his money and throws it away on worthless things. Moreover, he refuses to listen to those who advise him on how to manage his money wisely. Despite their counsel he continues to squander his resources. This category includes the gambler who loses his money and then begs people to help him pay off his gambling debts. The gambler pleads, "Please, have mercy on me! I will be so humiliated if I fail to pay off my gambling debts! My good name and credit will be ruined!" Pay no heed to his entreaties. Let him suffer humiliation! If you give him money you are only feeding his addiction and helping him to sin.

The 'ingrate' is the person who accepts the largesse of his benefactor and then goes out and tells everyone the falsehood, "You know what that man gave me? The garbage which he throws out to feed his dogs!" This is the kind of person who asks for many favors and large amounts of money. As long as his benefactor gives him all he wants, he is quiet and never even thanks him. But the moment his longtime benefactor dissatisfies him even once and gives him a little less than he expected, then he forgets everything he did for him in the past and despises him for the present disappointment.

Sefer Chassidim concludes by observing that a person who does not show gratitude to someone who helped him is likewise incapable of thanking Hashem for providing his benefactor with the wherewithal to have helped him.

◄§ Do Not Be Intimidated

Birkei Yosef (Yoreh Deah 257:6) relates that a poor man once approached the local gabbai tzedakah and threatened him, "If you don't increase my customary tzedakah allocation, I will go and work on Shabbos in order to make more money." The Rabbi ruled that the gabbai tzedakah should not be intimidated by such threats. If there is really no more money in the charity fund or it would pose a great burden to raise more money, the gabbai tzedakah is not obligated to go to extremes just because someone makes outlandish demands.

Similarly, we find in Sefer Chassidim (317) the case of two people who came for tzedakah but there was only enough money in the fund to help one of them. One was an upright, righteous man; the other, a wicked, profligate wastrel. Although it is clear that the righteous pauper takes precedence, in this case the wicked man threatened that if his requests were ignored he would abandon Judaism and convert to another religion, or, at the very least, he would go out and commit a crime or a sin. The author rules: "Give the charity funds to the righteous man who deserves it and let the wicked man go to Gehinnom!"

◄§ Perverse Righteousness

Sefer Chassidim (318) relates the story of a pauper who had nothing, yet was unable to admit his poverty. He refused to accept any form of charity, arguing, "If I take charity funds, I am stealing money that could go to help poor people!" He would borrow money from many people, promising that he would invest the money and pay them back at a designated time. But he never managed to pay anyone back, and was forced to borrow even more money from even more people, invoking God as his guarantor. Again he would fail to pay, epitomizing the verse, לֹוֶה רָשָׁע וְלֹא יְשַׁלֵּם, *The wicked man borrows but repays not* (Psalms 37:21). All the while the pauper continued to justify himself saying, "It is better to borrow and fail to pay than to accept charity and take away from the poor!" This misguided man is truly wicked because he borrows when he knows he cannot repay, desecrates the Name of God, and discourages people from making loans to worthy recipients in the future. About this perverse person King Solomon said, *Do not be overly righteous or excessively wise; why be left desolate?* (Ecclesiastes 7:16).

❧ We Are Not Responsible for Lazy Loafers

The Torah very clearly delineates the parameters of our obligation to help others, stating: כִּי תִרְאֶה חֲמוֹר שׂנַאֲךָ רֹבֵץ תַּחַת מַשָּׂאוֹ וְחָדַלְתָּ מֵעֲזֹב לוֹ עָזֹב תַּעֲזֹב עִמּוֹ, *If you see the donkey of someone you hate lying under its burden, would you refrain from helping him? — you shall help repeatedly **with him*** (*Exodus* 23:5). The Talmud (*Bava Metzia* 32b) teaches that if the animal's owner is not present or if he is physically unable to participate in the task of lightening the crushing load, the passerby must do it himself, and, if necessary, render assistance time and again. But if the owner is able bodied and can help his animal but refuses to do so because he expects the passerby to do it himself because it is a mitzvah, the passerby is excused, because the Torah qualified the commandment saying that it must be performed *with him,* with the animal's owner.

Kli Yakar (ibid.) observes: From here we learn how to respond to a segment of the paupers in our time who demand that the community support them with *tzedakah* while they refuse to do any gainful work even when they are capable of doing so. All they do is hurl insults at the community for failing to give them enough money. This is not what God had in mind when he commanded us to give charity. The will of God is that the poor man should make every effort to work and earn as much as he can for his family. If, after all his effort, he still finds himself with a deficit, then each and every Jew is obligated to support him again and again — even one hundred times.

❧ Help the Poor to Help Themselves

On this same subject *Sefer Chassidim* (1035) writes: There is a type of charity which does not seem to be charity but is really the most desirable charity in the eyes of God. This is when someone helps the poor man earn a living for himself, such as when he has an item or a book to sell which no one wants to buy and this benefactor purchases it from him. Or if one sees a poor man who is a skilled scribe who is unemployed, it is a great mitzvah to hire him to write and there is no finer form of *tzedakah,* because he is toiling over his craft and you are guaranteeing him a profit. But if you encounter a pauper who knows

the craft of the scribe or one who is suited to learn this craft [or another gainful skill] yet refuses to make the effort, this person is unworthy of charity. The prophet (*Isaiah* 5:7) denounced such paupers saying, לְצְדָקָה וְהִנֵּה צְעָקָה, *[He had hoped for] charity, but behold, it is a [scandalous] outcry!* And he repeated this denunciation of those who prefer charity to gainful employment saying, כִּי לֹא עַם בִּינוֹת הוּא, עַל כֵּן לֹא יְרַחֲמֶנּוּ עֹשֵׂהוּ וְיֹצְרוֹ לֹא יְחֻנֶּנּוּ, *For it is not a nation of understanding; therefore, its Maker will not show it mercy and its Creator will not be gracious unto it* (*Isaiah* 27:11).

Responsa Minchas Tzvi (Vol. III, Chapter 10) cites numerous *halachic* sources which support the above ruling of *Sefer Chassidim,* but he adds a cautionary note. One must always research every pauper carefully because no two situations are the same. Ostensibly, it may appear that the poor man is perfectly capable of working; however, he may actually be suffering from health problems which make it impossible for him to do any type of physical labor. Moreover, today, more than ever, we are painfully aware of many people who are physically fit, but who suffer from mental or emotional disorders, from mild to severe, which render them unsuited for a normal job.

Therefore, one must be very careful before he disqualifies someone from receiving charity and should be careful not to ruin the pauper's reputation. If one lacks the time or ability to thoroughly research the pauper's situation, then although he does not have to give him a sizable gift, he should give at least a *matanah muetes,* a small, token donation.

⇜ Verify the Facts

If you are told that a charity recipient is not really needy, you are nevertheless obligated to continue to give him *tzedakah* until his true status has been verified by careful inquiry (*Sefer Chofetz Chaim* 6:1, footnote).

⇜ The Pauper's Reputation Is His Livelihood

R' Shimon Sofer, son of the great Chasam Sofer of Pressburg, was a *gaon* and *tzaddik* in his own right. In his position of Chief Rabbi

of Cracow, Poland, he accomplished great things for his city and for all of Israel. However, his lofty Rabbinic position did not deter R' Shimon from humbly going from door to door to collect money for the poor.

Once, a very wealthy householder fell upon hard times and lost everything. He was forced to accept charity in order to provide the bare necessities for his family. In order to ease the plight of this unfortunate man, R' Shimon went around collecting on his behalf. When the Rav of Cracow approached a certain well-to-do man for a sizable donation, the fellow responded with audacity and asked, "Why is the Rav wasting his time helping this man who has always been one of the richest men in town? Certainly, he can't be that poor that he needs *tzedakah*! He must have money stashed away!"

R' Shimon calmly responded to this brazen assault and said, "You know, for the longest time I have been perplexed by a puzzling verse. King Solomon says, אַל תִּגְזָל דָּל כִּי דַל הוּא, a *Do not rob the poor man, for he is a poor man* (*Proverbs* 22:22). This warning makes no sense; why does King Solomon single out the poor man? Is it not prohibited to steal from both rich and poor alike? However, after hearing your accusations I finally have an explanation. In reality, the poor man possesses nothing worth stealing. The only thing of value that he does possess is his reputation for being poor, because this will arouse compassion and the rich will give him charity. Therefore, Scripture teaches, *Do not rob the poor man,* of what? Of the reputation he has, *for he is a poor man.* The same warning applies to you. Do not rob your once-wealthy neighbor who has fallen on hard times of his reputation as being needy and worthy of assistance" (*Chassidim Mesaprim*).

Summary of Halachah

Summary of Halachos of *Tzedakah* and *Maaser*

THIS IS A BRIEF DIGEST OF ISSUES TREATED MORE
COMPREHENSIVELY IN THE CITED SECTIONS OF THE
BOOK. PLEASE REFER TO THE SOURCES REFERENCED.

T*zedakah* and *maaser* are two interrelated aspects of the giving of
charity. (See *Maaser* — pages 122-124.)

➳ How Much to Give

1. Minimum: One-third of a shekel per year. This is equal to
 approximately four to five US dollars). (See *Maaser* — page 122.)
2. Maximum: Distributing one-fifth of annual earnings or profits is
 considered 'giving with a good eye.' Under special circumstances
 one may give even more than 20 percent of income to charity. (See
 Chomesh — pages 147, 149-151.)
3. Mediocre: One-tenth of annual earnings or profits — any less is
 considered 'giving with a bad eye.' (See *Maaser* — page 147.)

⮌ What Income Is Subject to Maaser

1. When a person begins to tithe, he must immediately give away ten-percent of his capital. In other words, if he starts out his career with money he received as a gift from his family or with an inheritance, he must give away 10% of his principal. Subsequently, he merely tithes his new profits. (See *Maaser* — pages 123, 129.)

2. An employee tithes his salary and bonuses and certain fringe benefits. (See *Maaser* — pages 129, 138.)

3. The investor tithes realized gains and dividends from his investments, subtracting losses. (See *Maaser* — pages 131-132.)

4. One must give *maaser* from a gift of money, a monetary inheritance, or a dowry. (See *Maaser* — pages 136-138.)

5. Money which is withheld from a person's salary and set aside to pay his income tax is not liable to *maaser* because the wage earner never received this money. However, if the taxpayer receives a refund from the I.R.S., the refund amount is considered to be new income from which *maaser* must be separated. (See *Maaser* — pages 133-136.)

⮌ What Income Is Exempt

1. Non-monetary gifts or inheritances. (See *Maaser* — pages 136-138.)

2. Monetary gifts earmarked for a specific purpose. (See *Maaser* — page 137.)

3. When somebody pays another person's bills or repays his debts, the beneficiary is exempt from giving *maaser* on this type of gain, because he did not receive any direct cash value. (See *Maaser* — pages 137-138.)

4. Corporations, public or private, have a legal identity in the eyes of the law, independent of their shareholders. Since *maaser kesafim* is a personal liability, the corporation itself has no tithing obligation. Individual shareholders are responsible for tithing from their own dividends or from profits from the sale of appreciated shares of stock. (See *Maaser* — page 133)

✑ When and How to Calculate Maaser

1. When a person undertakes to fulfill the mitzvah of *maaser,* he should keep in mind that he is not required to do so because of a Torah or Rabbinic obligation, but rather, he is following a hallowed Jewish custom. This allows one to employ certain leniencies in the practice of this custom. (See *Maaser* — pages 126-127.)

2. When one begins to practice the custom of tithing, one should state that he accepts the custom *bli neder,* without a vow. (See *Maaser* — page 127.)

3. It is a good idea to set up a separate bank or checking account where one deposits one-tenth of all money he earns or gains immediately upon receipt of the funds. However, it is often tedious and time-consuming to put *maaser* money into a separate account. Therefore, one may forego the establishment of a separate *maaser* fund and may keep all of his money in one place, as long as he keeps a ledger in which he records the amount of the tithe he owes on all of his income and how much charity he has disbursed. (See *Maaser* — pages 123, 129-130.)

4. A businessman should keep a special account book in which he enters his net earnings from business profits after deducting his business ['cost of production'] expenses. (See *Maaser* — pages 129-130, 132, 134.)

5. A specific date should be designated which will mark the end of an accounting period, at which time "the books will be closed" and the calculations will be made. This should be done at the very least, once a year, and more frequently if that is convenient. (See *Maaser* — page 129.)

6. At the time of accounting the person will calculate his annual profits from all of his dealings, and calculate his losses as well. The losses are deducted from his gains, and the remainder is the amount he must tithe. (See *Maaser* — page 129.)

7. During the entire accounting period, he should carefully record all of the sums he dispensed as charity. Even the smallest amount disbursed to the beggars who came to his door should be included. These charitable donations are deducted from his *maaser* obligation. (See *Maaser* — page 129.)

8. If, after balancing his accounts, one discovers that he still owes money to *maaser,* he should immediately set aside the amount he still owes and distribute it without delay. (See *Maaser* — page 130.)

9. If there are no poor people at hand to whom he can distribute the money, he may hold on to the balance of the *maaser* until the proper occasion for *tzedakah* presents itself. In the meantime, he may use this money for his own purposes and needs. When a poor person solicits him, however, he must give him some of that *maaser* immediately. (See *Maaser* — page 130.)

10. If he has no money available at that time, but he expects more *tzedakah* funds to be available to him soon, he is obligated to borrow money from elsewhere in order to respond to the request of the poor at once. (See *Maaser* — page 130.)

11. Sometimes, at the time of accounting, one discovers that his charitable donations throughout the year or the accounting period exceeded the amount he owed to *maaser* — he actually gave more than he was obligated to give. Some authorities allow him to carry the balance forward to the next year. He may deduct the amount of charity he gave this year in excess of his *maaser* debt from the amount he will owe to *maaser* in the following year. When a person establishes his *maaser* fund he should have in mind that, when necessary, he will balance his accounts in this way. (See *Maaser* — page 130.)

⊰ Paying One's *Maaser* Obligation in a Nonmonetary Fashion

1. The full value of all nonmonetary items or real-estate which one donates to the poor or to other worthy causes, is fully *maaser*-deductible. (See *Maaser* — page 144.)

2. If a professional or a craftsman donates his or her time or services to the poor, this may also be considered as a monetary donation to *tzedakah.* The donor should have in mind before he serves the poor that he wishes to deduct the value of his services from his maaser debt. (See *Maaser* — pages 144-145.)

3. Discounts: If a merchant sells an item to a poor person at a

discounted rate, or a professional charges him a reduced rate for his services as an act of charity, the amount of the discount is *maaser*-deductible. (See *Maaser* — page 145.)

4. If two merchants have the identical item for sale and one charges more than the other, if the higher priced merchandise is being sold by a poor man who qualifies for *tzedakah,* one may purchase it from the poor man and deduct the extra amount he paid from his *maaser* account. (See *Maaser* — page 127-128.)

◄§ Who Is Considered a Poor Person

1. The basic rule is that someone lacking a steady income and without sufficient funds in hand to support himself for one year, qualifies for charitable assistance. (See *Maaser* — pages 128-129, *Prioritize Your Giving* — page 372, *Support of Torah* — page 338.)

2. A person should try as much as possible to avoid taking *tzedakah.* (See *Prioritize Your Giving* — page 372.)

3. A person who earns enough to cover his ordinary expenses may be unable to pay for an extraordinary need, such as marrying off a child or paying for medical expenses. He is allowed to collect *tzedakah* for these purposes. There are different opinions as to whether the person who is 'selectively poor' is obligated to tithe the funds people donate for these special purposes. (See *Prioritize Your Giving* — page 373, *Hachnassas Kallah* — pages 397, 405.)

4. Two poor people can give their charity to one another. (See *Maaser* — page 139.)

◄§ Vaad HaTzedakah — Community Charity Research

1. The community may not legislate regulations which would prohibit individuals from collecting from door to door at any time. (See *The Right Way to Give* — pages 177-180.)

2. The community may establish a *Vaad HaTzedakah,* staffed by a

trained professional who will examine and verify the credentials and letters of recommendation presented by unknown collectors. The *Vaad* then issues an official document attesting to its findings and encouraging the local residents to assist the bearer of the document. (See *The Right Way to Give* — pages 181-182.)

3. The purpose of the *Vaad* is to facilitate and increase the distribution of *tzedakah,* not to impede it. The community may not *require* any collector to be certified by the *Vaad.*

◄§ Distribution of Charity Funds — Maximum Personal involvement

1. Our primary *tzedakah* responsibility is to those who, despite their hardship, maintain their dignity and do not collect from door to door. The level of our responsibility toward them is determined by our relationship with them and their personal status. (See *Prioritize Your Giving* — page 370.)

2. These special relationships may be divided into three broad categories:
 A. Relatives.
 B. Torah scholars and Torah institutions.
 C. Close neighbors — the closer the social and geographic proximity, the great the responsibility.
 (See *Prioritize Your Giving* — page 373-375.)

◄§ Priorities for Recipients

A. Relatives

1. The top priority is to support oneself and one's family. There is no closer relative than oneself. A poor person may separate the tithe and then give it to himself. A regular wage earner, under normal circumstances, *may not* use his charity or *maaser* money to pay for his regular household expenses. (See *Maaser* — pages 124, 128-129.)

2. Parents: It is preferable not to use charity money to support one's

parents, but if it is necessary, one may do so. Halachah accords them top priority for their children's *tzedakah*. (See *Prioritize Your Giving* — page 374.)

3. Dependent children: The definition of this category depends on the prevailing social norms. In earlier times, a child was considered a dependent only until the age of six! Today the general norm is for parents to support their children until they are old enough to go out and find employment that will make them financially self-sufficient. In our society the earliest age of 'independence' would be no sooner than after finishing high school. (See *Maaser* — pages 139-140.)

4. A parent *should not* support his dependent children from his *tzedakah* money. Since such support is a personal obligation, it may not be discharged with *maaser* or *tzedakah* money. However, if a dependent has a special need which the parent cannot cover with his regular income, the dependent is considered 'poor' and his needs become his parent's *tzedakah* priority. (See *Maaser* — pages 140-141.)

5. Once a child reaches the age at which he should be independent and self-supporting but is not, the parent has the right to pay for this child's support from *maaser*. (See *Maaser* — page 140.)

6. Tuition: Under ordinary circumstances, a parent *may not* pay the tuition for his child's elementary education from his *tzedakah* or *maaser* funds, because a child's education is a parent's personal obligation for which *maaser* funds may not be used. However, if the parent knows that the full tuition fee is beyond his means, he may stipulate with the school that he will give them a portion of the tuition as a charitable donation and that amount may be deducted from *maaser*. This is the preferred procedure. However, even if the school doesn't agree to this, it is sufficient for the parent to have in mind when he agrees to the tuition contract that a certain amount is tuition and a certain amount is a *maaser*-deductible donation to the school. (See *Maaser* — pages 140-141.)

7. Parents who committed themselves to supporting married children who are dedicating themselves to Torah study for a number of years, may pay their financial commitment from their *maaser*. However, they should give no more than half their *maaser* money to their own children or close relatives, and the other half should be for

all other charities (*Responsa Chasam Sofer, Yoreh Deah* 233. See also *Maaser* — pages 141-142, *Prioritize Your Giving* — page 374.)

8. Grandchildren come after children. (See *Prioritize Your Giving* — page 374.)

9. Grandparents come after grandchildren. (See *Prioritize Your Giving* — page 374.)

10. Brothers or sisters come after grandparents. (See *Prioritize Your Giving* — page 374.)

11. All other relatives come later. (See *Prioritize Your Giving* — page 374.)

B. Status — Torah Scholars

1. After one has provided for his close relatives, support of Torah scholars and institutions has top priority. (See *Prioritize Your Giving* — page 374, *Support of Torah* — pages 384-385.)

2. The man who possesses greater Torah knowledge takes precedence over the man of lesser Torah knowledge. The wife of a Torah scholar enjoys the same privileges as her husband. (See *Prioritize Your Giving* — page 375.)

3. For those on the same level of Torah scholarship, the order of priorities is based on *yichus,* or family status -a Kohen comes first, then a Levi and then a Yisrael. (See *Prioritize Your Giving* — page 375.)

4. If a person's Rebbe, his Torah teacher, is in need, then he takes precedence over all other Torah scholars, even those who surpass him in their knowledge. (See *Prioritize Your Giving* — page 375.)

5. When contributing *tzedakah* to yeshivos or Torah schools, a parent should give first to the institution where his own children are learning. Just as one should give his relatives top priority for charity, similarly, one should give top priority to the institutions that educate his relatives. (*Tzedakah Umishpat,* chapter 6, fn. 35. See also *Prioritize Your Giving* — page 374.)

6. It is a mitzvah to support Torah scholars who are researching, writing and publishing volumes of Torah scholarship to enhance the knowledge of the Jewish people. (See *Support of Torah* — pages 390-391.)

C. Geographic Proximity

1. Relatives come before close neighbors, close neighbors before residents of the same city, residents of one's city come before residents of all other cities. (See *Prioritize Your Giving* — page 375.)

2. To qualify for the status of a poor dweller of a city it is necessary to establish residence there for a minimum of thirty days. (See *Prioritize Your Giving* — page 375.)

3. Even when one category has precedence over another, some money should always be left over to help those in the lower category as well. (See *Prioritize Your Giving* — page 375.)

4. One should not give all of his charity to one poor person, even a close relative. (See *Prioritize Your Giving* — page 380.)

5. Feeding the hungry takes precedence over providing clothing for the naked. (See *Prioritize Your Giving* — page 375.)

6. Providing for the needs of a woman takes precedence over taking care of a man. (See *Prioritize Your Giving* — page 375.)

7. The poor of the land of Israel take precedence over the poor of the Diaspora. The poor of Jerusalem come before the poor of the other cities in the Holy Land. (See *Prioritize Your Giving* — pages 377-378.)

✺ Minimal Personal Involvement

1. If the collector is someone who randomly solicits everyone he can approach and goes from door to door, from shul to shul, from wedding to wedding, and from passerby to passerby, then the individual donor is absolved of maximum personal responsibility to support him. The beggar has chosen to solicit the entire Jewish world for support and has removed the 'mask of shame' from his face. (See *Prioritize Your Giving* — pages 370-371.)

2. The primary responsibility one has to this collector is not to embarrass him by turning him away empty-handed. A minimal donation of a quarter (of a US dollar) or even a dime, is usually acceptable. (See *Prioritize Your Giving* — pages 370-371.)

3. One is not obligated to become personally involved with random collectors. One need not invite them into his home and he may

give the token donation to them (in a respectful manner) as they stand outside his door. Women and children alone at home should be instructed *not to let strangers into the home!* (See *Prioritize Your Giving* — pages 370-371.)

4. A peremptory perusal of the documents displayed by the random collector is quite sufficient. It is not necessary to carefully research the letters of recommendation and the credentials of the random collector (or to make phone calls for verification) because it is beyond the ability of most people to properly verify such documents and the halachah doesn't require it of them. The succinct instructions of our Sages apply across the board: 'One who collects from door to door — give him (or her) a minimum, token donation.' (See *Prioritize Your Giving* — pages 368-370.)

5. There are, however, some logical variations in the level of 'minimum donation.' To the beggar who merely sticks out his hand to everyone, the smallest amount will suffice. But if someone goes around from door to door and shows documents to corroborate that he has a special plight for which large sums are needed, a bit more substantial amount (at least a dollar, or a even several dollars) is appropriate if one can afford it (R' David Feinstein and R' Tzvi Spitz. See also *Prioritize Your Giving* — page 371.)

6. One is not obligated to respond to requests through mass mailings or telephone solicitations. If one does wish to respond, a token donation is sufficient. One may keep any gifts or stamped envelopes that accompany a mail solicitation without making any payment. (See *Prioritize Your Giving* — pages 378-380.)

⋖§ *Chazakah* — *Established Obligation*

1. Once a person starts to support a needy individual or a Torah institution, he should not stop supporting them or decrease his level of support without a reason. If one merely says, "I am tired of supporting the same poor people or the same schools and I just feel like making a change," that would be inappropriate. (See *The Right Way to Give* — page 198.)

2. However, if circumstances have changed, one has the right to change his method of giving. Examples of these changes are: A)

The donor has taken an interest in other indigents or other institutions that he now feels need his support more than the original beneficiaries of his charity. B) The donor now has needy relatives who need his increased support. C) The donor finds that he now has less money for charity than he once had and must re-organize his priorities for allocating his *tzedakah* funds. (See *The Right Way to Give* — page 199.)

৺ Hachnassas Kallah

1. *Tzedakah* administrators, *gabbaei tzedakah*, who have charity money in their possession, should use it to marry off poor young women, for there is no greater charity than this. (See *Hachnassas Kallah* — page 404.)

2. It is preferable to use one's *tzedakah* money to marry off a poor orphan boy or girl than to use it for the purchase of a *Sefer Torah*, if the community already possesses a usable Torah scroll. (See *Hachnassas Kallah* — page 404.)

3. The preferred way is to give the poor man enough money to cover all his needs. For example, if the poor man wants to get married, we help him with all the wedding expenses, we rent him a dwelling, and we furnish it with beds and with everything else the home needs. If the bride or groom come from a more distinguished family, then the charity fund should make them a wedding on a higher scale, even though this will cost more money. (See *Hachnassas Kallah* — page 404.)

4. A poor man *should not* refuse to accept charitable assistance in order to marry off his children, especially one who has many daughters and is faced with overwhelming expenses. Moreover, even someone who usually is not in the category of a poor person in regard to general needs because he has enough to support himself under ordinary circumstances, may accept help from charity sources if he is unable to afford the great expenses entailed in marrying off children. (See *Hachnassas Kallah* — pages 397, 405.)

5. A person may use his *maaser* money for the mitzvah of *hachnassas kallah,* to marry off the children of poor people. (See *Hachnassas Kallah* — page 405.)

6. A person who doesn't have enough money to marry off his own children may use his own *maaser* money to pay for their wedding expenses. When he separates his *maaser* in the first place he should have in mind that he retains the right to use this money for all types of good causes, not just pure charity. Also, when the father initially commits himself to paying certain wedding expenses he should have in mind that he wishes to use his *maaser* money to pay for these costs (*Responsa Maharsham*, vol.1, 32; *Responsa Tzitz Eliezer*, vol. 9, 1. See also *Hachnassas Kallah* — page 397, 405.)

7. Before the time arrives to marry off their children, parents may anticipate their future financial needs and prepare for them. They may start a long-term savings plan to put away money in a special bank account to be used exclusively to pay for their children's weddings. They may use their *maaser* money for this as well (*Tzedaka Umishpat*, chapter 6, fn. 14. See also *Hachnassas Kallah* — page 397.)

8. *Responsa Minchas Tzvi* (chapter 7:14) observes that it is unfair for a parent to put away his *maaser* money in a bank account for the benefit of his own children long before his children need it, meanwhile depriving other indigents of assistance. The preferred method is for the parent to use the *maaser* money he sets aside as a *gemach*, a free loan fund, with the understanding that when his children come of age, these funds will be used for their wedding expenses.

9. Today it is a very common practice for parents who live in Israel to travel all over the world to collect money to marry off their children. The main thing they are collecting for is to buy apartments for their soon-to-be-wed children. Many donors feel that this is an unwarranted extravagance. Unfortunately, this is not the case. In Israel where rental apartments are the exception to the rule and most people own their apartment dwellings, most parents will not consider a *shidduch* unless there is an understanding that both sets of parents will help their children purchase an apartment of their own. [Of course, it's not necessary to have a luxury apartment on prime real-estate, and a simple flat in an outlying area will do.] Therefore, the purchase of an apartment is considered a legitimate part of the mizvah of *hachnassas kallah* (R' Tzvi Spitz).

❧ Free Loans to the Poor

1. The Chofetz Chaim recommends that when a person tithes his income, he should designate two-thirds of his funds for outright gifts to the poor, while retaining one-third to be used for giving the needy free loans. When the free-loan fund has grown to the point that there is enough money to cover the likely needs of his community, he can stop setting aside a third of his charity money for free loans and he can use all of his *maaser* monies for gifts to charity. (See *Maaser* — page 143.)

2. If one lends money to a poor person and suspects that he might not be able to repay, there are various opinions as to whether and how he can deduct the defaulted loan from his *maaser* account. (See *Maaser* — pages 143-144.) R' Moshe Feinstein ruled that it is preferred that at the time of the initial loan to the poor man, the lender should stipulate that if the borrower's poverty prevents him from repaying, the lender will forgive the debt and deduct it from his *maaser* obligation (*Iggros Moshe, Yoreh Deah* Vol. I, 153).

3. If a poor person requests a loan, one may borrow money from the bank for the sake of helping the poor man and make the interest payments on the loan, deducting these payments from his *maaser* account (*Iggros Moshe, Yoreh Deah* Vol. III, 93).

4. If a person has money earning interest in a savings account and he withdraws these funds in order to lend them to a poor person, the interest that the lender is forfeiting is considered a charitable donation and he may deduct this sum from his *maaser* account (*Iggros Moshe,* ibid.).

❧ Collection of Charity

1. In earlier times, the Jewish congregation was usually an autonomous, self-governing entity invested with the power to enforce both the laws of the Torah and its own unique rules and regulations of governance. As such, the *kehillah* could assess every one of its members, both rich and poor, to pay a specific amount of money for taxes and for *tzedakah.* Under those circumstances,

the community charity collectors, the *gabbaei tzedakah,* had to be appointed by the *kehillah,* and they were empowered to use various types of coercion — physical, social, verbal — to force recalcitrant individuals to contribute their fair share. Two trustees went around collecting *tzedakah,* and it was distributed by a *Bais Din* of three. (See *Gabbai Tzedakah* — pages 329-330.)

2. Nowadays, our *kehillos* are no longer empowered to enforce *tzedakah* assessments, and charity is generally donated voluntarily. Any individual, man, woman, or even child, has the right to represent any good cause they wish to help and to collect funds in any way they can. Those who contribute do so of their own free will (and at the risk of throwing their money away to an unworthy cause). They are relying entirely on the integrity of the collector. (See *Gabbai Tzedakah* — pages 330, 334.)

3. The self-appointed collector may reimburse himself for any expenses or losses he may have incurred during his collection and he may even take a salary or commission for his efforts. (See *Gabbai Tzedakah* — pages 335-336.)

4. When an organization delegates a fundraiser to collect for it, he may take a percentage of what he collects as a commission. However, there is an oral tradition (attributed variously to the *Chofetz Chaim, the Belzer Rebbe, R' Aharon Kotler*) that the collector may take no more than 49 percent of what he raises, so that the majority of the money should go to the institution. If the collector takes the majority, then he is misleading the donors, because they think they are giving to the cause, while in reality, the major share is going to the collector. (See *Gabbai Tzedakah* — pages 335-336.)

5. Sometimes a campaign is conducted to collect money to help a certain individual who is in need, and the fundraisers find that they have collected more money than necessary. The law is that even the extra funds belong to the person they were collected for. Moreover, even if the beneficiary died, the money belongs to his heirs. (See *Prioritize Your Giving* — pages 380-382.)

6. Under certain circumstances it is permissible for a charity collector to share information with other collectors by revealing the names of the people who gave him generous contributions. (See *The Right Way to Give* — pages 181-182.)

∝ From Whom Not to Accept *Tzedakah*

1. A collector should not accept a relatively large amount of money from a married woman without her husband's permission. (See *Women and Charity* — pages 355-359.)

2. Similarly, he shouldn't take more than a token amount from a minor or even a teenage dependent who has no (known) independent source of income, without parental permission. (See *Maaser* — page 146.)

3. A Jew should neither solicit nor accept alms from a non-Jew in public. All types of public assistance programs do not fall under the category of charity, because these are social benefits that the government provides to all of its citizens who meet certain socio-economic criteria. (*Shulchan Aruch Yoreh Deah* 254:1 and *Shach* ibid. See also *Non-Jews* — pages 408-410.)

4. Donations from a non-observant Jew may be accepted, provided that the irreligious donor makes no attempt to adversely influence or undermine the Torah values of the institution or the individual who is the recipient. (See *Worthy and Unworthy Recipients* — page 423.)

Pledges to *Tzedakah*

1. A pledge to give *tzedakah* must be paid immediately; otherwise one transgresses a negative commandment of the Torah. (See *Pledges to Tzedakah* — page 219-220.)

2. It is best not to make vows to charity lest one forget to honor his commitment and violate a Torah prohibition. However, when circumstances do warrant making a pledge to *tzedakah,* one should add, *bli neder,* 'without a vow'. (See *Pledges to Tzedakah* — page 220.)

3. In general, a Rabbi may annul most vows. However, Rabbis should not annul vows to charity because it will cause a loss to charity causes. (See *Pledges to Tzedakah* — pages 221-222.)

4. According to many, a firm, non-verbal, mental commitment to give *tzedakah is binding* and must be honored. (See *Pledges to Tzedakah* — page 222.)

❧ The Proper Performance of *Tzedakah*

1. No *berachah* is recited before giving *tzedakah*. (See *Right Way to Give* — page 185.)

2. Optimally, *tzedakah* should be given with the right hand, while standing. (See *Right Way to Give* — pages 184-185.)

3. *Tzedakah* should be given with a smiling face and a happy heart accompanied with words of comfort. Even if no financial contribution to the poor can be made, there is still a great mitzvah to encourage and lift the spirits of the needy. (See *Right Way to Give* — pages 171, 174.)

4. It is prohibited to ignore the poor. When collectors knock on the door one should answer their summons. It is especially meritorious to answer the door when it is most inconvenient or annoying, such as when one is famished and is sitting down to a meal. (See *Right Way to Give* — page 179.)

5. When fulfilling the needs of a close relative or a neighbor or some one you know, you should try to do the best you can. For an unknown person collecting from door to door, a minimal donation is sufficient. (See *Prioritize Your Giving* — pages 370-371.)

6. There is no obligation to respond to mail or telephone solicitations. If one wishes to participate, a minimum donation is sufficient. (See *Prioritize Your Giving* — page 378-330.)

7. If you have money to give to charity, but do not have it on your person, you should borrow money in order to respond to a pauper's request. (See *Maaser* — page 130.)

8. When supplying the poor with food or clothing and other non-monetary items, if possible, one should give them the best quality food and garments — not leftovers or shabby, used goods. (See *Right Way to Give* — page 196.)

9. One should make every effort to protect the poor recipient from embarrassment. Therefore charitable gifts should be distributed with utmost secrecy and confidentiality. (See *Right Way to Give* — pages 186-190.)

ᴥ Tzedakah During Prayer

1. It is appropriate to give tzedakah before every prayer. (See Prayer and Charity — pages 260-262.)

2. The custom of the Arizal was to set aside something for tzedakah while standing and saying the words, וְהָעֹשֶׁר וְהַכָּבוֹד מִלְפָנֶיךָ וְאַתָּה מוֹשֵׁל בַּכֹּל, All Wealth and glory come from You, and You alone rule over everything, in the prayer of וַיְבָרֶךְ דָּוִיד, Vayevarech David. (See Prayer and Charity — page 264.)

3. One should not give during the first paragraph of Shema or during Shemonah Esreh. (See Prayer and Charity — pages 264-265.)

4. The gabbai should not collect at a time that he would disturb people's kavanah, concentration, such as during the Torah reading. (See Prayer and Charity — page 265.)

5. According to the strict letter of the law, one is exempt from giving tzedakah throughout the entire prayer service because one who is engrossed in one mitzvah is exempt from another, הָעוֹסֵק בְּמִצְוָה פָּטוּר מִן הַמִּצְוָה. So if someone feels that giving charity will really disturb his prayers, he is not required to do so. However, it is commendable to prepare money in advance so that one can give tzedakah without disturbing his concentration. (See Prayer and Charity — pages 265-267.)

6. The general rule is that when one is randomly solicited for alms, it is sufficient to give a minimum amount, as little as a quarter or a dime, in order not to turn the poor away empty-handed. (See Prioritize Your Giving — pages 370-371.)

ᴥ Tzedakah When Leaving This World

It is highly recommended for a person to intensify his charitable distributions as he prepares to depart from this world. This is the subject of the chapter, "You Can Take It With You," page 276. See also the section on "Wills and Estates" in the chapter "Pledges to Tzedakah," pages 225-226.

This volume is part of
THE ARTSCROLL SERIES®
an ongoing project of
translations, commentaries and expositions
on Scripture, Mishnah, Talmud, Halachah,
liturgy, history, the classic Rabbinic writings,
biographies and thought.

For a brochure of current publications
visit your local Hebrew bookseller
or contact the publisher:

Mesorah Publications, ltd.

4401 Second Avenue
Brooklyn, New York 11232
(718) 921-9000
www.artscroll.com